Henri Matisse

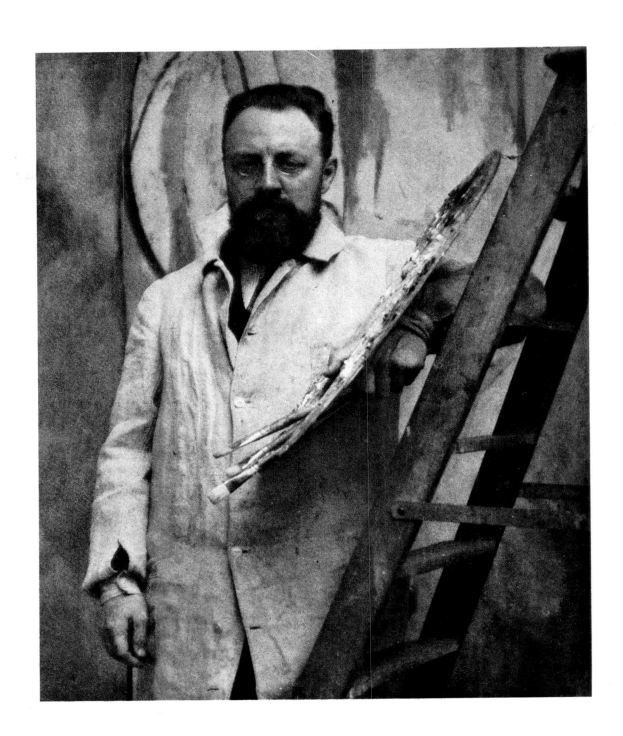

Henri Matisse

A RETROSPECTIVE

John Elderfield

THE MUSEUM OF MODERN ART, NEW YORK

DISTRIBUTED BY HARRY N. ABRAMS, INC., NEW YORK

Published in conjunction with the exhibition "Henri Matisse: A Retrospective" at The Museum of Modern Art, New York, September 24, 1992–January 12, 1993, organized by John Elderfield, Director, Department of Drawings, and Curator, Department of Painting and Sculpture, with the assistance of Beatrice Kernan, Associate Curator, Department of Drawings

The exhibition is sponsored by Philip Morris Companies Inc.

Additional support has been provided by the National Endowment for the Arts and The International Council of The Museum of Modern Art.

An indemnity for the exhibition has been received from the Federal Council on the Arts and the Humanities.

Produced by the Department of Publications
The Museum of Modern Art, New York
Osa Brown, Director of Publications

Edited by James Leggio
Designed by Jody Hanson
Production by Tim McDonough with Marc Sapir, assisted by Rachel Schreck
Composition by Trufont Typographers, New York
Color separation by L S Graphic, Inc., New York / Fotolito Gammacolor, Milan
Printed by L S Graphic, Inc., New York / Grafica Comense, Como
Bound by Novagrafica, Bergamo

Library of Congress Catalog Card Number 92-81515
ISBN 0-87070-433-8 (The Museum of Modern Art, paperbound)
ISBN 0-87070-432-X (The Museum of Modern Art, clothbound)
ISBN 0-8109-6116-4 (Harry N. Abrams, Inc., clothbound)

Published by The Museum of Modern Art, 11 West 53 Street, New York, New York 10019

Clothbound edition distributed in the United States and Canada by Harry N. Abrams, Inc., New York, A Times Mirror Company

Printed in Italy

Frontispiece: Matisse in his studio at Issy-les-Moulineaux, May 1913, with the unfinished *Bathers by a River* (pl. 193). Photograph by Alvin Langdon Coburn.

*See Credits at page 476 for additional notices.

Dedication

This book is dedicated by the Trustees of The Museum of Modern Art to Florene May Schoenborn, their colleague of many years, in gratitude for her extraordinary generosity to the Museum's collection, especially her gift of five masterworks by Henri Matisse.

The achievements of Henri Matisse speak a universal language of creativity and experimentation. It is particularly fitting, then, that we owe this definitive retrospective of Matisse's work to increased international understanding and openness to new ventures. By exploring the entirety of Matisse's artistic career, and by reuniting related but long-separated works, this exhibition casts new light on the artist's genius and his lifelong search for expression through color and form.

In the belief that a spirit of innovation is crucial to the vitality of our society, Philip Morris has been a strong supporter of the arts for nearly thirty-five years. We have sponsored a number of major exhibitions at The Museum of Modern Art, including "'Primitivism' in Twentieth-Century Art: Affinity of the Tribal and the Modern" and "Picasso and Braque: Pioneering Cubism." We are happy to help the Museum illuminate the art of our century through this important exhibition.

MICHAEL A. MILES
Chairman and Chief Executive Officer
Philip Morris Companies Inc.

Contents

FOREWORD

This volume is published on the occasion of the exhibition "Henri Matisse: A Retrospective," which continues one of the most important and longstanding traditions of The Museum of Modern Art's exhibition program: to offer for comprehensive examination and reappraisal works by individual major artists of the modern period. Matisse's work was, in fact, the subject of the very first loan exhibition that the Museum devoted to a single European artist, in 1931, and of the most renowned monograph that the Museum has published, Alfred H. Barr, Jr.'s *Matisse: His Art and His Public*, which accompanied a second major loan exhibition in 1951, three years before the artist's death. That was the last such Matisse retrospective in New York. The present exhibition is intended to show the totality of Matisse's achievement in a way never before possible. While recent exhibitions have been devoted to particular periods or specialized aspects of Matisse's work, there has not been anywhere a full-scale survey for over twenty years, and there has never been one of the scale and ambition of the retrospective recorded here.

As we made our plans for this project, we realized it would require extraordinary generosity and cooperation on the part of a great number of individuals and institutions. We are deeply grateful for the enthusiastic support that we received. The numerous lenders to the exhibition and contributors to its realization are specifically acknowledged elsewhere in this volume. However, we owe very special thanks to those institutions and private collectors who made multiple loans, depriving themselves for a time of large groups of major works. Prominent among such lenders are our colleagues at the Musée National d'Art Moderne, Centre Georges Pompidou, Paris, and The Hermitage Museum, St. Petersburg, as well as those in Baltimore, Chicago, Copenhagen, Moscow, Philadelphia, and San Francisco. Among private collectors, we are especially indebted to the members of the Matisse family, to whom we express our great appreciation for their generosity and encouragement.

For the exhibition in New York and for this publication, the individual guiding force has, of course, been John Elderfield, who conceived, planned, and carried out this complex undertaking. Director of the Museum's Department of Drawings and Curator in its Department of Painting and Sculpture, John Elderfield is internationally recognized as a Matisse scholar with a deep personal commitment to expanding the knowledge, understanding, and appreciation of Matisse's work. His very evident dedication, paired with his superb connoisseurship, has been a crucial element in convincing lenders to make quite exceptional loans to this exhibition. Of the great many colleagues on our staff who have very ably supported his efforts, special thanks are due to Beatrice Kernan, Associate Curator, who worked closely with him on all aspects of the exhibition; to James Snyder, Deputy Director for Planning and Program Support; and to Richard Palmer, Coordinator of Exhibitions. They and fellow staff members in all departments made essential contributions to the realization of this exhibition and publication.

A project on this scale necessarily entails extraordinary costs. We were very fortunate to receive generous sponsorship from Philip Morris Companies Inc., with which we have very successfully cooperated on memorable exhibitions in the past. These have been part of a long and remarkably distinguished record of support from Philip Morris for the arts in all mediums. We are most grateful to Michael A. Miles, Chairman and Chief Executive Officer to Philip Morris, and to the members of its Board of Directors, for their commitment to this endeavor. We owe very warm thanks to Stephanie French, Vice President, Corporate Contributions and Cultural Affairs, for Philip Morris, and to Karen Brosius, Manager, Cultural Affairs and Special Programs, who have given us continuing assistance and encouragement as the project developed.

We are also indebted to the Museum's International Council and to the National Endowment for the Arts for additional grants, in both cases continuing an admirable history of support for significant programs. Individual friends such as Mrs. Derald H. Ruttenberg have provided further assistance, for which we are most appreciative. Finally, the exhibition would not have been possible without the indemnity received from the Federal Council on the Arts and the Humanities. As in other major projects in the past, the interest, help, and advice of Alice M. Whelihan, Indemnity Administrator, in the realization of this complex undertaking have been invaluable.

Richard E. Oldenburg
Director, The Museum of Modern Art

PREFACE

The aim of the exhibition which this publication accompanies is, quite simply, to reveal the full extent and depth of Matisse's achievement, thus to clarify his identity as a modern artist. Toward this end, its more than four hundred works offer a more comprehensive and more completely balanced overview of his art than has hitherto ever been possible.

The first exhibitions that approached full-scale surveys of Matisse's work took place a few years before his death in 1954. These, at the Philadelphia Museum of Art in 1948 and at The Museum of Modern Art in 1951, culminated the broad international interest in Matisse that had grown in intensity since this Museum presented its first survey of his art in 1931. In the years after his death, a new, even broader audience developed, in part because it became increasingly evident just how profoundly his influence was continuing to affect contemporary painting. However, the first posthumous retrospective exhibition, almost entirely of paintings, at the Musée National d'Art Moderne, Paris, in 1956 was not to be followed by another major retrospective until that at the UCLA Art Galleries, Los Angeles, exactly a decade later. (This was the last major retrospective in the United States.) The retrospective at the Hayward Gallery, London, in 1968 was the first show to gather more than one hundred of Matisse's paintings. But it was still impossible to grasp the extraordinary range of his production until over two hundred paintings, along with works in other mediums, were shown at the Grand Palais, Paris, in 1970. This was the last major retrospective exhibition until the present one. Among its important contributions was to represent Matisse's early work in depth for the first time: more than a quarter of the paintings shown were made before 1904. This present exhibition also aims at revealing hitherto relatively neglected aspects of Matisse's achievement, but its main purpose is to provide as fully comprehensive an account as possible of the development of this great artist's work.

The need for such an exhibition became increasingly apparent to us; and not only because the years were passing since the 1970 Grand Palais retrospective. Additionally, our knowledge of Matisse has greatly increased since then, in large part owing to exhibitions that have examined specialized aspects and periods of his career. These have included exhibitions of his drawings, sculptures, and paper cutouts, and exhibitions of his paintings of the so-called Nice period and of his paintings made in Morocco.

While there are other specialized aspects and periods that await the examination they fully deserve, we came to feel that it was more important now to attempt to see Matisse whole. Part of the reason for this was that our collaboration on two of the specialized exhibitions, "The Drawings of Henri Matisse" in 1984–85 and "Matisse in Morocco" in 1990, demonstrated just how difficult it was to arrange exhibitions even of a restricted scope. It therefore seemed imperative, for purely practical reasons, that we move ahead now with plans for a full-scale retrospective if we were ever to hope to present one. More important, however, we felt it was essential that Matisse's art should be seen in the fully comprehensive manner that it deserved. We had organized such an exhibition of Picasso's work in 1980. We could do no less for Matisse, particularly given the fact that our 1931 exhibition was the very first that this Museum had devoted to any individual European artist, and that the founding director of the Museum, Alfred H. Barr, Jr., had done more than anyone else to further appreciation of this great artist.

To realize this project necessarily required the cooperation of all the important public and private collections of Matisse's work. It is only thanks to the generosity of many lenders, whose names are listed on page 475, and to the support of numerous individuals, who are thanked in the Acknowledgments, that we were finally able to achieve the truly full-scale retrospective we had hoped would be possible.

I had myself a personal reason for wanting this to happen. The Hayward Gallery and Grand Palais exhibitions in 1968 and 1970 had opened to me the exceptional profundity and apparently endless fascination of the artist's work. The first exhibition that I organized for this Museum, in 1976, was devoted to Matisse and his Fauve colleagues. Since then, my work on three other Matisse exhibitions and four publications had convinced me that we still do not comprehend the enormity of his achievement. I therefore resolved that when it became possible, the Museum should offer the opportunity of seeing the full range and depth of his work. This would provide, I thought, the foundation for a new evaluation of Matisse. I hope it will.

The focus of the exhibition is Matisse's paintings. We are fortunate in having been able to assemble some two hundred and seventy-five of these works, among them not only those that are widely acknowledged to be his greatest but also some that are less

familiar and some that are unknown except to specialists, never having previously been shown in an exhibition such as this. In every case, however, our aim has been to show art-historically important works of the highest possible quality for each phase of Matisse's career, and thus to show why Matisse so deserves to be esteemed.

Matisse, of course, was not only a painter. We include some one hundred and fifty works in other mediums. For his paper cutouts, which supplanted his paintings in his last years, we adopted the same criteria of selection as we did for his paintings. That is to say, we concentrated on major examples; did not attempt to represent fully the many smaller works; and eschewed works conceived as architectural commissions, both because of their immense size and because our essential focus was the development of his pictorial art. Likewise, we decided not to include ceramics, tapestries, stained-glass windows, and similar works, with the sole exception of one theatrical costume, from 1919–20, which anticipated the methods of the cutouts. And we represented Matisse's work on the chapel at Vence only through a few, extraordinary cutouts.

As for Matisse's sculptures, drawings, and prints, it seemed to us essential that they be represented, for they were intimately related to his work as a painter. And yet, it was clearly unnecessary to attempt retrospective accounts of his work in these mediums, since they have already been the subject of major exhibitions. We therefore were extremely selective, and included them only in those cases where some knowledge of them seemed to be utterly indispensable to an understanding of Matisse's contemporaneous work in color, which is the principal subject of the exhibition.

Undoubtedly, some visitors to the exhibition will miss works that they wish we had included. There are, indeed, a number of works we wish there had been space to include, but even so large an exhibition as this had to have some limit. We were therefore forced to decline some generous offers of works. Conversely, there were a number of works we would have liked ideally to have included, but which were unavailable owing to their fragile condition or to prohibition of their loan by the donors who gave or bequeathed them to the institutions where they are now housed. The most important of these works, however, we illustrate here.

In selecting and organizing the exhibition, I have worked with the assistance of Beatrice Kernan, with whom the catalogue section of this publication was prepared. The plates in that section record the exhibition and provide a full visual account of Matisse's development, the most complete such account that has ever been produced. We therefore reproduce in color every work that contains color (with the single exception of one work from the Barnes Foundation, for which we could not obtain permission to do so). The plates are arranged chronologically. Within

this framework, however, we have attempted to reveal important formal or iconographic relationships, and to communicate ideas about Matisse's development and working procedures through the grouping and juxtaposition of particular works. It was for this reason that we felt impelled, on occasion, to include some essential works unavailable to the exhibition. Our aim was to produce a visual account of the unfolding of Matisse's art that would be comprehensible on its own terms.

Preparation of the catalogue section of this publication required an extraordinary amount of detailed research, as did the accompanying chronology, which was compiled in collaboration with Judith Cousins. It had been our original intention to publish all of the research and documentation accumulated during work on the exhibition. However, it became evident that much more new material had been uncovered than could possibly be included in this already very large volume, and that it was simply impracticable to attempt simultaneously a second volume, given the extraordinary demands that this present volume and the exhibition itself placed upon us. But it is our intention to produce later—and with the benefit of seeing and closely inspecting all the works in the exhibition—a supplementary volume of documentation and detailed research. We there hope to publish the supporting data on which the numerous revised dates of works, and new information in the chronology, are based—and will undoubtedly reconsider some of the material presented here.

For readers less familiar with Matisse's work, I have attempted to characterize its main developments, in short introductions just before the chronology that precedes each group of plates. And in the chronology itself, we have sought to provide not only an account of Matisse's biography but also of the year-by-year development of his art, of his public reputation, and of his theoretical understanding of what he was about. The illustrations we include there, some of them previously unpublished, are intended to provide a representative view of the artist and his milieu within the necessarily restricted space available.

My introductory essay, "Describing Matisse," is neither a chronological nor a comprehensive account of Matisse's art. It focuses instead on selected aspects of his art with the aim of providing several starting points for reexamination of what comprises Matisse's identity as a modern artist. The identity of any great artist, of course, needs constantly to be reexamined: not only because each new generation will discover a somewhat different artist from the generation before, but also because such reexamination will help to check the spread of myths and generalizations that shield us from the complexities of a great artist's work. In Matisse's case, reexamination is especially needed because the popular view of him is still far too generalized. His art is formally more various, thematically more intriguing, and emotionally far more complex than is often acknowledged.

Like the work of other great artists, it seems to combine

many different patterns of significance. This being so, no single approach can hope to capture the broad range of its meanings. I do take for granted that all of Matisse's work expresses the structure of a single personality—however complex that personality may be. And I do take for granted that any approach to his work must grow out of experience of the work, including the experience of its totality, which close study of it reveals. In that sense, I presume total coherence. At the same time, I am convinced that if we are to come near to understanding the multiple levels of meaning in Matisse's art, we must be deeply skeptical about the adequacy of any single approach to it. After all, Matisse did not adopt a single approach to making his art, whose freedom includes freedom from traditional forms of unity. If he could accept a provisional sort of coherence, his commentators might reasonably be expected to do the same. For this reason, my introductory essay is organized with the help of not one but several broad thematic devices—ranging from what critics have said about Matisse to textual attributes of his art itself, and from mythical and psychological aspects of his work to its element of luxury and its form of address to the viewer. And it is organized this way not because Matisse's art is reducible to such themes but, rather, because themes of this sort provide a useful framework for both expanding and systematizing its discussion.

As Alfred Barr once observed, exhibition catalogues are prepared under conditions much closer to those of a newspaper office than of a university library. And it is a besetting problem in the preparation of such catalogues that curators and scholars must formulate their ideas before seeing all the works in an exhibition actually gathered together. However, I have at least had the opportunity, during the preparation of this exhibition, of having seen all these works—a privilege very few scholars have been accorded. It was the experience of revisiting familiar works, of seeing works that I had not been able to see for many years, and of seeing some works for the first time, which caused me to conclude that there is still a great deal about Matisse we do not understand. My introductory essay thus proceeds from a stance of interpretive doubt, in the hope that this may lead to future, broader understanding. I am not merely hopeful, however, but confident that the exhibition recorded in this book will definitely alter our understanding of Matisse—as well as afford undescribable pleasure.

JOHN ELDERFIELD
Director of the Exhibition

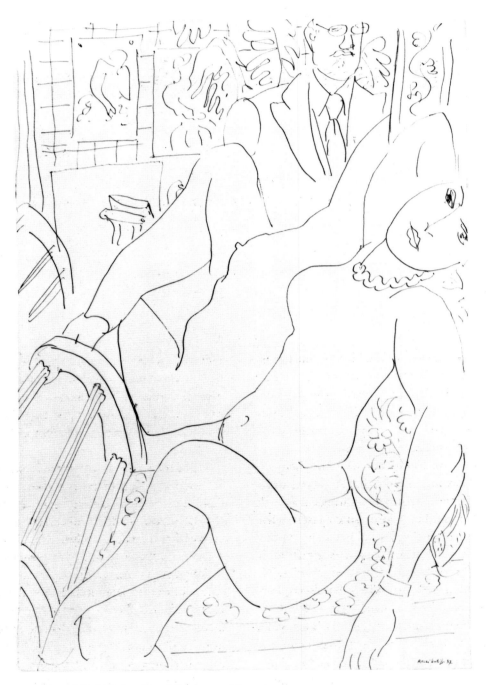

1. *Artist and Model Reflected in a Mirror*. 1937 (pl. 307).

Describing Matisse

John Elderfield

"We know Matisse much less than we admire him," wrote Christian Zervos in 1931.[1] Sixty years later, this remains true. It is still not altogether easy to recognize just how profoundly personal his art was, quite unlike anything by either his contemporaries or those who have chosen his influence, and yet far closer to the central preoccupations of our culture than its sometimes extravagant beauty makes it appear. We still do not see him whole.

His teacher, Gustave Moreau, told him that he was destined to simplify painting.[2] At times, he made paintings that look simple and self-evident because they convey so concisely what earlier painting, before Matisse, had conveyed in a more discursive form. But while this meant purification and elimination, it also meant enrichment and intensification. Indeed, conciseness of expression sometimes required compositions that do not look simple at all. Complexity of pictorial incident can speak as directly as can the barest, the most reduced of forms. This is one of the lessons that Matisse teaches us. Another is that the meanings of even the simplest of paintings may not be self-evident, but demand our patience. Matisse's art is imperious at many of its greatest moments, as is that of other major artists. And yet what it ultimately commands is our participation. We are invited to enter and explore what will turn out to be a highly unusual world. We soon notice that its geography and climate appear constantly to be changing. For Matisse paints the most unlike pictures, from the nearly indecipherable *Moroccans* (fig. 37) to the seemingly quite naturalistic *Moorish Screen* (fig. 11); from the fiercely colored *Music* (pl. 126) to the quietly contemplative *Silence Living in Houses* (pl. 377). And he makes sculptures, drawings, and prints; designs for costumes and stained-glass windows; and ultimately paper cutouts, a medium he invented for himself.

However, for all the variety within his oeuvre, his presence in each work is unmistakable once we have come to recognize its different guises. What is most unusual about the world of Matisse's art is, quite simply, that there is nothing else like it. No wonder, then, the full extent of his achievement is difficult to know.

The main reason why there is nothing else like what Matisse achieved is an historical one. Born in 1869, he made his first paintings in 1890: modest, realistic works of a kind that could well have been made much earlier in the nineteenth century, or even earlier than that. Only slowly did he become a truly modern painter. At the end, sixty years later (he died in 1954), he was making the grandest of his paper cutouts, works that would have seemed utterly incomprehensible at the time his career began. Even to the last, however, he clung tenaciously to imperatives of pictorial art that were very distant: specifically, to a belief in the priority of figural representation. The only modern artist who can be compared to him without ever-growing qualification, namely Picasso, maintained that belief, too. It is part of the reason why we so value both of them: they join modern art to a past whose achievements, if we esteem what these two artists stood for, we must value all the more. The formal substance of figural representation in historical styles of painting since the Renaissance is carried by these two great artists into the twentieth century. If painting can still hope for something analogous, it is owing to them as to no other artists of our time.

And yet, what Matisse achieved for modern art is without any parallel, because the alterations he found himself forced to make in the formal structure of painting are without parallel. He valued, and was determined to maintain, the traditional, physi-

cal substantiality of figural representation. But, eventually, the very luminous substance of painting itself came to fulfill the functions that form and structure had fulfilled earlier.[3] Matisse said that the peak of his aspirations was the art of Giotto.[4] Looking for a comparison for the revolution that Matisse effected, what Giotto did is precisely what comes to mind. There, too, we see pictorial art in an essential transition, wherein the substantiality of form and of luminous color momentarily combine. Matisse's revolution, of course, turned art in the direction opposite to Giotto's. Matisse was alone when he began to discover that the very colored stuff of which paintings are made can have an independent reality no less bodied and emotionally charged than the forms paintings depict. Others came to join him, and it might be expected that the magnitude of Matisse's discovery was such that it would have been emulated. What happened, instead, was that his original imperative—somehow to maintain for painting a power equivalent to that of traditional figural art—was often forgotten. And without that, there could be only painting whose color was merely a decoration. The imperative was inseparable from the conventions of representation. A picture did not need to be representational in the old, depictive sense, as Matisse's last cutouts demonstrate. But it did have to be, in the very broadest sense, a representation. Otherwise, it would have nothing to show.

A picture had also to be privately conceived. A human response to the visual world, however expressed, had to be a personal response, or it was no response at all. Of course personal, unmediated access to reality is as impossible for us as unmediated access to works of art. In both cases, we depend on preexisting conventions. And yet unless the fiction of such access could be maintained, however tenuously, or unless those conventions could be totally understood, how could there be personal knowledge of the world? These two lessons of Matisse's remain exemplary.

If we are to attempt, therefore, to gain a fuller knowledge of Matisse's art itself, we must adopt two stances that are contradictory—and neither of which is theoretically possible. First, we must pretend, despite knowing it is not true, that we can look directly at his work without the mediation of other artists' work and of critical theory. We will not, of course, be able to do this, or see his art unmodified by their presence. But the converse will also be true: We will surely find that what Matisse shows us will alter, if we allow it to, what we know from other works and from the history of ideas. It is thus quite wrong to contend that our view of art is irrevocably predetermined. The actual experience of art, especially of art as complex in its meanings as Matisse's, tells us otherwise. However, nothing I will say here can hope to demonstrate this. In contrast, the second stance I think we must take is amenable to discursive argument. It is the stance of requiring full knowledge of the conventions that shaped Matisse's art and have shaped our understanding of it: the art and the ideas that influenced him; the way his reputation was formed; his own understanding of his intentions; the biographical facts of his life; the way his art developed over time; the social and political context in which he worked; and so on. The list is endless. We can never hope to master it all. What I have to say here will, I hope, alter how we understand a few of these issues. Many, though, I leave untouched. For I concentrate on describing Matisse in his nature as an individual, examining selected aspects of his art which suggest that he is indeed a rather different individual, as an artist, from the one we think we know. But I do so precisely because the main shortcoming in our understanding of Matisse is that we still do not see him whole.

Several things hamper us. There is no catalogue raisonné of his paintings (nor is there a full biography); the complete extent and exact sequence of his art therefore remain unknown.[5] By focusing on separate periods of his career, Matisse studies have dissected his work, the better to examine it closely, and thereby have added immeasurably to our knowledge, but the resulting episodic view leaves us with a divided artist and even discards some of the parts.[6] The successive phases of his work were different and surprising in continually new ways, and there is no reason why there has to be a single, whole Matisse. Some artists never maintain a single, individual style, and even those who do so may at times work outside its boundaries. Yet the distinct stylistic periods established for some other artists—Matisse, I believe, among them—are in fact merely convenient chronological guideposts through territory far more continuous in its contours than generally acknowledged. We must see the entirety of the artist to understand this; such is the aim of the exhibition this publication accompanies.

Seeing the artist thus, we might perhaps recognize more clearly how there are some things he apparently cannot do without—whether or not that is his wish, and whether or not they form promising material for the kind of art he wants to make—and that this leaves him with no option but to risk everything and make a kind of art neither he nor anyone else could ever have predicted.

I. PROFOUND AND LUCID SIGHT

The first exhibition devoted solely to Matisse's art opened at Ambroise Vollard's gallery in Paris on June 1, 1904. Matisse was thirty-four; the exhibition chronicled his then extremely short, six-year development as a modern painter. In the preface to the catalogue, the critic Roger Marx summarized Matisse's aims by observing that he "delights in capturing anything that pleases his profound and lucid sight."[7] The full development of Matisse's art would occupy another fifty years after that first solo exhibition, during which time many, different, and contradictory judgments would be passed on the various phases of his career—and continue to be, for the more carefully his art is examined, the less easily categorized it appears. But for all that has been written and said about Matisse, Roger Marx's original insight still seems to hold true. Painting, for Matisse, is the medium that, more completely than any other, addresses itself to the immediate sensation of sight. Both the stimulus of visual sensations and the elementary visual components of a picture were more precious to him than to any other modern painter.

Thus, whether condemned as an apostle of ugliness, as he was in the years after 1905, or praised for the resplendence and immediacy of his color, now probably the most frequent of his praises, Matisse has almost invariably been considered an artist for whom visual sensation is preeminent—more often than not, the most important such artist of the twentieth century. And insofar as painting has traditionally been considered the foremost art of the visual, Matisse is therefore an exemplary painter. As the writer Pierre Courthion noted in 1934, "Matisse is a painter's painter. His work is purely visual."[8] And thus, Matisse lays claim to the title of our greatest painter.

Matisse's reputation as an artist devoted to the purely visual has caused him also to be viewed, however, as a hedonistic artist. For the view of Matisse as providing aesthetic pleasure through the decorative organization of the picture surface can be misinterpreted to suggest that he was devoted to pleasure alone. Bright colors, luxurious patterns, and harmonious forms, and a subject matter of imagined arcadias, rich interiors, and seductive nudes, have allowed interpretation of Matisse as an artist who celebrates the good life.[9]

This has unquestionably contributed to his popularity, for he seems thus to offer a dream of available luxury, touching upon deep-seated fantasies of permanent pleasure, unlimited wealth, and erotic appropriation. The financial value that has accrued to his art, while of course not unusual for the work of a highly esteemed painter, seems further to have enlarged the image of cornucopia. A puritan sensibility will be bothered by this. But so must anyone who is deeply affected by Matisse's art, especially if one lives and thinks in the latter part of the "modern,"

twentieth century. Modernism means toughness and struggle; often irony as well. If Matisse were indeed solely devoted to luxury and pleasure, he would be disqualified from truly major importance.

This being so, the main tendency in recent serious studies of the artist has been to oppose the view of him as a mere hedonist. In effect, it is said of Matisse what was said of Watteau and of Mozart: that although his work has been sometimes mistaken for Rococo frivolity, it is really something far more profound.[10] That is to say, his work is seen as transcending the merely pleasurable. Just as modernism itself has been considered transcendental in rising above the local conditions of its creation, so Matisse's art has been viewed as detaching itself from its apparent materialism.[11] It does so, its commentators have suggested, in any of three ways: in its abstraction, in its spirituality, and in its subjectivity.

First, its abstraction: Insofar as Matisse's is a quintessentially visual art, it is an art of aesthetic disinterestedness which supersedes the particularized connotations of both its subject matter and its pictorial means. Additionally, insofar as it is an art of the colored two-dimensional surface, it overthrows Renaissance illusionism to concentrate, as a modernist art, on the potentialities of the medium itself. Thus, if Matisse is a hedonist, he is a "cold hedonist," one whose "detachment . . . enables him to convert into a masterpiece a subject and an arrangement others could only use to decorate a candy box."[12] In short, he is "a pure artist,"[13] and what is "really seductive" about his work is "the paint, the disinterested paint."[14]

Second, its spirituality: Not necessarily opposed to the previous interpretation is the view that the harmony of Matisse's art, far from being merely relaxing, is restorative, beneficent, and spiritually uplifting; not a surrender to materialism but an escape from it. Thus he was not only a detached artist but one who painted "a region of ideal detachment," not merely a land of make-believe but "a land of ideal make-believe."[15] And thus, his enduring subject was really the Golden Age, the myth of primordial harmony, whose very sacredness required the purified pictorial language he created.[16] Once again, his art is seen as transcending the shallowly visual and pleasurable; in this case, he is seen as in effect transcending the picturesque for the sublime.

Third, its subjectivity: The remaining strategy for arguing Matisse's seriousness as an artist has been to suggest that the luminous surface conceals darkness beneath. Matisse is "the painter of the self absorbed in self-hood,"[17] and as with Watteau, beneath the apparent lightheartedness is a profound sense of unease, of inwardness and psychological depth. He said, in fact, that he was a painter not merely of visual sensations but of the

feelings such sensations evoked in him.[18] Thus, it might be said he was obsessed with aesthetic harmony precisely because he himself was not at peace; Matisse the man is clearly important to such an account of the art he produced.[19]

These three approaches to Matisse may be described, respectively, as formalist, iconological, and biographical or psychological. However, these terms necessarily simplify the range of critical possibilities each may contain (as do, of course, my foregoing summaries of them), and imply their mutual exclusivity and possible antagonism. I stress this now because I find all three approaches useful and necessary in their different ways and will make use of them all in the pages that follow. At the same time, they fall short of being totally persuasive because each, in its different way, seeks to overcome the element of luxury that Matisse's art unquestionably does contain. Matisse's art is indeed abstract, spiritual, and subjective. But it nonetheless remains also luxurious, in the sense of evoking a complex of emotions whereby feelings of plenitude, of intense sensuality, and of delight in the physical splendor available to our senses are blended. This element is integral to his art's immediately visual aspect, which therefore cannot be considered to be only or "purely" visual. The luxurious element is something deeply physical there, although also extremely elusive—like a reflective, pearlescent powder mixed into paint which, in some hands, will merely prettify a painting, but in others can give to color a special sheen. I do not say that Matisse's "luxury" will turn out to be his greatest originality. But I will venture to say that it will prove indispensable to our understanding him.

Early Descriptions

Where did the idea of Matisse's luxury come from? As we have seen, in the spring of 1904, Roger Marx described Matisse as an artist of "profound and lucid sight." To that critic, Matisse was a brilliant student of Gustave Moreau's who had absorbed the lessons of Cézanne and Manet, then had become an *intimiste* comparable to Vuillard. There were other influences on Matisse's early paintings, notably that of Neo-Impressionism, and some of his work was much bolder than Roger Marx allowed; it provoked criticism as unnecessarily violent for just that reason.[20] However, Marx's characterization of Matisse as having discovered a "harmonious synthesis" from his late Impressionist sources is a reasonable one, and fairly typical of how his early work was received by those sympathetic to new art.

A second and very different description of Matisse emerged in 1905, especially after he exhibited at that year's Salon d'Automne his first so-called Fauve paintings—landscapes made that summer at Collioure, and still lifes and portraits, including the notorious *Woman with the Hat* (pl. 64). Matisse's return to Neo-Impressionism the previous summer, to paint *Luxe, calme et*

volupté (fig. 9), had provoked the complaint, when this picture was exhibited at the spring 1905 Salon des Indépendants, that he had surrendered his magnificent gifts and become a theoretician.[21] The extraordinary originality of Matisse's new work at the autumn Salon of 1905 was acknowledged by perceptive critics. But even some of them—unsurprisingly, those with Symbolist sympathies and therefore likely to be hostile to Neo-Impressionism—repeated the charge that Matisse's art was "a product of theories."[22] The vibrating surfaces of juxtaposed, high-intensity color fragments in his Fauve paintings revealed an indebtedness to Neo-Impressionism. Although many were additionally indebted to Cézanne, van Gogh, and the Symbolist Gauguin, there was still sufficient evidence for the charge to be made.

Insofar as Matisse's art was described as theoretical, it was held to be removed from nature, and therefore artificial. But even the critic who most prominently made this charge, Maurice Denis, was at pains to distinguish Matisse's brand of artificiality—which he characterized as "painting relieved of everything accidental, painting in itself, the pure act of painting"—from the artificiality of decorative fabrics.[23] It is the notion of Matisse's purity as a visual artist that develops from Denis's criticism, not the notion of Matisse's luxury. Indeed, what would become the three main rebuffs to the later charge of luxury are already present in Denis. First: Because of Matisse's preoccupation with the pure act of painting, "one feels oneself to be entirely in the domain of abstraction." Second: Because the accidental is excluded, this is a "quest for the absolute." Third: "And yet—strange contradiction—the absolute is limited by the most relative thing there is: personal emotion." Thus Matisse's defense, that he was an abstract, spiritual, and subjective artist, actually preexisted the charge that he was a hedonistic one.

I stress this not only to remind us that the works which would provoke this charge had not yet been made in 1905, but also to point out that later defenders of Matisse effectively return to the critical claims that had accompanied his early, revolutionary breakthrough as a modern artist. The image of Matisse projected by his defenders is that of an artist of the avant-garde. In effect, they have seen Matisse within the context of the dominant paradigm of modernism. I will be arguing that he forces us to confront the insufficiency of that paradigm, particularly when viewed from the end of our modern century.

One often heard response to Matisse's Fauve paintings, however, has disappeared entirely from critical currency: the complaint that his work was ugly and incoherent. Leo Stein referred to *The Woman with the Hat* as "the nastiest smear I have ever seen."[24] The circle around Matisse was known as "the incoherents" before the term *les fauves*—"the wild beasts"—became popular.[25] "It was Matisse," wrote the American author Gelett Burgess, "who took the first step into the undiscovered land of the ugly."[26]

Of course, the reproof of ugliness and incoherence has been frequently made against many kinds of modern art, and almost inevitably disappears as the art in question becomes more familiar with the passing of time. We should not be surprised at the disappearance of such characterizations from Matisse criticism. Only, we should know that Matisse himself actively fought against them, and thereby, in the terms he used to defend his art, himself introduced the topic of luxury.

In Matisse's first and most important extended statement about the purposes of his art, "Notes of a Painter," published in December 1908, he made this remark, now a great stumbling block to appreciation of him:

What I dream of is an art of balance, of purity and serenity, devoid of troubling or depressing subject matter, an art which could be for every mental worker, for the businessman as well as the man of letters, for example, a soothing, calming influence on the mind, something like a good armchair which provides relaxation from physical fatigue.[27]

Of a not dissimilar remark by Keats—that the great end of poetry is "to soothe the cares, and lift the thoughts of man"—Lionel Trilling observed: "Such doctrine from a major poet puzzles and embarrasses us. It is, we say, the essence of Philistinism."[28] But it is, we should know, for Matisse as well as for Keats, the essence of a version of Romanticism that now seems so distant from us that it is difficult to comprehend: the idea that the function of art is to provide a very specialized kind of pleasure, vitally affective *because* therapeutic, not in spite of that fact. We need therefore to consider carefully the context and implications of what Matisse is saying.

By the date he wrote this statement, Matisse had turned from the excited Fauve style that had brought him notoriety to a style now usually characterized as "decorative," which made use of broad fields of bright color, rich arabesques, and simplified, flat forms. It is typified by *Harmony in Red* (fig. 2), which Matisse had included in a retrospective of his work at the 1908 Salon d'Automne, and *Game of Bowls* (pl. 110), which appeared as one of the illustrations for "Notes of a Painter." But he was still under attack for being incoherent; "Notes of a Painter" was his defense.

Matisse began by saying it was dangerous for a painter to write about his work, because too many people already think of painting as an appendage to literature. This appears to be but an apology for the text that ensues, and a preparation for what immediately follows: Matisse's insistence that although he has been attacked for not going beyond "the purely visual satisfaction" obtainable from looking at a picture, his principal aim is nonetheless expression, but a form of expression wherein "the thought of a painter must not be considered as separate from his pictorial means." In fact, the contrast of writing and painting is an important one for consideration of Matisse's art. It is pertinent to his dream of mental calm.

Matisse is saying, essentially, that while writing and paint-

ing are related as the thought and the pictorial means of an artist are related, the artist should be wary of writing: not only because revealing ideas exposes one to misunderstanding, but more important, because the artist should avoid narrative description. (That is already in books, he observed the following year.)[29] Instead, his "work of art must carry within itself its complete significance and impose that on the beholder even before he recognizes the subject matter." As in Giotto's work, the sentiment that emerges from the subject matter "is in the lines, the composition, the color. The title will only serve to confirm my impression." This is not to say that subject matter is unimportant; quite the opposite. Subject matter will be more powerfully affecting if it presents itself through the artist's expressive manipulation of his medium. Thus, instead of merely transcribing visual sensations—instead of seeking merely to copy nature—the artist should, rather, condense these sensations. Working toward serenity by means of simplification, he will be able to produce a more vivid, less accidental representation of the subject, lodged in the entire compositional arrangement of the work of art.

Despite Matisse's reputation as an artist devoted to the purely visual, he was actually mistrustful of visual sensations. They provided a false model of reality because they showed only its accidentality and not its essence. But writing was suspect, too; to rely on it would be to subordinate image to text, picture to title, and therefore to be just as illustrative as the recording of visual sensations is illustrative. Thus the painter can rely on neither texts nor visual appearances.

In 1909, in an interview with Charles Estienne, Matisse prolonged the attack on Impressionism as an art purely of visual sensation, begun in "Notes of a Painter."[30] Because Impressionism attempts to copy nature, it "teems with *contradictory sensations;* it is in a state of agitation." Rejecting this, Matisse works toward serenity by rejecting details (which provide contradictory sensations) in favor of the ensemble, which offers instead a condensed whole orchestrated by purity of line. "It is a question," he immediately adds, "of learning—and perhaps relearning—a linear script; then, probably after us, will come the literature." Estienne, clearly puzzled because Matisse also speaks vehemently against narrative description as the province of books, not paintings, adds parenthetically: "The reader should understand the word *literature* to mean a mode of pictorial illustration." Yes, but a mode of pictorial illustration with the clarity of a text, as condensed and as artificial; not something which pretends to natural immediacy and presence but, rather, something that disrupts natural presence because it is the product of human intervention and active conceptualization.[31] Matisse says that he expresses his *interior* visions.

There is a name for the idea that paintings can fulfill the functions of texts: *Ut pictura poesis.* Renaissance discussion of this famous Horatian concept provides the ultimate source for

Matisse's dream of mental calm. In considering the original meaning of the concept—a painting is like a poem and should speak to the intellect rather than to the senses—Renaissance theorists began to discover an alternative interpretation of the same phrase. Alberti, for example, contrasted ennobling paintings—those fulfilling the intellectual, didactic prescription of Horace—with ones of an opposite kind, whose justification was as follows. If painting is like poetry, might there not be a specifically "poetic" or lyrical sort of painting, one that, being relaxing—and pastoral—is similar in its effect on the human mind to music. Its aim, E. H. Gombrich observed (nearly paraphrasing Matisse) was to "help to restore the tired spirits of the man of affairs."[32] Matisse's dream of mental calm is a defense of painting that has the efficacy of the pastoral: a defense of the specifically pastoral paintings he had begun to make, which are based loosely on texts, and of his art as a whole, which had become as condensed as a poetic text, and was conceived in the spirit of pastoral.

And yet, Matisse's work continued to be described as ugly or incoherent. The "good armchair" image would later be used against him, but immediately the idea that he sought harmony and calm was greeted with considerable skepticism, at times with scorn. He was not yet a painter of luxury, even though he had himself invited such an interpretation. Within a very few years, however, he began to be called that. The reason for the change can be summed up in one word. The word is *Picasso*.

The Hedonist and the Radical

The retrospective exhibition of Matisse's work at the 1908 Salon d'Automne, which preceded publication of "Notes of a Painter," was a great honor for him. Previous such exhibitions had been accorded to important artists of the preceding generation, such as Renoir, Gauguin, and Cézanne; Matisse's established him as a modern master. Although still under attack from conservative critics, and a source of amusement to the general public, he attracted important new patrons, notably the Russian merchants Sergei Shchukin and Ivan Morosov; his increasing group of admirers and emulators pressed him to open an art school, which he did; by the autumn of 1909 he would have a generous contract with the Bernheim-Jeune gallery, and a villa, with a new, large studio, at Issy-les-Moulineaux in the Paris suburbs. But insofar as he was now a modern master, he was no longer leader of the avant-garde.

Reviewing the 1908 retrospective, the critic Charles Morice observed that Matisse "continues to worry his enemies without reassuring his friends."[33] Morice was puzzled by a separation of color and drawing he found in Matisse's art; he thought it to be a sign of internal conflict, and sensed in Matisse "a constant tension, a nervous exacerbation that is not, I believe, natural to him,

but that reflects the sickly state of a mind overworked by probing and ambition." This is evidence at once of how, from an early date, a crucial "incoherence" in Matisse's art was attributed to a psychological cause; how it was apparent, at least to a perceptive critic, that there was another side to Matisse than the reserved, professorial, and increasingly bourgeois image he publicly presented; and how Matisse's ambitiousness as an artist was beginning to create a certain resentment against him. The theme of a divided artist with divided means continued in criticism sympathetic to Matisse.[34] It was overshadowed, however, by the emergence of the image of Matisse—promoted in large part by those either resentful at his arrogant presumption of greatness or dismissive of his relevance to new painting, or both—as a merely pleasurable artist when compared with Picasso.

As a member of the jury of the 1908 Salon d'Automne, Matisse was instrumental in rejecting the new paintings of his former Fauve colleague Braque, which he apparently dismissed as "little cubes."[35] By then, Picasso's star was rising among avant-garde artists, critics, and collectors, and it seemed clear that Matisse's painting and that of the developing Cubists were set on opposite courses, identifiable, respectively, by the terms *color* and *form*. By 1910, as Matisse's international reputation grew, hostility toward his art increased in pitch among advanced as well as conservative critics. At the time of the spring 1911 Salon des Indépendants, he provoked criticism for his arrogance in having insisted on changing his submissions, after the vernissage, in order to include the recently completed, large *Pink Studio* (fig. 35).[36] At the Salon, the ubiquity of mediocre Fauve-derived paintings by his followers was a matter of some amusement and may have been influential in his decision to close his art school.[37] At the 1911 Salon d'Automne, the very ethereal, lightly painted pictures Matisse submitted were overshadowed by the first public manifestation of the Cubist followers of Picasso and Braque. The "complete absence of forms" in Matisse's work, wrote Guillaume Apollinaire, was "the very opposite of Cubism."[38] The critic Louis Vauxcelles observed: "There is almost nothing there. . . . If this goes on, Matisse will soon be giving us a white canvas."[39] But Matisse heard an even more hostile remark during a triumphant visit he made to Moscow that November to see his great decorative panels, *Dance (II)* and *Music* (pls. 125, 126), installed in Shchukin's palace. A gibe attributed to Picasso himself had followed him there: "Matisse is a *cravate*—a colored necktie."[40]

By March 1912, Apollinaire was writing that in Paris "the influence of Matisse is almost completely brushed aside."[41] Nonetheless, Apollinaire was consistently a fair, and often a generous critic to Matisse, although a member of the Picasso camp. Not so André Salmon, who has the dubious responsibility for putting into critical currency the idea that Matisse was a merely hedonistic painter.

In his book *La jeune peinture française*, published in 1912,[42]

Salmon begins by damning Matisse with faint praise and repeats the frequent complaint that he is an incoherent artist. But then comes a new attack: "His real gifts are gifts of skill, flexibility, prompt assimilation, of an exact science, but one quickly acquired—feminine gifts." Matisse's taste, he says, has been greatly praised but is second-rate. "It is a *modiste*'s taste, whose love of color equals the love of *chiffon*." Matisse cannot be ignored; he has place in history. "But whom to follow: Matisse or Picasso?" Salmon asks, leaving no doubt as to the answer.

I do not want to be understood as saying that Matisse's hedonism is simply the invention of one peevish and sneering critic. Salmon's text is important, however, because it marks the public introduction of this topic into Matisse criticism; because it introduces it in terms deriving from a longstanding tradition wherein painting dominated by color was downgraded by being called effeminate;[43] and because it introduces it through a contrast between Matisse and Picasso. I want to examine the implications of this contrast in a moment. But before I can do so, we need to trace how the idea of Matisse's hedonism was disseminated and see what associations attached to it.

It first must be said that the idea was soon accepted by Matisse's admirers as well as his detractors. It was not necessarily intended as a slur. Thus, praising the artist in 1913, Apollinaire flatly stated that Matisse "has always had a hedonistic concept of art."[44] It next should be said that Matisse himself persisted in stressing the harmoniousness of his work, both during these early years and for the remainder of his life.[45] During World War I, when Matisse's art became far more austere and when he developed friendly relations with Picasso and other artists and critics within the Cubist circle, the issue of his hedonism was held in abeyance. By 1920, however, after Matisse had settled in Nice and was making more naturalistic paintings, his art once again began to be described as hedonistic or luxurious.

This quality was defined in various ways by a number of critics writing at the time. For Léon Werth, it was dispassionate, disinterested luxury.[46] For André Lhôte, it was perceptual pleasure created by means of color.[47] For Clive Bell, it was the mark of a purely aesthetic and non-intellectual art, compared to Picasso's.[48] For Jean Cocteau, it was evidence of Matisse's lack of discipline and adventure, of his retreat into conservatism.[49] Thus, the rift continued to open between admirers of Matisse as a "purely" visual artist and detractors of Matisse as a "merely" visual artist. Additionally, Matisse became known as the more traditional artist, when compared to Picasso, notwithstanding the fact that Picasso, too, in this same period, was making nominally more conservative work than he had before.

Matisse's traditionalism, moreover, was often viewed as specifically French and notably bourgeois. As early as 1912, Kandinsky characterized Matisse's work as "specifically French, refined, gourmandizing," while insisting that Matisse always transcended these qualities to achieve the "divine."[50] The quali-

fication, a premonition of later criticism, was not made by writers of the 1920s. By the end of that decade, when Matisse was publicly known mainly for his Nice-period canvases—the earlier, more revolutionary works having disappeared into private collections, the majority outside France—his reputation was settling as an artist who carried forward the French tradition, whereas Picasso, the outsider, confused everyone with a succession of personal, avant-garde styles.[51] Matisse's much more private life than Picasso's abetted this interpretation: in 1934, Pierre Courthion observed that we know Matisse only from his work, whereas it is Picasso the man who fascinates us.[52] Abetting it even more was the fact that the audience for Matisse's art was no longer a small, avant-garde one, but rather so broad that in 1925 he had actually been voted the most important artist in France; as Roger Fry put it in 1930, "the more cultured rich at last succumbed to his spell."[53] Matisse's reputation therefore increased as a bourgeois as well as traditional artist. Few writers were as explicit as the Marxist Aleksandr Romm, who wrote in the mid-1930s that Matisse loved luxury, banished anything unpleasant, and made art for the privileged few.[54] But many writers said almost as much. Matisse unquestionably had sacrificed the interest of those who believed that modern art should look revolutionary; that modernism meant the avant-garde.

Meanwhile, the seeds of a drastic change in Matisse's reputation had already been sown. His large exhibition at the Georges Petit gallery in Paris in 1931 was dominated by Nice-period paintings of the preceding decade. However, it also contained important earlier works, some of them extremely radical. The proportion of earlier, radical works was increased when Alfred Barr brought a version of that retrospective to New York as the first ambitious exhibition devoted to a European artist at the recently opened Museum of Modern Art.[55]

I am not suggesting that this institution was solely responsible for Matisse's rehabilitation as an avant-garde artist. Only that the large international interest in Matisse, which grew through the 1930s by means of numerous monographs and exhibitions, was crucial to that rehabilitation, and that the art-historical understanding of Matisse pioneered by Barr, as an artist whose development alternated between "realistic" and "abstract" styles, was crucial to it as well.[56] In 1931, Barr thought he recognized the beginning of a new, more abstract cycle. He was correct. Matisse's flat, decorative style of the 1930s was still applied to subjects as luxurious, and bourgeois, as those of the preceding decade. But style, divided from subject, formed the basis of the new appreciation of Matisse. The artist's frequent public statements, which increased in number through the 1930s and 1940s, concerning the purity of his means encouraged such appreciation.[57] French publications and exhibitions began to shape a more homogeneous picture of French modernism that subsumed Matisse and Picasso into one broad development. Matisse's later works, including the highly abstracted Vence interiors of

1946–48 (pls. 375–387), published in vivid color reproductions in the magazine *Verve*,[58] together with the extraordinary reception afforded *Jazz* (pls. 357–367), and the appearance of the paper cutouts, consolidated Matisse's reputation as a great radical master and one who had created a magnificent *Alterstil*, or style of old age, as fully youthful as anything he had previously done.

Matisse's reputation as a radical artist was not to achieve its full height, however, until after his death. It came as the result not only of broadening critical acknowledgment of his work, now more frequently seen internationally in a series of major specialized and retrospective exhibitions;[59] it also, and more importantly, was the result of Matisse's influence on new art. His paintings of the 1930s and 1940s had been perceived as maintaining the vitality and innovative possibilities of that art in a period of great stylistic confusion, when the tradition of Picasso's Cubism decayed into mannerism and mediocrity. His example had certainly been critical to the development of American Abstract Expressionist painting in that way. But it was not until the 1960s, when so-called Color Field painters, Minimalists, and Pop artists could all, in their different ways, find inspiration in Matisse's work, that he fully recaptured the interest of the avant-garde, was acknowledged as a true radical, and again began to be described as the most important twentieth-century painter.[60]

But still, was not Picasso, perhaps, a more "serious" artist? And is he not a more influential one? For some, the old questions remain, especially now that the magnificent *Alterstil* of modernism itself—the American painting of the 1950s and 1960s that came so to value the purely visual, and therefore Matisse—is past. Evaluation of Matisse's importance is still tied to evaluation of Picasso's.

Matisse and Picasso

The comparison is inevitable. What the foregoing account suggests, however, is that the way Matisse's art is actually characterized (and Picasso's as well) depends upon the very fact, and history, of this comparison. Understanding of Matisse's art, like that of any artist, emerged and developed within the context of the understanding of the art of his time; it was, and continues to be, characterized within the context of what we understand modernism to be. Since 1912, when the contrast of Matisse and Picasso emerged as definitive of what modernism encompassed, the reputations of the two artists have been inextricably linked. This is to say not only that the indisputable differences between the two artists have been reified in terms of analogous oppositions, of which pleasure versus seriousness is but one. It is also to say that the very idea we have of modernism contains, if not indeed comprises, the idea of a protracted struggle for dominance between opposing systems, represented by Matisse and Picasso, each claiming for itself proprietary rights on an essential modernism.

Thus the contrasting names Matisse and Picasso are in effect synecdoches for supposedly analogous contrasts of extraordinarily broad range on which our image of modernism depends. I will leave it to the reader to consider the fuller implications of this territorial and ideological struggle and content myself, rather, with attempting to look at Matisse's art in the knowledge that its understanding has been historically determined, to a large extent, by contrast with Picasso's. In light of the preceding account of Matisse's reputation, the sets of oppositions that regulate the contrast between the two artists can be tabulated as follows. First, the stylistic oppositions:

Matisse	*Picasso*
Fauvism	Cubism
Color	Monochrome
Decorativeness	Austerity
Flatness and shape	Space and form
Perception / vision	Conception / intellect
Unity	Fragmentation

Already the distortions have begun to appear. For example: Is not Fauvism as much a style of fragmentation as is Cubism? And these nominally descriptive terms carry evaluative connotations. Such connotations increase when we move on to oppositions of stylistic effect. The most obvious are:

Harmony	Dissonance
Facility	Difficulty
Simplicity	Complexity

Needless to say, Matisse's early reputation for ugliness and incoherence disappears in these oppositions, as does the idea of an artist whose facility might disguise internal struggle. (Conversely, Picasso's extraordinary facility, especially as a draftsman, disappears too.) I am not claiming, of course, that these characterizations of Matisse's or of Picasso's art remain unchallenged or unqualified in accounts of their work; only that they are pervasive, and that if we are radically to rethink the work of either of them we would do well to pay more than passing attention to the opposite column. This becomes especially urgent when we see how oppositions in an apparently purely descriptive area are renewed in other, more judgmental areas. Thus, the foregoing oppositions can all too easily lead to interpretation of these artists' world views as, respectively:

Detached and accepting	Critical and engaged
Artificial	Real
On holiday	At war

And these oppositions transfer to, and are transferred from, common views of Matisse's and Picasso's artistic and personal sensibilities, which offer these contrasts:

Traditional	Avant-garde
Methodical	Mercurial
Uninfluential	Influential
French bourgeois	International bohemian
Unimportant biography	Important biography
Distinct genres	Blurred genres
Painter	Artist

And so on. There is much that can be said about these individual oppositions and the analogies between them (and I have by no means exhausted the possible list). At this stage, however, I wish to make only two general points.

First, I want to repeat my claim that to a very important extent these oppositions pervade discussion of modernism as a whole, not just of Matisse and Picasso. And as part of this I now want to add that the oppositions later imputed to modernism are back-projected onto these two artists. An obvious, although I believe unnoticed, example of this is to be found in how their colleagues have been characterized. Our understanding of Derain's relationship with Matisse in the Fauve years depends upon our imagining Derain in Picasso's mercurial image, which reinforces our opposite image of Matisse. Likewise, discussion of the Picasso/Braque relationship has characterized Braque in terms reminiscent of stereotypes of Matisse, even to the extent of viewing Braque also as an artist of "feminine" gifts.[61]

A more important form of back-projection, however, for this present study is one that affects our appreciation of Matisse by forcing his work into one or another prejudicial interpretive structure. I observed earlier that the image of Matisse now put forward by his defenders is that of an artist of the avant-garde—the image that he gained in 1905 with the Fauve breakthrough, but lost by 1912 to Picasso. While Matisse eventually regained the interest of the avant-garde, the qualities that we commonly associate with avant-gardism are qualities exemplified by Picasso's art and not by Matisse's, as my chart of opposing terms suggests. Insofar as the avant-garde image has been recovered for Matisse, it has naturally enough been by placing emphasis on those aspects and periods of his work which best support it. Thus, the consensus established in the 1960s concerning what was most important and most relevant about Matisse drew particular attention to those aspects and periods of his work that could be seen as bridging the territorial boundaries of my opposing columns. The Fauve pictures fulfill these conditions, not only because they mark Matisse's historical avant-garde moment but also because they are complex and fragmented. But even more so do his decorative paintings around 1910 fulfill these conditions, for though harmonious they are untraditionally bold and conceptual; so do his experimental paintings from World War I, because they are austere and difficult; and his late cutouts, because they go beyond painting. The advantage of seeing Matisse in this way is that one escapes the narrow view of his art

as being opposite to Picasso's. But one does so only to see Matisse's art through the filter of an idea of modernism that derives more from Picasso than from Matisse.

If we find this distorting, as I think we must, we will want to separate Matisse from Picasso while maintaining his avant-garde importance. This has been done, we have seen, by stressing the preeminently visual character of his work while dismissing its luxuriousness. This interpretation developed from the purely, or mainly, stylistic appreciation of his work that became important again in the 1930s; it became the standard interpretation offered by formalist criticism in the 1960s, when Matisse's reputation reached its full height. Matisse seemed even more important than Picasso: he transcended the messiness of blurred genres, bohemian cant, biographical details, social or political conflict, and so on; in short, all the extra-artistic things that belong merely to a vulgar, romanticized idea of the avant-garde.

Here, however, another form of back-projection obtains. Matisse's reputation as a preeminently visual artist made his work paradigmatic for an exclusively formalist interpretation of modernism, as an art accessible solely through aesthetic intuition, through judgments of taste. This interpretation, projected back onto Matisse, manifested itself in a hardening view of his art as mainly a formalist enterprise. When his hedonism was noticed, for example, it was presented as "cold hedonism and ruthless exclusion of everything but the concrete, immediate sensation";[62] that is to say, as a form of aesthetic disinterestedness—and additionally as something revealing a far more meritorious form of toughness and engagement than evidenced by any vulgar avant-gardist, because applied to the practice of art itself.

Insofar as this view of Matisse is based on judgments of taste, it is less bound to history than is the view which positions him within the avant-garde. As a stylistic view, it is associable with stylistic interpretations like Alfred Barr's which developed in the 1930s. But as a purely aesthetic view, it is less likely to accept than is an avant-garde view the common art-historical periodization of Matisse's career, pioneered by Barr, into realistic and abstract, therefore conservative and innovative, phases. Let us say, for instance, that my judgments of taste find the Nice period to be stronger than usually conceded and the late period of the cutouts to be weaker. My judgments of taste may ignore the conservatism of the former and may not be swayed by the innovativeness of the latter. But by the same token, I may in that case simply be seeing Matisse through the filter of an idea of modernism which is essentially aesthetic, and which can distort him, just as the avant-garde filter distorts him.

Insofar as we approach Matisse (or any artist) aesthetically, we will elevate what strikes us as being more articulately expressed, more radiant with intensity, over what we think is merely interesting. We will be right in doing so, even though our preferences can never fully be explained. Matisse did not prize

all of his paintings equally; neither should their audience. However, an aesthetic view of Matisse will run the risk of overlooking, or minimizing, an unresolved or overextended work and will find perhaps too much to admire in small and exquisite beauties. *Luxe, calme et volupté* (fig. 9) and *Le bonheur de vivre* (fig. 31), to take the two most prominent examples, are not masterpieces, judged aesthetically. But if we view them only aesthetically—indeed, from any purely formalist standpoint—we may miss not just their iconographical importance but also the chance to see in a raw state the materials of pictorial expression that Matisse will meld and purify in later, aesthetically more successful works. Of course if we see them only iconographically, we will miss far more. If the avant-garde interpretation of Matisse scans the list of Picasso's attributes for those it can apply to Matisse, then the aesthetic interpretation picks and chooses among the list of Matisse's attributes, selecting only those which serve its own particular purpose. Neither option is satisfactory.

These lists of attributes provide alternative views not only of modernism, however. And this brings me to the second general point I wish to make about them: They offer alternative views of the world. The ultimate antagonism between Matisse and Picasso is far greater than that for proprietary rights on modernism; if it were only that, it would hardly engage us to the extent it does. Instead, it tells of competing claims on a reality to which each assumes privileged access. Thus not merely modernism but reality itself occupies the empty space between the two columns of my chart. It is our world that is both harmonious and dissonant, simple and complex; that presents itself as flatness and shape and as space and form; and that can be apprehended both perceptually and conceptually, by vision and by the intellect. The sequence of opposed analogies comes down in the end to anciently contrasting views on the world that determine its reality. Matisse is an iconophile who loves and trusts the visual; Picasso is an iconoclast who repudiates its artifice.[63]

I said earlier that, for Matisse, visual sensations were not to be trusted, because contradictory, and that he aimed at a mode of representation with the clarity of a text. The contrast of image and text is immediately associable with that of iconophilia and iconoclasm, and consequently has hovered around comparative discussion of Matisse and Picasso. The art of Picasso has thus attracted semiotic analysis while the art of Matisse has not, for all his talk of signs. Even without practicing that form of analysis, one way to open the boundaries that have surrounded Matisse, and not co-opt him to an external ideal of the avant-garde, is to question the exclusively imagist Matisse by allowing room for a textual Matisse. Recent iconological studies have begun but by no means exhausted this possibility, as I hope to show.

An additional contrast that attaches to the contrast of the visual and conceptual, and which I will also examine, is suggested by the terms that André Salmon used to attack Matisse, in comparison with Picasso, in 1912. He said that Matisse was a *modiste* with feminine gifts. The issue of gender is an important one, both because it brings to the fore a traditional, albeit biased interpretation of "decorative" painting that has bearing on Matisse's luxury; and because it discloses an interpretation of the art of painting, as practiced by Matisse, that deserves examination despite its prejudicial form. Salmon is saying, in effect, that Matisse the painter of colored surfaces is involved with the display of costumed bodies and the space they ornament; his paintings are confined to this narrow sphere of external display.[64] Salmon follows what some writers since at least the eighteenth century had been saying: that attraction to the sensuous surfaces of things is characteristic of female vision.[65] This interpretation runs counter to another familiar, equally prejudicial view of Matisse, which sees his paintings of odalisques as designed for the gratification of the male eye. We need to ask ourselves how these utterly opposite interpretations, neither of which survives close examination, can be attached to the same artist.

Intersecting this last contrast is that between the visual and physical. Matisse, of course, was a sculptor as well as a painter; almost as original a sculptor as he was a painter. Even alone, this fact makes nonsense of the idea of Matisse as preoccupied only with the visual. And it upsets facile comparison with Picasso, since it was Picasso's contribution to this medium, in his early constructions, that was the more purely visual. But Matisse's painting as well as his sculpture requires consideration for the tension between the visual and the physical his representations convey.

A final contrast will bring this section to a close, a contrast of geography, attributed to Picasso: the often quoted statement that he and Matisse were respectively "the North and South Poles."[66] So familiar is this statement and so wittily does it conjure up the popular stereotypes, uncovering the metaphor behind our talk of the polarization of these two artists' styles, that it usually appears without comment. But it is most peculiar nonetheless. For it was Matisse, of course, who was actually the Northern artist—really a Flemish painter, born nearer to Brussels than to Paris, let alone the Mediterranean—while Picasso was in fact the artist from the South. Yet the South also connotes hedonistic pleasures, the North austerity, and if we pursue the analogy through their work, it appears that the artists have switched poles. Although an apparently trivial example of how Matisse's reputation stands, the analogy aptly summarizes how his interpretation as a painter of visual pleasure proceeds from a rhetoric of differences and exclusivity that does not bear close examination. This is not to say that such an interpretation is false or illusory. It has been exaggerated, certainly, and wrongly characterized. But, as we have seen, attempts to deny and dismiss it have not been successful. It must have meaning.

So our next question becomes, to use Picasso's terminology: How does this man actually of the North become a man of the South. The answer is simple: By displacement.

II. An Impossible Coherence

Matisse was born on New Year's Eve of 1869 in the old wool-manufacturing town of Le Cateau-Cambrésis on Flanders Field, one of the traditional battlegrounds of Northern Europe.[67] He was brought up in the nearby village of Bohain-en-Vermandois, where his father was a prosperous grain merchant and where his "artistic" mother painted china and made hats. It is a cold, inhospitable region of gray skies above a flat landscape with distant horizons, punctuated by church steeples around which cluster villages of dull brick houses; a drab agricultural area of economic importance where someone with business acumen, such as Matisse's father, could do very well.

Matisse was a sickly, docile child apparently unfitted to follow his father's business—or thought fit for social advancement to a professional career. So he was sent to Paris to study law. Graduating with honors, he returned to his native region as a law clerk in the town of Saint-Quentin. Around his twentieth birthday, however, an attack of acute appendicitis forced him to convalesce at his parents' home. His mother gave him a paint box to keep him from being bored. As he tells it later, it was an epiphany:

When I started to paint, I felt transported into a kind of paradise. . . . In everyday life, I was usually bored and vexed by the things that people were always telling me I must do. Starting to paint, I felt gloriously free, quiet and alone.[68]

To paint was to be transported from the prosaic world of external reality to a paradisal world of his own creation. The act of painting itself, quite irrespective of what it produced, effected this displacement. Indeed, the very presence of the paint did. He remembered, "The moment I had this box of colors in my hands, I had the feeling that my life was there."[69] The act of painting and the medium of painting retained this meaning for him. They were, respectively, the means and the materials to build a new and protected, but free life. Or at least to enter such a life; for additional meanings attached to painting that made it seem beyond his control and not quite, or not only, the solace and comfort the paradisal image suggests, but also dangerous and abnormal in its freedom. It was, therefore, not finally a self-created realm of omnipotent pleasures but instead an obscure, instinctual region that had entrapped him. Toward the end of his life, he recalled: "I was driven on by something, I do not know what, by a force which I see today as something alien to my normal life as a man. . . . So I have been no more than a medium, as it were."[70]

Talking with the writer Louis Aragon, Matisse used the same analogy to explain how making a work of art made him feel like a passive conduit for the expression of instinctual forces that he did not quite understand. "I execute the drawing almost with the irresponsibility of a medium,"[71] he said. Matisse presents the world of his art as an irrational one, almost free from the responsibilities of action that govern public life; in effect, as some mythical world through the looking glass, which, mirroring external reality, forms its obverse. He signed his first original painting in reverse, "essitaM H."[72] And in the section of the text for *Jazz* headed "Bonheur" ("Happiness"), he wrote approvingly of successful Japanese artists' changing their names to protect their freedom.[73] He speaks as if art were not formed by personal will but, rather, had a life of its own to which the artist's life is subject. His art thus calls for his self-effacement. It is a world into which personality retreats. But because it is a world of instinct, its retreat is both threatened by and threatening to the public, rational world. Recalling his discovery of painting, Matisse said: "Like an animal that rushes to what he loves, I plunged straight into it, to the understandable despair of my father, who had made me study other things."[74] Pierre Schneider puts it well: "Painting intruded upon an area of consciousness dominated by his father, as an obscure, instinctual force."[75]

The image thus presented by the artist and his commentator is of filial rebellion, undertaken to discover some wildlife preserve of the imagination. The hypersensitivity to questions of influence that characterizes Matisse's statements about his art—his belief that "the personality of the artist develops and asserts itself through the struggle it has to go through when pitted against other personalities," and that it would be cowardly and insincere to avoid this struggle[76]—reinforces such an interpretation. In turn, the strong element of emulation implicit in this statement attaches Matisse's rebellion to the familiar theme of the anxiety of influence: Matisse's developmental struggle as an artist offers itself as a simulacrum of the struggle against paternal authority. Integral to this theme is the idea that rivalry requires admiration of whoever is opposed. Thus, Matisse seeks not merely to reject but finally to match the authority he rejects. His rebellion is *shaped* by the resistance of authoritarian values.[77] Indeed, he himself condoned the idea that his personality and his art had an extremely rational side, which came from his father, as well as a visionary, Romantic side, which came from his mother.[78] "Slowly I discovered the secret of my art," he said. "It consists of a meditation on nature, on the expression of a dream which is always inspired by reality."[79] That is to say, his dream must have all the authority of reality, must be as real as reality itself if it is to be a rival version of it. It will be as rigorous, detached, and objective as any product of rationality, as methodical in its manufacture as possible.

Three pairs of contrasts form in parallel here: (a) dream

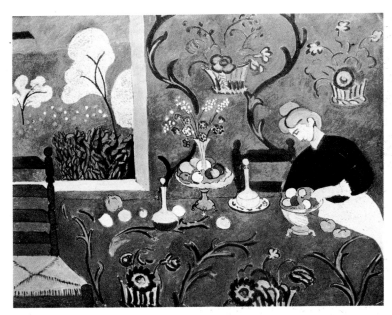

2. *Harmony in Red / La desserte*. 1908 (pl. 105).

3. Diego Velázquez. *Christ in the House of Mary and Martha*. c. 1618. Oil on canvas, 23⅝ × 40¾" (60 × 103.5 cm). National Gallery, London.

versus reality; (b) irrational compulsion, which plunges Matisse into this fantasy world, versus rational, paternal authority; and (c) Matisse's struggle for his own artistic identity, versus the artists of the past. The element the three have in common is the contrast of the private and the public. And yet, Matisse by no means rejects the public realm, only what he perceives as the constraints imposed by what is external. According to him, for example, "Cézanne did not need to fear the influence of Poussin, for he was sure not to adopt the externals of Poussin; whereas . . . his technique was too strongly affected by Courbet, and Cézanne found his expression limited by Courbet's technique."[80] The closer the influence, Matisse observes, the more perilous it is, because it becomes more difficult to see beyond its external features. Reliance on the external he summarizes with the word *imitation*. "When one imitates a master, the technique of the

master strangles the imitator and forms a barrier which paralyzes him. I could not repeat this too often."[81] Likewise, an artist trying literally to imitate external reality is like a tailor trying to make a suit "by fastening it to the body of the customer by means of numerous alterations which bind the victim and paralyze his movements."[82]

These extraordinary and surely excessive metaphors of a body smothered or physically constrained gain even more force when we realize that what Matisse is describing is apparently not claustrophobia but something more like agoraphobia. The open spaces and exposed surfaces of external reality and history are what coil around and threaten to strangle him. They drive him to the inner world. And the model for his painting becomes the interior. The paradigmatic work is that great masterpiece *Harmony in Red* of 1908 (fig. 2), a reimagining of Matisse's first ambitious composition, *The Dinner Table* of 1896–97 (pl. 13). Here, Matisse shows us an interior that resembles the external world of nature without simply imitating nature. And his pictorial representation of the interior resembles that of his own prototype painting without imitating that prototype. Imitation of both external reality and of past painting are thus avoided. What is more, this picture offers "a kind of paradise" full of solace but at the same time vital and mysterious, one that therefore seems not merely a retreat from reality but a heightened, almost hallucinatory version of reality. The purposes of everyday life are momentarily held in suspense. The external is brought inside.

Let us look at *Harmony in Red* and see how Matisse achieves this effect. He does so in at least four ways.

First: The still life on the table is simply taken from nature. It is pure nature without the intervention of human technique.[83] Matisse's 1896 painting *Breton Serving Girl* (fig. 4), which first announced the theme that led eventually to *Harmony in Red*, derives from Chardin's *Saying Grace* (fig. 5) in the Louvre. It maintains the theme of domestic work characteristic of Chardin, showing signs of food having been prepared. No subsequent still life by Matisse I know of does so. He will later show us flowers that are patently cultivated, but hardly ever are they out of season. And he will never show us anything industrial or commercial, anything that belongs exclusively to the modern world. His subject matter is largely that of nature without culture, telling of a precultural, prehistorical harmony.[84] Insofar as we perceive it culturally and historically, that is Matisse's doing.

Second: Matisse's presentation of nature, on the table, is of nature found scattered and then collected. It is as if the fruit had simply fallen from the tree ready to be gathered up. This reinforces the effect of primal abundance but adds new associations to it, most evidently the sense that it is the action of the hands, of touch, that gathers the abundance of nature. The servant gathers the fruit and shows it to us in the bowl she holds. And we see that this picture, too, is a kind of container into which nature has

Far left:
4. *Breton Serving Girl*. 1896 (pl. 12).

Left:
5. Jean-Baptiste-Siméon Chardin. *Saying Grace*. 1740. Oil on canvas, 19½ × 15¼″ (50 × 39 cm). Musée du Louvre, Paris.

been fitted. It, too, is shown to us, and in a way that emphasizes its proximity to our touch.

It is often observed that Matisse has carried the flat patterning of the back wall onto the table, thereby joining everything as one flat plane. This is true, and yet everything remains as near and as accessible as the table. The patterning of the back wall appears to have grown from the flowers on the table, and below them from the baskets of flowers on the tablecloth that rest on the picture's bottom edge. Like those baskets, the picture is thus a woven container which looks flat, but which offers an effect of enclosure nonetheless. And like the carafes of wine on the table, it is a container of colored liquids that is transparent to the eye. The ubiquity of containers and vessels in Matisse's pictures is not, of course, accidental. His great series of pictures with bowls of goldfish is but the most explicit realization of the theme: how things put into a graspable container, and therefore exemplary of touch, are there displayed to the eye.

Third: A picture that presents itself as a container can be metaphorical of the body, which is also a container.[85] Again, the goldfish pictures are the most explicit in this regard. What is within their depicted containers is patently alive. But *Harmony in Red*, too, is metaphorical of the body. It is a container of fluids, organically shaped objects, and arabesques like sinews or veins; and it is of course blood red. Moreover, the subject of the picture is centered on the body and its reach; specifically, on a woman's body that reaches into nature. Like a number of Matisse's other greatest pictures, this one addresses the place of the biological body in nature. The body seeming to merge with nature is the subject of *Blue Nude: Memory of Biskra* (fig. 7). Bodies reaching to

the limits of nature's hold form the subject of *Dance* (pl. 112; fig. 22). The woman in *Harmony in Red* is an intermediary between nature and culture. In this respect, too, the internal and external are reconciled.

Fourth, and finally: The internal and external are effortlessly reconciled. The bowl of fruit is weightless as the woman shows it to us, almost an appendage of her.[86] The plenitude of nature is simply presented to us in the picture. It requires no work at all.

The servant in Velázquez's *Christ in the House of Mary and Martha* (fig. 3) offers a useful comparison. She is locked in mundane toil; behind her, a window (or picture or mirror) opens onto a sacred world exalted by Christ's presence. Matisse's *Harmony in Red* is exactly the opposite. The framed external world is of an ambiguous season, either winter with snow on the trees or spring with blossoms that have not yet produced fruit.[87] In either case, what we see outside is preparatory to what we see inside: warmth and fecundity, a landscape of abundance for our enjoyment with even an available chair to occupy there. Nature takes over the interior and expands it, making it larger and more generous than the world outside. Often with Matisse, the fecundity of nature outside, seen through a window, will be brought inside. The famous *Open Window* of 1905 (pl. 61) is but one of numerous examples of how windows or doorways form, in his own words, "a passageway between the exterior and the interior."[88] But almost without exception, the interior is privileged; a cocoon of warmth.[89]

Before finishing with *Harmony in Red*, I need to acknowledge that my attention to its subject matter leaves its formal or ab-

stract aspects unexplored. But I have wanted immediately to stress that Matisse is a representational not an abstract artist. Although this is obvious, nevertheless let me elaborate on it.

The Representational Sign

Clearly, our appreciation of *Harmony in Red* is an appreciation of color and pattern to a greater, more heightened extent than is the case with its predecessor, *The Dinner Table*, made roughly a decade before. But we do a great injustice to it, as well as to the earlier picture, if we hold that color and pattern themselves are the aspects of it that most matter. Of course they matter. They matter as they do, however, because we recognize their representational functions and Matisse's subsumption of these functions into color and pattern.[90] In *Harmony in Red*, representation itself is the result of the movement of areas of colored paint—of color that floods over the plane of the canvas, channeled and directed by arabesque drawing, until it occupies the surface as the pure chromatic substance of painting in its fundamental state. Thus, the interior is re-presented to us as an original vision.

Matisse insisted that the successful work of art carried within itself its full significance—within "the lines, the composition, the color"—and imposed that on the viewer "even before he recognizes the subject matter."[91] When quoting these words of Matisse earlier, I said that he referred to how subject matter should not be illustrated. That would leave it in the external world, we now know. Instead, the sensations provoked by subject matter were to be condensed in the expressive manipulation of the painting medium. (Thus to gain the clarity of a text, I added.) I can now enlarge on this, and say that while subject matter does not manifest itself directly, because Matisse's art is not illustrative—making it difficult on occasion to decipher the subject at all (*The Yellow Curtain* of c. 1915 [pl. 183] is a good example)—there is never any doubt that what we are seeing is a representational picture. Matisse's acts of condensation are still condensations of representation. In them, the representational does seem to shrink. But never *away* from representation; quite the opposite: further into itself.[92] Not in the manner of the most condensed Analytical Cubist paintings, into a kind of coded sign language, but rather into a sequence of dense, replete symbols whose full significance is unknowable, indeed evaporates, except in the context of the whole sequence. Matisse's own use of the word *signe* will help to clarify this.

In "Notes of a Painter," Matisse described how he sought to realize his intuition of what constituted the "essential character" of his subject.[93] The act of painting was an attempt to *re-create* a prior mental image; that is to say, it was akin to recalling a memory. Thus he told his students: "Close your eyes and visualize the picture; then go to work."[94] Again, we notice how the external is brought inside. The process of working, therefore, is

one of "representing" (re-presenting) the subject, not "copying" it, he said, "and there can be no color relations between it and your picture; it is the relation between the colors within your picture, which are the equivalent of the relation between the colors in your model, that must be considered."[95] In creating the relations internal to the picture, "it is necessary," Matisse insists, "that the various signs [*signes*] I use be balanced so that they do not destroy each other."[96] The word *signes* here is usually translated as "marks," and Matisse does seem to use it to include every kind of painterly trace. Thus, he goes on to describe how he will keep changing the areas of color in a picture until a combination of colors is found that renders what he calls "the totality of my representation." This process of repainting he calls "transposition," referring not merely to the change of color itself but, more broadly, to its function: to produce a harmonious balance between juxtaposed areas of color that transposes into painting his prior mental image of the subject, thus re-creating it.

This is in 1908. His description of color transposition appears to be based on his repainting of *Harmony in Red*, which was originally blue or blue-green. The picture may now "seem completely changed," and is, in external appearance, but it remains the same picture, nonetheless.[97] It remains the same picture because the mental image Matisse is painting is not a pre-formed idea, in the sense of something separate from the means of its pictorial realization, but rather, an idea whose form will finally be discovered within those means. What is more, the mental image he is painting condenses not the appearance of the subject but the feeling it evokes in him. The painted image that results will therefore correspond to that mental image—will become a transposed, realized form of that mental image—only when it evokes the same emotions that the subject itself did originally. "I do not literally paint that table," Matisse says, "but the emotion it produces in me."[98] When the work is completed—and this *tells* him when it is completed—"the painter finds himself free and his emotion exists complete in his work. He himself, in any case, is relieved of it."[99]

So, the process of transposition is a process of surrendering emotion. "My reaction at each stage," Matisse says, "is as important as the subject."[100] It must be, because the picture is repainted until it provokes the feeling of relief. There is, naturally, a name for this process—sublimation—as Matisse somewhat unwillingly conceded: "When I attain unity," he wrote, "whatever I do not destroy of myself which is still of interest—I am told that this is transformed, sublimated, I am not absolutely certain which."[101]

In order to understand what he means, let us return to the question of signs and notice that, in the 1930s, Matisse developed a more specialized understanding of them than as painterly traces.

He spoke of his art of the thirties, which set aside the relative naturalism of the so-called Nice period of the preceding decade,

as a "return to the purity of the means" of his work around the time of "Notes of a Painter."[102] By the end of the thirties, the number of his statements about the purposes of his art had increased, as he seemed determined to develop a revised theoretical model with the authority of that seminal text. Returning to the topic of his not copying nature, he spoke to Louis Aragon about drawing a tree:

I shan't get free of my emotion by copying the tree faithfully, or by drawing its leaves one by one in the common language, *but only after identifying myself with it. I have to create an object which resembles the tree. The sign for the tree, and not the sign that other artists may have found for the tree: those painters, for instance, who learned to represent foliage by drawing 33, 33, 33. . . . The truly original artist invents his own signs. . . . The importance of an artist is to be measured by the number of new signs he has introduced into the language of art.*[103]

The conclusion is hard to accept. We can understand why Matisse, fearful of imitation, will stress original invention. But surely it is the intensity, not the number, of an artist's inventions that matters. And yet Matisse clearly does stress quantity. Talking to Pierre Courthion in 1931 about how an artist cannot himself understand the full meaning of his art, he had done the same thing: "A painter doesn't see everything that he has put in his paintings. It is other people who find these treasures in it, one by one, and the richer a painting is in surprises of this sort, in treasures, the greater its author."[104] Quality is thus equated with quantity. Putting these two statements together, we find again the idea of a painting as a container; here, as a treasure chest of original signs.

In the 1930s and early 1940s, Matisse's theory of signs was in the main a theory of drawn signs. As such, it ultimately derived from the concept of a "linear script," which he had mentioned to Charles Estienne in 1909 when recapitulating ideas in "Notes of a Painter."[105] In an important 1939 statement whose very title, "Notes of a Painter on His Drawing," consciously refers to that earlier text, Matisse used such terms as "plastic writing" (*l'écriture plastique*), "plastic signs" (*signes plastiques*), "the page is written" (*la page est écrite*), and so on, to tell of how drawing, and specifically drawing in ink, afforded the purest, most direct expression of his emotions, and consequently was the essential language of signs.[106] The principal theme of his ink drawings, he said, was his models: female models posed nude, as in the drawings *Large Nude* of 1935 (pl. 308) and *Artist and Model Reflected in a Mirror* of 1937 (fig. 1); or in decorative costumes, as in the *Rumanian Blouse* drawings of the same period (pl. 325). The emotion aroused by the models "does not appear particularly in the representation of their bodies," Matisse insists. Indeed, "if I met such women in the street," he says, "I should run away in terror." Rather, his emotion is manifested in the whole architecture or orchestration of the drawing. Therefore, "it is perhaps sublimated sensual pleasure," he concedes.

Artist and Model Reflected in a Mirror perfectly illustrates this. The body of the model is unimaginable away from the sheet; at the least, if extracted it would appear to be deformed and terrifying. For it has surrendered its unity to the unity of the sheet. Matisse's own image may be difficult to find at first; its location is concealed in the sheet. But the image of the model is concealed in the very means of its representation. The representational has been attenuated into signs which orchestrate the whole surface as much as they describe the model. That is, the model dissolves into her reflection, and both dissolve as graspable images as they spread in waves of analogous curves across the white sheet. This ripple of movement is what breathes air into the composition. And the compartments opened by the irregularly spaced lines look as if they were unfolded parts of a complex, pleated construction: something originally volumetric that has been pulled flat. Signs of the volumetric, and of the sensuality integral to it, sprawl out over the paper in a reverie on female beauty with the artist himself looking on.

"The emotion of the ensemble" is the important thing, Matisse had told his students some thirty years earlier, "the interrelation of objects, the specific character of every object—modified by its relation to the others—all interlaced like a cord or a serpent."[107] The arabesque is therefore a crucially important sign because it will weave the surface as a web of signs, as a whole fabric. Its value to Matisse is indicated by his talking of "the jewels or the arabesques" in his drawings, and of how they coordinate his drawings in a way that subsumes the functions of form and tonality. He was pleased to be told that their total effect suggested the play of muscles in action.[108] The web of signs produces an equivalent to corporealization.

Signs mean condensation. They give access to the essential character of things. Matisse's need for signs responds to the same need expressed by the hero of Proust's great novel: "I felt that I was not penetrating to the full depth of my impressions, that something more lay behind that mobility, that luminosity, something which they seemed at once to contain and to conceal."[109] That last phrase is crucial. We are not dealing here, in either artist, with a kind of Neoplatonism, where appearances contain timeless essences which are the only things that really and wholly exist. We are dealing, rather, with ambivalence: that Romantic sense of appearance as, in Northrop Frye's words, "at the same time revealing and concealing reality, as clothes simultaneously reveal and conceal the naked body."[110] In Matisse's drawings of his models, the fabric woven by the web of signs is a kind of costume, a decorative surface that conceals the image of the model, to reveal the sensual pleasure provoked by the model. (Hence, representations of models who actually wear costumes—always of Matisse's choosing—form an important theme in his art as a whole.) The decorative surfaces of his paintings function similarly.

For Matisse, achievement of decorative surface unity—

6. *Plum Blossoms, Green Background.* 1948 (pl. 383).

whether by forming a web of signs or by repainting areas of the picture to achieve it, or both—relieved him of the emotion produced by the subject. It is in this way that the emotion, he concedes, is sublimated. The ambivalence of his work is that its use of representation forces the viewer into maintaining simultaneously direct and oblique address to it: acknowledging not merely that it is "abstract" as well as representational (for the means of representation are themselves "abstract"), but far more crucial, that what we are shown directly, the unified decorative surface, is an oblique way of showing us what otherwise simply cannot be shown. It is important and relevant that we recognize what is illustrated in Matisse's work. However, not because the illustrated subject itself will seem possessed of emotion and convey meaning, but precisely because it will not; we may therefore be moved and find meaning in "the emotion of the ensemble." And part, a large part, of the poignancy of that emotion will be due to the fact that it is disassociated from its very source in order to be shown.

To say that the painting *Odalisque with Red Culottes* (pl. 263) shows a provocative bare-breasted nude, or that the drawing of the model Antoinette known as *La chevelure* (pl. 237) shows a beautiful face, evinces imprecision either of language or of looking. The apparent lure of these illustrated women is opposed by the stony rigidity of the former and the blank mask of the latter with its most extraordinarily deformed eye, and by the pull of our interest to the embellished surface as a whole. I do not say, of course, that the results are ugly. They are not. The painting and the drawing are both unabashedly sensual: the former, a light-bathed field of visual enjoyment; the latter, a stream of sensuality

that is sharp and elegant at the base of the sheet but transforms into something soft and impalpable as it rises. Matisse, we know, sought out models for their seductiveness and beauty. But it is his paintings and drawings that possess these qualities, not the models they represent. Matisse does not, cannot, simply illustrate these qualities in his models. He cannot do so because he is a modern artist. Some of the poignancy of his art is that of modernist compensation: its need to find other, oblique means to show us what illustration once could show us directly, it seems, but apparently no longer can. And he cannot do so because he is Matisse. The poignancy of his particular, oblique means of conveying emotion is the distance that it opens from the objects of his desire.

This, too, brings compensation. If it is important that we recognize what is illustrated in Matisse's work, and that its illustration has surrendered meaning, it is because we are thus forced to confront how the illustrated parts appeal to each other for their meaning: they appeal to each other through representational analogy. In *Woman in an Embroidered Blouse with Necklace* (pl. 326), a hand rested against the side of a face is seen to be different from and similar to strands of hair on the opposite side, and the counterpoint of curling lines repeats in the two sides of the embroidered blouse, where it metaphorically transforms into a floral garden. In *Odalisque with Magnolias* (fig. 12), pantaloons covering the opened thighs of a model are unlike but also like the opened magnolia behind her and the magnolia fuses with the leaf-patterned screen. In *Plum Blossoms, Green Background* (fig. 6), a blank oval describes a model's face and similar ovals are used to describe pears in a bowl before her, and it is imperative that we acknowledge the different representational functions of the oval; otherwise we will not see and cannot be affected by their subsumption into a common shape. Matisse's rhyming of human and vegetable life does not cancel out but depends upon their difference. This is also to say: Matisse's sublimation, which disperses emotion from objects to the relations between objects, empties both face and fruit of features, to leave behind signs that mark simultaneously the absence of literal desirable objects and the displacement of desire from them to the ensemble.[111]

The dual function of Matisse's signs, to mark absence and displacement, is integral to his conception of painting as I described it earlier. Painting is the means of effecting displacement from an external world of appearances to an internal world of the imagination. And painting gives authority to that internal world by re-presenting in an oblique form the absent world outside. The associations we have noticed as attaching to signs—of treasures with which to fill containers; of woven decorative costumes revealing and concealing bodies; of internal bodily elements beneath the skin—reinforce that connection with the privileged world of the interior and its creation by metaphorical transformation of the world outside.

The Language of Signs

I said that Matisse's early conception of signs was, broadly, of painterly traces and that their transformative function was largely thought of as effected by transpositions of color. I then observed that in the 1930s and early 1940s Matisse developed a more specialized theory of drawn signs. This did not mean, however, that color was excluded from his theory. It was part of it because drawn signs, he claimed, produced coloristic effects: they modified the white of the paper, creating effects of light and tonality "which quite clearly correspond to color."[112] He was thinking of pen-and-ink drawings like his *Rumanian Blouse* drawings of 1936–37 (pls. 325, 326), where the pattern of lines creates a kind of fluorescent palpitation comparable to that produced, in his early Fauve paintings, by curling strips of paint of contrasting hue set against the white ground of the canvas. These paintings had been "drawn" with strips of color. Thus a drawing is "a painting made with reduced means."[113]

And yet, he had to allow, "painting is obviously a thing which has more to it."[114] Therefore, "a colorist drawing is not a painting. You would have to find an equivalent in color—this is what I can't quite manage," he wrote to Bonnard in 1940. "My drawing and my painting are separated."[115] He was thinking of the reciprocity of drawing and color in paintings like that year's *Rumanian Blouse* (pl. 328), where color fills in pre-drawn compartments. It was "the eternal conflict of drawing and color in the same individual," he wrote the following year.[116]

Matisse's conception of signs in color and line took one final turn. By the end of the 1940s, his art comprised mainly colored paper cutouts and drawings in black ink made with a thick brush. Color and drawing are apparently still separated. And yet, the two mediums have a common basis, one that conflates Matisse's two preceding methods for creating transformative signs. The first, color transposition, had meant repainting areas of color until "the color was proportioned to the form" of the area it occupied.[117] The second had meant drawing condensed images. The methods combine in the creation of images from drawn areas, whose contours are determined from the inside. For example, in the ink drawing *Dahlias and Pomegranates* of 1947 (pl. 381), the gesture that spreads area also creates the line that surrounds area. The paper cutouts were conceived similarly, by "drawing with scissors on sheets of paper colored in advance, one movement linking line with color, contour with surface."[118] Here, Matisse's scissor-drawing responds to his sense of the "quantity of colored surface" he needs.[119] This forms the ultimate sign, for the interior generates the exterior and is coextensive with it. And the character of this ultimate sign reveals a source for Matisse's conception of signs earlier than any I have mentioned: the "drawn" strips of color in his Fauve paintings. There, drawing and color combine, and the interior and exterior of an area are formed together.[120]

Matisse offered the clearest exposition of his ultimate conception of signs in a 1951 interview published under the title "Testimonial."[121] In it, he used the metaphor of a chess game. He said that he had never tried to play chess: "I can't play with signs that never change. This Bishop, this King, the Queen, this Castle mean nothing to me." We are to understand that a sign is created at the moment of its use, usually as one of a sequence of interdependent signs and always for a particular context outside of which it is useless, without meaning. "For that reason," he concluded, "I cannot determine in advance signs which never change and which would be like writing: that would paralyze the freedom of my invention."[122]

Since we remember that Matisse had nevertheless referred to his signs created by drawing as "plastic writing," the foregoing conclusion might come as a surprise. And yet, earlier he had said that he could not get free of emotion by copying an object in "the common language," but rather had to "identify" himself with the object by creating a sign that "resembles" it instead. An immediate conclusion might be that Matisse's "plastic" signs differ from the signs used in the common language of writing because they are iconic, not symbolic, referring by means of resemblance or analogy and not, like words or other arbitrary signs, by convention. On occasion he did indeed use the term *hieroglyph* synonymously with the term *sign*.[123]

The enormous problems associated with the idea of iconic signs need not concern us. What must, however, is that Matisse's signs obviously cannot be distinguished from the conventional, unchanging signs of writing by saying they are created within a specific context and are not preexistent like words. Although Matisse appears to be saying just that, nonetheless his signs depend for their basic meaning on their representational appeal; therefore, they do in fact rely on preexisting conventions of representation. (Their basic meaning may of course be precised contextually, but that is also true of words.) Instead, what Matisse is really saying is that using unchanging signs would be like using ordinary writing; but because "plastic writing" is a more freely *invented* writing, it offers the artist a privileged access to reality not available to "the common language."

What kind of access? In attempting to answer this question, I need to turn to the concept of metaphor, because this concept dominates Matisse's statements about the functions of signs, and because our overall view of Matisse as an artist depends upon it. His modernist distaste for realism; his Symbolist-influenced preoccupation with analogous forms; his thematic concern with reconciliation of the internal and the external; his obsession with harmony and with memory: all these things, and more, are connected by the concept of metaphor. Essential to metaphor is the appeal that one image or word makes to another. Based on resemblance and the possibility of replacement, it calls attention to what is absent by substituting for it what is present and

similar, offering reconciliation between them. (Metaphor means, literally, a carrying of the identity of things from one place to another.) So too, Matisse's interior world resembles the exterior world but displaces it.

To Matisse's admirers, the metaphorical basis of his art is exemplary. It signals his recovery of primal harmony between the self and the world. To his detractors, the metaphors he uses to assert this harmony, notably the recurrent analogy of the human and the vegetable whose paradigmatic form is the *femme-fleur* ("woman-flower"), are weak in their refusal of distinctions between things, even demeaning to the human, specifically the female.[124] And it must be conceded that his metaphors, if examined separately from their contexts, are indeed somewhat hackneyed. Intrinsically, they lack force because the two terms of the comparison (*femme* and *fleur*) are not widely enough separated from each other, being traditionally associated terms; there is not the distance necessary for truly vivid metaphor.

In practice, however, his metaphors can have extraordinary and quite unexpected force. Thus, for example, the metaphorical association I mentioned earlier, in the painting *Plum Blossoms, Green Background* (fig. 6), of a woman's face and similarly oval pears is, in principle, quite ordinary. Yet it radiates energy across the distance between these elements; the painting comes alive around them, as if sparked by their linkage, and so animated is the colored surface that it seems even to overflow the limits of its frame. This is not to be explained solely by the physical distance between the elements that Matisse compares. He will often directly juxtapose analogous forms to comparable effect. The point remains that he compares traditionally associated elements. Vivid metaphor usually makes unlike things similar, discovering unexpected resemblances in distant terms; this happens, certainly, in Cubist paintings, where we are often amazed to be shown how the most dissimilar objects are made to resemble each other and share a common geometry. Matisse's approach is entirely opposite. A pictorial sign, we have heard Matisse say, "resembles" the object from which it derives. But the objects, and signs, that he compares *already* resemble each other. This leads me to conclude—because I do find Matisse's metaphors to be forceful—that the sheer fact of resemblance in an analogy was not particularly important to him.

Why would Matisse choose to compare already similar elements? An obvious answer is: To reveal their differences, as if comparing a pair of twins. (And this is the time to remember how many pairs of paintings he made.) However, Matisse insisted that his aim was to achieve unity by stressing "the affinity between things," their "rapport," which he compared to that of love.[125] It would be outrageous to claim that he did not know what he was doing. Besides, intuition suggests that what he says is true. It is possible, nevertheless, that his explanation of his aim exhibits the same ambivalence we have noticed in his work. The direct message may contain an oblique one. It may be that

affinity, rapport, love need to be created; that is to say, do not independently exist. Or more narrowly, it may be that affinity, rapport, love are not revealed in the resemblance between things but can be inferred, rather, from the form their differences take.[126]

The deep structure of Matisse's work, if it can be put that way, is essentially metaphorical. Matisse remembers a prior mental image of his subject—a clear vision of a whole that no longer, therefore, exists—and seeks to recover it in his painting by piecing together separate experiences into a common harmony. As with Proust, the action of memory is what links experiences on the basis of their similarity. Although the specific metaphors which form the surface of Matisse's work can be bland, the significant thing is not the presence of particular metaphors but, rather, how our perception of Matisse's paintings is made to *proceed* by perceived similarities. That is to say, what is important is the *linkage* between them. "Without metaphor, Proust says, more or less, no true memories," observes one of his commentators. "We add for him and for all: without metonymy, no linking of memories, no story, no novel."[127]

This contrast of metaphor and metonymy is indebted to the application of these terms by the linguistician Roman Jakobson to the study of aphasia, a severe speech disorder.[128] Metaphor, we know, is concerned with the resemblances between things. It selects features based on their similarity. Metonymy, in contrast, is concerned with the *attributes* of things. It substitutes an attribute (or adjunct or cause) of a thing for the thing itself, based on their contiguity. Jakobson's crucial observation was that aphasiacs who had difficulty in *selecting* the correct linguistic units tended to use metonymic expressions, while those who had difficulty *combining* linguistic units tended to use metaphorical expressions. Whereas metaphor, because it is "selective," finds meaning in the relationship between a chosen element and one that could potentially replace it, metonymy, because it is "combinative," does so in the relationship of linked chains of elements. For this reason, Matisse could not revise his pictures simply by means of insertions and substitutions. Each part took its impetus from another; in order to change even one part, he was therefore often forced to repaint the entire work.[129] His art, he never tired of repeating, was a constructional one.

Matisse's constructional method is thus broadly metonymic. His art is also metonymic in a second way: in its extensive use of the closely related figure of synecdoche (naming a part of a thing for the whole, or vice versa). The best example of this is how the right, middle-ground figure in *Le bonheur de vivre* (fig. 31), his first fully arcadian representation, was reimagined as the painting *Blue Nude* (fig. 7) and the sculpture *Reclining Nude (I)* (fig. 8), and how the sculpture was pictured in an extended sequence of still-life compositions (for example, pls. 107, 153, 154). These two versions of metonymy may be described as formal and iconographical.

7. *Blue Nude: Memory of Biskra.* 1907 (pl. 93).

8. *Reclining Nude (I) / Aurora.* 1906–07 (pl. 92).

A third version of metonymy, which closes the gap between it and metaphor, manifests itself in Matisse's indifference to resemblance. He is indifferent to resemblance because he is preoccupied with likeness. He does not care about the surface appearance of things that may cause them to seem similar; he is interested, rather, in their essential *attributes*, which may be alike regardless of appearances. His preoccupation with likeness leads him to the use of analogy, that is, metaphor. But what truly matters to Matisse is the authenticity of the analogy; that is to say, what it is that *causes* things to be alike. Hence, the force of the comparison, in *Plum Blossoms, Green Background,* of the ovals describing the woman's face and the pears depends on the fidelity of these shapes to their context, which links them.[130] Thus linked, they are made to collaborate. They are seen to share attributes, not only passively, because they resemble each other, but also actively, because they react structurally with each other.

To take another example, *Blue Nude* cannot be constructed with anatomical correctness; the figure has to be rebuilt in a way that at the same time builds its context. The figure *is* the painting, and vice versa. Unquestionably, the result is metaphorical: evocative and suggestive of an alternative world. In rebuilding the figure, Matisse rhymed it with its surrounding landscape, thereby reinforcing the idea of geographical transposition. But once more, the result is an intrinsically weak metaphor: again, the *femme-fleur*. It demands that we look further. Looking, we are brought back to this figure which *is* the painting. It is at this point that the gap between metaphor and metonymy will close.

Just before it closes, however—and I will explain how in a moment—let me make a final use of these two terms, and specifically Jakobson's interpretation of them. Already, the incidence of "weak" metaphors in Matisse's work has pointed us to the importance there of metonymy and the combinative structural activities associated with it. But there is another lesson for study of Matisse's work to be learned from Jakobson—from his observation that aphasiacs who had difficulty combining linguistic units tended to use metaphorical expressions. Thus the predominance of metaphor in Matisse's art may be construed as telling of difficulties of combination. We are correct in noticing that combinative activities are important to him. They are crucially important; he is obsessed with achieving compositional unity. But he is so obsessed, we now can surmise, because unity continually eluded him.

It has become customary to compare Matisse's structural methods with Cézanne's, unsurprisingly given Matisse's apparently boundless admiration for this "god of painting," as he called him.[131] A Cézanne painting, however, constitutes an equilibrium of pictorial forces interacting with each other to effect a sense of the constancy and unity of the natural world beneath its changing appearance. Often, and especially in the case of his late work, the pictorial field appears to be in only *provisional* equilibrium. The extraordinary tension that exists between the pictorial elements—largely because they seem simultaneously anchored to the literal surface and descriptive of space behind it—places the equilibrium of the pictorial field as if in constant jeopardy.[132]

The spatial stress of Matisse's art is very different from this. It is unique to him. It results from the separation and detachment of pictorial elements within and despite the wholeness of the pictorial field. To my knowledge, only one commentator on Matisse, W. S. Di Piero, has fully noticed how his art "desires a complete expression of particulars, which are absorbed but not disintegrated into a welded whole."[133] The web of signs seeks fusion, the emotion of the ensemble; this being so, wholeness is marked by the release of emotion. In *Artist and Model Reflected in a Mirror* (fig. 1), signs of a pulled-apart body swim in waters of

desire where metaphor spawns metonymy, the one alternating rapidly with the other, until the sheet absorbs them. And yet Matisse is continually forced back to what had originally generated emotion; therefore to what is unavailable to him. Di Piero's conclusion—that the result is "an image of separation and estrangement, and of nostalgia for an impossible coherence"[134]—should be read as referring not only to Matisse's construction of his pictures but also to our perception of them, which includes our hope and expectation that out of the coincidence of things a fused whole may appear.

If Cézanne's painting offers *provisional* equilibrium, Matisse's, then, offers *potential* unity: the potential of achieving unity. This accords with his acknowledgment, toward the end of his life, that his researches could never be over; also, that they began by his studying *separately* the elements of pictorial construction with the aim of exploring how they could be combined "with their intrinsic qualities undiminished in combination."[135] Additionally, it accords with the themes of geographical exploration that recur in his art. He is always yearning for another place: the Mediterranean coast in the Fauvist summer of 1905; the North African landscape of Biskra in *Blue Nude;* Morocco in 1912–13; Oceania in his later years. No sooner is one location colonized than a more desirable, always more distant one appears on the horizon. Likewise, the journey of making a painting aims at something impossible to achieve. Hence the extraordinary amount of repetition in Matisse's art. He is constantly redoing the same subjects: returning to a given subject time and again; making pairs and extended series of pictures of it; and reworking the same picture over and over again. Nothing is ever quite final, it seems. This evidences an endless cycle of hope of achieving unity, and disillusionment at not having discovered an ultimate unity. It also exemplifies the combinative axis of his art.

I have suggested that the ubiquity of metaphor in Matisse's work tells of difficulties of combination. But what is difficult to attain is precisely what gives his art its power, and its power can be such as entirely to remake the metaphors that may seem at first sight solely to control its meaning.

Thus, for example, with *Blue Nude,* we first acknowledge the metaphorical association of woman and landscape, noting how Matisse has rhymed the contour of the woman's hip and buttocks with the arched frond of the palm tree in the oasis behind her. Then, we acknowledge two things together. First, that the force of what we see does not depend on the mere resemblance of woman and plant. In fact, they look alike but quite different, and Matisse has accentuated their difference by bonding each to its own separate spatial zone even to the extent (and this seems puzzling) of causing the woman to appear to be underground.[136] Second, and simultaneously I think, we acknowledge that Matisse has actually collided, not only juxtaposed, the two zones—the one below ground appearing to push upward. A shock is in store for us. Woman and landscape seem almost to

exchange attributes; the woman looks like an unearthed vegetable; the landscape looks soft and warm, the paint having been stroked on lovingly to form a translucent skin. The inherent passivity of metaphor, depending on resemblance, has been metonymically activated. There is a further shock. As the passive *femme-fleur* (woman-flower) thus becomes the active *femme-fleurir* (to flower), we may imagine the woman expanding and flourishing, a symbol of fecundity. We are in this way returned to metaphor, which is invigorated. And clearly we cannot say that a metaphor is "weak" if this is what has occurred. This is part of what I meant when I said earlier that the gap between metaphor and metonymy is closed.

I also meant this: The figure and the picture itself exchange attributes. The figure is anatomically reconstructed to become the means of composing the picture. Matisse achieves this effect through metaphorical association of the figure and its surroundings. The figure thus belongs to its surroundings, to the picture as a whole; and the picture is corporealized. I therefore said of *Harmony in Red* and of Matisse's line drawings of the 1930s that they are "metaphorical" of the body. I will continue to use that expression because I no longer need to refer frequently to metonymy. Certainly these works do not *resemble* bodies except in a very superficial way, in their general rectilinearity, for example. Rather, they are corporealized because they are given bodily attributes. They are containers; they are centered on bodily reach; their linearity does not look like that of a skeleton or sinews but functions like those things; they have a skin of paint but it does not usually look like skin. They *substitute* for the body; they replace it. Substitutive desire requires metonymy. But again, the gap between metaphor and metonymy is closed.

They substitute for the body because, for Matisse, the unity of the work of art was analogous to that of the body, and vice versa. In "Notes of a Painter," the dominant ideas of stability, order, and wholeness are all associated with the human body, as paradigmatic of these qualities and the main subject of his art. Cézanne is admirable because his paintings are composed so that "you will always be able to distinguish each figure clearly and know which limbs belong to each body."[137] A curious tribute, as Lawrence Gowing pointed out, adding: "This alertness to the possibility of physical disjunction was typically hypersensitive, as if it involved some real danger of dismemberment."[138] Viewed in this light, my claim that Matisse was incapable of achieving consummate unity has alarming consequences. I will examine them later in this essay.

To conclude this second main section, two things remain to be done. One is to say more about the privileged access to reality Matisse apparently claimed for his "plastic writing"; and the other is to discuss one painting, *Luxe, calme et volupté* of 1904–05 (fig. 9), which was Matisse's first attempt to imagine for himself what a truly privileged form of reality could look like. That will return us to the question of displacement, which began this

section of the essay. It will not mean abandoning the theme just introduced but will extend it: how painting substitutes for the body.

Looking at Life with the Eyes of a Child

In 1953, the year before his death, Matisse described his privileged access to reality, in the title of a short text, as "Looking at Life with the Eyes of a Child."[139] The date and the operative word in the title span Matisse's life, and he begins his text by remarking that creative talent is not inborn but something an artist needs to acquire. It can only be acquired by dismissing the "flood of ready-made images" that surrounds us. These "are to the eye what prejudices are to the mind."[140] In order to avoid these distortions, the artist "has to look at life as he did when he was a child." Matisse gives two examples of how he has achieved this primal, unmediated view of reality. They are familiar to us: color transpositions and drawn signs. The chapel at Vence, he says, employs both of these approaches, in its stained-glass windows, made after paper cutouts, and its ceramic tiles, made after brush drawings in black ink.

In Matisse's last extended statement about his art, his introduction to the book *Portraits* of 1954, he expanded on this.[141] He explained that it is emphasis on reason which distorts. The example he chose to illustrate this point reverted if not to his childhood then to his youth. He told how, waiting for a telephone call in a post office in Picardy, he drew a woman's head without thinking about what he was doing and was surprised, when he finished, to see that he had drawn his mother's face. His conclusion was that "the mind which is composing should keep a sort of virginity for certain chosen elements, and reject what is offered by reasoning." Sensations should be allowed to come to the artist like the scents and sounds of the countryside, which is to say involuntarily, not like visual sensations at all. And indeed, Matisse effectively rejects not merely reasoning and preexisting imagery but a visual model for gaining access to reality.

Before describing "the revelation at the post office," as he called it, he had said that "the essential expression of a work depends almost entirely on the projection of the feelings of the artist in relation to his model rather than on organic accuracy to the model." The idea of the artist as a passive medium apparently contradicts this. But Matisse wants it both ways. He wants us to imagine a mutual flow of unconscious feeling between artist and model which will allow "almost total identification" of artist with model. And he wants something else both ways. He wants to produce an internal, mental image that is also an external, visual image, because that is how the internal image must manifest itself. In order to explain the privileged form of his access to reality, which tells what it is really like, he invokes the mental

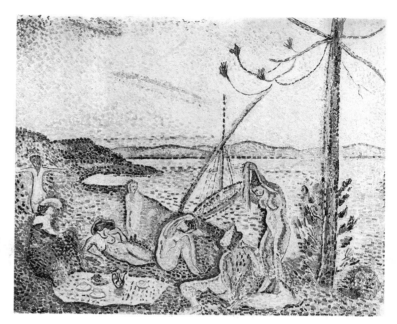

9. *Luxe, calme et volupté.* 1904–05 (pl. 50).

image as something involuntarily impressed on him as the reward for his projection of desire. If he is sufficiently desiring, a true image of reality will appear. And if he is fully open to sensations, which requires a sort of virginity associable with childhood, he will be able to receive such a true image.[142] But because he is an artist, he wants the current that flows between artist and model to physically manifest itself; the external, visual image that does so will have extraordinary power. His art will therefore be the scene of a struggle between a deep-seated, iconoclastic distrust of the external, visual image, associable with childhood innocence, and an equally compelling, iconophiliac fascination with its powers, associable with adulthood as an artist. The result, again, is a form of construction that shows separation and estrangement, and nostalgia for a coherence impossible to obtain.

Let us now look at *Luxe, calme et volupté* (fig. 9). Matisse's first imagination of a truly privileged reality shows us what is impossible to obtain.

Matisse painted this picture after an oil study he made in the summer of 1904 of his wife and one of his sons on the beach at Saint-Tropez (pl. 49). In the finished work, the figure of Mme Matisse with a picnic set out beside her localizes the scene, and the child now stands beside her, wrapped in a towel. But clearly it is not a genre picture. Matisse has transformed Saint-Tropez to a far more distant location, to a sort of paradise populated by nymphs, an atemporal island arcadia reachable only by boat, like Cythera. The title of the picture confirms this. Matisse took it from Baudelaire's poem "L'invitation au voyage," where the poet invites his mistress to leave the ordinary world and go with him, and love him in an ideal land that resembles her: "*Là, tout n'est*

10. *Landscape, Saint-Tropez*. 1904. Pencil on paper, 12⅛ × 7⅞" (31 × 20 cm). Musée Matisse, Nice-Cimiez.

qu'ordre et beauté, / Luxe, calme et volupté" ("There, all is order and beauty, / Luxury, calm, and sensual delight").[143]

Much has been written about the literary inspiration of this work in an attempt to precise its iconography. However, it seems fairly certain that its title was an afterthought on Matisse's part, and as Jack Flam has pointed out, when the Baudelairean association occurred to Matisse he may well have confused "L'invitation au voyage" with the adjacent poem in *Les fleurs du mal*, "Le beau navire," where the poet says to his mistress: "I want to paint your beauty / Where childhood is allied to maturity."[144] Flam interprets this as referring to Mme Matisse. I think it has a broader meaning.

But if it was an afterthought, how can it be relevant? The picture cannot be an illustration of a poem if it is not clear which poem Matisse refers to. None of his invented compositions, in fact, can be precisely matched with texts. They do not, like more traditional Western figure compositions, tell known stories. They are closer to genre than to history paintings in telling *unknown* stories, but they are nonetheless unlike genre paintings in that their stories are indecipherable.[145]

Matisse drew ecumenically on earlier art; iconographical research illuminates this. However, greater specificity does not necessarily mean greater relevance. Matisse's compositions are not puzzles to be solved. Their difficulty does not exist to be cleared up. It is integral to their meaning: it prolongs their temporality, enforcing their sense of reverie, and far from shut-

ting us out from them admits us to them, inviting our slow exploration. (Their incompleteness as unified wholes, which is an aspect of their difficulty, does too.) So, what is the relevance of the Baudelairean association if it was only an afterthought and therefore was unintended? I follow Stanley Cavell's explanation of this problem: "He didn't intend the reference, but, being an artist he did something even better; he re-discovered, or discovered for himself, in himself, the intention of the myth itself, the feelings and wants which originally produced it."[146]

In *Luxe, calme et volupté*, the boat is beached and the Venus Anadyomene figure has come out of the sea. She and her attendants are right in front of us. The arcadian distant is extraordinarily near.

It is near because the picture is a tangible wall composed of Neo-Impressionist bricks. But while tangibility will always produce an effect of proximity, uprightness will usually oppose it, opening a picture like a window. Here, uprightness is opposed. Horizontality overtakes the lower part of the picture. Horizontality is created almost entirely by figural means: the figures disposed on the ground radiate horizontality around them. They recline, crouch, sit, and eventually stand as if cataloguing for us the sequence of postures by which the ground can be occupied. And they bring the picture within our reach. It becomes not a window but a container—full of natural things effortlessly available to us. In this respect, it is like *Harmony in Red;* except that at this earlier moment in Matisse's career the containment is incomplete. The picture dislocates along the diagonal of the near shoreline, beyond which a separated uprightness marked by recessive spatiality—a more ordinary, realistic outside world—is found.

A similar diagonal appears in a curious landscape drawing that Matisse made in the summer of 1904 at Saint-Tropez (fig. 10). From its bottom edge there protrude Matisse's hand (holding a pencil) and, somewhat comically, his foot—and also the diagonal of the paper on which he is drawing the work that we see. The area in *Luxe, calme et volupté* enclosed by the diagonal is just as close as that. For Matisse, I said earlier, art itself—not only what it could illustrate—held a paradisal meaning. We do not need to specify the iconography of *Luxe, calme et volupté*, but we do need to know that the figures on its beach have art-historical prototypes. They live in the bounded world of painting itself.

Thus, conflated in the picture are two privileged worlds: the arcadian world and the world of art. There is a third.

The domestic motif in *Luxe, calme et volupté*—Mme Matisse with the picnic beside her—is located within the zone of privilege and infuses that zone with its meaning: not only with its contemporaneity, which makes the past present and the distant near, but with its interiority as well. Nominally, a still life has been taken outside, which has caused this picture to be compared with Manet's *Le déjeuner sur l'herbe*. A more telling comparison, I think, is with Seurat's *Poseuses*, which brings idealized

nudes *inside* and sets them against the backdrop of a painting of an exterior. As with *Harmony in Red*, the natural world comes inside. And again as with *Harmony in Red*, it does so because of the kindness of a woman.

The maidservant who gathers before her the bountiful products of nature in *Harmony in Red* was a remembrance of the model shown in *The Dinner Table* of 1896–97, Caroline Joblaud, the mother of Matisse's natural daughter, Marguerite. In *Luxe, calme et volupté*, the woman is Matisse's wife, Amélie. In both cases, the fact that the paradisal world is presided over by a woman should recall to us how Matisse said his first glimpse of that world was too. Then, it was his mother who fulfilled that role, when she gave him a box of colors while he was ill. Discussing Matisse's first experience of and subsequent obsession with painting which resulted from this gift, I observed how he acknowledged this to be a form of filial rebellion against authority, broadly conceived to include the tyranny of external appearance as well as the art of the past. Matisse's private, interior world opposed the public, external world whose coils and close surfaces threatened to smother him. To this should now be added two further observations.

First: The state of dream or reverie characteristic of Matisse's paradisal world was originally revealed to him in the condition of illness. Perhaps it *was* the condition of illness, the limbo of an altered bodily state, albeit one that was ameliorated by female comfort. This would explain the almost hallucinatory quality of *Luxe, calme et volupté* as well as the unnerving interpenetration, in the 1904 drawing just mentioned, of the artist's physical presence with the landscapes he observes before him. And it would explain Matisse's statement that his obsession with painting carried him along by a force he described as "alien to my normal life as a man."[147]

Second: That statement, however, may be read in another way. Its essential meaning, clearly, is that painting became an obsession that took him away from the life expected of him into a life of the imagination. But its gendered emphasis additionally reminds us that the imaginative world of painting in which he lived was, originally, a female world, and that his rebellion against and emulation of paternal authority were matched by maternal identification. This is not, of course, an unusual pattern of male development. What is unusual, however, is the way in which, for Matisse, this most basic contrast of gender, and its association with the discovery of painting in the condition of illness, appears to reverberate through his very conception of painting, intensifying both its ambitions and its meanings. Hence the images of separation and estrangement and "nostalgia for an impossible coherence" of which Di Piero speaks. Hence Matisse's desperate striving to create a wholeness associable with the body and achieved authoritatively by Cézanne ("*le père de nous tous*"),[148] failure in which evokes feelings of dismemberment. And hence the model of painting that Matisse did create: a

protected interior, metaphorical at once of the body and of the fecundity of nature, which meanings combine in the maternal body. Two opposed bodily prototypes are thus to be found in Matisse's art.

In *Harmony in Red*, the woman is a surrogate for the viewer's experience of the paradisal interior, including the experience of its first viewer, the artist. In *Luxe, calme et volupté*, this is not the case. The surrogate is not easily noticed at first, but once we see who it is, our experience of the picture is utterly changed. It is the child. Matisse is "looking at life with the eyes of a child."

It should be obvious that a path has been opening which, if pursued, will lead to Freud. I prefer to take instead a less obvious one. It leads back to Baudelaire: not to Baudelaire as a poet but to him as a critic, to the author of "The Painter of Modern Life."[149] There we find a compelling explanation of how illness, creativity, and childhood are associated. For Baudelaire writes that "convalescence is like a return to childhood"; that "our youthful impressions . . . are strangely related to the intensely colored impressions that we felt on recovering from a physical illness." He invites us: "Imagine an artist whose state of mind would always be like that of the convalescent, and you will have the key to the character of. . . ." He offers here his Monsieur G (Constantin Guys), but let us say, instead, Matisse. Let us say that because Baudelaire subsequently asks us to complete our conception of this "eternal convalescent" by asking us to "consider him also as a child-man, as a man in constant possession of the genius of childhood, that is, as a genius for whom no aspect of life has been *dulled*." That is, we can add, as someone who looks at life with the eyes of a child. Matisse's privileged view of reality requires precisely what Baudelaire construes genius to be: "simply *childhood recovered* at will, childhood now endowed, in order to express itself, with virile organs and with an analytical mind that enables it to order and arrange all the materials accumulated involuntarily."

Luxe, calme et volupté does refer to the Baudelaire of "L'invitation au voyage" and "Le beau navire." However, a more profound association exists with Baudelaire the critic, who specifies what the fullest implication of "childhood . . . allied to maturity" can be. This said, let us return to the child in Matisse's painting, whom I called a surrogate self-portrait.

The child does two things. He looks down at the nudes before him. And he faces out toward us, the only figure in the picture to do so. His first function resembles that of the woman in *Harmony in Red* looking down at a bountiful still life. To recognize this is to see that the picture is a mass of symbolism that may be read as offering in various ways glimpses of maternal plenitude and premonitions of adult sexuality.[150] I will leave this for the reader to explore because it is easily discovered here; because I will be talking about it again in another, less obvious context; and because the second function that the child performs is more complex, more interesting, and finally more important.

I said that the child is a surrogate for the viewer in the picture, which means its first viewer, Matisse. The viewer is not drawn into the picture but is already there, facing out as if reflected in a mirror. This reminds us: We have seen that small face elsewhere. It looks out to us from the 1937 drawing *Artist and Model Reflected in a Mirror* (fig. 1). It does so in other works, for example *Carmelina* of 1903–04 (pl. 37) and *Interior with a Phonograph* of 1924 (pl. 258), where it also is seen in a mirror. This phenomenon opens Matisse's art to discussion in rather different terms that will alter our understanding of the interiority of his pictorial space, suggesting how it is enclosed and how it opens to the world outside it.

The facing child in *Luxe, calme et volupté*, and its association with Matisse's mirrored representations of himself, recalls how a young child's perception of its body as separate from that of its mother is aided by seeing its image in a mirror. The most familiar account of this topic is that of Jacques Lacan, who spoke of a "mirror stage" of infantile development between the infant's undifferentiated sense of self and the achievement of self-identity.[151] What Lacan observed of the infant's recognition of itself in this intermediate stage, through, and as, a mirrored image—and of how fantasy takes root in the condition of alienation this produces, in order to rejoin image and self—is unquestionably relevant to this picture if we acknowledge the suggestion that the child is a surrogate self-portrait. Viewed thus, the distant arcadian world of the picture is an imagination of the artist's self as physically distant—that is, as still not yet separated from the undifferentiated world of the child—while the effect of proximity he imposes upon the arcadian world is, conversely, an imagination of his desire for distinct and integrated selfhood.

The opposition of these two states is intimately related, of course, to the contrast of interior and exterior I discussed earlier, and to the contrast of gender associable with it. So is the additional opposition suggested by Lacan's characterization of the fantasy occurring at the "mirror stage." He observes that it is atemporal and can be superseded only by the acquisition of history through language, which joins the child to a world of preexisting conventions. The contrast of fantasy and convention is surely also a part of the meaning of *Luxe, calme et volupté*; indeed, it is integral to Matisse's art as a whole.

I am not arguing that Matisse knew of such future speculation about childhood perception; that would have been impossible. Nor am I arguing that he actually presents the world as a child might perceive its mirrored image; that would be absurd. I am suggesting, however, that such speculation can inform our understanding of Matisse's practice, given the fact that he explicitly claimed for his art a primal view of the world comparable to that of a child.

An observation made by Maurice Merleau-Ponty on the peculiar spatiality of the mirrored or "specular" image, as he describes it, has immediate relevance to what we have learned about the interior space of Matisse's art.[152] Space clings to the specular image, he says. A similar "spatiality of adherence" characterizes the way that the spatial environment attaches itself to the figural motifs in Matisse's painting. This is partly a lesson learned from Cézanne, but it goes beyond that. For example, in Nice-period paintings like *Odalisque with Magnolias* (fig. 12), the very atmosphere of light is as softly palpable as the body of the model; body and setting are adhered in a common substance. A peculiar effect results. That form of spatiality is vividly real but unreachable, like the imaginary space behind the surface of a mirror. The visual image is a specular, non-physical reality; a projected, distant image of physical reality. And yet, the physicality—and with it the eroticism—of the image is present to us. This is undeniable. But it is so vividly present to us precisely because, as with a mirror image, the physical is felt in our own, proximate space. The visual and tactile are as if in separate locations. A child will be amused at the separation of its physical and specular images. Matisse will, at times, play games with their separation. He does so in the drawing *Artist and Model Reflected in a Mirror*, showing us a physical and a reflected, specular model within a specular space, where he himself is also to be seen, reflected in a mirror. His physical image, therefore, and another, truly physical image of the model, must be in front of the drawing in which they are mirrored. Matisse puts the point far more concisely than I have done: "Just as when I look in the mirror, I remain outside of the subject."[153] He identifies with the subject at a distance. In this sense as well, unity is impossible to obtain.

The physical viewer remains outside, but cannot forget his mirror image inside. And if the child in *Luxe, calme et volupté* is indeed a mirror image, what the child sees within the picture, the group of nudes, must seem unreal to the external viewer for the simple reason that there is nothing external to the picture, before it, to produce a mirror image of the nudes.[154] It is as if the nudes are invisible except to the child within the picture. And this may be a reasonable explanation for the odd juxtaposition of the contemporaneous Mme Matisse and the arcadian nudes. She cannot see them; they exist only in the eyes of the child. This asks the external viewer, which includes us, to think of them as mental images, too. Their placement in a totally unreal space, the invisible plane of the mirror itself, floats them toward us as imaginings. They are made to belong to a space that is continuous with our space. The creation of such a proximate space, which includes us, will become one of the most enduring characteristics of Matisse's art.

While the picture conceived as a window looks out and away from us, the picture conceived as a mirror looks back at us. Insofar as Matisse's pictures present themselves as windows, they do so as windows with opaqued surfaces, their imagery coating the inside. Matisse shows us an interior world. It is

therefore crucial that the surfaces of his paintings not be perceived as *outer* surfaces, beyond which might be found something more important. So application or technique opaques the surface, marking it as an *inner* surface. Tactility counters vision and its wish to see through, by maintaining surface itself as the locus of all meaning.

Hence the relative failure of Matisse's few watercolors. I know that Matisse is celebrated for the way his films of paint appear to breathe by revealing the presence of the white ground. They do. But they do not open transparently on the world. Even in the most thinly or incompletely coated pictures—for example, the first *View of Notre-Dame* of 1914 (pl. 176)—the white ground does not so much breathe *through* the paint film as breathe *with* it; the surface as a whole palpitates like a breathing body. Matisse's habit of scraping or scratching the paint film—as in the second *View of Notre-Dame* of 1914 (pl. 177)—may seem to indicate his frustration with the enclosure within which he finds himself. But it never pierces through or appears to pierce through the surface. To the contrary, Matisse's gesture of finally reaching the limit of his enclosed world is a victory of touch which, marking that limit and affirming its proximity, overcomes frustration, and brings an extraordinary release of creativity.[155]

In *Luxe, calme et volupté* (to close what I have to say about this picture), the internal viewer, the child, marks like an obelisk the limits of its world. Once the functions of that viewer are grasped, it seems impossible to travel any further into the picture; the external world beyond is but a painted backdrop. And the one nude I have not yet mentioned shows us it is. At the extreme left, she stretches out her arms and leans gently against the wall of paint with her back to us, as later, Matisse's sequence of *Back* sculptures would lean resignedly against the limits of their world.

III. An Experiment in Luxury

The artist and critic Amédée Ozenfant observed of Matisse's Nice-period pictures: "This hankering for comfort . . . When I hear him taking this line *à la Fragonard*, I have the feeling it is a feint."[156] Pierre Schneider, who quotes this statement, juxtaposes with it Matisse's own comment that the splendid display in these pictures "should not delude us," for within their torpid atmosphere "there is a great tension brewing, a tension of a specifically pictorial order, a tension that comes from the interplay and interrelationship of elements."[157] What we are confronted with, Schneider concludes, is a kind of trap. What presents itself to the eye as a naturalistic picture is not that. Abstraction only simulates realism. To visually explore a picture like *The Moorish Screen* (fig. 11) is to realize that its apparently fully illusionistic space, which opens in front of the viewer, is actually projected back toward the viewer: linear perspective, and the patterning within it, is altered so that instead of opening onto depth the picture opens out as surface. It is on the literal surface of the picture that the table, for example, appears impossibly to stand.

The patterning of screens, wallpaper, and fabrics is, of course, vital to the expression of surface because it is specifically an attribute of surface.[158] This leads to a second feint: Matisse presents us with what looks like a figural illustration, but the distraction of pattern is such that it is difficult to focus on the figure or figures he illustrates. In *The Moorish Screen*, Matisse helps himself by putting the figures in ethereal white costumes. But patterning alone will suffice to distract our attention from the figural illustration, and we begin to see what he means by sublimating the emotional charge of the figures into the pictorial architecture of the whole.

Matisse transfers attributes of the figures—decorativeness, density, tactility—to the pictorial architecture of the whole, and this is why figures can appear to be emptied of significance and why a contrast between excess and emptiness characterizes pictures of this kind. Matisse offers us an excess of information about this interior, carefully describing even tiny, insignificant areas that could reasonably have been ignored. This is partly his first feint, his realist strategy: to convince us by redundancy, accumulating far more information than description requires. But it is also his second feint: this information is robbed from the figures. That is, Matisse displaces the eroticism of the body to its surroundings. In this way, his painting is "metaphorical" of the body.

And the two feints are thus one. For the painting to recall the body, it must seem not only a container—a room—but one that is physically proximate and denies that it has any contradictory function; denies that it can function as a room. Perspective is therefore denied, both to affirm the proximity of the painted surface and to prevent its functioning as a normal room. This is also why the architecture of the room is covered by artificial and unreal pattern. It is not merely that space must be enclosed lest it open onto another space. The room itself must be enclosed, concealed, lest its function as a room rival the function which pattern projects onto its walls. Patterning fills the surface in

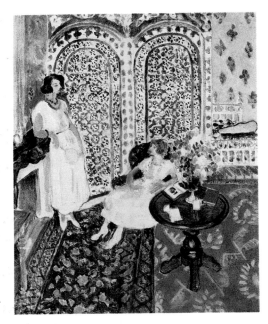

11. *The Moorish Screen.* 1921 (pl. 254).

impersonation of a spatial setting to create the effect (à la Fragonard) of no realistic location at all—rather of an eroticized plane substituting for the eroticism of the body, beautifully tinted with color and stroked carefully by the brush everywhere.[159]

Matisse's hedonism in his Nice pictures is colder, however, than that of his Rococo prototypes. The surface is beautifully marked but does not display much spontaneity of touch. It is very deliberately filled in. Matisse à la Fragonard—or more often à la Watteau, whom he copied in some of the most curious of his Nice-period pictures[160]—is still the Matisse of pictures like *Harmony in Red*. What I have said about the function of patterning in *The Moorish Screen* applies to the earlier picture, and to many earlier and later pictures as well. Matisse's Nice-period paintings have too often been isolated from the rest of his oeuvre. A further, more extreme function of patterning most definitely suggests their association.

In the painting *Odalisque with Gray Culottes* of 1926–27 (pl. 279), the optical dazzle of the striped wallpaper is such that it can appear impossible for us to focus on the figure at all. It is almost as if a flash bulb had gone off in front of our eyes. Something similar happens when we look at *Corner of the Artist's Studio* of 1912 (pl. 151), the most undervalued masterpiece among the Russian Matisses. This time, it is an optical flicker, the effect of a strobe, produced by the vibration of the patterned curtain and the nasturtium leaves, that seems to blind us to the picture's central motif. In both cases, it is not enough to say that our visual attention is merely claimed elsewhere; it is *denied* here.

I do not mean to exaggerate. Of course, our only possible apprehension of these pictures is visual. As we know, Matisse is a painter's painter. His work is purely visual. Therein lies its

beauty. All the same, with these pictures at least, we feel blinded by their beauty.

The phenomenon by which our vision is seemingly denied in the nominally most important part of the picture, and claimed by another part or parts of the picture, is rarely manifested as dramatically as it is in these two works. Their drama results from the clash produced when claim and denial meet on such equal terms. Usually one or the other dominates, since only one is needed to fulfill both their functions. For example, the bodies described by means of negative spaces in *The Swimming Pool* of 1952 (pl. 406) seem like gaps in our vision; not gaps that our vision looks through to something else, but gaps in our vision itself.[161] Their denial of our vision has the effect of refracting it across the whole surface. Our vision does not have to be claimed elsewhere but looks elsewhere of its own accord. Conversely, the ubiquitous patterning of *The Painter's Family* of 1911 (fig. 36) claims our vision. Matisse does not have to deny our vision access to the figures in this picture. It looks elsewhere of its own accord. In both cases, it looks elsewhere, in vain, for a place to focus. For if vision is thus shuttled about the surface, it may rest anywhere but can settle nowhere. This is to say: Vision is claimed everywhere; and therefore, everywhere it is denied. In the act of looking, in the very activity claimed for looking, the cognitive act of *seeing* is denied.

I will have more to say about this later, because I believe it to be indispensable to an understanding both of the appearance of Matisse's pictures and of the artistic psychology that produced them. But now, I want to consider its relevance to Matisse's representation of women during the Nice period. This leads me to a subject that will at first seem unrelated to the question of vision, but is not. The subject is what Matisse's women seem to be doing.

This sounds, perhaps, like a non-subject. For Matisse's women rarely seem to be doing anything at all, except perhaps staring at a goldfish bowl, playing some music, reading a book, something to keep themselves occupied. But that is the point: whether or not they are doing anything, they are preoccupied. This keeps them both still and silent, qualities Matisse valued in his models, and what artist would not? However, he draws attention to their stillness and silence. (A moment of stillness and silence is precisely what we are shown in *The Moorish Screen;* an instant, but one that persists in the picture and in our memory.) And we see withheld from Matisse's models the possibility of communication through gesture or speech. The possibility that they could thus communicate is suggested by the apparent realism of their settings—only to be withdrawn from them when we see that their settings are not, in fact, realistic; that there is no room for them to walk in or for their speech to be heard. They do not act but are acted upon; they apparently do not give but receive. In *The Moorish Screen*, the presence of an open book, a vase of flowers, and an open violin case suggests their receptive-

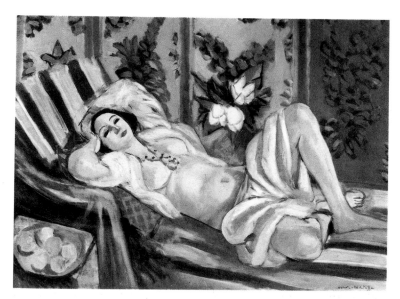

12. *Odalisque with Magnolias.* 1923 or 1924 (pl. 266).

ness to sensations; how sensations can come to them almost as Matisse said they came to him, like scents and sounds of the countryside carried in the air. Only, the models in this picture are so utterly preoccupied that nothing can touch them.

Unquestionably, this is a world of sensations, indeed of sensations in excess. And yet the models in this and virtually all of Matisse's Nice-period pictures (and many outside this period) seem oddly alienated from what is around them. The tokens of synesthesia—flowers and images of music—which should connect them with their surroundings are, instead, absorbed into and color their surroundings. The often immense vases of flowers merge into the patterning around them and remain unnoticed by the models. And when the models make music, it too flows into their surroundings—with *Pianist and Checker Players* (pl. 257) into the very pattern of the wallpaper—only to leave the music-makers unmoved. And images of books merely reinforce the immunity and separateness of the models within their worlds. They do not open to alternative worlds: often the pages are blank or black. Needless to say, windows—even when, exceptionally, opened—offer no means of escape.

If, then, these women neither act on their surroundings nor are acted on by them, are they no more than imprisoned there? A range of connotations that attaches to their representation suggests as much. This is, perhaps, a harem for the pleasure of men, more precisely of one man; an imaginary re-creation of Morocco in the tradition of French Orientalist painting.[162] Matisse's overtly exotic Nice-period pictures, like *The Hindu Pose* (pl. 264), suggest as much; so do those, like *Odalisque with Gray Culottes* (pl. 279), whose Orientalism is filtered through the work of Ingres. But this aspect of Matisse's art has been greatly exaggerated. In the Nice period, the mood is as often sensual in a

geographically closer way: sometimes it is an utterly domestic sensuality. However, as we have seen, it is conveyed in settings that look extremely artificial. Their artificiality does, at times, connote a harem. More often, though, and more basically, it connotes a theater, a construction of make-believe for the delectation of the man who built it. And additionally, the floral arabesques in the Nice-period paintings suggest a contemporized simulacrum of the amoral paradisal garden, the only possible version of it available to Matisse's painting in its nominally naturalistic form.[163]

All of these connotations tell, in their different ways, of women released from the demands of action but held available to the viewer. The environment, and often the costumes, in which they are held are luxurious and sensual. At the same time, as already mentioned, the means of their depiction lack evidence of sensual spontaneity, à la Fragonard or à la Watteau.

Matisse's pictures illustrate a world that is extremely orderly and well managed, for all its appearance of excess; his illustrational means are orderly and well managed, too. The pictures are extremely carefully painted, even frugal in the economy of their means. In the case of two most beautiful Nice-period pictures— *Interior with a Phonograph* (pl. 258) and *Interior: Flowers and Parakeets* (pl. 259)—the orderliness with which the finery is presented specifically recalls that of Dutch interiors, notably Vermeer's, similarly suggesting the control of property by domestic virtue.[164] The path from Vermeer to Matisse passes an artist whose work Matisse had copied regularly in the Louvre and whose influence suffuses the pictures of the 1920s, an artist of the Rococo period very different from Fragonard or Watteau: namely Chardin. Matisse's pictures are like Chardin's in showing utterly preoccupied, absorbed figures in interiors that the artist has carefully crafted, paying attention to every fraction of the picture surface, suggesting his vigilance and concern for what he shows.[165] In Chardin's pictures, the figures perform tasks that require vigilance. In Matisse's, the artist alone assumes that role. Matisse imposes domestic order on what he sees, as well as luxury, calm, and sensual pleasure.

Discussing *Harmony in Red* (fig. 2), I observed that its composition ultimately derived from Chardin, but that Matisse's transformation of his original source removed its connotations of domestic work. Most of his subsequent still lifes and interiors, before Nice, are removed from a domestic context. Their principal location is the artist's studio. In an interior like *The Pink Studio* (fig. 35), for example, what we see is not domestic work but evidence of the work of painting. In 1908, the same year Matisse painted *Harmony in Red*, he wrote in "Notes of a Painter": "What I dream of is an art of balance, of purity and serenity."[166] In *Harmony in Red*, the painted environment as well as the means of its painting embodied those qualities. The same is true of *The Pink Studio*, except that the paintings and sculptures represented in the studio did so additionally. Art, for Matisse, had always

been a principal source for art. Until he moved to Nice, it was often a part, and sometimes a principal part, of its subject as well. It would become so again, in the great Vence interiors of 1946–48 (pls. 375–387). In the thirty-year period between the move to Nice and the Vence interiors, he still made some depictions of paintings within paintings. By and large, however, a different form of reciprocation between painting and the painted interior obtains.

A Nice-period interior such as *The Moorish Screen* (fig. 11) is like *Harmony in Red* in that the painted environment as well as its painting embodies balance, purity, and serenity. But it is different in that Matisse now literally creates, *before* painting, the harmonious environment he had previously only imagined. The environment itself, even prior to its painting, is a representation of the qualities that Matisse sought for painting, which is why it can be shown in a naturalistic way. In addition, though, if the artificially created environment embodies qualities that Matisse sought for his painting, its representation can *replace* the representation, in a studio interior, of a Matisse painting. For it is already itself a representation of a Matisse painting. Matisse is, in effect, representing a representation when he paints *The Moorish Screen*. Painters of still life have in principle done the same thing. But only in principle and never so systematically.

This meant, for Matisse, that the orderly world of his painting could actually be shown in what looked like a real world, even a domestic world, although of course it was an artificial simulation of one. The artifice of his Nice-period pictures is evident, I have suggested, in their underlying abstractness, on the one hand, and in their exotic, pastoral, and theatrical connotations, on the other. However, their essential artifice—which includes the forms of it just mentioned—lies in the fact that they represent the essential qualities of painting as Matisse understood them. These, too, are paintings about painting. The qualities Matisse required of painting are, in fact, figurally represented in the representations of his models. This is also to say that these representations embody the privileged, primal view of reality that Matisse claimed for his art as a whole.

Odalisque with Magnolias (fig. 12), we saw earlier, can be construed as a specular image in that its spatiality is vividly real but unreachable, and in that the physicality and with it the eroticism of the represented model—also vividly real—are felt as if in our own proximate space. Let us now look more closely at what occurs.

The depicted model carries the exotic, pastoral, and theatrical connotations I have referred to. She is a half-dressed odalisque, unquestionably sexual. She is shown in a setting that is a simulacrum of a pastoral garden. And she is displayed as if in a theatrical *tableau vivant*. However, the model does not quite seem to display *herself* to us. She may not appear to be as fully preoccupied as most of Matisse's other models of this period, but it is evident that the black bars of her eyes are either, in fact,

eyelashes (in which case she is asleep) or unseeing eyes. In either case, we are invisible to her. To use Michael Fried's terminology, the "theatricality" of the image is effaced, or at least opposed, by its "absorption."[167] The absorption of the model has the effect of rendering her oblivious to the viewer's presence, as if the proscenium curtain of this theater had never been raised. Thus she does not *invite* our gaze, but is merely subject to it. The decision is the viewer's, and the viewer has to decide to make it. While her absorption—including, especially, her not seeing us—makes her actually more physically, including sexually, vulnerable to us, it also forces us to pause for a moment at least, both to acknowledge her vulnerability and to wonder at the cause of the absorption which makes her so vulnerable. What if the picture depicts that exact moment of pause?

Let us say that it does. Let us say that we are shown that mere instant of time. If this is true, we are being shown something imaginary in the present, the lingering freshness of the past condensed into a moment of almost no duration. We move and the moment is over. And only for that moment did the unquestionable eroticism of the figure belong solely to the figure. As we move, and explore what we see, that eroticism floods into and suffuses the whole picture. The surrounding space clings to the bodily image. In this "spatiality of adherence," the model's body belongs to her surroundings.

But let us say, now, that this picture depicts more than a moment, and instead a continuing state. What then? The answer, I think, is that the presence of the model is dispersed across the time of our looking. The apparent unity of the picture fractures in our looking, as the separate parts of it—even those parts that compose the model—compete among themselves for our attention. This forces us to abandon the fixity of our viewing position before it. Our vision is continually moved on and can settle nowhere. The physicality, the eroticism, of the model is ubiquitous in the picture; it is "in the lines, the composition, the color," as Matisse says.[168] It cannot be seen precisely anywhere. It must therefore be *felt* elsewhere, in our own proximate space. This is part, at least, of what Matisse meant when he said that "the work of art must carry within itself its complete significance and impose that on the viewer even before he recognizes the subject matter."[169] Looking with the aim of recognizing will not reveal that significance. In this case, the more we look, the less we can rely on what we see to tell us the truth.

Everything, it seems, is in disguise. The magnolia is a depicted flower; but also a depiction on a depicted screen; and also an image of the model's sexuality. The screen evokes a theater, therefore a public space; but also a boudoir, and therefore a private one. The still life in the foreground suggests both a domestic interior and a studio. The model wears a quasi-Oriental costume, but she herself is not Oriental. And so on. Everything in the picture is fake, a kind of costume, requiring interpretation. Our interpretation requires the kind of

absorption—and *becomes* the kind of reverie—that the picture illustrates: one that goes on and on.[170]

Paintings of this kind challenge the familiar assumption that representations of women by male artists are governed solely by oppositions between the active and possessing male and the passive and lacking female, and oppositions associated with these.[171] For the very meaning of *Odalisque with Magnolias* is accessible to us only if we surrender voyeuristic distance from it; moreover, the painting forces us to do so. The critic Claude Roger-Marx observed of Matisse in 1938: "It is as a genuine egoist that he seizes these living beings [his models], conceiving them almost as objects and observing them less for themselves than for the displays and visual pleasure that he wants to derive from them." Hence "the rather distant character of his art."[172] Here, in crux, is the misunderstanding. Matisse's art is, indeed, the art of an egoist, distant and aloof. And yet, our experience of his art is not only experience of its distanced representation of reality. We simply cannot maintain our distanced view on what Matisse shows us. Because his "displays and visual pleasure" demand our interpretation, we must absorb ourselves in them, attempting ourselves to recover the emotion that is dispersed and disguised there. And this is the time to notice that the models in Matisse's Nice pictures frequently appear to be *waiting.* And it is the time to remember that some of Matisse's greatest paintings—such as *Nymph and Satyr* (pl. 111)—are pictures of delayed union, of near-consummation held in suspense, in a manner comparable to what Keats described on the Grecian urn. Also, that the metaphorical structure of his pictures expresses difficulties of combination, and reaches for a unity and coherence apparently impossible to obtain.

Responding to Claude Roger-Marx, Matisse insisted that his models were not conceived as objects, arguing that they "are never just 'extras' in an interior" but "the principal theme" in his work.[173] The "plastic signs" that transformed them "sublimated sensual pleasure." Thus, a response to sexuality provoked a response to form. Conversely, though, it may be said that a response to form included, and released, a response to sexuality. The female figure is formalized; the emotions it evokes are sublimated. At the same time, however, form itself is imbued with sexuality. Matisse is aloof from what he represents; as we have heard, "the projection of the feelings of the artist in relation to the model" is what matters.[174] And yet the models are not merely vehicles for self-projected fantasies, because the artist is inescapably dependent upon his models. He poses a model in a way "which best suits *her nature,*" Matisse says, and he becomes "a slave of that pose." The emotion evoked by a particular model will be isolated in a bodily posture: arms clasped behind the head; one leg tucked behind the other; the head enclosed by folded arms. Such a motif, at once representational and abstract, will entrance him. The shape taken by the body will design the picture.

Faces and Figures

I am not quite finished with Matisse's representation of women. But what I have finally to say about this topic will lead us elsewhere. It begins with Matisse's representation of women's faces.

I said that the body of the model in *Odalisque with Magnolias* withdraws into its surroundings. It also withdraws into itself. By this, I do not mean only that it withdraws into paint. (It does that, of course; for example, her clasped arms metamorphose into a pillow of paint.) I also mean that a vast psychological interval opens between viewer and model. She seems unwakeable, unreachable, so deep in her preoccupation that she can never return from it. This quality, as I have explained, is manifested in the picture as a whole. It is very specifically manifested in Matisse's treatment of the model's face.

The blackness of the model's eyes either encloses her in preoccupation, in sleep, or it describes a mask, or it does both. Usually, Matisse shows one or the other. Models look down, or away, or appear to sleep; or they face us with unseeing eyes, or eyes that will not accept our gaze.[175] Preoccupation is signaled either by their looking elsewhere than at the viewer or by their looking at but not seeing the viewer. Paradigmatic of these two approaches are two great pictures of 1905, *The Woman with the Hat* (pl. 64) and *The Green Line* (pl. 65). In *Odalisque with Magnolias,* the two approaches are, indeed, combined, which contributes to the mystery and elusiveness of this extraordinary image. We should notice now that Matisse's most mysterious portraits do the same. I am thinking, for example, of *Portrait of Mme Matisse* of 1913 (fig. 40), where the mask-face is ever so slightly tipped down and to the side, the very life of the portrait hinging on that minute angle, and *Portrait of Mlle Yvonne Landsberg* of 1914 (pl. 171), where the mask-face turns away but leaves its eyes stranded as if on a frontal plane—a more brutal solution that adds unease to an otherwise exuberant work. What the odalisque and these two portraits show are images that face us, as if in a mirror, turning away from us into themselves. An image I considered earlier, the child in *Luxe, calme et volupté,* shows the same thing. It is the extirpation of seeing from the body as it withdraws its attention into itself.

Regardless of how Matisse signals preoccupation, he confers on his models an unsettling aloofness. It is one that conflates a sense of momentary withdrawal into the self, akin to the distraction shown in many of Manet's portraits, with a mood of more persistent withdrawal, akin to the alienation shown in many of Degas's.[176] It is an aloofness at once serene and disquieting, both sensual and cold, not seen elsewhere in modern painting. The nearest precedent for it appears in the simple, remote face that Ingres projected onto the oval head of Mme de Senonnes in an otherwise luxurious portrait that Matisse deeply admired (fig. 15).[177]

Many faces that Matisse paints are even simpler and seem

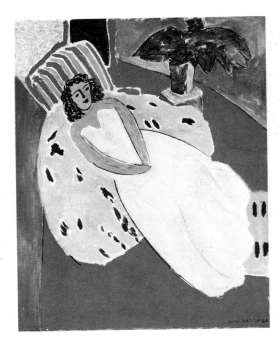

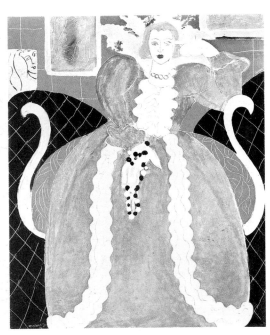

Right:
13. *Young Woman in White, Red Background*. 1946 (pl. 373).

Far right:
14. *Woman in Blue / The Large Blue Robe and Mimosas*. 1937 (pl. 317).

even more to have been applied to the form of the head. The face in *Odalisque with Magnolias* is a summary account of the model's features apparently painted onto the oval after it had been made. Matisse had used this method since his Fauve years but had alternated it with another, wherein more sculpturally complete faces seem squashed on the surfaces of paintings like kneaded volumes of clay. In the Nice period, the simpler approach dominated, and in the 1930s and 1940s was ubiquitous. It seems so casual: just drawing on the face at the end. There is a film of Matisse painting *Young Woman in White, Red Background* of 1946 (fig. 13), and we see that this is exactly what he does.[178]

But he does not get it right the first time. He must have erased it, because we see him later, this time in slow motion, applying it again. When Matisse saw this slow-motion sequence, he felt "suddenly naked," he said, because he saw how his hand "made a strange journey of its own" in the air before drawing on the model's features.[179] It was not hesitation, he insisted: "I was unconsciously establishing the relationship between the subject I was about to draw and the size of my paper." This can be taken to mean that he had to be aware of the entire area he was composing before he could mark a particular section of it.[180] That is certainly part of his meaning. He had to be conscious of internal scale, the relative size of his compositional elements, since their meaning depended on their relationships to each other and to the surface area as a whole. But Matisse's statement actually refers to *external* scale, the relationship between the face he will draw and the entire area he will compose.

Very little is there to describe the face in the 1946 painting (fig. 13), just a few strokes of the brush. It is so utterly rudimentary that the suspicion has to arise that Matisse was simply not interested in creating a resemblance. We have heard that before, but not its corollary: that he was interested instead in showing a face on the threshold of not being recognizable at all. Whereas Giacometti, notably, seemed to be fascinated by the moment at which an advancing shape becomes recognizable to us as a figure, Matisse seemed to be fascinated by precisely the reverse. The face of this model appears more distant from us than the painted proximity of the whole figure suggests, certainly more distant than Matisse's proximity to the model allowed. The effect is, first, to show the perspective of the figure's posture, pushing back in space the vividly striped fabric above the face, which nevertheless visually distracts us from the face. But it is also, second, to make the whole figure seem visually distant, which otherwise, swelling and spread out across the surface, seems graspably near.

The recessive pose in this picture, which calls for the first of these effects, disguises the second. *Woman in Blue* (fig. 14), a frontal portrait, shows the second in a purer form. There, the face is a mere tracery of forms on the surface of the painting. It is not quite that we have to peer at it to see it: there is no sense of optical frustration in what Matisse produces. The features are just clear enough to be properly recognizable. And yet the face withdraws from us—and from the sumptuous finery beneath it, like the face of Mme de Senonnes. (The pose of the model, however, recalls another, even more renowned Ingres portrait.) Sometimes Matisse does the opposite thing. The face in *Portrait of Greta Prozor* of 1916 (pl. 98) levitates before the phantom body. Matisse's unmarked faces sometimes advance, as at the right of *Bathers by a River* of 1916 (fig. 38); and sometimes recede, as in *Plum Blossoms, Green Background* of 1948 (fig. 6), where the face is

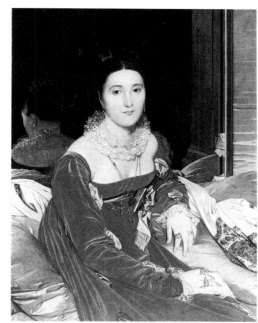

15. Jean-Auguste-Dominique Ingres. *Mme de Senonnes*. c. 1814. Oil on canvas, 41¾ × 33⅛" (106 × 84.3 cm). Musée des Beaux-Arts, Nantes.

an absorbent pink substance in the distance, which we are asked to imagine being filled and saturated by the intense red of the surface below. And sometimes the whole figure summarily retreats, as it does in *The Studio, quai Saint-Michel* of 1916–17 (pl. 206). In all cases, the distanced parts are also on, or are imaginable on, the surface. This is the function of the bright red lips that Matisse peculiarly paints like decals on the faces in *Odalisque with Magnolias, Woman in Blue*, and other pictures. Distance is not an illusory somewhere else. It is an attribute of what is here and near.

The phenomenon I am describing is unquestionably related to the sense of preoccupation evinced by Matisse's models; to Matisse's vigilance toward them; to the constraints imposed on our seeing in the act of looking; and indeed, to the essential element of displacement in Matisse's representations. To cause figures that seem graspably near also to seem visually distant is to effect a form of displacement that encloses the figures in protective custody within their own worlds, where they are visible to us but where our vision does not allow us to reach to them there. Nor does it need to, for they remain near to us. What we see, as if at a distance, on the face of *Woman in Blue* are not obscured and shadowy features. Like the face of Mme de Senonnes, it is a clear face projected at a remove, a face seen in full light and illuminated by the clarity of light. And light, of course, is the only thing that is not imposed on Matisse's figures. Costumes, settings, anatomy even, are imposed. But light is not. In *The Moorish Screen* and *Odalisque with Magnolias*, everything else may be fake, but light has an almost touchable reality to it as it spreads in color across the spaciousness of separated forms. The figures it illuminates partake of the same touchable reality,

which we can only imagine—not at the ends of our fingers but, rather, through our impossible, unnecessary reach.

Even that most intangible element, light, is made to seem both physical and visual within the light-filled spaces of Matisse's paintings. Visual experience is contested by physical experience, and vice versa. Within the space of his paper cutouts, the contest is exacerbated and thereby reveals a surprising conclusion to the story of visual distance I am telling.

While preparing the mural *Dance* (pl. 291) for the Barnes Foundation in the early 1930s, Matisse used pre-painted, cut paper as a compositional aid. He found himself touching and manipulating color as an independent element as he had never done before. The reality of color itself, as something simultaneously visual and physical, would obsess him for the remainder of his career.

In his paintings of the 1930s and 1940s, color is set down as discretely and flatly, and usually as brightly, as possible. Matisse would erase a previous day's efforts so that the struggle of creation did not show. What mattered now was a pattern of color that looked as if it had found its way onto a picture of its own accord. Thus paintings whose very subject matter comprised a pattern of color—namely, figures in decorative costumes— became a principal means of expression. In *Woman in Blue* (fig. 14), for example, the very construction of a costume and a painting are offered as analogous. Both costume and painting are carefully crafted from panels of color seamed by drawing into a decorative whole. At least, the wonder of a painting like *Woman in Blue* is that it looks as if it had been so constructed: in fact, the color filled pre-drawn compartments. Color and drawing were conceived separately. The visual and the physical remained separate in Matisse's practice. The cutout medium allowed their integration. Panels of color could be crafted physically by the drawing action of scissors. But still, the same problem remained: How were these panels to be combined?

In many of Matisse's larger multicolored cutouts, the physically crafted pieces of colored paper are separately placed on brilliantly illuminated white grounds. The sharply cut edges mark the limits of the physical and enclose each of the pieces. Never before had Matisse put unity in such jeopardy. Too often, the pieces are isolated in their physicality and will not visually communicate, except as repetitive pattern.[181] Of such works, only *The Parakeet and the Mermaid* (fig. 16) is fully successful; in large part this is because the two eponymous figures, widely separated at the opposite limits of our lateral vision of the huge leaf-filled composition, are such individual and such distant elements. Our perception happily stretches to meet, reach, and attempt to combine them, as if wishing to extend itself to acquire new and complex knowledge.[182] (The visual distance of Matisse's painted figures is a similarly encouraging one.) With this main exception, the greatest of the multicolored cutouts avoid a continuous white ground, with its preexisting light, and, rather,

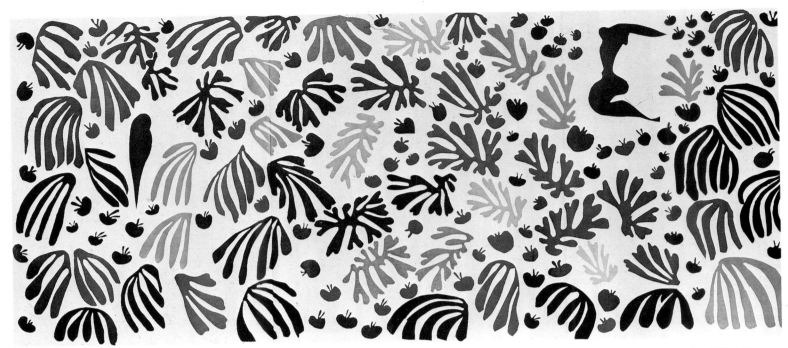

16. *The Parakeet and the Mermaid.* 1952. Gouache on paper, cut and pasted, on white paper; six panels, 11′ ¾″ × 25′ 4⅜″ (337 × 773 cm) overall. Stedelijk Museum, Amsterdam.

create light in a fabric that interweaves the physical and the visual. Matisse does this by filling the entire surface with a complex pattern of cutout pieces of differing shape and size, as, for example, in *The Wine Press* (pl. 395); by pre-structuring a white ground with a repetitive grid-pattern, as in *Chinese Fish* (pl. 392), thus to mobilize the shapes on top; by forming a background of cutout pieces into such a grid-pattern to similar effect, as in *Amphitrite* (pl. 369); or, most successfully, by creating chromatic chords of large, boldly juxtaposed parts, as in *Memory of Oceania* (pl. 411) and *The Snail* (pl. 412), where vast slabs of color paper the surface—positive presences whose radiance and whose rhythmic organization distribute an implicit voluptuousness through these immense works.

That most privileged of subjects, the human figure, was not easily accommodated, however, in this world of pure color. In saying this, I refer not only to the fact that, with rare exceptions, Matisse used a single color, blue, for images of the human figure in his cutouts. The unity of the figure usually required that it be represented by a single color, and blue possessed the density that was needed; besides, it was the color of many of Cézanne's Bathers. But images of the human figure created an additional problem. When discussing the Barnes mural, *Dance* (pl. 291), Matisse observed that in "architectural painting . . . the human element has to be tempered, if not excluded," lest the viewer identify with it and therefore be stopped from receiving the atmosphere of the expansive whole.[183] Matisse's very last series of paintings, the Vence interiors of 1946–48, tempered and usually excluded the human figure for the same reason. If the

viewer had been allowed to identify with it, the flood of intense color that fills the surface of these extraordinary paintings would have been arrested in its movement. As it is, it seems almost to overflow the limits of the canvas. *The Parakeet and the Mermaid* is successful precisely because the figural elements are rendered so summarily and pulled to the lateral limits of the surface. The environmental *Swimming Pool* (pl. 406) is thus exceptional in that its expansive surfaces are actually composed by figural means. This is certainly Matisse's most dynamic and possibly his most original cutout. Figures are given whole, are decomposed, and are given in negative shape. The soaring movement of the work is a movement of bodily flux that plunges across the wall to escape the limitations of the pictorial frame. But the effect of the visually immaterial thus provided is, simultaneously, an effect of the physically tangible, of color carved into substantial shape. Such a balance of the visual and the physical is the very subject of the cutouts of individual figures that Matisse made, most especially the *Blue Nude* series (pls. 399–402) and *Acrobats* (pl. 405). These are less radical works than *The Swimming Pool*. Yet, they are finally just as surprising works—even more moving works, perhaps, because "the human element" remains intact.

With these blue cutouts, Matisse reengages the interrelation of the physical and visual with extraordinary freshness and immediacy. He forms his physical, cutout images on a white ground that does not connote light, that connotes nothing at all except free space, and whose literal limits are therefore unimportant. These figural images need no support: these images *are* figures. They have the physicality of figures; we can see the

modulations and the density of their surfaces. And like the figures in Matisse's paintings I discussed earlier, they seem distanced from us: in part because these figures are smaller than life size; in part because they fold in on themselves as contained and constructed abstract motifs. The energy they project is that of a body concentrated within itself, not merely posed but poised in the space that flows around it. We now see, I think, that the contest between the physical and the visual that takes place in Matisse's figurative paintings and in these cutouts is a contest whose most natural arena is neither medium. It is sculpture.

The Visual and the Physical

It is Matisse's sculpture that preeminently enacts the contest between what William Tucker has described as "the grasped and the seen."[184] With the exception of the *Backs*, Matisse made smaller than life size, and often very much smaller, sculptures by means of modeling. Their volumes demand to be grasped manually for they were conceived within the hand, by the reaching and enclosing hand. Even the larger pieces, like *Large Seated Nude* of the middle to late 1920s (pl. 272), offer themselves to us through their graspable parts.[185] The solidity of the grasped volume is thus manifest to us. And even without physically touching

Matisse's sculptures we can see that they are solid.[186] Their very surfaces express solidity. They are not illusionistically worked to produce the effect of body *beneath* the surface. Rather than seeming to cover internal mass, surface simply comprises the physical boundary of mass, just as, in the cutouts, the scissored edge of a shape comprises its physical boundary. There is no sense of clay having been spread and kneaded as surface. The marks it bears are of the hand compacting it as mass or of the knife cutting down the mass or into it. Matisse's sculptures are felt as *things*—solid, weighty, durable. For that reason alone sculpture was important to him. It meant he could create objects, which were also figures, out of inert matter.

But Matisse's sculptures are not only things. They are also images. And they are images insofar as they are distanced, displaced things. Tucker says that "Matisse consciously *models the figure seen at a distance*."[187] In 1908, comparing drawing and sculpture for his students, Matisse said that form "must be much more definitely expressed in a sculpture, which must carry from a distance."[188] Of course, we can look at a Matisse sculpture from any distance we choose, but even when viewing from close up we cannot bridge our distance from it. This is partly an attribute of the small size of the sculptures and of the compactness of their handling. But more important, it is the result of Matisse's visual ordering of their parts. *La serpentine* of 1909 (fig. 21), for example, presents itself to our looking as a view. It is a visual motif, framed

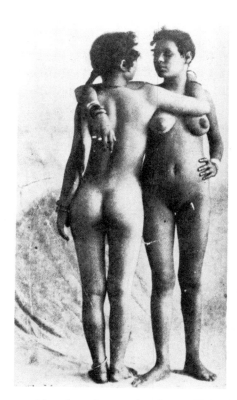

17. Magazine photograph of two Tuareg women on which Matisse based the sculpture *Two Women*.

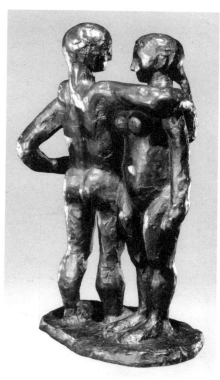

18. *Two Women*. 1907 (pl. 94).

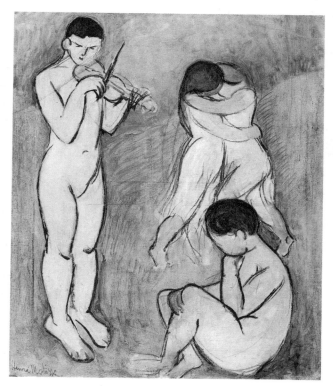

19. *Music (oil sketch)*. 1907 (pl. 100).

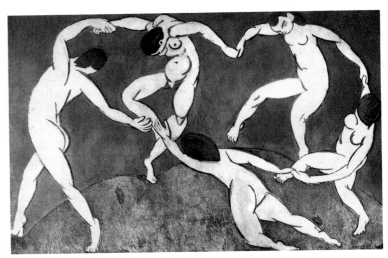

20. Magazine photograph on which Matisse based the sculpture *La serpentine*.

21. *La serpentine*. 1909 (pl. 122).

22. *Dance (II)*. 1909–10 (pl. 125).

on two sides, composed of solids and voids of equal importance. Anatomical plausibility is beside the point. Anatomy provides the source of the motif but is altered at the behest of a visual order. Matisse's sculpture, he told an interviewer in 1950, was a complement to his painting, parallel and with its own unique expressive potential. "But I sculpted as a painter," he insisted. "I did not sculpt like a sculptor."[189] He could reasonably have said of *La serpentine* what he said of his painting, "Above all, I do not create a woman, *I make a picture*."[190]

As a painter, he sees volume as imagery. His sculpture emits imagery, Pierre Schneider observes, noting how the multiple views offered by some of his sculptures are not intimations of an unseen whole but comprise individual seen wholes.[191] They are like different paintings or drawings of the same posed model. Each view is an image of the subject—a distanced projection of it. In the case of the sculptures, the separation of our experience of the sculpture, as an image, from our experience of the subject, the figure, is aided, William Tucker says, by Matisse's use of banal and familiar academic poses.[192] Their very conventionality contrasts with what is made of them. The same thing may be said of the banal subjects of Matisse's paintings of the 1920s and of his use of worn metaphors. And Tucker's conclusion—that this separation of image from subject allows for liberation of feeling for the subject, notably a feeling of intense sexuality—is true of these other contexts as well. Because the specular image and the physical image are separate, the eroticism of the physical is made present to us.

Painting and modeled sculpture associate in the subject of the figure. Sculpture is different because it works with the figure alone, whereas in painting the figure is within and forms part of a spatial context; therefore, the contrast and comparison of the perceived and the real is more strongly manifested in sculpture. But Matisse takes the lesson of sculpture back to his painting. "I

took up sculpture," he said, "because what interested me in painting was a clarification of my ideas. . . . That is to say, it was done for the purpose of organization, to put order into my feelings and to find a style to suit me. When I found it in sculpture, it helped me in my painting."[193] Thus sculpture clarified for painting the relationship of the perceived and the real. Additionally, the contrast and comparison of painting and sculpture—their being, respectively, the perceptual and the real—clarified that relationship for both mediums.

Two pairs of examples: the painting *Male Model* of c. 1900 (fig. 25) and the sculpture *The Serf* of 1900–04 (fig. 23); the painting *Standing Model* of 1900–01 (pl. 28) and the sculpture *Madeleine (I)* of c. 1901 (pl. 27). But these are very straightforward. There are some less obvious groups of examples: for instance, a photograph of two Tuareg women (fig. 17), the sculpture *Two Women* of 1907 (fig. 18),[194] and the couple in the background of the painting *Music (oil sketch)* of 1907 (fig. 19); or there is the group composed of a photograph of a posed model (fig. 20), the sculpture *La serpentine* of 1909 (fig. 21), and the upper central figure in the painting *Dance (II)* of 1909–10 (fig. 22). We should notice that throughout this process, Matisse learns from sculpture for painting and learns from painting for sculpture; that he re-presents volume as imagery and re-presents imagery as volume; and that he enrolls in this process images other than his own.

Matisse does more than transpose pictorial and sculptural motifs; much more. In fact, his re-presentation of the sculptural as the pictorial, and vice versa, is evidenced not only by a volume, a thing, becoming an image, or by an image becoming a volume. For additionally, attributes associable with the one can reappear in the other, surprisingly so, as the following three examples demonstrate.

First: The sculpture *Two Women* not only transforms the

visual motif of its photographic source into a physical motif. In addition, the physical shape of the new motif—a rectangle—refers to the shape of the photograph itself, not merely to the shape of the image in the photograph. Matisse pulls the two figures to a common vertical axis and joins them as an upright slab, marked bottom and top by the delimiting horizontals of the base of the sculpture and an impossibly straight arm. (The shoulder had to be dislocated to achieve this.) Conversely, the embracing figures in the painting *Music (oil sketch)* are linked down a vertical axis, only to be twisted away from rectilinearity to produce a graspably shaped motif isolated in space—like a sculpture, though no more resembling a sculptural image than *Two Women* resembles a photograph.

In the case of *Two Women*, Matisse transfers to a sculptural image the sense of a continuous, bounded spatial field that is associated with pictorial art. In the case of the embracing couple in *Music*, he transfers to a pictorial image the sense of isolation in unbounded space that is associated with sculpture. But he is doing more than using one medium to recall another. He is combining in each work as a whole the sense that it is a bounded container, and the sense that it is also a bodily container isolated in space. And he is altering how we read the meaning of each of these works. He is making us work to find it. In the case of the sculpture, we have to look to the pictorial to find it; in the case of the painting, to the sculptural. We have to look for meaning where we do not expect to find it. This makes it seem, when found, all the more real. Displacement produces meaning.

And the method of the displacement is what guides us in the search for meaning. In both works the method is the same: the images are redesigned by drawing. In the painting, it is drawn contours that convey the sense of the sculptural. In the sculpture, it is the redrawing of the figures that makes a pictorial rectangle of them. Drawing most closely associates painting and sculpture, not only conventionally but instrumentally. We will see this in my second example. But we will see something else as well.

Second: The painting *Blue Nude* (fig. 7) was, we know, based on the sculpture *Reclining Nude (I)* (fig. 8), before the latter was quite completed. The exaggerated contours of the figure in the painting lie flatly on the surface as signs for the body, and they convey a sense of the sculptural because of their exaggeration—but also because we are invited to look down on the figure, disposed on the ground as if it were a sculpture. Meanwhile, the sculpture *Reclining Nude (I)* is composed on a rectangle as if it were a painting. When I last mentioned *Blue Nude*, I said that the figure *is* the painting, and vice versa. I should now modify this and say that the *image* of the figure is the painting, and vice versa. This is not meant as a retraction, so to return to a more conventional version of the relationship between the figure and its representation, but rather to offer a more unconventional version

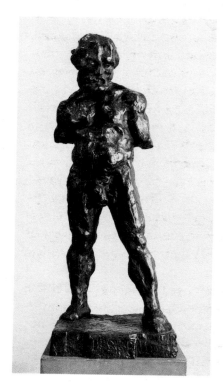

23. *The Serf.* 1900–04 (pl. 25).

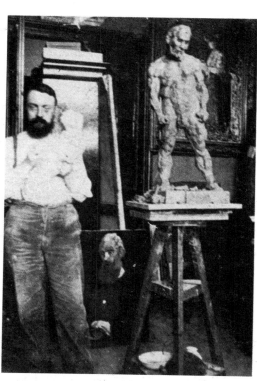

24. Matisse in 1903 or 1904 with the painting *The Monk in Meditation* (c. 1903) and the sculpture *The Serf* before the arms were removed.

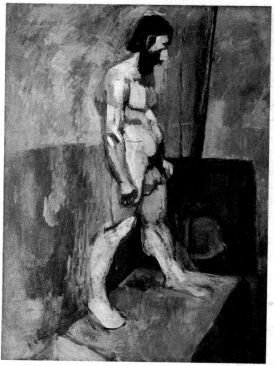

25. *Male Model.* c. 1900 (pl. 26).

that applies, by extension, to sculpture as well. In both cases, the figure is the image. What differentiates them is that the pictorial image is bonded to a vertical ground and the sculptural image to a horizontal ground, whether or not the image itself is horizontal. That is not unconventional. What is, however, is the way Matisse will recall the pictorial ground in a sculptural image and the sculptural ground in a pictorial image.

His four sculptures *The Back (I–IV)* (pls. 121, 167, 191, 294) are exceptional in forming sculpted images on the vertical ground of painting. Sculpture may share attributes of painting but usually shuns its vertical support. For Matisse, painting—inevitably visual—was associated with verticality; sculpture—inevitably physical—with horizontality. It was by introducing into paintings an intimation of horizontality that the physical could find its place within their vertical shields. *Blue Nude* suggests that this is true. So does *Harmony in Red:* the vertical membrane of its surface appears as if slit open at the right to admit the figure of the servant; her presence forces us to read the table she arranges as being horizontal; and thus, the visual delights upon that table gain in physicality. In *Luxe, calme et volupté*, as we have seen, an effect of horizontality is produced by the drawing of the reclining figures to mark the zone of privilege in front of the viewer. This painting, too, suggests that for Matisse horizontality and physicality were intimately related.

A number of the greatest paintings that Matisse made in the period of his most prolific sculptural activity argue the opposite, apparently: the two versions of *Le luxe* of 1907 (pls. 102, 103), *Game of Bowls* of 1908 (pl. 110), the incomparable *Bathers with a Turtle* of that same year (fig. 34), *Nymph and Satyr* of 1908–09 (pl. 111). These are all affirmatively surface compositions, vertical sheets of color identified with the picture plane and impenetrable by horizontality. They disprove my case, it would seem. And yet, they surely evoke the most extraordinary sensations of physicality. As we will see later, they make use of perhaps Matisse's most brilliant feint of all.

My third and final example of how the pictorial and sculpted associate in Matisse's work is a general one. It returns us to the subject of "signs." Matisse's ultimate conception of signs, we remember, united drawing and color. The areas formed by the brush in his late ink drawings and the areas formed by scissors in his paper cutouts had a common basis: the interior and exterior of each kind of area were formed simultaneously and were thus symbiotic. A source for this conception of signs, we saw, was Matisse's early Fauve canvases, with their "drawn" strips of color. But there is a more important source: his sculpture. The surface of a Matisse sculpture, we recently learned, comprises the physical boundary of its mass, just as, in the cutouts, the scissored edge of a shape comprises its physical boundary. Matisse's ultimate conception of signs is, finally, a sculptural conception, for the physical material of sculpture affords a natural symbiosis of interior and exterior. His ultimate *pictorial* signs—brush-drawn areas and scissored areas—are thus as if cross-sections taken of *sculptural* material. "Cutting directly into color reminds me of a sculptor's carving into stone," Matisse said.[195] The ultimate sign is a sculptural slice.

IV. A PRIMAL SCENE

The painter Frank Auerbach once asked, "When did Picasso grow up?" The answer: "With the portrait of Gertrude Stein, of course—so many sittings, scribbling at a piece of mud."[196] Matisse grew up making a sculpture, *The Serf* (fig. 23), accumulating pieces of mud. It needed an astonishing five hundred sittings over a four-year period begun in 1900. It was still not finished when Matisse had himself photographed beside the almost grossly physical plaster in a pose of unmistakable self-projection (fig. 24). By the time it was cast, deprived of its arms, the representation of male bodily power had become a mutilated image of servitude.

The painting *Male Model* of c. 1900 (fig. 25) was probably made around the time the sculpture was started. The painting is composed of great patches of paint stuck onto the surface like chunks of clay. But Matisse is not only interested in the body as an immense patched-together mass; he also wants to wrestle from it a fretwork of contours that convey the muscularity of the figure as the literal arrises do in the sculpture. He is not building on top of a linear structure. He is finding a linear structure between his accumulated patches, then reinforcing it. He seems to find himself marking the gutters in blue and the ridges in red. But the gutters come to look like actual breaks in the surface, into which our vision disappears. So he finds himself occasionally reversing the system. The effect resembles that of the welded seams of his sculptures, which serve at once to lock and to separate juxtaposed planes. (When they are too smooth we have reason to be suspicious of the authenticity of the cast.) Neither behind nor above the form, they are the means of its tentative cohesion.

In *Male Model* they do not quite cohere. The planes flap free

at times. The most patent example is the patch of paint that represents either the nose or the chin of the model, we cannot be sure which. The image threatens to fall apart.

✓ This painting is clearly indebted to Cézanne. So is the sculpture, *The Serf*. The sculpture is frequently characterized as Rodinesque, and there is reason for this. Matisse, as a modeler, had no option except to work from Rodin's example. He even had Rodin's model Bevilacqua pose for *The Serf*. And yet, it is a Cézannist not a Rodinesque ambition that strives to hang together the patches of clay as a unified image. Parts of the image may engage our attention as phenomena—of strangely harsh beauty—but their meaning is incomprehensible except in the context of the whole. In "Notes of a Painter," Matisse alluded disparagingly to a sculptor, and he had to be thinking of Rodin, who composed only from fragments and therefore produced only confusion.[197] Then immediately, he applauded Cézanne as the paradigm of an artist who achieved pictorial unity. Then, immediately, he associated that pictorial unity with the unity of the body.

When I referred earlier to this passage from "Notes of a Painter," I said that alarming consequences therefore attached to Matisse's failure to achieve pictorial unity. *Male Model* and *The Serf* are extraordinary images, but they are not fully unified ones. It was a dilemma: a work of art must be as whole and complete as the body it represents, and yet the means of its making, if acknowledged, tended to pull it apart.

It is customary to think of these Cézannist works as representing an abrupt reaction to the highly colored Corsica and Toulouse paintings that preceded them. They do. But it was those preceding paintings which first pulled images apart. The Toulouse still lifes, especially, transformed matter into pure chromatic substance that needs no anchoring; the parts pulsate with and radiate energy that hovers on the surface as if a vibrating cushion of heat.[198] Matisse read Paul Signac's book *D'Eugène Delacroix au néo-impressionnisme*, and its message—that the common aim of painting since Delacroix was to realize color with maximum force—unquestionably affected him. It answered a hitherto suppressed need that was finally more than pictorial: to discover in painting a pleasurable world where prosaic objects would glow with a new kind of material value, one found in "a love of the materials for painting for their own sake."[199] Subsequently, Matisse would paint and repaint a carefully chosen, small group of still-life objects as if he could never quite extract from them all the potential richness they contained. In 1900, however, there was still a barrier to his doing so. To construct a painting purely from the relationships among colors, whose descriptive function is only summarily indicated, meant surrendering not only realistic depiction, and with it the traditional, tonal substantiality of painting, but also the traditional completeness of painting. Unsurprisingly, the most radical of the early still lifes, *Still Life with Oranges (II)* (pl. 20), is an unfinished

work. The sacrifice was apparently too great. That, at least, seems to be the argument *Male Model* makes.

The example of Cézanne offered wholeness and unity of a very substantial kind. And yet a renunciation was involved. The alternative, though, meant a far greater renunciation—of the wholeness of the image. Almost against his will, it seems, Matisse found himself forced to make it. The hacked-off limbs of *The Serf* most dramatically symbolize his surrender. But it is also evident in the way that an extremely substantial body, for example in *Carmelina* (pl. 37), is projected onto the surface to compete with a dislocated pattern of elementary geometric shapes. And it is evident in his making, in addition to Cézannist paintings, softly tonal and even Gauguinesque works in this 1900–04 period. Their decorative surfaces contain an element of anxiety that produces far greater results than could come from someone more easily satisfied. Still, Matisse is not satisfied. And of course, the element of anxiety increases. The pictures will not sell. He has to move back in with his parents. He concocts a misguided scheme to have a group of mostly family friends accept pictures in return for supporting him. That fails. He considers giving up painting. He is struggling, it is clear, not only with the authority of Cézanne but with the very problem of achieving personal authority. And getting nowhere.[200]

It is, therefore, hard not to see the anomalous group of costumed figures that Matisse painted in 1903—his first in this genre—as indications of problems of self-identity.[201] Some are clearly Cézannist in inspiration; others, the more beautiful pictures, less so. We know that Matisse said they were, in effect, potboilers.[202] But this only supports the foregoing interpretation. Matisse must step partly outside of his profession as an artist, partly outside of a role hitherto modeled after Cézanne, to produce these disguised representations: Spanish musicians, an actor, a monk. The last is clearly a disguised self-portrait. Matisse placed this harsh, bearded face between himself and his sculpture *The Serf* when he posed for the photograph mentioned earlier (fig. 24). He is sending a mixed message: mostly masculine assertion, but also self-sacrifice and servitude. The costumed figures likewise send a mixed message. All are preoccupied figures. However, the actor and monk are paralyzed in the gloomy severity of their representation, while in marked contrast, the musicians, dressed in exotic costumes, are absorbed in creative tasks in spacious, decorative surroundings. Matisse at this time is extremely uncertain of his direction.

At this most dangerous moment, Matisse discovered another mentor than Cézanne, and another model of unity than Cézanne's, and they were so welcoming because he had met them before. They were, of course, Signac and Neo-Impressionism. In 1904, after the fiasco of Matisse's first one-artist show, at Ambroise Vollard's—Matisse's last, desperate attempt to sell the work he had been accumulating—the thirty-four-year-old artist accepted Signac's suggestion to spend the summer at Saint-

Tropez, where Signac had a house. *Luxe, calme et volupté*, that atavistic return to childhood experience, was the result.

Like Children in the Face of Nature

Signac was only six years older than Matisse, but in 1904 he was the very model of a successful artist, president of the Salon des Indépendants.[203] His commitment to painting constructed of color was exemplary. And the paintings that Signac made were as solidly and methodically constructed as the brick houses of Bohain. For these reasons, he was to be admired, indeed envied. Signac, moreover, was not as doctrinaire in his tastes as his own paintings might suggest; it was not necessary to be a fully fledged Neo-Impressionist to have his support.[204] Most of the paintings that Matisse made in Saint-Tropez were not Neo-Impressionist in style. In works like *St. Anne's Chapel* (pl. 43) and *The Terrace, Saint-Tropez* (pl. 44), he clung to a form of Cézannism. But he eventually succumbed. As we have seen, a loosely Neo-Impressionist painting of the beach at Saint-Tropez (pl. 49) became the basis for *Luxe, calme et volupté*, made that winter.

Matisse would subsequently be dismissive of the "scientific" methods of Neo-Impressionism and would strongly disavow the very idea of painting by theory.[205] Nevertheless, the second Neo-Impressionist phase of his career, though very brief, is extremely important. It has immediate bearing on the development of Matisse's art through the painting of *Le bonheur de vivre* in 1905–06, when he finally repudiated Signac's influence; that is to say, on Matisse's creation of Fauvism. Therefore, it has bearing on the entire later development of Matisse's art. "Fauvism is not everything," he said, "but it is the foundation of everything."[206] Neo-Impressionism, we might add, is the foundation of Fauvism—but the foundation that Matisse dismantled in order to create Fauvism. What happened is complicated. In order to explain it, we need to follow not only a stylistic development but also, in effect, a psychological development. For in this period Matisse matures as a painter by rejecting the authority of Neo-Impressionism, to make an art that finally escapes the constraints of earlier authority—an art of unconstrained freedom that is truly his own. I will therefore describe what happens with the aid of a psychological model of development. This will help to uncover a most basic aspect of Matisse's Fauve paintings—their refusal to emulate the form of completion hitherto traditional to painting—and will, additionally, open to us the broadly mythic dimensions of his subsequent work.

In using this model, I am not suggesting that Matisse's artistic development should be viewed as reducible to the facts of his biography. The primal themes of Matisse's art, which I will be describing, are not uniquely his, of course, but rather our common property. Why else should we be affected by them? If

we are affected, it cannot be because we find Matisse himself affecting. He was not, particularly; usually quite the reverse. If I make him seem interesting, then I am glad, because his strange, selfish life was exemplary in its own way. It, and his art, were the only things that finally were real to him. Once, in the mid-1930s, preparing to go to London to see a major exhibition of Oriental art and declaiming about how important that art was, he suddenly stopped and said he would not go: "I don't really take an interest in it," he said. "I take an interest only in myself [*Je ne m'intéresse qu'à moi*]."[207] But still, his life, or its psychology, is not the subject of his art. If it were, it would lack aesthetic authority, which is impersonal.

That said, let us begin by noting that Matisse submitted only with great difficulty to Neo-Impressionism. He was "anxious . . . madly anxious" that summer at Saint-Tropez, reported the Neo-Impressionist painter Henri-Edmond Cross, who saw him there and told him, "You won't stay with us long."[208] His anxiety is to be attributed to his simultaneous attraction to the discipline of the Neo-Impressionist method and fear of submitting to it. The psychological model that can aid understanding of what subsequently happened I borrow from Richard Wollheim's account of Ingres's struggle against parental authority.[209] What subsequently did happen, in fact, is that Matisse eventually opposed the influence of Signac's Neo-Impressionism with the influence of Ingres, to create the climactic work of Fauvism, *Le bonheur de vivre*.

Wollheim's account of Ingres's development tells of conflicting impulses: on the one hand, idealization of the father; on the other, the need to alter, reorder, and thereby assume control over the world he has inherited from him—which means humanizing the father he has idealized. "Idealization," Wollheim says, "being a defense against the anxiety that envy generates, is cousin to envy itself . . . [sharing] the same insensitivity to the individuality, to the actual nature, of things and persons so that art, carried out under the aegis of an idealized figure, becomes an art of preconception." That is to say, art is held to preexist the work of making it, which becomes a chore.

This is precisely what painting became for Matisse with Neo-Impressionism. He made a cartoon for *Luxe, calme et volupté;* prepared it in advance, then filled in the blocks of color, generally following the methods Signac recommended. It would be exaggerating Signac's importance to Matisse to say that Matisse idealized him. Neo-Impressionism, however, being an objective, rational system, offered what idealization offers. "The idealized figure," Wollheim says, "promises to liberate the artist from the pains and uncertainties of toil." Neo-Impressionism promised just that. However, "the redemptive aspect of art is that . . . it rewards the move toward the more realistic identifications," that is to say, the less idealistic ones, "and it does so precisely by freeing itself from the effortlessness of preconception, and returning to the trial and error, the creativity, of work."

And in this trial and error, in the creative work of picture-making, reside the instrumental means of reordering the world.

As Cross had predicted, Matisse did not stay long with Neo-Impressionism. At first, he hedged his bets. In 1904–05, he would at times make two versions of a picture: one generally following the Neo-Impressionist formula and one that took liberties with it, infusing it with a Cézannist treatment and with Cézanne's refusal of preconception. Whether the Cézannist picture followed the Neo-Impressionist picture, or vice versa, Matisse was beginning subversively to oppose preconception by a discovery of meaning within the work of making. Some of his Neo-Impressionist pictures, for example *Notre-Dame* (pl. 41), are spontaneous oil sketches that do not look planned at all. Works of this kind provided the model for Fauvism, which would be "not a voluntary attitude arrived at by deduction or reasoning; it was something that only painting can do."[210] Matisse's opposition to preconception, begun within the context of Neo-Impressionism, thus triumphed in Fauvism. Even in Fauvism, however, it remained subversive in the sense that Matisse seems to have conceived of his Fauve paintings, at first, not as finished works of art but as preparatory ones.

Fauvism is still misunderstood. In large part, this is because its primary identification is still with the summer of 1905 at Collioure and with that year's Salon d'Automne, where the Collioure pictures and others done shortly thereafter were first shown. Although the barbarous connotations that originally attached to the name *les fauves* ("the wild beasts") faded along with the shock that the pictures originally produced, Fauvism continues to be romanticized as a moment of spontaneous rebellion that produced a rebellious art. Matisse and his colleagues did acknowledge that what they had created embodied an emotional extremism which could not last;[211] that is not in dispute. What is, however, is the way that Fauvism has been thus hypostatized as essentially a style of the summer and autumn of 1905. Anything made later which exhibits different stylistic characteristics therefore appears a development of (or from, or beyond) Fauvism. This deterministic model is injurious to our understanding of all avant-garde art in Paris from and after 1905, not only Fauve art. But it is particularly damaging to an understanding of Matisse's. It has the effect of creating two deep divisions in his art of this period. The first bears the name Fauvism; the second, the name *Le bonheur de vivre*. These two names regulate instead of aiding appreciation of what Matisse made. The first stands for a transient episode concerned with transient perceptual effects, emotionally excited and addressed solely to the eye. It requires, and is required by, the second, which stands for a work of enduring influence concerned with permanent, conceptual stability, emotionally calm and addressed through the eye to the imagination. I will come to *Le bonheur de vivre* in a moment. It is the name Fauvism that is at issue now. Its romanticized meaning crumbles before the documentary evidence.

On July 14, 1905, Matisse wrote to Signac from Collioure: "I have the feeling that I'm not doing much, because my work consists of oil sketches [*esquisses*] and watercolors that may be useful for me in Paris."[212] Signac had earlier written to him that he simply could not understand painters complaining about the weather preventing them from completing their pictures. "In that case," he joked, "there would be no painters in a country where it rained or the wind blew all the time." And added: "To my mind, it is futile and dangerous to battle thus with nature. The quickest method of notation is still the best. It provides you with the most varied information and, at the same time, leaves you free to *create* afterward."[213] The emphasis is Signac's. We might want to emphasize "afterward." Unquestionably, Matisse's July 14 letter talks of his work as preparatory. Of course, that may have been simply to go along with Signac while disguising what he was really about; two weeks later, he was writing to ask Henri Manguin if he knew the date for submitting work to the Salon d'Automne.[214] But that can be read to mean either he had work he was eager to show, or he was eager to know whether he had time yet to produce it. We do know that by the time he sent his paintings done in Collioure, and shortly thereafter in Paris, to the Salon d'Automne, he was very pleased with them. To Signac he wrote: "It was the first time that I was glad to exhibit, for my things may not be very important but they have the merit of expressing my feelings in a very pure way, which is what I have been trying to do ever since I began painting."[215] The least we can say is that Matisse came to feel pleased with his possibly unimportant, nominally preparatory, work and decided to exhibit it. But we can say more than that.

Matisse had arrived in Collioure in mid-May 1905 and remained there until early September.[216] On June 6, he wrote to Albert Marquet saying he had so far made only two small oil sketches plus some watercolors and drawings.[217] The bulk of the summer's work was therefore done in the three months June through August. Matisse described its extent in a letter to Signac from Paris on September 14, "Yesterday I had a visit from Félix Fénéon, to whom I displayed my work from Collioure, that is to say, forty watercolors, a hundred or so drawings, and fifteen canvases."[218]

Surprisingly, the implications of this inventory have never properly been examined. And yet, at least three important conclusions can be drawn from it. First: although Fauvism is commonly considered a spontaneous style and Collioure its crucible, it is clear that Matisse either worked somewhat infrequently or spent longer on each of his works than their effect of spontaneity suggests. Second: although Fauvism "was something only painting can do," most of Matisse's works that summer were drawings. Third: the inventory shows that too many canvases by Matisse are currently attributed to that summer in Collioure. A significant number were painted later.

We know that the large Neo-Impressionist picture Matisse

called *Le port d'Abaill* (pl. 63) was painted in Paris in the autumn.[219] It has long been considered anomalous. For the standard account of the Collioure summer is that Matisse worked successively through the influences of, first, Signac's Neo-Impressionism; second, van Gogh's turbulent draftsmanship; and third, Gauguin's flat color planes, to create the spontaneous synthesis of these three in Fauvism. This cannot be correct. We know that on July 14, Matisse did write to Signac that he had realized the color and the drawing of his Neo-Impressionist painting *Luxe, calme et volupté* (which Signac had purchased) were not in accord.[220] But two weeks later, we know from André Derain, Matisse was still working in a Neo-Impressionist manner.[221] I think it is very likely indeed that a number of pictures of Collioure in a Neo-Impressionist or clearly Neo-Impressionist-influenced style were actually done in Paris afterward.[222] I think it is also very likely that the small *pochades*, certainly done at Collioure, were conceived as preparatory works.[223] Larger works, too, may have been conceived thus. (We know that a larger landscape [fig. 28] *did* serve as a preparatory study for *Le bonheur de vivre*.) But we cannot be sure; nor can we be sure where all these works were painted. Nor, finally, does it matter. What matters is that Matisse made both preparatory works and works whose nominally preparatory state he accepted, or came to accept, as finished; at times, we may be sure, the same work fulfilled both conditions.

Acceptance of "unfinish" was not, of course, new. Since the eighteenth century, at least, it had been understood to contribute to the beauty of paintings. And by the middle of the nineteenth century, Baudelaire could write that "in general, what is *complete* [*fait*] is not *finished* [*fini*], and . . . a thing that is highly *finished* need not be *complete* at all."[224] Matisse, however, asks us to take a further step; one that is personal to him. Freedom from finish is intrinsically liberating in making a painting, but additionally offers a further freedom: insofar as a work of art can be considered preparatory, it comprises a possible image, a future image. Thus Matisse can maintain the fiction of idealization even as he subversively works to destroy it.[225] The intensity of his Fauve paintings owes a great deal to the tension between preconception and creative invention that they display. We know these paintings were preconceived in drawings, often on the canvas itself, on top of which the work of painting takes place. Matisse has it both ways. He does have an image in his mind, and works in painting to re-create it—but he does not simply imitate his preconception. The work of painting instead *replaces* the drawing that sketched it out. This is why the practice of drawing occupied so much time at Collioure. The essential revolution of Fauvism was drawing in paint.

When Matisse wrote to Signac about the separation of drawing and painting in *Luxe, calme et volupté*, he said: "The one, drawing, depends on linear or sculptural plasticity; the other, painting, depends on colored plasticity." The terms he uses derive immediately from a statement of Cézanne's published in July 1904, when Matisse and Signac were together at Saint-Tropez, where it presumably was discussed.[226] But Matisse does not return from Signac to Cézanne. "Cézanne constructed his paintings, but color—that magic—was still to be found after him," Matisse said later.[227] Matisse would construct from color. He began to do so by combining linear and colored plasticity. By drawing in curls and strips of colored paint, he realized how both his Neo-Impressionist painting *and* his earlier Cézannist painting had been flawed. In both cases, he had been trying to build color and drawing into a tightly formed unit, like an articulated suit of armor. He had been starting with a preconceived idea of wholeness and trying to replicate that. This had not been an error, exactly, not a misunderstanding; it was a reasonable way of proceeding. But it was based on a false understanding of the character of things: an ideology, a coherent, rule-governed system, which happened to be in error and thus prevented direct access to things.

Fauvism was not merely a new way of making a picture. It was a new way of conceiving the world. It was a non-imitative way. Matisse creates not the effects of light but light itself, in abrupt contrasts of red and green and similarly vibrating polarities. And it was a way of rebuilding the world from scratch: by conforming to a preconceived image, certainly, but a preconceived image that Matisse himself could only imagine, and one that he hoped to see made real. Thus, idealization gives way to instrumentality. But instrumentality is not yet claimed. The work of building a painting is left incomplete. Matisse stops short of taking complete control.

Fauvism is thus appropriately called a revolution, because it breaks with authority. The fiction of the not-yet-completed allows Matisse access to a state that *preexists* authority. Hence his frequent remarks to the effect that Fauvism represented a *return*: to the fundamentals of expression;[228] to the purity of means;[229] to pre-rational, instinctive, and unskilled expression; to being able to ask "What do I want?" without bothering whether the result was "intelligible to others."[230] The model of the not-yet-completed, I need hardly say, is the child. Of himself and Derain at Collioure, Matisse observed: "We were at the time like children in the face of nature and we let our temperaments speak. . . ."[231]

The reader will remember that I claimed the child in *Luxe, calme et volupté* was a surrogate self-portrait of Matisse, and that the essential Baudelairean message of this picture was that an artist's genius is "simply *childhood recovered* at will." Thus, before Fauvism, Matisse had dealt iconographically with the theme of childhood. Now, with Fauvism, he has created a form of painting made as if with the temperament of a child. The next step will be to repaint, with the benefit of his new, more appropriate vocabulary, an instinctive, prelapsarian world associable with childhood experience. Matisse takes that step in *Le bonheur de vivre*.

26. *La japonaise: Woman Beside the Water*. 1905 (pl. 51).

27. *Mme Matisse in the Olive Grove*. 1905. Oil on canvas, 18 × 21¾″ (45.7 × 55.2 cm). Private collection.

A Golden Age

The form it assumes will appear in a moment. To explain that form, I need first to smooth the division which quite proper recognition of this picture's importance has created in the development of Matisse's art. It is a crucial picture, as will become evident. It announced a new direction in Matisse's art, "beyond" Fauvism. But not by overthrowing Fauvism; rather, by remedying some of its deficiencies. The most important was its intolerance of figural representation.

The Fauve paintings composed exclusively of fields of drawn paint marks made figural representation very difficult. If Matisse tried to maintain the identity of the figure, as he did in *Mme Matisse in the Olive Grove* (fig. 27), the independent continuity of the surface was weakened and the figure's grounded presence still not assured. But if he maintained the continuity of the surface, as he did in *La japonaise* (fig. 26), the figure was camouflaged and tended to disappear. To paint his Fauve portraits, Matisse therefore introduced broad areas and continuous contours into this pure fragmentation style, referring to Cézanne again and to Gauguin, as can be seen from *The Woman with the Hat* (pl. 64) and *The Green Line* (pl. 65). This made figural representation possible. But it still did not make *bodily* representation possible. The dominance of the vertical picture plane is such that while the surface, taken frontally and as a whole, affords a spatial reading of the work, we cannot easily imagine ourselves reaching through space to grasp the image painted on the surface.

Such, of course, is the radicalness of Matisse's Fauve canvases: the optical field, given as a continuum, is identified with the vertical picture plane in such a way that no alternative reality to that associable with the vertical surface is imaginable. That surface became the very locus of meaning. Only what existed there, and could never conceivably exist elsewhere, sufficed to recall external reality with all the urgency Matisse had experienced it. This led him to treat the surface never as merely something transparent to its meaning but always as something self-referential, in the sense that the images it displays show not the functioning structure of things, but rather what the process of painting had thrown up to reimagine their identities. This also led him, I want to argue, contrary to what one usually hears, to treat the flatness of the surface as extremely problematical. *Le bonheur de vivre* is said to divide Matisse's art because it initiated newly explicit involvement on his part with the surface flatness of painting. I think it did the opposite. I think it marked the point at which Matisse turned this convention of all painting against the dominance of the picture plane.

Compare *Le bonheur de vivre* (fig. 31) with the 1905 Collioure landscapes whose composition it generally borrows (pl. 52; fig. 28). They are flat; their images are projected frontally onto the picture plane. The ink-and-pencil study (fig. 29) for *Le bonheur de vivre* is unquestionably not as flat as they are. Its space is that of a theater set. The subsequent oil study (fig. 30) and then the final composition draw back the imagery to the surface. But something has drastically changed. The frontal plane is ex-

28. *Landscape at Collioure / Study for "Le bonheur de vivre."* 1905 (pl. 58).

29. *Study for "Le bonheur de vivre."* 1905–06. Pen and ink and pencil on paper, 6⅞ × 8⅞" (17.5 × 22.5 cm). Private collection.

pressed but bows inward. A horizontal plane is imagined for the figures, for without it where could they possibly exist; as with *Luxe, calme et volupté*, the horizontally reclining figures radiate horizontality. But now, it is a kind of horizontality that does not seem opposed to the verticality of the surface—that seems neither to constrain nor to be constrained by that verticality. With *Le bonheur de vivre*, the picture plane is still continually felt as the underlying form, but it is never felt as a constraint. Matisse was apparently determined to be free of the mere plane, and the more he could do so, the more of course he could make use of the plane as a matter not of convention but of choice. And the more he could do that, the more deeply felt his use of it could be.

Le bonheur de vivre "was painted through the juxtaposition of things conceived independently but arranged together," Matisse said.[232] It is an even greater mass of borrowings than *Luxe, calme et volupté*. Its sources range from prehistoric cave paintings to Rococo *fêtes champêtres*, from Greek vases to works by Matisse's contemporaries.[233] The most prominent source is *The Golden Age* (fig. 32) of Ingres, and it is significant, I believe, that Matisse endeavors to bring himself close to Ingres, the pinnacle of the French academic system in the nineteenth century, and not merely a painter of idealized nudes but a painter of idealization and its humanization in the instrumental work of painting. But attempts to specify the iconographical sources for *Le bonheur de vivre* run aground because there are simply too many to bring them to bear in our appreciation of the picture. This suggests that what is important about them is their number, what they have in common, and their juxtaposition.

The multitude of sources Matisse refers to suggests that he was endeavoring to relate himself to a large number of predecessors—to avoid dependence on any one authority by depending on many. He thus avoids inferiority by the very ambitiousness of his borrowings. But additionally, he tantalizes us with his borrowings, inviting us to make an apparently limitless journey into the past. And yet, most of his sources have something in common. They are pastoral compositions, not history paintings; paintings not of significant actions but of significant inaction. They allude to the past as a harmonious Golden Age of amoral pleasures, and they do so through representation of the posed body. Matisse's promiscuous juxtaposition of such borrowings offers an anthology of desires; a personal chrestomathy about the past, his past, as a historical and biological field of dreams. This painting is about the origins of desire.

Its title is important. It is sometimes referred to as *La joie de vivre*. However, it is not the joy of life that we see: not Walt Whitman, Isadora Duncan, and nude bathing. Rather, it is the happiness, the contentment of living; something slower, dreamier, far more deeply interior.[234] It shows scenes of eroticism and love-making but hardly of passionate love. There is only one unambiguously male figure, the goatherd-piper tucked off at the right background, a symbol of pastoral innocence looking over toward the nude figures like the child in *Luxe, calme et volupté*.[235] The rest are female or androgynous, with the presumed exception of the crouched figure in the right foreground, who appears to have fused with the adjacent reclining woman to produce perhaps the most bizarre image Matisse ever painted.

As Leo Steinberg noted of the picture, the figures are not Vasari's "magnets to the eye."[236] To look at them directly offers too little pleasurable reward. The heavy outlines draw energy from them and shunt our vision away, "so that a figure is no sooner recognized than we are forced to let it go to follow an expanding, rhythmical system." Seeking an analogue in nature for this effect, Steinberg realizes that it is not like a "stage on which solid forms are deployed: a truer analogue would be a

30. *Oil sketch for "Le bonheur de vivre."* 1905–06 (pl. 72).

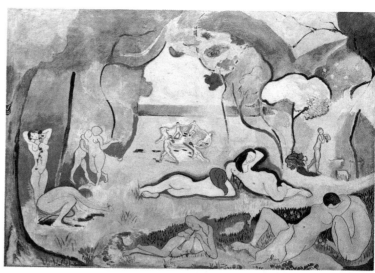

31. *Le bonheur de vivre.* 1905–06 (pl. 73).

circulatory system, as . . . of the blood, where stoppage at any point implies a pathological condition." He does not make the further association. But we should. Matisse describes "the contentment of living" physiologically, by means of analogy with the living body.

The myth of the Golden Age, the earliest age of mankind, has always carried associations of birth and awakening.[237] Matisse's version of this myth is no exception. As an etiological fable, explaining how man came to be alienated from nature, it has always offered a vision of a state of lost innocence. More often than not, this prelapsarian state is identified, seasonally, with the verdure of spring and, biologically, with the "originality" of childhood either preceding or accompanying the awakening of sexuality. Again, Matisse's version of the myth is no exception. Before I discuss its seasonal reference, let me consider its childhood reference.

Of *Luxe, calme et volupté*, I said that it presented images of adult sexuality and maternal plenitude. So does its successor, *Le bonheur de vivre*. It does so most evidently in the bizarre image in the right foreground: a female pose of ancient art-historical lineage as a focus of adult male sexual longing returns to us as a scene of maternity, with a fetal body not yet fully emerged from its cocoon of warmth.[238] Whereas images of adult sexuality and maternal plenitude are juxtaposed in *Luxe, calme et volupté*, in *Le bonheur de vivre* they are conflated. Whereas the former picture juxtaposes contemporary and idealized works, the latter shows us a purely idealized world from which all trace of the contemporary has been banished. In both of these respects, *Le bonheur de vivre* is the more deeply atavistic work: the picture of a primal scene. It is not only this; a Freudian interpretation of the picture will not reveal to us all its dimensions. It would be foolish to expect it to. Still, interpretation of the "interior" world of *Le*

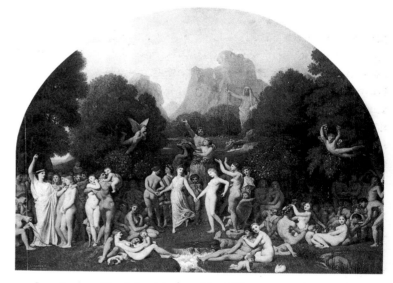

32. Jean-Auguste-Dominique Ingres. *The Golden Age.* 1862. Oil on paper mounted on wood panel, 18⅞ × 24¼″ (47.9 × 62.9 cm). The Fogg Art Museum, Harvard University Art Museums, Cambridge, Massachusetts. Bequest of Grenville L. Winthrop.

bonheur de vivre as, effectively, a pre-Oedipal world can aid understanding of the contrast of internal and external realities which, I have claimed, is essential to Matisse's own conception of his art.

Early in this essay, I referred to Matisse's distrust of the external, a distrust he summarized by the word imitation, meaning imitation of external reality and of the externals of past art. And I referred to what I said were excessive metaphors that he used to describe the injurious effects of the external: a body smothered or physically constrained. I said these images of claustrophobia were used apparently to describe agoraphobia. Insofar as they do so, they may be considered analogous to the

protective shield against stimuli that Freud refers to in *Beyond the Pleasure Principle:* the "special envelope or membrane" designed to filter worldly sensations and thus defend against potentially injurious external excitations.[239] To pursue the analogy, this imaginary screen allows Matisse to be both in the world and out of it, open to sensations but protected from their merely external aspects. The work of painting necessarily must take Matisse into the external world, into the public realm of common language, of preexisting conventions, established by earlier authoritative artists, which predetermine how reality is perceived. Maturity as an artist means imposing his own vision on that external world. And yet his vision will be shaped by preserving the internal as a benign, pre-Oedipal region of untroubled *bonheur.* Consequently, the extraordinary intensity of Matisse's achievement in the period opened by *Le bonheur de vivre* can be thought of as resulting from a contest between these opposing impulses.

However, this contest of the internal and external may be viewed in a different way. The associations of birth and awakening that attach to the Golden Age refer, I noted, not only to the "originality" of childhood but also to the verdure of spring. *Le bonheur de vivre* may thus be considered a "biological" picture not only psychologically but also mythically, as evoking the rebirth and renewal of the powers of nature. If Fauvism was a return to origins, to the fundamentals of expression associable with childhood experience and manifested in the not-yet-completed, then

Le bonheur de vivre, a finished picture, completes Fauvism; its primal world is explicitly a world of origins, an eternally fecund spring. What Northrop Frye says of all literature is broadly true of all painting. Its "mythical backbone . . . is the cycle of nature, which tells from birth to death and back again to rebirth."[240] With Fauvism, and specifically with *Le bonheur de vivre,* Matisse's painting attaches itself to the beginning of this mythical cycle. The idealized, internal world of *Le bonheur de vivre* is a world of natural beginnings; inevitably, then, it is a world that cannot last, however much Matisse might wish to preserve it, even by making it the model of his art as a whole. Viewed in these terms, too, what happens after *Le bonheur de vivre* may be seen to reveal conflicting impulses: nostalgia for its original world and, increasingly, acknowledgment that it cannot be made to last. Moreover, insofar as myth preserves the primitive identity of personal character and personal development, the psychological and the mythical join. For both, *Le bonheur de vivre* is a scene of rebirth.

Viewed art-historically, it is too. I will conclude this essay by discussing some of the events of the roughly ten years that followed. In this period, which sees the creation of Matisse's greatest masterpieces, painting itself is reborn as a modern art. This was not only Matisse's doing, of course, but it would have been impossible without what he made and without the example he set for others.

V. The Birth of Modern Painting

Three years before his death, Matisse told an interviewer: "From *Le bonheur de vivre*—I was thirty-five then—to this cutout—I am eighty-two—I have not changed . . . because all this time I have looked for the same things, which I have perhaps realized by different means."[241] This should warn us against looking for stylistic or procedural continuity as we begin to consider what happened after *Le bonheur de vivre.*[242] If we heed this warning, we will view a painting like *Girl Reading* (fig. 33), probably done contemporaneously with *Le bonheur de vivre,* as evidence of Matisse's readiness to look, at the very same time, for the same things by different means. *Girl Reading* pictures absorption; associates absorption with horizontality; offers that plane of absorption as a quieter, clearer zone than what is outside it; and presents the absorbed figure and that horizontal plane in a relationship of mutual reinforcement. Additionally, the subject of reading tells us that the subject of absorption is a story.

Books and readers appear frequently in Matisse's art and complement his narrative figure compositions. It is no accident,

of course, that his first illustrated book, *Poésies de Stéphane Mallarmé* (pls. 295–300), recapitulated the motifs of his early figure compositions and accompanied a return to figure compositions, with the Barnes mural, *Dance* (pl. 291), in the early 1930s. And it is significant that, when discussing the mural, he compared a picture to a book,[243] and when discussing his books said, "I do not distinguish between the construction of a book and a painting."[244] *Girl Reading,* the representation of reading, complements *Le bonheur de vivre,* the representation of a story; both are books that invite our reading. The great figure compositions that Matisse made after *Le bonheur de vivre* are textual works, albeit of an untraditional kind.

If we heed Matisse's warning about "different means," his subsequent paintings of 1906 will become more explicable. Matisse's failure to develop immediately the so-called decorative style of *Le bonheur de vivre* will not bother us as it has bothered earlier commentators on his work, myself included. We will not need to explain his apparent return to a kind of empirical Fauv-

33. *Interior with a Young Girl/Girl Reading.* 1905–06 (pl. 67).

ism as hesitation or consolidation. To the contrary, we will view paintings like *Pastoral* (pl. 76) or *Still Life with a Geranium* (pl. 79) as forward moves: attempts to transform the interior world of *Le bonheur de vivre* into real, external worlds—into, respectively, a real landscape with real enough figures, and a surrogate landscape with figures in the form of sculptures on a studio table. And we will understand why sculpture became so important to him that year. The movement of the circulatory system of *Le bonheur de vivre* required that the forms of its inhabitants be drained of bulk and substance. They are figures, not bodies. The figure means outline, symbol, and abstraction; the body means volume, reality, and mortality. Through sculpture Matisse could reengage the body.

One of the many reasons why *Blue Nude* of 1907 (fig. 7) assumes such importance is that in it, figure and body are reunited. Here, not only does outline connote volume, symbol connote reality, and abstraction connote mortality. (Figure will always connote body, reminding us of what is absent.) But additionally, the surface itself is corporealized. Figure and body are both present.

In this respect, *Blue Nude* is a great summation. In another, closely related respect it is, too. Matisse apparently designated it the third picture of a sequence begun by *Luxe, calme et volupté* and developed by *Le bonheur de vivre*.[245] The figure represented in *Blue Nude* appears in the preceding works. The image of absorption and its effect of temporal dilation, the picturing of concentration on horizontality, and the relationship of mutual reinforcement between horizontality and the human figure associate the three works. But only now is the frontality of the picture plane associated with groundedness and horizontality in such an intimate and audacious way. It is so definitive a solution to Matisse's investigations of how horizontally disposed images can them-

selves spread the illusion of horizontality through a picture as to permit no immediate development.

The very fusion of painting and figure in *Blue Nude* took Matisse into new territory. But he found himself facing old problems. *Blue Nude* was so conclusively constructed from the unfolding of surface rhythms that it forced him to reengage the most basic condition of 1905 Fauvism: namely, adjusting everything in a picture only to the surface plane. And as the frontality, the verticality, of the surface thus claimed his attention again, his subject matter changed. Vertical, standing figures began to dominate his pictures. There was, of course, a great danger in what he was attempting. Representation of horizontality had been compatible with conceiving a picture flatly on the surface because it opposed the dominance of the picture plane, saving such a picture from becoming merely a flat decoration. But the more that verticality dominated a decoratively conceived picture, the greater the risk that it would become only a decoration.

At first, therefore, in pictures like *Standing Nude* (pl. 95) and *La coiffure* (pl. 101), Matisse avoided adjusting everything to the picture plane, enrolling sculptural and Cézannist modeling to open an internal space. However, he was soon composing more flatly than ever before. The great series of figure paintings begun in the late summer of 1907 and continuing through 1909 with internalized, self-absorbed, and predominantly vertical subjects—which includes the two versions of *Le luxe* (pls. 102, 103), *Game of Bowls* (pl. 110), *Nymph and Satyr* (pl. 111), and the greatest of the series, *Bathers with a Turtle* (fig. 34)—are pure surface compositions. And yet, they are no mere decorations. As I said earlier, they make use of Matisse's perhaps most brilliant feint of all.

It is this: Once again, Matisse used subject matter to oppose the dominance of the picture plane; and once again, he did so by employing subjects that radiate horizontality, but now in an entirely unprecedented way. The dominant figures are vertical. Even when somewhat sculptural, they seem to be all elevation and no ground plan. They cannot radiate horizontality. But the sources of their absorption can: the subject matter of these pictures takes place on the ground. They all tell stories whose only certainty is that something happens on the ground—which no longer, it seems, need actually be pictured as ground, except as the flat surface "ground" of figural representation.

Matisse had discovered Giotto. On a trip to Italy in the summer of 1907, he had discovered the greatest model of all. The borrowed and altered pictorial device—an imaginary shelf on the bottom edge of a composition—was but a symptom of a much greater emulation. "Giotto is the peak of my aspiration," he wrote to Pierre Bonnard as late as 1946. "But the journey toward something which, in our time, would constitute the equivalent is too long for one life."[246] Here was the model of an impossible unity. It was an ideal as distant and original, and as unrecoverable, as the primal scene of *Le bonheur de vivre*. But it did exist in

art. It could be seen. Thus, while Matisse's art could never achieve that particular completion,[247] his art could continually aspire to its own completion. Thus, the birth of modern painting recalls the birth of Western painting. The radicalness of Matisse's painting returns to its roots and grows again.

But, perhaps, what Matisse's painting does is to close the period of Western art begun by Giotto. When Matisse returned to Paris after the summer of 1907, he saw a painting that suggested as much. Needless to say, he hated it. He said that Picasso's *Les demoiselles d'Avignon* was an outrage. And yet Picasso's picture helped him. Not as much as the work of Giotto helped him. But it did help him to see before him the path he would not, could not, take—a path, he eventually realized, that had begun where his own had, in Cézanne, and that looked out onto the same terrain, both visual and sculptural, and that was dominated by the female figure. And the ambitiousness of Picasso's picture fueled his own ambition as well as helped to define it. The picture he painted in response, *Bathers with a Turtle* (fig. 34), was the most authoritative he had ever made. I wish to focus what I have to say about Matisse's imaginary figure compositions on this picture, and will concentrate on three topics: its puzzling subject, its pictorial means, and the form of authority it reveals.

Image and Text

Its subject is not inexplicable, like the subject of *Le luxe (I)* and *(II)*, for example, done the year before. There, it was not at all certain what was going on. We think *Le luxe* may show a Venus, who, having emerged from the sea, is being dried off and presented with a bouquet of flowers.[248] But we have to know the story of Venus to understand its retelling, and the retelling does not make it humanly accessible to us as would more traditional representations;[249] it makes it less accessible, if anything. In *Bathers with a Turtle*, however, we do know what is going on. A tortoise is being fed by one of three nude bathers on what appears to be a stretch of grass beside the sea. Only, we do not understand the significance of this. Matisse's intention in making a picture of this subject is puzzling.

Both *Le luxe* and *Bathers with a Turtle* are very clear pictures, pictorially. But because the *subject* of *Le luxe* is not clear, it begs for explanation. It begs us to reunite its image with a missing text. It is not an allegory; at least, not a convincing allegory: this would suppress our interpretive doubt. And yet, because it does force us to confront the relationship of image and text, it does partake of the mode of allegory. This mode, Walter Benjamin argued, bears a natural affinity to historical moments when ideologies and their unities fall apart.[250] In allegory, image and text—what signifies and what is signified—are pulled apart. For Benjamin, the allegorical mode is central to the modern historical moment because it reenacts the pain of our disconnectedness.

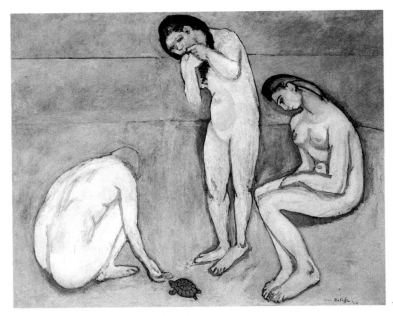

34. *Bathers with a Turtle*. 1908 (pl. 109).

Of Matisse it can be said that because the unity available to Giotto is not possible in our time, a kind of allegory becomes the vehicle of his desire for an impossible coherence.

Le luxe is thus a "failed" allegory. In our time a successful allegory cannot be painted. However, insofar as it partakes directly of the allegorical mode—opposing image to text so blatantly—it is idealistic. Unity may be as impossible to know as it is impossible to know for certain what this picture represents. But the picture presumes the possibility of such knowledge. It presumes a correct interpretation, even though it cannot provide it. In this respect, it maintains the authoritarianism of allegory. This is a weakness in the picture.

Bathers with a Turtle, however, acknowledges the impossibility of a correct interpretation. Matisse's intention is puzzling. And yet, because the subject of the picture is clear, it does not beg to be reunited with a missing text in the way that *Le luxe* does. It is even more puzzling than *Le luxe*, because its subject *replaces* a text acknowledged to be unknowable, missing. Not necessarily unknown or unfindable: Sarah Whitfield has suggested that the picture might well describe the myth of Apollo and Dryope, in which Apollo disguised himself as a tortoise and let Dryope and her friends, the Hamadryads, play with him.[251] This is very plausible. Knowledge of this text uncovers an important association of the picture, an element of primal sexuality.[252] But that element does not require the mediation of a text for its comprehension. The picture seems fully complete without an external text; and even with an external text, Matisse's intention remains puzzling. The picture rejects correct interpretation. Consequently, it opens to our interpretation in a way that *Le luxe* does not. It is a mystery, whereas *Le luxe* is a problem, to use a distinction suggested by the philosopher Gabriel Marcel: "A

problem is something met which bars my passage. It is before me in my entirety. A mystery, on the other hand, is something in which I find myself caught up, and whose essence is therefore not to be before me in its entirety."[253]

As a mystery, *Bathers with a Turtle* is at once remote from us and humanly welcoming. It is an awe-inspiring picture, with its bold, banded field of intense colors pressing up around the curious figurative incident, at once tender, slightly comical, and almost frightening. The latter quality derives from the posture of the central figure, which may well have been originally conceived as a flautist, like the one in the background of *Le bonheur de vivre*, but which became, with the help of borrowing from an African Congo sculpture,[254] an image of gnawing anxiety. But it also derives from the absolute candor with which the picture confronts the theme of dislocation. The only connectiveness possible is that of a fetal figure, the one being born in *Le bonheur de vivre*, offering a wisp of a leaf to, of all things, a tortoise. It is an absurdity worthy of Samuel Beckett: three giants on a bare seashore waiting for a tortoise to take a bite.

This is a different Matisse. He shows himself for the first time to be an extremely anxious, self-absorbed, even pessimistic painter, but one who has found new security precisely because of the very ruthlessness with which he acknowledges his doubt.

He still refers to old security, to Cézanne. The triangular composition of *Bathers with a Turtle* recalls the Cézanne picture, *Three Bathers* (see page 85), Matisse purchased at the time of his marriage and tenaciously held on to, a talisman, even in times of the most desperate hardships. Perhaps the *festina lente* theme of his own 1908 *Bathers* picture acknowledges the length of his struggle with Cézanne. But finally he steps out of Cézanne's shadow. The estranged color field and frank separation of color and drawing are entirely his own. Fauvist drawing in paint had allowed Matisse to combine the sculptural plasticity of drawing with the colored plasticity of painting, and in this way bypass Cézanne. Earlier, he had seemed doomed to imitate Cézanne by seeking vainly to weld together color patches by means of drawing. Now, he accepts his divided means. Even Cézanne, in the end, accepted incomplete unities: the large Cézanne retrospective at the 1907 Salon d'Automne had shown that. It was a memorial exhibition. Perhaps it was acknowledgment of Cézanne's death that liberated Matisse.

Or perhaps it was seeing what Picasso was doing after Cézanne. The welded armor of Picasso's *Three Women* of 1907–08, done contemporaneously with and finished later than *Bathers with a Turtle*, must have reminded Matisse of a form of provisional unification he found unacceptable. When the former Fauve Braque showed the jury of the 1908 Salon d'Automne, of which Matisse was a member, the pictures he had painted that summer at Cézanne's L'Estaque, Matisse saw where this approach led. This was the well-known occasion when he dismissed them as "little cubes." What is less frequently noticed is

that Matisse said he remembered that "the drawing and values were decomposed" in Braque's pictures.[255] Both Matisse and the Cubists were embarking on decomposed pictures. However, the Cubists, like Cézanne, were showing a decomposed world as well. In 1908, Matisse, having escaped Cézanne as they had not yet quite done, was showing something else.

I spoke of a contest in Matisse's art after *Le bonheur de vivre*, between the wish to preserve an internal, idealized world and the need to escape from its primal cocoon through the work of painting. *Bathers with a Turtle* pictures the newly discovered realities of an internal place apart. Along with Matisse's other great figure compositions of this period, it replaces the earlier world of eternal spring with imaginations of experience that may be, or that are, dislocated—even the ring of *Dance* is broken—but which Matisse acknowledges as being in their normal state; they are therefore subject to his painterly control. The season of innocent pleasure is over. Decomposition, being a fact of life, a fact of his life, can be isolated and dispassionately examined in a picture of figures on a beach.

In *Bathers with a Turtle*, I said, image replaces text. Image and text are pulled apart, and the image that remains is as condensed as a poetic text. In this painting, separation of image and text may be considered analogous to separation of field and figure, and consequently to separation of the visual and physical realms, of the specular image and the bodily image. This is Matisse's very first painting wherein the figural elements are isolated from each other, separately placed against the colored field. And yet, just as space clings to the specular image, so color presses up around the figural incident. The design of the color field itself, the very pressure exerted by the field against the figure, can do the work of connecting now.

The phenomenon of the specular image, the mirror image, produces the initial sense of estrangement that makes self-contemplation possible. Poussin's great painting of Narcissus, which Matisse had copied in the Louvre, contains such a message. Matisse found justification for the direction his art had taken by adopting an attitude of self-observation. In 1907, he told Apollinaire: "I found myself or my artistic personality by looking over my earlier works. They rarely deceive. There I found something that was always the same and which at first glance I thought to be monotonous repetition. It was the mark of my personality, which appeared the same no matter what different states of mind I happened to have passed through."[256] Subsequently, this same attitude informed the very processes of his art. "My reaction at each stage," he said, "is as important as the subject . . . it is a continuous process until the moment when my work is in harmony with me."[257] This meant adjusting the field of color until figure and field were inseparable. When that is achieved, the image embodies the text; the visual is imbued with the physical; and Matisse's work is in harmony with him, its first viewer, standing before the picture.

The clarity of Matisse's new vision of painting is a victory of the self. It is autocratic, a matter of fiat. Thus "plastic art will inspire the most direct emotion by the simplest of means."[258] For a complex, perpetually suspended dance of contradictory movements, "three colors . . . blue for the sky, pink for the bodies, green for the hill." Matisse drew it and painted the three colors in. The result, *Dance (II)* (fig. 22), is a quite new order of reality wherein the design of color produces the figural design composing the pictorial rectangle. The concluding picture of the series, *Music* (pl. 126), was more difficult. Intensity of emotion had become equated with intensity of color: for the sky, "the bluest of blues. The surface was covered to saturation, to the point where blue, the idea of absolute blue, was conclusively present. A bright green for the earth and vibrant vermilion for the bodies."[259] Adding paint was like adding emotion—or like directing and controlling emotion.

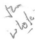

The key was this, he didactically explained: "Notice that the color was proportionate to the form. Form was modified according to the interaction of neighboring colors. The expression came from the colored surface, which struck the spectator as a whole."[260] For *Music*, the process of adjusting the quantities of color was extremely difficult. At times, he did not adjust form as he adjusted color, but drew everything in advance and then carefully filled in the picture with colors appropriate to the size of the compartments they occupied. This process of painting was just as difficult; it became an "all or nothing" process whose result he awaited with increasing anxiety.[261] In either case, for Matisse, unlike the Cubists, form came last; it became "conclusively present" only through color.[262] In *Music*, when the surface was thus composed of color, humanity as such faded into the musicians' elemental drone. No other modern artist convinces us as Matisse does that humanity's displacement in painted color is sufficient compensation.

In these great pictures, with their barest of settings, Matisse strikes a redemptive note. He recalls a mythical past and appeals to us to accept its present reality. His pictorial construction is the form of his appeal. Narrative continuity with the past having been lost for modernism, to paint imperative pictures that gave narration a commanding role (however much the traditional forms of narration must be modified to allow it that role) would be to hope to rejoin modern art to the loftiest products of the Western tradition. To make unquestionably modern paintings, but works that invite our reading as traditional history paintings did, and to give them subjects that tell of ancestry, was to suggest a sense of the wholeness of past and present as expressed in one unified history. The theme of remembrance is placed at the center of our reading of these works; the vividness of its realization makes the distant seem near and the past genuinely new. We have seen nothing quite like what Matisse shows us, yet it is familiar to us and we recognize it.

The acquisition of history, moreover, by joining the artist (and the viewers of his art) to the world of preexisting conventions, suggests reconciliation of the private and public realms. The great public themes of our common culture may be experienced privately. Thus public, historical "authority" may be personally regained. Matisse does not come out and say this, of course. To do so would require the old authoritarianism of allegory. Matisse's art is indeed imperious, because its means are so uncompromising. And yet it commands active participation rather than simple assent. It allows variety of response because, although of deeply personal motivation, it will not impose any sort of personal attitude on us.[263] *Music* seems nominally bereft of human interest because Matisse shows no interest in anything except his art. His chilling objectivity is that of other great artists. All that he will actually tell us in *Bathers with a Turtle* is what Shakespeare tells us in *Timon*: "I have, in this rough work, shap'd out a man." And he will say no more. His inspiration advances, "moves itself / In a wide sea of wax . . . Leaving no tract behind."

Of course, there are occasions on which Matisse's imperiousness can seem a trifle condescending, especially when it descends to the less exalted subject of the real, external world. Thus, while *Algerian Woman* of 1909 (pl. 116) is a marvel of fiercely required structure—the vivid patterning of costume and setting seems simply demanded by the means of its painting—the contemporaneous *Spanish Woman with a Tambourine* (pl. 115) is almost an illustration, rather than an embodiment, of Matisse's control; almost a form of picturesque. Again, as in 1903, the costumed figure alerts us to a problem. Here, it is the problem of fully reengaging the external world. *Harmony in Red*, painted the year before, in 1908, had been an imaginative re-creation of the spring-like, maternal interior. But that, surely, was irreconcilable with what Matisse was now attempting. The pendant picture, *Conversation* (pl. 152), makes this evident. It caused him extraordinary trouble, and he probably did not complete it until 1912. It is a picture of alienation: of alienation from the Edenic garden—seen through the window, which looks like a decorative picture of Matisse's making on the wall—and of sexual alienation; Matisse's victory of the self appears to have met with some very stern opposition indeed.

He retreats to the studio. The domestic table transforms to a studio table in the still lifes he painted after *Harmony in Red*. That he can control. In pictures like *Still Life with Blue Tablecloth* of 1908–09 (pl. 114), his presence is compulsively, aggressively asserted in their address to the fixed and often transfixed observer. The observer is faced with an apparently seductive and therefore inviting surface, but a finally impenetrable one, the space it gives onto having been so wrenched about by the artist that it manifests his sole occupancy and his control.[264] Matisse bends, as if in his hands, the vertical patterned plane as it descends, so that it comes to form a horizontal shelf which can

fundtz.

support apparently tangible objects. The whole plane appears to be laminated onto the surface of the picture, or to have been pulled almost away from the surface, a kind of peel, a thick, dense peel. The reality of the illusion is what matters, as in the figure compositions. The horizontal shelf is a materialization of the imagined horizontal ground of those compositions. And the still-life objects it so forcibly thrusts upon our attention—quite different from their presentation in the 1906 still lifes which reimagined pastoral landscapes, like *Still Life with a Geranium* (pl. 79)—are solid, tangible evidence of the rough work of the painter's craft.

Compared with these, the Spanish still lifes of the winter of 1910–11 (pls. 133, 134) are different again. Now it is not the reality of the illusion that is important. Rather, it is the illusion of the reality.[265] In 1908–09, we were asked to believe in the tangible reality of what we were shown. Everything was made proximate to us. A year or so later, everything seems to dissolve. The still-life objects no longer appear to be tangible objects on an area of pattern but, instead, areas of pattern themselves. The dominant controlling idea of the 1908–09 pictures, expressed by the single downward sweep of pattern, has been replaced by an amalgam of separate, counterpointed themes, each identified by its own pattern. The patterns fuse; the separate identities of things are surrendered. The surface has not been overlaid by pattern, but seems to have been *overtaken* by organic pattern, as if by some particularly invasive form of ground cover.

Matisse has, if not surrendered his control, admitted a less autocratic manner of government. No other conclusion appears possible. Wanting to explain what has happened, we reasonably look for outside explanation. It is obvious. In October 1910, having installed *Dance (II)* and *Music* at the Salon d'Automne, he left for Munich and saw a great exhibition of Islamic art, where the Persian miniatures were a particular revelation to him. They offered, for Matisse, a simulacrum of a world that was free from imperious control; the separate spatial pockets that organize their surfaces suggested a more democratic order. Additionally, they offered an alternative to the tradition of Western painting, to the tradition of the past whose authority he had been striving to emulate.

When Matisse returned to Paris from Munich, he found that the clamor of hostile criticism surrounding *Dance (II)* and *Music* had caused his patron, Sergei Shchukin, to cancel his commission of them. The very next day, at this moment of public humiliation, Matisse's father died. It is tempting to view the changes that occurred in Matisse's art also in this light, especially since the changes took him into a more privately enclosed world; the world of the great 1911 paintings of studio interiors and of the 1912–13 paintings of Morocco. Thus, now that the original, ultimate authority was gone, Matisse was finally free to take his place, and therefore was freed from the need to emulate authority. But it is not as simple as this. Matisse was a self-regarding

artist, and therefore likely to be deeply affected by the events of his personal life. But he was also, and this is no contradiction, an extremely impersonal artist: in the sense that the depth of his self-regard made him extremely realistic about the fact that anything purely personal in art would be incomprehensible. "The arts have a development which comes not only from the individual," he said, "but also from a cumulative force, the civilization which precedes us. One cannot do just anything."[266] So, changes in his art (in any art) cannot be explained by reference to biographical events in the way that changes of style by Picasso have been explained by his changes of mistresses. Biographical events are relevant, though, in that the cumulative force of Matisse's art embraced, and interrogated, everything that was personal. Because he was so self-absorbed, the very conditions of living were an essential theme of his art, perhaps its most important theme.[267] It is hard to believe that Oriental art would have had quite the impact on him it did if he had not recognized there a private paradise. For the first time, for Matisse, a private theme finds a specific external correlative.

Oriental art showed Matisse a decorative universe, a cocooned world, the eternally fecund spring he had earlier imagined—but it was distant, vital, sexual, and of course unquestionably external. Because it was non-Western, it was therefore removed from the dangers of the historically "external." Even more important, though, it revealed to Matisse how external reality could be represented without its *seeming* external: it would now be made to resemble internal reality as he had previously imagined it. Persian miniatures, he said, "showed me all the possibilities of my sensations. I could find again in nature what they should be. By its properties this art suggests a larger and truly plastic space. That helped me to get away from intimate painting."[268] A painted interior need not be intimate, domestic; it could become something larger, something expansively external, like nature. "Thus my revelation came from the Orient," he said as late as 1947.[269] It may seem an excessive acknowledgment. But this was a true alternative: one that was reachable as Giotto was not. Matisse's phrase for it—*"véritable éspace plastique"*—describes a true plastic space, a space authentically his own.

Artifice and Reality

The years after Matisse painted the primal *Le bonheur de vivre* witnessed his birth as a modern painter. Or rather, his *rebirth*, through Fauvism, and his subsequent growth as a great modern painter. His greatest works of this period, I have suggested, can be understood in terms of a mythical, biological cycle which begins with the rebirth and renewal of the powers of nature.

There are two halves to the cycle, Northrop Frye tells us. The first half, "the movement from birth to death, spring to

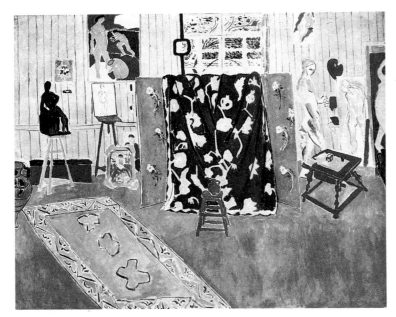

35. *The Pink Studio*. 1911 (pl. 136).

winter, dawn to dark," is what we witnessed in the years through 1910.[270] It began with the pastoral world of Fauvism, entered the primal world of *Le bonheur de vivre*, but soon lost its innocence and grew emotionally more intense in the great figure compositions. This first half of the cycle, says Frye, is that to which, in drama, the tragedy and the history play belong. It is "the basis of the great alliance of nature and reason, the sense of nature as a rational order in which all movement is toward the increasingly predictable." There are surprises, "but the pervading feeling is of something inevitable working itself out." It is a period of hubris and assertion whose inevitable consequence is tragic, because in nature those things count for nothing. Then the second half of the cycle begins.

I ask only that this be kept in mind as the background (or backbone, as Frye has it) of Matisse's development. Not everything can or should be related immediately to it. But I do think that especially the great figure compositions, from the prelapsarian *Le bonheur de vivre* to the uncomfortable, alienated *Music*, gain in appreciation when viewed in this context. And so does what happens next.

The second half of the great cycle moves from death to rebirth, from darkness to a new dawn. In drama, it is the period of the romance. In Matisse's art, it is the period of blatant Orientalism, of the great decorative interiors, of Morocco. In the Spanish still lifes which open this period, we are now shown, I said, the illusion of the reality, whereas in the first half of the cycle we had been shown the reality of the illusion. Throughout this period, things seem mysterious, out of the common order of things. In the romance, Frye says, "the conception of the *same* form of life passing through death to rebirth of course goes outside the order of nature together." This may seem rather far

from Matisse by now. But it is in this period that the characters he had invented in *Le bonheur de vivre* and its succeeding works are revived and reborn—in his studio interiors. For example, in *Goldfish and Sculpture* of 1912 (pl. 153), the now familiar *Reclining Nude (I)* (fig. 8), which we will remember is subtitled *Aurora*, appears as a living presence, a Hermione awoken from a statue. Let us look briefly at one of the pair of great studio pictures Matisse painted in 1911, *The Pink Studio* (fig. 35), and observe more closely what happens.

It is not, finally, as great a picture as *The Red Studio*, but it has been unjustly neglected on that account, considered a more naturalistic work, even a preparatory work. It is neither. It is the first masterpiece of Matisse's newly democratic form of pictorial order: a simultaneous order of separated parts, an order that welcomes us as his earlier pictures did not. Being the first of its kind, it makes it easy for us. It has a fixed place of entrance and exit: the fall of patterned fabric on the screen. But there is no fixed itinerary once inside.

That patterned fabric is arresting in the same way that Matisse's early paintings as a whole had been arresting: it can transfix us. And this painting as a whole is entirely and instantaneously comprehensible from such a viewpoint. However behind the plane defined by the screen, on either side of it, are suspended separate, peripheral points of interest. From a transfixed position we cannot actually experience these as centers of interest, only peripherally as a simultaneous order around the focus of our attention, the way we experience out-of-focus things. To experience them as centers of interest, we must give up our fixed position in front of the picture and imaginatively enter it. Once there, we can engross ourselves in the various incidents in whatever order we happen to encounter them. They compete among themselves for our interest, in part because of the varied perspectival viewpoints on some of them, but mainly because most of them have strong individual identities as represented works of art. Looking is therefore comparing, and means moving from one work of art to the next. Thus we are mobilized by the picture even while we are absorbed in it. The fixity of our viewing position must dissolve. When, finally, we leave the picture, we are encouraged to do so the way we came in.

That fabric hanging on the screen with the wings opened toward us does suggest a doorway. Given the organic pattern of the fabric, the image suggests the entrance to a garden. It also suggests the surface of a decorative painting, the surface of *this* painting. But it does allow that behind the decorative surface is an imaginary zone we can enter, and that its imaginative content will be discovered behind the plane of the screen. And there, lined up along the studio wall, are all the really interesting things, the figurative works of art: a group of fictional characters (we have met them before) living impossibly in a privileged zone, outside the ordinary order of nature, which we can imagine ourselves entering.

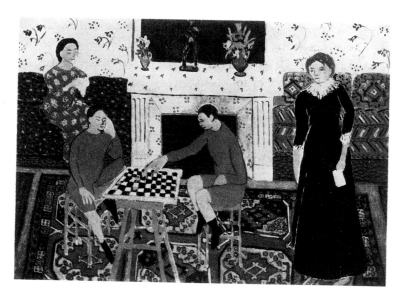

36. *The Painter's Family.* 1911 (pl. 137).

It always takes time, of course, to read a painting. Even with a painting that presents itself instantaneously, we will want to explain that instantaneity to ourselves by returning to it, to examine its parts and hold them in readiness in our mind until they fall back into place and can be perceived instantaneously again.[271] This is what happens, I think, in our viewing of *The Pink Studio*. Usually, though, instantaneity of presentation and pictorial unification go hand in hand. What we see first and what falls back into place afterward is pictorial unity. In Matisse's picture, this is not the case. At first and at last it comprises a simultaneous order of separated parts that *remain* separate. Its only unity is the unity we discover on our temporal journey within it. Its unity is imaginary; we cannot actually see its unity, since we cannot see the parts together as a single unit.

Le bonheur de vivre had been "painted through the juxtaposition of things conceived independently but arranged together," Matisse said, "whereas afterward, I tried to get more unity in my composition."[272] Even his most compulsively unified pictures, however, surrender their unity to our viewing. *Still Life with Blue Tablecloth* (pl. 114), for example, at first a solid, frontal slab, becomes after a while a mobile continuum, a sea of flux. Matisse's experience of Persian miniatures showed him how an effect of visual mobility need not be opposed to an effect of visual unity, but could realize a newly imaginary kind of unity. The miniatures contained multiple areas of different patterning, each one denoting a different pocket of space, which together formed a whole—because the geometric boundaries of each area recalled the boundaries of the whole composition—but a whole that presented itself as decentralized, spatially dislocated, and, most important, constructed. They offered a solution to a problem Matisse had been struggling with since his Cézannist paintings of 1900: how to create a picture that was an articulated construc-

tion of parts, like a body, but that simultaneously opened to a sense of interior space that was not an illusion.

The Painter's Family (fig. 36), which Matisse made immediately after *The Pink Studio*, most clearly shows the influence of Persian miniatures on his art—"reversing Western perspective at a stroke," it has been correctly observed.[273] The patterned spatial pockets clash dissonantly, and our unified experience of the picture is to be found in our experience of its disaccord, not in its formal coherence as a decoratively patterned surface. In reproduction, it may look flat and distanced from us. But it, too, demands that we imaginatively enter it. The means of our access is Western perspective, the single instance of it in the picture: namely, the checkerboard, which welcomes the individual viewer like a patterned pavement in a Renaissance painting. Here, a giantly enlarged hand points it out for us. And entering the picture thus, we are asked to imagine the picture itself as a kind of patterned, compartmented board across which we can travel.

This work is unique in its period in showing us Matisse's family: not a particularly united group, it seems, but one which has nevertheless gathered for the occasion and over which he distantly presides. (A cast of *The Serf*, reduced in size, can be seen on the mantelpiece.) The organically decorated setting creates for them a kind of formal garden, very French with its orderly parterres. Matisse often will place his "reborn" figures, usually in the form of works of figural art, within an imagined nature. The garden-entrance motif in *The Pink Studio* has that function. In paintings of his studio made in the spring and summer of 1912, he juxtaposed floral images drawn from nature and images of figural art, and pondered the transformation of the natural to the artificial in the room dedicated to such transformation. The figural images he used were originally details of *Le bonheur de vivre*. In each of the *Nasturtiums with "Dance"* pictures (pls. 149, 150), he shows us, therefore, a detail of a detail. And the studio he shows it in is a detail of the studio painted as a panorama the previous year. Synecdoche makes possible massive condensation, as art and nature are enjambed. Matisse brings us up close to the Edenic map he is drawing, and we have to wonder why. In *Corner of the Artist's Studio* (pl. 151), the patterned fabric familiar from *The Pink Studio* reappears, but painted in the colors and with the corporeality of *Dance*, as if that figural subject had burst into organic pattern and thereby fused with nature. To reinforce this message, a fragment of *Le luxe (II)*, echoing the shape of a nearby repeated flower, is shown in the top left corner.

The complexity of meanings thus produced by interpenetrating forms and levels of reality is, quite literally, incredible. Such things do not happen in the natural world. And yet we are impressed by the illusion that they do; that this cannot be happening, but is. But we are also impressed for other reasons. In the first place, that this impossible form of nature is the creation of special circumstances, of willed circumstances; that it

is forced into existence in the work and artifice of painting, and does not emerge helplessly, as images associate impossibly in dreams.[274] And in the second place, that the force creating all this, though willful, draws it from within predictable reality and does not impose it from outside; the force itself seems deeply rooted in reality and fully capable of entirely taking over the predictable world from within.

It does. The figure paintings Matisse made in Morocco in 1912–13 are simultaneously representations of ordinary external reality and representations of an incredible world. Morocco, the "Oriental" site itself, afforded the very special circumstances for this to happen. And once it did happen, the polarized forms of expression characterizing the two halves of the mythic natural cycle simply collapsed. Faced by *Zorah Standing* (pl. 160), for example, it seems no longer relevant to ask whether this incredible figure did or did not exist in the real world. It is wonderfully simple: Matisse travels to an incredible place and records it. Travelers are always bringing home wonders, incredible but real.[275]

The hotel rooms and apartments of Nice—from the Beau-Rivage and the Méditerranée to the Régina (where Queen Victoria had stayed) and the appropriately named villa Le Rêve—would be even better than Morocco. Matisse could construct the incredible himself. There, the fictional characters he had been painting would be truly reborn in realistic enough form. *Zorah Standing* is both incredible and real because of how the figure is costumed. Earlier costumed figures Matisse painted had suggested, in 1903, problems of artistic identity and, in 1909, problems of contact with external reality. His Moroccan costumed figures make a virtue of their confusion of identity and their confusion of what constitutes external reality. In Nice, as we have seen, not only the figures Matisse painted but also the very form of his painting rejoiced in the feints and ambiguities of an essentially theatrical world. Thus what happened when Matisse moved to Nice in the winter of 1917–18 was continuous with what happened in Morocco in 1912 and 1913. But what of the five years between?

The Methods of Modern Construction

What happens is mysterious. It is almost as if the Matisse we know drops out of sight, disappears and returns five years later. The works of this period are so "un-Matissean": dark, somber, and ungraceful. Alfred Barr described it as a period of "austerity and abstract experiment."[276] This catches the note of frantic search and the effect of formal difficulty that characterize his work at the time. But it hardly prepares us for the extraordinary authority of the work.

The reasonable suggestion, often heard, that Matisse, now returning to live part of the time within Paris, confronts Cubism

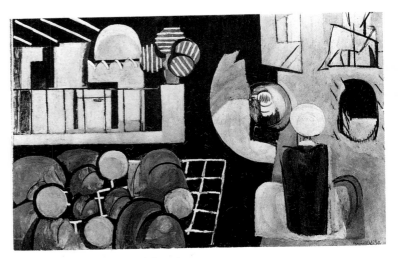

37. *The Moroccans*. 1915–16 (pl. 192)

in this period, supports the idea of experimentation. Still, I think we will want to know why Matisse put himself in a position to confront Cubism, and will want a better explanation than competition with Picasso to understand the result. After all, a wary give-and-take had been happily continuing for quite a while. By 1910, both were painting very forcibly expanded pictures, taut as a drumhead; stylistically very different, of course, but equally decentralized and conceived on the surface. In 1911, Matisse's pictures of juxtaposed rectangular patterns explored an area not entirely dissimilar to that which collage would begin to explore the following year. We know that Picasso's collages and collage-like pictures interested Matisse, as did Juan Gris's, when he settled into this period's work.[277] But direct confrontation with Cubism seems to be more the result than the cause of the major overhaul of his work that Matisse carried out during these years.

World War I has been offered as an explanation. I do think it is unquestionable that his works in this period reflect the anxieties of their time. But it would be inaccurate to say that they show he shared these anxieties. He did as a man, we know.[278] His paintings, however, if they embody anxiety, embody it independently of its source; his paintings are not "dated" by it. And I remain unconvinced that the use of distortion and somber colors offers evidence enough to speak of anxiety at all. Matisse would spend World War II painting society ladies, ballerinas, and similarly unanxious subjects. I can imagine an argument that sees these as a reaction *against* the anxiety of war. But I would not believe that argument, either.

Having swept art-historical and social influences out of the interpretive parlor, what are we left with? With the question: Is this Matisse recognizable as the artist we know? And if so, which earlier Matisse does he most resemble?

I do think we have seen a similar artist, a painter of similarly fierce ambition producing pictures of similarly fierce and unsettling intensity. It is the artist we left in 1910 at the end of the first half of the mythic cycle I described earlier. And we know that

this is the artist we are looking for because the mysterious period opens with Matisse picking up again important projects left unfinished earlier, and which he can close once he has dealt with them to his satisfaction. I am thinking of the *Back* sculptures, the second and third of which date to 1913 and 1916 (pls. 167, 191), and the third panel originally meant to accompany *Dance* and *Music*, which Matisse took up again in 1913 and completed in 1916 as *Bathers by a River* (fig. 38).[279] There are other indications of the continuity of the two periods, including: Matisse's creation in 1916 of another great imaginary figure composition, *The Moroccans* (fig. 37); his preoccupation with rough-hewn figural representation; his obsessive painterly adjustments to get the correct quantities of color in a picture; and the very bleak, impersonal interest of these utterly objective works. The point, in short, is that Matisse has turned back the cycle. He had unfinished business to address. In saying this, I do not only mean that he had left something unfinished which he needed to continue with. I mean something else as well.

For all the dissonance that has been unleashed on us by modern art, we remain uncomfortable with the idea that art can become not just dissonant but incoherent. We look for unity in a successful work and, of course, we find it there. The reason is not difficult to discover. The very notion of unity is an organic one; Matisse's association of unity with the human body only confirms what we already know, or believe: namely, that we ourselves are unified and coherent beings.

It may be objected, I realize, that modern works of art simply, or not so simply, offer a new kind of coherence. This argument has the merit of not separating modern from earlier work, and I should make it clear that I am not arguing their separation. What I am proposing, though, is that if we approach Matisse's art—especially his art of this most crucial period—with the preconception of its unity, we will miss much that is essential to it. Indeed, we will be unable to fathom some of its most obvious characteristics: for example, the self-evident inconsistency of his development in this period. But neither will we be able to fathom his art if we approach it with a preconception of its disunity. Both approaches are too crude. We need something more precisely adapted to the means of meaning in Matisse's art.

I want to consider three key characteristics, or formal devices, of his art of the period 1913–17, which also are important for his art as a whole and what I have just been saying about it. I borrow their names from the criticism of literary works. The first formal device I will discuss is *caesura:* Matisse's tendency to create compositional breaks within his pictures, separating the elements they enclose. The second is *aporia:* his real, or pretended, uncertainty about what he is doing; by extension, the subversion of logic his pictures contain. The third and final device is *ellipsis:* his tendency to leave out of his pictures things we might reasonably expect to find there.

First, caesura. This is not a new subject to us. We have seen

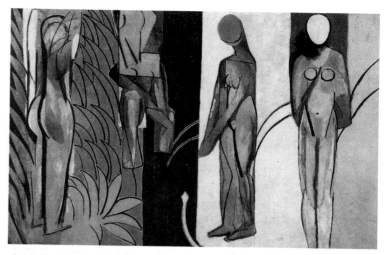

38. *Bathers by a River.* 1909–16 (pl. 193).

many instances of Matisse's compositional breaks: detailed ones, as with the imperfect articulation of his Cézannist paintings of 1900, and more generalized ones, as with the open, decomposed structure of the Nice-period paintings. The spatial-cell structure of Oriental art, as Matisse used it, was formed by compositional breaks. While the mythic form of a picture like *The Moroccans* of 1916 (fig. 37) is a return to that of *Music* of 1909–10 (pl. 126), and the isolation of elements in these works is analogous, the later picture unquestionably partakes of the spatial-cell structure. Thus we look at its separated parts as dislocated in space as well as on the surface.

What separates also joins. This is why the unity/disunity polarity is too crude. Barr described the three sections of *The Moroccans*—Moroccan men at the right, leafy melons to the left, architecture above the melons—as three movements of a symphony.[280] His description reminds us of the temporality of our viewing. Matisse's breaks suspend things in the flux of time. As Henri Bergson, a philosopher Matisse admired, wrote of separated temporal incidents within "duration": "Discontinuous though they may appear . . . they stand out against the continuity of a background on which they are designed, and to which indeed they owe the intervals that separate them." Each of Matisse's separated parts is likewise "only the best-illuminated point of a moving zone . . . which in reality makes up our state."[281]

Bergson's metaphor of visibility is a very apt one for a picture like *The Moroccans*. Its connecting, and separating, tissue is impenetrably dark to our vision. In the 1913–17 period Matisse used a great deal of black. He once said it was "a force," and that he depended on it "to simplify the construction."[282] But then he added that the black of *The Moroccans* was "a grand black which is as luminous as the other colors in the painting." Thus, it *produces* a kind of light; only we cannot see into it. He used black on occasion outside this period to fulfill the dual functions of separating and connecting, and also of preventing seeing and pro-

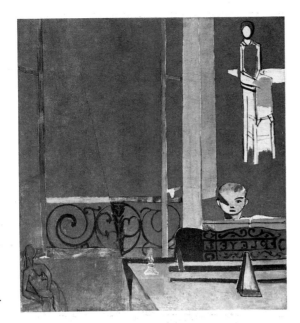

39. *Piano Lesson.*
1916 (pl. 188).

ducing luminosity. We have noticed how the pages of books in Matisse's paintings are often black, or blank. In a great 1939 painting of a woman reading (pl. 321), a black mirror reflects back its luminosity, and we see that the surfaces of Matisse's paintings, insofar as they produce rather than imitate light, are akin to mirrors. However, the fields of color that suspend separated incidents are more frequently red; sometimes very deep blue. Important examples are, of course, *The Red Studio* of 1911 (pl. 146) and *Large Red Interior* of 1948 (pl. 387) and others in that magnificent series of interiors at Vence. With the paper cutouts, Matisse usually composed on a white ground.

Black, red, deep blue, and white present themselves as extreme, namable, artificial colors whose signifying relationship to the natural world is likely to be a symbolic one. Mixed, less readily namable hues appear to be more naturalistic—virtually indexical signs in recording effects of light or climate on natural things. The colors Matisse favored for grounds do not seem acted on in this way. They seem to be out of external nature, inside. Black prevents seeing. White, as in the white paper of a drawing, does not signify. Red both opposes its naturalistic contrast, green, and (as we noticed with *Harmony in Red*) connotes the interior of the body. Blue is more difficult because it connotes sky or water, but very deep blue opposes light-evoking orange and becomes the twilight prior to dark. What separates, and connects, is that which is not in external nature—that which the light of the natural world cannot enter but which is itself luminous. Throughout his work, that which separates and connects does not receive light but gives light. His paintings are not windows onto an external nature. They are not windows through which light passes, but mirrors that return light, and with it a transformed nature. Matisse thought of his paintings as emitting a beneficent radiation.[283] Their glow is that of a lumi-

nous space having the substantial reality of the objects it contains. The whole plane of a picture is invaded by their tangibility, and all is luminous substance.

The *Jeannette* sculpture series is ended when Matisse allows invasion of the whole by the parts he had separated from it. In the great full-length portraits of this period (pls. 171, 198), the figure is as wholly identified with the pictorial rectangle as in the contemporaneous *Back* sculptures (pls. 167, 191), but in both cases has to be dismembered in the process. Matisse is ruthless in his dissection of the body. The *Backs* are hacked and chiseled into parts. In the paintings, space invades and dislocates bodies. In *The Italian Woman* (pl. 200), the surface itself dislocates, forming two distinct skins, one of which drapes over the model's shoulder like a shawl. *White and Pink Head* (pl. 180) is a fretwork of crudely abutted parts. All make use of what Matisse somewhat coyly described (referring to his still life after de Heem, pl. 182) as "the methods of modern construction."[284] He did not simply mean Cubism, although what he meant included that. He meant modern order, which could be disorder.

This leads me to the second formal device I want to discuss, aporia. For all Matisse's formal command in this period, he also appears to be uncertain about the subjects he addresses. One of the reasons for employing the device of caesura in details of a picture is that he seems uncertain about what he wants to realize. Thus parts are left uncombined. And thus toward the end of this period he paints more than fifty pictures of the model Lorette, as if uncertain which one constitutes her true image. He becomes a kind of Hamlet of painting.

This comparison dissolves, though, in the very recklessness with which Matisse's uncertainty manifests itself. Each picture is unsure of its outcome. But he keeps plunging back into uncertainty and paints his most dissimilar pictures in this period. Sometimes they are pairs of pictures in more naturalistic and more abstract modes: for example, the two versions of *Notre-Dame* in 1914 (pls. 176, 177); the two Pellerin portraits in 1916–17 (see fig. 43); *Piano Lesson* in 1916 (fig. 39) and *The Music Lesson* in 1917. More often, though, they are alternative versions of the same subject, as in the Lorette pictures notably, or alternative approaches to varied subjects, all of which supersede the polarities of the naturalistic and the abstract. After this period, they are polarities no more. Matisse will continue to paint different versions of the same subject, but never again opposed naturalistic and abstract versions. The distinction dissolves because the gap between what is seen and what is painted is now permanently kept open. One of the returns of this period is that Matisse reenacts the fall from innocence of realistic representation. He confirms for himself that meaning can be produced only in the material of painting. Thus, each painting is an individual struggle, uncertain of its outcome, to a far greater extent than ever before. He is a prisoner of painting and will never escape except by abandoning painting at the very end.

Consequently, the two-part process of the pre-1913 paintings, where color was applied to a preconceived framework of drawing, disappears. Matisse will often, it seems, begin with a drawn framework. But almost inevitably it cedes to the process of color adjustment and color transposition. Drawing will reemerge, but now indivisible from the manipulation of areas of paint. The process of painting creates containers of colored and drawn signs. The most astonishing things can happen in this process. A painting of a shy young woman, Yvonne Landsberg (pl. 171), will transform into a bursting centrifugal image that resembles not so much the Futurist pictures to which it has been tediously compared but more a regal Elizabethan portrait such as a Bettes or a Gheeraerts might have painted: a modern, troubled icon of Gloriana.

Matisse no longer represents postures: he does things to the body. In this respect, he reengages Cézanne. His reciprocation of color and drawing—of coloristic plasticity and sculptural plasticity—in the process of painting is Cézannist. And yet, the result is often a field of isolated signs that Cézanne would have found incomprehensible. Matisse achieves the most radical forms of contraction. Drawn contours are under immense pressure from each side. When they contain images—as for example in *The Blue Window* of 1913 (pl. 165) and *Gourds* of 1916 (pl. 184)—these images have extraordinary density. They swell and they are imploded. Their visual mass evokes the sculptural and yet they are coexistent with the surface, unimaginable away from it. The whole surface is dense with clues of tactile experience. This is partly the result of the pressure imposed on contours. And it is partly the result of the most evident form of Matisse's aporia, his letting the uncertain work of painting so plainly show.

In this respect, *Piano Lesson* (fig. 39) is an exemplary picture: not only for the signs of its working but also for the gloss on the process provided by the subject. The incomplete, austere image at the top right—a representation of a recent representation, the 1914 *Woman on a High Stool* (pl. 170)—is an aloof supervisor of a lesson that takes place under duress.[285] Just in case we miss the point, Matisse diagonally opposes the work supervisor with an image of now impossible leisure—another representation of a representation, this time an earlier one: the most sexual of all his sculptures, the 1908 *Decorative Figure* (pl. 106). Additionally, he rhymes the wedge of shadow on the pupil's face with the metronome that holds him captive in time. We have seen the face of the pupil before, in *Luxe, calme et volupté* and other works. Matisse imagines himself practicing under duress. His work isolates him from the world of sensual pleasure. However, it does recover one aspect of that earlier, primal world: the aspect of privacy.

A painting is not finished and given over; it is still held by Matisse, not yet released from his work. Later, he would cultivate an "apparent facility" to hide his efforts and thus maintain the privacy of his creation.[286] Now he lets his labor show. Nevertheless, the mark of his hand that scumbles and scratches at the

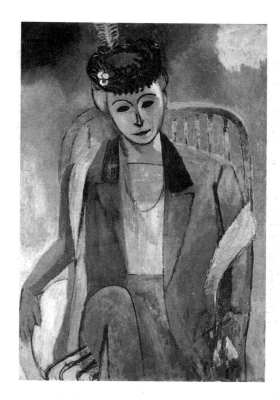

40. *Portrait of Mme Matisse*. 1913 (pl. 168).

surface of a painting affirms his presence there as a highly personalized one, engaged in essentially private work. He is building things so privately conceived that apparently even he cannot quite understand what he is doing. The apotheosis of this aspect of the period's work takes the form of four studio visits he lets us make to no. 19, quai Saint-Michel. In the first painting, he has not yet begun work (pl. 169). The subject, a goldfish bowl, is distant and the surface relatively intact. In the second, however, the same subject is thrust before us, scarred by the work of painting, and we intuit but hardly can see the painter, bound up in the means of his making, at the right (pl. 179). The third painting reveals the painter to us, but in a curious disguise: partly a wooden studio figure, partly a figure from one of his own paintings (the recently completed *Bathers*) who has come inside and picked up a palette, but does nothing (pl. 204). I am allegorizing, of course, although the picture does not require it. But I think it is unquestionable that it shows a moment of incompletion, of immobilizing doubt in the process of painterly work. The final painting illustrates incompletion: in the unfinished canvas, propped on a chair, and in the three wraith-like canvases that seem to hover on the wall above the sleeping, sensual model. The painter is absent again; the not-yet-completed work of painting awaits his return. To stand before this picture is to participate in the waiting it describes (pl. 206).

This discussion must recall what I said earlier about Matisse's Fauve canvases. The artist battles with ideology—in this case, modern construction—by battling both with preconception and with finish. The not-yet-completed canvas allows

41. Jean-Auguste-Dominique Ingres. *Louis-François Bertin*. 1832. Oil on canvas, 45¾ × 37⅜″ (116.2 × 94.9 cm). Musée du Louvre, Paris.

42. Paul Cézanne in his studio at Aix-en-Provence in front of his *Large Bathers* (now in The Barnes Foundation, Merion Station, Pennsylvania). 1904. Photograph by Émile Bernard (detail).

43. *Portrait of Auguste Pellerin (II)*. 1917 (pl. 199).

access to an instinctual state preexisting the authority with which he battles. He thus opposes idealism with instrumentality. Except here, despite the unfinish, instrumentality is claimed and with it the potential of newly created authority. Matisse breaks apart the figure to remake it, painfully patching it together in plausible, potential wholes—creating figures that corporealize the spaces they occupy and that, for all their austerity, regain as if under sufferance a sensuality easily missed because it is a kind we have never seen before.

Apollinaire seems incomprehensible when he describes the 1913 *Portrait of Mme Matisse* (fig. 40) as "the most voluptuous painting that has been done in a long time," and simply mad when he compares it to "the magnificent and carnal paintings of the aged Renoir."[287] And yet what Matisse shows us, I think, is what is inevitably carnal even if unapproachable in this penitential moment: the very physicality of the body. Requiring over one hundred sittings,[288] the painting presents itself to us as manifestly corporeal; the surface was worked and molded and scratched until its own physicality replaced that of the sitter, who apparently wept for the disappearance of the naturalistic image that comprised its early state.[289] Its formation renounces the sensuality of the subject, to produce what can seem to be a masked image, but also reminds us of that sensuality in the delicate beauty of the carefully redrawn contours and flashes of limpid color. The picture thus reminds us that Eros is a condition, not a desire; that it persists even in the absence of desire; that even when desire is forbidden or unrewarded, carnality

endures and must be endured. The period opened by this extraordinary portrait presents itself as a Lenten period of renunciation, whose traditional purpose was to recognize and exorcise the principle of sterility. The period appropriately is closed, therefore, by the rebirth of fertility, in the long series of paintings of Lorette, which lead naturally to the fecund images of Nice. But I am getting ahead of myself.

The third and final formal device I want to discuss, ellipsis, has already made its appearance. Caesura occurs because things are omitted. Aporia does not allow for completion. Ellipsis straddles these two other devices. However, it has its own distinct characteristics. The most important is that it allows the viewer to bridge the gap of caesura, and encourages the viewer to discover what aporia is too uncertain to say. Thus we take up the work of finishing that Matisse leaves undone. The work, the painting, acquires completion in our viewing.

This is not, in principle, unusual in modern painting, or in earlier painting either. What is, though, is the extent to which we are enrolled in the act of rebuilding, in the viewing of Matisse's paintings of this period. Matisse shows us an area of internal privacy which, in the great compositions particularly, is specified as distant, a place where unities have fallen apart and whose only coherence is a black vacuum into which we cannot see. A picture like *The Moroccans* (fig. 37) or *Bathers by a River* (fig. 38) is coherent enough, seen purely on the surface; the viewer's eye will slide over it. But once drawn within it, we bump into its disconnected parts as if in a dark room.[290]

Then rebuilding begins. The blackness of *The Moroccans* is that of an internal space under extraordinary compression; the pressure it exerts is directed outward. While at first—fascinated by the incident the picture contains—we are drawn into its interior, where we experience its disunity, we then find ourselves ousted from it, for the surface proves to be impenetrable. The internal space, which logically should retreat, instead forces itself forward. The picture, we see, is a solid block, whose bodily mass pushes toward us. And the three, separated zones of the picture, we also see, seem to float at different spatial levels on top of this massive rectangle. The picture appears to yawn open, its enormous planes ready to slide apart. Instead, now, of being drawn into the painting, the opposite happens: the painting appears capable of engulfing us.

We see now that the purpose of Matisse's ellipsis, which keeps the parts of a picture disengaged from each other, is to allow us to imagine them moving. We also see now that these parts are all shallow slices of reality—signs—arranged spatially parallel to each other and to the picture plane. This arrangement is imminent with movement. *Bathers by a River* seems at first sight to be a pure surface construction of *abutted* planes. But here again, these planes can be imagined as the surface manifestations of advancing internal space. In this case, it is as if something originally pleated had been pulled taut, opened and expanded until the very depth within its concertina folds is stretched out before us, pushing toward us the human presences that resided there.

The Privacy of Painting

Matisse thus asks our help to rebuild. He shows us a primal, unseeable space from which, with our help, a potential unity may emerge. In saying this, I allude again, and for the last time, to the theme of paternal emulation. For in returning, in the 1913–17 period, to the mythic themes he had left in 1910, Matisse returns to that theme too. Before it could be put to rest, at this belated, deferred moment, a likeness of the stern businessman from Bohain had actually to be painted. A commission late in 1916 accidentally offered the opportunity. It was unneeded; completed in a somewhat cavalier fashion; and then the painting was refused. The sitter, Auguste Pellerin, was a powerful industrialist and also a great collector; he had the largest collection in France of the works of Cézanne. Matisse did what he had never done before with a portrait commission: he offered to make a second version.[291] The picture that resulted (fig. 43) is the equivalent for Matisse to what the portrait of Bertin (fig. 41) was for Ingres, "a belated attempt to repair and reconstruct the father"[292]—in Matisse's case, both the father from Bohain and

also, of course, Cézanne, whom Pellerin is actually made somewhat to resemble in Matisse's representation of him (fig. 42).[293] As with Ingres's portrait, the first impression of Matisse's is of uncompromising, rigid power. The second is of a figure stirring into life: a human figure, not merely a masked, inaccessible one. The stern face softens as it floats toward us welcomingly. We look back at it as its first viewer did, as in a mirror.

What happens next is entirely logical. The second Pellerin portrait was completed in May 1917. That summer, Matisse gathered his family around him and painted them freely in quiet relaxation in a picture titled *Music Lesson* (see page 241), utterly different from the cacophonous *Painter's Family* (fig. 36) done six years before. This first image of familial contentment was, however, the last. And even here, there is a note of estrangement. Mme Matisse is expelled, and sits outside. And above her, dwarfing her, is an image so massive that it advances into the interior space: an enormously enlarged version of the 1907 sculpture whose pose had always signified *luxuria*. Before the year was out, Matisse had moved to Nice, where that image would be replicated in a multitude of forms for the remainder of his life.

This should not end, though, on a biographical note. If we willingly join Matisse in his work of rebuilding, it is surely because his *paintings* interest us. And what he attempts to repair and reconstruct in the difficult years before his move to Nice is the art of painting itself. This would remain his aim. At Nice, it meant turning at first to a form of naturalism. The momentum of the avant-garde as a whole seemed to be faltering; to conserve painting, Matisse had to save his own painting from avant-garde mannerisms. And if it required a more conservative form of painting to do so, then this conservative form would do cleverly and covertly what before had been done boldly and openly. And thus it would be possible, eventually, to go back to and develop an earlier, more radical form. Indeed, what happened after 1930 was yet another return to the methods and themes of Matisse's most fiercely ambitious moment, twenty years earlier. His reprising *Dance* for the Barnes Foundation mural (pl. 291) is only the most obvious evidence of this.[294] As we have seen, his recovery of the most radical element of his painting, the independent reality of color, led him eventually beyond painting. But he altered painting so decisively in the process that our experience of *any* painting must be affected by what he achieved.

And he also renewed its most traditional claims: to connect us to the whole body of the world; to project the immediacy of experience; to do what only painting can do. Matisse's art was indeed the product of intensely private imperatives. But he saw that in painting itself, a private life is impossible; that the meaning of his paintings was to be found in the privacy others could discover there. This was a luxury to be shared.

Notes to the Text

Wherever possible, references for quotations from Matisse and from early writings on his work are made not only to the original sources but also to the following, more easily accessible anthologies, which are herein cited in abbreviated form. It should be noted, however, that at times the anthologies reprint only excerpts from the original sources and that on occasion their translations have been modified in the present text.

FOURCADE 1972 Dominique Fourcade, ed., *Henri Matisse: Écrits et propos sur l'art* (Paris: Hermann, 1972).

FLAM 1973 Jack D. Flam, ed., *Matisse on Art* (New York: Phaidon, 1973; rpt., New York: Dutton, 1978).

FLAM 1988 Jack Flam, ed., *Matisse: A Retrospective* (New York: Levin, 1988).

1. Christian Zervos, "Notes sur la formation et le développement de l'oeuvre de Henri-Matisse," *Cahiers d'art*, vol. 6, no. 5 (1931), p. 9; trans. Flam 1988, p. 269.

2. Jacques Guenne, "Entretien avec Henri Matisse," *L'art vivant*, vol. 1, no. 18 (September 15, 1925), p. 4; in Fourcade 1972, p. 81; trans. Flam 1973, p. 54.

3. This perhaps most essential innovation of Matisse's work is the principal subject of Lawrence Gowing's *Matisse* (New York and Toronto: Oxford University Press, 1979); see especially p. 59.

4. Letter to Bonnard, May 7, 1946, in *Bonnard–Matisse Correspondance, 1925–1946*, ed. Jean Clair (Paris: Gallimard, 1991), p. 127; in Fourcade 1972, p. 49, n. 15.

5. See the Bibliographical Note in the present volume for a summary of the literature on Matisse.

6. Thus, for example, Yve-Alain Bois, in his "Matisse and 'Arche-drawing,'" in *Painting as Model* (Cambridge, Mass., and London: MIT Press, 1990), p. 268, n. 59, takes the "periodization current in Matisse criticism" to reflect a consensus as to the "discontinuity" of Matisse's oeuvre, which allows him to exclude the Nice period from his broad theoretical study of the artist. He does acknowledge "the necessity of not neglecting this period in Matisse's oeuvre," but still subscribes to "the common idea of a certain slackening and of a 'return to order'" in this period. The 1987 exhibition "Henri Matisse: The Early Years in Nice, 1916–1930" at the National Gallery of Art, Washington, D.C., has apparently not convinced those interested in Matisse that nominally "conservative" paintings can, in fact, be as satisfying, and as adventurous, as nominally "advanced" ones; but that is a prejudice that affects other artists, too. Conversely, the relative neglect of Matisse's painting of the 1930s and 1940s, to give the most obvious example of another under-appreciated period of his work, is simply due to the fact that these paintings have not so often been seen, especially of late.

7. Roger Marx, Preface to *Exposition des oeuvres du peintre Henri Matisse* (Paris: Galerie Vollard, June 1–18, 1904), p. 4; trans. Flam 1988, p. 44.

8. Pierre Courthion, *Henri-Matisse* (Paris: Rieder, 1934), p. 51; trans. Flam 1988, p. 300.

9. Norman Bryson, "Signs of the Good Life," *The Times Literary Supplement*, no. 4382 (March 27, 1987), p. 328. The ubiquity of this idea, and the erotic associations that attach to it, are exemplified by an advertisement for a 1987 lecture on Matisse at a major New York museum, which informed us: "Matisse was one of the all-time great seducers." I quoted this in my "Matisse: Myth vs. Man," *Art in America*, vol. 75, no. 4 (April 1987), pp. 13–21, and by a wonderful coincidence, I

presume, an advertisement for the Mayor gallery in London facing the opening page of this article illustrated Tom Wesselmann's *Great American Nude No. 29* of 1962, an interior which represents, in addition to the eponymous nude and sundry consumer products, Matisse's painting *The Rumanian Blouse* of 1939–40 (pl. 328).

10. See Norman Bryson, *Word and Image: French Painting of the Ancien Régime* (Cambridge and London: Cambridge University Press, 1983), p. 67, for a discussion of Watteau which will be instructive to anyone interested also in Matisse. Since I cite Bryson's article on Matisse, "Signs of the Good Life" (note 9, above), as an example of what I believe to be a mistaken view of the artist, I am pleased to be able to acknowledge here how fascinating I have found his writing on earlier artists.

11. James D. Herbert, "Matisse Without History," *Art History*, vol. 11, no. 2 (June 1988), pp. 301–02. Herbert's general point is well taken. However, he fails to address the fact that Matisse himself spoke of his art as transcendental in purpose. The crucial difficulty here is to acknowledge Matisse's own understanding of his art while separating it from the broader transcendental ideology of modernism to which it contributed. I remain to be convinced, therefore, of the socially contextual view of the artist Herbert apparently recommends.

12. Clement Greenberg, *Henri Matisse (1869–)* (New York: Abrams; Pocket Books, 1953), n.p., quoted in John O'Brian, "Greenberg's Matisse and the Problem of Avant-Garde Hedonism," in Serge Guilbaut, ed., *Reconstructing Modernism: Art in New York, Paris, and Montreal, 1945–1964* (Cambridge, Mass., and London: MIT Press, 1990), pp. 159, 165.

13. Clive Bell, "Matisse and Picasso: The Two Immediate Heirs to Cézanne," *Arts and Decoration*, vol. 14, no. 1 (November 1920), p. 44; in Flam 1988, p. 195.

14. Greenberg, *Henri Matisse*, n.p., quoted in O'Brian, "Greenberg's Matisse" (note 12, above), p. 165.

As we shall see, this "formalist" understanding of Matisse, although founded on very early writings on the artist, did not begin to grow in importance until after his so-called Nice period of the 1920s. This form of interpretation was institutionalized by the publication of Alfred H. Barr, Jr.'s *Matisse: His Art and His Public* (New York: The Museum of Modern Art, 1951). Only in the 1970s did its prestige begin to decline.

15. Gowing, *Matisse* (note 3, above), pp. 56, 93.

16. While the iconographical and iconological aspects of Matisse's art were not ignored in earlier criticism of his art, they began to attract broader attention only around 1970. They are integral to Gowing's *Matisse, 1869–1954* (London: Arts Council of Great Britain, 1968), which rehearsed many of the themes of his 1979 book—often wrongly considered to be a purely formalist study—but their main advocate has been Pierre Schneider, whose book *Matisse* (New York: Rizzoli, 1984) took the motif of the Golden Age as its main theme.

17. Gowing, *Matisse*, p. 93.

18. See, for example, Matisse, "Notes d'un peintre," Introduction by George Desvallières, *La grande revue* (December 25, 1908), pp. 733–34; in Fourcade 1972, p. 42; trans. Flam 1973, p. 36.

19. The principal study of Matisse to date to stress the biographical connotations of his work is Jack Flam's *Matisse: The Man and His Art, 1869–1918* (Ithaca, N.Y., and London: Cornell University Press, 1986). I compare Flam's and Schneider's approaches to the artist in my "Matisse: Myth vs. Man" (note 9, above).

20. For example Charles Morice, "Art moderne," *Mercure de France* (August 1904), pp. 530–34; trans. Flam 1988, pp. 44–45.

21. Louis Vauxcelles, "Le Salon des indépendants," *Gil Blas* (March 23, 1905); trans. Flam 1988, pp. 45–46.

22. André Gide, "Promenade au Salon d'Automne," *Gazette des beaux-arts*, vol. 34, no. 582 (December 1, 1905), p. 483; trans. Flam 1988, p. 50.

23. Maurice Denis, "La peinture," *L'Ermitage* (November 15, 1905); trans. Flam 1988, p. 48, and for the following quotations, pp. 47–48.

24. Leo Stein, *Appreciation: Painting, Poetry, and Prose* (New York: Crown, 1947), p. 158.

25. Michel Puy, *L'effort des peintres modernes* (Paris: Albert Messein, 1933), p. 62.

26. Gelett Burgess, "The Wild Men of Paris," *The Architectural Record*, vol. 27 (May 1910), p. 402; in Flam 1988, p. 119.

27. Matisse, "Notes d'un peintre" (1908; note 18, above), pp. 741–42; in Fourcade 1972, p. 50; trans. Flam 1973, p. 38.

28. Lionel Trilling, "The Fate of Pleasure: Wordsworth to Dostoevsky," in Northrop Frye, ed., *Romanticism Reconsidered* (New York: Columbia University Press, 1963), p. 85.

29. Charles Estienne, "Des tendances de la peinture moderne: Entretien avec M. Henri-Matisse," *Les nouvelles* (April 12, 1909), p. 4; in Fourcade 1972, p. 61; trans. Flam 1973, p. 48.

30. Ibid.

31. See W. J. T. Mitchell, *Iconology: Image, Text, Ideology* (Chicago and London: University of Chicago Press, 1987), p. 43. I am indebted to Mitchell's important book for what I have to say, here and elsewhere, about the relationship of image and text in Matisse's art.

32. E. H. Gombrich thus describes Alberti's account in the *Ten Books on Architecture* of the therapeutic possibilities of pastoral decorations; *Norm and Form: Studies in the Art of the Renaissance* (Chicago: University of Chicago Press, 1966; rpt. 1985), p. 114. Alberti also recommended the *practice* of painting for its therapeutic qualities, saying he would turn to it "when I am tired of more pressing affairs"; *On Painting*, ed. John R. Spencer (New Haven, Conn., and London: Yale University Press, 1966), p. 67.

For discussion of how the pastoral entered into recent discussion of Matisse, see O'Brian, "Greenberg's Matisse" (note 12, above), pp. 145–51. And for an alternative historical reading of Matisse's statement, in the context of the decorative arts, see Joseph Masheck, "The Carpet Paradigm: Critical Prolegomena to a Theory of Flatness," *Arts Magazine*, vol. 51, no. 1 (September 1976), pp. 82–109.

"Notes of a Painter" has been studied for its Neo-Impressionist sources in Catherine C. Bock, *Henri Matisse and Neo-Impressionism, 1898–1908* (Ann Arbor, Mich.: UMI Research Press, 1981), pp. 100–08. It is also the principal subject of the extremely useful book by Roger Benjamin, *Matisse's "Notes of a Painter": Criticism, Theory, and Context, 1891–1908* (Ann Arbor, Mich.: UMI Research Press, 1987).

33. Charles Morice, "Art moderne" (November 1, 1908); trans. Flam 1988, p. 73, and for the following quotation, p. 75.

34. For example, in Jacques Rivière, "Une exposition de Henri-Matisse," *Études* (Paris, 1911); trans. Flam 1988, pp. 121–22. This review of Matisse's Bernheim-Jeune retrospective of 1910 was probably written that year.

35. William Rubin, *Picasso and Braque: Pioneering Cubism*, with a documentary chronology by Judith Cousins (New York: The Museum of Modern Art, 1989), p. 355.

36. André Salmon (La Palette), "Courrier des ateliers," *Paris-journal* (April 25, 1911), p. 4, announced Matisse's

replacement of *L'espagnole* by a very large canvas, *Intérieur*. In a subsequent report (ibid., April 27, 1911, p. 5), Salmon published what purported to be a letter to the editor, signed "un groupe d'exposants," complaining of the favoritism of the officials of the Indépendants in having allowed this to happen.

37. See, for example, Frantz Richard, "Deux kilomètres entre les fauves," *Gil Blas* (April 21, 1911), p. 2; cited (as "Deux kilomètres des fauves") in Marit Werenskiold, *The Concept of Expressionism: Origin and Metamorphoses* (Oslo: Universitetsforlaget, 1984), p. 71, n. 44; André Salmon, "Le 27e Salon des indépendants," *Paris-journal* (April 20, 1911), p. 5.

38. Guillaume Apollinaire, "Les cubistes," *L'intransigeant* (October 12, 1911); in *Chroniques d'art, 1902–1918*, ed. L.-C. Breunig (Paris: Gallimard, 1960), p. 201; trans. *Apollinaire on Art: Essays and Reviews, 1902–1918*, ed. L.-C. Breunig (New York: Viking, 1972), p. 185. The two works Matisse exhibited are illustrated in the present volume (pls. 143, 144).

39. Louis Vauxcelles, "Au Grand Palais: Le Salon d'automne," *Gil Blas* (September 30, 1911), p. 2; trans. Flam 1988, p. 314.

40. Yu. A. Rusakov, "Matisse in Russia in the Autumn of 1911," *The Burlington Magazine*, vol. 117, no. 866 (May 1975), p. 289. Rusakov cites an excerpt from an article written by V. Skansky, "Anri Matiss," *Zhivoe slovo* (October 31, 1911).

41. Guillaume Apollinaire, "Les 'Indépendants': Les nouvelles tendances et les artistes personnels," *Le petit bleu* (March 20, 1912); in *Chroniques d'art* (note 38, above), p. 230; trans. *Apollinaire on Art*, p. 217.

42. André Salmon, "Les fauves," *La jeune peinture française* (Paris: Société des Trente, Albert Messein, 1912), pp. 15, 19; trans. Flam 1988, p. 129.

43. See Rozsika Parker and Griselda Pollock, *Old Mistresses: Women, Art, and Ideology* (New York: Pantheon, 1981), for discussion of the downgrading of "effeminate" art.

44. Guillaume Apollinaire, "Salon d'automne: Henri-Matisse," *Les soirées de Paris* (November 15, 1913); trans. *Apollinaire on Art* (note 38, above), p. 330, and Flam 1988, p. 151.

45. Early references include Clara T. MacChesney, "A Talk with Matisse, Leader of Post-Impressionists," *New York Times* (March 9, 1913), p. 12, in Flam 1973, pp. 49–53; Marcel Sembat, "Henri Matisse," *Cahiers d'aujourd'hui*, no. 4 (April 1913), pp. 185–94, in Flam 1988, pp. 144–50. See also the entry "Harmonie" in the index of Fourcade 1972, pp. 348–49.

46. Élie Faure, Jules Romains, Charles Vildrac, and Léon Werth, *Henri-Matisse* (Paris: Georges Crès, 1920), pp. 31–48; discussed in Julius Meier-Graefe, "Matisse, das Ende des Impressionismus," *Faust*, no. 6 (Berlin: Erich Reiss, 1923/24), pp. 1–5; trans. Flam 1988, pp. 218–19. Werth's account of Matisse's "luxury" is one of the most extraordinary contributions to literature on the artist. He describes a fictional wealthy collector of great paintings from Rembrandt to Manet. The collector tires of these old works, finding them lacking the vividness of what he considers to be real luxuries: stylish fashions, a young woman, a beautiful car. So he replaces them with modern paintings, notably the most extraordinary Picassos, only to become dissatisfied with them, too. The richer he becomes, the more he savors luxury. And he realizes that what is wrong with both his old and his new paintings is that they are by artists who display their emotions and in doing so reveal disagreeable lives which smell of sweat. So all are banished—except one. A single Matisse replaces all the rest. "It has the simplicity of ultimate luxury."
Werth was one of a number of writers acutely conscious of the commodification of contemporary painting that accompanied a speculative boom in the French art market after World War I. Matisse's reputation in the 1920s was strongly affected by that change in

the market. This broad subject is studied in Malcolm Gee, *Dealers, Critics, and Collectors of Modern Painting: Aspects of the Parisian Art Market Between 1910 and 1930* (New York and London: Garland, 1981), and Christopher Green, *Cubism and Its Enemies: Modern Movements and Reactions in French Art, 1916–1928* (New Haven and London: Yale University Press, 1987), chaps. 7, 8.

47. André Lhôte, "Notes," *Nouvelle revue française* (1923); trans. Flam 1988, pp. 215–16.

48. Bell, "Matisse and Picasso" (1920; note 13, above), p. 44; in Flam 1988, pp. 194–95.

49. Jean Cocteau, "Déformation professionnelle," *Le rappel à l'ordre* (May 12, 1919), rpt. in *Le rappel à l'ordre, 1918–1926* (Paris: Stock, 1926), pp. 98–99; trans. Flam 1988, pp. 174–75.

50. Wassily Kandinsky, *Über das Geistige in der Kunst* (1912), translated as *On the Spiritual in Art*, in Kenneth C. Lindsay and Peter Vergo, eds., *Kandinsky: Complete Writings on Art*, (Boston: Hall, 1982), vol. 1, pp. 151–52.

51. Herbert, "Matisse Without History" (note 11, above), p. 298. The market for Matisse's art has still to be thoroughly examined. His Fauve work quickly found support, as did that of other Fauves (see David Cottington, "Cubism and the Politics of Culture" [Ph.D. dissertation, Courtauld Institute, University of London, 1986], chap. 4). Increasingly, however, Matisse's clients living in Paris were replaced by foreign clients, notably of course Shchukin and Morosov. This market collapsed with World War I. It was replaced, after the war, by a much broader, French market (see note 46, above).

52. Courthion, *Henri-Matisse* (note 8, above), p. 50; trans. Flam 1988, p. 300.

53. The 1925 vote was the result of an *enquête* in the periodical *L'art vivant*; see Green, *Cubism and Its Enemies* (note 46, above), pp. 136, 138, where necessary qualifications to use of the term "avant-garde" in this period will be found. Roger Fry's statement appears in his *Henri-Matisse* (Paris: Chroniques du Jour; New York: E. Weyhe, [1930]), p. 48; in Flam 1988, p. 249.

54. Aleksandr Romm, *Henri Matisse* (Leningrad: Ogiz-Izogiz, 1937), esp. pp. 7, 13, 15–16; in Flam 1988, pp. 301–19.

55. See the chronology in the present volume for a summary of the variations among Matisse's 1930–31 retrospective exhibitions.

56. Alfred H. Barr, Jr., *Henri-Matisse* (New York: The Museum of Modern Art; Norton, 1931), p. 27.
Barr's 1951 book on Matisse (note 14, above), which developed the outline of his 1931 study, is still the only rigorously art-historical study of virtually Matisse's entire career. When it appeared, it provoked some criticism of its art history (for example, Anthony Blunt, "Matisse's Life and Work," *The Burlington Magazine*, vol. 95, no. 609 [December 1953], pp. 399–400), but by and large was acknowledged to be the greatest monograph that had appeared on a modern artist. Such was its prestige that it seemed actually to discourage further detailed art-historical study. Only over the past ten to fifteen years has new scholarship been developed on Matisse, and his work still remains under-explored when compared to that of other important modern artists.

57. This may quickly be seen in Flam 1973, which gives Matisse's principal statements and writings in chronological order. See also the relevant sections of the Chronology in the present volume.

58. See, for example, the following three special issues which *Verve* devoted to Matisse: *Henri Matisse: De la couleur* (vol. 4, no. 13, November 1945); *Henri Matisse: Vence, 1944–1948* (vol. 6, nos. 21–22, October 1948); and *Dernières oeuvres de Matisse, 1950–1954* (vol. 9, nos. 35–36, July 1958).

59. This period of appreciation of Matisse is, roughly, that between The Museum of Modern Art, New York,

retrospective of 1951 and the Grand Palais, Paris, retrospective of 1970, including the critical reverberations of the latter. Other important retrospective exhibitions of this period include those at the Musée National d'Art Moderne, Paris, in 1956; the UCLA Art Galleries, Los Angeles, in 1966; and the Hayward Gallery, London, in 1968. Important specialized exhibitions included those of sculpture (Tate Gallery, London, 1953 and 1956) and paper cutouts (Kunsthalle, Bern, 1959; Musée des Arts Décoratifs, Paris, and The Museum of Modern Art, New York, 1961).

60. See, for example, the statements by a broad range of contemporary artists collected in "Eight Statements: Interviews by Jean-Claude Lebensztejn," *Art in America*, vol. 63, no. 4 (July–August 1975), pp. 67–75; also Thomas B. Hess's defense against the demeaning connotations of Matisse's hedonism, "Matisse: Hedonist Juggler," *New York Magazine*, vol. 6, no. 49 (December 3, 1973), pp. 102–03. The recent exhibition catalogue *After Matisse* (New York: Independent Curators, Inc., 1986), with essays by Tiffany Bell, Dore Ashton, and Irving Sandler, offers interpretations of Matisse's influence that are continuous with those of the 1960s and 1970s.

61. See Rubin, *Picasso and Braque* (note 35, above), pp. 17, 22, 42–47. D.-H. Kahnweiler referred to Braque's work as "feminine" in 1916 (ibid., p. 45), while Picasso himself described Braque as "*ma femme*" (ibid., pp. 47, 61, n. 129). For further, polemical discussion of opposed characteristics of Picasso and Braque, see Leo Steinberg's remarks in *Picasso and Braque: A Symposium* (New York: The Museum of Modern Art, 1992), pp. 247–48. At that same symposium, Picasso/Braque as a parallel to Picasso/Matisse was briefly discussed (ibid., pp. 115, 153, 162–63, 297).

62. Clement Greenberg, "Review of an Exhibition of Joan Miró," *The Nation* (June 7, 1947); in John O'Brian, ed., *Clement Greenberg: The Collected Essays and Criticism* (Chicago and London: University of Chicago Press, 1986), vol. 2, p. 155.

63. The form of the foregoing discussion is indebted to Mitchell, *Iconology* (note 31, above), chap. 4, where opposed analogies in Lessing are discussed.

64. See ibid., p. 110, on Lessing's gender-based understanding of poetry and painting. Analogously, the comparison of Picasso and Matisse is often presented as that of *artist* and *painter*, with the implication that an "artist" overcomes the decorative limitations of a mere "painter."

65. See note 43, above.

66. Fernande Olivier, *Picasso et ses amis*, Preface by Paul Léautard (Paris: Stock, 1933), p. 103; trans. Jane Miller as *Picasso and His Friends* (New York: Appleton-Century-Crofts, 1965), p. 84.

67. In the absence of a biography of Matisse, the most accessible accounts are those contained in Gaston Diehl, *Henri Matisse* (Paris: Pierre Tisné, 1954); Barr, *Matisse* (note 14, above); Schneider, "Moments in a Life," *Matisse* (note 16, above), pp. 715–40; and Flam, *Matisse* (note 19, above). See also the Bibliographical Note in the present volume.

68. Quoted in Maurice Raynal et al., *History of Modern Painting: Matisse, Munch, Rouault—Fauvism, Expressionism* (Geneva: Skira, 1950), p. 28.
Matisse's illness is commonly thought to have occurred in the winter of 1889–90. However, this is not certain. Therefore, it is also uncertain whether his first experience with painting did take place on this occasion. What matters here is that he said it did.

69. Interviews with Pierre Courthion, 1941 (interview 1, p. 8), Pierre Courthion Papers, The Getty Center for the History of Art and the Humanities; trans. Flam, *Matisse* (note 19, above), pp. 27–28.

70. Henri Matisse, "Message à sa ville natale," prepared for the inauguration of the Musée Matisse at Le Cateau-Cambrésis, November 8, 1952; in Fourcade 1972, p. 319; trans. Schneider, *Matisse* (note 16, above), p. 716.

71. [Louis] Aragon, *Henri Matisse: A Novel*, vol. 1 (London: Collins, 1972), p. 129.

72. In the present text and in the caption, Matisse's signature on this work (which reverses the letters themselves as well as their order) could not be exactly duplicated.

The first two paintings that Matisse made, which preceded this one, were apparently those done while he was recuperating from appendicitis. They were copies of color reproductions of landscapes, which he also signed in reverse (interviews with Courthion, 1941 [note 69, above; interview 1, p. 8]).

73. Matisse, *Jazz* (Paris: Verve, 1947), n.p.; in Fourcade 1972, p. 239; trans. Flam 1973, p. 113.

74. Interviews with Courthion, 1941 (note 69, above; interview 1, p. 8); trans. Flam, *Matisse* (note 19, above), p. 28.

75. Schneider, *Matisse* (note 16, above), p. 716.

76. Guillaume Apollinaire, "Henri Matisse," *La phalange*, vol. 2, no. 18 (December 15, 1907), pp. 481–85; in Fourcade 1972, p. 56; trans. Flam 1973, p. 32.

77. Here and later in this essay, I am indebted to Richard Wollheim's discussion of this theme in his *Painting as an Art* (Princeton, N.J.: Princeton University Press, 1987), especially his study of Ingres, pp. 250–86.

78. Schneider, *Matisse* (note 16, above), pp. 715–16, where we are also told that it was Matisse's mother who insisted he be paid an allowance to support his studies as a painter, despite his father's opposition to his career. In 1914, Matisse wrote: "I know that Seurat is the opposite of a romantic, of which I am one—a romantic; but with a good half of the scientist, the rationalist, which makes for the struggle from which I emerge sometimes victorious, but breathless" (Danièle Giraudy, ed., "Correspondance Henri Matisse–Charles Camoin," *Revue de l'art*, no. 12 [1971], p. 17).

79. Guenne, "Entretien avec Henri Matisse" (1925; note 2, above), p. 5; in Fourcade 1972, p. 83; trans. Flam 1973, p. 55.

80. "Henri Matisse vous parle," *Traits* (March 8, 1950), p. 5; in Fourcade 1972, p. 317; trans. Flam 1973, p. 126.

81. Ibid.; in Fourcade 1972, p. 317; trans. Flam 1973, p. 126.

82. Matisse, "Divagations," *Verve*, vol. 1, no. 1 (December 1937), p. 84; in Fourcade 1972, p. 157; trans. Flam 1973, p. 77.

83. The wine depicted in the painting would seem to be an exception to this, and yet this comprises nature naturally transformed by fermentation.

Having drafted this essay, I read with enormous interest Norman Bryson's *Looking at the Overlooked: Four Essays on Still-Life Painting* (Cambridge, Mass.: Harvard University Press, 1990). His discussion of Xenia, pp. 21–29, is relevant to what I say here. My subsequent choice of Velázquez's *Christ in the House of Mary and Martha* to compare with *Harmony in Red* is indebted to his discussion of it, pp. 153–54.

84. Matisse did make some paintings of oysters and other sea food to be eaten raw (e.g., pls. 346, 348), which support my point. By and large, his still lifes are placed on a studio table or a simulacrum of one. As I discuss later, Chardin's influence returns in paintings of the Nice period, when Matisse briefly reinstated "domestic" subjects. Even there, however, there is no sign of actual domestic work. The only form in which the industrial would enter his art, I believe, is the small group of landscapes, seen through the windshield of a car, that Matisse painted in 1917. See Flam, *Matisse* (note 19, above), pp. 467–68, for illustrations, including a photograph of the artist painting one of these works (significantly, for the point I am making) in his studio.

85. On painting as metaphorical of the body, see Wollheim, *Painting as an Art*, chap. 6, especially pp. 310–15.

86. The woman's posture in relation to the bowl of fruit she has collected was the part of the picture that gave Matisse the most trouble. This may be seen from a color photograph of an early state of the painting in Flam, *Matisse* (note 19, above), p. 231. (It is reproduced in black-and-white in the chronology of the present volume, page 180.) It is evident that, originally, she bent over the bowl and pulled it toward her, with her right hand around its stem and the fingers of her left hand clutching the rim. In the finished work, her right hand is a mere ghost and the fingers of her left hand have actually disappeared.

87. Since Barr interpreted the whiteness of the trees as snow, to support his idea that this painting was reworked in the winter of 1908–09 (*Matisse*, p. 126), a somewhat hilarious scholarly debate has ensued as to whether what we see is snow or, in fact, blossoms (see the citations given in Flam, *Matisse* (note 19, above), pp. 230, 493, n. 33). There is a simple solution. An eyewitness account of a visit to Matisse's studio on April 20, 1908, when the painting was in progress, describes how "suddenly the air is a swirl of flying, white atoms that seem to be blossom-petals, or snowflakes—one cannot differentiate them" (Inez Haynes Irwin, typescript diary of March 25–May 5, 1908, pp. 105–06; Arthur and Elizabeth Schlesinger Library of the History of Women, Radcliffe College, Cambridge, Massachusetts). I am grateful to Judith Cousins for having drawn this document to my attention. It additionally demonstrates that a preliminary version of the first *Back* sculpture was already in existence on April 20, 1908.

88. E. Tériade, "Matisse Speaks," *Art News Annual*, 21 (1952), p. 53; in Flam 1973, p. 135.

89. The major exception, *Conversation* of 1908–12 (pl. 152), the pendant to *Harmony in Red*, is, needless to say, a troubling picture—precisely because it is not clear that the interior is privileged; it seems not to be. Significantly, its subject, though not clear either, appears to be marital conflict. This is significant because the privileged interior depicted in *Harmony in Red* is presided over by a woman, who is a surrogate for the spectator's experience of the delectable things that Matisse's picture gathers before us.

90. See Jeremy Gilbert-Rolfe, "Matisse the Representational Artist," *Artforum*, vol. 17, no. 4 (December 1978), pp. 48–49. My later comments on the importance of metonymy as well as metaphor for Matisse notwithstanding, this article (which discusses *Plum Blossoms, Green Background*) remains a most useful corrective to overemphasis on Matisse's "abstraction."

91. "Notes d'un peintre" (1908; note 18, above), p. 741; in Fourcade 1972, pp. 49–50; trans. Flam 1973, p. 38.

92. William Rubin sees in Matisse's work a tendency common to much twentieth-century French painting wherein "the image, though it carried with it the sentiments that its subject first inspired in [Matisse], developed in favor of the needs of the pictorial configuration, and thus *away* from the motif, in the direction of abstractness." Picasso, he says, goes the other way, always wanting to make a figure or an object from a patch of paint or piece of material. (*Picasso and Braque* [note 35, above], p. 23.) The antithesis is credible. And yet, it requires modification. At times, Matisse does move from a more "representational" to a more "abstract" image, but not always; and whether he does so or not, it might be said that he moves actually *toward* the motif as he had first intuited it. The needs of the pictorial configuration, that is to say, are the needs of realizing the motif as an image, as with any representational artist.

93. "Notes d'un peintre" (1908; note 18, above), p. 736; in Fourcade 1972, p. 45; trans. Flam 1973, p. 37.

94. "Matisse Speaks to His Students, 1908: Notes by Sarah Stein," Barr, *Matisse*, (note 14, above), p. 550; in Flam 1973, p. 45. In 1943, Matisse told Aragon: "When I close my eyes, I see the objects better than I do with my eyes open, stripped of accidental detail, and that is what I paint" (trans. in Flam 1988, p. 167). Matisse's numerous paintings of figures sleeping or otherwise absorbed in reverie, some of which I discuss later, allude to this internalized state, and thereby represent the condition of their representation. So do, in a related sense, his imaginary figure compositions insofar as they present themselves as representations of dreams. On Matisse's sleeping figures, see Isabelle Monod-Fontaine, *Matisse: Le rêve, ou les belles endormies* (Paris: Adam Biro, 1989).

95. "Notes by Sarah Stein" (1908), p. 552; in Flam 1973, p. 45.

96. "Notes d'un peintre" (1908; note 18, above), p. 738–39; in Fourcade 1972, p. 46; trans. Flam 1973, p. 37.

97. Ibid. In subsequent statements, Matisse regularly returned to the idea of transposition. On occasion, he compared it to a game of chess: "The appearance of the board is continually changing in the course of play, but the intentions of the players who move the pawns remain constant" ("On Modernism and Tradition," *The Studio*, vol. 9, no. 50 [May 1935], pp. 236–39; in Flam 1973, p. 72). Matisse's constant intention is to re-create his prior mental image of the subject—if we will, his intuition of the simplified board, free of surrendered pieces at the end of play.

98. MacChesney, "A Talk with Matisse" (1913; note 45, above), p. 12; in Flam 1973, p. 51.

99. E. Tériade, "Constance du fauvisme," *Minotaure*, vol. 2, no. 9 (October 15, 1936), p. 3; in Fourcade 1972, p. 129; trans. Flam 1973, p. 74.

100. Ibid.

101. Matisse, "On Transformations," excerpt from a letter from Matisse to his son Pierre, June 7, 1942, originally published as "In the Mail," in *First Papers of Surrealism* (New York: Coordinating Council of French Relief Societies, 1942), n.p.; in Flam 1973, p. 90.

102. See note 99, above.

103. Aragon, *Henri Matisse* (note 71, above), vol. 1, p. 110.

104. Pierre Courthion, "Rencontre avec Matisse," *Les nouvelles littéraires* (June 27, 1931), p. 1; in Fourcade 1972, p. 90; trans. Flam 1973, p. 65.

105. See note 29, above.

106. Matisse, "Notes d'un peintre sur son dessin," *Le point*, vol. 4, no. 21 (July 1939), pp. 10, 13; in Fourcade 1972, pp. 160, 162; trans. Flam 1973, pp. 81–82.

107. "Notes by Sarah Stein" (1908; note 94, above), p. 552; in Flam 1973, p. 45.

108. "Notes d'un peintre sur son dessin" (1939; note 106, above), pp. 10, 12; in Fourcade 1972, p. 160; trans. Flam 1973, p. 81.

109. Marcel Proust, *Swann's Way*, trans. C. K. Scott Moncrieff (New York: Modern Library, 1928), p. 232.

110. Northrop Frye, "The Drunken Boat: The Revolutionary Element in Romanticism," in *Romanticism Reconsidered* (note 28, above), pp. 20–21.

111. All signifiers are, of course, the material substitutes for something that is immaterial and absent, namely the signified. Thus, all representation is based on the condition of absence. Matisse's art is unusual, however, in frequently drawing our attention to the associations of loss, nostalgia, unattainability, and so on, that attach to absence. His literal emptying of forms of mass or of features became perhaps his most common way of doing this.

112. "Notes d'un peintre sur son dessin" (1939; note 106, above), p. 10; in Fourcade 1972, p. 159; trans. Flam 1973, p. 81.

113. Georges Charbonnier, "Entretien avec Henri Matisse" (1950), *Le monologue du peintre* (Paris: René Julliard, 1960), vol. 2, pp. 14–15; trans. Flam 1973, p. 141.

114. Ibid., p. 15; trans. Flam 1973, p. 141.

115. Letter to Bonnard, January 13, 1940, in *Bonnard–Matisse Correspondance, 1925–1946* (note 4, above), p. 66; in Fourcade 1972, pp. 182–83.

116. Letter to André Rouveyre, October 6, 1941; in Fourcade 1972, p. 188.

117. E. Tériade, "Visite à Henri Matisse," *L'intransigeant* (January 14 and 22, 1929); excerpt rpt. as "Propos de Henri Matisse à Tériade," *Verve*, vol. 4, no. 13 (December 1945), p. 56; in Fourcade 1972, p. 96; "Entretien avec Tériade," *L'intransigeant* (October 20 and 27, 1930); trans. Flam 1973, p. 58.

118. André Verdet, "Entretiens avec Henri Matisse," in *Prestiges de Matisse* (Paris: Émile-Paul, 1952), p. 71; in Fourcade 1972, p. 250; trans. Flam 1973, p. 147.

119. Matisse, "Témoignages," ed. Maria Luz, *XXᵉ siècle*, n.s., no. 2 (January 1952), p. 66; in Fourcade 1972, p. 247; trans. Flam 1973, p. 137.

120. The common method of Matisse's cutouts and late brush drawings, and its source in *Le bonheur de vivre*, were acutely noted and discussed at length in Bois, "Matisse and 'Arche-drawing'" (note 6, above). I cannot agree with the "Matisse system" that Bois erects on this basis: because it neglects entirely the Nice period (see note 6, above) and because it presumes a greater continuity of procedure on Matisse's part than actually existed (see note 242, below). Nevertheless, Bois's discussion of color transpositions and their relationship to drawing is a very thorough and important one.

121. Matisse, "Témoignages" (1952; note 119, above), pp. 66–67; in Fourcade 1972, pp. 246–49; trans. Flam 1973, pp. 136–37.

122. Ibid. In fact, Matisse did determine signs in advance when making his cutouts in the sense that their cutting preceded, and was thus independent of, their placement. It is clear from studio photographs that cutout "signs" were, additionally, moved from one composition to another. See my *The Cut-Outs of Henri Matisse* (New York: Braziller, 1978), especially the photographs on pp. 98, 108–09, 125.

123. For example, see Aragon, *Henri Matisse* (note 71, above), vol. 1, p. 107, paraphrasing a conversation with Matisse.

124. Bryson, "Signs of the Good Life" (note 9, above), p. 328.

125. Verdet, "Entretiens avec Henri Matisse" (1952; note 118, above), p. 76; trans. Flam 1973, p. 147.

126. Matisse thus observed of the painting *The Siesta* of 1905 (pl. 60): "The same red is used for the child's dress and elsewhere in the picture; well, *you cannot see* that it's the same red shown in light and shadow, and that the difference between them is a matter of relationships" (Aragon, *Henri Matisse* [note 71, above], vol. 1, p. 138). To Gaston Diehl, he said: "It is solely a question of playing up differences" (Matisse, "Rôle et modalités de la couleur," in Gaston Diehl, ed., *Les problèmes de la peinture* [Lyon: Éditions Confluences, 1945], p. 238; in Fourcade 1972, p. 200; trans. Flam 1973, p. 99).

127. Gerard Genette, "Métonymie chez Proust, ou la naissance du Récit," *Poétique*, vol. 2 (1970), pp. 156–73, as quoted by David Lodge, "The Language of Modernist Fiction: Metaphor and Metonymy," in Malcolm Bradbury and James McFarlane, eds., *Modernism, 1890–1930* (Harmondsworth: Penguin, 1976), p. 493.

128. Roman Jakobson, "Two Aspects of Language and Two Types of Aphasic Disturbances," in Roman Jakobson and Morris Halle, *Fundamentals of Language* (The Hague, 1956), pp. 55–82. Speech (and writing), Jakobson explains, involves two operations: the selection and the combination of linguistic units. Since the "selective" axis of language requires choosing between similar terms, it is the means of generating metaphor. In contrast, metonymy belongs to the "combinative" axis because it operates with terms that are contiguous in language and in reality. Weakness in the structural activity associated with one linguistic figure leads to the use of the opposite figure. My discussion of this topic is indebted to Lodge, "The Language of Modernist Fiction" (note 127, above), pp. 481–96.

129. Matisse stressed this on a number of occasions in his writings and statements. See, for example, Diehl, *Henri Matisse*, p. 22; Schneider, *Matisse*, p. 376; Barr, *Matisse*, p. 184 (notes 67, 16, 14, above).

130. See Lodge, "The Language of Modernist Fiction" (note 127, above), p. 494.

131. Guenne, "Entretien avec Henri Matisse" (1925; note 2, above), p. 5; in Fourcade 1972, p. 84; trans. Flam 1973, p. 55.

132. I do not intend here to undo the association of Cézanne and Matisse that Matisse himself affirmed and that has become standard in Matisse scholarship, an association now established as of equal importance to that of Cézanne and the Cubists. Only, I suggest that Cézanne's stylistic influence on Matisse has still not been sufficiently separated from his influence on the Cubists. Even Flam's fine discussion of this subject (*Matisse* [note 19, above], pp. 20–22) leaves the reader with the assumption that Matisse took over Cézanne's conception of a picture as a fused field of interpenetrating forces. So does Bois's ("Matisse and 'Arche-drawing'" [note 6, above], pp. 48–51), in large part because the aim of both artists is seen as subsuming the parts of a picture to an "all-over treatment of the surface." In both cases, what is missing is that Matisse rejected the fragmentation of subject matter suggested by Cézanne and pursued by the Cubists. Because he did so, figure could never fuse fully into field, but remained partially estranged from it. Matisse did sound like Cézanne when speaking of looking for "an equilibrium of forces" in *Harmony in Red* (Fourcade 1972, p. 129, n. 96). Unsurprisingly, he explains his new purposes in familiar terms. And yet, the parts of a picture—the forces—do not accumulate and fuse as in a Cézanne but, rather, are stressfully separated. Matisse's notion of equilibrium, unlike Cézanne's, is of the balance of parts that can never fully be unified. Hence, Matisse's notion of "unfinish" does not presume the possibility of finish, as it does in Cézanne.

133. W. S. Di Piero, "Matisse's Broken Circle," *The New Criterion*, vol. 6, no. 9 (May 1988), p. 28.

134. Ibid., p. 27.

135. Matisse, "La chapelle du Rosaire," in *Chapelle du Rosaire des Dominicaines de Vence* (Vence, 1951), n.p.; in Fourcade 1972, p. 258; trans. Flam 1973, p. 128.

136. Flam, *Matisse* (note 19, above), p. 195.

137. "Notes d'un peintre" (1908; note 18, above), p. 739; in Fourcade 1972, p. 48; trans. Flam 1973, p. 38.

138. Gowing, *Matisse* (note 3, above), p. 69.

139. Matisse, "Il faut regarder toute la vie avec des yeux d'enfants," Régine Pernoud, ed., *Le courrier de l'UNESCO*, vol. 6, no. 10 (October 1953); in Fourcade 1972, pp. 321–23; trans. Flam 1973, pp. 148–49.

140. Interestingly, Matisse cites popular imagery, presumably because he considers it to be "the common language" in its most materialistic form.

141. Matisse, "Portraits," preface to *Portraits* (Monte Carlo: André Sauret, 1954), pp. 11–17; in Fourcade 1972, pp. 175–81; trans. Flam 1973, pp. 150–53. I discuss the implications of "the revelation at the post office" at some length in my *The Drawings of Henri Matisse*, Introduction by John Golding (London: Arts Council of Great Britain and Thames & Hudson, 1984), pp. 19–22.

142. Relevant to this are Matisse's statements calling for artists to remain celibate (for example, Léon Degand, "Matisse à Paris," *Les lettres françaises* [October 6, 1945], p. 7; in Fourcade 1972, p. 305; trans. Flam 1973, p. 104), which otherwise seem incomprehensible.

143. Let us note, in passing, that his mistress and this ideal land will not, in fact, resemble each other but have common attributes. Also, that this ideal land for Baudelaire is a northern one, Holland, which is thus transformed.

I discuss the genesis and evolution of this work in my *Matisse in the Collection of The Museum of Modern Art* (New York: The Museum of Modern Art, 1978), pp. 36–39.

144. A letter that Matisse wrote to Simon Bussy on September 19, 1905 (quoted in my *Matisse in the Collection of The Museum of Modern Art*, p. 180, n. 6), suggests that the title was an afterthought, and indicates Matisse's confusion as to which poem he was thinking of. See Flam, *Matisse* (note 19, above), p. 118, for the suggestion that it was, in fact, "Le beau navire." The couplet quoted in translation in the text reads, *"Je veux te peindre ta beauté, / Où l'enfance s'allie à la maturité."*

145. See E. H. Gombrich, "Action and Expression in Western Art," in his *The Image and the Eye: Further Studies in the Psychology of Pictorial Representation* (Ithaca, N.Y.: Cornell University Press, 1982), p. 101.

146. Stanley Cavell, "A Matter of Meaning It," in his *Must We Mean What We Say?* (Cambridge and London: Cambridge University Press, 1969), pp. 235–36.

147. See note 75, above.

148. Raymond Escholier, *Matisse, ce vivant* (Paris: Arthème Fayard, 1956), p. 45; in Fourcade 1972, p. 84; trans. Raymond Escholier, *Matisse from the Life* (London: Faber, 1960), p. 43.

149. The most accessible English translation of Baudelaire's article (which originally appeared in *Le Figaro* [November 26, 28, December 3, 1863]) is in Jonathan Mayne, ed. and trans., *The Painter of Modern Life and Other Essays by Charles Baudelaire* (London: Phaidon, 1964; New York: Da Capo, n.d.), pp. 1–40. However, I quote here from the more fluent translation in Lois Boe Hyslop and Francis E. Hyslop, Jr., eds. and trans., *Baudelaire as a Literary Critic* (University Park, Penn.: Pennsylvania State University Press, 1964), pp. 294–95.

150. The clue that should alert us to this is that Matisse has done something that appears comically naive: he has made a pun between the nudes on the beach and the still life laid out on the cloth beside them, a pun that appears farfetched and leaves us cold. This is, of course, what Freud called a "dream joke," a means of displacement. The metaphysical association of *femme* and *fleur* discussed earlier is akin to this.

151. Jacques Lacan, "The Mirror Stage as Formative of the Function of the I as Revealed in Psychoanalytic Experience" (originally published in *Revue française de psychanalyse*, no. 4 [October–December 1949], pp. 449–55), in *Écrits: A Selection*, trans. Alan Sheridan (New York: Norton, 1977), pp. 1–7. Lacan's concept of the "mirror stage" has been related to Matisse's work in rather different terms by David Carrier, "Matisse: The End of Classical Art History and the Fictions of Early Modernism," in his *Principles of Art History Writing* (University Park, Penn.: Pennsylvania State University Press, 1991), pp. 227–29, following a discussion of mirrors in Matisse's paintings and drawings (pp. 222–26).

152. Maurice Merleau-Ponty, "The Child's Relations with Others," trans. William Cobb, in *The Primacy of Perception*, ed. James M. Edie (Northwestern University Press, 1964), pp. 125–41. Merleau-Ponty's discussion elaborates on that of Lacan and also makes reference to Henri Wallon's *Les origines du caractère chez l'enfant* (Paris, 1949).

153. Sketchbook note, 1951, quoted in Schneider, *Matisse* (note 16, above), p. 417, n. 72. Very relevant to what I have been saying is the fact that Matisse's first self-representations in his paintings take the form of small representations of a framed self-portrait drawing which faces the viewer. In the first instance (pl. 5), it is placed near what is either a mirror or a glazed drawing with a highly reflective surface. In the second (pl. 8), it is juxtaposed with two empty picture frames. Matisse, we should note, did not paint many self-portraits; only one or two of truly major importance and none at all after 1917. When he appears in a painting, he usually is hidden there or he shows himself from the back, which amounts to the same thing. In both cases, the effect is to seem to lure the viewer into the picture, and identify with the artist's self-representation, only to push the viewer back. (Again, the viewer should be understood to include Matisse.) More frequent are surrogate self-portraits, which often take the form of musicians, usually violinists. Matisse once offered the astonishing explanation that he himself had taken up the violin so that he could support his family if he went blind. This is relevant to what I have to say later about Matisse's denial of our visual access to the nominally most important parts of some of his paintings.

154. Thus, the two functions of the child in *Luxe, calme et volupté* I refer to here—looking down on the nudes and facing out to the external viewer—are performed not simultaneously but alternatively.

155. See Wollheim, *Painting as an Art* (note 77, above), pp. 292–94, on touch in Picasso's work. Matisse's preoccupation with surface includes his habit of layering paintings in a way that makes clear there is another color beneath the one we see, even to his willingly accepting, it seems, the crackle effect produced by the differing drying times of superimposed layers of paint.

156. Amédée Ozenfant, *Mémoires, 1886–1962* (Paris: Seghers, 1968), p. 215; quoted by Schneider, *Matisse*, p. 506.

157. Schneider, *Matisse* (note 16, above), p. 506.

158. The extraordinarily subtle functions of patterning in these paintings await the study they deserve. I would only quickly observe, on the one hand, that by juxtaposing areas of repetitive patterning the contours of these areas tend to be disguised, thus further offsetting the effect of linear perspective; and on the other, that the expression of surface thus provided is not merely one of flatness: the pattern is dense with intimations of depth and tactility, most evidently so in the case of the crosshatched patterning Matisse frequently uses. Since crosshatching is a conventional method of describing volume, we remember that function of it even as it covers non-volumetric surfaces. Devices of this kind show Matisse to be extremely aware of the formal properties of his pictorial language; only now he requires of us more careful, considered looking to notice this. This is part of his strategy to extend the time of our viewing—something which begins in the decorative interiors of 1911, as we shall see later.

159. For Fragonard's and Boucher's use of this effect, see Bryson, *Word and Image* (note 10, above), pp. 92–100.

160. *Vénitienne* (*Girl with a Tricorne*) of c. 1922, in the Memorial Art Gallery, University of Rochester, Rochester, New York (illustrated in Élie Faure et al., *Henri-Matisse* [Paris: Georges Crès, 1923; a reissue, with new plates, of the 1920 book cited in note 46, above], pl. 42); *Ancilla* of c. 1922 (ibid., pl. 43); *Le concert au paravent mauresque* (*Le concert vénitien*) of 1923 (Escholier, *Matisse from the Life* [note 148, above], pl. 34).

161. See my *Matisse in the Collection of The Museum of Modern Art* (note 143, above), p. 167.

162. On Matisse's 1920s Orientalism, see Kenneth E. Silver, *Esprit de Corps: The Art of the Parisian Avant-Garde and the First World War, 1914–1925* (Princeton, N.J.: Princeton University Press, 1989), pp. 258–64. Silver makes over-much, I think, of the colonialist implications of Matisse's Orientalism, but offers a useful comparison with Ingres, specifically with Ingres's 1842 *Odalisque and Slave*; the comparison holds for Matisse's *Odalisque with Gray Culottes*, to which I refer here.

163. I discussed the pastoral connotations of these representations in *The Drawings of Henri Matisse* (note 141, above), pp. 94–95. Reviewing this book, Jed Perl claimed that I was thus refusing to acknowledge their eroticism (Perl, "Matisse," *The New Criterion*, vol. 3, no. 10 [June 1985], pp. 24–25). I continue to believe that simply to acknowledge the eroticism that some, but by no means all, convey is not enough, and that to say they "are surely meant as a turn-on," as Perl does, is to misunderstand even the most apparently erotic of them. He is perspicacious in saying that responses to sexuality and to pictorial harmony are relatable as human responses to the implications of form, but does not take the necessary next step, which is to ask whether Matisse's paintings are as purely masculinist in their human responses to the implications of form as they appear to be at first sight. Matisse himself allowed a masculinist interpretation of what he was doing. He once said that he needed the model's presence "to keep my emotions going, in a kind of flirtation, which ends in a rape." (Aragon, *Henri Matisse* [note 71, above], vol. 1, p. 236). But he continued: "Rape of what? Of myself, of a certain emotional involvement with the object that appeals to me." What he fantasized himself doing is of course not necessarily illustrated in what he painted; we have to allow that the fantasy could be maintained only by preventing others from sharing in it. See Wollheim, *Painting as an Art* (note 77, above), pp. 260–61, 285–86, for discussion of a closely related aspect of Ingres's work. Of Ingres's odalisques, Wollheim observes that, at the moment of their representation, they are secluded from the gaze of men and therefore chaste.

164. See Bryson, *Looking at the Overlooked* (note 83, above), p. 111, who draws on Simon Schama, *The Embarrassment of Riches: An Interpretation of Dutch Culture in the Golden Age* (Berkeley: University of California Press, 1988).

165. For discussions of Chardin of great interest for consideration of Matisse's work, see Michael Fried, *Absorption and Theatricality: Painting and Beholder in the Age of Diderot* (Berkeley: University of California Press, 1980), pp. 46–53; Michael Baxandall, *Patterns of Intention: On the Historical Explanation of Pictures* (New Haven, Conn., and London: Yale University Press, 1985), pp. 74–104; Bryson, *Looking at the Overlooked* (note 83, above), pp. 166–70.

166. Matisse, "Notes d'un peintre" (1908; note 18, above), p. 741; in Fourcade 1972, p. 50; trans. Flam 1973, p. 38.

167. Fried, *Absorption and Theatricality* (note 165, above), is but the most explicit of this author's studies of how certain artists of the eighteenth and nineteenth centuries will "find a way to neutralize or negate the beholder's presence, to establish the fiction that no one is standing before the canvas" (ibid., p. 108). As will be obvious, I have found Fried's writings on this subject of enormous interest. My remarks on how Matisse's pictures offer themselves to the viewer are indebted to his work.

168. Matisse, "Notes d'un peintre" (1908; note 18, above), p. 741; in Fourcade 1972, p. 50; trans. Flam 1973, p. 38.

169. Ibid.; in Fourcade 1972, p. 49; trans. Flam 1973, p. 38.

170. The fact that most of Matisse's odalisques are French women in disguise contributes to the uncertainty his paintings convey. It is therefore not accidental that his most erotic works are the prints and drawings of actual Oriental models made at the end of the 1920s and in the early 1930s (see pls. 287, 288). Because they seem to be "real" odalisques, they seem sexually available. More often, Matisse shows us women playing at being odalisques, like the "court ladies" in *Le chant du rossignol*, whose costumes he designed in 1920 (see the illustration of these in Robyn Healy and Michael Lloyd, *From Studio to Stage: Costumes and Designs from the Russian Ballet in the Australian National Gallery* [Canberra: The Australian National Gallery, 1990], p. 52). The connection between femininity and "masquerade" has been the subject of much recent discussion. See, for example, J. Riviere, "Womanliness as a Masquerade," in H. M. Ruitenbeek, ed., *Psychoanalysis and Female Sexuality* (New Haven, Conn.: College and University Press, 1966) and, more broadly, L. Mulvey, "Visual Pleasure and Narrative Cinema," *Screen*, vol. 16, no. 3 (Autumn 1975).

171. See Michael Fried's summary of the associations that attach to this assumption in his "Courbet's 'Femininity,'" in Sarah Faunce and Linda Nochlin, eds., *Courbet Reconsidered* (New York: The Brooklyn Museum, 1988), p. 43. Anyone interested in what I have to say about the critical tradition of Matisse's "femininity" will also be interested in Fried's essay, if only to see how different the two cases are because a comparable critical tradition did not exist for Courbet.

172. Claude Roger-Marx, "The Drawings of Henri Matisse" (1938); trans. Flam 1988, p. 324. Claude Roger-Marx was the son of Roger Marx, whom I quoted near the beginning of this essay.

173. "Notes d'un peintre sur son dessin" (1939), p. 13; in Fourcade 1972, p. 162; trans. Flam 1973, p. 81.

174. Matisse, "Portraits" (1954; note 141, above), p. 13; in Fourcade 1972, p. 177; trans. Flam 1973, p. 151.

175. See note 94, above.

176. For this aspect of the work of Manet and Degas, see Wollheim, *Painting as an Art* (note 77, above), pp. 149–50.

177. Aragon, *Henri Matisse* (note 71, above), vol. 1, pp. 89, 223, citing Matisse's admiration of the portrait especially on account of Mme de Senonnes's swelling throat.

178. *Matisse*, written and directed by François Campaux, with commentary by Jean Cassou, Comptoir Général Cinématographique, 1946.

179. Rosamond Bernier, "Matisse Designs a New Church," *Vogue* (February 15, 1949), p. 132. Quoted in Bois, "Matisse and 'Arche-drawing'" (note 6, above), p. 46.

180. It is interpreted thus by Bois, ibid., pp. 46–47.

181. See Dominique Fourcade, "Something Else," in *Henri Matisse: Paper Cut-Outs* (St. Louis: The St. Louis Art Museum; Detroit: The Detroit Institute of Arts, 1977), p. 52.

182. William Tucker uses this expression of our "distanced" experience of Matisse's sculpture. See William Tucker, "Matisse's Sculpture: The Grasped and the Seen," *Art in America*, vol. 63, no. 4 (July–August 1975), p. 62. The compositional means of this cutout remained unique in modern pictorial art until the Unfurled paintings of Morris Louis. My remarks on this series of Louis's paintings in *Morris Louis* (New York: The Museum of Modern Art, 1986), pp. 61–64, apply to Matisse's great cutout as well.

183. Matisse, letter to Aleksandr Romm, February 14, 1934; in *Matisse: Paintings, Sculpture, Graphic Work, Letters* (Moscow: The State Pushkin Museum, 1969), p. 131; in Fourcade 1972, p. 146; trans. Flam 1973, p. 68.

184. Tucker, "Matisse's Sculpture" (note 182, above), p. 62.

185. Matisse's fondness for the device of the looped arm that springs from the shoulder to return to the neck or hip accentuates graspability. The device reminds Tucker of the handle of a cup or jug (ibid., p. 64). It is one that Matisse also uses often in his paintings, especially from 1920 onward. Many is the woman who brings one or both of her hands to her head, or rests her elbow on something, or does both. This makes her seem graspable, or anchors her in space, or does both.

186. Of course, Matisse's bronzes are literally hollow, but this is merely conventional to cast sculpture and does not intrude in our experience of these works. Their bronze material is also, of course, conventional, but it deserves mention here that for all Matisse's apparent amateurishness as a sculptor, he was clearly extremely conscious of bronze as a material. In this respect, he differs from, say, Degas, another painter-modeler whose original waxes are unquestionably superior to the bronzes. When Matisse worked in plaster rather than clay, it is a different matter, as can be seen from the plasters of the four *Back* sculptures, now in the collection of the Musée Matisse at Le Cateau-Cambrésis. The second and third *Back* sculptures, worked extensively in plaster, possess a far greater intensity when seen in that material as compared to bronze. This is less true of the fourth *Back*, where Matisse reworked the image in clay, and not true at all of the first *Back*, done solely in clay. Only the bronzes of *Back (II)* and *(III)* (pls. 167, 191) with an extremely dark patina (for example, those in the collection of the Tate Gallery, London) come close to approximating the brittle vitality of the plasters. Conversely, the plaster version of *Madeleine (I)* that exists, painted a terra-cotta color (The Nasher Collection, Dallas), seems lacking in structure when compared with the bronze. Only the terra-cotta of *Reclining Nude (I)* is compelling, and that may be to some extent because it reminds us of its representation in Matisse's paintings.

187. Tucker, "Matisse's Sculpture" (note 182, above), p. 65.

188. "Notes by Sarah Stein" (1908; note 94, above), p. 551; in Flam 1973, p. 44.

189. Charbonnier, "Entretien avec Henri Matisse" (1950; note 113, above), p. 14; trans. Flam 1973, p. 141. Because Matisse sculpted as a painter, he seems to have abjured the complex armatures conventional to figurative sculpture; thus, *Reclining Nude (I)* simply fell apart while he was working on it. This meant, however, that he forced himself to construct the figure as he realized it, or that he avoided constructional problems either by keeping to a small size or by choosing self-supporting poses (notably the reclining figure), or by making a rudimentary armature a part of the work (as with *La serpentine*). In any event, the visuality of Matisse's sculpture should be distinguished from that built on a complex armature, where the structural integrity of the figure may never be at issue. Visual form gains the power it does in Matisse's sculpture only because it is built as mass. (I am indebted here to a discussion with William Tucker on the general function of the armature in modeled sculpture.)

190. "Notes d'un peintre sur son dessin" (1939; note 106, above), p. 14; in Fourcade 1972, p. 163; trans. Flam 1973, p. 82.

191. See Schneider, *Matisse* (note 16, above), pp. 563–66.

192. Tucker, "Matisse's Sculpture" (note 182, above), p. 66.

193. Conversation with Pierre Courthion, quoted in Jean Guichard-Meili, *Henri Matisse: Son oeuvre, son univers* (Paris: Fernand Hazan, 1967), p. 170; trans. Flam 1973, p. 174, n. 10.

194. The sculpture *Two Women* is usually referred to as *Two Negresses*; however, this was a later title, apparently first used in February 1930, when the work was exhibited at the Thannhauser gallery, Berlin, as *Zwei Negerinnen* (no. 88). The piece appears to have been exhibited in the 1908 Salon d'Automne as *Groupe de deux jeunes filles*.
The work is usually dated to 1908. However, a photograph of Matisse taken at Collioure in the summer of 1907 shows the work in progress with the photograph on which it was based fastened to a panel behind it. See the Chronology, page 136.

195. Matisse, *Jazz* (1947; note 73, above), n.p.; in Fourcade 1972, p. 237; trans. Flam 1973, p. 112.

196. Quoted in Robert Hughes, *Frank Auerbach* (London: Thames & Hudson, 1990), p. 202.

197. "Notes d'un peintre" (1908; note 18, above), p. 739; in Fourcade 1972, p. 47; trans. Flam 1973, pp. 37–38.

198. These works have been studied in *Matisse: Ajaccio–Toulouse, 1898–1899: Une saison de peinture* (Toulouse: Musée d'Art Moderne, 1986), yet still await more detailed consideration. It is customary to refer to Matisse's liberation as occurring through his first experience of landscape painting in the South. Some of the landscapes are indeed very free, but many remain conceived within a rather conventional Impressionist framework. It is the still lifes that are the most radical, and it is not by any means certain that all commonly attributed to Toulouse were in fact painted there. For example, *Still Life with Oranges (II)* (pl. 20) could well have been done subsequently in Paris. At any rate, there is reason to doubt the idea that *plein-air* landscape painting was the primary means of Matisse's liberation.

199. Guenne, "Entretien avec Henri Matisse" (1925; note 2, above), p. 5; in Fourcade 1972, p. 83; trans. Flam 1973, p. 55.
The issue of Matisse's own materialism is a complicated one. He regularly deplored acquisitiveness and painting for the sake of making money; see the entry "Argent" in the index of Fourcade 1972, p. 336. And yet, accounts exist which describe his love of money and keen business sense; see, notably, Jane Simone Bussy, "A Great Man," *The Burlington Magazine*, vol. 128, no. 995 (February 1986), pp. 80–84; and Janet Flanner, "Profiles: King of the Wild Beasts, Parts I and II," *The New Yorker* (December 22 and 29, 1951), respectively pp. 30–46 and 26–49, reprinted in Janet Flanner, *Men and Monuments* (New York: Harper, 1957), pp. 71–116. It is indisputable, I think, that Matisse lived part of his fantasy life in rich fabrics, golden fruit, and images of luxury as much as Cézanne lived his in the rocks and foliage around Mont Sainte-Victoire. His early penury, and his father's opposition to his vocation, cannot be irrelevant to this. I do not say that golden fruit and expensive pictures should be thought of as surrogates for his father's golden grain and the wealth it produced, only that paternal emulation was important to him, and that Matisse sought, in effect, to outdo the materialist world. "My luxury? Is it not communicable, being something more precious than wealth," he once wrote (Aragon, *Henri Matisse* [note 71, above], vol. 1, p. 240).
An interesting parallel thus exists between Matisse's making objects more beautiful and precious than they actually were and Karl Marx's concept of commodity fetishism, the projection of life and value onto inanimate objects produced by labor. In fact, Marx's and Matisse's rhetorical strategies for arguing that ordinary objects do come to have mysterious powers are similar. Marx says that his analysis "dissipates the mist" through which products appear to be merely objective products of the social character of their labor, and allows him to reorganize their fetishistic qualities (see Mitchell, *Iconology* [note 31, above], pp. 188–89). Matisse says that his analysis, which reveals to him the image of a thing as it really is, erases "the mist which until then had prevented me from

seeing it" ("Portraits" [1954; note 141, above], p. 15; in Fourcade 1972, p. 180; trans. Flam 1973, p. 152). Both arguments are drawn from Romantic aesthetics and refer to a true, potent reality beneath the cloak of appearance.

200. See, for example, Matisse's letters to Simon Bussy, July 15, 1903 (Fourcade 1972, pp. 86–87, n. 26), and July 31, 1903; trans. Flam, *Matisse* (note 19, above), pp. 80, 82–83.

201. Not unrelated to the issue of Matisse's self-identification is the fact that he changed the form of his name to "Henri-Matisse" at the time of the 1904 Salon d'Automne. This was apparently done so that his Salon entries would henceforward be listed in the catalogues among names beginning with H rather than M, thus to distinguish himself from the marine painter Auguste Matisse. It should be noted that in addition Matisse thus distinguished himself from his younger brother, also named Auguste Matisse, who took his place by following their father's profession.

202. See note 200, above.

203. For Signac and Matisse, see especially Bock, *Matisse and Neo-Impressionism* (note 32, above), pp. 49–50 and passim.

204. Bock, *Matisse and Neo-Impressionism*, p. 139, n. 3, correcting something I had written earlier. There was a limit, however, to Signac's taste, which Matisse overstepped with *Le bonheur de vivre*. Bock describes Signac's reaction to that work as "indignant and disappointed" (ibid., p. 93); this is an understatement.

205. See the entry "Théorie" in the index of Fourcade 1972, p. 362.

206. Georges Duthuit, *Les Fauves: Braque, Derain, van Dongen, Dufy, Friesz, Manguin, Marquet, Matisse, Puy, Vlaminck* (Geneva: Trois Collines, 1949), p. 10.

207. Bussy, "A Great Man" (1986; note 199, above), p. 81; excerpt rpt. Flam 1988, p. 323.

208. See my *Matisse in the Collection of The Museum of Modern Art* (note 143, above), p. 39.

209. Wollheim, *Painting as an Art* (note 77, above), pp. 265–77, and for quotations which follow.

210. Matisse, "Rôle et modalités de la couleur" (1945; note 126, above), pp. 237–38; in Fourcade 1972, p. 199; trans. Flam 1973, p. 99.

211. See my *The "Wild Beasts": Fauvism and Its Affinities* (New York: The Museum of Modern Art, 1976), p. 40. A characteristic statement by Matisse on this subject appears in Tériade, "Matisse Speaks" (1952; note 88, above), pp. 42–43; in Flam 1973, p. 132.

212. Quoted in Sarah Whitfield, *Fauvism* (London: Thames & Hudson, 1990), p. 62.

213. Signac to Matisse, summer 1905; ibid., p. 72.

214. Matisse to Manguin, July 31, 1905; ibid., p. 76.

215. Letter of September 28, 1905; quoted in Schneider, *Matisse* (note 16, above), p. 188.

216. See Judi Freeman, *The Fauve Landscape* (Los Angeles: Los Angeles County Museum of Art, 1990), p. 68.

217. Ibid., p. 72.

218. Quoted in Schneider, *Matisse* (note 16, above), p. 262.

219. See my *Matisse in The Collection of The Museum of Modern Art* (note 143, above), p. 180, n. 6.

220. Matisse to Signac, July 14, 1905; quoted in Freeman, *The Fauve Landscape* (note 216, above), p. 73.

221. Derain to Maurice Vlaminck, July 28, 1905, in *Lettres à Vlaminck* (Paris: Flammarion, 1955), pp. 154–55; discussed in my *The "Wild Beasts"* (note 211, above), p. 70.

222. Almost certainly done back in Paris, I believe, are those for which drawings exist which the paintings closely follow, such as *Woman with a Parasol* (illus. Flam, *Matisse* [note 19, above], p. 132) and *Mme Matisse in the Olive Grove* (illustrated in the present text). It is clear from an X-ray of *The Roofs of Collioure* (pl. 62) that it was painted on top of a very carefully rendered drawing (see A. Izerghina, *Henri Matisse: Paintings and Sculptures in Soviet Museums* [Leningrad: Aurora, 1978], p. 126); I think it very probable that it, too, was painted back in Paris. Its infilled areas are more static than those of, for example, *The Open Window* (pl. 61); its few, summary foreground figures are comparable to the figures in *The Port of Abaill, Collioure* (pl. 63). A group of paintings showing nude figures posed in landscapes, among them *Pastoral* (pl. 76) and *Nude in a Wood* (pl. 78), are frequently said to have been done in Collioure in 1905. If Matisse's inventory is to be trusted, these must have been done there the following summer, as must some Collioure landscapes often dated to 1905 (for example, *Landscape at Collioure* [illus. Flam, *Matisse*, p. 126] and the stylistically similar landscape in the Barnes Foundation).

223. Matisse's inventory of his Collioure works refers to *"toiles."* These *pochades* are on board, and yet he surely included them within the fifteen *toiles* he mentions.

224. "The Salon of 1845," in Jonathan Mayne, trans. and ed., *Art in Paris, 1845–1862: Salons and Other Exhibitions Reviewed by Charles Baudelaire* (Oxford: Phaidon, 1965), p. 24.

225. The continuity of Matisse's Neo-Impressionism and Fauvism was first fully discussed by Bock (*Matisse and Neo-Impressionism* [note 32, above], pp. 84–96) and has been elaborated by Bois ("Matisse and 'Arche-drawing'" [note 6, above], pp. 8–21 and passim). I cannot agree with the former, however, when she says (p. 148, n. 85) that there is nothing new about Matisse's Collioure paintings and that they differ from those of his Neo-Impressionist colleagues only "because they are the work of an individual with a different temperament, history and degree of talent." This simply begs the question of how any stylistic development occurs. Nor can I agree with the latter when he says (p. 54) that Matisse's "real point of departure" is *Le bonheur de vivre* (fig. 31). Matisse did work at Collioure, and in Paris afterward, within the context established by Neo-Impressionism—and by Gauguin, van Gogh, and others. But the extent of his extemporization and of his constructive juxtaposition of non-imitative colors is simply without precedent and is a matter not merely of degree but of conception. He probably did not realize the full implications of what he had achieved until he became mired down trying to complete the *The Port of Abaill, Collioure* (pl. 63) in the autumn. By then, however, the move had already been made. Unquestionably, the order of reality shown in *The Open Window* (pl. 61) or *André Derain* (pl. 53), for example, is quite unlike that shown in Neo-Impressionist painting. That order of reality is fully continuous with that of *Le bonheur de vivre*, although the latter picture unquestionably clarified it. Moreover, while that latter picture occasioned the real rupture between Matisse and Signac, it seems clear that Matisse was fully aware by the time he was struggling with *The Port of Abaill* that Neo-Impressionism was of no more use to him. Describing that struggle in a letter to his friend Bussy, Matisse also reported that Signac had purchased *Luxe, calme et volupté* (fig. 9); he added cynically: "It is also in little dots, which caused Signac to buy it from me, of course" (see my *Matisse in the Collection of The Museum of Modern Art* [note 143, above], p. 180, n. 6).

226. See *The Drawings of Henri Matisse* (note 141, above), p. 38, and Bock, *Matisse and Neo-Impressionism* (note 32, above), pp. 64–65.

227. André Marchand, "L'oeil," in Jacques Kober, ed., *Henri Matisse* (Paris: Pierre à Feu [Maeght], 1947), p. 51; in Fourcade 1972, p. 84, n. 19; trans. Flam 1973, p. 114.

228. Tériade, "Constance du fauvisme" (1936; note 99, above), p. 3; in Fourcade 1972, p. 128; trans. Flam 1973, p. 74.

229. Ibid.

230. Tériade, "Matisse Speaks" (1952; note 88, above), p. 43; in Flam 1973, p. 132.

231. Diehl, *Henri Matisse* (note 67, above), p. 32.

232. Interviews with Courthion, 1941 (interview 9, p. 126); trans. Schneider, *Matisse* (note 16, above), p. 242.

233. The literature on possible sources for *Le bonheur de vivre* is large. See, for example: Barr, *Matisse*, pp. 88–89; my *The "Wild Beasts,"* pp. 97–102; and Flam, *Matisse*, pp. 156–63 (notes 14, 211, 19, above).

234. Flam says that the title *Joie de vivre* was given to the painting by Albert Barnes when he purchased it from the Steins (*Matisse*, [note 19, above], p. 157). In fact, Matisse himself occasionally referred to the picture thus, for example in his 1941 conversations with Courthion (note 69, above), and it was used by members of his family (thus, it is given in this form in the catalogue of the 1970 Grand Palais, Paris, exhibition, *Henri Matisse: Exposition du centenaire*, p. 29, which employs family-established titles). However, Matisse more frequently used the title *Le bonheur de vivre*, which he originally assigned to the work at the time of its first exhibition, at the Salon des Indépendants of 1906.

235. I realize that the "possessive" male may be thought of as outside the scene. The idea has merit, for the relationship of the most sensually drawn female (the right-hand middle-ground figure) to the contours of the tree that bends over her reimagines a motif that Matisse certainly knew: the relationship in Correggio's painting in the Louvre of the body of Antiope to the arm of Jupiter above her, which lifts the branch of a tree to reveal her body. However, if we allow this reading, it effectively places the viewer at the *back* of the picture. The viewer *before* the picture is not allowed such close access. In a way that we have seen before, Matisse encloses his figures in absorption so that they are oblivious to the external, facing viewer. And as I explain next, he forces the viewer's eye to keep on moving, preventing it from settling long on any single figure.

236. Leo Steinberg, "Contemporary Art and the Plight of Its Public," in his *Other Criteria: Confrontations with Twentieth-Century Art* (London, Oxford, and New York: Oxford University Press, 1972), p. 7.

237. See Harry Levin, *The Myth of the Golden Age in the Renaissance* (New York: Oxford University Press, 1969). More recent, useful discussions of the pastoral relevant to Matisse's work include Annabel Patterson, *Pastoral and Ideology: Virgil to Valéry* (Berkeley and Los Angeles: University of California Press, 1987), and the exhibition catalogue *Places of Delight: The Pastoral Landscape* (Washington, D.C.: The Phillips Collection in association with the National Gallery of Art, 1988).

238. See Margaret Werth, "Engendering Imaginary Modernism: Henri Matisse's *Bonheur de vivre*," *Genders*, no. 9 (Fall 1990), pp. 49–74, for a fascinating study of the questions of gender and sexuality surrounding this painting, including discussion (p. 65) of the fetal form of the right foreground image. Werth's article raises more questions than it answers, as its author acknowledges, and its psychoanalytic hypotheses suffer from not being related either to the artist's biography or to other works he produced. Nevertheless, its basic conclusion—that Matisse's pastoral myth of origins refers to "the maternal body [as] ground for the myth of imaginary unity" (p. 69)—is, I think, indisputable.
In Freudian terms, the right foreground image is "uncanny," *unheimlich* (literally, "un-home-like"): something secretly familiar that has undergone repression and then returned in an unfamiliar guise (see "The Uncanny," *The Standard Edition of the Complete Psychological Works of Sigmund Freud*, ed. James Strachey [Lon-don: Hogarth, 1953–66], vol. 17, p. 245). Viewed in these terms, Matisse's fantasy of the historical and biological past becomes primarily a picture of the maternal body, "the former home of all human beings." Indeed, the joke that Freud reported when discussing intra-uterine experience—"love is homesickness"—would thus become an appropriate subtitle for *Le bonheur de vivre*.

239. Freud, *Beyond the Pleasure Principle; Standard Edition*, vol. 18, p. 27. The gloss on this in the following sentence borrows from Charles Bernheimer, "A Shattered Globe: Narcissism and Masochism in Virginia Woolf's Life-Writing," in Richard Feldstein and Henry Sussman, eds., *Psychoanalysis and . . .* (New York and London: Routledge, 1990), p. 190.

240. Northrop Frye, *A Natural Perspective: The Development of Shakespearean Comedy and Romance* (New York: Harcourt, 1965), p. 119.

241. Matisse, "Témoignages" (1952; note 119, above), p. 66; in Fourcade 1972, p. 246; trans. Flam 1973, p. 136.

242. It is often said that the cutouts formed Matisse's ultimate solution to what he called "the eternal conflict of drawing and color in the same individual" (Fourcade 1972, p. 188), for which *Le bonheur de vivre* first proposed a solution by remedying the separation of color and drawing in *Luxe, calme et volupté*. But this does not address how he got from the first to the last solution. Bois, "Matisse and 'Arche-drawing'" (note 6, above), is devoted mainly to this problem and proposes that with *Le bonheur de vivre* Matisse foreclosed the very possibility of conflict between drawing and color. He follows what John Golding and I wrote in *The Drawings of Henri Matisse* (note 141, above), pp. 12, 38–40, about the importance in Fauvism of drawing in color, but goes a further step, suggesting that this revealed to Matisse a kind of area drawing that comprised, in effect, a language "prior" to the separation of drawing and color. This allows for continuity between *Le bonheur de vivre* and the cutouts and has the added advantage of avoiding the idea that Matisse's essential task is one of "overcoming" conflict, an idea as problematical as the notion that he sought to overcome the merely hedonistic. (Both ideas merely dismiss the aspect of his art their proponents happen to dislike.) However, Bois's theory leaves us with two difficulties. First, even if we are prepared to characterize the relation of drawing and color not as a conflicted one, but as compromising a prior unified language which may merely reveal gaps when things did not go as Matisse wished; even so, we must acknowledge, I think, that the territory between *Le bonheur de vivre* and the cutouts is marked, statistically, by more gaps than unities. And second, Matisse simply did not say that there was procedural continuity between the two, but rather stressed his "different means." Even this very novel interpretation of Matisse offers what is ultimately an organic, Romantic model of his art. Thus, I obviously cannot agree with Rosalind Krauss's recent assertion that "most art-historical assumptions about Matisse are convincingly swept away by the logic of [Bois's] argument" ("Letters," *Art in America*, vol. 80, no. 5 [May 1992], p. 31).

243. Letter to Aleksandr Romm, February 14, 1934, in *Matisse: Paintings, Sculpture, Graphic Work, Letters* (Moscow: The State Pushkin Museum, 1969), p. 131; in Fourcade 1972, p. 147; trans. Flam 1973, p. 69.

244. Matisse, "Comment j'ai fait mes livres," *Anthologie du livre illustré par les peintres et sculpteurs de l'École de Paris* (Geneva: Skira, 1946), p. xxiii; in Fourcade 1972, p. 213; trans. Flam 1973, p. 109.

245. *Blue Nude* was exhibited at the 1907 Salon des Indépendants under the title *Tableau III*. Flam, *Matisse*, p. 196, made the association with the preceding two works, shown at the Indépendants in, respectively, 1905 and 1906. It is possible, of course, that the title printed in the catalogue was not Matisse's.

246. Letter to Bonnard, May 7, 1946, in *Bonnard–Matisse Correspondance* (note 4, above), p. 127; in Fourcade 1972, p. 49, n. 15.

247. Di Piero, "Matisse's Broken Circle" (note 133, above), p. 28, quoting Matisse's statement on Giotto.

248. Robert Reiff, "Matisse and Torii Kiyonaga," *Arts Magazine* (February 1981), pp. 164–67, related *Le luxe (I)* to Kiyonaga's *Visitors to Enoshima*. Another possible source is Prud'hon's *Crucifixion* in the Louvre, which Matisse had copied as a student.

249. See Gombrich, "Action and Expression in Western Art" (note 145, above), pp. 78–104.

250. Benjamin's conception of allegory is examined in relationship to Courbet's work, in a manner that is relevant to Matisse's, in Linda Nochlin's "Courbet's Real Allegory: Rereading *The Painter's Studio*," in Faunce and Nochlin, eds., *Courbet Reconsidered* (note 171, above), pp. 21–23.

251. Letter to the author, May 5, 1992.

252. Of course, Apollo was an embodiment of the rational and civilized side of man's nature. However, this obscure episode in the story of Apollo allows interpretation as a temporary surrender of rationality to sensual pleasure. If I am correct in thinking that the central figure was originally a flautist, then a further association exists with the Apollo myth; namely, with that of the musical contests between Apollo and Marsyas and between Apollo and Pan. In both cases, Apollo's adversaries played reed pipes, instruments that were accepted phallic symbols and whose coarse notes were thought to stir the passions. Apollo, in contrast, played a stringed instrument, felt to have a spiritually uplifting quality. Matisse himself, of course, played the violin, and violinists in his paintings are commonly taken to be surrogate self-portraits.

253. Quoted in Denis Donoghue, *The Arts Without Mystery* (Boston and Toronto: Little, Brown, 1983), p. 12.

254. The pose of the figure also recalls that of the left-hand figure in *Music* (oil sketch) (fig. 19). The sculpture, which Matisse owned, is illustrated in Jack Flam, "Matisse and the Fauves," in William Rubin, ed., *"Primitivism" in Twentieth-Century Art: Affinity of the Tribal and the Modern* (New York: The Museum of Modern Art, 1984), p. 214, where a still life by Matisse of about 1906–07 which shows the sculpture is also illustrated. The pose of hands to face also recalls that of a figure in Gauguin's painted wood relief *Soyez amoureuses, vous serez heureuses* of 1901. See Gowing, *Matisse* (note 3, above), p. 105, where the Gauguin is compared to Matisse's *Music* (pl. 126).

255. Tériade, "Matisse Speaks" (1952; note 88, above), p. 50; in Flam 1973, p. 134.

256. Apollinaire, "Henri Matisse" (1907; note 76, above); in Fourcade 1972, p. 55; trans. Flam 1973, p. 31.

257. Tériade, "Constance du fauvisme" (1936; note 99, above), p. 3; in Fourcade 1972, p. 129; trans. Flam 1973, p. 74. See Gowing, *Matisse* (note 3, above), pp. 105–07, for discussion of the importance of the artist's self-observation; and pp. 94–95, for discussion of *Dance (II)* and *Music*, to which what I say here is indebted.

258. Estienne, "Entretien avec M. Henri-Matisse" (1909), p. 4; in Fourcade 1972, p. 61; trans. Flam 1973, p. 48.

259. Tériade, Visite à Henri Matisse," (1929; note 117, above); in Fourcade 1972, p. 96; trans. Flam 1973, p. 58.

260. Ibid.

261. For example, Matisse sent Michael Stein a postcard dated May 26, 1911, on which he included the following note with his sketch of *The Painter's Family*: "It is well under way, but as it isn't finished, there is nothing to say—that isn't logical, but I am uncertain of its success. This all or nothing is very exhausting" (Barr, *Matisse* [note 14, above], pp. 152–53).

262. See note 259, above.

263. See Frye, *A Natural Perspective* (note 240, above), p. 34, for this quality in the works of Shakespeare. My reference to *Timon* was prompted by Frye's, p. 36.

264. Again, a comparison with Ingres suggests itself. See Wollheim, *Painting as an Art* (note 77, above), p. 275.

265. I borrow this contrast from Frye, *A Natural Perspective* (note 240, above), p. 123, and will return to it later.

266. Tériade, "Constance du fauvisme" (1936; note 99, above), p. 3; in Fourcade 1972, p. 128; trans. Flam 1973, p. 74.

267. Gowing, *Matisse* (note 3, above), p. 111.

268. Matisse, "Le chemin de la couleur," ed. Gaston Diehl, *Art présent*, no. 2 (1947), p. 23; in Fourcade 1972, p. 203; trans. Flam 1973, p. 116.

269. Ibid.; in Fourcade 1972, p. 204; trans. Flam 1973, p. 116.

270. Frye, *A Natural Perspective*, pp. 119–21, for this and the quotations from Frye which follow.

271. See E. H. Gombrich, "Moment and Movement in Art," in *The Image and the Eye* (note 145, above), p. 51.

272. See note 232, above.

273. Gowing, *Matisse* (note 3, above), p. 111.

274. See Frye, *A Natural Perspective* (note 240, above), p. 123.

275. See my "Matisse in Morocco: An Interpretive Guide," in *Matisse in Morocco: The Paintings and Drawings, 1912–1913* (Washington, D.C.: National Gallery of Art, 1990), pp. 224–26.

276. Barr, *Henri-Matisse* (note 56, above), p. 18.

277. On these specific aspects of Cubist influence, see my *Matisse in the Collection of The Museum of Modern Art* (note 143, above), pp. 100–02, 105–07. The best general discussion of this subject remains John Golding's *Matisse and Cubism* (Glasgow: University of Glasgow Press, 1978).

278. See, notably, Matisse's letter of June 1, 1916 to Hans Purrmann, quoted in Barr, *Matisse* (note 14, above), pp. 181–82. The influence of the war, and of Cubism, on Matisse's work of this period is sensitively treated in Catherine C. Bock, "Henri Matisse's *Bathers by a River*," *The Art Institute of Chicago Museum Studies*, vol. 16, no. 1 (1990), pp. 45–55, 92–93.

Relevant to this is a postcard that Matisse wrote in 1953 to the then director of The Art Institute of Chicago, informing him that *Bathers by a River* (just acquired by that institution) was one of his five pivotal works, another being *The Moroccans* (fig. 37) (see Bock, "Henri Matisse's *Bathers by a River*," p. 55). We do not know what the other three are, but may surmise that they are probably *Music* (pl. 126) and *Dance (II)* (fig. 22)—the original companions to the *Bathers by a River*—and *Le bonheur de vivre* (fig. 31), because Matisse stressed its crucial importance to him around the time he wrote to Chicago. If this is correct, all five pivotal works belong to one or the other period I associate here.

279. The extraordinary photographs of Matisse working on *Bathers by a River* taken in May 1913 by Alvin Langdon Coburn, which we reproduce here for the first time (see pages 236, 238, 239), conclusively demonstrate how it evolved from a composition of more organic shapes comparable to that of *Music*.

280. Barr, *Matisse* (note 14, above), p. 173.

281. Henri Bergson, *Creative Evolution* (1911), trans. Arthur Mitchell, Foreword by Irwin Edman (New York: Modern Library, 1944), p. 5.

282. Matisse, "Le noir est une couleur," *Derrière le miroir*, no. 1 (December 1946), n.p.; in Fourcade 1972, pp. 202 (n. 64), 203; trans. Flam 1973, pp. 106–07.

283. Gowing, *Matisse* (note 3, above), p. 107.

284. Tériade, "Matisse Speaks" (1952; note 88, above), p. 42; in Flam 1973, p. 132.

285. Gowing, *Matisse* (note 3, above), p. 130.

286. "Letter from Matisse" (February, 14, 1948), in *Henri Matisse: Retrospective Exhibition of Paintings, Drawings, and Sculpture* (Philadelphia: Philadelphia Museum of Art, 1948), pp. 15–16.

287. Apollinaire, "M. Bérard inaugure le Salon d'automne," *L'intransigeant* (November 14, 1913); in *Chroniques d'art*, p. 331 and Flam 1988, p. 151. Apollinaire, "Salon d'automne: Henri-Matisse," *Les soirées de Paris* (November 15, 1913); trans. *Apollinaire on Art*, p. 331 and Flam 1988, p. 151.

288. Barr, *Matisse* (note 14, above), p. 183.

289. Flam, *Matisse* (note 19, above), p. 371.

290. Of his *Themes and Variations* drawings, Matisse wrote: "When I make my drawings—'Variations'—the path traced by my pencil on the sheet of paper is, to some extent, analogous to the gesture of a man groping his way in the darkness. I mean that there is nothing foreseen about my path: I am led. I do not lead. I go from one point in the thing which is my model to another point which I always see in isolation, independent of the other points toward which my pen will subsequently move" (quoted in Aragon, *Henri Matisse* [note 71, above], vol. 1, p. 234). This text beautifully conflates the notions of "disunity" and unseeable internal space that I have been discussing. It is interesting to note that Matisse did attempt drawing blindfolded. A chalk drawing made in this way appears in the background of a photograph reproduced in the present volume (page 356). And it is also interesting that in 1916, the year of *The Moroccans*, Matisse purchased Courbet's *The Source of the Loue* (now in the Albright-Knox Art Gallery, Buffalo, New York). The cave-like shape on the right edge of Matisse's painting is only a superficial instance of a much deeper affinity.

291. The most thorough account of the two Pellerin paintings may be found in Isabelle Monod-Fontaine, *Matisse* (Paris: Musée National d'Art Moderne, Centre Georges Pompidou, 1989), p. 58.

292. Wollheim, *Painting as an Art* (note 77, above), p. 277.

293. Matisse's interest, in the contemporaneous Lorette paintings, in the multiplicity of images producible from one face finds its counterpart here in his interest in more than one face sharing the same image. Another example of this is the 1914 print of Bourgeat (pl. 173), of which we are told: "En gravant cette plaque Matisse pense à un ami d'enfance, le Dr. Vassaux, et c'est bien plus le portrait de Vassaux qu'il exécute que celui de Bourgeat" (Marguerite Duthuit-Matisse and Claude Duthuit, *Henri Matisse: Catalogue raisonné de l'oeuvre gravé [. . .]* [Paris, 1983], vol. 1, p. 36, no. 40). It should additionally be observed that the painting represented behind Pellerin in Matisse's portrait of him would seem to be a work by Cézanne.

294. On the eve of this essay's going to press, a preliminary, discarded version of the Barnes mural was rediscovered in France. See Pierre Schneider, "Henri Matisse: 'La danse' ressuscitée," *L'express*, no. 2134 (June 5–11, 1992), pp. 52–56, 58. It is clear even from a reproduction that this preliminary version does not employ the banded fields of the two completed versions, and is therefore much closer to Matisse's bare figure/ground compositions of 1909–10.

The plates record the exhibition "Henri Matisse: A Retrospective," with the following exceptions. Three works in the exhibition are reproduced as text figures, in the chronology, as indicated in their respective captions. And, in order to fully document Matisse's development, we have included a number of works unavailable to the exhibition (either because of their fragile condition or because of restrictions imposed when they were donated or bequeathed to the institutions where they are now housed), notably pls. 50, 58, 64, 73, 126, 145, 163, 290, and 291. A precise checklist of the exhibition's contents is available from the Museum.

TITLES OF WORKS. Wherever possible, the titles given here are the earliest published titles on record, unless superseded by others that became established within Matisse's lifetime. There are two general exceptions to this policy: (1) For most paintings dating from 1917 to 1930, we follow (with occasional slight modification) the detailed descriptive titles given in *Henri Matisse: The Early Years in Nice, 1916–1930* (see the Bibliographical Note), which were developed in consultation with the Archives Henri Matisse in order to distinguish works of similar subjects. (2) In the case of prints and illustrated books, the titles follow those assigned in the catalogues raisonnés of these works (also cited in the Bibliographical Note). Throughout, a diagonal slash (/) is used to divide two alternative titles when both became established in Matisse's lifetime and remain in common use.

Parentheses enclosing numerals indicate that these numerals were not part of the original title. We have included them, however, especially in the case of pairs of works, to show the order in which such works are thought to have been made.

Titles placed in square brackets have been given when they significantly differ from the ones that became established later in Matisse's lifetime. The bracketed titles are the earliest published titles on record or, in the case of works in Section VI, the titles used in the artist's own records, as listed by his assistant, Lydia Delectorskaya, in her book *L'apparente facilité* (see the Bibliographical Note). On a few occasions, two such titles appear in brackets, divided by a semicolon.

PLACES AND DATES OF EXECUTION. Places of execution are given by city and, when known, by the name of Matisse's residence or studio, further details of which may be found in the chronology. Dates of execution are given by year, preceded by season, where known, except for: works which are dated more precisely by their inscriptions; and those works in Section VI where it is known that precise records were kept by Lydia Delectorskaya, as shown in *L'apparente facilité.*

Any part of either the place or date of execution enclosed in square brackets indicates that no firm documentation (such as references in contemporaneous letters or accounts, or inscriptions on the work itself) exists for this information, and that it represents, rather, what our research indicates to be probable. Where there is less certainty as to the date of a work, the designation "c." for *circa* is also used; where we have proposed or adopted a particularly speculative date, a question mark is used.

Dates for sculpture refer to the date of execution of the original clay or plaster model.

MEDIUMS AND DIMENSIONS. This information derives from the owners or custodians of the works as provided to the Museum. Drawings and prints are on white or near-white paper, unless noted otherwise. The description "gouache on paper, cut and pasted" is used for Matisse's cutouts, to indicate that the paper in these works was pre-painted by the artist or his assistants. Dimensions are given in inches and (in parentheses) in centimeters; height precedes width, followed, in the case of sculpture, by depth. Unless otherwise specified, drawings and cutouts are works on paper, for which sheet sizes are given. For prints, plate or composition sizes also appear.

INSCRIPTIONS. Inscriptions are shown in the precise form in which they appear on the works, and their locations are indicated. In the case of sculpture, in order to avoid detailed descriptions of the location only the inscription itself is generally listed. Where a founder is known, that information follows the inscription.

COLLECTIONS. These are given in the form requested by the owners or custodians of the works. In many cases, we have indicated former collections when the objects in question previously belonged to major early collectors of Matisse's work or were in private collections for which important published catalogues exist. This information, however, is necessarily highly selective.

Plates and Chronology

Catalogue by John Elderfield with Beatrice Kernan
including a chronology compiled with Judith Cousins

15/30
Henri Matisse

Henri Matisse Etching [1900–03]. Drypoint, printed in black: composition 5⁵⁄₁₆ × 7⁷⁄₈″ (15.1 × 20.1 cm); sheet 13 × 20¹⁄₁₆″ (32.9 × 51 cm). The Museum of Modern Art, New York. Gift of Mrs. Bertram Smith.

PART I ✦ 1869–1905

DISCOVERING MODERN ART

Matisse's first experience of painting was as a twenty-year-old law clerk in 1890, convalescing from appendicitis at his parents' home in the northern French town of Bohain-en-Vermandois. Painting opened for him, he said, a kind of paradise, set apart from the prosaic world. Within a year or so, he had abandoned law and was in Paris studying painting.

His earliest works were dark still lifes in a manner ultimately derived from Dutch naturalism. At the École des Beaux-Arts in Paris, he made academic studies from plaster casts and from posed models (see pl. 4), and he copied pictures at the Louvre (pl. 3). While he rejected the stultifying conservatism of academic training, nonetheless its emphasis on representation of the human figure and on deep knowledge of the art of the past would assume great importance for him, too. In the middle and late 1890s, however, it was modern art that slowly began to engage his attention. The forms in his still lifes softened and started to brighten, acquiring a silvery, Corot-like luminosity (pl. 6). The landscapes he painted during summers spent in Brittany (pls. 10, 11) are sometimes desolate vistas, revealing an unexpected side of Matisse that recalls Edvard Munch. But still lifes and landscapes alike opened his art to the sensation of naturalistic light, and consequently to Impressionism. His *Dinner Table* (pl. 13) of 1896–97, though not overtly Impressionist, is nevertheless his first truly modern work, marking the point at which he irrevocably commits himself to the vocabulary of contemporary painting.

Once this commitment is made, Matisse's art rapidly changes. During an extended stay in Corsica and Toulouse in 1898–99, he produced an important group of paintings in high-

key, arbitrary colors and with unnaturalistically broken or atomized forms (pls. 14–17, 19, 20). The still lifes in particular are constructed purely from the relationships between colors, whose descriptive function is only summarily indicated. These "proto-Fauve" paintings suddenly reveal the nature of Matisse's genius as a colorist: his using color not to imitate light, but to create it.

These paintings also reveal his emerging interest in Neo-Impressionism and in the work of Cézanne. Back in Paris, the latter would predominate. Indeed, Matisse began to emulate Cézanne and would speak of him as a "god of painting." Until 1904, an architectonic style concerned with expressing volume as color—through juxtaposed patches of different colors, as in *Male Model* (pl. 26), or through sculptural masses composed of variations of a single color, as in *Carmelina* (pl. 37)—dominated his production. Paintings in this style, based mainly on the bodily image, are physically more substantial than any he had done earlier: ruggedly and energetically modeled. Not surprisingly, they led him to study sculpture. Less probable, perhaps, was his working simultaneously in a variety of other styles during this same period. Next to Cézannist works, there are also delicately tonal paintings (pl. 34), almost Gauguinesque paintings (pl. 38), and others that return to a form of Neo-Impressionism (pl. 41).

This last alternative to Cézannism became, by late 1904, his principal means of expression. *Luxe, calme et volupté* (pl. 50), painted in a fully fledged Neo-Impressionist style, was his first imaginary figure composition. This modernized image of arcadia reimagined the pastoral paintings he had studied in the Louvre, to create anew a paradisal world of his own.

Matisse at age nineteen with his mother, Anna Héloïse Gérard Matisse, 1889.

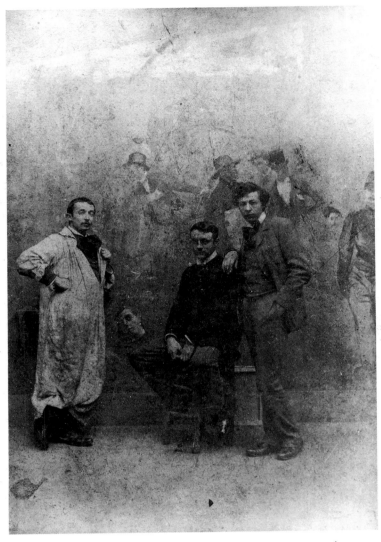

The atelier of Adolphe-William Bouguereau, 1891–92. Left to right: Émile Jean, Matisse, and Jean Petit.

1869

DECEMBER 31: Henri-Émile-Benoît Matisse born in the north of France at Le Cateau-Cambrésis, in the house of his maternal grandparents; is the first child of Émile-Hippolyte-Henri Matisse, a hardware and grain merchant, and his wife, Anna Héloïse Gérard.

1870

JANUARY: His parents, formerly domiciled in Paris, settle in Bohain-en-Vermandois (near Le Cateau-Cambrésis).

1872

JULY 9: Birth of brother, Émile-Auguste, in Bohain. (Dies April 4, 1874.)

1874

JUNE 19: Birth of brother, Auguste-Émile, in Bohain.

1882

SEPTEMBER: Attends the Collège de Saint-Quentin and the Lycée Henri-Martin in Saint-Quentin, to 1887.

1887

OCTOBER: Arrives in Paris and registers at law school.

1888

AUGUST 4: Passes law examination. Subsequently returns to Bohain.

1889–90

Works as a clerk in a law office in Saint-Quentin.

Attends early morning classes, studying the elements of drawing, at the municipal École Quentin de La Tour in Saint-Quentin, which offers training in tapestry and textile design.

After a severe attack of appendicitis, recuperates for a number of months at his parents' home in Bohain. During convalescence, begins painting as an amateur after being given a box of colors by his mother. Will make his first painting, *Still Life with Books*, in June 1890 (pl. 1).

Is exempted from military service, July 23, 1889.

Having recovered his health, returns to work at the law office in Saint-Quentin. Continues to paint in his spare time.

1891

Decides to abandon law career in favor of painting. His father strenuously objects, but finally permits him to go to Paris to study and provides an allowance.

OCTOBER 5: Registers at the Académie Julian in Paris, preparing for the entrance competition to the École des Beaux-Arts; lists his ad-

The Music Lesson (after Jean-Honoré Fragonard). [c. 1893–96]. Oil on canvas, 33 × 41″ (84 × 104 cm). Private collection.

The Hunt (after Annibale Carracci). 1894. Oil on canvas, 54″ × 8′ 4″ (137 × 254 cm). Musée de Grenoble.

dress as no. 32, rue des Écoles. Studies under the conservative painter Adolphe-William Bouguereau, who, along with the École des Beaux-Arts itself, will come to symbolize for him everything moribund in the art of the past.

1892

FEBRUARY: Fails entrance examination to the École des Beaux-Arts.

Disillusioned with working under Bouguereau, leaves the Académie Julian. A visit to the Musée des Beaux-Arts in Lille, where he sees paintings by Chardin and Goya, bolsters his determination to go on painting.

SPRING (OR THE FOLLOWING WINTER): Draws from plaster casts of antique sculpture in the courtyard of the École des Beaux-Arts. Attracts the attention of the newly appointed, liberal instructor, the Symbolist painter Gustave Moreau, who invites him to join his studio informally. There, he draws and paints from the model and, at Moreau's urging, makes quick sketches on the streets of Paris.

OCTOBER 10: To maintain academic standing, enrolls for a year at the École des Arts Décoratifs, taking courses in geometry, perspective, and composition. Becomes friendly with fellow student Albert Marquet.

1893

APRIL 25: Encouraged by Moreau to study at the Louvre, registers to copy Jan Davidsz. de Heem's *La desserte* (pl. 3). Over the next eleven years, will copy over twenty-five works at the Louvre, some from the Spanish, Dutch, and Italian schools, but most of them French paintings from the seventeenth and eighteen centuries, including works by Poussin, Watteau, Fragonard, and Chardin. Some copies are done for his relatives in Le Cateau.

OCTOBER: Re-enrolls for a further year at the École des Arts Décoratifs, again taking courses in geometry and perspective.

1894

SEPTEMBER 3: Birth of his daughter, Marguerite Émilienne, to Caroline Joblaud, in Paris.

WINTER: Again prepares for the entrance examination to the École des Beaux-Arts.

1895

MARCH: Accepted by the École des Beaux-Arts after passing the examination; finishes forty-second out of eighty-six candidates accepted. Officially admitted to Moreau's class, which he paints as *The Atelier of Gustave Moreau* (pl. 4). Other students of Moreau's, several of whom will become Matisse's lifelong friends, include Simon Bussy, Charles Camoin, Georges Desvallières, Henri Evenepoel, Jules Flandrin, Charles Guérin, Henri Manguin, Albert Marquet, Theodor Pallady, Georges Rouault, and André Rouveyre.

MAY–JUNE: At the Palais Galliera, sees the large centennial exhibition of Corot, whose influence will be reflected in the silvery tonality of still lifes such as *Still Life with Grapes* (pl. 6).

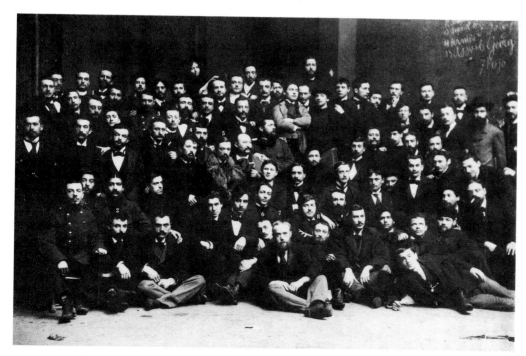

Gustave Moreau's students at the École des Beaux-Arts, 1897. (1) Matisse, (2) Edmond Milcendeau, (3) René Piot, (4) François Martel, (5) Simon Bussy, (6) Albert Marquet, (7) Georges Rouault, (8) Léon Bonhomme, (9) Henri Evenepoel.

Prior to summer, has moved into the fifth floor of no. 19, quai Saint-Michel, near Notre-Dame; this will be his Paris residence until 1908.

SUMMER: Spends ten days at Belle-Île in Brittany with the painter Émile Wéry.

1895–96 SEASON

DECEMBER: Cézanne has his first one-artist exhibition, organized by Ambroise Vollard. Matisse may see the exhibition. At this date, however, his own paintings, mainly still lifes and interiors such as *Woman Reading* (pl. 5), continue to be tonally conceived.

1896

FEBRUARY: The state purchases his 1894 copy after Annibale Carracci's *The Hunt*.

APRIL: Exhibits at the Salon des Cent, the triennial exhibition of the Symbolist journal *La plume*, in its rue Bonaparte galleries. This is his first recorded exhibition.

APRIL 25–MAY: Exhibits five paintings at the prestigious Salon de la Société Nationale des Beaux-Arts, a relatively conservative salon. Sells two paintings; one of them, *Woman Reading* (pl. 5), is bought by the state. Is honored by election as an associate member of the Société Nationale, nominated by its president, Pierre Puvis de Chavannes.

Matisse at the time of his marriage to Amélie Parayre, 1898.

Amélie Parayre (Mme Matisse) in Ajaccio, Corsica, 1898.

The Buffet (after Jean-Baptiste-Siméon Chardin). 1896. Oil on canvas, 6′ 3″ × 50¾″ (190 × 129 cm) Musée de Montélimar. On extended loan to the Château de Grignan.

SUMMER: Second and more prolonged stay with Wéry in Brittany, where he paints *Open Door, Brittany* (pl. 9), grisaille landscapes (pls. 10, 11), and Dutch-inspired still lifes and interiors, including *Breton Serving Girl* (pl. 12), for which Caroline Joblaud poses. Meets the Australian painter and collector John Russell.

1896–97 SEASON

OCTOBER: Returns to Paris and to Moreau's studio. Begins work on a state-commissioned copy of Chardin's *The Buffet* and on a large painting, *The Dinner Table* (pl. 13), having been encouraged by Moreau to undertake an ambitious composition.

1897

FEBRUARY: Gustave Caillebotte's bequest of Impressionist paintings is put on view in a newly constructed annex of the Musé du Luxembourg. Matisse is especially interested in the work of Claude Monet.

FEBRUARY 10: Legally recognizes Marguerite as his daughter. His relationship with her mother, Caroline Joblaud, will end later in the year.

MARCH 18–APRIL 3: Simon Bussy exhibits landscapes at the Durand-Ruel gallery; he introduces Matisse to the elder Impressionist Camille Pissarro, who accompanies Matisse on a visit to the Caillebotte bequest. Pissarro becomes a friend and advisor of Matisse.

APRIL 24: Opening of the Salon de la Société Nationale; he exhibits five paintings, including *The Dinner Table* (pl. 13), which offends the more conservative members of the Salon and is hung badly. Moreau, however, defends the picture.

LATE JUNE: Begins a copy of Chardin's *The Ray* (pl. 32), which he will transform over the years through about 1903.

SUMMER: Third trip to Brittany. Again paints in Belle-Île, this time in a more Impressionist manner. Acquires two van Gogh drawings through John Russell.

1897–98 SEASON

AUTUMN: Is back in Paris. Plans to marry Amélie-Noémie-Alexandrine Parayre (from Beauzelle, near Toulouse), whom he has met some months earlier.

Relationship with Moreau deteriorates because of the overtly Impressionist character of Matisse's new work.

Sees works by van Gogh and Cézanne at Ambroise Vollard's gallery.

1898

JANUARY 8: Marries Amélie Parayre. The two spend their short honeymoon in London; while there, Matisse, following Pissarro's advice, sees works by J. M. W. Turner. The couple will return to Paris.

1898–99 SEASON: AJACCIO/TOULOUSE

FEBRUARY: With Mme Matisse, leaves Paris for a six-month stay in Ajaccio, Corsica, his first visit to the south. His works there, such as *Sunset in Corsica* (pl. 14) and *Small Door of the Old Mill* (pl. 16), are more freely painted and higher-keyed in color than any he has done before.

APRIL 18: Death of Gustave Moreau. His studio at the École des Beaux-Arts will be taken over by Fernand Cormon.

MID- TO LATE JUNE: With Mme Matisse, briefly visits Paris, then returns to Corsica. While in Paris, he may see the Salon des Indépendants (April 19–June 18), where Paul Signac's Neo-Impressionist paintings are on view, or exhibitions of Cézanne at the Ambroise Vollard gallery (May 9–June 10), Pissarro at the Durand-Ruel gallery (June 1–18), and Monet at the Georges Petit gallery (June 1–30). During May–July, Signac's book *D'Eugène Delacroix au néo-impressionnisme* is published serially in *La revue blanche*.

AUGUST: With Mme Matisse, travels from Corsica to the Toulouse region (Beauzelle and Fenouillet), where the two remain with Mme Matisse's family for six months while she is pregnant.

In this period, his paintings, especially the still lifes, become increasingly bold in their use of vivid, arbitrary colors; these works are thus subsequently considered "proto-Fauve."

Paul Cézanne. *Three Bathers*. c. 1879–82. Oil on canvas, 23¾ × 21½" (60.3 × 54.6 cm). Musée du Petit Palais, Paris. Formerly collection Henri Matisse.

1899

JANUARY 10: Birth of first son, Jean Gérard, in Toulouse.

Toward the end of this stay in Toulouse, some of his paintings, for example *Sideboard and Table* (pl. 19), reveal the influence of Neo-Impressionism in their densely painted, dappled surfaces.

FEBRUARY: With family, returns to Paris, to no. 19, quai Saint-Michel. Still works in the high-key color of his "proto-Fauve" style, which will continue into 1900, in works such as *Still Life Against the Light* (pl. 18). However, Neo-Impressionist influence will give way to more planar composition as he is affected by Cézanne.

Works under Fernand Cormon at the École des Beaux-Arts but finds his teaching uninspiring. Will be asked to leave at the end of the year because he is then thirty years of age.

MARCH: The Durand-Ruel gallery holds an important exhibition of Symbolists, Neo-Impressionists, and "colorists" grouped around Odilon Redon. In neighboring rooms are displayed works by the older Impressionists.

MAY: Exhibits four still lifes and a drawing in the Salon de la Société Nationale; this is the last time he participates in a conservative salon. The critic Raymond Bouyer notices the influence of Chardin and Cézanne in his work.

SUMMER: Spends a month in Toulouse with Mme Matisse and her family, then returns to Paris.

1899–1900 SEASON

From Vollard, buys Cézanne's painting *Three Bathers* and Rodin's plaster bust of Henri de Rochefort; exchanges one of his own paintings with Vollard for Gauguin's Tahitian *Head of a Boy*; purchases a van Gogh drawing.

Begins his first sculpture in the round, a study after Antoine-Louis Barye's *Jaguar Devouring a Hare*; the work will be completed in 1901.

With the birth of his son Jean, his difficulty in selling paintings, and his outlay of funds for purchasing works of art, Matisse's family suffers increasing financial problems.

OCTOBER: Mme Matisse opens a millinery shop at no. 25, rue de Châteaudun in Paris, to supplement the family's income.

Matisse joins Marquet in a job painting decorations of the Grand Palais, being built for the Exposition Universelle to open in May 1900.

DECEMBER: Cézanne exhibition at the Ambroise Vollard gallery.

1900

Still in financial hardship, which will continue through 1903. In these years, his art reveals the strong influence of Cézanne, most evidently in the facet modeling of works such as the 1900 painting *Male Model* (pl. 26) and the 1900–04 sculpture *The Serf* (pl. 25). Other works, such as the *Self-Portrait* (pl. 22) of about 1900, one of his first painted self-portraits, conflate Cézanne-influenced modeling with the high-key color characteristic of the 1899 Toulouse paintings, while yet others, such as *Carmelina* (pl. 37) of 1903–04, reveal a more continuously modeled style. Makes numerous drawings, especially from the figure, in these years, as well as his first etchings. Also makes a stylistically very diverse group of paintings of Pont Saint-Michel and Notre-Dame, seen from the window of his quai Saint-Michel studio (pls. 39, 40, 42).

MAY 10–26: Redon exhibition at the Durand-Ruel gallery. Matisse purchases two pastels, *Radiant Flowers* and *Death of the Buddha*.

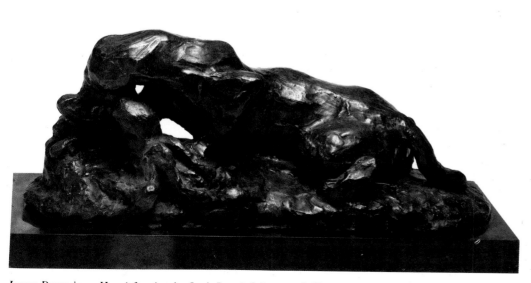

Jaguar Devouring a Hare (after Antoine-Louis Barye). [1899–1901]. Bronze, 9⅛ × 22 × 9⅛" (23 × 56 × 23 cm). Musée National d'Art Moderne, Centre Georges Pompidou, Paris.

Notre-Dame as seen from the window of Matisse's studio on the quai Saint-Michel, Paris.

1900–01 SEASON

JUNE 1–LATE NOVEMBER: Retrospective exhibition of Rodin sculptures in a specially constructed pavilion on the place de l'Alma in Paris; includes the small-scale *Walking Man*, considered to have influenced Matisse's *The Serf* (pl. 25).

JUNE 13: Birth of his second son, Pierre, in Bohain.

JULY 9: Returns to the Académie Julian; remains for one month.

AUTUMN–WINTER: Attends sculpture classes in the evenings at the École d'Art Municipale and works at the studio of La Grande-Chaumière under the sculptor Antoine Bourdelle. Draws from life at the Académie Colarossi. For a few months, beginning in September, studies figure painting with Eugène Carrière at the Académie Carrière, where he meets Jean Biette, Auguste Chabaud, André Derain, Pierre Laprade, and

Jean Puy, and where he paints *Standing Model* (pl. 28) and *Model with Rose Slippers* (pl. 31). When the Académie Carrière closes, works with this group in Biette's studio. Remains in contact with friends from Moreau's studio, including Camoin, Manguin, and Marquet.

Makes many drawings after sculptures in the Louvre. Shows his drawings to Auguste Rodin, who praises their facility but suggests he do more detailed works.

1901

WINTER: Contracts bronchitis; his father takes him to Villars-sur-Ollon, Switzerland, for several weeks to recuperate. There he paints a few landscapes of modest size.

MARCH 15–31: Sees the van Gogh retrospective exhibition at the Bernheim-Jeune gallery; there Derain introduces him to Maurice Vlaminck. Shortly afterward, Matisse visits the

two of them at Chatou and is impressed by their work.

APRIL 20–MAY 21: Exhibits at the Salon des Indépendants for the first time, showing ten works—sketches, still lifes, and figure studies, possibly including *Model with Rose Slippers* (pl. 31). Elected a *sociétaire* of the Salon.

Father discontinues his allowance, possibly as a result of seeing the Salon des Indépendants.

JULY 8: His brother, Auguste-Émile, marries Jeanne-Louise-Rosalie Thiéry. They will reside in Bohain-en-Vermandois.

1901–02 SEASON

WINTER: Matisse and his family stay at his parents' home in Bohain-en-Vermandois until February; there he paints *Studio Under the Eaves* (pl. 33).

1902

FEBRUARY: At her recently opened gallery, Berthe Weill exhibits works by six former students of Moreau's, including Flandrin, Marquet, Jacqueline Marval, and Matisse.

MARCH 28–MAY 5: Exhibits six paintings at the Salon des Indépendants.

APRIL: Berthe Weill finds a buyer for one of his works, the first to be sold by a dealer.

1902–03 SEASON

WINTER: With Mme Matisse, again goes to Bohain; except for brief visits to Paris, remains in that region through the end of 1903.

1903

MARCH 20–APRIL 25: Camoin, Manguin, Marquet, Matisse, and Puy are represented in the Salon des Indépendants, along with the future Fauves Othon Friesz and Raoul Dufy, whom Matisse has not yet met. He shows seven paintings and a drawing.

MAY 4–31: Represented in a group exhibition at the Berthe Weill gallery by two still lifes.

MAY–JUNE: Apparently sees an exhibition of Islamic art at the Musée des Arts Décoratifs (Pavillon de Marsan).

SPRING OR SUMMER: Mme Matisse, in poor health, gives up her millinery business.

JULY: With his family, moves to Lesquielles-Saint-Germain, some distance from Bohain, for the remainder of the year.

During the summer, attempts to improve financial situation by establishing a syndicate of twelve art collectors who would guarantee him an income, in return for paintings. The scheme fails.

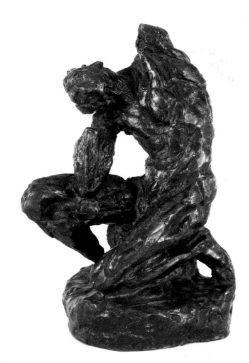

Écorché (after a plaster cast of a 16th-century Florentine sculpture). [Paris, c. 1900–03]. Bronze, 9 × 5 × 6″ (23 × 12.7 × 15.1 cm). Inscribed: "HM 2/10." Hirshhorn Museum and Sculpture Garden, Smithsonian Institution, Washington, D.C. Joseph H. Hirshhorn Bequest, 1981. (Included in the exhibition).

1903–04 SEASON

OCTOBER 31–DECEMBER 6: First exhibition of the juried Salon d'Automne; includes works by Pierre Bonnard, Maurice Denis, Paul Sérusier, Félix Vallotton, Édouard Vuillard, and a large Gauguin memorial exhibition. Matisse exhibits two paintings.

1904

EARLY IN THE YEAR: With family, moves back to Paris.

FEBRUARY 21–MARCH 24: Salon des Indépendants includes work by Camoin, Kees van Dongen, Dufy, Friesz, Pierre Girieud, Manguin, Marquet, Matisse, Jean Metzinger, Puy, Vallotton, and Louis Valtat, and a special exhibition of Cézanne. Matisse becomes a *secrétaire adjoint* and exhibits six paintings, which are praised by the critic Roger Marx. Another critic, Maurice Nanteuil, praises especially *Studio Under the Eaves* (pl. 33).

BY MARCH 22: André Level has purchased three paintings from Matisse for the Peau de l'Ours, a consortium of art investors officially established one month earlier under the direction of Level.

APRIL 2–30: Group exhibition of work by Camoin, Manguin, Marquet, Raoul de Mathan, Matisse, and Puy at the Berthe Weill gallery. Matisse shows six works.

APRIL 12–JULY 14: Exhibition of French primitives, including illuminated manuscripts and paintings from the fourteenth to the sixteenth centuries, held at the Louvre (Pavillon de Marsan) and the Bibliothèque Nationale, which Matisse sees.

APRIL 13: Begins copying Raphael's portrait *Baldassare Castiglione;* his last recorded copy made at the Louvre, it is purchased by the French state in October.

JUNE 1–18: Has his first one-artist exhibition, at the Ambroise Vollard gallery; includes forty-five paintings and one drawing, ranging in date from about 1897 to 1903. In the introduction to the catalogue, the critic Roger Marx praises him for having spurned fashionable success and recommends his harmonious synthesis of the lessons of Manet and Cézanne. The exhibition is not successful, however.

JULY 12: With Mme Matisse and son Pierre, leaves Paris to spend the summer in Saint-Tropez near Paul Signac, whom he has met earlier in the year. Another Neo-Impressionist painter, Henri-Edmond Cross, is staying at nearby Le Lavandou. Matisse remains until late September. At first, he continues to work in a Cézanne-influenced style, in which he paints *The Terrace, Saint-Tropez* (pl. 44) and *Still Life with a Purro (I)* (pl. 45), but eventually approaches Neo-Impressionism in *The Gulf of Saint-Tropez* (pl. 46). In the autumn and winter, from *The Gulf of Saint-Tropez* he will develop his first imaginary figure composition, the ambitious *Luxe, calme et volupté* (pl. 50), painted in a Neo-Impressionist style. Also in that style, makes still lifes and landscapes.

1904–05 SEASON

OCTOBER 1: Is in Paris, until mid-May 1905.

OCTOBER 15–NOVEMBER 15: The Salon d'Automne includes individual galleries devoted to Cézanne (to which Matisse lends his own Cézanne, *Three Bathers*), Puvis de Chavannes, Redon, Renoir, and Toulouse-Lautrec. Matisse exhibits fourteen paintings and the two sculptures *The Serf* (pl. 25) and *Madeleine (I)* (pl. 27). In the catalogue, begins the practice of hyphenating his name, as Henri-Matisse (to avoid confusion with the painter Auguste Matisse). The critic Louis Vauxcelles singles him out as the strongest of the group of former Moreau students. His work attracts the attention of Leo Stein.

DECEMBER 13–31: Signac exhibition at the Druet gallery.

1905

EARLY IN THE YEAR: Visits Derain and Vlaminck at Chatou.

FEBRUARY: Introduces Derain to Vollard, who purchases the contents of Derain's studio and becomes his dealer.

FEBRUARY 10–25: The first exhibition of the Intimist painters, at the Henry Graves gallery, includes one work by Matisse along with works by Bonnard, Laprade, and Vuillard.

MARCH 24–APRIL 30: The Salon des Indépendants includes retrospective exhibitions of Seurat and van Gogh (Matisse lends one of his van Gogh drawings). Matisse is on the hanging committee, and a number of artists soon to be associated with Fauvism are represented in the Salon. He exhibits eight works, including *Luxe, calme et volupté* (pl. 50), which attracts considerable attention and confirms his position of leadership among his contemporaries.

MARCH 25: The French state purchases one of his Neo-Impressionist landscapes from the Indépendants, its last Matisse purchase for seventeen years.

APRIL 6–29: Shows six paintings in an exhibition with Camoin, Manguin, and Marquet at the Berthe Weill gallery.

The terrace of Paul Signac's villa, La Hune, in Saint-Tropez.

1. Still Life with Books
 Nature morte aux livres [Mon premier tableau]

Bohain-en-Vermandois, June 1890

Oil on canvas, 8½ × 10⅝″ (21.5 × 27 cm)
Signed and dated lower right: "essitaM. H. / Juin 90."
Musée Matisse, Nice-Cimiez

2. Still Life with Books
 Nature morte aux livres [Mon deuxième tableau]

Bohain-en-Vermandois, 1890

Oil on canvas, 15 × 17¾″ (38 × 45 cm)
Signed and dated lower left: "H. Matisse. 90"
Private collection

3. La desserte (after Jan Davidsz. de Heem)
 La desserte (d'après Jan Davidsz. de Heem)

Paris, 1893

Oil on canvas, 28¾ × 39⅛″ (73 × 100 cm)
Not signed, not dated
Musée Matisse, Nice-Cimiez

4. The Atelier of Gustave Moreau
L'atelier de Gustave Moreau [Intérieur d'atelier]

Paris, [c. 1895]

Oil on canvas, 25⅝ × 31⅞″ (65 × 81 cm)
Signed lower left: "Henri Matisse"
Private collection

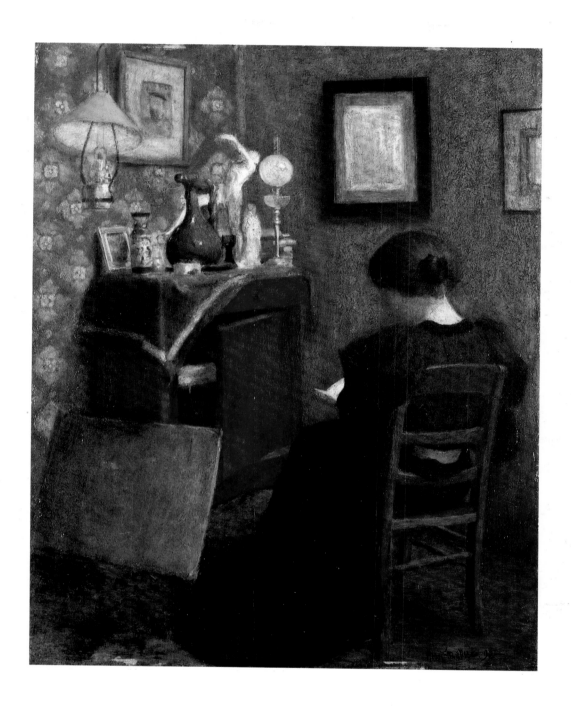

5. Woman Reading
 La liseuse

Paris, summer–winter 1895

Oil on wooden panel, 24¼ × 18⅞" (61.5 × 48 cm)
Signed and dated lower right: "Henri Matisse 95-"
Musée National d'Art Moderne, Centre Georges Pompidou, Paris

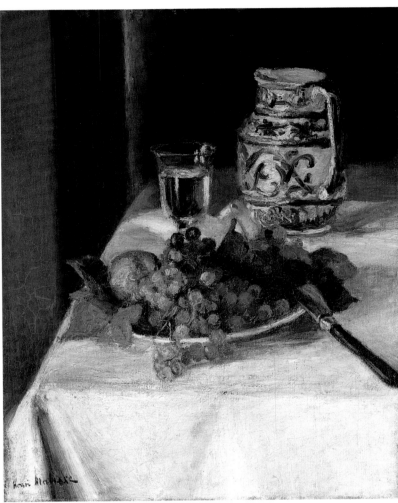

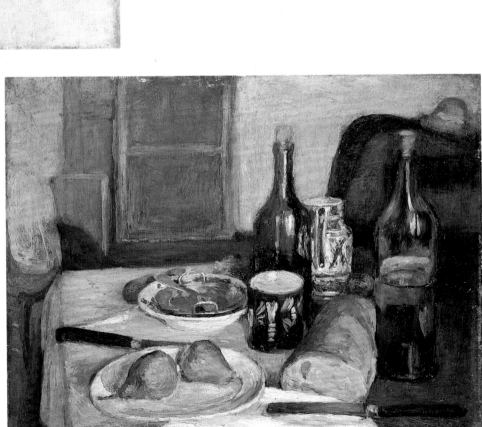

6. Still Life with Grapes
Nature morte aux raisins

Paris or Brittany, [c. 1896]

Oil on canvas, 25½ × 19⅝″ (65 × 50 cm)
Signed lower left: "Henri Matisse"
Private collection

7. Still Life with Black Knives
Nature morte aux couteaux noirs

Paris or Brittany, [c. 1896]

Oil on canvas, 23⅝ × 33½″ (60 × 85 cm)
Not signed, not dated
Fonds National d'Art Contemporain.
On deposit at Musée Fabre, Montpellier

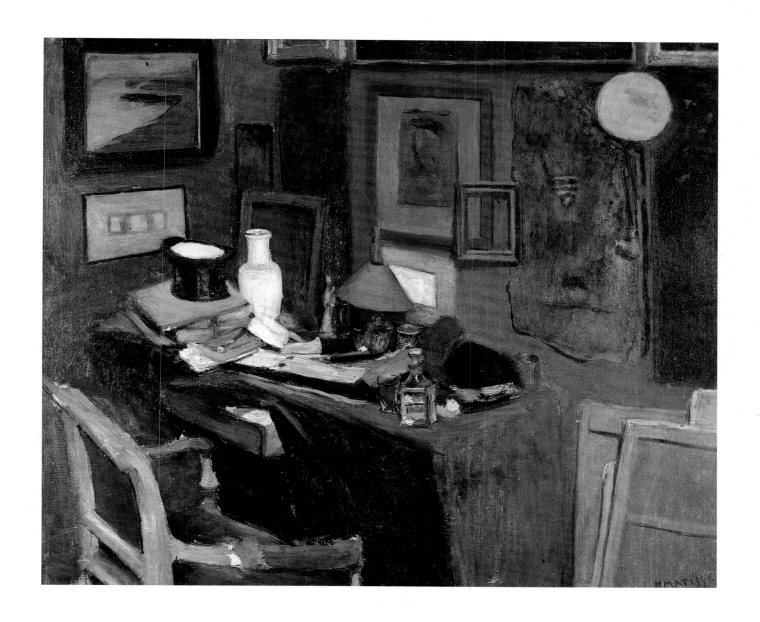

8. Interior with a Top Hat
 Intérieur au chapeau haut de forme

Paris, [autumn–winter 1896]

Oil on canvas, 31½ × 37½" (80 × 95 cm)
Signed lower right: "H MATISSE"
Private collection

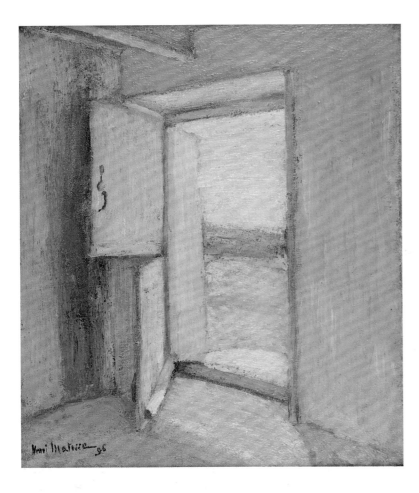

9. Open Door, Brittany
 La porte ouverte, Bretagne

Brittany, summer 1896

Oil on canvas, 13⅞ × 11¼″ (35 × 28.5 cm)
Signed and dated lower left: "Henri Matisse / 96"
Private collection
Formerly collection Michael and Sarah Stein

10. Seascape at Goulphar
 Marine à Goulphar

Brittany, summer 1896

Oil on canvas, 18⅛ × 31⅞″ (46 × 81 cm)
Signed and dated lower left: "Henri Matisse 96-"
Private collection

11. Large Gray Seascape
Grande marine grise

Brittany, [summer 1896]

Oil on canvas, 34½ × 57⅞″ (87 × 147 cm)
Not signed, not dated
Private collection

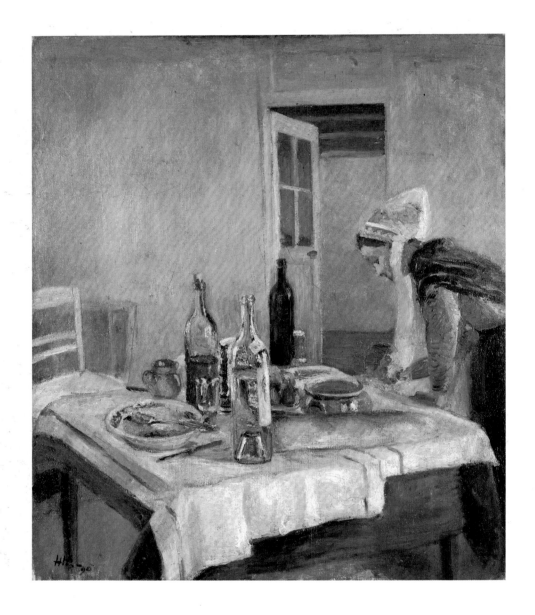

12. Breton Serving Girl
La serveuse bretonne

Brittany, summer 1896

Oil on canvas, 35½ × 29½" (90 × 75 cm)
Signed and dated lower left: "HM-96"
Private collection

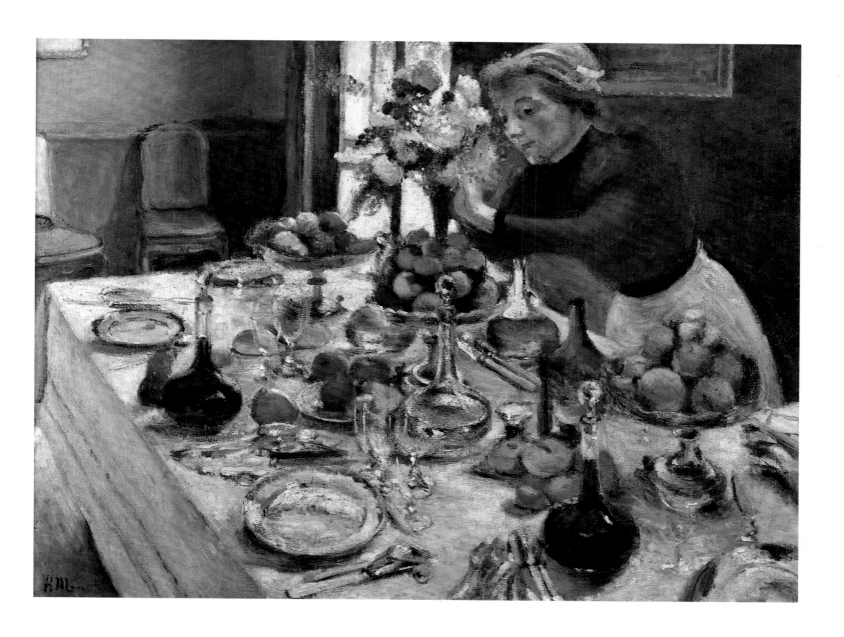

13. The Dinner Table
 La desserte [Les préparatifs (nature morte)]

Paris, autumn 1896–spring 1897

Oil on canvas, 39⅜ × 51½″ (100 × 131 cm)
Signed lower left: "HM."
Private collection
Formerly collection Ambroise Vollard

14. Sunset in Corsica
Coucher de soleil en Corse

Corsica, spring–summer 1898
Oil on canvas, 12⅞ × 16″ (32.8 × 40.6 cm)
Signed lower left: "Henri-Matisse"
Private collection

15. The Courtyard of the Mill
La cour du moulin

Ajaccio, Corsica, spring–summer 1898
Oil on canvas, 15⅛ × 18⅛″ (38 × 46 cm)
Signed and dated lower left: "H MATISSE 98"
Musée Matisse, Nice-Cimiez

16. Small Door of the Old Mill
Petite porte du vieux moulin

Ajaccio, Corsica, spring–summer 1898

Oil on canvas, 18⅞ × 14⅛″ (48 × 36 cm)
Signed lower right: "Henri-Matisse"
Private collection
Formerly collection Leo Stein

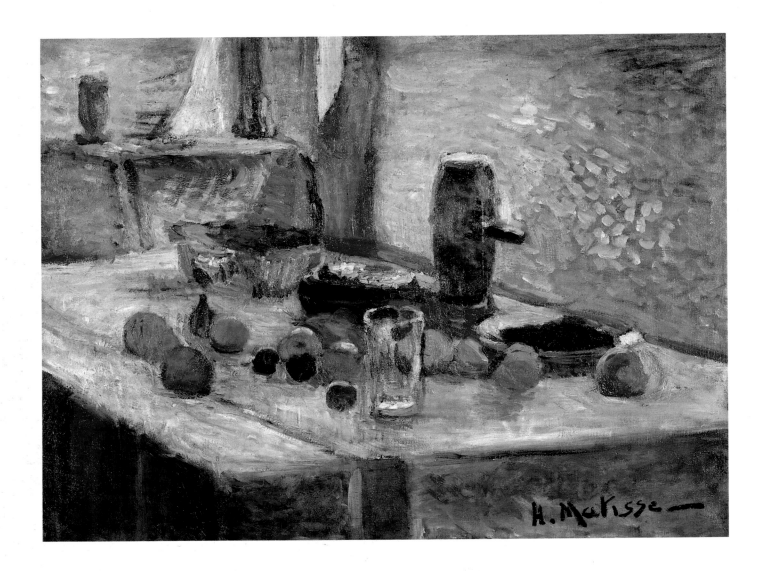

17. First Orange Still Life
 Première nature morte orange

[Toulouse, early 1899]

Oil on canvas, 22 × 28¾″ (56 × 73 cm)
Signed lower right: "H. Matisse-"
Musée National d'Art Moderne,
Centre Georges Pompidou, Paris

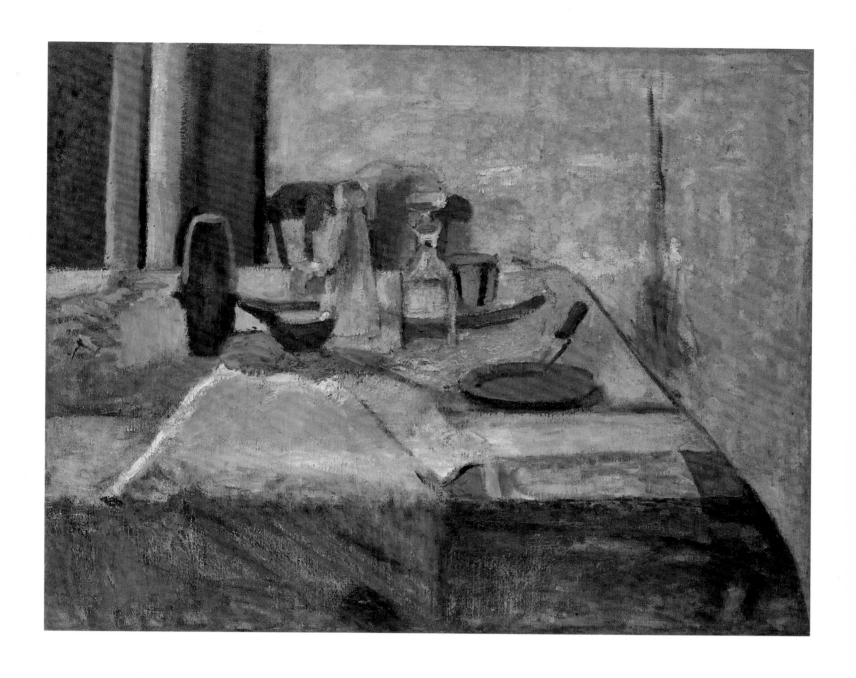

18. **Still Life Against the Light**
 Nature morte à contre-jour

[Paris, winter–spring 1899]

Oil on canvas, 29⅛ × 36⅞″ (74 × 93.5 cm)
Not signed, not dated
Private collection

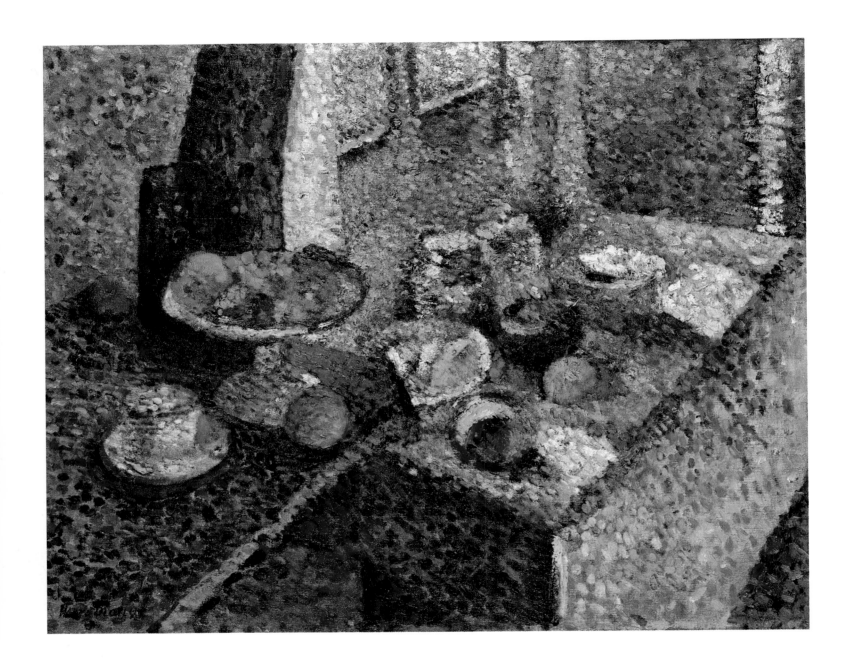

19. Sideboard and Table
 Buffet et table

[Toulouse, winter or summer 1899]

Oil on canvas, 26½ × 32½″ (67.5 × 82.5 cm)
Signed lower left: "Henri Matisse"
Private collection, Switzerland
Formerly collection Michael and Sarah Stein

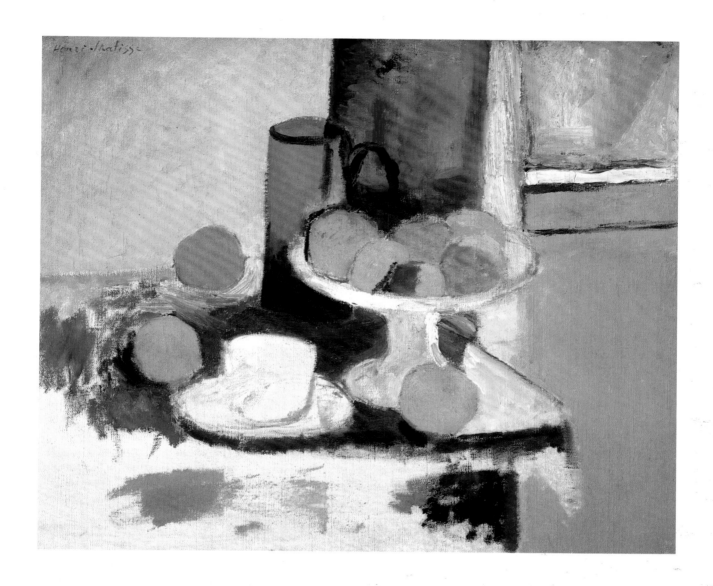

20. **Still Life with Oranges (II)**
Nature morte aux oranges (II)

Toulouse or Paris, [winter–summer 1899]

Oil on canvas, 18⅜ × 21¾″ (46.7 × 55.2 cm)
Signed upper left: "Henri-Matisse"
Washington University Gallery of Art, St. Louis.
Gift of Mr. and Mrs. Sydney M. Shoenberg, Jr., 1962

21. Self-Portrait
Autoportrait

[Paris, c. 1900]

Oil on canvas, 25⅛ × 17¾″ (64 × 45.1 cm)
Signed lower left: "Henri-Matisse"
Private collection

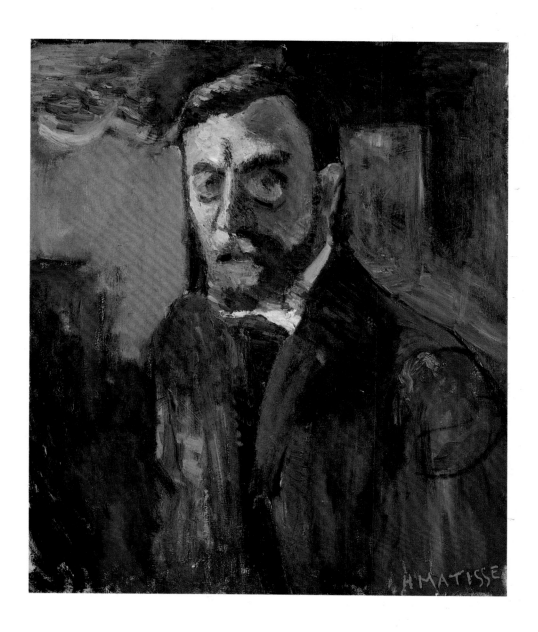

22. Self-Portrait
Autoportrait

[Paris, c. 1900]

Oil on canvas, 21⅝ × 18⅛″ (55 × 46 cm)
Signed lower right: "H MATISSE"
Musée National d'Art Moderne,
Centre Georges Pompidou, Paris

23. Still Life with a Chocolate Pot
Nature morte à la chocolatière

[Paris, c. 1900]

Oil on canvas, 28¾ × 23⅜" (73 × 59.5 cm)
Signed lower left: "Henri-Matisse"
Collection Alex Maguy
Formerly collection Michael and Sarah Stein

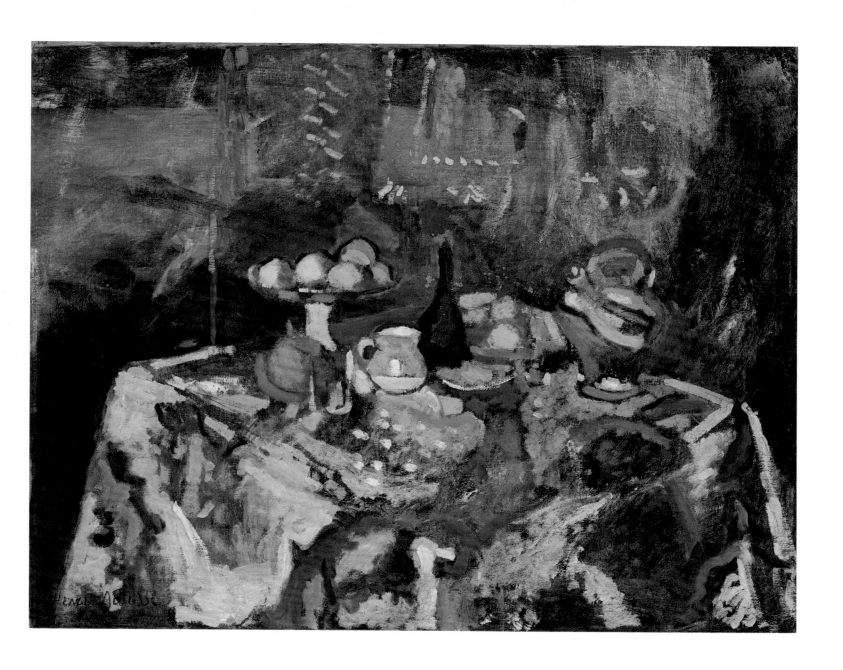

24. Still Life with Blue Tablecloth
Nature morte au camaïeu bleu

Paris, [c. 1900–02]

Oil on canvas, 28¾ × 36⅛″ (73 × 92 cm)
Signed lower left: "Henri-Matisse"
The Hermitage Museum, St. Petersburg
Formerly collection Sergei Shchukin

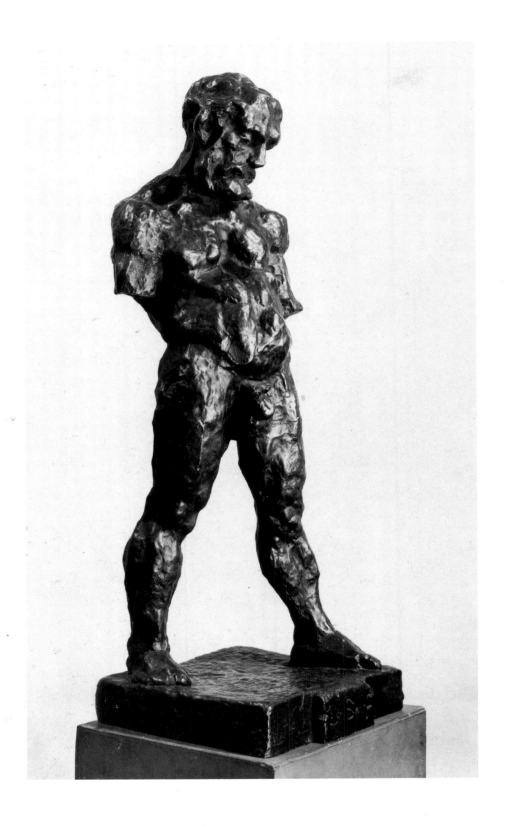

25. The Serf
 Le serf

Paris, [1900–04]

Bronze, 37⅜ × 13⅜ × 13″ (92.3 × 34.5 × 33 cm)
Inscribed: "Henri Matisse" and "Le Serf"
Founder A. Bingen-Costenoble
The Museum of Modern Art, New York.
Mr. and Mrs. Sam Salz Fund

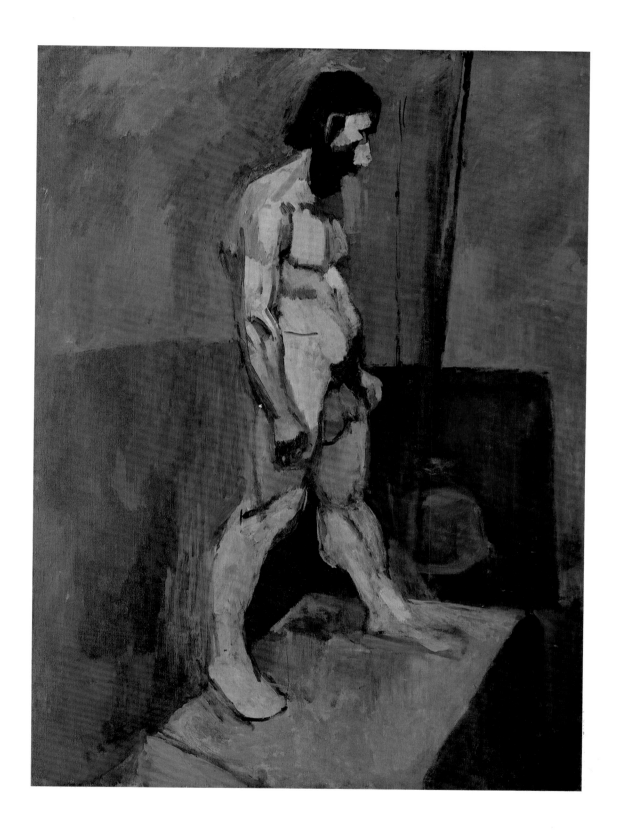

26. Male Model
L'homme nu

Paris, [c. 1900]

Oil on canvas, 39⅛ × 28⅝″ (99.3 × 72.7 cm)
Not signed, not dated
The Museum of Modern Art, New York.
Kay Sage Tanguy and Abby Aldrich Rockefeller Funds

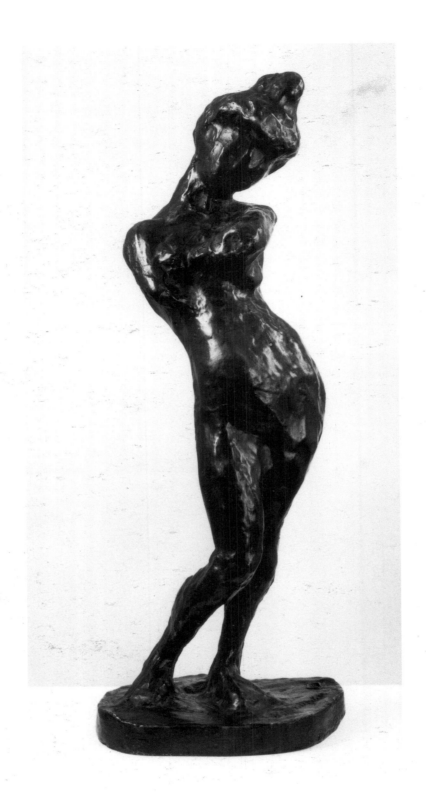

27. Madeleine (I)

Paris, [c. 1901]

Bronze, 23½ × 7¾ × 9″ (59.7 × 19.7 × 22.9 cm)
Inscribed: "Henri Matisse 2/10"
Founder C. Valsuani
Weatherspoon Art Gallery, Greensboro, North Carolina.
Cone Collection, 1950

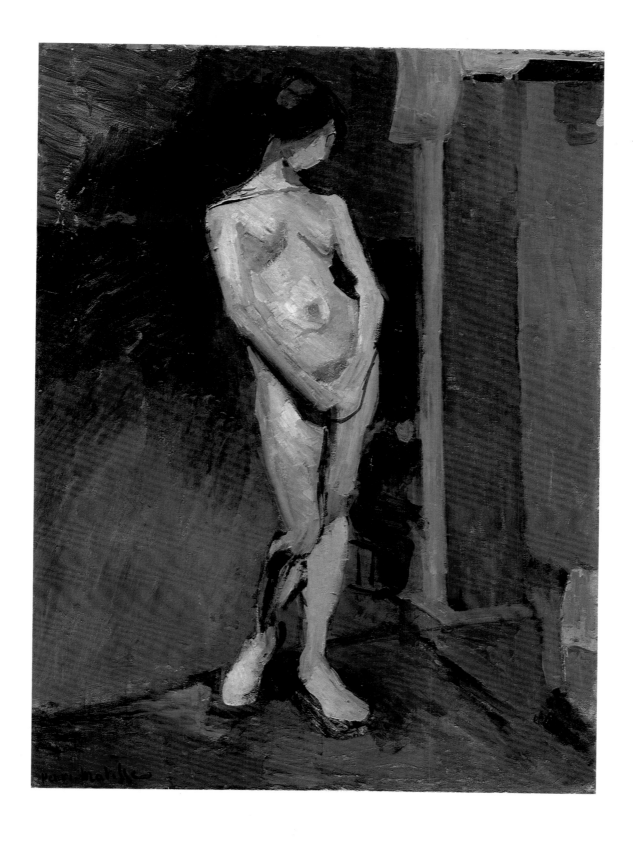

28. Standing Model / Nude Study in Blue
 Modèle debout / Académie bleue

Paris, Académie Carrière, [autumn 1900–spring 1901]

Oil on canvas, 28¾ × 21⅛″ (73 × 54 cm)
Signed lower left: "Henri-Matisse"
Tate Gallery, London. Bequeathed by C. Frank Stoop, 1933
Formerly collection La Peau de l'Ours

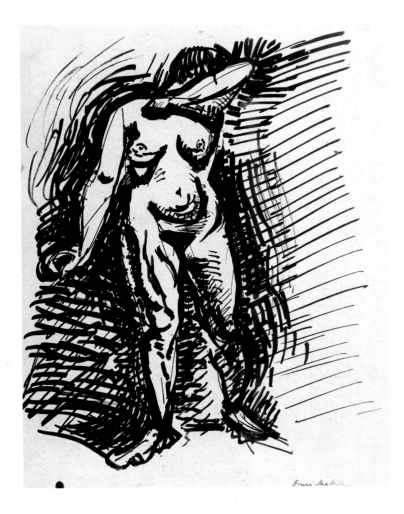

29. **Study of a Standing Nude, Her Arm Covering Her Face**
Étude de femme nue debout, bras cachant le visage

Paris, [c. 1901–03]

Brush and pen and ink on paper, 10⅜ × 8″ (26.4 × 20.3 cm)
Signed lower right: "Henri-Matisse"
The Museum of Modern Art, New York. Gift of Edward Steichen

30. **Study of a Standing Nude, Seen from the Back**
Étude de femme nue debout, de dos

Paris, [c. 1901–03]

Pen and ink on paper mounted on cardboard, 10⅝ × 7⅞″ (27 × 20 cm)
Signed lower right: "Henri-Matisse"
Musée de Grenoble. Agutte-Sembat Bequest
Formerly collection Marcel Sembat

31. Model with Rose Slippers
 Nu aux souliers roses [Étude]

Paris, Académie Carrière, [autumn–winter 1900–01]

Oil on canvas, 28¾ × 23⅝″ (73 × 60 cm)
Signed upper right: "H. Matisse"
Jan Krugier Gallery, Geneva
Formerly collection Jean Puy

32. The Ray (after Jean-Baptiste-Siméon Chardin)
 La raie (d'après Jean-Baptiste-Siméon Chardin)

Paris, [1897–1903]

Oil on canvas, 45¼ × 56″ (115 × 142 cm)
Not signed, not dated
Musée Matisse, Le Cateau-Cambrésis

33. Studio Under the Eaves
L'atelier sous les toits

Bohain-en-Vermandois, [autumn–winter 1901–02]

Oil on canvas, 21½ × 17½″ (55 × 44.5 cm)
Signed lower left: "Henri Matisse"
The Syndics of the Fitzwilliam Museum, Cambridge
Formerly collection La Peau de l'Ours

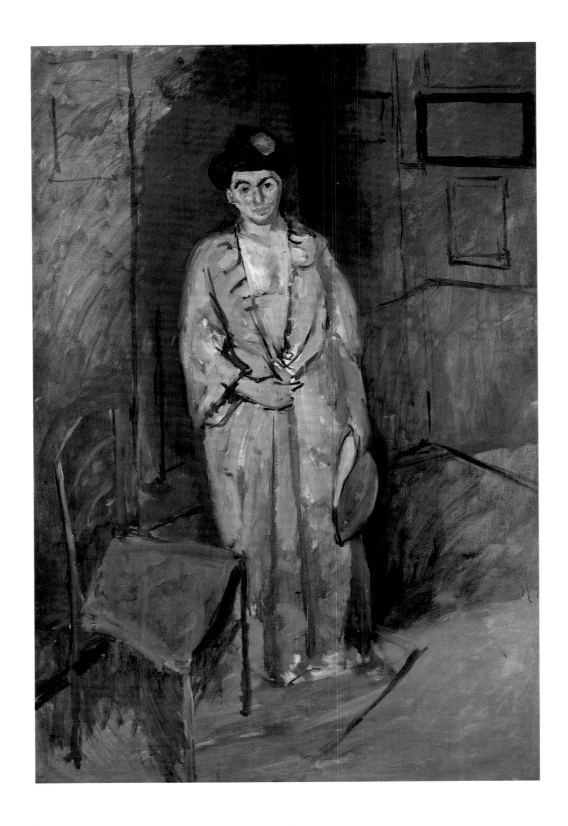

34. Mme Matisse in a Japanese Robe
Mme Matisse en japonaise

Paris or Bohain-en-Vermandois, [c. 1901]

Oil on canvas, 46 × 31½″ (116.8 × 80 cm)
Not signed, not dated
Private collection

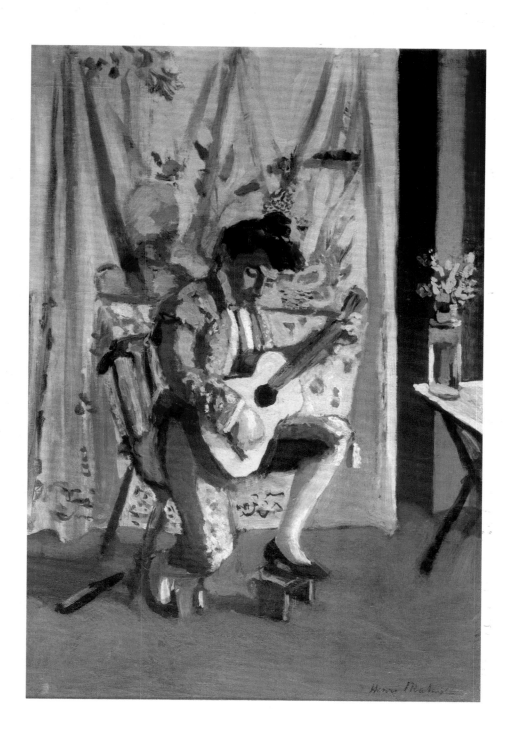

35. Guitarist
 La guitariste

Paris or Bohain-en-Vermandois, [c. 1902–03]

Oil on canvas, 21½ × 15″ (54.6 × 38.1 cm)
Signed lower right: "Henri Matisse"
The Colin Collection

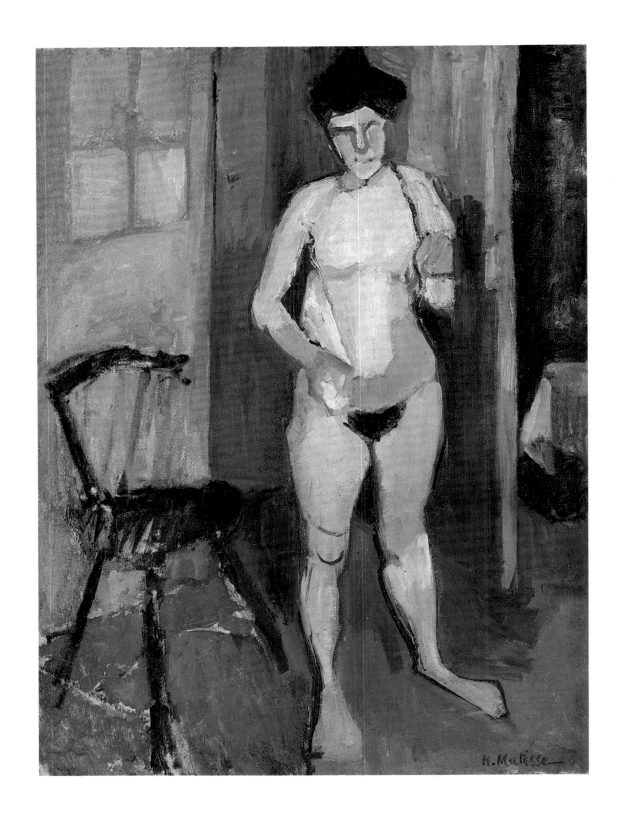

36. Nude with a White Towel
Nu à la serviette blanche

[Paris, c. 1902–03]

Oil on canvas, 31⅞ × 23½″ (81 × 59.5 cm)
Signed lower right: "H. Matisse"
Collection Mr. and Mrs. Gifford Phillips, New York
Formerly collection Jean Puy

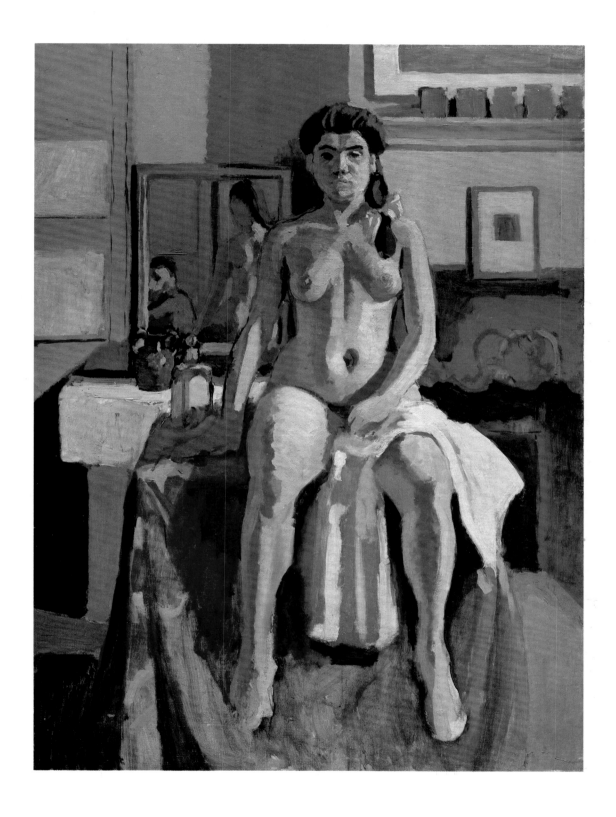

37. Carmelina
Carmelina [La pose du nu]

Paris, quai Saint-Michel, [c. 1903–04]

Oil on canvas, 32 × 23¼″ (81.3 × 59 cm)
Signed lower left: "Henri-Matisse"
Museum of Fine Arts, Boston. Tompkins Collection

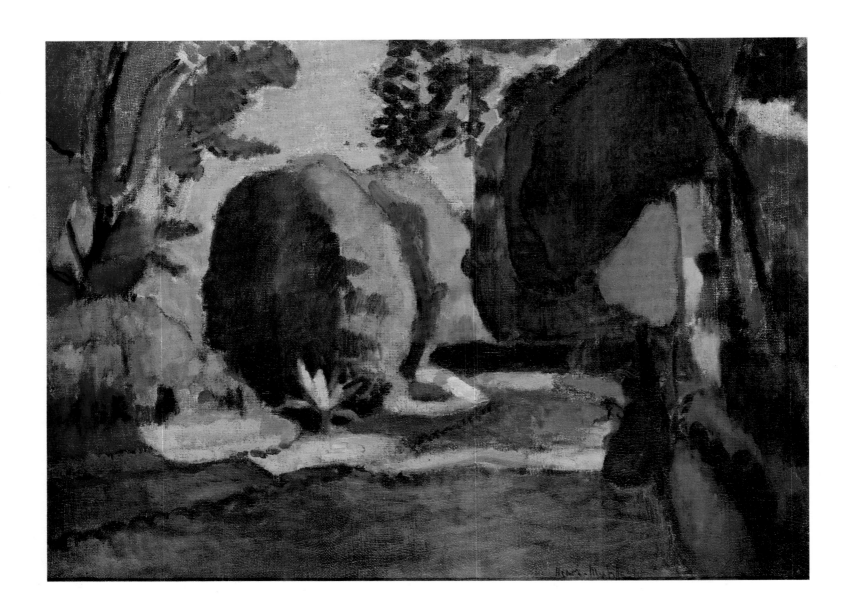

38. The Luxembourg Gardens
Le Jardin du Luxembourg

Paris, [c. 1902]

Oil on canvas, 23⅜ × 32″ (59.5 × 81.5 cm)
Signed lower right of center: "Henri-Matisse"
The Hermitage Museum, St. Petersburg
Formerly collection Sergei Shchukin

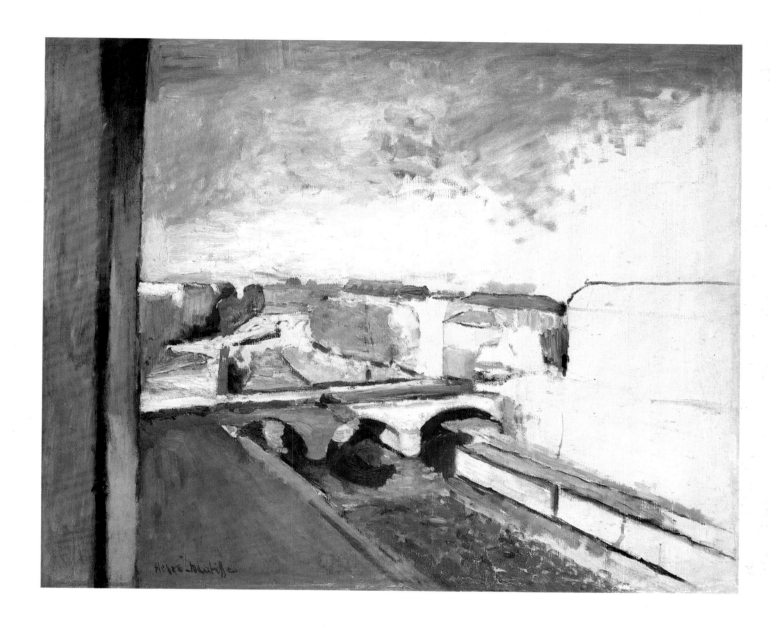

39. Pont Saint-Michel

Paris, [c. 1900]

Oil on canvas, 23⅞ × 28″ (58 × 71 cm)
Signed lower left: "Henri-Matisse"
Private collection

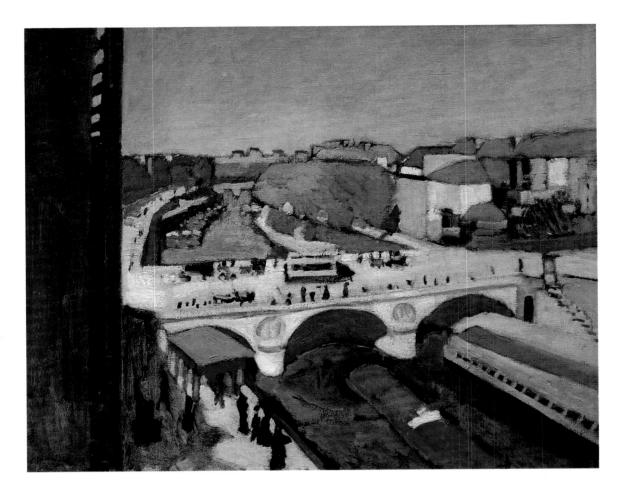

40. Pont Saint-Michel

Paris, [c. 1900]

Oil on canvas, 25½ × 31¼″ (64.8 × 80.6 cm)
Signed lower left: "Henri Matisse"
Collection Mrs. William A. M. Burden, New York
Formerly collection Oskar and Greta Moll

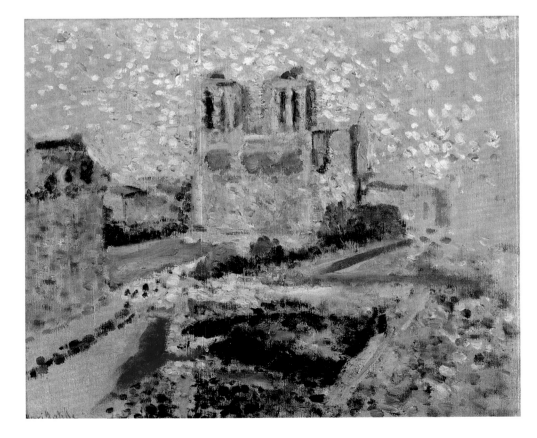

41. Notre-Dame

Paris, [autumn 1904–spring 1905]

Oil on canvas, 17¾ × 21⅝″ (45 × 55 cm)
Signed lower left: "Henri Matisse"
Moderna Museet, Stockholm

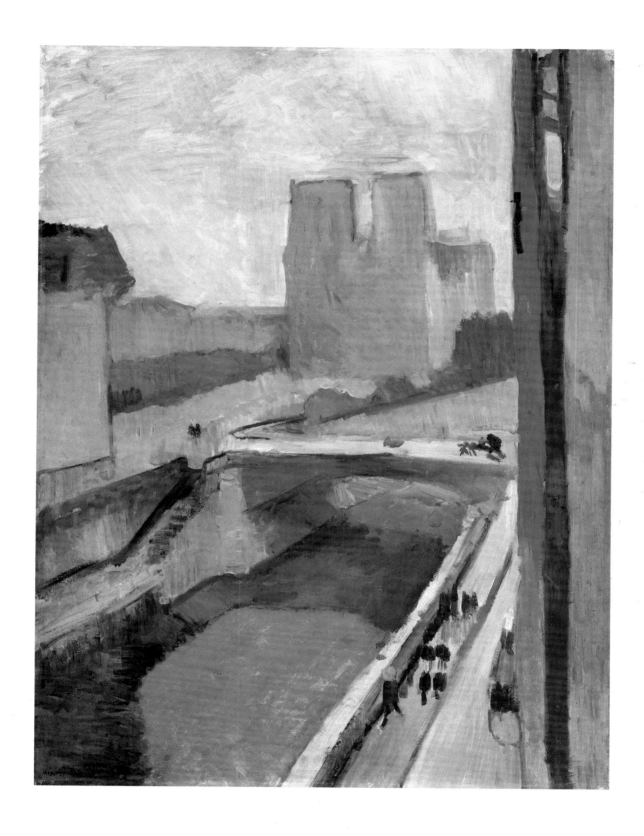

42. Notre-Dame in the Late Afternoon
 Notre-Dame, fin d'après-midi [Notre-Dame, effet d'après-midi]

Paris, 1902

Oil on paper mounted on canvas, 28½ × 21½" (72.5 × 54.5 cm)
Signed and dated lower left: "Henri Matisse 1902"
Albright-Knox Art Gallery, Buffalo. Gift of Seymour H. Knox, 1927

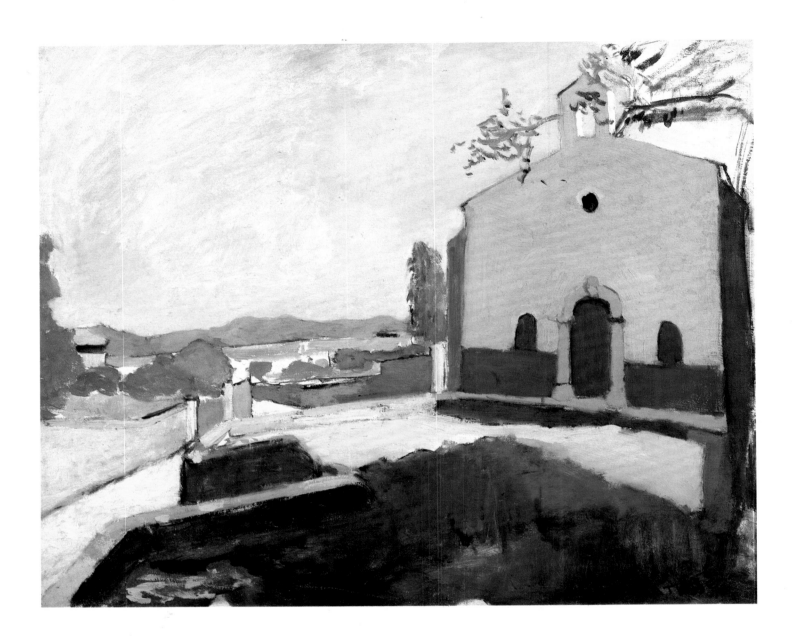

43. St. Anne's Chapel
La chapelle Sainte-Anne

Saint-Tropez, summer 1904

Oil on canvas, 23⅝ × 28¾″ (60 × 73 cm)
Signed lower right: "H. MATISSE"
Private collection

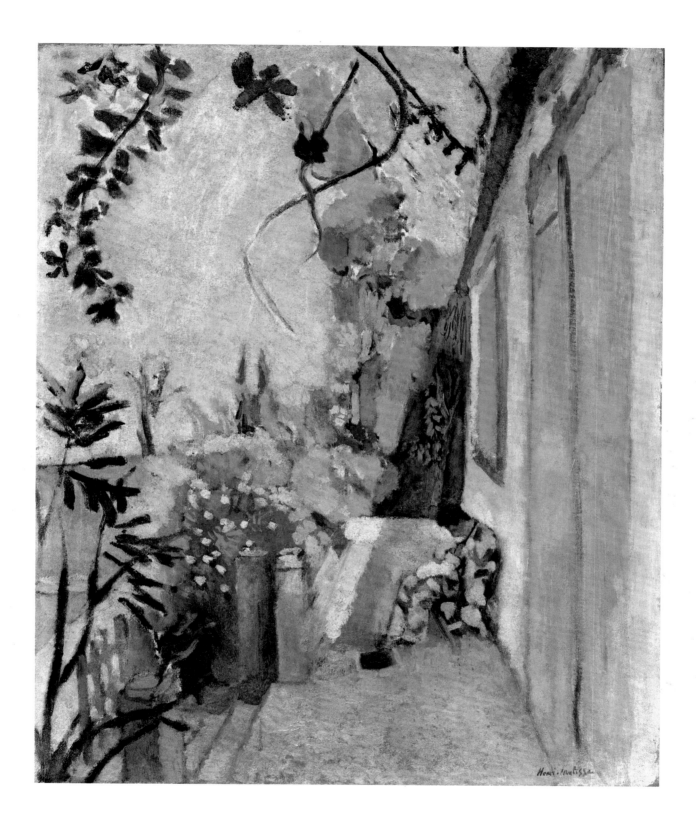

44. The Terrace, Saint-Tropez
 La terrasse, Saint-Tropez

Saint-Tropez, summer 1904

Oil on canvas, 28¼ × 22¾″ (72 × 58 cm)
Signed lower right: "Henri-Matisse"
Isabella Stewart Gardner Museum, Boston.
Gift of Thomas Whittemore

45. Still Life with a Purro (I)
Nature morte au purro (I)

[Saint-Tropez, summer 1904]

Oil on canvas, 23¼ × 28½" (59 × 72.4 cm)
Signed lower right: "Henri Matisse"
The Phillips Family Collection

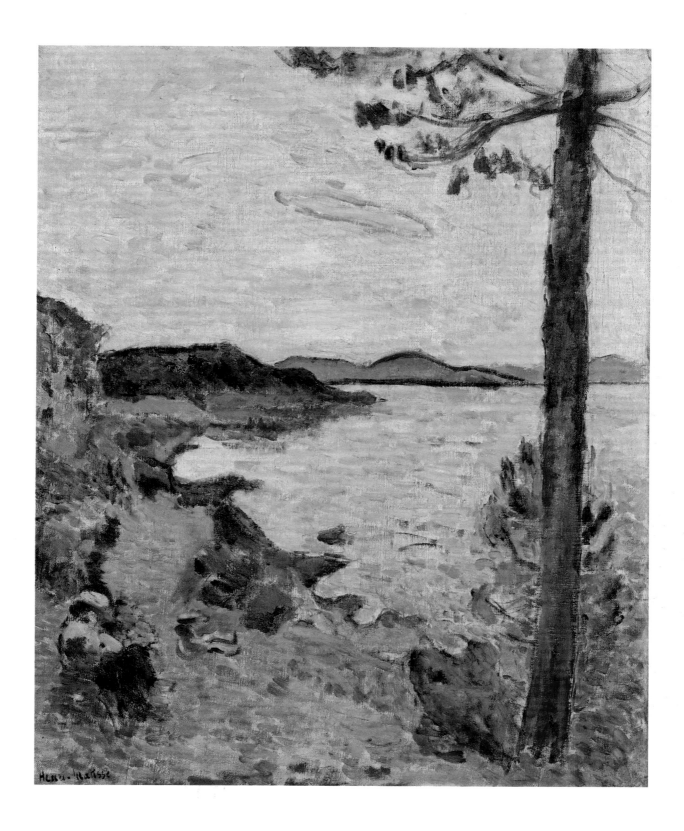

46. The Gulf of Saint-Tropez
 Golfe de Saint-Tropez

Saint-Tropez, summer 1904

Oil on canvas, 25½ × 19⅞″ (65 × 50.5 cm)
Signed lower left: "Henri-Matisse"
Kunstsammlung Nordrhein-Westfalen, Düsseldorf

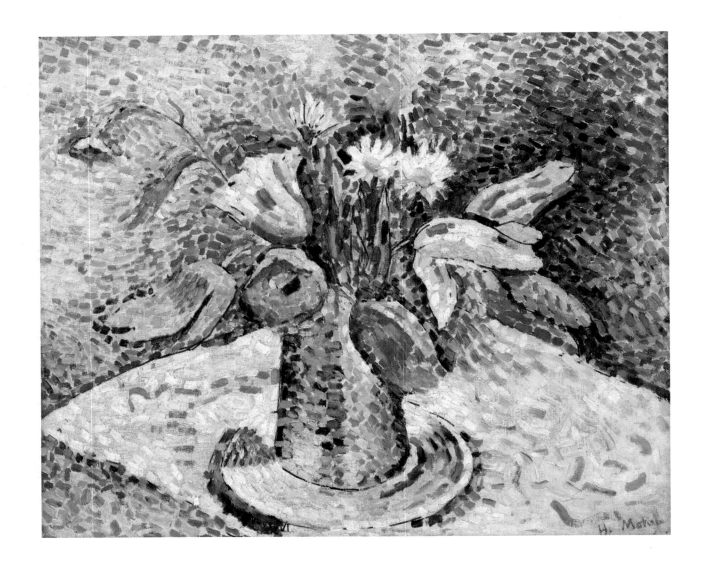

47. Parrot Tulips (II)
Tulipes perroquet (II)

[Paris, spring 1905]

Oil on canvas, 18 × 21¾″ (46 × 55 cm)
Signed lower right: "H. Matisse"
Private collection, Liechtenstein
Formerly collection Chester Dale

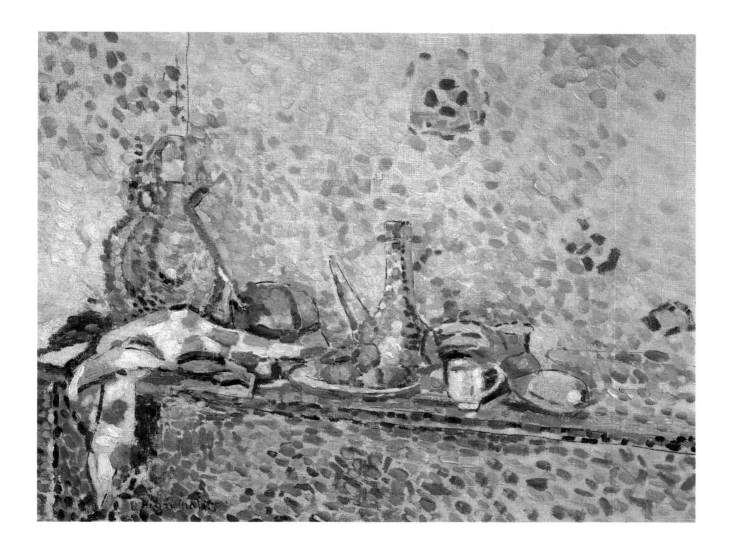

48. Still Life with a Purro (II)
 Nature morte au purro (II)

Saint-Tropez or Paris, [summer 1904–spring 1905]

Oil on canvas, 10¾ × 14″ (27.3 × 35.6 cm)
Signed lower left: "Henri Matisse"
Collection Mrs. John Hay Whitney

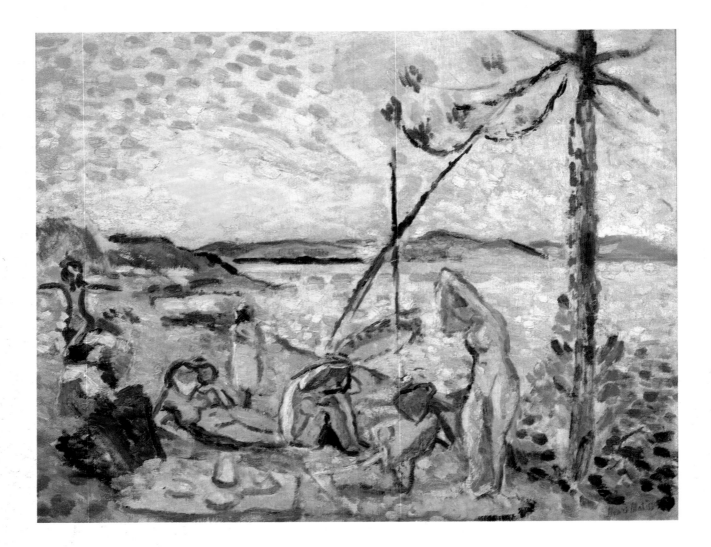

49. Study for "Luxe, calme et volupté"
Étude pour "Luxe, calme et volupté"

Saint-Tropez or Paris, [summer–winter 1904]

Oil on canvas, 12¾ × 16″ (32.2 × 40.5 cm)
Signed lower right: "Henri Matisse"
The Museum of Modern Art, New York.
Promised gift of Mrs. John Hay Whitney

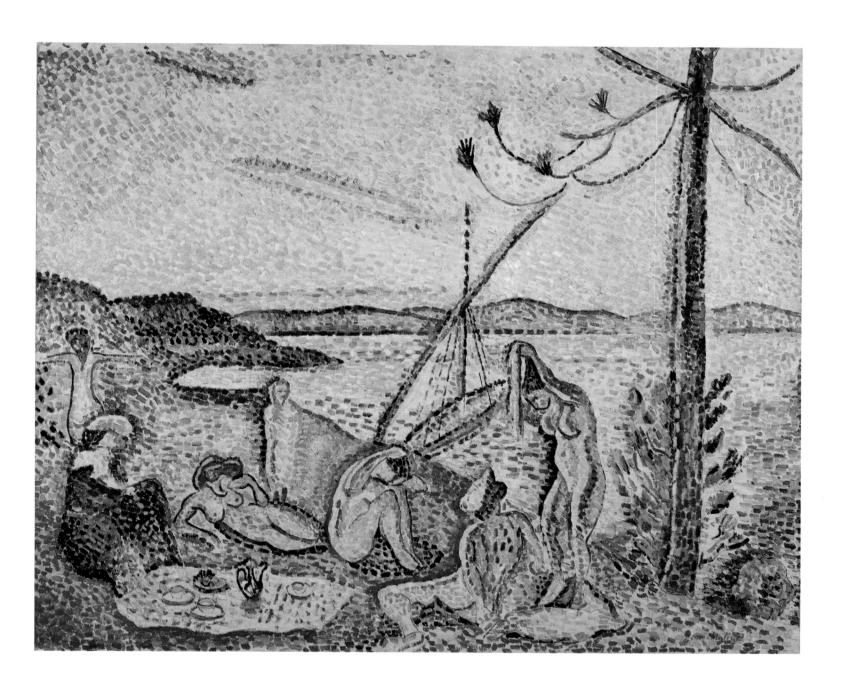

50. Luxe, calme et volupté

Paris, autumn–winter 1904–05

Oil on canvas, 38½ × 46½″ (98.5 × 118 cm)
Signed lower right: "Henri-Matisse"
Musée d'Orsay, Paris
Formerly collection Paul Signac

Matisse's window looking out onto the harbor at Collioure, the motif of *The Open Window* (pl. 61) of 1905.

PART II ✦ 1905–1907

THE FAUVIST EPOCH

Matisse spent the summer of 1905 working alongside André Derain in the small Mediterranean seaport of Collioure (pls. 51–62). The paintings they made there, and in Paris on their return, caused a sensation at the Salon d'Automne, in October, when they were exhibited alongside works by other of Matisse's acquaintances, including Maurice Vlaminck and Henri Manguin. This group of artists became known as *les fauves* ("the wild beasts") for the supposedly violent appearance of their paintings.

Fauvism meant, as Matisse later said, construction by means of color, and was therefore the source of everything that followed in his art. Color, free from tonal modeling, would be used not to imitate external reality, but rather to convey the artist's response to his subject. The immediacy of that experience was embodied in the very immediacy of color, revealing the pure chromatic substance of painting in its most fundamental state. In his *Landscape at Collioure* (pl. 52) and similar works, he drew with color: with curls and strips of intense reds and greens, and similarly contrasting hues, placed separately on the white ground of the canvas to create a dazzling effect of vibrating light. Often, however, he combined drawn strips of color with broad colored areas, as in the famous *Open Window* (pl. 61), and increasingly would use many different kinds of painterly marks within one picture, thus orchestrating the surface with complex harmonies and dissonances.

Le bonheur de vivre (pl. 73), painted in the autumn and winter of 1905–06, brought to an abrupt end the period of visually excited Fauve painting; it offered instead an effect of indolent calm, using broad areas of color bounded by arabesque contours that are reminiscent at times of Ingres and at others of Gauguin, to picture a primal world, a Golden Age, populated by images of sexuality. Through 1906, Matisse explored fragments of this world in the form of pastoral landscapes (pls. 76, 78) and still lifes that resembled such landscapes, with images of his own sculptures for figures (pls. 79, 83). He also painted some boldly flattened paintings, such as *The Young Sailor (II)* (pl. 90), but by the end of the year his interest in sculpture, and in the sculptural in painting, had contributed to his creation of the notorious *Blue Nude: Memory of Biskra* (pl. 93), an image at once flattened to the surface and evocative of extraordinary volume, set in an imaginary North African oasis and symbolic of fertility.

In 1907, the year that saw renewed interest in Paris in the work of Cézanne, and when Picasso painted *Les demoiselles d'Avignon*, Matisse began to separate his sculptural and pictorial interests. He continued to make sculpture, and some of his paintings of the human figure, including *Standing Nude* (pl. 95), reflect that activity, but increasingly he would summarize and flatten the painted figure into surface pattern. Fauvism had been a return to the fundamentals of pictorial expression; it came to require the very simplest means. During a trip to Italy that summer, Matisse saw the work of Giotto and other early Renaissance painters. This confirmed for him the path he had chosen. The first version of the mysteriously allegorical *Le luxe* (pl. 102), painted on his return, is still a dappled Fauve painting. The second (pl. 103) is a simpler and more decorative work than any he had done before.

André Derain. *Matisse Painting Mme Matisse in a Japanese Robe at the Seashore.* 1905. Pen and ink on paper, 12³⁄₁₆ × 18⅞″ (31 × 48 cm). Private collection.

1905 (continued)

MID-MAY: With his family, leaves Paris for Collioure, where he spends the first of several summers. Remains until September.

JULY: Derain joins him in Collioure for the summer; together they make a brief visit to Spain.

Through Étienne Terrus, a painter from nearby Elne, meets Aristide Maillol, who introduces him and Derain to the painter Georges-Daniel de Monfreid, custodian of Gauguin's archives and late Oceania pictures.

This summer, working alongside Derain, makes his first Fauve paintings: small, spontaneous oil studies (pls. 54–57) and freely conceived landscapes using curls and strips of contrasting colors set against a white ground (pls. 52, 58); and interiors, such as *The Open Window* (pl. 61), which combine this approach with broad areas of color. Also does numerous drawings and watercolors, and probably makes paintings on the basis of some of these when he is back in Paris.

1905–06 SEASON

EARLY SEPTEMBER: Returns to Paris, where in early autumn he paints the dramatic Fauve portrait of Mme Matisse titled *The Woman with the Hat* (pl. 64) and other works; at the same time begins a large Neo-Impressionist painting, *The Port of Abaill, Collioure* (pl. 63), originally intended for the Salon d'Automne but not shown there.

SEPTEMBER 13: Félix Fénéon, who had organized the Seurat exhibition at this year's Indépendants, visits Matisse's studio.

MID-SEPTEMBER: Signac purchases *Luxe, calme et volupté* (pl. 50). It will be installed in the dining room at his villa, La Hune, in Saint-

André Derain. *Portrait of Henri Matisse.* 1905. Oil on canvas, 18⅛ × 13¾″ (46 × 34.9 cm). Tate Gallery, London. Purchased from Mme Henri Matisse (Grant-in-Aid), 1958.

Tropez by the end of the month. It will not be seen again publicly until 1950.

OCTOBER 18–NOVEMBER 25: The Salon d'Automne; exhibition of Matisse's summer and autumn 1905 paintings and those of his associates causes a sensation. Works by Camoin, Derain, Manguin, Marquet, Matisse, and Vlaminck are shown in room VII along with a quattrocento-like bust, causing the critic Louis Vauxcelles to comment, *"Donatello chez les fauves,"* and christen the Fauve movement. Among Matisse's ten controversial submissions are *The Open Window* (pl. 61) and *The Woman with the Hat* (pl. 64). Friesz, Puy, Rouault, and Valtat are also represented. The Salon includes retrospectives devoted to Ingres, Manet, and Renoir. Around this time, Matisse paints the portrait of his wife known as *The Green Line* (pl. 65).

OCTOBER 21–NOVEMBER 20: Exhibits with Camoin, Derain, Dufy, Manguin, Marquet, and Vlaminck at the Berthe Weill gallery.

Takes a studio in the Couvent des Oiseaux at no. 56, rue de Sèvres (which he will maintain until spring 1908). There begins work on *Le bonheur de vivre* (pl. 73), a large, imaginary, arcadian figure composition, on the basis of a landscape painted at Collioure (pl. 58) and of Ingres-influenced drawings (pl. 74). The large, flat color areas and arabesque drawing of the finished picture apparently repudiate his Fauvism of summer and autumn 1905; yet over the winter he also continues to pursue a spontaneous mixed-technique style in paintings such as *The Idol* (pl. 66) and *Interior with a Young Girl* (pl. 67).

The Stein family (Gertrude, Leo, Michael, and Sarah) purchases *The Woman with the Hat* (pl. 64), the Steins' first Matisse acquisition, on the last day of the Salon. Leo Stein is afterward taken by Manguin to meet Matisse (who, Leo will recall, is at work on *Le bonheur de vivre*). Leo in turn will bring Michael and Sarah Stein to Matisse's studio.

1906

JANUARY 15: Through Michael and Sarah Stein, Etta Cone meets Matisse; buys several of his works during the year. Around this date, Signac visits Matisse's studio and sees *Le bonheur de vivre* (pl. 73); he dislikes it intensely.

FEBRUARY 22–MARCH 25: Matisse is represented by seven works in an exhibition of La Libre Esthétique in Brussels. From this date onward begins to be represented in exhibitions outside France.

MARCH 19–APRIL 7: His second large one-artist exhibition is held, at the Druet gallery, opening one day before the Indépendants. Exhibits fifty-five paintings, three sculptures, and watercolors and drawings, as well as his first lithographs and woodcuts, made earlier in the year.

MARCH 20–APRIL 30: Exhibits a single work, *Le bonheur de vivre* (pl. 73), at the Salon des Indépendants. It will be bought by Leo Stein, while the smaller oil sketch (pl. 72), exhibited at the Druet gallery, is purchased by Michael and Sarah Stein.

Georges Braque probably meets Derain and Matisse at this time.

APRIL: Leo and Gertrude Stein arrange for Matisse and Picasso to meet.

MAY 10–26: Briefly in Collioure. Travels to Algeria; visits Algiers, Biskra, Constantine, and Botna.

MAY 26–JUNE 30: First exhibition of the Cercle de l'Art Moderne in Le Havre. Exhibits two 1905 Collioure landscapes. Will also participate in the group's second and third exhibitions, in 1907 and 1908.

END OF MAY: Returns to Collioure for the summer; remains there until early October. During the summer, paints landscapes with nude figures, including *Pastoral* (pl. 76), and still lifes, some with images of his own sculpture, among them *Still Life with a Plaster Figure* (pl. 83). Also paints portraits, including two versions of *The Young Sailor* (pls. 89, 90), the second of which, possibly done in the autumn or winter, develops the so-called decorative style of *Le bonheur de vivre* (pl. 73).

1906–07 Season

EARLY OCTOBER: Is in Paris, until mid-November.

Two-page spread from *L'illustration*, November 4, 1905, featuring works shown at that year's Salon d'Automne.

His growing interest in African sculpture is shared by Vlaminck and Derain; he buys his first African sculpture during the autumn, about the same time that Derain acquires a Fang mask from Vlaminck. Matisse will draw Picasso's attention to African art.

Probably around this time, meets the Russian collector Sergei Shchukin, who has already purchased a large still life, a drawing, and two lithographs by Matisse the previous spring.

OCTOBER 6–NOVEMBER 15: Exhibits five works, including *Flowers* (pl. 82), *Still Life with a Plaster Figure* (pl. 83), *Marguerite Reading* (pl. 85), and *Still Life with a Red Rug* (pl. 86), at the Salon d'Automne; Biette, Camoin, Derain, van Dongen, Dufy, Friesz, Manguin, Marquet, Puy, Rouault, and Vlaminck are also represented. The Salon includes a large exhibition of Russian art, organized by the impresario Sergei Diaghilev, as well as retrospectives of Eugène Carrière, Gustave Courbet, and Gauguin.

MID-NOVEMBER: Visits Derain in L'Estaque, en route to Collioure. Mme Matisse and Marguerite join him in Collioure; except for a visit to Paris, the three remain there until July 1907. Begins the sculpture *Reclining Nude (I)* (pl. 92), which recapitulates the pose of the right middle-ground figure in *Le bonheur de vivre* (pl. 73) and of the sculpture *Reclining Figure in a Chemise* (pl. 75).

Matisse frequently sees Maillol in Banyuls-sur-Mer.

1907

EARLY JANUARY: The sculpture *Reclining Nude (I)* (pl. 92) is damaged in modeling; he paints the same motif as *Blue Nude: Memory of Biskra* (pl. 93), and completes the sculpture afterward.

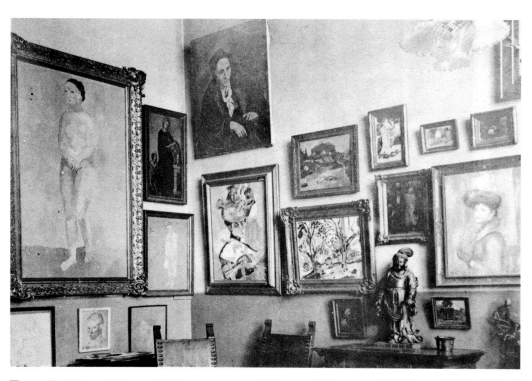

The studio of Leo and Gertrude Stein at no. 27, rue de Fleurus, Paris, c. 1907. Left: Picasso's *Nude with Joined Hands* of 1906. Top: Picasso's *Portrait of Gertrude Stein* of 1905–06. Center: Matisse's *The Woman with the Hat* (pl. 64). To its right: Matisse's *The Olive Trees* of 1906.

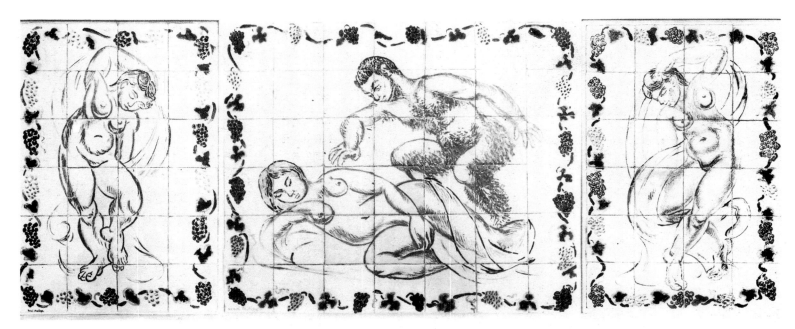

Nymph and Satyr (triptych made for Haus Hohenhof, Hagen). [spring 1907]. Painted and glazed tiles: left panel 23 × 15⅝″ (58.5 × 39.9 cm); center panel 22¼ × 26⅜″ (56.5 × 67 cm); right panel 22⅜ × 15″ (57 × 38 cm). Karl-Ernst Osthaus Museum, Hagen.

FEBRUARY–MARCH: Exhibition of Islamic textiles and miniatures at the Musée des Arts Décoratifs (Pavillon de Marsan).

LATE FEBRUARY: Is back in Paris; will remain until late April.

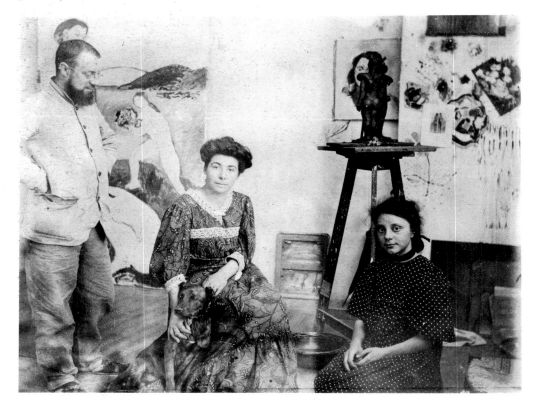

In Matisse's studio at Collioure, summer 1907. Left to right: Matisse, Mme Matisse, and Marguerite. Behind Matisse: *Le luxe (I)* (pl. 102). Behind Marguerite: the sculpture *Two Women* (pl. 94).

MARCH 14: His first recorded sale to the Bernheim-Jeune gallery is made, through Félix Fénéon, who has been affiliated with Bernheim-Jeune since 1906 and is responsible for bringing young artists into the gallery. In the following winter, Matisse will participate in two group exhibitions there.

MARCH 20–APRIL 30: Exhibits drawings, woodcuts, and the painting *Blue Nude: Memory of Biskra* (pl. 93), as *Tableau III*, at the Salon des Indépendants. *Blue Nude*, purchased by Leo Stein, excites controversy. Its bold distortions are widely attacked by the critics as ugly; however, the work is also recognized as a Cézanne-inspired picture, like Derain's *Bathers* of 1907, also shown at the Indépendants.

Makes ceramic tiles and plates at the atelier of André Méthey in Asnières, as well as a ceramic triptych commissioned for Karl-Ernst Osthaus's Haus Hohenhof in Hagen.

LATE APRIL: Is back in Collioure, where through the summer he makes the sculpture *Two Women* (pl. 94) and paints landscapes, including *Brook with Aloes* (pl. 96), and a group of decorative figure compositions, including *Music (oil sketch)* (pl. 100) and *La coiffure* (pl. 101).

JULY 14: With Mme Matisse, leaves Collioure for Italy, traveling via Cassis (where they visit Derain and Girieud), La Ciotat (Braque, Friesz), Saint-Clair (Cross), Saint-Tropez (Manguin). In Italy, proceeds to Fiesole, where Leo and Gertrude Stein have rented Villa Bardi for the summer. At the Steins', meets Walter Pach, who will play an important role in promoting Matisse's art in the United States. Visits Florence, Siena, Arezzo, Ravenna, Padua, and Venice. Is deeply impressed by the art of Andrea del Castagno, Duccio, Giotto, Piero della Francesca, and Paolo Uccello. In mid-August, returns to Collioure, where he paints *Le luxe (I)* (pl. 102).

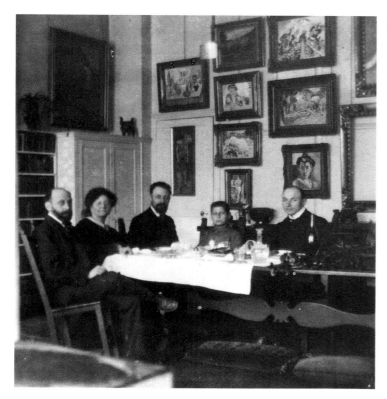 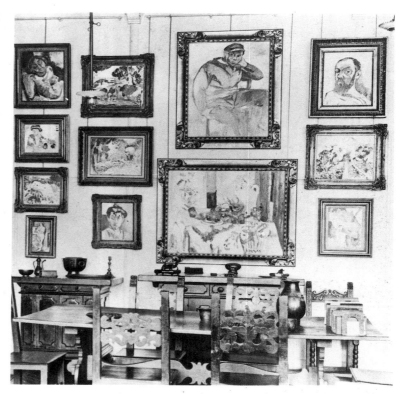

The apartment of Michael and Sarah Stein at no. 58, rue Madame, Paris, c. 1907. In the photograph at left, seated around the table are (left to right) Michael and Sarah Stein, Matisse, Allan Stein, and Hans Purrmann. On the wall behind them are several of Matisse's paintings, including *Pink Onions* (pl. 87), above Matisse, and *The Green Line* (pl. 65) and *Oil sketch for "Le bonheur de vivre"* (pl. 72), behind Purrmann. In the photograph at right, on the same wall (reinstalled) can be seen *The Young Sailor (I)* (pl. 89), top center; *Self-Portrait* (pl. 88), top right; and *Branch of Flowers* (pl. 77), bottom right.

1907–08 Season

EARLY SEPTEMBER: Is in Paris, until June 1908.

OCTOBER 1–22: Exhibits several works, including *Music (oil sketch)* (pl. 100) and *Le luxe (I)* (pl. 102), in the Salon d'Automne, but the jury rejects *La coiffure* (pl. 101). The Salon includes a large retrospective exhibition of Cézanne.

NOVEMBER–DECEMBER: Matisse and Derain probably see *Les demoiselles d'Avignon* (painted in June–July) in Picasso's studio. Matisse is disturbed by the picture.

Matisse and Picasso exchange paintings: Picasso's 1907 still life *Pitcher, Bowl, and Lemon* for Matisse's 1906–07 portrait of Marguerite (pl. 98).

A class taught by Matisse is organized on the initiative of Sarah Stein and Hans Purrmann. With the financial assistance of Michael Stein, a studio space is secured at the Couvent des Oiseaux at no. 56, rue de Sèvres, where Matisse already has his own studio.

DECEMBER 15: *La phalange* publishes an article on Matisse by Guillaume Apollinaire, based on interviews with the artist; includes four quoted statements by Matisse and reproduces four of his recent paintings.

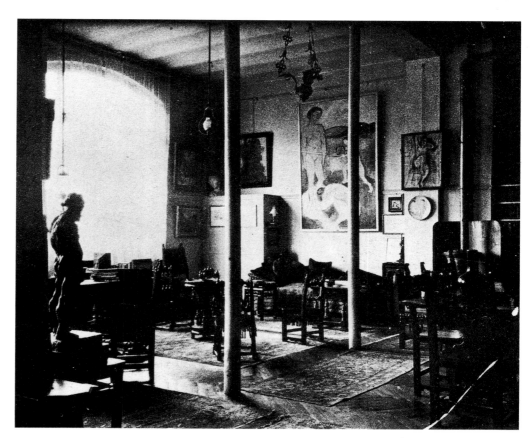

The apartment of Michael and Sarah Stein, c. 1908. On the back wall: *Le luxe (I)* (pl. 102), on loan from Matisse. In the left foreground: *The Serf* (pl. 25).

51. La japonaise: Woman Beside the Water
 La japonaise au bord de l'eau

Collioure, summer 1905

Oil and pencil on canvas, 13⅞ × 11⅛″ (35.2 × 28.2 cm)
Signed lower left: "Henri-Matisse"
The Museum of Modern Art, New York. Purchase and
partial anonymous gift
Formerly collection Michael and Sarah Stein

52. Landscape at Collioure
 Paysage à Collioure

Collioure, [summer 1905]

Oil on canvas, 15⅜ × 18¼″ (39 × 46.2 cm)
Signed lower left: "Henri Matisse"
The Museum of Modern Art, New York.
Fractional gift of Mrs. Bertram Smith

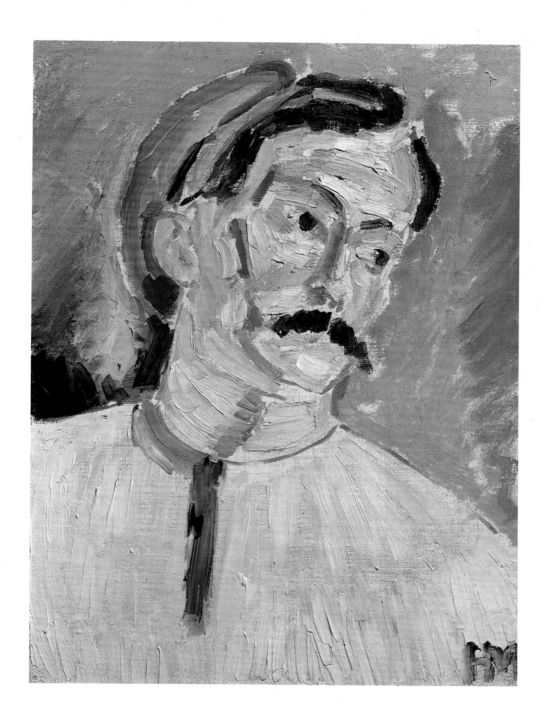

53. André Derain

Collioure, summer 1905

Oil on canvas, 15½ × 11⅜" (39.4 × 28.9 cm)
Signed lower right: "HM." On side of stretcher: "MATISSE"
Tate Gallery, London. Purchased with assistance from the Knapping
Fund, the National Art-Collections Fund and the Contemporary Art
Society and private subscribers, 1954
Formerly collections Michael and Sarah Stein; Christian Tetzen-Lund

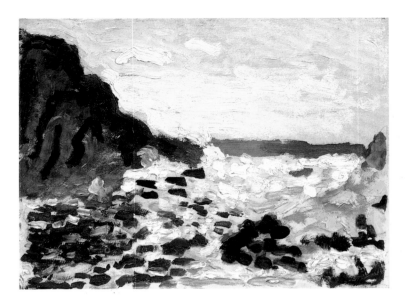

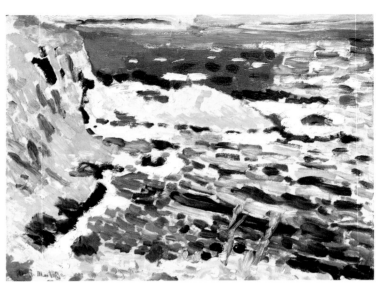

54. Seascape: Beside the Sea
 Marine: Bord de la mer

Collioure, [summer 1905]

Oil on cardboard, 9⅝ × 12¾″ (24.5 × 32.4 cm)
Signed lower right: "Henri Matisse"
San Francisco Museum of Modern Art. Bequest of Mildred B. Bliss
Formerly collection Michael and Sarah Stein

55. Seascape: La Moulade
 Marine: La Moulade

Collioure, [summer 1905]

Oil on wooden panel, 9½ × 12¾″ (24.2 × 32.3 cm)
Signed lower left: "Henri-Matisse"
Private collection, courtesy Barbara Divver Fine Art

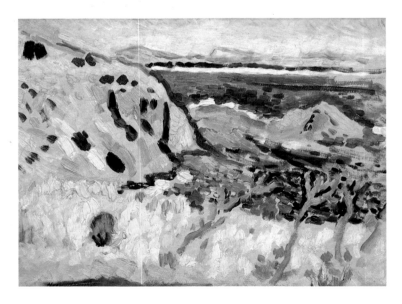

56. Seascape: La Moulade
 Marine: La Moulade

Collioure, [summer 1905]

Oil on cardboard, 10¼ × 13¼″ (26.1 × 33.7 cm)
Signed lower left: "Henri Matisse"
San Francisco Museum of Modern Art. Bequest of Mildred B. Bliss
Formerly collection Michael and Sarah Stein

57. Landscape: Les Genêts
 Paysage: Les Genêts

Collioure, [summer 1905]

Oil on wooden panel, 12 × 15⅝″ (30.5 × 39.7 cm)
Signed lower right: "Henri-Matisse"
San Francisco Museum of Modern Art. Bequest of Elise S. Haas
Formerly collection Michael and Sarah Stein

58. Landscape at Collioure / Study for "Le bonheur de vivre"
 Paysage de Collioure / Étude pour "Le bonheur de vivre"

Collioure, summer 1905

Oil on canvas, 18⅛ × 21⅝″ (46 × 55 cm)
Signed lower left: "Henri Matisse"
Statens Museum for Kunst, Copenhagen. J. Rump Collection
Formerly collections Michael and Sarah Stein; Christian Tetzen-Lund

59. Woman at the Window
 Femme devant la fenêtre

Collioure, [summer 1905]

Oil on canvas, 12½ × 11¾″ (31.8 × 29.8 cm)
Not signed, not dated
Private collection

60. Interior at Collioure / The Siesta
 Intérieur à Collioure / La sieste

Collioure, summer 1905

Oil on canvas, 23¼ × 28⅜″ (59 × 72 cm)
Signed and dated lower right: "Henri Matisse 1905"
Private collection, Switzerland

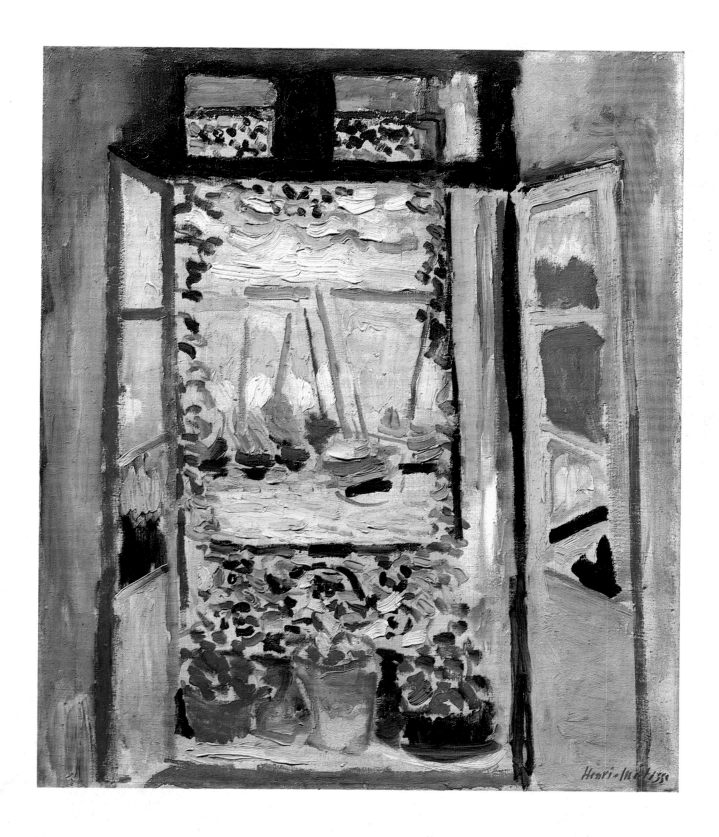

61. The Open Window
 La fenêtre ouverte

Collioure, summer 1905

Oil on canvas, 21¾ × 18⅛″ (55.2 × 46 cm)
Signed lower right: "Henri-Matisse"
Collection Mrs. John Hay Whitney

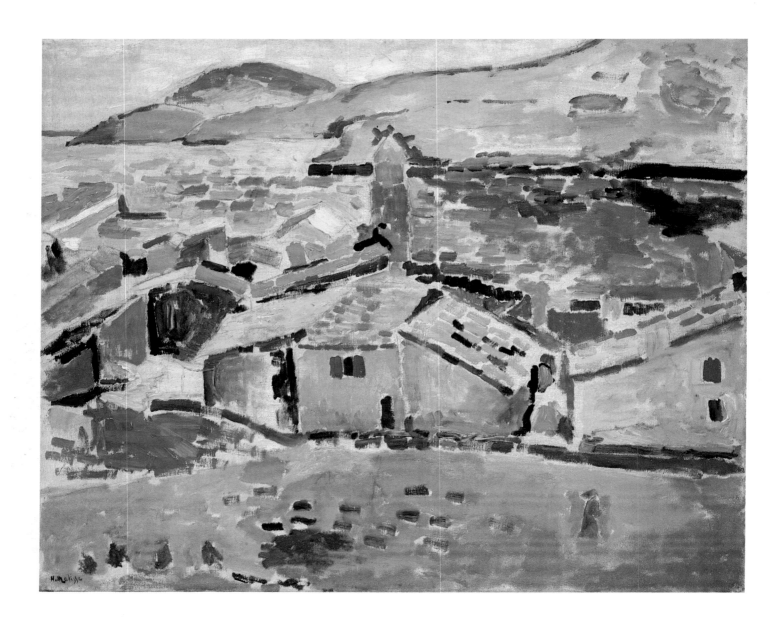

62. The Roofs of Collioure
Les toits de Collioure

Collioure or Paris, [summer–autumn 1905]

Oil on canvas, 23 ⅜ × 28 ¾″ (59.5 × 73 cm)
Signed lower left: "H. Matisse"
The Hermitage Museum, St. Petersburg
Formerly collection Sergei Shchukin

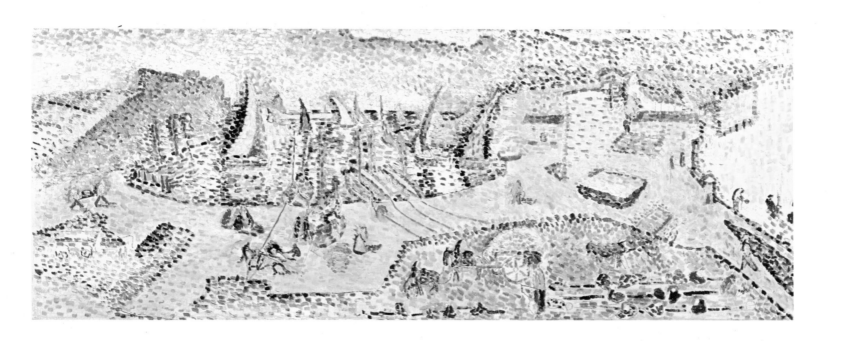

63. The Port of Abaill, Collioure
Le port d'Abaill, Collioure

Paris, autumn–winter 1905–06

Oil on canvas, 23⅝ × 58¼″ (60 × 148 cm)
Not signed, not dated
Private collection

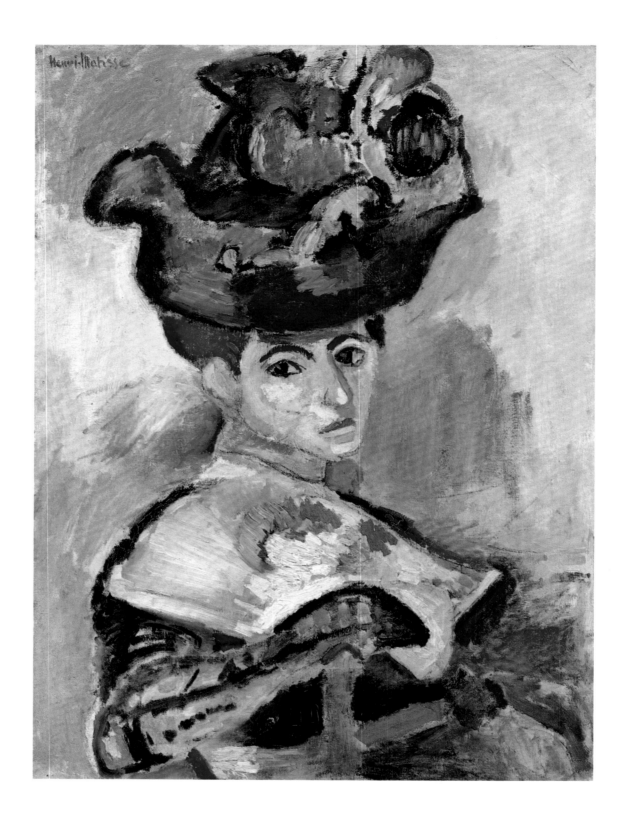

64. The Woman with the Hat
La femme au chapeau

Paris, autumn 1905

Oil on canvas, 31¾ × 23½″ (80.6 × 59.7 cm)
Signed upper left: "Henri-Matisse"
San Francisco Museum of Modern Art. Bequest of Elise S. Haas
Formerly collections Leo and Gertrude Stein; Michael and Sarah Stein

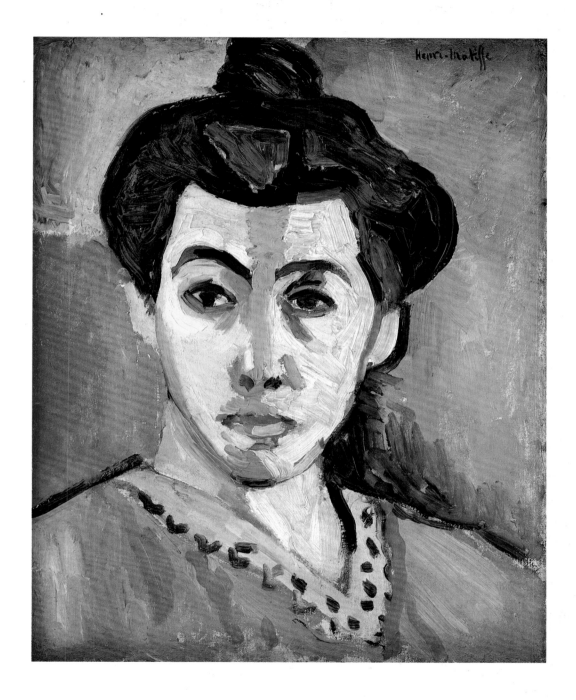

65. Portrait of Mme Matisse / The Green Line
 Portrait de Mme Matisse / La raie verte

Paris, [autumn–winter 1905]

Oil on canvas, 16 × 12⅞″ (40.5 × 32.5 cm)
Signed upper right: "Henri-Matisse"
Statens Museum for Kunst, Copenhagen. J. Rump Collection
Formerly collections Michael and Sarah Stein; Christian Tetzen-Lund

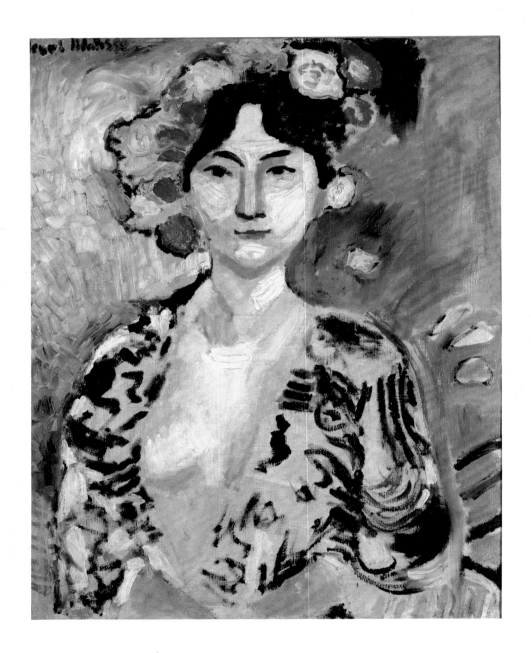

66. The Idol
 L'idole

[Paris, autumn–winter 1905–06]

Oil on canvas, 28¾ × 23⅝″ (73 × 60 cm)
Signed upper left: "Henri Matisse"
Private collection

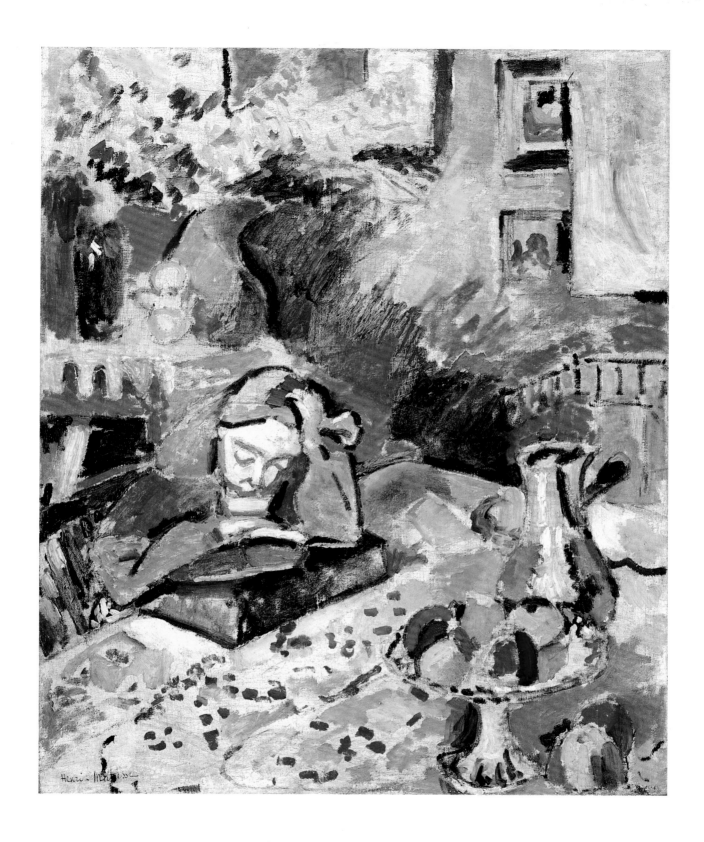

67. Interior with a Young Girl / Girl Reading
Intérieur à la fillette / La lecture

[Paris, autumn–winter 1905–06]

Oil on canvas, 28⅝ × 23⅜″ (72.7 × 59.4 cm)
Signed lower left: "Henri-Matisse"
Private collection
Formerly collection Félix Fénéon

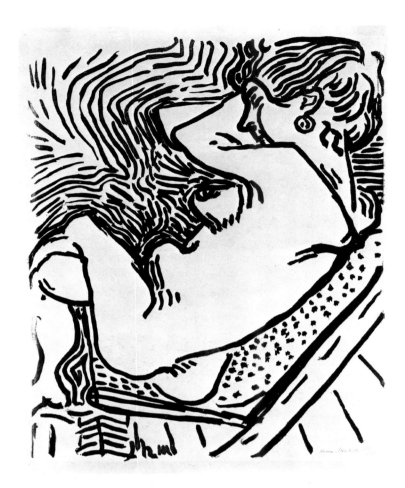

68. Seated Nude
Nu assis / Le grand bois

Paris, [early 1906]

Woodcut, printed in black: composition 18¹¹⁄₁₆ × 14¹⁵⁄₁₆″ (47.5 × 38 cm);
sheet 22⅝ × 18¹⁄₁₆″ (57.5 × 46 cm)
Signed lower left of center: "hm." Lower right in ink: "Henri-Matisse 33/50"
The Museum of Modern Art, New York. Gift of Mr. and Mrs. R.
Kirk Askew, Jr.

69. Nude in a Folding Chair
Nu dans une chaise pliante

Paris, [early 1906]

Brush and ink on paper, 25⅞ × 18⅜″ (65.7 × 46.7 cm)
Signed lower right: "Henri-Matisse"
The Art Institute of Chicago. Gift of Mrs. Potter Palmer

70. Seated Nude
 Nu assis / Petit bois clair

Paris, [early 1906]

Woodcut, printed in black: composition 13 7/16 × 10 7/16″
(34.2 × 26.6 cm); sheet 18 1/16 × 11 1/4″ (46 × 28.4 cm)
Signed lower left: "HM." Lower right in pencil: "Henri-Matisse"
The Museum of Modern Art, New York.
Abby Aldrich Rockefeller Fund

71. Jeanne Manguin

Paris, [autumn 1905–spring 1906]

Brush and reed pen and ink on paper, 24 1/2 × 18 1/2″ (62.2 × 46.9 cm)
Signed lower right: "Henri-Matisse"
The Museum of Modern Art, New York. Given anonymously

72. Oil sketch for "Le bonheur de vivre"
Esquisse pour "Le bonheur de vivre"

[Paris, autumn–winter 1905–06]

Oil on canvas, 16⅛ × 21½″ (40.6 × 54.6 cm)
Signed upper left: "Henri-Matisse"
San Francisco Museum of Modern Art. Bequest of Elise S. Haas
Formerly collection Michael and Sarah Stein

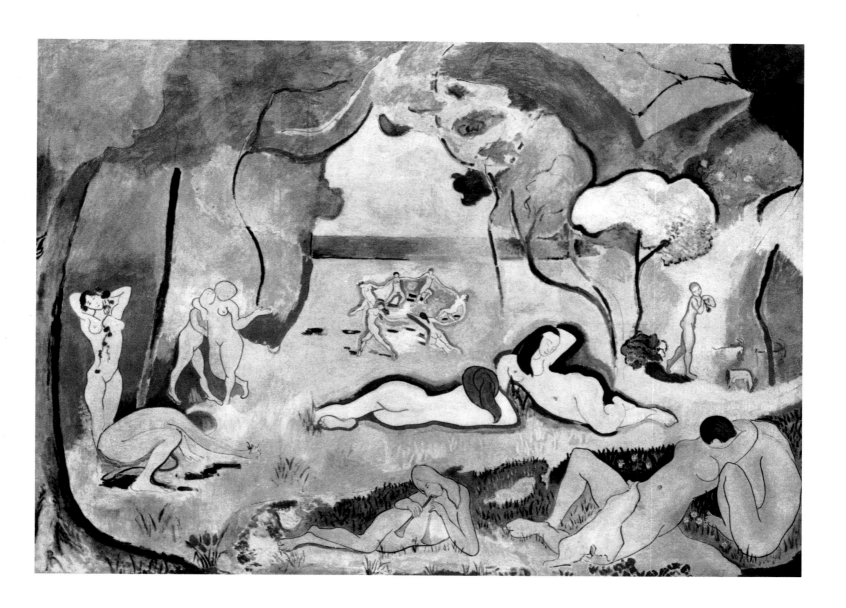

73. Le bonheur de vivre

Paris, Couvent des Oiseaux, autumn–winter 1905–06

Oil on canvas, 68½″ × 7′9¼″ (174 × 238.1 cm)
Not signed, not dated
The Barnes Foundation, Merion Station, Pennsylvania
Formerly collections Leo Stein; Christian Tetzen-Lund

74. Reclining Nude Playing Pipes: Study for "Le bonheur de vivre"
Nu allongé jouant du pipeau: Étude pour "Le bonheur de vivre"

Paris, [autumn–winter 1905–]06

Pen and ink on paper, 18 × 23¾″ (45.8 × 60.4 cm)
Signed and dated lower right: "Henri-Matisse 1906"
Private collection

75. Reclining Figure in a Chemise
Nu couché à la chemise

Paris or Collioure, [1906]

Bronze, 5⅝ × 12 × 6⅛″ (14.3 × 30.5 × 15.5 cm)
Inscribed: "HM 10/10"
Founder C. Valsuani
Hirshhorn Museum and Sculpture Garden,
Smithsonian Institution, Washington, D.C.
Gift of Joseph H. Hirshhorn, 1966

76. Pastoral
 La pastorale

Collioure, [summer 1906]

Oil on canvas, 18⅛ × 21⅝″ (46 × 55 cm)
Signed lower right: "Henri-Matisse"
Musée d'Art Moderne de la Ville de Paris

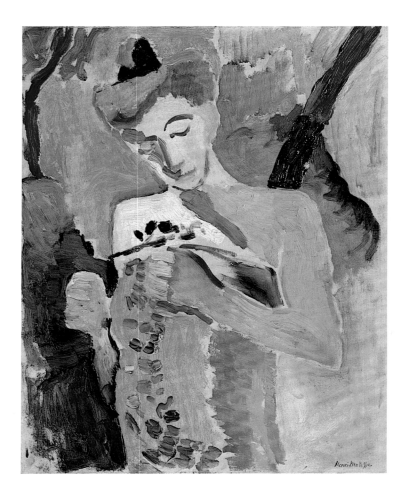

77. Branch of Flowers
La branche de fleurs

Collioure, [summer 1906]

Oil on canvas, 15¾ × 12½″ (40 × 31.8 cm)
Signed lower right: "Henri-Matisse"
Collection Mr. and Mrs. J. Irwin Miller
Formerly collection Michael and Sarah Stein

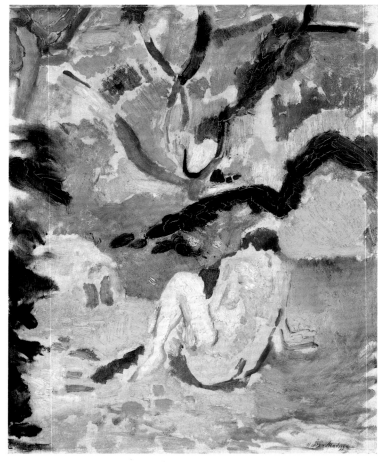

78. Nude in a Wood
Nu dans les bois

Collioure, [summer 1906]

Oil on wooden panel, 16 × 12¾″ (40.6 × 32.4 cm)
Signed lower right: "Henri-Matisse"
The Brooklyn Museum, New York. Gift of Mr. George F. Of

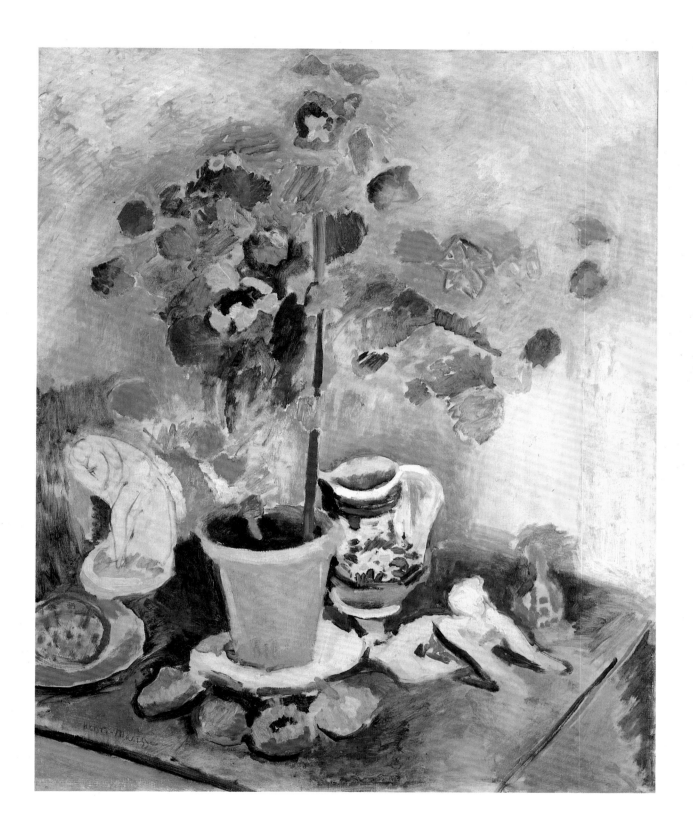

79. Still Life with a Geranium
 Nature morte au pélargonium [Le géranium]

[Collioure, summer 1906]

Oil on canvas, 38½ × 31½″ (97.9 × 80.2 cm)
Signed lower left: "Henri-Matisse"
The Art Institute of Chicago. Joseph Winterbotham Collection
Formerly collection Oskar and Greta Moll

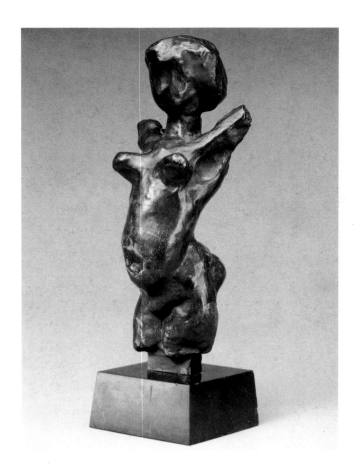

80. La vie / Torso with Head
La vie / Torse avec tête

Paris or Collioure, [c. 1906]

Bronze, 9⅛ × 4 × 3″ (23.2 × 10.2 × 7.6 cm)
Inscribed: "Matisse 2/10"
The Metropolitan Museum of Art, New York.
The Alfred Stieglitz Collection, 1949

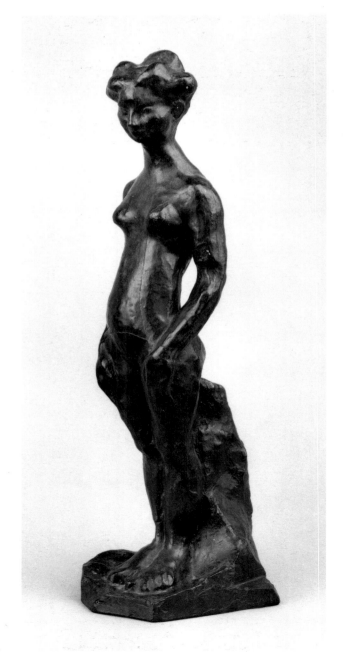

81. Standing Nude
Nu debout

Collioure, [summer 1906]

Bronze, 19 × 4¾ × 6¾″ (48.3 × 12 × 17.1 cm)
Inscribed: "7/10 HM"
Founder C. Valsuani
Private collection, courtesy Stephen Mazoh and Company, Inc.

82. Flowers
Fleurs

Collioure, [summer 1906]

Oil on canvas, 23 × 28¼″ (58 × 71.5 cm)
Signed lower right: "Henri-Matisse"
Collection The Duke of Roxburghe
Formerly collection Oskar and Greta Moll

83. Still Life with a Plaster Figure
Nature morte à la statuette

Collioure, [summer 1906]

Oil on canvas, 21¼ × 17¾″ (54 × 45.1 cm)
Signed lower left: "Henri-Matisse"
Yale University Art Gallery, New Haven, Connecticut.
Bequest of Mrs. Kate Lancaster Brewster
Formerly collection Oskar and Greta Moll

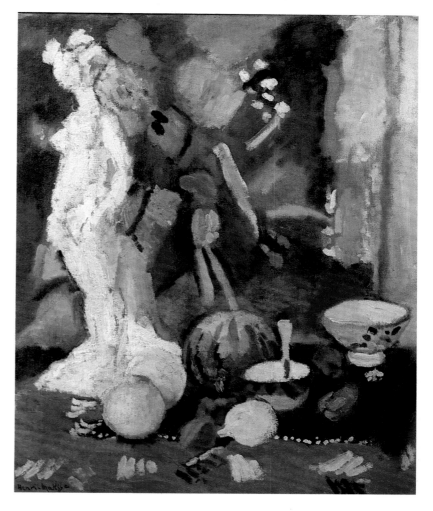

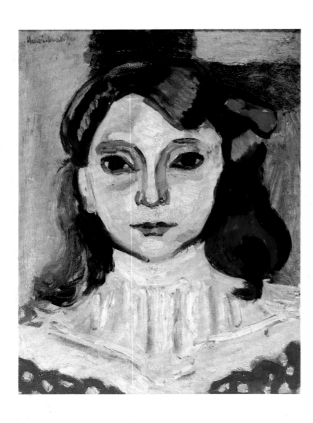

84. Marguerite

[Collioure, summer 1906]

Oil on wooden board, 12½ × 9½″ (31.8 × 24.1 cm)
Signed upper left: "Henri-Matisse"
Collection Marion Smooke, Trustee of the
Smooke Family Revocable Trust

85. Marguerite Reading
Marguerite lisant [La liseuse]

[Collioure, summer 1906]

Oil on canvas, 25⅝ × 31⅞″ (65 × 81 cm)
Signed lower left: "Henri-Matisse"
Musée de Grenoble. Agutte-Sembat Bequest
Formerly collection Marcel Sembat

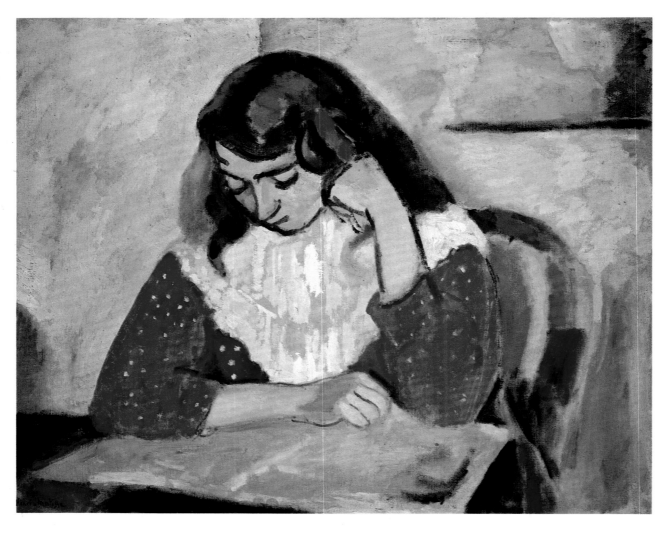

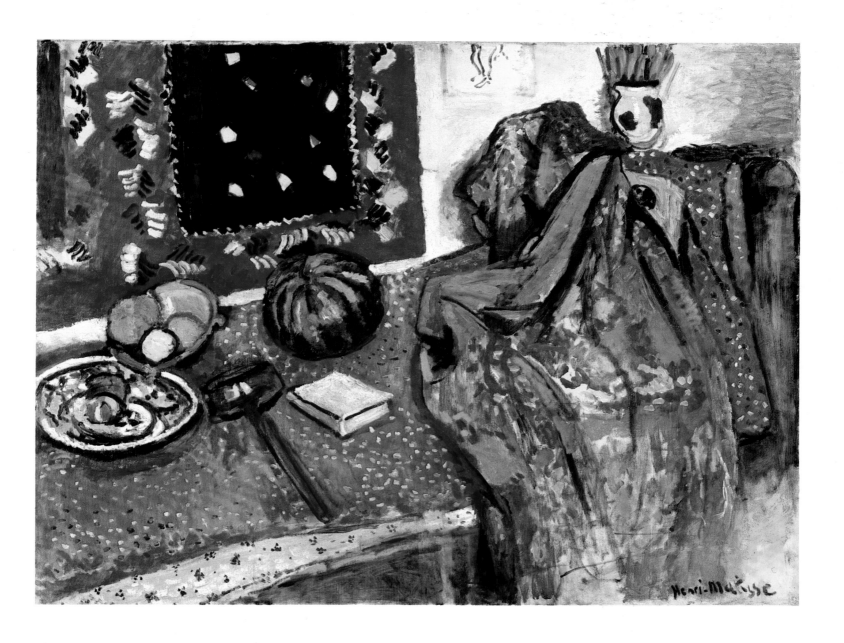

86. Still Life with a Red Rug
Nature morte au tapis rouge

Collioure, [summer 1906]

Oil on canvas, 35 × 45⅞″ (89 × 116.5 cm)
Signed lower right: "Henri-Matisse"
Musée de Grenoble. Agutte-Sembat Bequest
Formerly collection Marcel Sembat

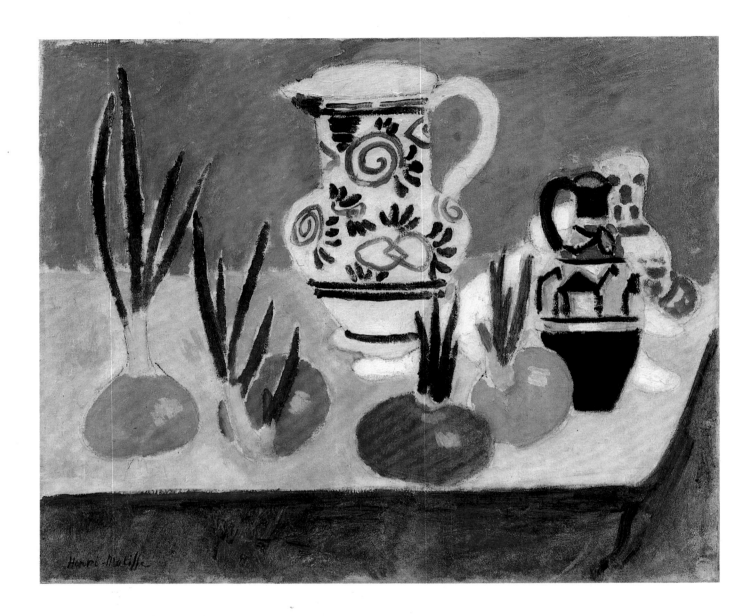

87. Pink Onions
Les oignons roses

Collioure, [summer 1906?]

Oil on canvas, 18⅛ × 21⅝″ (46 × 55 cm)
Signed lower left: "Henri-Matisse"
Statens Museum for Kunst, Copenhagen. J. Rump Collection
Formerly collections Michael and Sarah Stein; Christian Tetzen-Lund

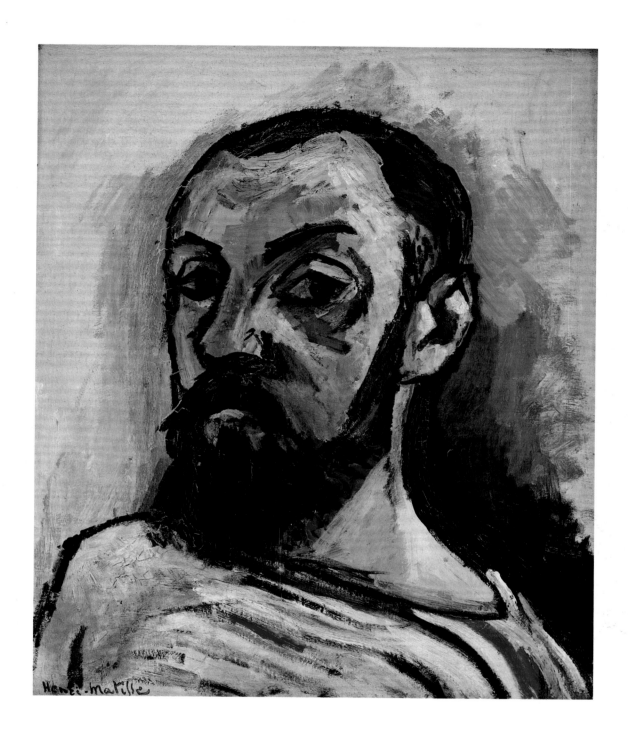

88. Self-Portrait

Autoportrait

[Collioure, summer 1906?]

Oil on canvas, 21⅝ × 18⅛″ (55 × 46 cm)
Signed lower left: "Henri-Matisse"
Statens Museum for Kunst, Copenhagen. J. Rump Collection
Formerly collections Michael and Sarah Stein; Christian Tetzen-Lund

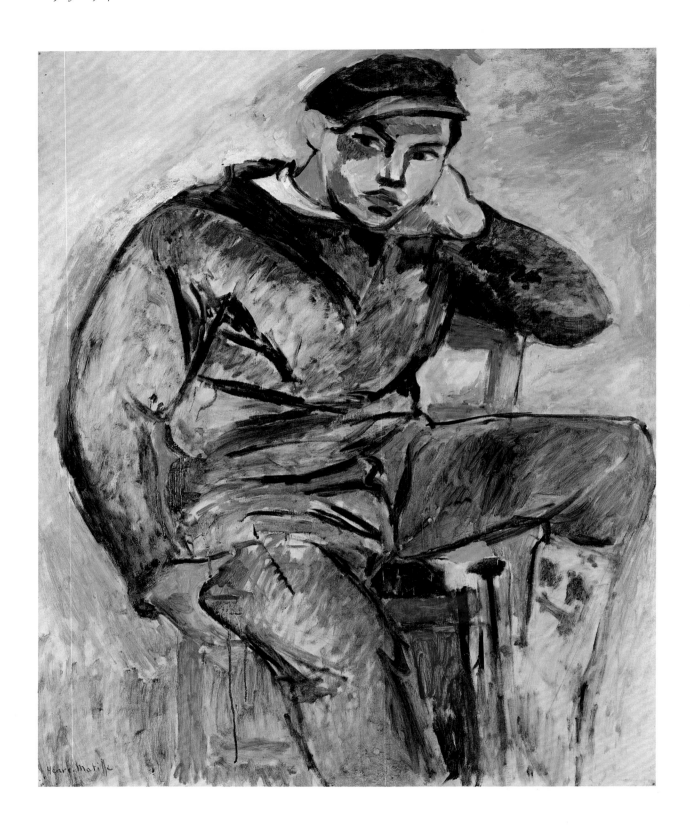

89. The Young Sailor (I)
Le jeune marin (I)

Collioure, summer 1906

Oil on canvas, 39¼ × 32¼″ (100 × 82 cm)
Signed lower left: "Henri-Matisse"
Private collection
Formerly collections Michael and Sarah Stein; Trygve Sagen

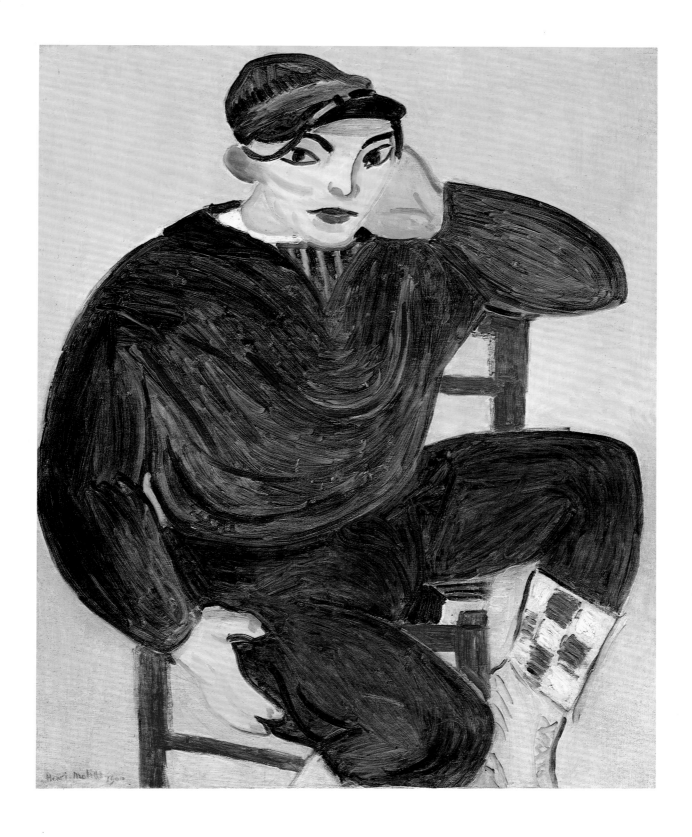

90. The Young Sailor (II)
Le jeune marin (II)

Collioure or Paris, [summer–winter] 1906

Oil on canvas, 40 × 32¾″ (101.5 × 83 cm)
Signed and dated lower left: "Henri-Matisse 1906"
The Jacques and Natasha Gelman Collection
Formerly collection Leigh B. Block

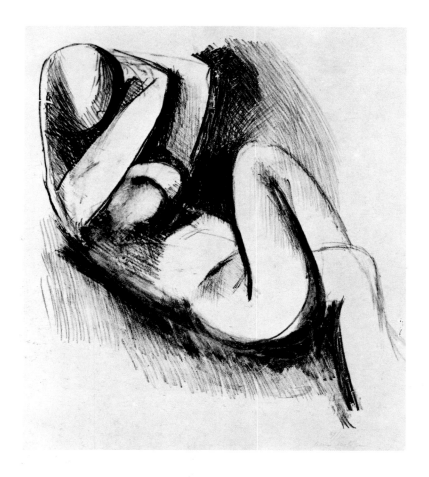

91. **Large Nude**
 Le grand nu

[Paris, early 1906 or early 1907?]

Lithograph, printed in black: composition 11³⁄₁₆ × 9¹⁵⁄₁₆″
(28.5 × 25.3 cm); sheet 17¹¹⁄₁₆ × 13⁷⁄₈″ (45 × 35.3 cm)
Signed lower right in pencil: "37/50 / Henri-Matisse"
The Museum of Modern Art, New York. Gift of Abby Aldrich
Rockefeller (by exchange)

92. **Reclining Nude (I) / Aurora**
 Nu couché (I) / Aurore

Collioure, winter 1906–07

Bronze, 13½ × 19¾ × 11¼″ (34.3 × 50.2 × 28.6 cm)
Inscribed: "Henri Matisse"
Private collection

93. Blue Nude: Memory of Biskra
 Nu bleu: Souvenir de Biskra [Tableau III]

Collioure, early 1907

Oil on canvas, 36¼ × 55¼" (92.1 × 140.4 cm)
Signed (in 1926–27) lower right: "Henri-Matisse"
The Baltimore Museum of Art. The Cone Collection, formed by
Dr. Claribel Cone and Miss Etta Cone of Baltimore, Maryland
Formerly collections Leo Stein; Alphonse Kann; John Quinn

94. Two Women
Groupe de femmes / Deux négresses [Groupe de deux jeunes filles]

Collioure, summer 1907

Bronze, 18⅜ × 10⅛ × 7⅞" (46.6 × 25.6 × 19.9 cm)
Inscribed: "Henri Matisse / 1/10"
Hirshhorn Museum and Sculpture Garden, Smithsonian Institution,
Washington, D.C. Gift of Joseph H. Hirshhorn, 1966

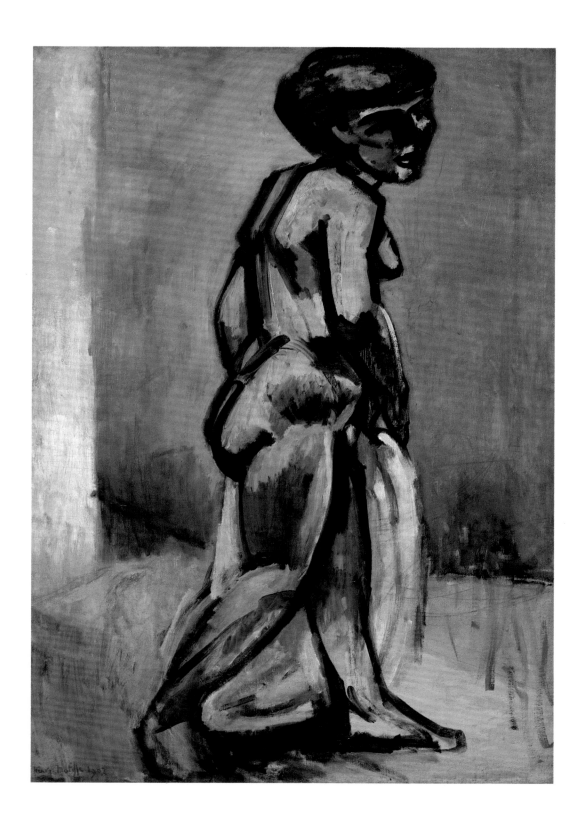

95. Standing Nude
 Nu debout [Étude de nu]

[Collioure, late 1906 to] 1907

Oil on canvas, 36¼ × 25½" (92.1 × 64.8 cm)
Signed and dated lower left: "Henri-Matisse 1907"
Tate Gallery, London. Purchased 1960

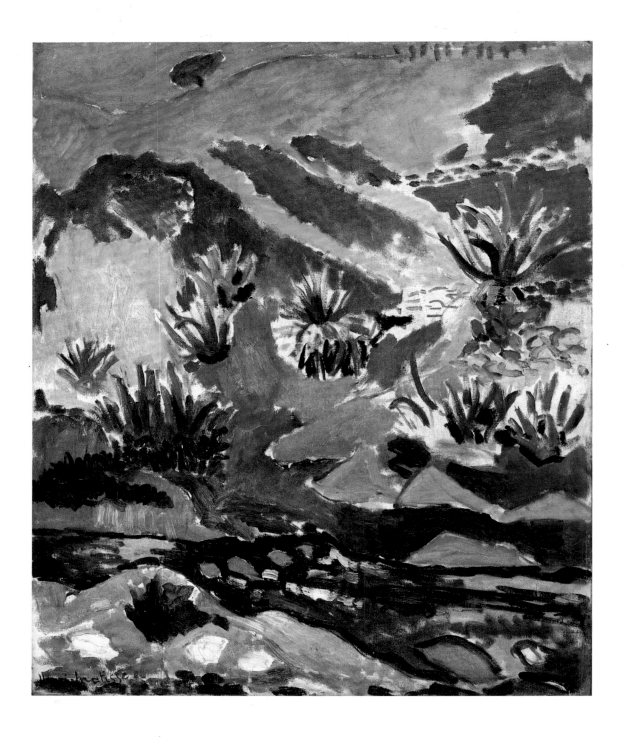

96. Brook with Aloes
Le ruisseau aux aloès

Collioure, spring–summer 1907

Oil on canvas, 28¾ × 23⅝″ (73 × 60 cm)
Signed lower left: "Henri-Matisse"
The Menil Collection, Houston
Formerly collection Alphonse Kann

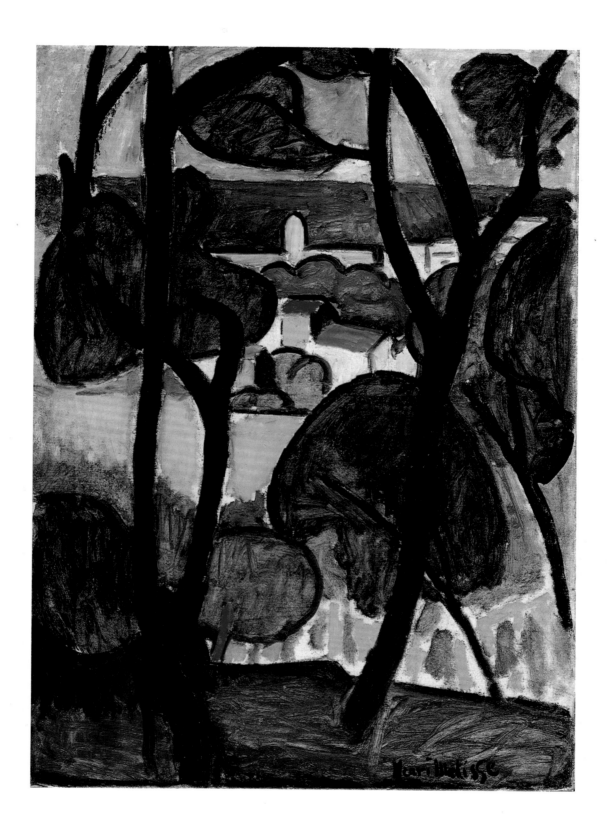

97. View of Collioure
 Vue de Collioure [Collioure à travers les arbres]

[Collioure, summer 1907, or Paris, 1907–08]

Oil on canvas, 36¼ × 25⅞″ (92 × 65.5 cm)
Signed lower right: "Henri Matisse"
The Jacques and Natasha Gelman Collection
Formerly collection Michael and Sarah Stein

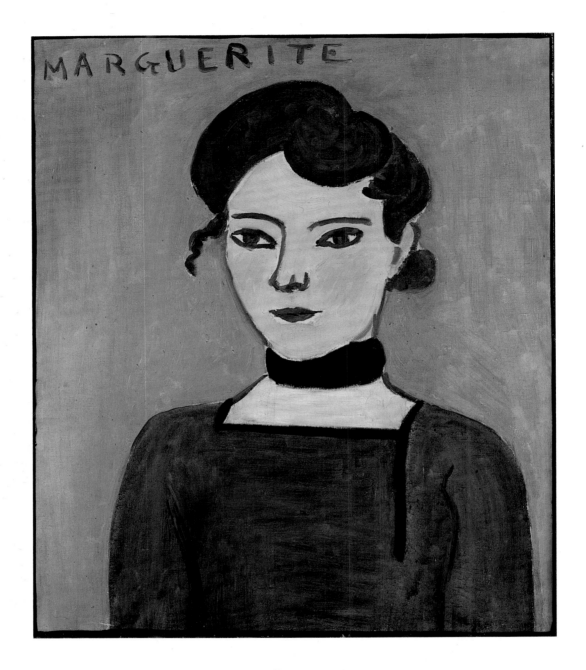

98. Marguerite

Collioure or Paris, [1906 or 1907]

Oil on canvas, 25½ × 21¼″ (65 × 54 cm)
Not signed, not dated. Inscribed upper left: "MARGUERITE"
Musée Picasso, Paris
Formerly collection Pablo Picasso

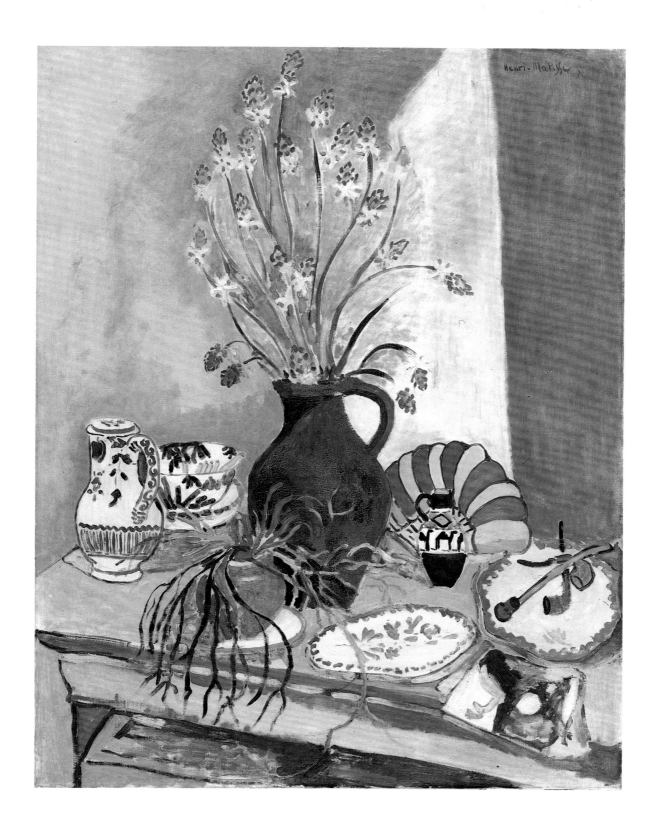

99. Still Life with Asphodels
Nature morte aux asphodèles

[Collioure, 1907]

Oil on canvas, 44⅞ × 34¼″ (114 × 87 cm)
Signed upper right: "Henri-Matisse"
Museum Folkwang, Essen
Formerly collection Karl-Ernst Osthaus

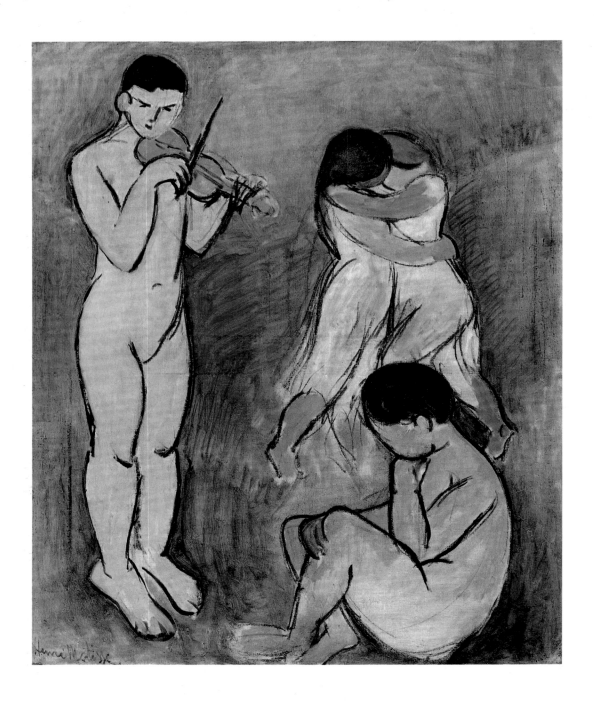

100. Music (oil sketch)
La musique (esquisse)

Collioure, spring–summer 1907

Oil on canvas, 29 × 24″ (73.4 × 60.8 cm)
Signed lower left: "Henri Matisse"
The Museum of Modern Art, New York. Gift of A. Conger
Goodyear in honor of Alfred H. Barr, Jr.
Formerly collections Leo and Gertrude Stein; John Quinn

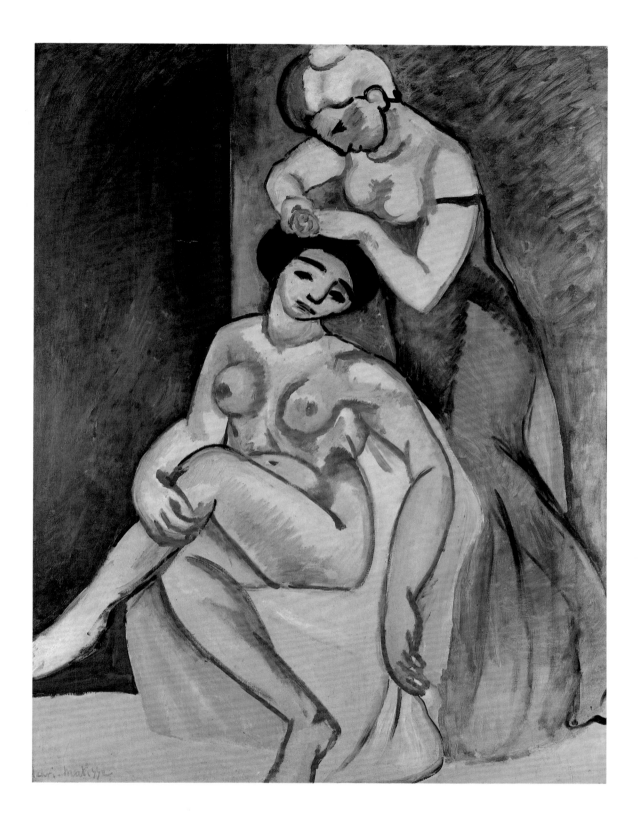

101. La coiffure

Collioure, spring–summer 1907

Oil on canvas, 45⅝ × 35″ (116 × 89 cm)
Signed lower left: "Henri-Matisse"
Staatsgalerie, Stuttgart
Formerly collections Michael and Sarah Stein; Trygve Sagen

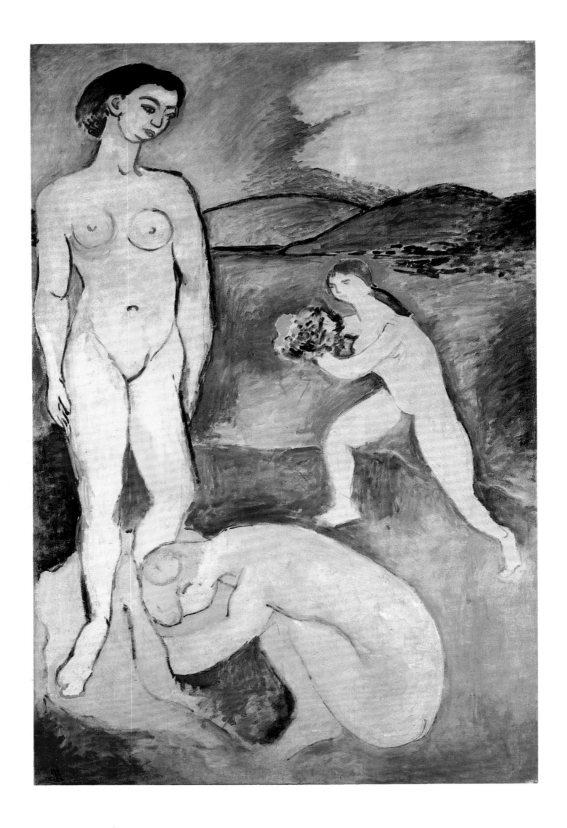

102. Le luxe (I)
Le luxe (I) [Le luxe (esquisse)]

Collioure, summer 1907

Oil on canvas, 6′ 10⅝″ × 54⅜″ (210 × 138 cm)
Signed lower left: "H.M."
Musée National d'Art Moderne, Centre Georges Pompidou, Paris
Formerly on loan from the artist to the collection of Michael and Sarah Stein

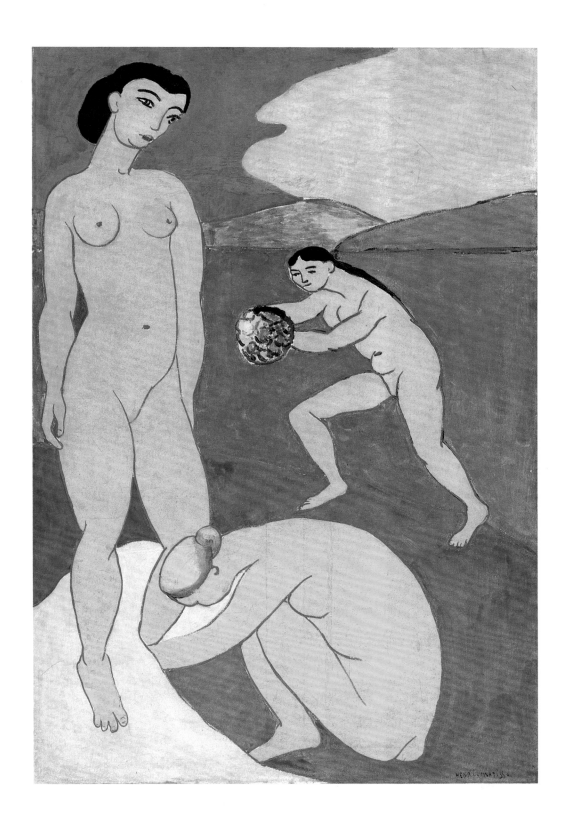

103. Le luxe (II)

Collioure or Paris, [summer 1907 to 1908?]

Casein on canvas, 6'10½" × 54⅜" (209.5 × 138 cm)
Signed lower right: "HENRI-MATISSE"
Statens Museum for Kunst, Copenhagen. J. Rump Collection

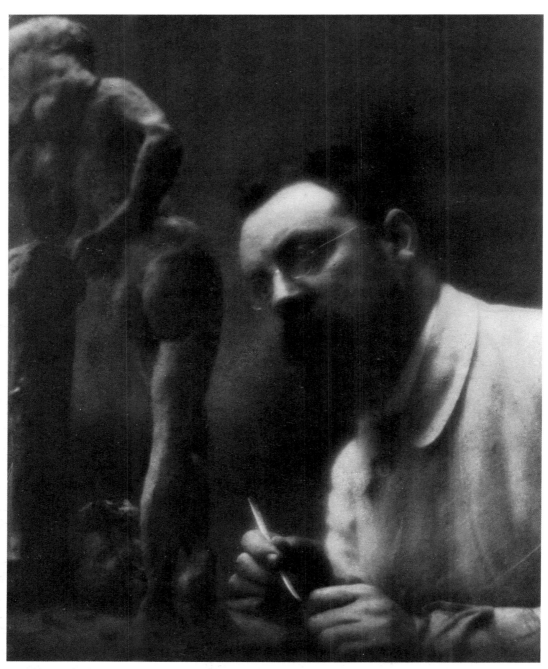

Edward Steichen. *Matisse with "La serpentine."* autumn 1909. Platinum print, 11¹¹⁄₁₆ × 9¼″ (29.6 × 23.4 cm). The Museum of Modern Art, New York. Gift of the photographer.

PART III ✦ 1908–1913

ART AND DECORATION

In "Notes of a Painter," written in 1908, Matisse described his aim as an artist: to discover the "essential character" of things beneath their superficial appearances, thus to produce "an art of balance, of purity and serenity," decorative in conception and expressive of his emotional reactions to the subjects he painted. His great still lifes and interiors of this period—such as *Harmony in Red* (pl. 105), with its vibrant, continuous field of color designed by arabesque drawing—exemplify the decorative aspect of his art. Works of this kind move fully beyond the fragmented surfaces of Fauvism to give to color an even greater reality of its own; it floods over the frontal plane of the canvas, submerging details of things. The form of Matisse's representation is determined by the movement of areas of colored paint.

Color being the primary substance of his art, form was "modified according to the interaction of neighboring colors," Matisse said. Thus the color was "proportionate to the form." He was describing *Music* (pl. 126), with *Dance (II)* (pl. 125) the climactic work in the series of ambitious figure compositions of the period. These were conceived in the tradition begun by the fresco paintings of Giotto, but remade that tradition in so extreme and simplified a way that they looked barbaric to many of Matisse's contemporaries. They were antithetical, certainly, to Cubism, which emerged in this same period—not only in their emphasis on color but also in their preservation of the wholeness of the human figure. For Matisse, the unity and integrity of the work of art were analogous to those of the figure itself. Thus sculpture continued to fascinate him. But he sculpted in the manner of a painter, he said; that is, he made visual images in

this physical medium, such as *La serpentine* (pl. 122), which is composed of solids and voids of equal importance. Thus, his work in sculpture clarified for his painting the visual organization of form.

In 1911, Matisse's art changed, in part due to the influence of Persian miniatures. *The Painter's Family* (pl. 137), one of the four great "symphonic" interiors he made that year, rejects Western perspective. Its profusely patterned, spatially dislocated surface seems to present the interior from a variety of different viewpoints. *The Red Studio* (pl. 146), at the end of the year, suspends separated incidents within a field of color flatter than any painted since Giotto, but nevertheless open to the eye, which travels from one part of the picture to the next as if in a journey through time.

The following year, Matisse made two trips to Morocco and found there—in its landscape (pl. 147) and in the brightly colored costumes of its people (pls. 160, 161)—what seemed to him a literal equivalent of the decorative harmony he had been pursuing. This allowed him to return to nature, he said. The paintings he made in France between these two trips address the contrast of art and nature by juxtaposing floral motifs with representations of his own works of art, which are seen in the room dedicated to study of that contrast—the artist's studio (pls. 149–151, 153, 154). In Morocco itself, his painting reaches the apogee of decorativeness and artificiality; yet, with the so-called Moroccan Triptych (pls. 157–159), it also begins to become more searchingly empirical—the intuitively worked, colored surface conveys the vividness of external reality, experienced as a luminous, harmonic field.

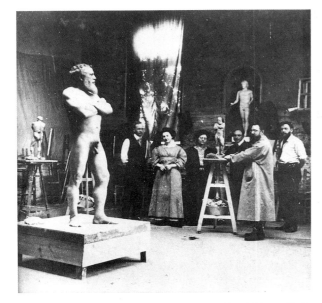

Sculpture class at the Académie Matisse, Hôtel Biron, Paris, c. 1909. Left to right: Jean Heiberg, unidentified woman, Sarah Stein, Hans Purrmann, Matisse, Patrick Henry Bruce.

Matisse (center) and his students at the Académie Matisse, 1909–10.

1908

EARLY JANUARY: Opening of the Académie Matisse at the Couvent des Oiseaux, with an initial group of about ten students: includes the Americans Patrick Henry Bruce, Annette Rosenshine, Sarah Stein, and Max Weber; the Germans Oskar and Greta Moll and Hans Purrmann; the Hungarians Joseph Brummer and Bela Czobel; and the Swede Carl Palme. In the three years of the school's existence, the majority of the some 120 students that pass through it are foreign. The students draw, paint, and make sculpture, with particular emphasis on working from the model. Matisse gives criticisms of individual works but also speaks more generally: about how his students might perceive nature more fully by considering its essential forms; about constructing paintings from relations of colors that do not copy nature but render the emotion it evokes; about avoiding theories and preconceived effects and instead allowing imagination to enrich observation.

Paints a portrait of his student Greta Moll (pl. 104), which he completes after studying a Veronese portrait in the Louvre.

Sergei Shchukin brings a fellow Russian collector, Ivan Morosov, to Matisse's studio. The two become important collectors of his work. By 1913, Shchukin will have acquired thirty-six Matisse paintings and Morosov eleven. Purchases by Leo and Gertrude Stein begin to diminish.

SPRING: The Couvent des Oiseaux having been sold by the state, Matisse moves his residence, studio, and school to the Hôtel Biron (the former Couvent du Sacré-Coeur) at no. 33, boulevard des Invalides. Marquet has moved into Matisse's former apartment on the fifth floor at no. 19, quai Saint-Michel. The American painter Morgan Russell joins Matisse's classes.

Before he moves, Matisse paints the large *Bathers with a Turtle* (pl. 109), possibly a reply to Picasso's *Les demoiselles d'Avignon*. It is the first of a trio of imaginary figure compositions he paints this year, the others being *Game of Bowls* (pl. 110) and *Nymph and Satyr* (pl. 111), the latter completed in 1909. They are accompanied by work in sculpture, including the beginning of the first of the *Back* series (pl. 121). The simplicity, even serenity, of the figure compositions is in sharp contrast with the profusely ornamented *Harmony in Red* (pl. 105), painted in the same period.

MARCH 20–MAY 2: The Salon des Indépendants; includes work by Braque. Matisse does not participate; no longer shows regularly at the Indépendants.

APRIL 6–25: One-artist exhibition of his watercolors, drawings, and prints at Alfred Stieglitz's Little Galleries of the Photo-Secession (known as "291") in New York. The exhibition is arranged through the mediation of the American photographer Edward Steichen, who has met Matisse through Sarah Stein.

APRIL 18–MAY 24: Exhibits five paintings at the first Salon de la Toison d'Or (Salon of the Golden Fleece) in Moscow, including *The Terrace, Saint-Tropez* (pl. 44) and *Still Life with a Geranium* (pl. 79). The first of three exhibitions sponsored by Nicolai Riabushinsky, it presents complementary sections of French and Russian art; includes a comprehensive selection of French Post-Impressionists, with the Fauvist group well represented. The April issue of Riabushinsky's magazine *Zolotoe runo/La toison d'or* reproduces the Matisse works from the exhibition.

APRIL 20: The American writer Gelett Burgess and his friend Inez Haynes Irwin visit Matisse's studio, where they see his recent work, including *Bathers with a Turtle* (pl. 109), and unfinished versions of *Decorative Figure* (pl. 106) and *The Back (I)* (pl. 121). Burgess is interviewing artists (including Braque, Derain, Friesz, Auguste Herbin, Matisse, and Picasso) for an article eventually published as "The Wild Men of Paris" in *The Architectural Record* (May 1910).

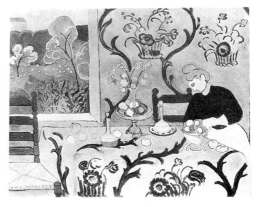

Harmony in Red (pl. 105), photographed in its blue or blue-green state, 1908.

JUNE: Makes his first trip to Germany, with Hans Purrmann; visits Speyer, Munich, Nuremberg, and Heidelberg. Returns to Paris for the summer.

1908–09 SEASON

AUTUMN: It may be at this time that Matisse brings Shchukin to Picasso's studio in the Bateau-Lavoir, where Shchukin will see *Les demoiselles d'Avignon* and purchase two paintings.

OCTOBER 1–NOVEMBER 8: Matisse has an important retrospective exhibition of eleven paintings, six drawings, and thirteen sculptures at the Salon d'Automne. *Harmony in Red* (pl. 105) has been purchased by Shchukin before the Salon. Originally a blue or blue-green picture, it is reworked in red to accentuate the effect of a continuous arabesque field, but whether before or shortly after its exhibition is uncertain. Around this time, Matisse possibly begins a pendant to the work, *Conversation* (pl. 152), which will be completed in 1912.

As a member of the Salon's jury, he had reportedly referred to Braque's L'Estaque landscapes as being composed of "little cubes." Braque's works were rejected.

OCTOBER 9: Sarah Stein arranges for Bernard Berenson to meet Matisse. Berenson will vigorously defend Matisse's work in a letter to the editor of *The Nation* (published November 12), which on October 29 had disparaged Matisse's contribution to the Salon d'Automne.

This autumn or winter, paints *The Girl with Green Eyes* (pl. 113), the first of a group of figures in decorative costume that will extend into the following spring, accompanied by still lifes against decorative backdrops, such as *Still Life with Blue Tablecloth* (pl. 114).

OCTOBER 15: Rodin takes rooms in the Hôtel Biron (now the Musée Rodin), where Matisse has his studio.

NOVEMBER 9–28: Braque has an exhibition at Daniel-Henry Kahnweiler's gallery, featuring the series of L'Estaque paintings rejected by the jury of the Salon d'Automne. The catalogue text is by Guillaume Apollinaire.

NOVEMBER 25–DECEMBER 12: Kees van Dongen exhibition at the Bernheim-Jeune gallery.

DECEMBER 11–31: Matisse exhibits with Manguin, Marquet, and Puy at the Berthe Weill gallery.

DECEMBER 14–JANUARY 9, 1909: Large exhibition of works by Seurat at the Bernheim-Jeune gallery.

DECEMBER 25: Matisse's "Notes d'un peintre" is published in *La grande revue*, with a preface by Georges Desvallières, unofficial editor of

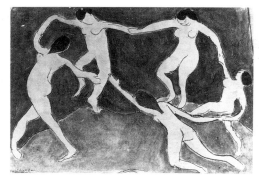

Composition No. I. 1909. Watercolor on paper, 8⅝ × 12½" (21.9 × 32 cm). The Pushkin Museum of Fine Arts, Moscow. Watercolor sketch after *Dance (I)* (pl. 112) sent by Matisse to Shchukin.

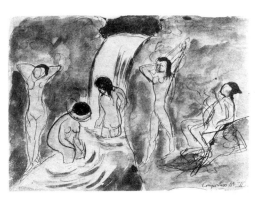

Composition No. II. 1909. Watercolor on paper, 8⅝ × 11⅝" (21.9 × 29.5 cm). The Pushkin Museum of Fine Arts, Moscow. Watercolor sketch sent by Matisse to Shchukin proposing a painting to accompany *Dance*, which would eventually become *Bathers by a River* (pl. 193).

the journal's art pages, who is said to have initiated the article. The essay is a defense and justification of his art for the general public and a response to his rivals and critics. It is accompanied by six illustrations of his paintings of 1906–08, including *Marguerite Reading* (pl. 85), *Standing Nude* (pl. 95), *Portrait of Greta Moll* (pl. 104), *Nude, Black and Gold* (pl. 108), and *Game of Bowls* (pl. 110). Within a year, "Notes d'un peintre" will be translated into Russian and German.

In this important statement about the purposes of his art, Matisse stresses six broad points: his aim is a form of expression inseparable from his pictorial means; he seeks to condense his sensations received from nature, thereby to produce a more lasting and stable art than that of the Impressionists; he transposes colors until their juxtaposed areas create an intuitively found unity that does not copy nature but realizes its essential character; clarity and order are necessary to a picture and will convey its significance to the viewer even before its illustrated subject is recognized; his art is intended to have a soothing, calming influence on the mind; by basing his art on

nature, he avoids preconception and rules, but is nevertheless bound to the expression of his time.

LATE DECEMBER: With Purrmann, is in Berlin, preparing an exhibition that will be on view at Paul Cassirer's gallery in January. The exhibition is greeted with extremely hostile reactions, including those of Max Beckmann. In Berlin he sees Oskar and Greta Moll and meets Max Liebermann and August Gaul. During the return trip, he meets the Belgian architect Henry van de Velde and stops at Hagen to visit Karl-Ernst Osthaus, founder of the Museum Folkwang and a patron of Matisse's.

1909

JANUARY: *Camera Work* publishes an article by Charles H. Caffin reporting on his visit to Matisse's studio around April 1908.

JANUARY 24–FEBRUARY 28: Exhibits nine drawings and four paintings at the second Salon de la Toison d'Or in Moscow.

FEBRUARY 7: Is in Cassis, in the south of France. Remains there for four weeks; returns to Paris.

FEBRUARY 21: Shchukin, having recently purchased *Nymph and Satyr* (pl. 111) and *Still Life with Blue Tablecloth* (pl. 114), writes to Matisse, acknowledging receipt of *Harmony in Red* (pl. 105); also mentions the theme of Dance. In March, Matisse will paint a large oil sketch of this subject, *Dance (I)* (pl. 112), and shows it to Shchukin when he visits Paris that month.

Matisse's studio, constructed in the garden behind his house at Issy-les-Moulineaux in 1909.

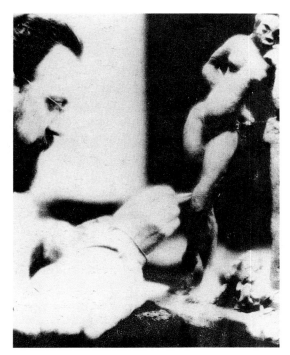

Matisse at work on *La serpentine* (pl. 122), autumn 1909. Photograph by Edward Steichen.

Magazine photograph on which Matisse based *La serpentine* (pl. 122).

Matisse at work on *Still Life with "Dance"* (pl. 124) in his studio at Issy-les-Moulineaux, probably autumn 1909. In the background is the completed *Dance (I)* (pl. 112).

In an interview with Charles Estienne in March (published in *Les nouvelles* on April 12), Matisse suggests that he has a commission for three paintings to decorate a staircase, saying the first will represent Dance; the second,

Music; and the third, a scene of repose. The first two paintings are *Dance (II)* (pl. 125) and *Music* (pl. 126). The third, apparently begun at this time and offered to Shchukin, will be reworked in 1913 and 1916 to become *Bathers by a River* (pl. 193).

By March 31, Shchukin has confirmed a commission for two paintings, on the subjects of Dance and Music, for the stairway of his Moscow residence.

MARCH 25–MAY 2: Exhibits four works in the Salon des Indépendants.

JUNE: The Hôtel Biron is sold. On July 1, he leases a house at no. 42 (later renumbered 92), route de Clamart, in Issy-les-Moulineaux, a southwestern suburb of Paris. During the summer has a large studio built there, a prefabricated demountable structure suggested by Edward Steichen; there he will paint *Dance (II)* (pl. 125) and *Music* (pl. 126).

The art section of the June issue of *Zolotoe runo/La toison d'or* is devoted to Matisse, reproducing three drawings and thirteen paintings, including the recently completed *Dance (I)* (pl. 112), with an article by Alexandre Mercereau and a Russian translation of "Notes d'un peintre." This is the most complete publication on Matisse in any language before 1920.

JULY: With his family, is in Cavalière, near Saint-Tropez; will remain there until September. Exchanges visits with Michael and Sarah Stein, staying at nearby Le Trayas. Also sees Cross, at Le Lavandou. Makes figure paintings, including *Bather* (pl. 119), in preparation for the Shchukin commission panels.

1909–10 SEASON

SEPTEMBER: Takes up residence at Issy-les-Moulineaux. Spends less time at his school.

SEPTEMBER 18: Signs a three-year contract with Bernheim-Jeune, offered to him by Félix Fénéon, now the manager of the gallery. This raises the prices of his works and, with Shchukin's patronage, makes him financially secure.

OCTOBER 1–NOVEMBER 8: Exhibits only two works in the Salon d'Automne. The Salon includes a retrospective exhibition of the German nineteenth-century painter Hans von Marées.

Is at work on the sculptures *The Back (I)* (pl. 121) and *La serpentine* (pl. 122) as well as the panels commissioned by Shchukin. Steichen photographs him modeling *La serpentine*.

1910

JANUARY 10–22: Cézanne exhibition at the Bernheim-Jeune gallery. Matisse lends his own Cézanne painting, *Three Bathers*.

FEBRUARY 14–MARCH 5: Has a large retrospective exhibition at the Bernheim-Jeune gallery. Includes sixty-five paintings and twenty-five drawings dating from 1893 onward; only ten paintings are for sale, the large majority of the others being already in private collections. Most of the reviews are unfavorable, and Apollinaire notes that the entire press treats Matisse with "a rare violence."

Music (pl. 126) in progress, winter 1909–10.

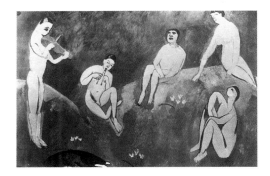

Music (pl. 126) in progress, winter 1909–spring 1910.

The artist's parents, Émile-Hippolyte-Henri Matisse and Anna Héloïse Gérard Matisse, before October 1910.

FEBRUARY 27–MARCH 20: Exhibition of his drawings at the "291" gallery in New York. Black-and-white reproductions of paintings are also shown. Three of the drawings are donated that year by Mrs. Florence Blumenthal to The Metropolitan Museum of Art, the first of Matisse's works to enter an American museum's collection.

MARCH: Is briefly in Collioure. Visits Toulouse.

MARCH 18–MAY 1: Shows one work at the Salon des Indépendants, *Girl with Tulips* (pl. 130), a painting of Jeanne Vaderin, who is also the subject of his *Jeannette* sculptures, the first two of which (pls. 127, 128) are made early this year. Reviews of the painting are mixed; Apollinaire defends Matisse's art.

SPRING: For the first time, is represented by paintings in the annual exhibition of the Berlin Secession; shows three portraits.

APRIL 18–30: Shows a drawing after Delacroix in "D'après les maîtres" at the Bernheim-Jeune gallery, the first modern commercial exhibition of copies, organized by Félix Fénéon.

APRIL 20–MAY 5: The exhibition "Prima mostra italiana dell'impressionismo," organized under the aegis of *La voce*, is held at the Lyceum Club in Florence. Matisse is represented by a landscape owned by Bernard Berenson.

JUNE 6: Henry McBride, Bryson Burroughs, and Roger Fry visit him at Issy-les-Moulineaux; they see *Dance (II)* (pl. 125).

SUMMER: Is in Paris; makes short trips to Dieppe in June, and Chartres and Rouen in August.

JULY 16–OCTOBER 9: Represented in Sonderbund exhibition in Düsseldorf.

1910–11 SEASON

OCTOBER 1–NOVEMBER 8: Exhibition of *Dance (II)* (pl. 125) and *Music* (pl. 126) at the Salon d'Automne, his only works shown. Their simplified forms and vivid colors cause a sensation, and they are widely attacked by the critics, including those from Russia. Shchukin, who sees the paintings at the Salon, decides not to accept them, but will change his mind on his way back to Moscow, on November 11. Apollinaire is virtually alone in defending the two paintings.

OCTOBER: Matisse goes with Marquet to see an important exhibition of Islamic art in Munich, a few days before its closing on October 9; is joined on the way by Purrmann. Matisse particularly studies the rugs, bronzes, and Persian miniatures. Meets Hugo von Tschudi, director of the Munich Neue Staatsgalerie. Returns October 14.

OCTOBER 15: Death of Matisse's father, in Bohain.

NOVEMBER 8–JANUARY 15, 1911: Represented by three paintings, twelve drawings, eight sculptures, and a decorative vase at "Manet and the Post-Impressionists," the first of two influential exhibitions organized by Roger Fry at the Grafton Galleries, London. Includes works by Cézanne, Gauguin, and van Gogh; Picasso is also represented, as are artists who have been associated with Matisse: Derain, Friesz, Manguin, Marquet, Puy, Rouault, Valtat, and Vlaminck. The exhibition comes as a shock to the British public and receives intense publicity. There is a strong reaction to Matisse's *The Girl with Green Eyes* (pl. 113).

NOVEMBER 16: Travels to Spain; remains there through mid-January. Visits Madrid, Córdoba, Seville, and Granada, seeing the important Moorish monuments; returns to Seville in early December. Paints *Seville Still Life* (pl. 133) and *Spanish Still Life* (pl. 134).

The Matisse family, c. 1911. Standing, left to right: Pierre, Jean (with a friend perched on his shoulders), Matisse, and Mme Matisse. Seated: Marguerite.

DECEMBER 17: Shchukin's panels *Dance (II)* (pl. 125) and *Music* (pl. 126) arrive in Moscow.

1911

JANUARY 17: En route back to Paris, visits Toledo, where he sees paintings by El Greco.

LATE JANUARY: Is back in Paris. Stays in Issy-les-Moulineaux until May. By summer, will close the Académie Matisse.

APRIL 21–JUNE 13: Exhibits at the Salon des Indépendants. Submits *The Manila Shawl* (pl. 135), as *L'espagnole*, and another portrait; after the vernissage, when most of the reviews have been written, replaces *The Manila Shawl* with *The Pink Studio* (pl. 136), the first of the four great "symphonic" interiors he paints this year.

Postcard from Matisse to Michael Stein with a sketch of *The Painter's Family* (pl. 137), May 26, 1911.

MAY 26: Writes to Michael Stein, indicating that he is working on *The Painter's Family* (pl. 137), the second major 1911 interior, which strongly reflects the influence of Persian miniatures.

Left to right: Matisse, Albert Weisgerber, and Hans Purrmann in the Löwenbräukeller, Munich, October 1910.

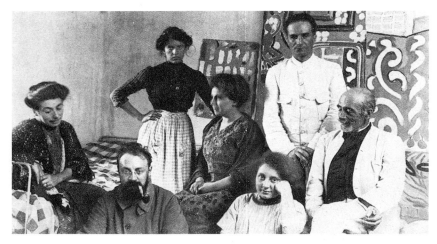

In Matisse's studio at Collioure, summer 1911. Left to right: Mme Matisse, Matisse, a servant (standing), Olga Merson, Marguerite Matisse, the painter Albert Huyot (standing), and Mme Matisse's father, M. Parayre. In the background: *Interior with Aubergines* (pl. 145).

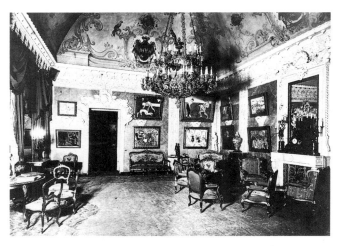

Paintings by Matisse in Sergei Shchukin's house in Moscow, c. 1912. To the right of door, top row: *Nymph and Satyr* (pl. 111) and *Game of Bowls* (pl. 110); bottom row: *Spanish Still Life* (pl. 134) and *Still Life with Blue Tablecloth* (pl. 114). To the left of mantel, top: *The Roofs of Collioure* (pl. 62); bottom: *Still Life with Blue Tablecloth* (pl. 24).

SUMMER: Is in Paris in June. In July, he is in Collioure, where he remains through late September, before returning to Paris. While in Collioure, paints *Portrait of Olga Merson* (pl. 141), landscapes (pls. 142, 143), and his third large 1911 interior, the richly ornamented *Interior with Aubergines* (pl. 145), for which *Still Life with Aubergines* (pl. 144) serves as a study.

1911–12 SEASON

OCTOBER 1–NOVEMBER 8: Exhibits *View of Collioure* (pl. 143) and *Still Life with Aubergines* (pl. 144) as *"esquisses décoratives"* at the Salon d'Automne. In this period, completes work on *Jeannette (III)* (pl. 138) and *Jeannette (IV)* (pl. 139), and paints the last and most radically abstracted of his great 1911 interiors, *The Red Studio* (pl. 146).

MID-OCTOBER: Marquet, in Tangier since mid-August, returns to Paris with a series of new paintings showing views of the Casbah.

NOVEMBER 1: At Shchukin's invitation, Matisse departs for Saint Petersburg and Moscow. In Moscow, will be a guest in Shchukin's home; the patron wishes to discuss future projects and ask his advice about placement of the pictures already owned. Matisse is impressed by Russian icons, which he sees at the Kremlin and in the collection of I. S. Ostroukhov. On November 22, leaves Moscow for Paris.

1912

JANUARY 27: With Mme Matisse, departs for the first of two trips to Morocco. Mme Matisse will stay in Tangier until the end of March, Matisse until mid-April. Paints landscapes, including *Periwinkles* (pl. 147), having received a landscape commission from Ivan Morosov; still lifes, including *Basket of Oranges* (pl. 148); and figure paintings.

MARCH 14–APRIL 6: First exhibition of his sculptures in America is held at the "291" gallery in New York, organized by Steichen and selected by the artist with Steichen. Includes six bronzes, five plasters (probably including those of the first four *Jeannette* sculptures; pls. 127, 128, 138, 139), one terra-cotta, and twelve drawings. The show is attacked by the critics; none of the works are sold.

APRIL 14: Leaves Tangier for Marseille, en route to Paris.

MAY 25–SEPTEMBER 30: Represented in Sonderbund international exhibition in Cologne, which is modeled partially on the "Manet and the Post-Impressionists" exhibition in London. Includes a large room devoted to Edvard Munch. Sixteen works by Picasso are shown, five by Matisse.

SPRING–SUMMER: Is in Issy-les-Moulineaux. In an extremely productive period of work, makes a number of ambitious paintings, some with dense blue grounds. Among them are the two versions of *Nasturtiums with "Dance"* (pls. 149, 150); *Conversation* (pl. 152); and a group of paintings with goldfish (pls. 153–155).

Is visited by the journalist Clara T. MacChesney, whose interview with him will be published in the *New York Times* on March 9, 1913, during the Armory Show, and by the Danish art historian Ernst Goldschmidt, who discusses with him *The Red Studio* (pl. 146) for an article to be published on January 5, 1913, in the "Kronik" ("Chronicle") section of *Politiken*. Is also visited by Shchukin, who purchases four of this period's paintings as well as one that had been made in Morocco.

Briefly visits Marquet in Rouen.

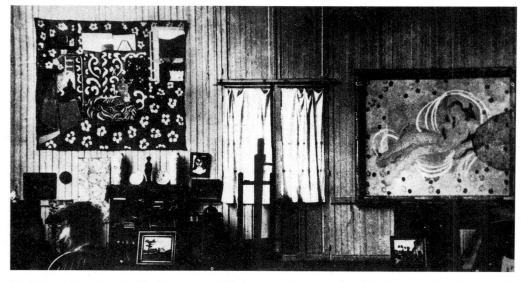

Matisse's studio at Issy-les-Moulineaux, possibly late 1911. On the wall, at left: *Interior with Aubergines* (pl. 145). At right: *Large Nude* of 1911, a work later destroyed by the artist but depicted in *The Red Studio* (pl. 146).

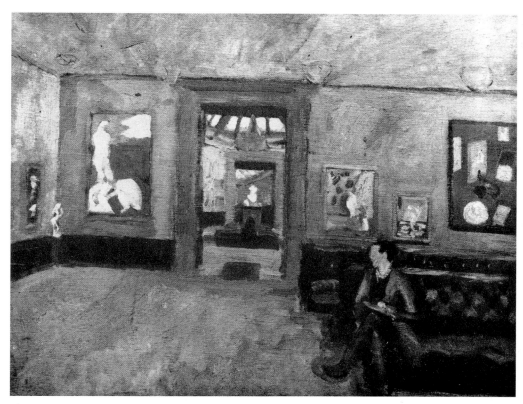

Roger Fry. *A Room in the Second Post-Impressionist Exhibition (The Matisse Room)*. 1912. Oil on canvas, 20¼ × 25″ (51.3 × 62.9 cm). Musée d'Orsay, Paris. Gift of Mrs. Pamela Diamand. Depicted, left to right: *La serpentine* (pl. 122) in plaster, *Le luxe (II)* (pl. 103), *Still Life with Aubergines* (pl. 144), *Wild Daffodils* of 1911, and *The Red Studio* (pl. 146).

buys, may be made, or completed, back at Issy-les-Moulineaux.

OCTOBER 1–NOVEMBER 8: Exhibits two works at the Salon d'Automne: *Nasturtiums with "Dance" (II)* (pl. 150) and another interior, probably *Corner of the Artist's Studio* (pl. 151).

OCTOBER 5–DECEMBER 31: In the "Second Post-Impressionist Exhibition," organized by Roger Fry at the Grafton Galleries in London, is represented by nineteen paintings, eight sculptures, and drawings and prints. Among the important works included are *Dance (I)* (pl. 112), *The Red Studio* (pl. 146), *Conversation* (pl. 152), *The Back (I)* (pl. 121) in plaster, and the first four *Jeannette* sculptures (pls. 127, 128, 138, 139).

NOVEMBER 22: Is joined in Tangier by Mme Matisse and Camoin.

1913

MID-FEBRUARY: With Mme Matisse, leaves Tangier for France. Camoin will remain in Tangier.

JUNE–OCTOBER: Exhibition of Persian miniatures at the Musée des Arts Décoratifs.

JULY 7–31: Represented by four paintings in Moderne Bund exhibition in Zurich, which includes also works by Jean Arp, Robert Delaunay, Vasily Kandinsky, Paul Klee, and Franz Marc.

1912–13 SEASON

SEPTEMBER 18: Renews his contract with the Bernheim-Jeune gallery for another three years.

SEPTEMBER 30: Departs for second trip to Morocco; arrives in Tangier on October 8. Will remain until mid-February 1913.

Again works on a landscape commission for Morosov, which will be fulfilled by the so-called Moroccan Triptych, comprised of *Landscape Viewed from a Window* (pl. 157), *On the Terrace* (pl. 158), and *The Casbah Gate* (pl. 159). Also makes figure paintings for Shchukin, including *Zorah Standing* (pl. 160) and *The Standing Riffian* (pl. 161). The large, decorative *Moroccan Café* (pl. 163), which Shchukin also

Matisse and Mme Matisse during the second trip to Morocco, winter 1912–13.

Two installation views of Matisse's exhibition of Moroccan paintings at the Bernheim-Jeune gallery, Paris, April 1913. In the photograph at left can be seen (from left to right): *The Serf* (pl. 25); an unidentified drawing; and the so-called Moroccan Triptych, comprised of *Landscape Viewed from a Window* (pl. 157), *On the Terrace* (pl. 158), and *The Casbah Gate* (pl. 159). In the photograph at right: *Calla Lilies* of 1912–13, *Jeannette (III)* (pl. 138) in plaster, *The Seated Riffian* of 1912–13, *Jeannette (I)* (pl. 127) in plaster, and *Calla Lilies, Irises, and Mimosas* (pl. 162).

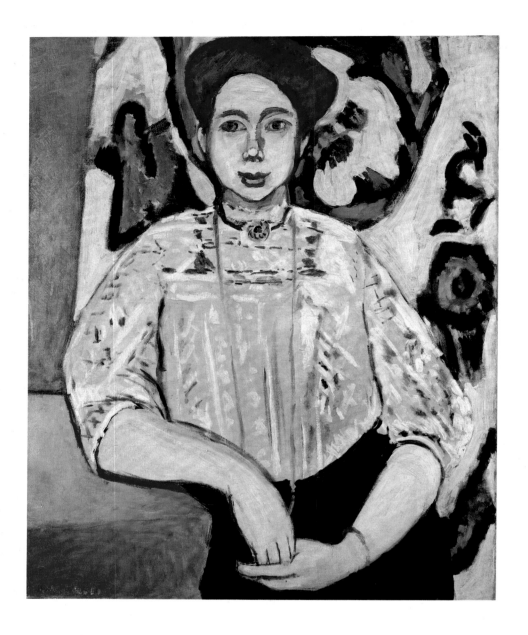

104. Portrait of Greta Moll
Portrait de Greta Moll

Paris, [early] 1908

Oil on canvas, 36½ × 29″ (93 × 73.5 cm)
Signed and dated lower left: "Henri Matisse 1908"
The Trustees of The National Gallery, London
Formerly collection Oskar and Greta Moll

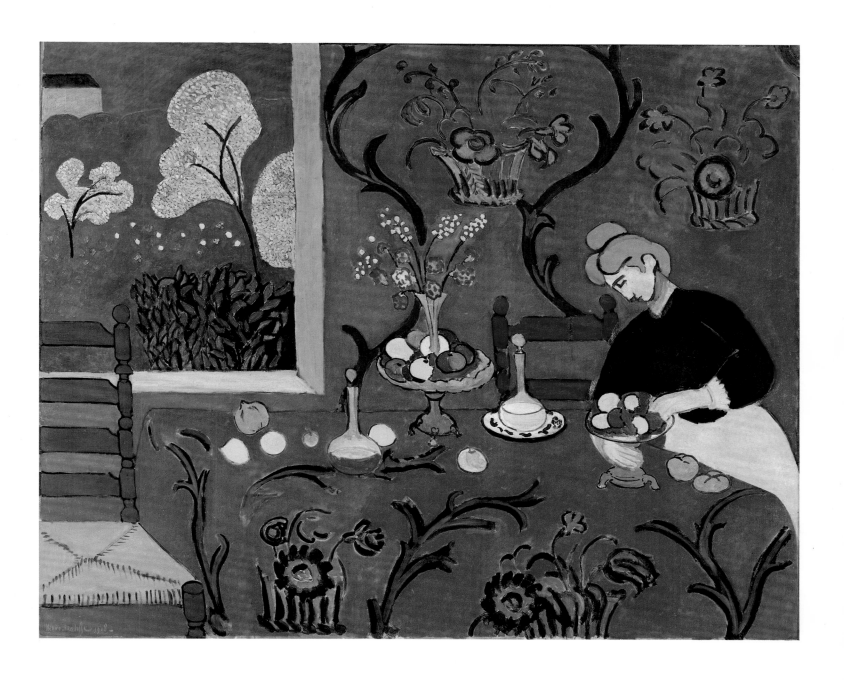

105. Harmony in Red / La desserte
Harmonie rouge / La desserte [Panneau décoratif
pour salle à manger; La chambre rouge]

Paris, Hôtel Biron, spring [–autumn] 1908

Oil on canvas, 70⅞″ × 7′ 2⅝″ (180 × 220 cm)
Signed and dated lower left: "Henri-Matisse 1908-"
The Hermitage Museum, St. Petersburg
Formerly collection Sergei Shchukin

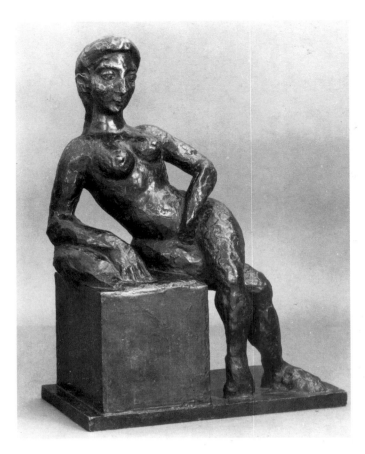

106. Decorative Figure
Figure décorative

Paris, Hôtel Biron, spring–summer 1908
Bronze, 28⅜ × 20¼ × 12¼″ (72.1 × 51.4 × 31.1 cm)
Inscribed: "August / 1908 / HM" and "H4"
Hirshhorn Museum and Sculpture Garden, Smithsonian Institution,
Washington, D.C. Gift of Joseph H. Hirshhorn, 1966

107. Sculpture and Persian Vase
Sculpture et vase persan [Nature morte, bronze à l'oeillet]

Paris, [winter–summer] 1908

Oil on canvas, 23⅞ × 29″ (60.5 × 73.5 cm)
Signed and dated lower right: "Henri Matisse 08."
Nasjonalgalleriet, Oslo
Formerly collections Michael and Sarah Stein; Christian Tetzen-Lund

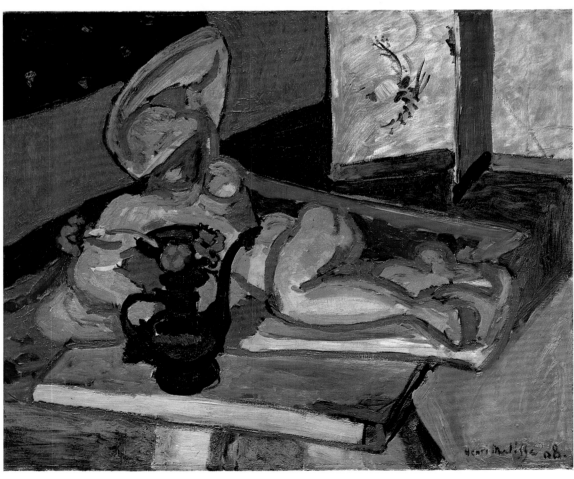

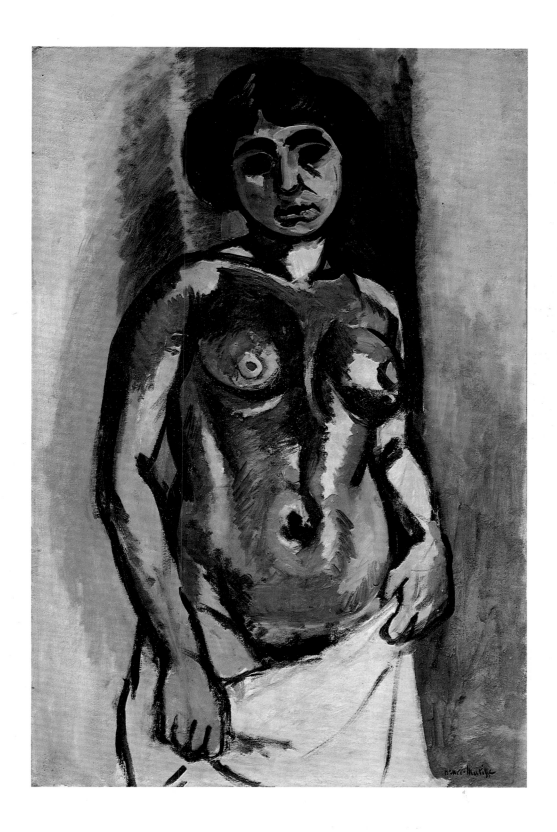

108. Nude, Black and Gold
 Nu, noir et or

Paris, Hôtel Biron, [summer–autumn 1908]

Oil on canvas, 39⅜ × 25⅝″ (100 × 65 cm)
Signed lower right: "Henri-Matisse"
The Hermitage Museum, St. Petersburg
Formerly collection Sergei Shchukin

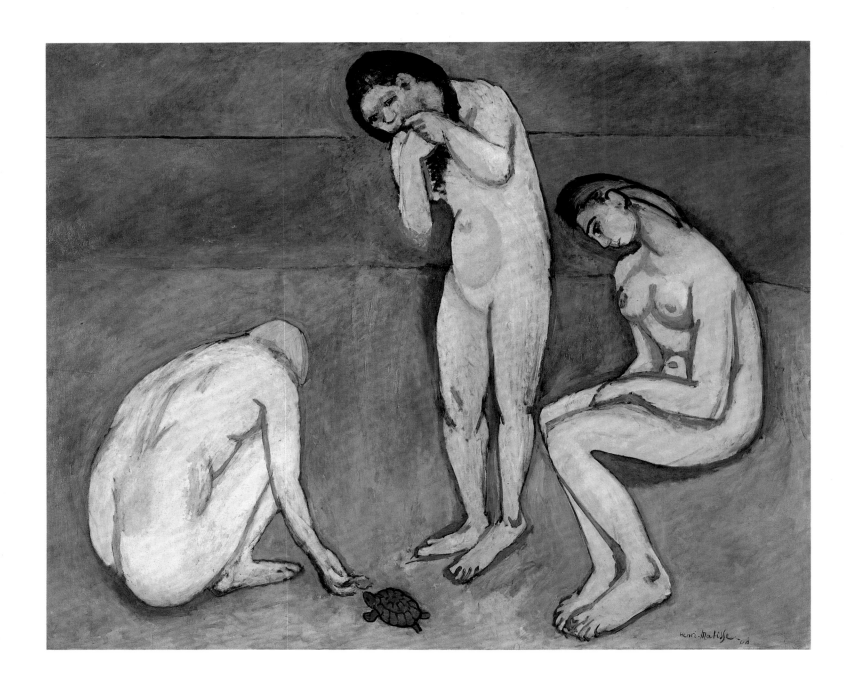

109. Bathers with a Turtle
Baigneuses à la tortue [Trois femmes au bord de la mer]

Paris, [Couvent des Oiseaux, early] 1908

Oil on canvas, 70½″ × 7′3¾″ (179.1 × 220.3 cm)
Signed and dated lower right: "Henri-Matisse–08"
The St. Louis Art Museum. Gift of Mr. and Mrs. Joseph Pulitzer, Jr.
Formerly collections Karl-Ernst Osthaus; Museum Folkwang, Hagen
and Essen

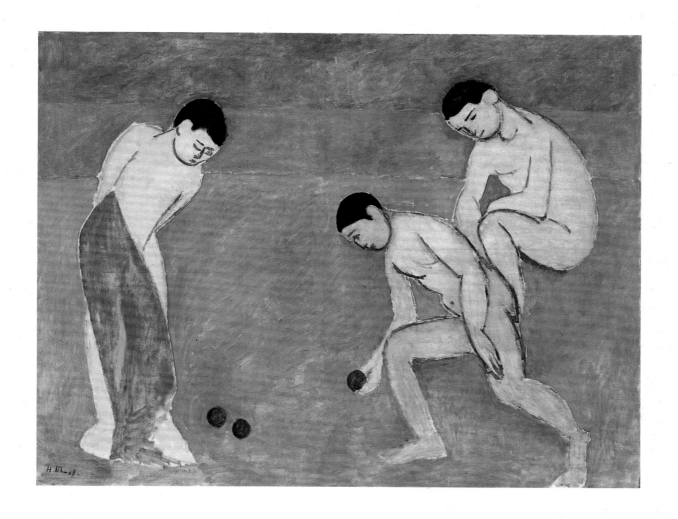

110. Game of Bowls
Joueurs de boules [Jeu de balles]

Paris, [Couvent des Oiseaux or Hôtel Biron, winter–autumn] 1908

Oil on canvas, 44⅝ × 57″ (113.5 × 145 cm)
Signed and dated lower left: "H.M 08-"
The Hermitage Museum, St. Petersburg
Formerly collection Sergei Shchukin

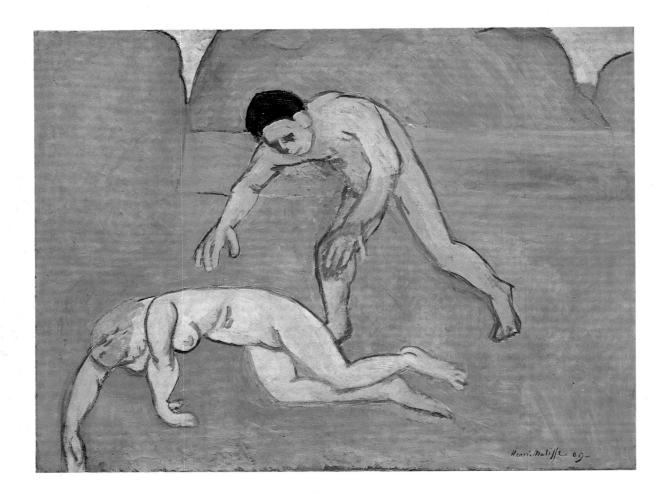

III. Nymph and Satyr
La nymphe et le satyre [Le faune surprenant une nymphe]

Paris, Hôtel Biron, winter 1908–09

Oil on canvas, 35 × 46″ (89 × 117 cm)
Signed and dated lower right: "Henri-Matisse 09-"
The Hermitage Museum, St. Petersburg
Formerly collection Sergei Shchukin

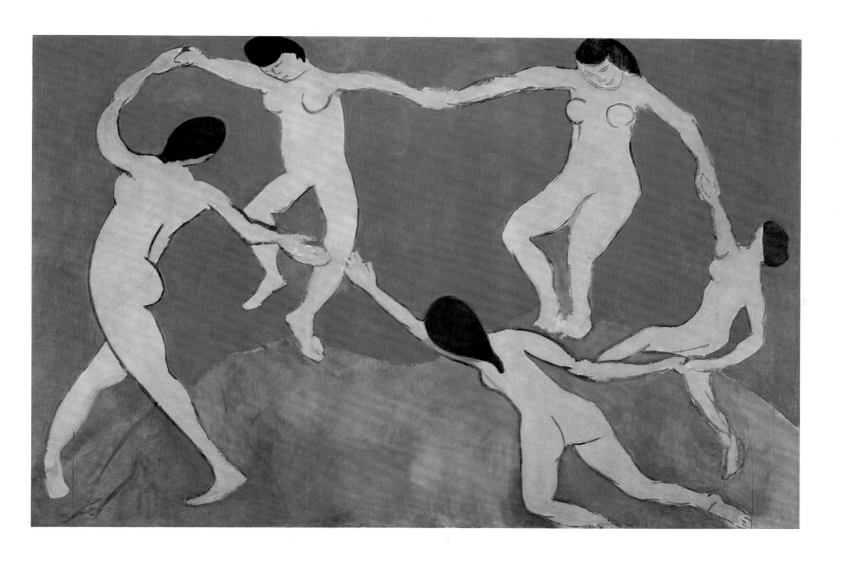

112. Dance (I)
La danse (I) [La danse (esquisse de panneau décoratif)]

Paris, Hôtel Biron, early 1909

Oil on canvas, 8′6½″ × 12′9½″ (259.7 × 390.1 cm)
Not signed, not dated
The Museum of Modern Art, New York. Gift of Nelson A.
Rockefeller in honor of Alfred H. Barr, Jr.
Formerly collection Walter P. Chrysler, Jr.

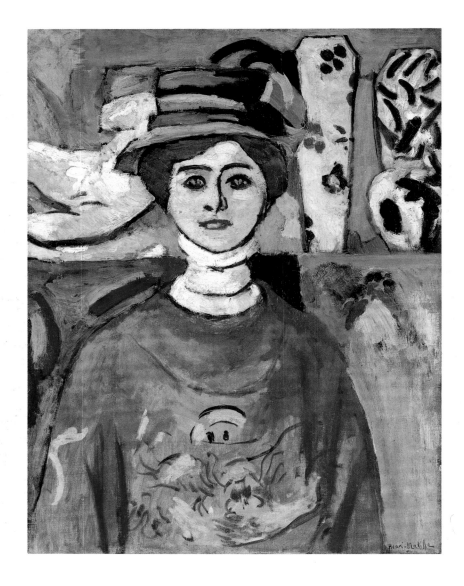

113. The Girl with Green Eyes
La fille aux yeux verts

Paris, Hôtel Biron, [autumn–winter 1908]

Oil on canvas, 26 × 20″ (66 × 50.8 cm)
Signed lower right: "Henri-Matisse"
San Francisco Museum of Modern Art.
Bequest of Harriet Lane Levy

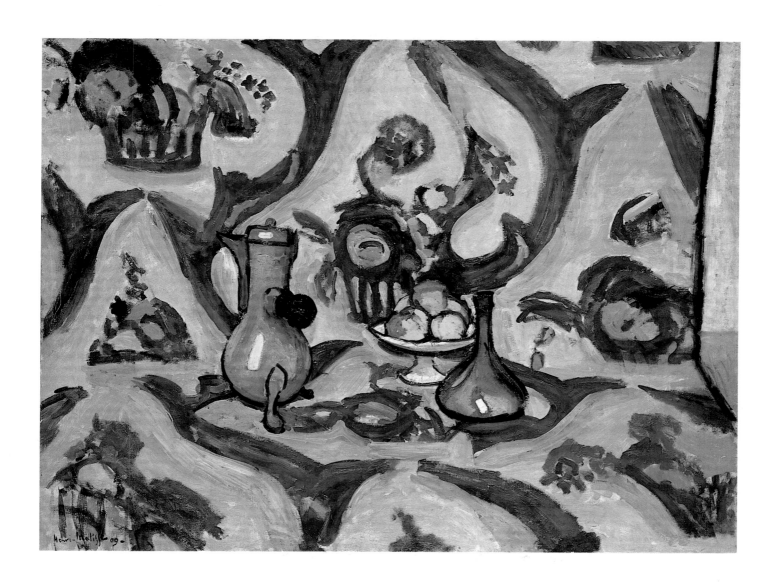

114. Still Life with Blue Tablecloth
Nature morte au camaïeu bleu

Paris, Hôtel Biron, [late 1908–early] 1909

Oil on canvas, 34⅝ × 46½″ (88 × 118 cm)
Signed and dated lower left: "Henri-Matisse 09-"
The Hermitage Museum, St. Petersburg
Formerly collection Sergei Shchukin

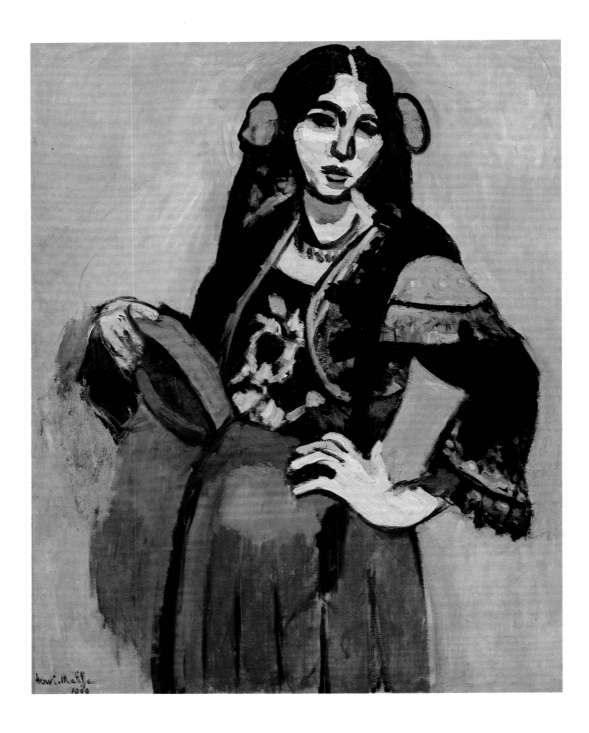

115. Spanish Woman with a Tambourine
L'espagnole au tambourin

Paris, Hôtel Biron, early 1909

Oil on canvas, 36¼ × 28¾" (92 × 73 cm)
Signed and dated lower left: "Henri-Matisse / 1909"
The Pushkin Museum of Fine Arts, Moscow
Formerly collection Sergei Shchukin

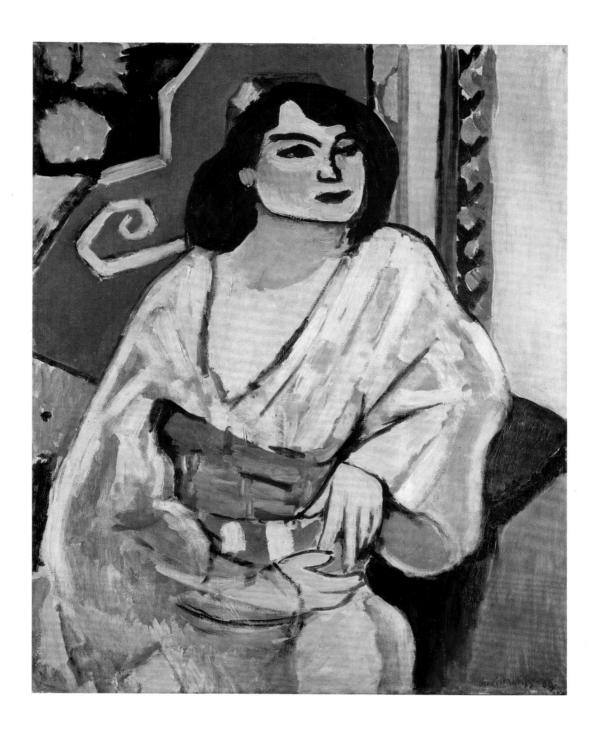

116. Algerian Woman
L'algérienne

Paris, Hôtel Biron, spring 1909

Oil on canvas, 31⅞ × 25½" (81 × 65 cm)
Signed and dated lower right: "Henri-Matisse 09"
Musée National d'Art Moderne, Centre Georges Pompidou, Paris

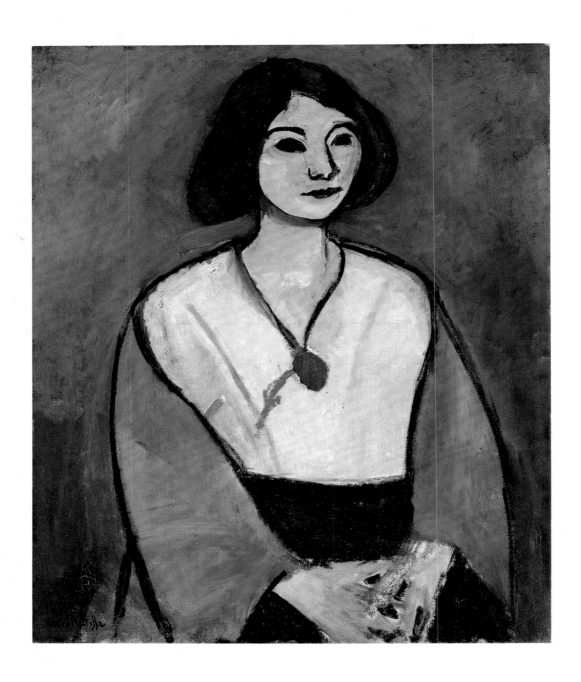

117. Lady in Green
La dame en vert

Paris, Hôtel Biron, or Cavalière, [winter–summer 1909]

Oil on canvas, 25½ × 21¼″ (65 × 54 cm)
Signed lower left: "Henri Matisse"
The Hermitage Museum, St. Petersburg
Formerly collection Sergei Shchukin

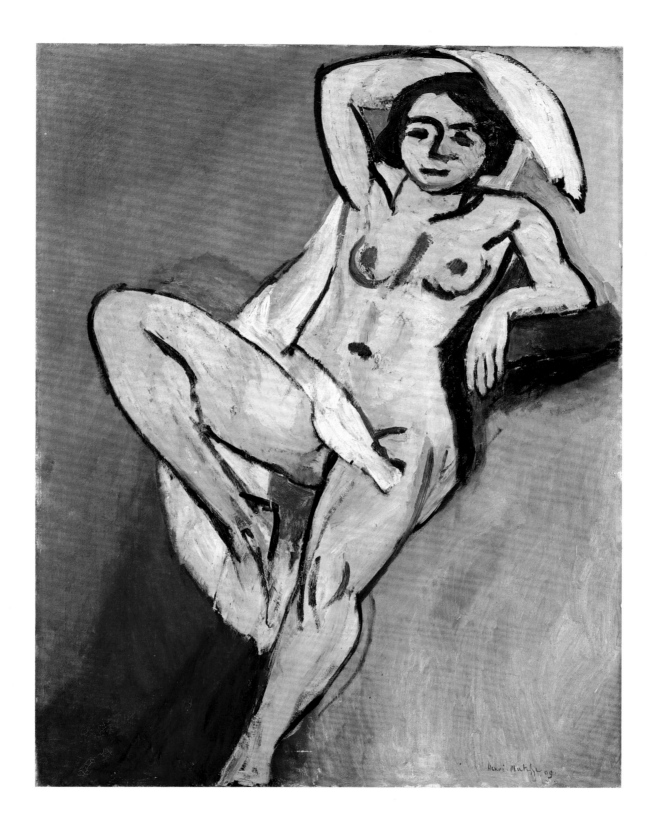

118. Nude with a White Scarf
Nu à l'écharpe blanche

Paris, Hôtel Biron, winter–spring 1909

Oil on canvas, 45⅞ × 35″ (116.5 × 89 cm)
Signed and dated lower right: "Henri-Matisse 09."
Statens Museum for Kunst, Copenhagen. J. Rump Collection
Formerly collection Christian Tetzen-Lund

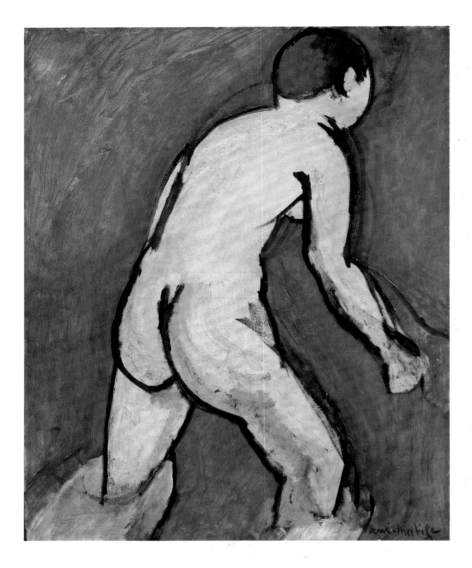

119. Bather
Baigneuse

[Cavalière, summer 1909]

Oil on canvas, 36½ × 29⅛″ (92.7 × 74 cm)
Signed lower right: "Henri-Matisse"
The Museum of Modern Art, New York.
Gift of Abby Aldrich Rockefeller

120. Standing Nude, Seen from the Back
Nu debout, de dos

Issy-les-Moulineaux, [autumn 1909]

Pen and ink on paper, 11⅜ × 7¼″ (29 × 18.5 cm)
Signed lower right: "Henri-Matisse"
National Gallery of Canada, Ottawa

121. The Back (I)
Nu de dos (I)

Paris, Hôtel Biron, and Issy-les-Moulineaux, spring 1908–late 1909

Bronze, 6' 2⅜" × 44½" × 6½" (188.9 × 113 × 16.5 cm)
Inscribed lower left: "Henri Matisse." Lower right: "H.M. / 2/10 / 1909"
Founder C. Valsuani
The Museum of Modern Art, New York. Mrs. Simon Guggenheim Fund

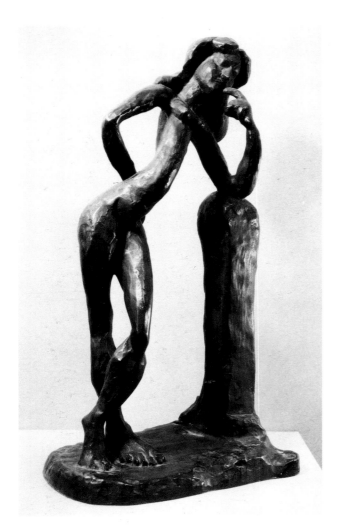

122. La serpentine

Issy-les-Moulineaux, autumn 1909

Bronze, 22¼ × 11 × 7½″ (56.5 × 28 × 19 cm)
Inscribed: "Henri Matisse 1/10"
The Museum of Modern Art, New York.
Gift of Abby Aldrich Rockefeller

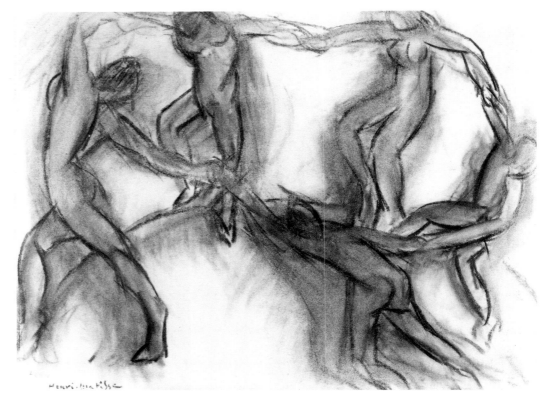

123. Study for "Dance (II)"
 Étude pour "La danse (II)"

[Issy-les-Moulineaux, 1909–10]

Charcoal on paper mounted on cardboard,
18⅞ × 25⅝″ (48 × 65 cm)
Signed lower left: "Henri-Matisse"
Musée de Grenoble. Agutte-Sembat Bequest
Formerly collection Marcel Sembat

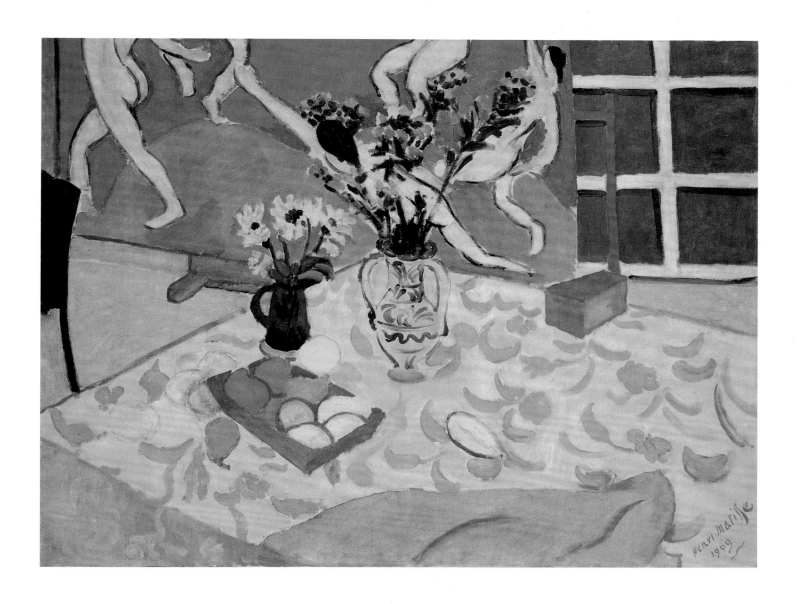

124. Still Life with "Dance"
 Nature morte à "La danse"

Issy-les-Moulineaux, [autumn–winter] 1909

Oil on canvas, 35 × 45⅝″ (89 × 116 cm)
Signed and dated lower right: "Henri-Matisse / 1909/"
The Hermitage Museum, St. Petersburg
Formerly collection Ivan Morosov

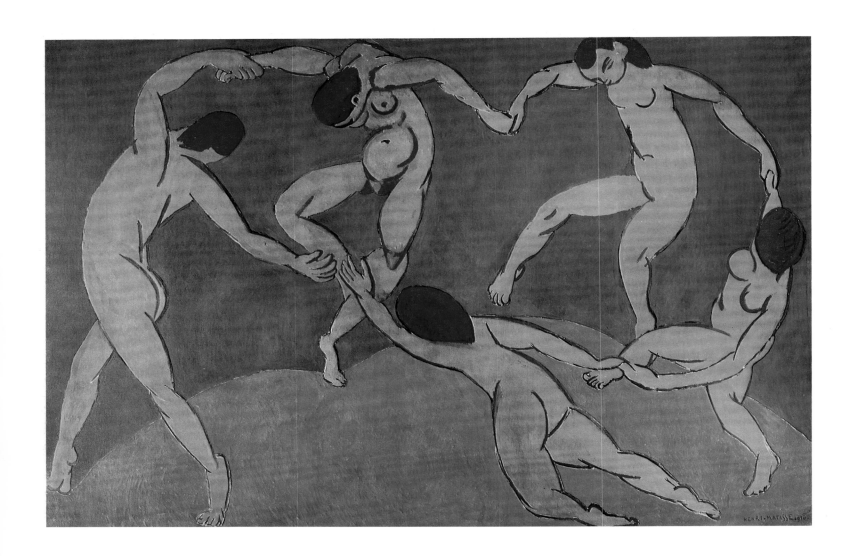

125. Dance (II)

La danse (II) [La danse (panneau décoratif)]

Issy-les-Moulineaux, [late 1909–summer] 1910

Oil on canvas, 8′ 5⅝″ × 12′ 9½″ (260 × 391 cm)
Signed and dated lower right: "HENRI-MATISSE 1910."
The Hermitage Museum, St. Petersburg
Formerly collection Sergei Shchukin

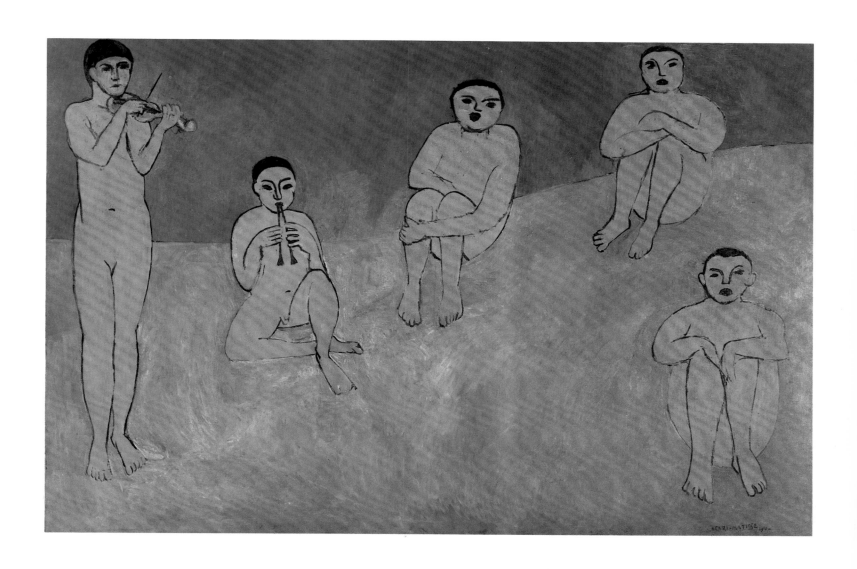

126. Music

La musique [La musique (panneau décoratif)]

Issy-les-Moulineaux, [late 1909–summer] 1910

Oil on canvas, 8′ 5⅝″ × 12′ 9¼″ (260 × 389 cm)
Signed and dated lower right: "HENRI-MATISSE 1910-"
The Hermitage Museum, St. Petersburg
Formerly collection Sergei Shchukin

127. Jeannette (I)

Issy-les-Moulineaux, [early 1910]

Bronze, 13 × 9 × 10″ (33 × 22.8 × 25.5 cm)
Inscribed: "0/10 HM"
The Museum of Modern Art, New York.
Acquired through the Lillie P. Bliss Bequest

129. Girl with Tulips (Jeanne Vaderin)
Jeune fille aux tulipes (Jeanne Vaderin)

Issy-les-Moulineaux, [early 1910]

Charcoal on paper, 28¼ × 23″ (73 × 58.4 cm)
Estate stamp lower right: "H. Matisse"
The Museum of Modern Art, New York.
Acquired through the Lillie P. Bliss Bequest

128. Jeannette (II)

Issy-les-Moulineaux, [early 1910]

Bronze, 10⅜ × 8¼ × 9⅝″ (26.2 × 21 × 24.5 cm)
Inscribed: "2/10 HM"
The Museum of Modern Art, New York.
Gift of Sidney Janis

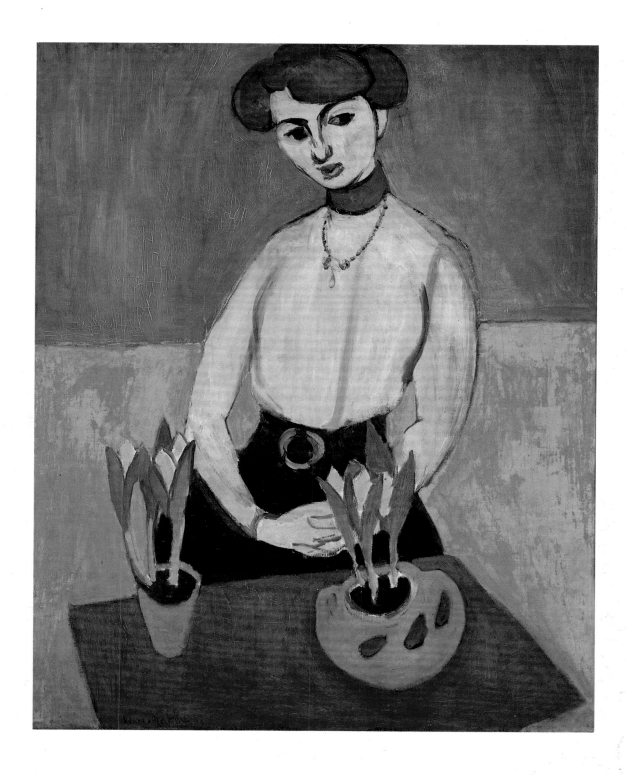

130. Girl with Tulips (Jeanne Vaderin)
Jeune fille aux tulipes (Jeanne Vaderin)

Issy-les-Moulineaux, early 1910

Oil on canvas, 36¼ × 29″ (92 × 73.5 cm)
Signed and dated lower left: "Henri-Matisse 10"
The Hermitage Museum, St. Petersburg
Formerly collection Sergei Shchukin

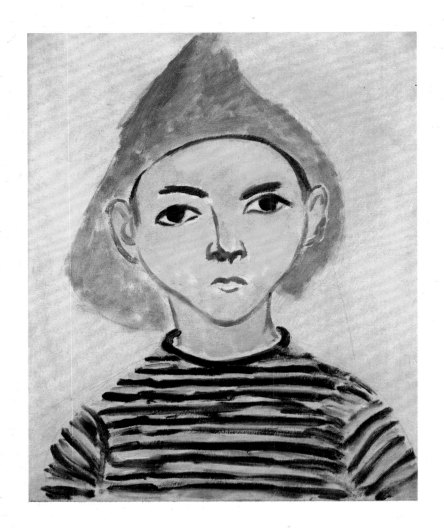

131. Portrait of Pierre Matisse
Portrait de Pierre Matisse

[Cavalière, summer 1909]

Oil on canvas, 16 × 13″ (40.6 × 33 cm)
Not signed, not dated
Private collection

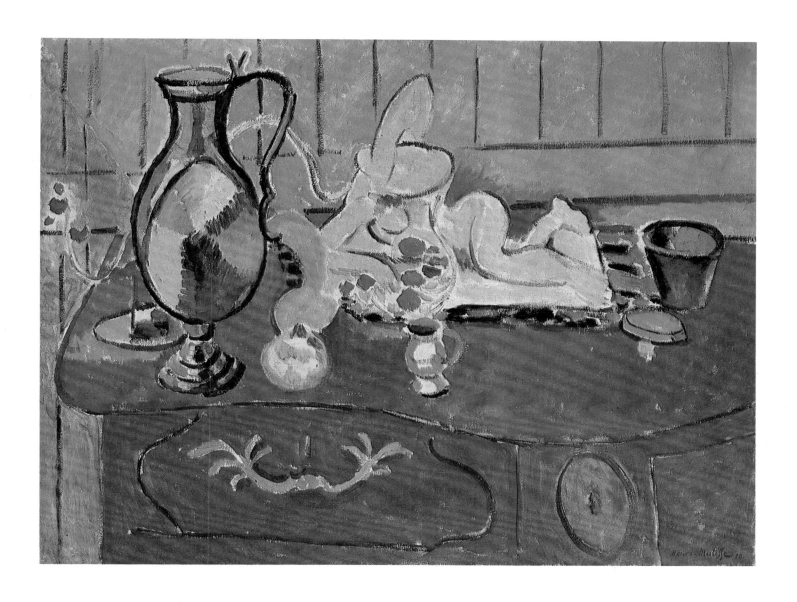

132. Still Life with a Pewter Jug and Pink Statuette
Nature morte au pot d'étain et statuette rose

Issy-les-Moulineaux, 1910

Oil on canvas, 35 ⅜ × 46″ (90 × 117 cm)
Signed and dated lower right: "Henri-Matisse 10."
The Hermitage Museum, St. Petersburg
Formerly collection Sergei Shchukin

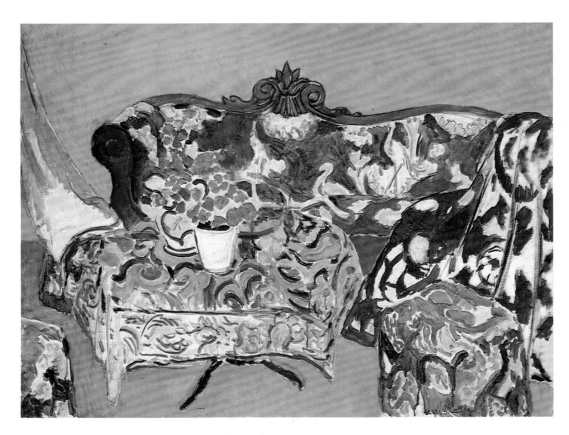

133. Seville Still Life
Nature morte (Séville)

Seville, winter 1910–11

Oil on canvas, 35⅜ × 46″ (90 × 117 cm)
Signed lower right: "Henri-Matisse"
The Hermitage Museum, St. Petersburg
Formerly collection Sergei Shchukin

134. Spanish Still Life
Nature morte (Espagne)

Seville, winter 1910–11

Oil on canvas, 35 × 45⅝″ (89 × 116 cm)
Signed lower right of center: "Henri-Matisse"
The Hermitage Museum, St. Petersburg
Formerly collection Sergei Shchukin

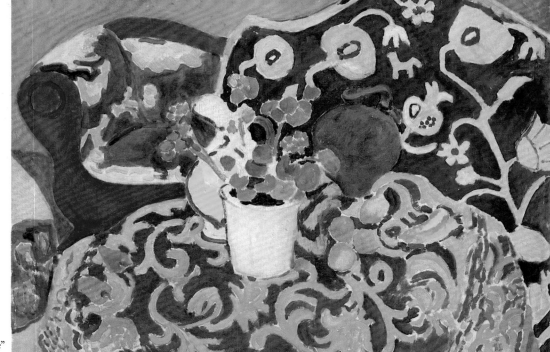

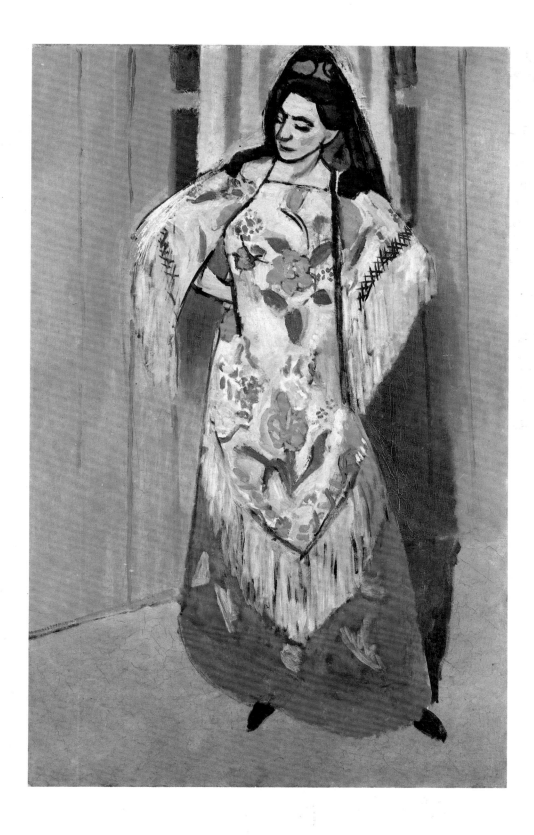

135. The Manila Shawl
Le châle de Manille [L'espagnole]

Issy-les-Moulineaux, winter–spring 1911

Oil on canvas, 46⅜ × 29¾″ (118 × 75.5 cm)
Signed and dated lower left: "Henri Matisse 1911"
Rudolf Staechelin Family Foundation, Basel

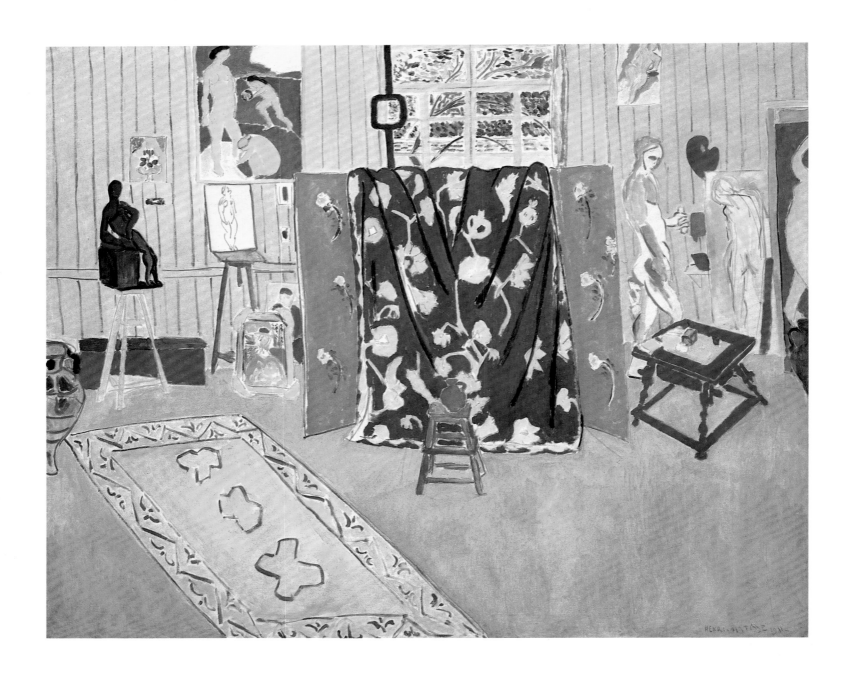

136. The Pink Studio
 L'atelier rose

Issy-les-Moulineaux, winter–spring 1911

Oil on canvas, 70⅝″ × 7′ 3″ (179.5 × 221 cm)
Signed and dated lower right: "HENRI-MATISSE 1911-"
The Pushkin Museum of Fine Arts, Moscow
Formerly collection Sergei Shchukin

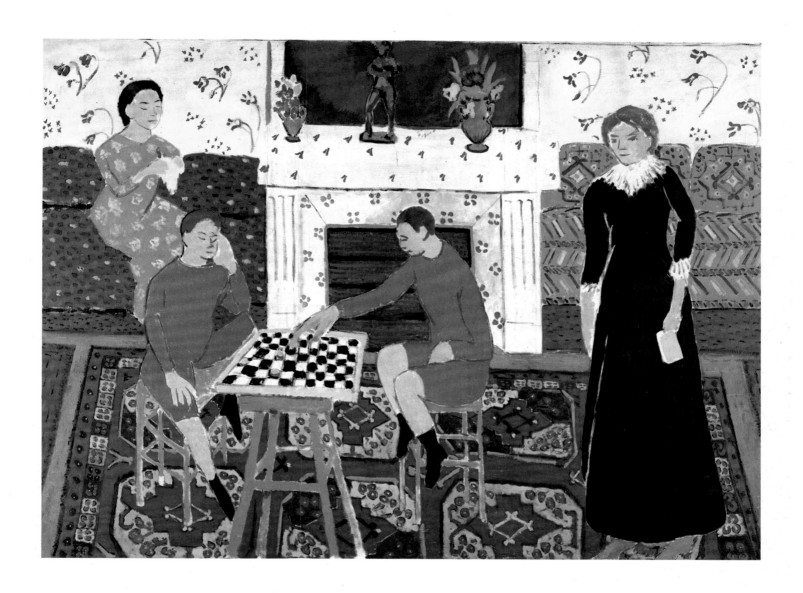

137. The Painter's Family
 La famille du peintre [Portrait de famille]

Issy-les-Moulineaux, spring 1911

Oil on canvas, 56¼″ × 6′ 4⅜″ (143 × 194 cm)
Signed and dated on back of subframe: "Henri Matisse 1911"
The Hermitage Museum, St. Petersburg
Formerly collection Sergei Shchukin

Above, left:

138. Jeannette (III)

Issy-les-Moulineaux, [spring 1910–autumn 1911]

Bronze, 23¾ × 10¼ × 11″ (60.3 × 26 × 28 cm)
Inscribed: "5/10 HM"
The Museum of Modern Art, New York. Acquired through the
Lillie P. Bliss Bequest

Above, right:

139. Jeannette (IV)

Issy-les-Moulineaux, [spring 1910–autumn 1911]

Bronze, 24⅛ × 10¾ × 11¼″ (61.3 × 27.4 × 28.7 cm)
Inscribed: "5/10 HM"
The Museum of Modern Art, New York. Acquired through the
Lillie P. Bliss Bequest

Right:

140. Seated Nude (Olga)
 Grand nu accroupi (Olga)

[Collioure, summer 1911?]

Bronze, 16¾ × 9¾ × 13⅛″ (42.5 × 24.6 × 33.2 cm)
Inscribed: "H.M. / 10/10"
Hirshhorn Museum and Sculpture Garden, Smithsonian Institution,
Washington, D.C. Gift of Joseph H. Hirshhorn, 1966

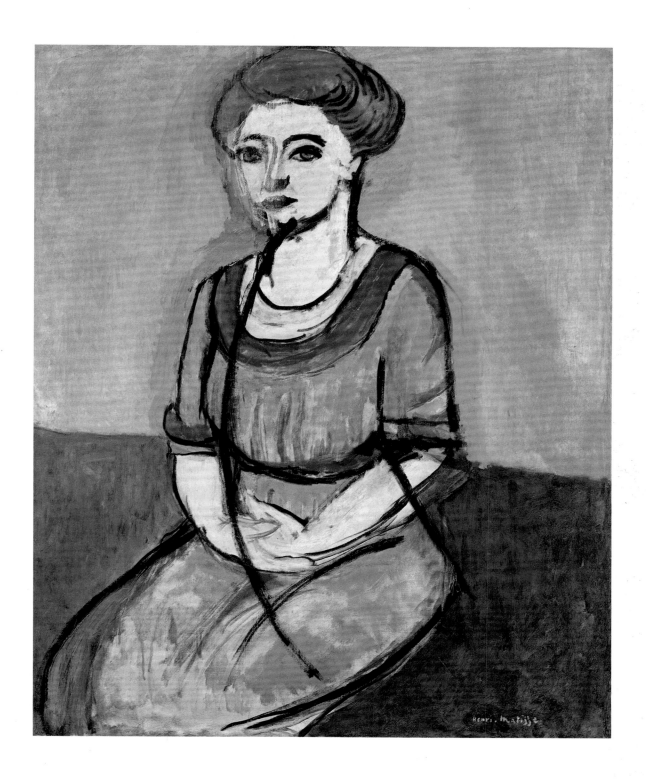

141. Portrait of Olga Merson
Portrait d'Olga Merson

[Collioure, summer 1911]

Oil on canvas, 39¼ × 31¾″ (100 × 80.6 cm)
Signed lower right: "Henri-Matisse"
The Museum of Fine Arts, Houston. Museum purchase with funds
provided by the Agnes Cullen Arnold Endowment Fund

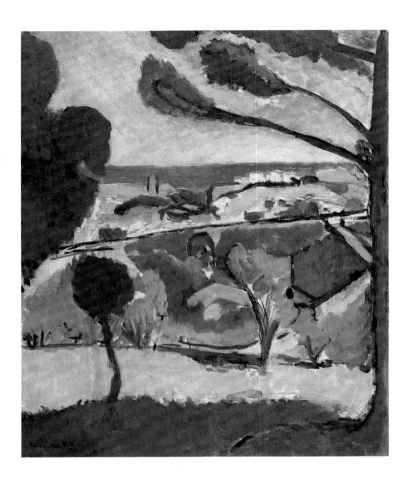

142. View of Collioure and the Sea
Vue de Collioure et la mer

Collioure, summer 1911

Oil on canvas, 23⅞ × 19⅝" (61 × 49.6 cm)
Signed lower left: "Henri-Matisse"
The Museum of Modern Art, New York.
Nelson A. Rockefeller Bequest
Formerly collection Michael and Sarah Stein

143. View of Collioure
Vue de Collioure

Collioure, [summer 1911]

Oil on canvas, 35½ × 46½" (90.2 × 118.1 cm)
Signed lower right: "Henri-Matisse"
Collection Mr. and Mrs. Donald B. Marron, New York
Formerly collections Paul Poiret; Georges Salles

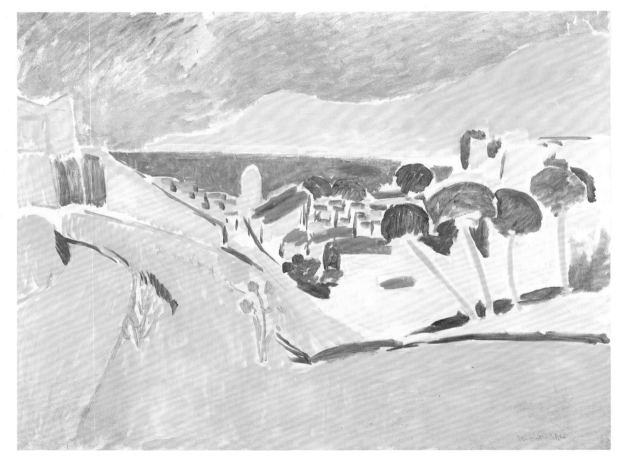

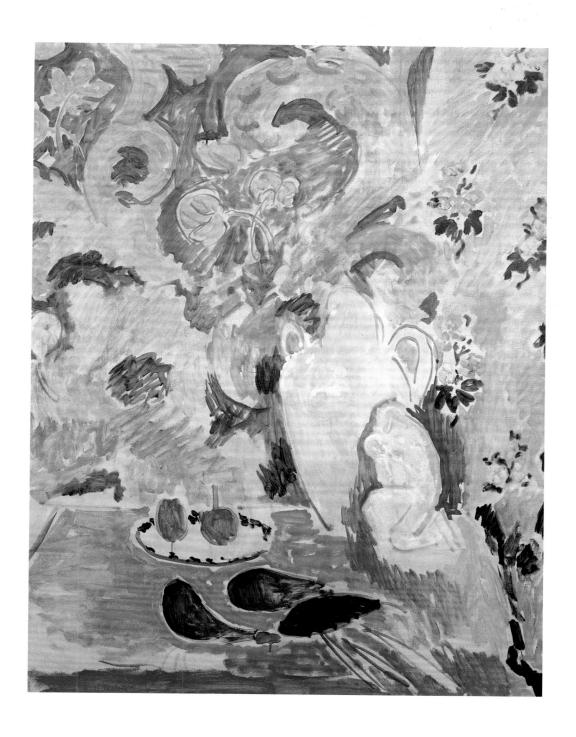

144. Still Life with Aubergines
Nature morte aux aubergines

[Collioure, summer 1911]

Oil on canvas, 45¾ × 35⅛″ (116.2 × 89.2 cm)
Signed lower left: "Henri-Matisse"
The Museum of Modern Art, New York.
Promised gift of Mrs. Bertram Smith

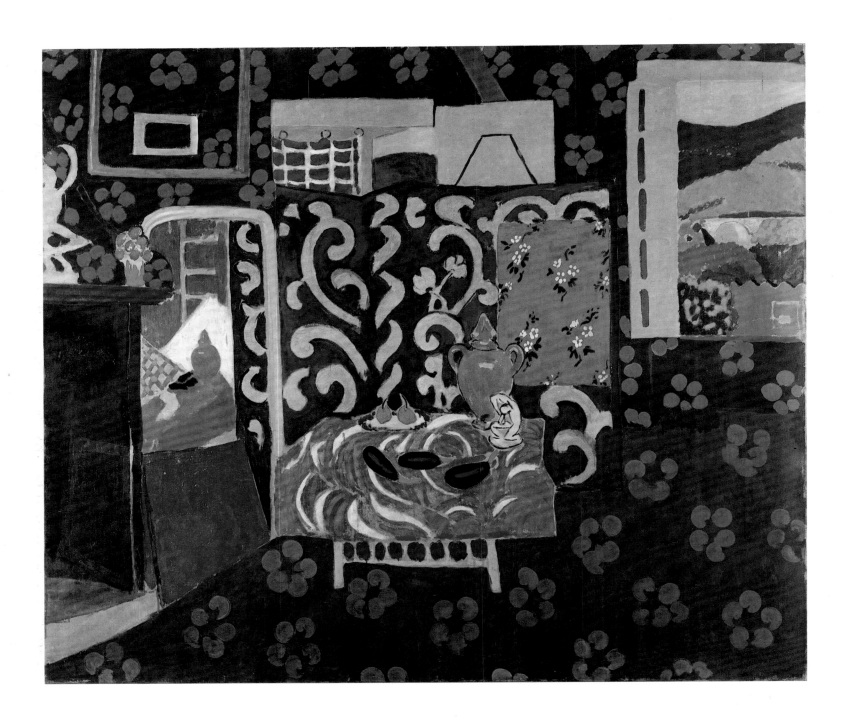

145. Interior with Aubergines
Intérieur aux aubergines

Collioure, summer 1911

Distemper on canvas, 6' 10⅜" × 8' 7⅞" (212 × 246 cm)
Not signed, not dated
Musée de Grenoble. Gift of the artist, in the name of his family
Formerly collection Michael and Sarah Stein

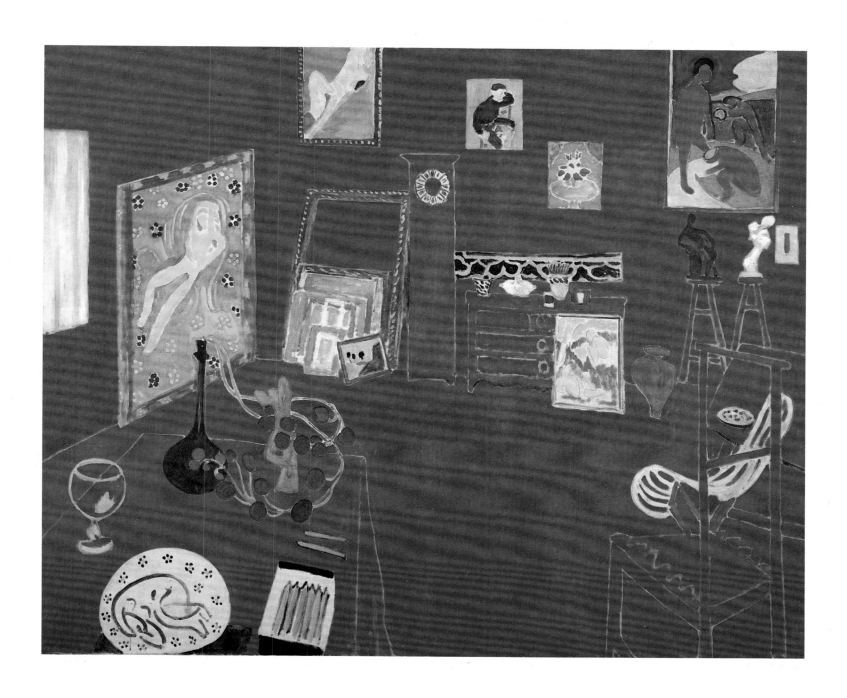

146. The Red Studio
L'atelier rouge [Le panneau rouge]

Issy-les-Moulineaux, [autumn 1911]

Oil on canvas, 71¼″ × 7′ 2¼″ (181 × 219.1 cm)
Signed lower left: "Henri-Matisse"
The Museum of Modern Art, New York.
Mrs. Simon Guggenheim Fund
Formerly collection George Tennant

147. Periwinkles / Moroccan Garden
Les pervenches / Jardin marocain

Tangier, winter–spring 1912

Oil, pencil, and charcoal on canvas, 46 × 32¼″ (116.8 × 82.5 cm)
Signed and dated lower left: "Henri-Matisse–1912"
The Museum of Modern Art, New York. Gift of Florene M. Schoenborn
Formerly collection Paul Guillaume

148. Basket of Oranges
Corbeille d'oranges

Tangier, winter–spring 1912

Oil on canvas, 37 × 32⅝″ (94 × 83 cm)
Signed lower left: "Henri Matisse"
Musée Picasso, Paris
Formerly collection Pablo Picasso

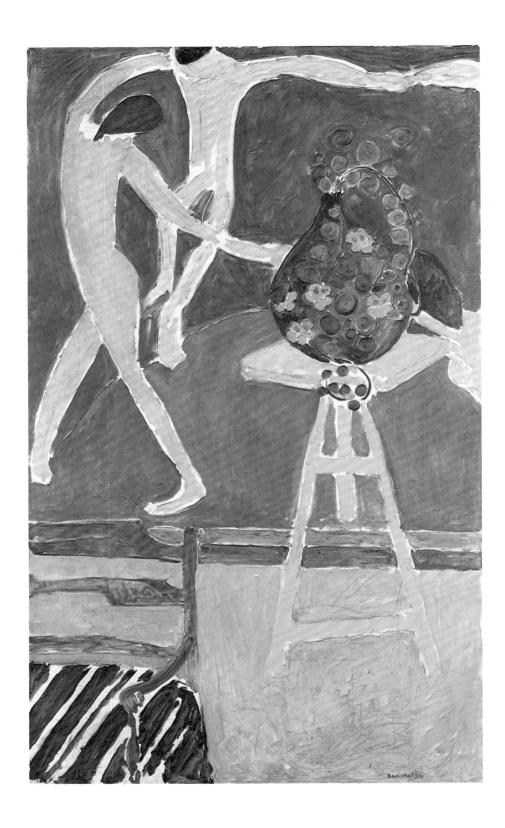

149. Nasturtiums with "Dance" (I)
 Capucines à "La danse" (I)

Issy-les-Moulineaux, spring–early summer 1912

Oil on canvas, 6′ 3½″ × 45⅜″ (191.8 × 115.3 cm)
Signed lower right: "Henri-Matisse"
The Metropolitan Museum of Art, New York.
Bequest of Scofield Thayer, 1982
Formerly collection Oskar and Greta Moll

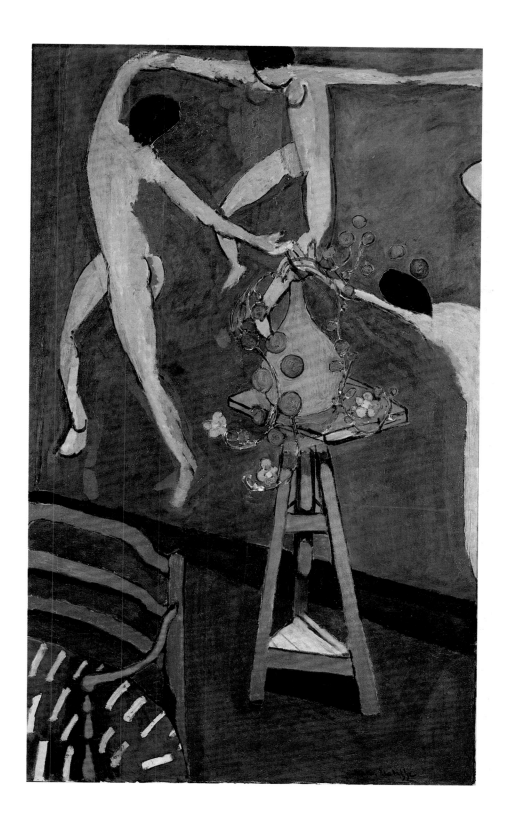

150. Nasturtiums with "Dance" (II)
Capucines à "La danse" (II)

Issy-les-Moulineaux, spring–early summer 1912

Oil on canvas, 6′ 3″ × 44 ⅞″ (190.5 × 114 cm)
Signed lower right: "Henri-Matisse"
The Pushkin Museum of Fine Arts, Moscow
Formerly collection Sergei Shchukin

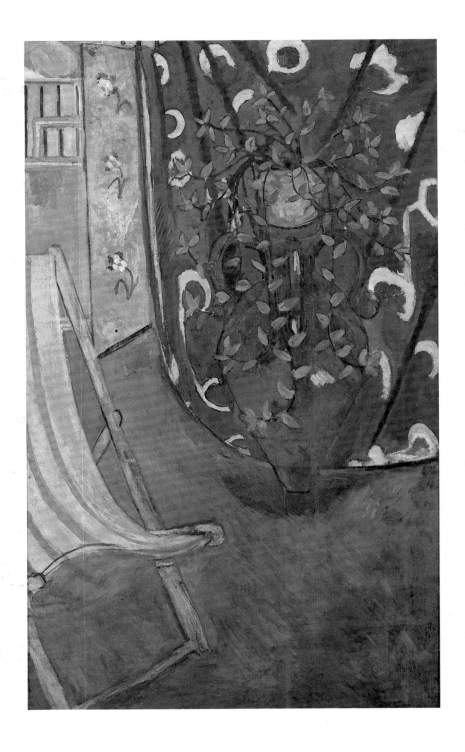

151. Corner of the Artist's Studio
Coin d'atelier

Issy-les-Moulineaux, [spring–summer 1912]

Oil on canvas, 6′ 3½″ × 44⅞″ (191.5 × 114 cm)
Not signed, not dated
The Pushkin Museum of Fine Arts, Moscow
Formerly collection Sergei Shchukin

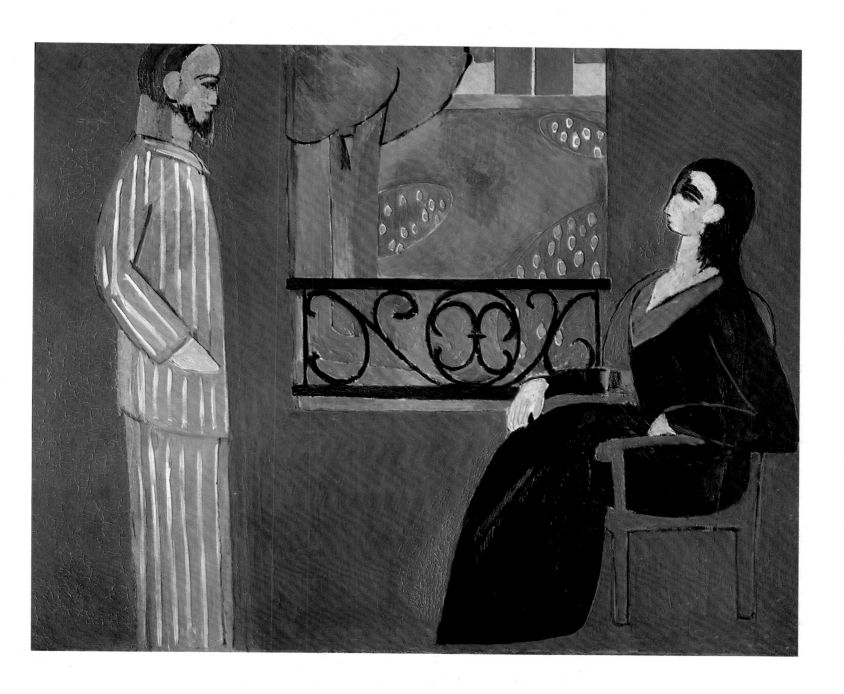

152. Conversation
La conversation

Issy-les-Moulineaux, [winter 1908–09 to early summer 1912]

Oil on canvas, 69⅝″ × 7′ 1⅛″ (177 × 217 cm)
Not signed, not dated
The Hermitage Museum, St. Petersburg
Formerly collection Sergei Shchukin

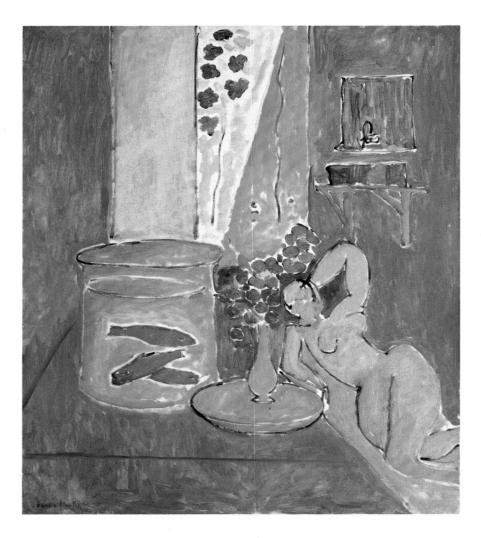

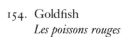

153. Goldfish and Sculpture
Poissons rouges et sculpture

Issy-les-Moulineaux, [spring–summer 1912]

Oil on canvas, 45¾ × 39½" (116.2 × 100.5 cm)
Signed lower left: "Henri Matisse"
The Museum of Modern Art, New York.
Gift of Mr. and Mrs. John Hay Whitney
Formerly collection Hans Purrmann

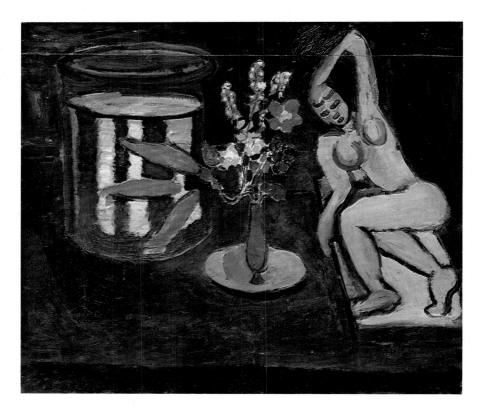

154. Goldfish
Les poissons rouges

Issy-les-Moulineaux, [spring–summer 1912]

Oil on canvas, 32¼ × 36¾" (82 × 93.5 cm)
Signed lower left: "Henri-Matisse"
Statens Museum for Kunst, Copenhagen. J. Rump Collection
Formerly collection Christian Tetzen-Lund

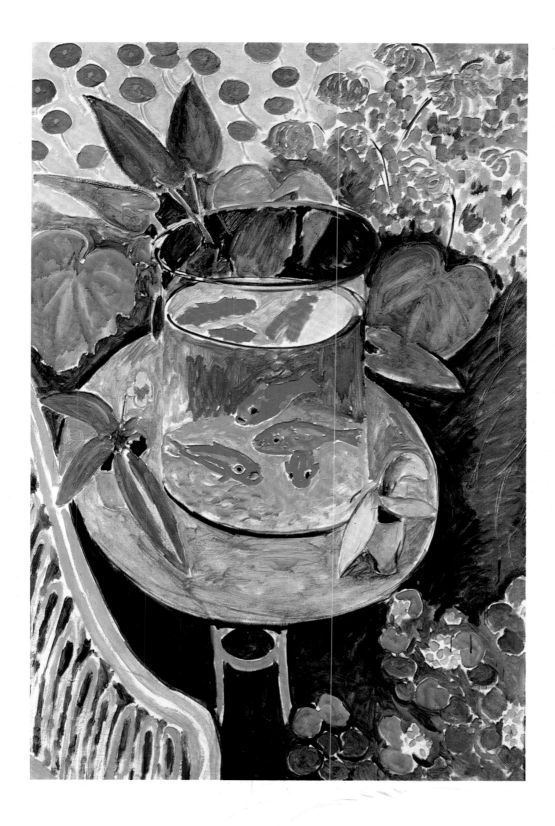

155. Goldfish
Les poissons rouges

Issy-les-Moulineaux, spring–early summer 1912

Oil on canvas, 57½ × 38⅛″ (146 × 97 cm)
Not signed, not dated
The Pushkin Museum of Fine Arts, Moscow
Formerly collection Sergei Shchukin

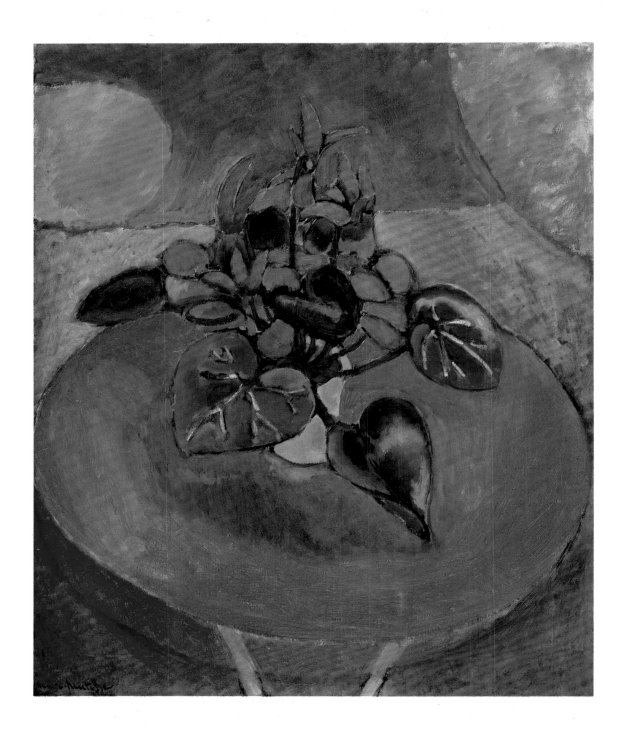

156. Purple Cyclamen
Cyclamen pourpre

Issy-les-Moulineaux, [early 1911 and spring 1912 or 1913]

Oil on canvas, 28¾ × 23⅝″ (73 × 60 cm)
Signed lower left: "Henri-Matisse"
Private collection
Formerly collection John Quinn

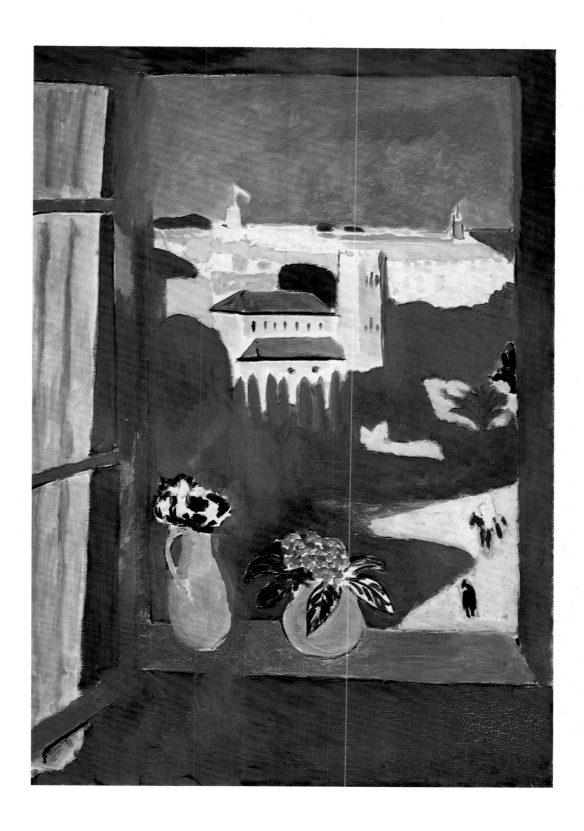

157. Landscape Viewed from a Window
Paysage vu d'une fenêtre

Tangier, spring 1912 [and winter 1912–13]

Oil on canvas, 45¼ × 31½″ (115 × 80 cm)
Not signed, not dated
The Pushkin Museum of Fine Arts, Moscow
Formerly collection Ivan Morosov

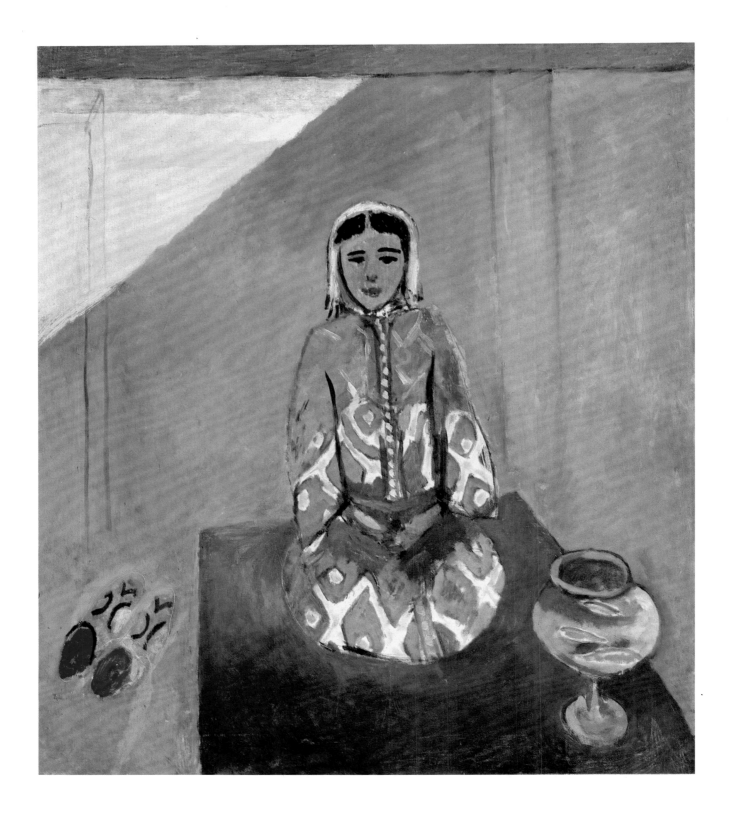

158. On the Terrace
Sur la terrasse

Tangier, winter 1912–13

Oil on canvas, 45¼ × 39⅜″ (115 × 100 cm)
Not signed, not dated
The Pushkin Museum of Fine Arts, Moscow
Formerly collection Ivan Morosov

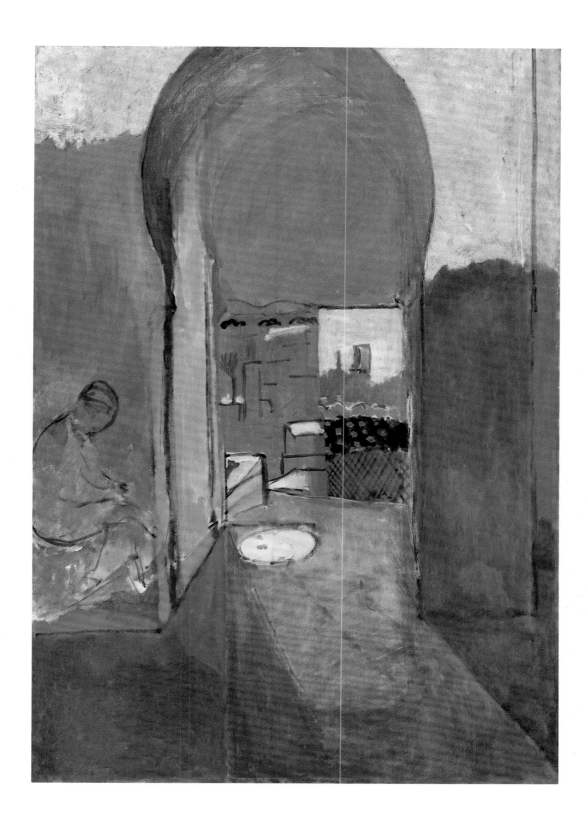

159. The Casbah Gate
Porte de la casbah

Tangier, winter 1912–13

Oil on canvas, 45⅝ × 31½″ (116 × 80 cm)
Not signed, not dated
The Pushkin Museum of Fine Arts, Moscow
Formerly collection Ivan Morosov

160. Zorah Standing
Zorah debout

Tangier, late 1912

Oil on canvas, 57½ × 24″ (146 × 61 cm)
Not signed, not dated
The Hermitage Museum, St. Petersburg
Formerly collection Sergei Shchukin

161. The Standing Riffian
Le rifain debout

Tangier, late 1912

Oil on canvas, 57⅝ × 38½″ (146.5 × 97.7 cm)
Not signed, not dated
The Hermitage Museum, St. Petersburg
Formerly collection Sergei Shchukin

162. Calla Lilies, Irises, and Mimosas
Arums, iris et mimosas

Tangier, early 1913

Oil on canvas, 57¼ × 38¼″ (145.5 × 97 cm)
Signed and dated lower left: "Henri-Matisse. Tanger 1913"
The Pushkin Museum of Fine Arts, Moscow
Formerly collection Sergei Shchukin

163. Moroccan Café
 Café marocain

[Tangier, winter 1912–13 and/or Issy-les-Moulineaux, spring 1913]

Distemper on canvas, 69¼″ × 6′10⅝″ (176 × 210 cm)
Not signed, not dated
The Hermitage Museum, St. Petersburg
Formerly collection Sergei Shchukin

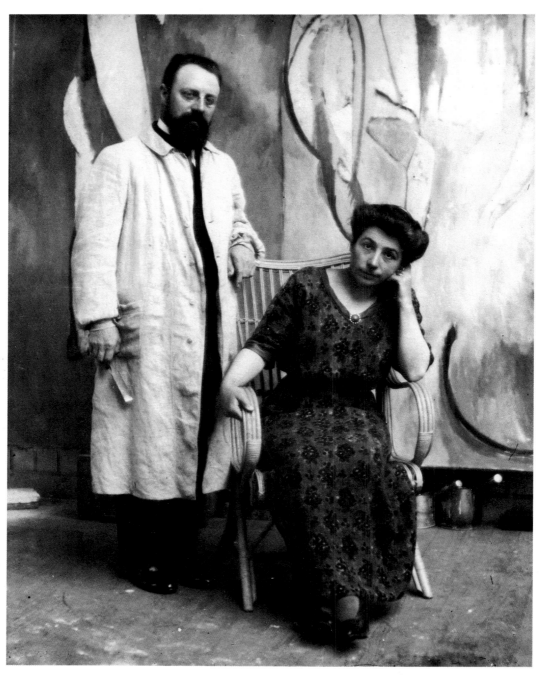

Matisse and Mme Matisse in the studio at Issy-les-Moulineaux, May 1913, with the unfinished *Bathers by a River* (pl. 193). Photograph by Alvin Langdon Coburn.

PART IV ✦ 1913–1917

ABSTRACTION AND EXPERIMENTATION

The period of Matisse's art from 1913 to 1917—after his second trip to Morocco and before he moved to Nice—is seemingly the most "un-Matissean" of his entire career. It is a time of restless experimentation that produced often severe, highly abstracted, and even geometrically constructed paintings lacking the hedonistic exuberance normally associated with his art. The work of these years is said to reflect the influence of Cubism; Matisse was in contact with artists such as Picasso and Juan Gris and did acknowledge that he used "the methods of modern construction." It is also said to reflect the anxieties of World War I. Both explanations are reasonable. And yet, this period's work is not as anomalous as it appears at first sight. Matisse pursues his perennial aim of uncovering the "essential qualities" of things beneath their ephemeral, external appearances. Only now, he radically decomposes the very structure of things in order to uncover their essence, and the symbols that result are more ruthless in their simplification than ever before.

The continuity of Matisse's purpose is also made evident by his return to earlier, unfinished projects. Thus, this period opens in 1913 with the second of the *Back* sculptures (pl. 167) and work on the enormous *Bathers by a River* (pl. 193), a picture originally designed as a decoration to accompany *Dance (II)* and *Music* (pls. 125, 126) in 1909–10. It will close after the third *Back* (pl. 191) is made and *Bathers by a River* is finally completed, in 1916. These new works develop Matisse's preoccupation with using the figure to design the pictorial rectangle. Now, the figure is dissected in order to do this—its parts defined as separate compositional

units—or it is reduced to an ominously elemental state, a minimal diagram of human presence.

Occasional paintings of this period are so boldly simplified that their subjects are almost indecipherable. But even these clearly derive from external reality. In the great sequence of interiors that climaxes in *The Studio, quai Saint-Michel* (pl. 206), he revises and reduces the subjects into schematic patterns of analogous forms, while miraculously maintaining very specific description of the natural fall of light. As ever, structure is the result of, and recalls, visual experience. Even the highly geometrized *Piano Lesson* (pl. 188) is thus a naturalistic picture as well as an abstract one.

Among the most extraordinary works of the period are the portraits. They begin, with *Portrait of Mme Matisse* (pl. 168), in an almost penitential mood that stifles without quite cancelling an innate sensuality. The most untraditional pictures follow, from *Portrait of Mlle Yvonne Landsberg* (pl. 171), with its great incised curves that spread the figure into the surrounding space, to *The Italian Woman* (pl. 200), where the surface of the painting dislocates into two distinct skins, one of which drapes over the model's shoulder like a shawl. The latter painting began a group of nearly fifty, done in 1916–17, of the same model, Lorette, the first instance of his making such an extended series of works on one subject. As the series develops, more purely naturalistic paintings appear (pl. 211), and Matisse begins to dress his model in quasi-Oriental costumes (pls. 207, 210). He paints almost as if in Morocco again.

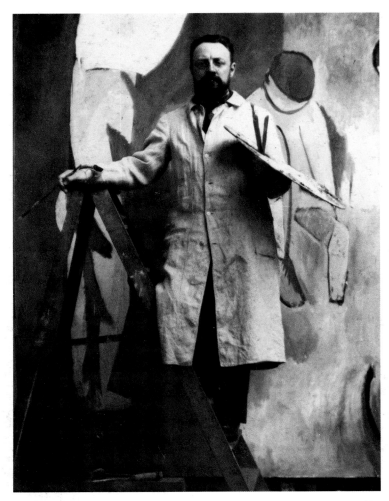 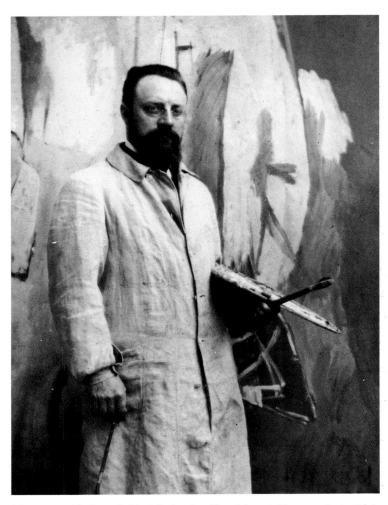

Above and opposite page: Four views of Matisse in his studio at Issy-les-Moulineaux, May 1913, with the unfinished *Bathers by a River* (pl. 193). Photographs by Alvin Langdon Coburn.

1913 (continued)

FEBRUARY: With Mme Matisse, returns to France from Tangier, visiting Ajaccio in Corsica and Menton en route. Is in Marseille, February 27; in Paris or Issy-les-Moulineaux by early spring.

FEBRUARY 17–MARCH 15: Represented by seventeen works, including *Blue Nude: Memory of Biskra* (pl. 93), *Le luxe (II)* (pl. 103), and *The Red Studio* (pl. 146), in the "International Exhibition of Modern Art," the so-called Armory Show, in New York. Reduced versions of the exhibition are later shown in Chicago, March 24–April 16; and Boston, April 28–May 19. Matisse's work, like that of the other advanced artists represented, is vehemently attacked in the press. At Chicago, students of the Art Institute school burn in effigy his *Blue Nude* and *Le luxe (II)*.

MARCH 31–APRIL 12: At the Druet gallery, Marquet exhibits paintings done in Morocco.

APRIL 14–19: Exhibition of fourteen of Matisse's Moroccan paintings, along with drawings and a survey of his sculpture, at the Bernheim-Jeune gallery. Shchukin and Morosov have already purchased most of the works in the exhibition. The exhibition of Moroccan works is the occasion for Marcel Sembat's article on Matisse in the April issue of *Cahiers d'aujourd'hui*.

APRIL 14–26: Camoin exhibits Moroccan paintings at the Druet gallery.

APRIL–MAY: Matisse is represented by four paintings, including *Dance (I)* (pl. 112), in an exhibition of the Berlin Secession. Also has an exhibition at the Fritz Gurlitt gallery in Berlin, May 1–10.

MAY: Through Gertrude Stein, the American photographer Alvin Langdon Coburn meets Matisse and photographs him in his studio at Issy-les-Moulineaux, working on *The Back (II)* (pl. 167) in plaster and on an early state of *Bathers by a River* (pl. 193). This spring through the autumn, his work becomes more architectonic and then severe. He also paints *Flowers and Ceramic Plate* (pl. 164), *The Blue Window* (pl. 165), and *Portrait of Mme Matisse* (pl. 168); he contemplates painting a remembrance of Morocco but will not begin this work, *The Moroccans* (pl. 192), for another two and a half years.

LATE AUGUST–EARLY SEPTEMBER: Is seeing Picasso; the two go horseback riding together.

1913–14 SEASON

SEPTEMBER: Makes a down payment on the house he has been renting in Issy-les-Moulineaux since 1909.

OCTOBER 12–JANUARY 16, 1914: Represented by two paintings and five lithographs in "Post-Impressionist and Futurist Exhibition" at the Doré Galleries, London, organized by Frank Rutter, curator of the Leeds City Art Gallery.

NOVEMBER: Exhibits at the Fritz Gurlitt gallery in Berlin. Three of his paintings are lent by Oskar and Greta Moll.

NOVEMBER 15–JANUARY 5, 1914: Exhibits one work at the Salon d'Automne, *Portrait of Mme Matisse* (pl. 168), completed by November 4 after more than one hundred sittings. To Apollinaire, reviewing the Salon in the November issue of *Les soirées de Paris*, "this portrait, together with *The Woman with the Hat* [pl.

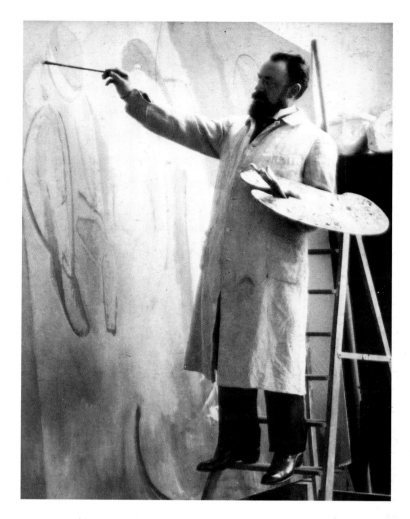

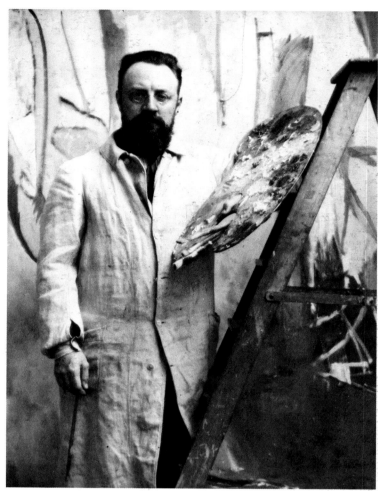

64], in the Stein collection, ranks as the artist's masterpiece."

After the opening of the Salon, hires a model from whom he probably paints *Gray Nude with a Bracelet* (pl. 166). In this period, returns to printmaking, and will continue to make etchings, drypoints, and lithographs in 1914.

DECEMBER: Takes a studio in Paris, on the fourth floor of the building at no. 19, quai Saint-Michel, below his old studio, which is now occupied by Marquet. Here, through the early summer of 1914, will paint austere and increasingly abstracted portraits, such as *Woman on a High Stool (Germaine Raynal)* (pl. 170) and *Portrait of Mlle Yvonne Landsberg* (pl. 171). Begins an important series of paintings of and from the window of the studio, including *Interior with a Goldfish Bowl* (pl. 169) and two views of Notre-Dame (pls. 176, 177).

1914

JANUARY 10: Robert Rey publishes in *L'opinion* an account of his recent visit to Matisse's house and studio at Issy-les-Moulineaux; among the works he appears to have seen are a state of

Bathers by a River (pl. 193), *The Seated Riffian* of 1912–13, and at least three of the *Jeannette* sculptures in plaster. He notes that the house contains early works by Matisse alongside works by Cézanne, Gauguin, and Redon, and many pieces of African art.

MARCH 2: Auction of the Peau de l'Ours collection, which includes ten Matisses and twelve Picassos, at the Hôtel Drouot. At the auction, Picasso's *Family of Saltimbanques* of 1905 is shown publicly for the first time.

SPRING: Meets Carlo Carrà and Ardengo Soffici. Is also in contact with Gino Severini.

MAY 15: *Les soirées de Paris*, under the editorship of Apollinaire, reproduces seven recent works by Matisse, among them *The Blue Window* (pl. 165), *Interior with a Goldfish Bowl* (pl. 169), *Woman on a High Stool* (pl. 170), and *Still Life with Lemons* (pl. 181).

LATE SPRING TO MID-JULY: Paints *Portrait of Mlle Yvonne Landsberg* (pl. 171), accompanied by drawings, drypoints, and etchings. Around this time, makes other portrait etchings, including one of Matthew Stewart Prichard (pl. 172), an Englishman with whom he discusses the philosophy of Henri Bergson.

JULY: Has an exhibition at the Fritz Gurlitt gallery in Berlin. At his insistence, Michael and Sarah Stein lend nineteen paintings from their collection. Because of the outbreak of war, the pictures cannot be returned to them. When the United States enters the war, in 1917, the pictures are threatened with seizure as enemy property; many are sold to the Scandinavians Christian Tetzen-Lund and Trygve Sagen.

Bathers by a River (pl. 193) in progress, in Matisse's studio at Issy-les-Moulineaux, after May 1913.

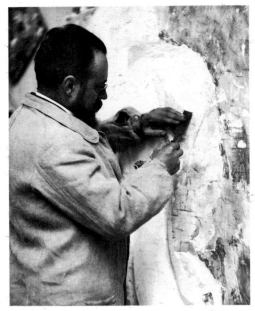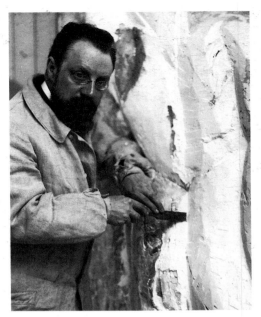

Matisse in his studio at Issy-les-Moulineaux, May 1913, at work on *The Back (II)* (pl. 167). Photographs by Alvin Langdon Coburn.

AUGUST: During the general mobilization for war with Germany, Matisse, now aged forty-four, tries to enlist but is rejected. Braque, Camoin, Derain, Manguin, Puy, and other of his acquaintances do enter the army.

EARLY SEPTEMBER: With Mme Matisse, leaves Paris and goes to Nantes, Bordeaux, and then Toulouse (where their children have been sent). The two arrive at their house in Collioure on September 10.

MID-SEPTEMBER TO LATE OCTOBER: Is in Collioure, where he paints the starkly simplified *French Window at Collioure* (pl. 178), not shown publicly until 1966. Often sees Juan Gris, with whom he discusses painting. Marquet is also in Collioure.

1914–15 SEASON

LATE OCTOBER–DECEMBER: Is in Paris and Issy-les-Moulineaux. Will remain through summer 1915, except for a brief visit to Arcachon, near Bordeaux, during the winter. At the quai Saint-Michel studio, paints *Goldfish and Palette* (pl. 179) and, probably that winter, *White and Pink Head* (pl. 180), both with a high degree of abstraction. Takes violin lessons from Armand Parent, leader of the Parent Quartet and an exponent of contemporary music. Through the war years, will see many of the artists, poets, and critics who remain in Paris, including Albert Gleizes, Gris, Metzinger, Walter Pach, Picasso, and Severini.

1915

JANUARY 20–FEBRUARY 27: Has a large exhibition at the Montross gallery in New York, organized by Pach. This is his first fully repre-sentative one-artist show in New York; includes fourteen paintings, among them *Purple Cyclamen* (pl. 156) and *Portrait of Mlle Yvonne Landsberg* (pl. 171), which will be acquired by, respectively, John Quinn and Louise and Walter Arensberg; as well as nearly fifty prints and drawings; and eleven sculptures, among them four states of *Jeannette*.

SUMMER: Is in Issy-les-Moulineaux; remains through November. In this year, apparently does little painting, concentrating instead on printmaking. His few paintings are extremely abstracted, as with his *Still Life after Jan Davidsz. de Heem's "La desserte"* (pl. 182), based on his earlier Louvre copy but done in a Cubist-influenced style.

1915–16 SEASON

MID-NOVEMBER: Sells his recent still life after de Heem to Léonce Rosenberg; admires at Rosenberg's gallery Picasso's recently completed *Harlequin*. Begins work on *The Moroccans* (pl. 192), completed the following autumn.

EARLY DECEMBER: Trip to Marseille with Marquet, followed by a brief stay at L'Estaque.

1916

EARLY JANUARY: Is in Martigues, near Marseille.

JANUARY 15–FEBRUARY 1: Gino Severini's "First Futurist Exhibition of the Plastic Art of War" at the Boutet de Monvel gallery in Paris.

FEBRUARY: Is in Paris; remains in the city and Issy-les-Moulineaux for most of the year.

MARCH 2–APRIL 15: Represented in the Triennale, the first major salon since the beginning of the war, at the Jeu de Paume.

SPRING: Two Danish painters, Axel Salto (publisher of the review *Klingen*) and Jens Adolf Jerichau, visit him at Issy-les-Moulineaux; they see, in progress, *The Moroccans* (pl. 192) and *Bathers by a River* (pl. 193). (Salto's account of the visit will be published in the April 1918 issue of *Klingen*.) During this spring-to-autumn period, in addition to those works he paints a group of boldly simplified still lifes (pls. 185, 186), *The Window* (pl. 187), and *Piano Lesson* (pl. 188); and makes the sculpture *The Back (III)* (pl. 191) and probably *Jeannette (V)* (pl. 189).

JUNE 13: Opening of a group exhibition at the Galerie des Indépendants; Derain, Dufy, Matisse, and others are represented.

EARLY JULY: Roger Fry is in Paris. With Diego Rivera and others, visits Matisse and sees his recent work.

JULY 16–31: Matisse shows two paintings and a drawing in the large exhibition "L'art moderne en France," also known as the Salon d'Antin, organized by André Salmon, at the Barbazanges gallery. Includes the first public showing of *Les demoiselles d'Avignon*.

SUMMER: He may make brief trips to Marseille and Nice. Returns to Issy-les-Moulineaux.

1916–17 SEASON

AUTUMN: In Paris, paints portraits of Michael Stein and Sarah Stein (pls. 194, 197) and begins a portrait of Greta Prozor (pl. 198). Begins *The Italian Woman* (pl. 200), thought to be his first painting of the model Lorette, of whom he will make nearly fifty paintings by the end of 1917; this is the first instance of his making such an extended series of works based on one model. The series reveals his transition to a more naturalistic style. Some of the paintings show Lorette in exotic costumes. Related to this series are two final paintings of the Paris studio, *The Painter in His Studio* (pl. 204) and *The Studio, quai Saint-Michel*

Sketch for *The Moroccans* (pl. 192) in a letter to Charles Camoin, November 1915.

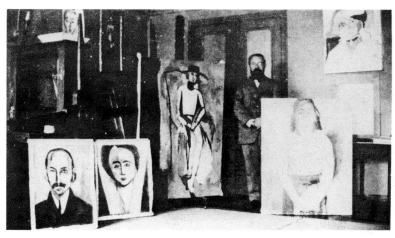

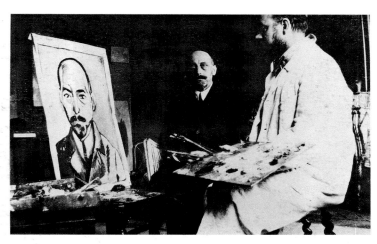

Matisse in his quai Saint-Michel studio, autumn or winter 1916. Left to right: *Portrait of Michael Stein* (pl. 194), *Portrait of Sarah Stein* (pl. 197), an early state of *Portrait of Greta Prozor* (pl. 198), an early state of *The Italian Woman* (pl. 200). On the wall: *Marguerite in a Leather Hat* of 1914.

Matisse at work on *Portrait of Michael Stein* (pl. 194) in his quai Saint-Michel studio, Paris, probably autumn 1916.

(pl. 206), both of which depict paintings of Lorette in progress. The so-called Three Sisters triptych culminates the series.

OCTOBER 29–NOVEMBER 26: Represented by three works in an exhibition of French painting at the Winterthur Museum in Switzerland. Also shown at the Kunsthalle Basel, January 10–February 4, 1917.

NOVEMBER 18–DECEMBER 10: Represented in a major exhibition of modern French art at the Kunstnerforbundet in Oslo. The exhibition is organized by the Norwegian painter Walther Halvorsen, a former student of Matisse's, whose wife, the actress Greta Prozor, Matisse paints (pl. 198). Jean Cocteau, Apollinaire, and André Salmon write prefaces to the catalogue.

NOVEMBER 19–DECEMBER 5: Represented in the first "Lyre et palette" exhibition, at the studio of the Swiss painter Émile Lejeune, known as the Salle Huygens. Paul Guillaume presents twenty-five objects from his collection of sculptures and masks from Africa and New Caledonia.

DECEMBER 31: Attends the banquet in honor of Apollinaire and the publication of *Le poète assassiné*, held at the Palais d'Orléans and organized by Gris, Picasso, Paul Dermée, Max Jacob, Pierre Reverdy, and Blaise Cendrars.

1917

JANUARY: Is in Issy-les-Moulineaux and Paris; will remain until October, except for brief trips.

MAY: Completes a second portrait of Auguste Pellerin (pl. 199) after the first is refused; Pellerin, the great Cézanne collector, will however decide to accept both.

With Marquet, visits Monet at Giverny.

SPRING–SUMMER: Is in Issy-les-Moulineaux, where he paints *The Rose Marble Table* (pl. 213); landscapes at nearby Trivaux (pls. 214, 215); and *Music Lesson*, which reprises the previous year's *Piano Lesson* (pl. 188) in a naturalistic style.

JULY: Visits Chenonceaux with Marquet and Jacqueline Marval.

OCTOBER 19: Signs a new three-year contract with the Bernheim-Jeune gallery.

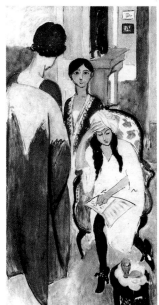
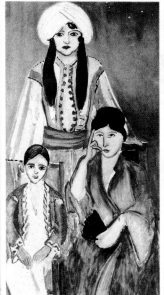
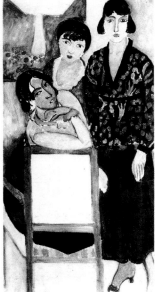

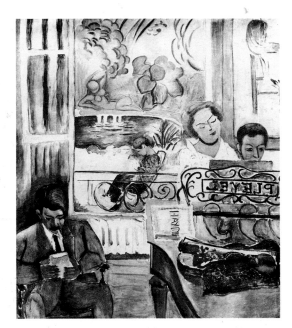

The so-called Three Sisters Triptych. Left: *Three Sisters with an African Sculpture*. Center: *Three Sisters with a Gray Background*. Right: *Three Sisters and "The Rose Marble Table."* [1917]. Oil on canvas, each panel 6′ 5″ × 38″ (195.6 × 96.5 cm). The Barnes Foundation, Merion Station, Pennsylvania.

Music Lesson. summer 1917. Oil on canvas, 8′ × 6′ 10½″ (243.8 × 209.5 cm). The Barnes Foundation, Merion Station, Pennsylvania.

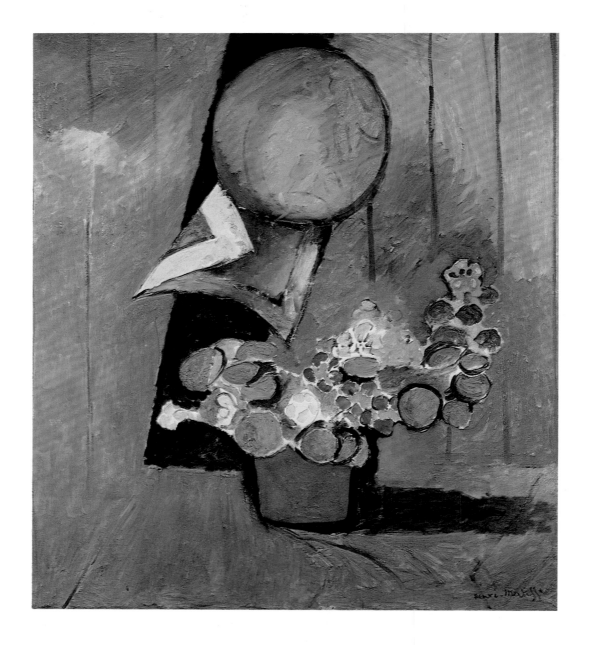

164. Flowers and Ceramic Plate
Fleurs et céramique

Issy-les-Moulineaux, [spring–autumn 1913]

Oil on canvas, 36¾ × 32½″ (93.5 × 82.5 cm)
Signed lower right: "Henri-Matisse"
Städelsches Kunstinstitut, Frankfurt

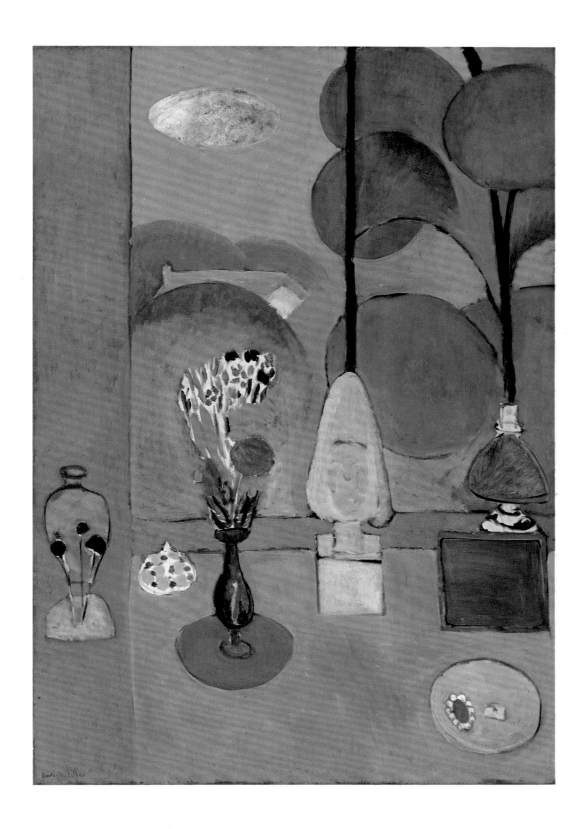

165. The Blue Window
La fenêtre bleue [La glace sans tain]

Issy-les-Moulineaux, [summer 1913]

Oil on canvas, 51½ × 35⅝″ (130.8 × 90.5 cm)
Signed lower left: "Henri-Matisse"
The Museum of Modern Art, New York. Abby Aldrich Rockefeller Fund
Formerly collections Karl-Ernst Osthaus; Museum Folkwang, Hagen and Essen

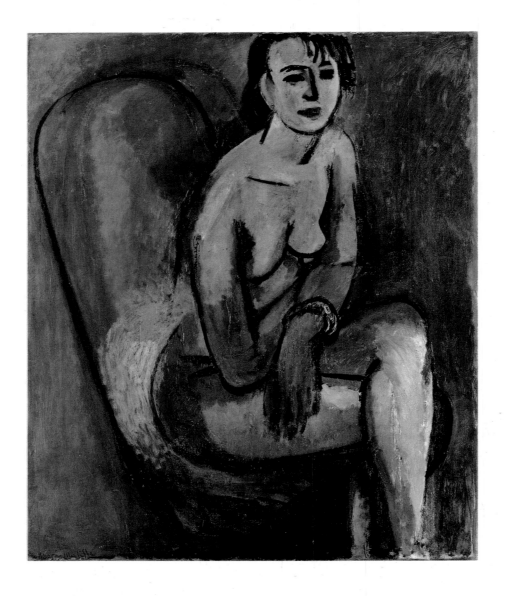

166. Gray Nude with a Bracelet
Nu gris au bracelet

Issy-les-Moulineaux or Paris, quai Saint-Michel, [winter 1913–14]

Oil on canvas, 29½ × 24″ (75 × 61 cm)
Signed lower left: "Henri-Matisse"
Kunsthaus Zürich, on anonymous extended loan

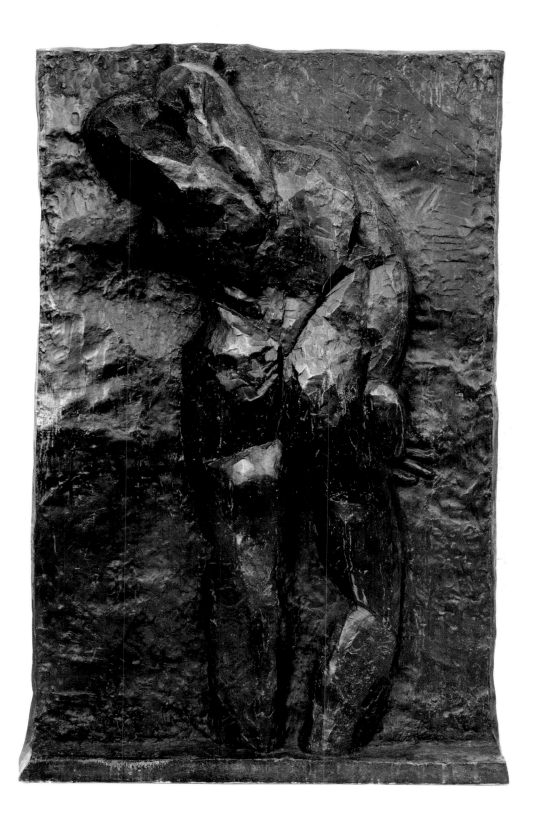

167. The Back (II)
 Nu de dos (II)

Issy-les-Moulineaux, spring–early autumn 1913

Bronze, 6′ 2¼″ × 47⅝″ × 6″ (188.5 × 121 × 15.2 cm)
Inscribed lower left: "Henri Matisse." Lower right: "HM 2/10"
The Museum of Modern Art, New York. Mrs. Simon Guggenheim Fund

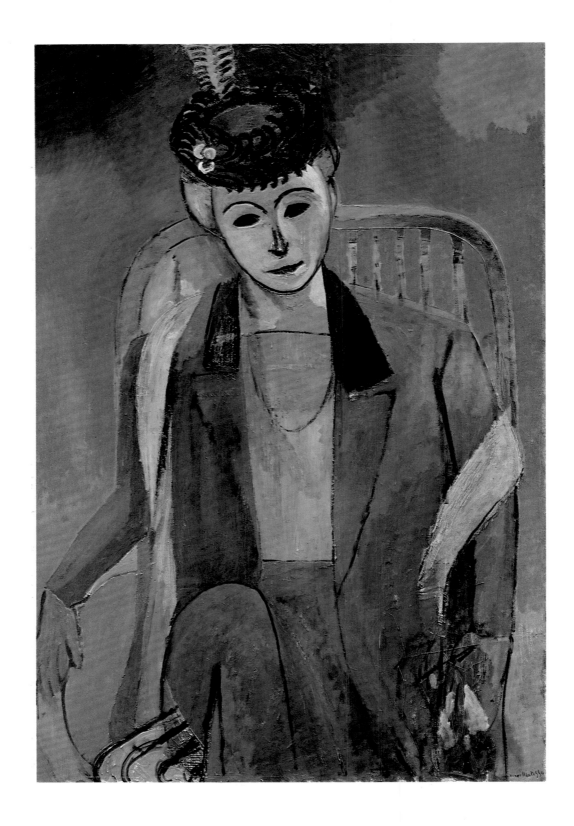

168. Portrait of Mme Matisse
Portrait de Mme Matisse

Issy-les-Moulineaux, summer–early autumn 1913

Oil on canvas, 57 × 38⅛" (145 × 97 cm)
Signed lower right: "Henri Matisse"
The Hermitage Museum, St. Petersburg
Formerly collection Sergei Shchukin

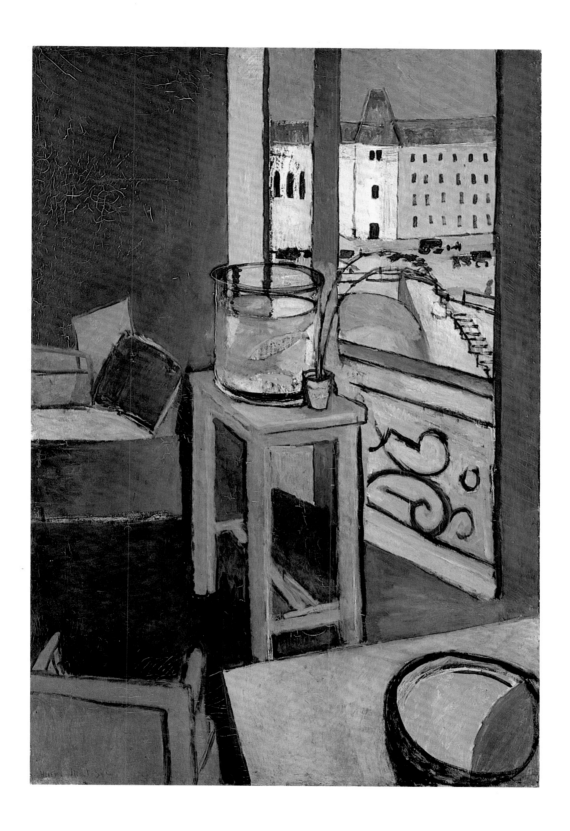

169. Interior with a Goldfish Bowl
Intérieur, bocal de poissons rouges

Paris, quai Saint-Michel, [early 1914]

Oil on canvas, 57⅞ × 38⅛″ (147 × 97 cm)
Signed lower left: "Henri-Matisse"
Musée National d'Art Moderne, Centre Georges Pompidou, Paris

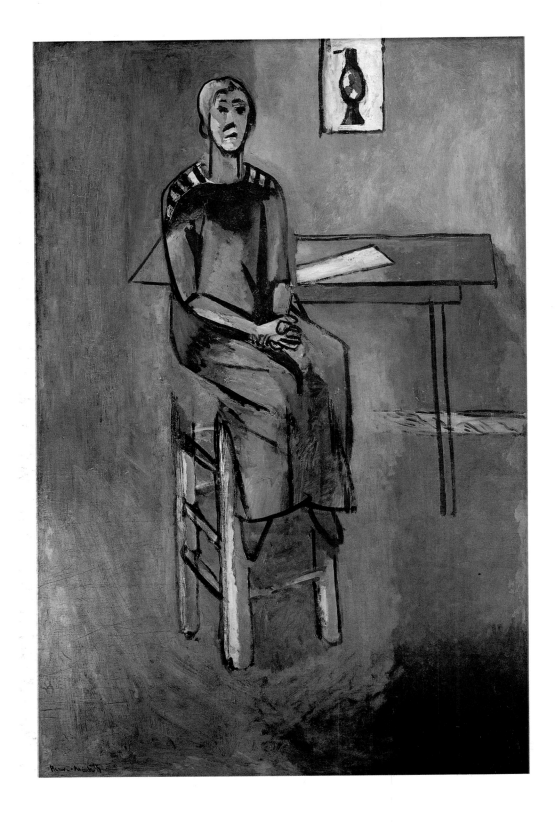

170. Woman on a High Stool (Germaine Raynal)
Femme au tabouret (Germaine Raynal)

Paris, quai Saint-Michel, [early 1914]

Oil on canvas, 57⅞ × 37⅝″ (147 × 95.5 cm)
Signed lower left: "Henri-Matisse"
The Museum of Modern Art, New York. Gift of Florene M.
Schoenborn and Samuel A. Marx (the former retaining a life interest)

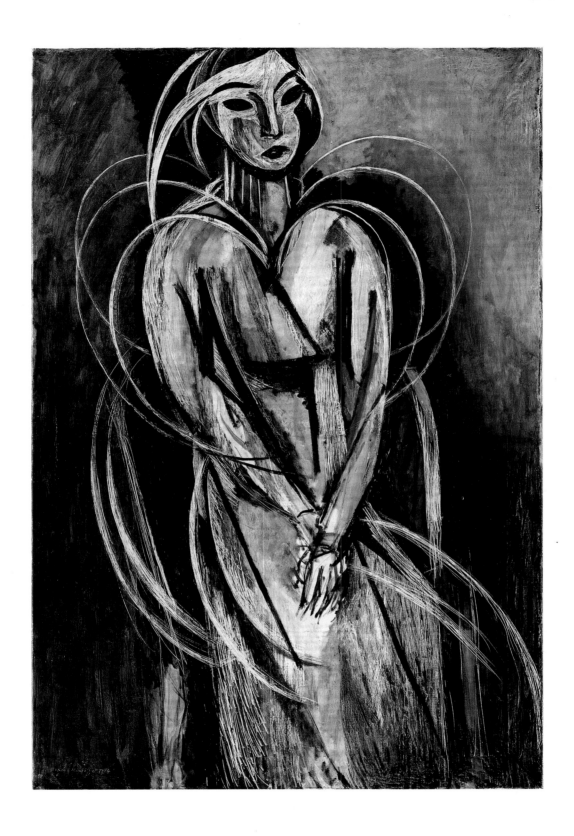

171. Portrait of Mlle Yvonne Landsberg
Portrait de Mlle Yvonne Landsberg

Paris, quai Saint-Michel, [spring–early summer] 1914

Oil on canvas, 58 × 38⅜″ (147.3 × 97.5 cm)
Signed and dated lower left: "Henri-Matisse 1914"
Philadelphia Museum of Art. The Louise and Walter Arensberg Collection

172. Matthew Stewart Prichard

Paris, quai Saint-Michel, [summer 1914]

Etching, printed in black: composition 7⅛ × 4¾″ (18.1 × 12.1 cm);
sheet 15¾ × 11¼″ (40 × 28.5 cm)
Signed lower right of sheet in ink: "essai / H. Matisse"
The Museum of Modern Art, New York. Purchase Fund

174. Mlle Yvonne Landsberg

Paris, quai Saint-Michel, [spring–summer 1914]

Etching, printed in black: composition 7⅞ × 4⁵⁄₁₆″ (20.1 × 11 cm);
sheet 17¹¹⁄₁₆ × 12½″ (45 × 31.8 cm)
Inscribed lower right of sheet in ink: "f. a-quinze ed / quatrième ép. /
Henri-Matisse-"
The Museum of Modern Art, New York. Gift of Mr. and Mrs. E. Powis Jones

173. Charles Bourgeat (Resembling Dr. Vassaux)
Charles Bourgeat (ressemblant à Dr. Vassaux)

Paris, quai Saint-Michel, [1914]

Etching, printed in black: composition 7¹⁄₁₆ × 5⅛″ (18 × 13 cm);
sheet 14¾ × 11″ (37.5 × 28 cm)
Inscribed lower right of sheet in ink: "tirage à quinze exempl. / troisième epr. / Henri-Matisse"
The Museum of Modern Art, New York. Acquired through the Lillie P. Bliss Bequest

175. Branch of Lilacs
La branche de lilas

Paris, quai Saint-Michel, or Issy-les-Moulineaux, spring 1914

Oil on canvas, 57½ × 38¼″ (146 × 97.2 cm)
Signed and dated lower right: "Henri-Matisse 14"
Private collection

176. View of Notre-Dame
Une vue de Notre-Dame

Paris, quai Saint-Michel, [spring 1914]

Oil on canvas, 57⅞ × 38½" (147 × 98 cm)
Signed lower left: "Henri-Matisse"
Kunstmuseum Solothurn. Dübi-Müller-Foundation

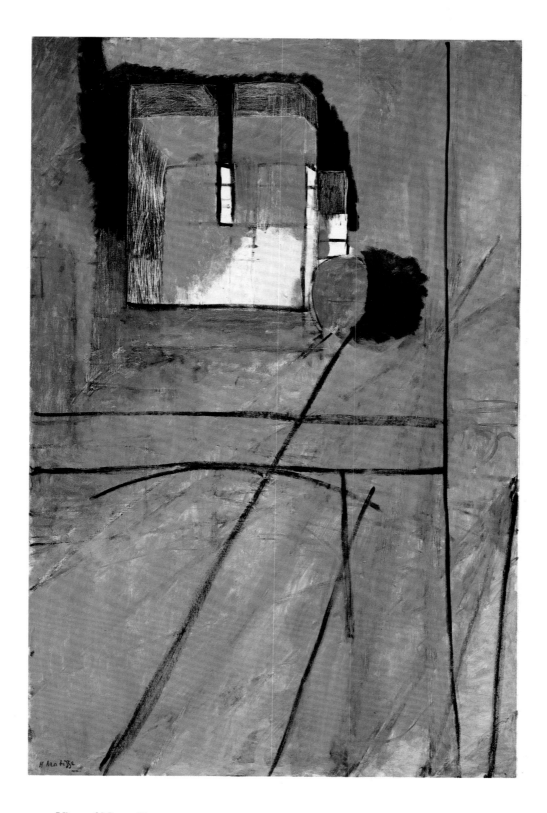

177. View of Notre-Dame
Une vue de Notre-Dame

Paris, quai Saint-Michel, [spring 1914]

Oil on canvas, 58 × 37⅛″ (147.3 × 94.3 cm)
Signed lower left: "H Matisse"
The Museum of Modern Art, New York. Acquired through the
Lillie P. Bliss Bequest, and the Henry Ittleson, A. Conger Goodyear,
Mr. and Mrs. Sinclair Funds, and the Anna Erickson Levene Bequest
given in memory of her husband, Dr. Phoebus Aaron Theodor Levene

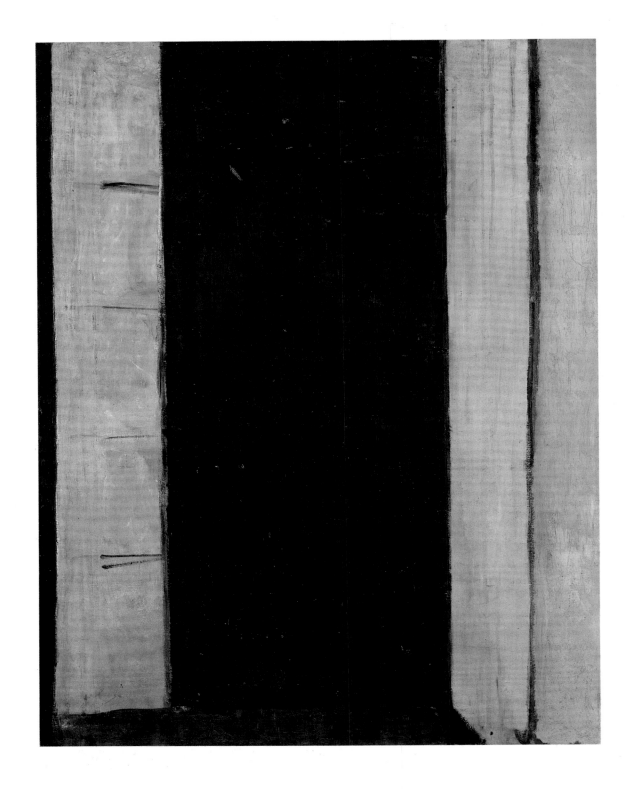

178. French Window at Collioure
Porte-fenêtre à Collioure

Collioure, [autumn 1914]

Oil on canvas, 45⅞ × 35″ (116.5 × 89 cm)
Not signed, not dated
Musée National d'Art Moderne, Centre Georges Pompidou, Paris

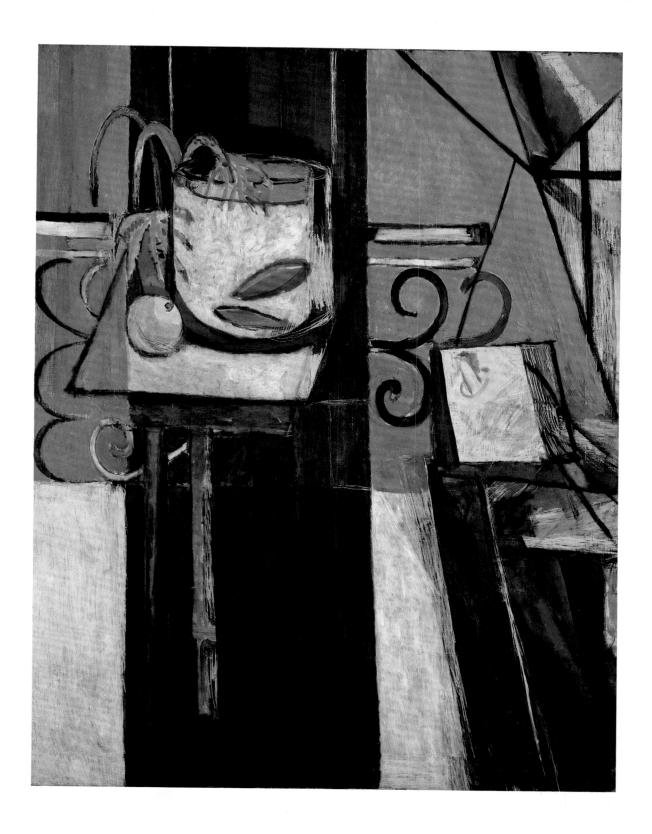

179. Goldfish and Palette
Poissons rouges et palette

Paris, quai Saint-Michel, autumn 1914

Oil on canvas, 57¾ × 44¼″ (146.5 × 112.4 cm)
Signed lower right: "Henri-Matisse"
The Museum of Modern Art, New York. Gift of Florene M.
Schoenborn and Samuel A. Marx (the former retaining a life interest)
Formerly collection Jacques Doucet

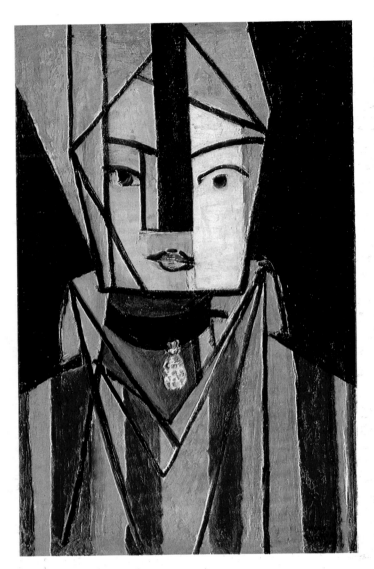

180. White and Pink Head
Tête blanche et rose

Paris, quai Saint-Michel, [autumn 1914 to 1915]

Oil on canvas, 29½ × 18½" (75 × 47 cm)
Signed lower right: "Henri / Matisse"
Musée National d'Art Moderne, Centre Georges Pompidou, Paris

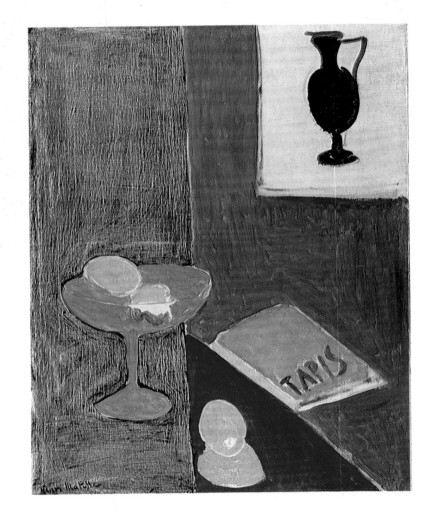

181. Still Life with Lemons Which Correspond in Form
to a Drawing of a Black Vase on the Wall
*Nature morte aux citrons dont les formes correspondent
à celles d'un vase noir dessiné sur le mur [Les citrons]*

Paris, quai Saint-Michel, [early 1914]

Oil on canvas, 27¾ × 21¾" (70.5 × 55.2 cm)
Signed lower left: "Henri Matisse"
Museum of Art, Rhode Island School of Design, Providence.
Gift of Miss Edith Wetmore

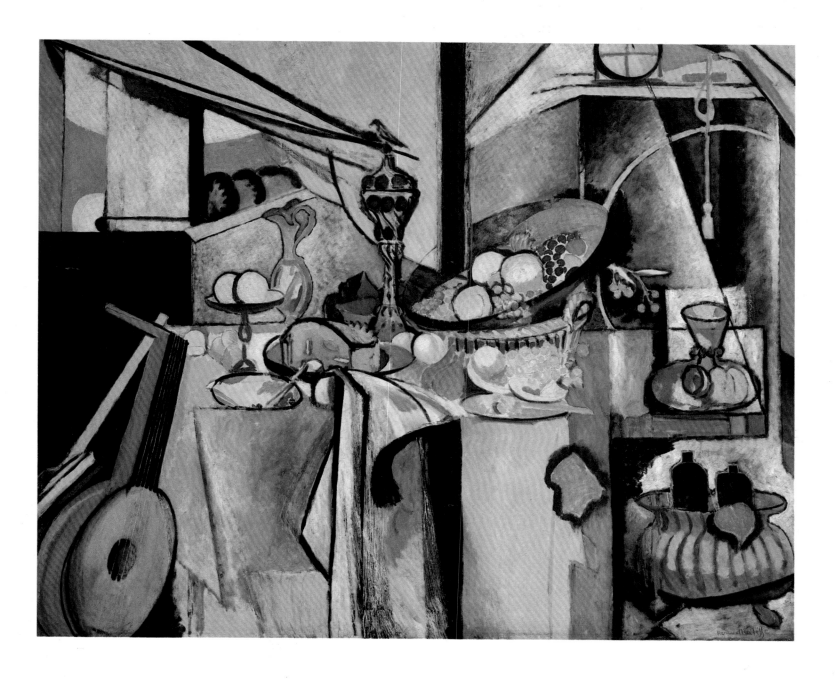

182. Still Life after Jan Davidsz. de Heem's "La desserte"
Nature morte d'après "La desserte" de Jan Davidsz. de Heem

Issy-les-Moulineaux, [summer–]autumn 1915

Oil on canvas, 71¼″ × 7′ 3″ (180.9 × 220.8 cm)
Signed lower right: "Henri-Matisse"
The Museum of Modern Art, New York. Gift of Florene M.
Schoenborn and Samuel A. Marx (the former retaining a life interest)
Formerly collection John Quinn

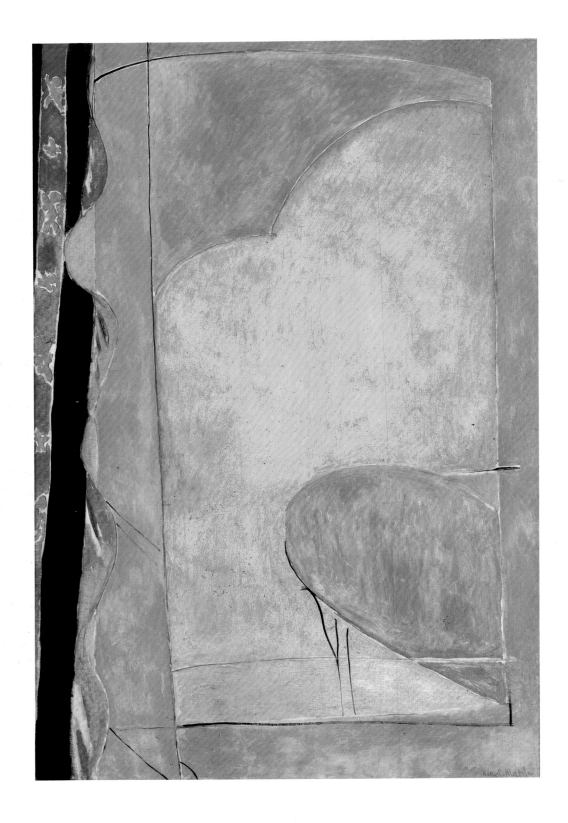

183. The Yellow Curtain
Le rideau jaune

Issy-les-Moulineaux, [c. 1915]

Oil on canvas, 57½ × 38⅛″ (146 × 97 cm)
Signed lower right: "Henri-Matisse"
Stephen Hahn Collection, New York
Formerly collection Alphonse Kann

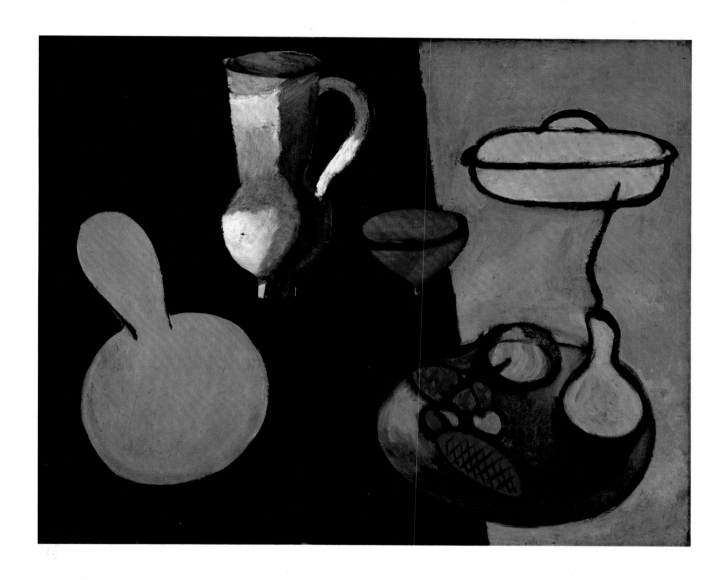

184. Gourds
Les coloquintes

Issy-les-Moulineaux, [late 1915–summer] 1916

Oil on canvas, 25 ⅝ × 31 ⅞″ (65.1 × 80.9 cm)
Signed and dated lower left: "Henri-Matisse 1916"
The Museum of Modern Art, New York. Mrs. Simon Guggenheim Fund
Formerly collections Léonide Massine; Paul Guillaume

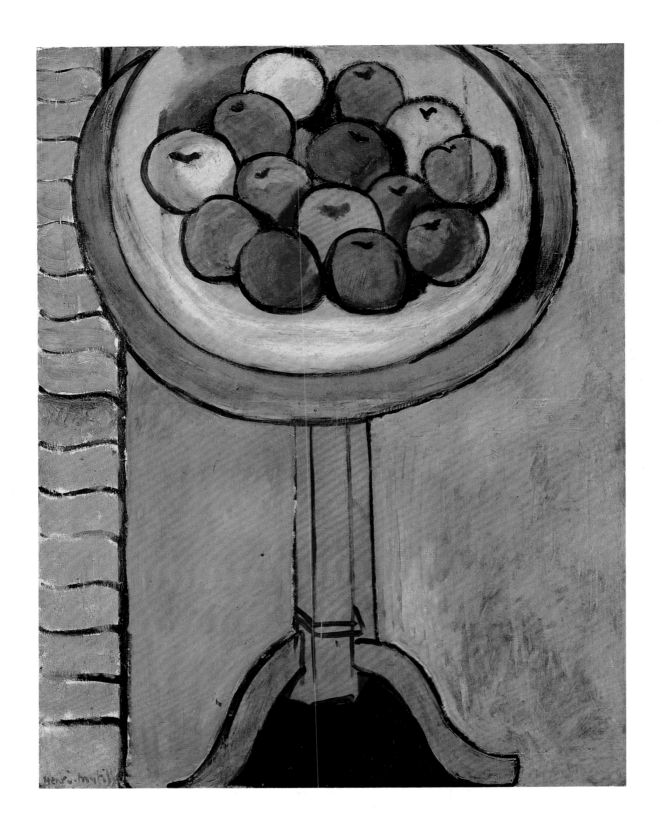

185. Bowl of Apples on a Table
Les pommes sur la table, sur fond vert

Issy-les-Moulineaux, [summer–autumn] 1916

Oil on canvas, 45¼ × 35¼″ (114.9 × 89.5 cm)
Signed lower left: "Henri-Matisse"
The Chrysler Museum, Norfolk, Virginia. Gift of Walter P. Chrysler, Jr.

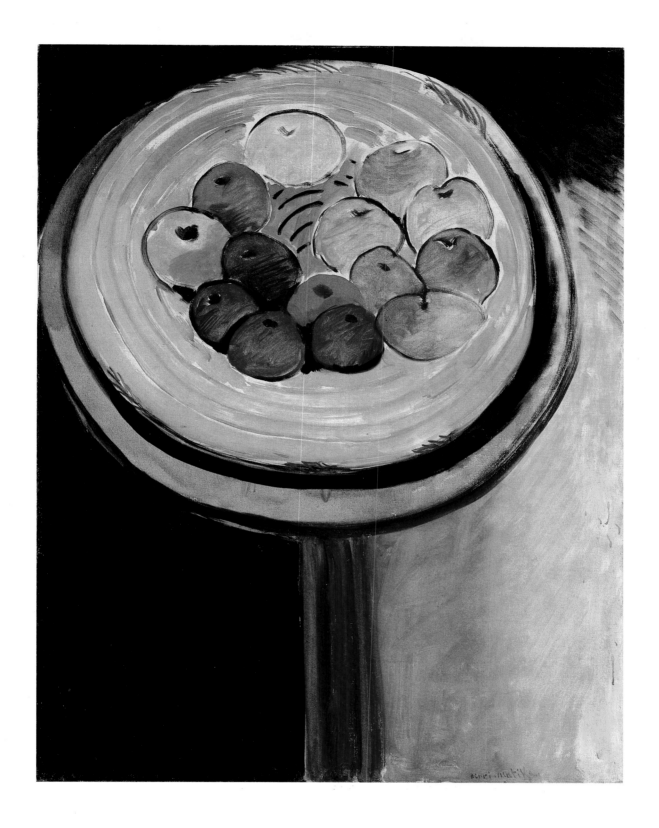

186. Apples
Les pommes

Issy-les-Moulineaux, [summer–autumn] 1916

Oil on canvas, 46 × 35″ (116.9 × 88.9 cm)
Signed lower right: "Henri-Matisse"
The Art Institute of Chicago. Gift of Florene May
Schoenborn and Samuel A. Marx
Formerly collection John Quinn

187. The Window
 La fenêtre

Issy-les-Moulineaux, spring 1916

Oil on canvas, 57½ × 46″ (146 × 116.8 cm)
Signed upper left: "Henri-Matisse"
The Detroit Institute of Arts. City of Detroit Purchase

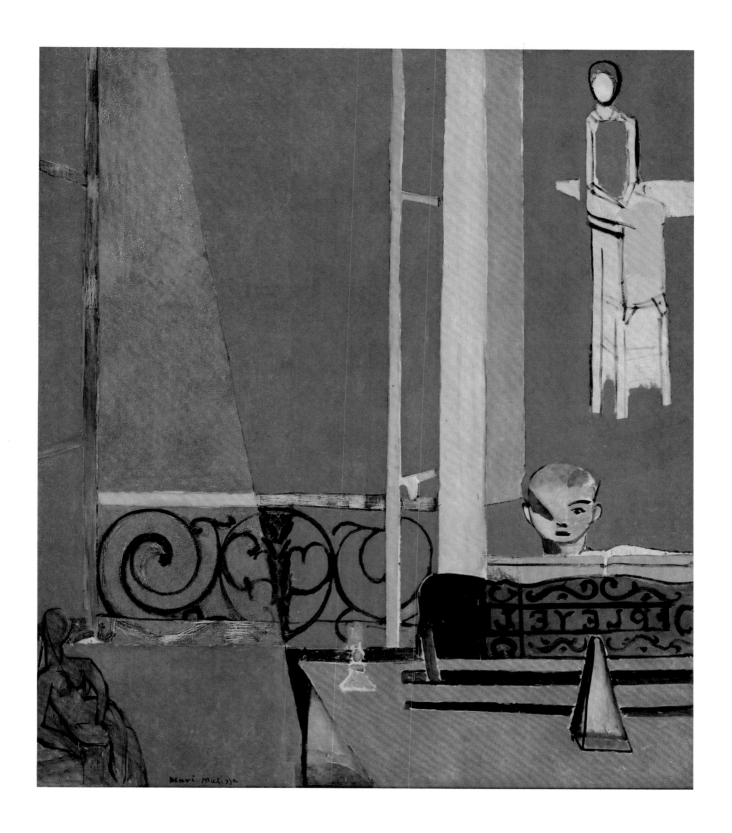

188. Piano Lesson
La leçon de piano

Issy-les-Moulineaux, summer 1916

Oil on canvas, 8′½″ × 6′11¾″ (245.1 × 212.7 cm)
Signed lower left of center: "Henri-Matisse"
The Museum of Modern Art, New York. Mrs. Simon Guggenheim Fund
Formerly collections Paul Guillaume; Walter P. Chrysler, Jr.

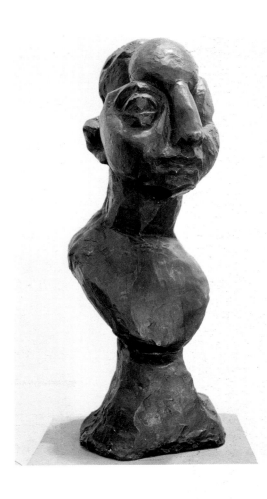

189. Jeannette (V)

Issy-les-Moulineaux, [1916]

Bronze, 22⅞ × 8⅜ × 10⅝″ (58.1 × 21.3 × 27.1 cm)
Inscribed: "5/10 HM"
The Museum of Modern Art, New York.
Acquired through the Lillie P. Bliss Bequest

190. Sculpture and Vase of Ivy
Sculpture et vase de lierre

Issy-les-Moulineaux, [summer 1916–spring 1917]

Oil on canvas, 31⅜ × 39⅜″ (80 × 100 cm)
Signed lower left: "Henri-Matisse"
Tikanoja Art Gallery, Vaasa, Finland
Formerly collection Walter Halvorsen

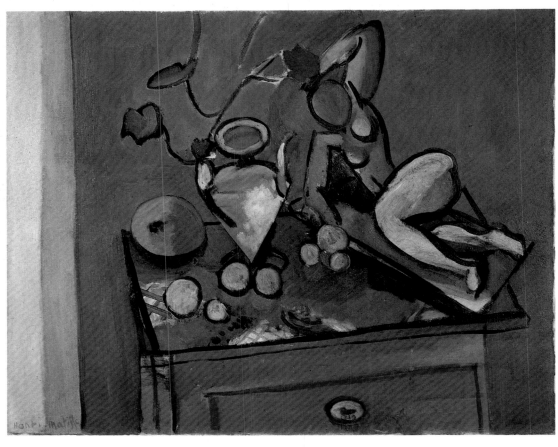

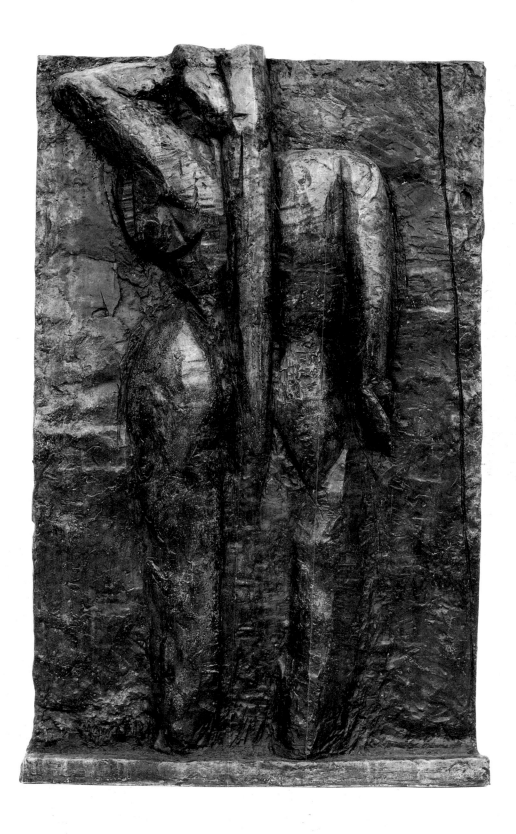

191. The Back (III)
 Nu de dos (III)

Issy-les-Moulineaux, [spring–summer 1916]

Bronze, 6′ 2½″ × 44″ × 6″ (189.2 × 111.8 × 15.2 cm)
Inscribed lower left: "Henri M." Lower right: "H.M 1/10"
Founder C. Valsuani
The Museum of Modern Art, New York. Mrs. Simon Guggenheim Fund

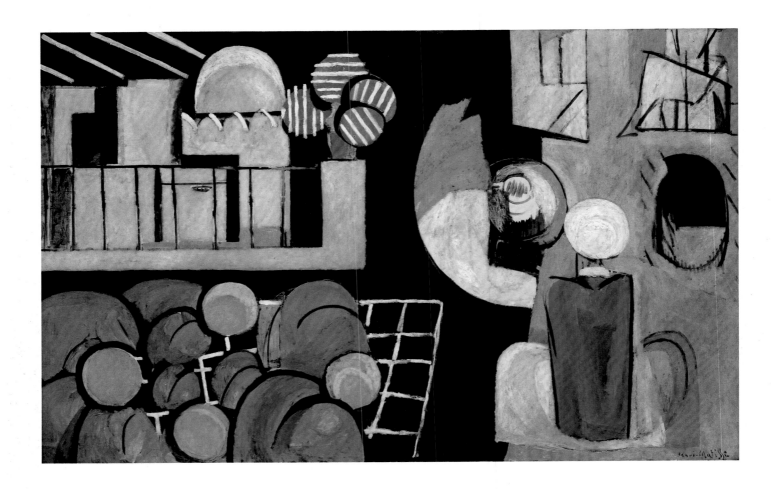

192. The Moroccans
Les marocains

Issy-les-Moulineaux, late 1915–autumn 1916

Oil on canvas, 71⅜″ × 9′ 2″ (181.3 × 279.4 cm)
Signed lower right: "Henri-Matisse"
The Museum of Modern Art, New York.
Gift of Mr. and Mrs. Samuel A. Marx

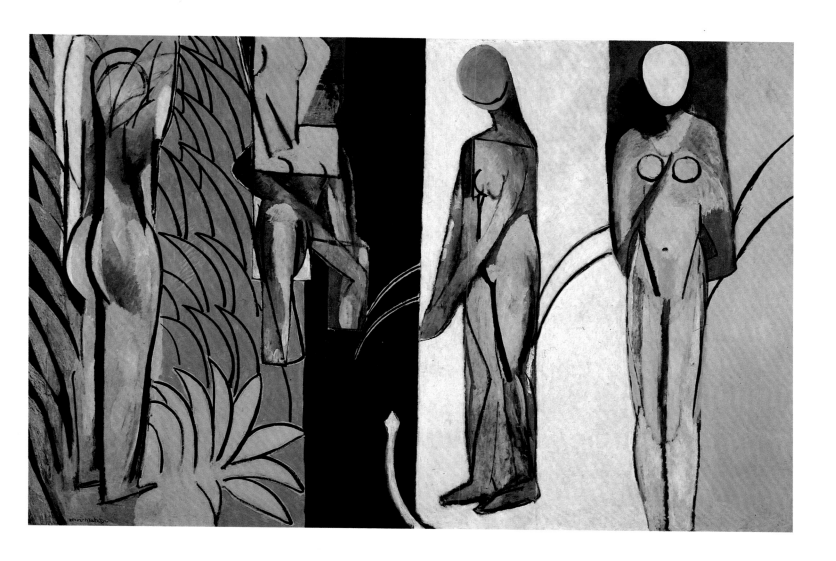

193. Bathers by a River

Femmes à la rivière [Baigneuses; Jeunes filles au bain]

Issy-les-Moulineaux, spring 1909 to 1910; spring–early autumn 1913;
spring–autumn 1916

Oil on canvas, 8′ 7″ × 12′ 10″ (261.8 × 391.4 cm)
Signed lower left: "Henri-Matisse"
The Art Institute of Chicago. Charles H. and Mary F. S. Worcester Collection
Formerly collection Paul Guillaume

195. Greta Prozor

Paris, quai Saint-Michel, [autumn–winter 1916]

Pencil on paper, 21⅞ × 14⅝" (55.5 × 37 cm)
Signed lower left: "Greta Prozor / Henri Matisse"
Musée National d'Art Moderne, Centre Georges Pompidou, Paris

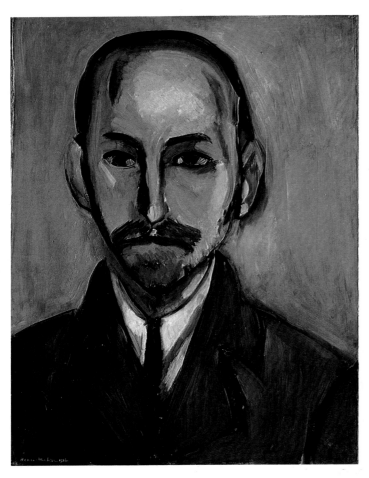

194. Portrait of Michael Stein
Portrait de Michael Stein

Paris, quai Saint-Michel, [autumn] 1916

Oil on canvas, 26½ × 19⅞" (67.3 × 50.5 cm)
Signed and dated lower left: "Henri-Matisse 1916."
San Francisco Museum of Modern Art. Michael and Sarah Stein
Memorial Collection. Gift of Nathan Cummings
Formerly collection Michael and Sarah Stein

196. Study for "Portrait of Sarah Stein"
Étude pour "Portrait de Sarah Stein"

Paris, quai Saint-Michel, [autumn] 1916

Charcoal on paper, 19⅛ × 12⅝" (48.5 × 32.1 cm)
Inscribed lower right: "a Mad.e Michel Stein /
hommage respectueux / Henri-Matisse 1916"
San Francisco Museum of Modern Art.
Gift of Mr. and Mrs. Walter A. Haas
Formerly collection Sarah Stein

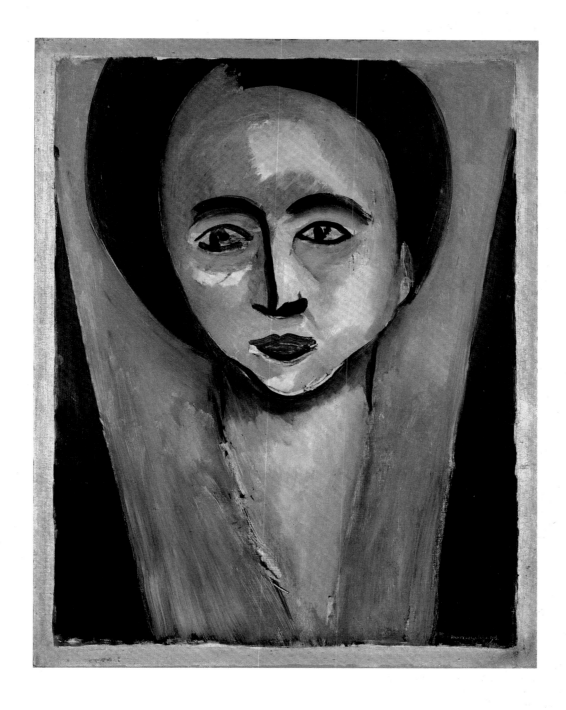

197. Portrait of Sarah Stein
 Portrait de Sarah Stein

Paris, quai Saint-Michel, [autumn] 1916

Oil on canvas, 28½ × 22¼″ (72.4 × 56.5 cm)
Signed and dated lower right: "Henri-Matisse 1916."
San Francisco Museum of Modern Art. Michael and Sarah Stein
Memorial Collection. Gift of Elise S. Haas
Formerly collection Michael and Sarah Stein

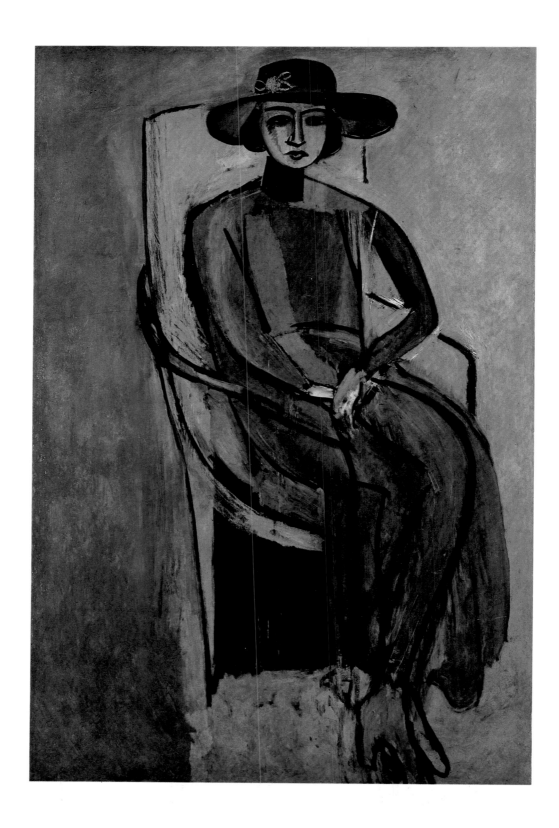

198. Portrait of Greta Prozor
Portrait de Greta Prozor

Paris, quai Saint-Michel, [autumn–winter] 1916

Oil on canvas, 57½ × 37¾″ (146 × 96 cm)
Not signed, not dated
Musée National d'Art Moderne, Centre Georges Pompidou, Paris

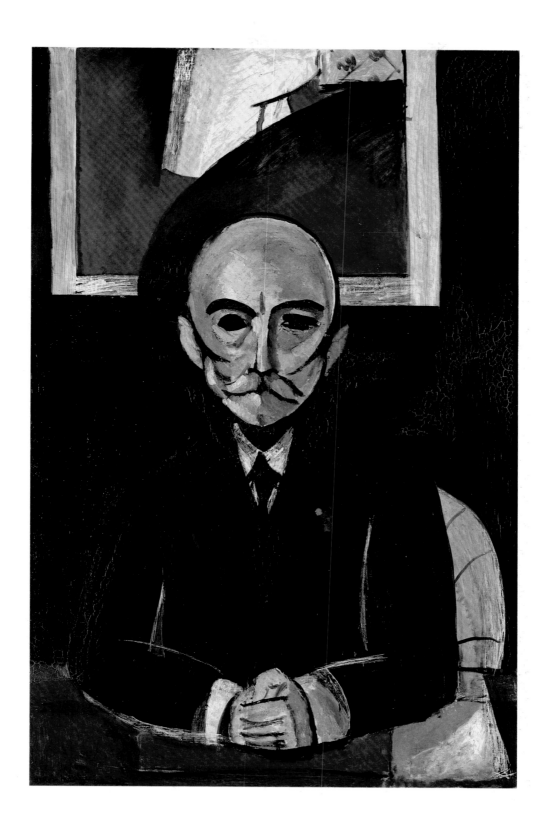

199. Portrait of Auguste Pellerin (II)
Portrait d'Auguste Pellerin (II)

Paris, winter–spring 1917

Oil on canvas, 59 × 37⅞" (150.2 × 96.2 cm)
Signed and dated lower left: "Henri-Matisse mai 1917"
Musée National d'Art Moderne, Centre Georges Pompidou, Paris
Formerly collection Auguste Pellerin

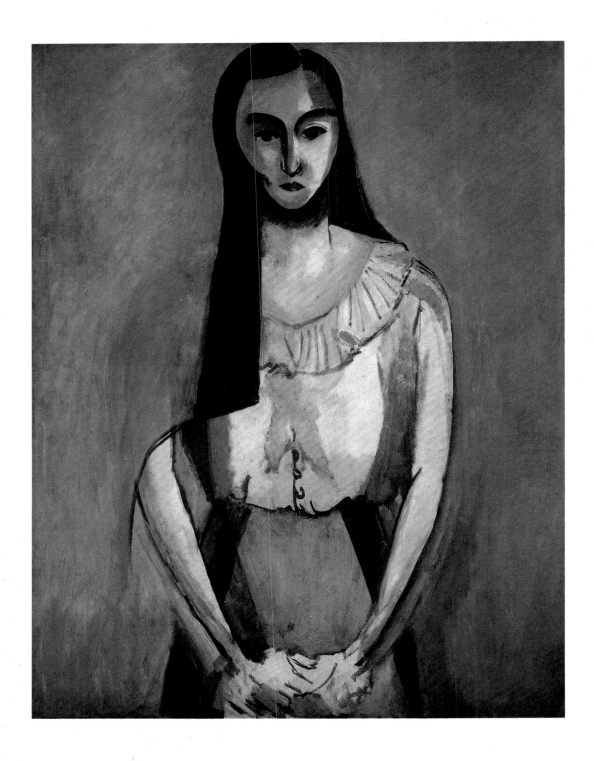

200. The Italian Woman
L'italienne

Paris, quai Saint-Michel, [autumn–winter 1916]

Oil on canvas, 46 × 35¼" (116.7 × 89.5 cm)
Signed lower right: "Henri-Matisse"
Solomon R. Guggenheim Museum, New York. By exchange, 1982
Formerly collection John Quinn

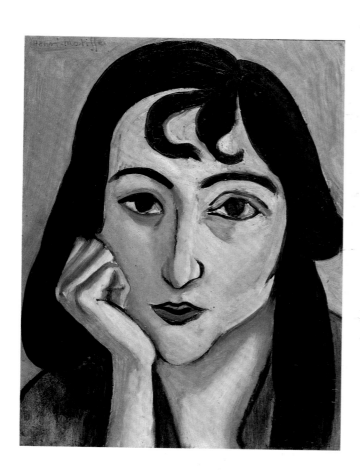

201. Head of Lorette with Two Locks of Hair
Tête de Lorette aux deux mèches

Paris, quai Saint-Michel, or Issy-les-Moulineaux, [1917]

Oil on wooden panel, 13¾ × 10⅜″ (34.9 × 26.4 cm)
Signed upper left: "Henri-Matisse"
Private collection
Formerly collection Paul Guillaume

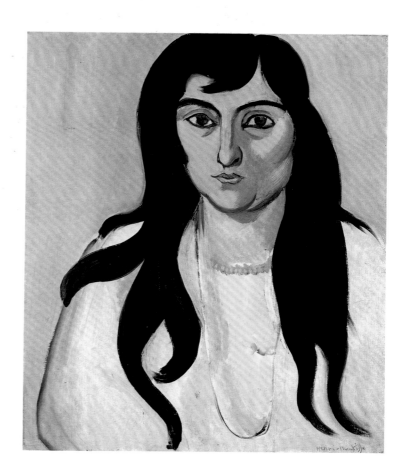

202. Woman with Amber Necklace
La femme au collier d'ambre

Paris, quai Saint-Michel, or Issy-les-Moulineaux, [winter–summer 1917]

Oil on canvas, 21⅞ × 18⅜″ (55.5 × 46.5 cm)
Signed lower right: "Henri-Matisse"
Private collection
Formerly collection Hjalmar Gabrielson

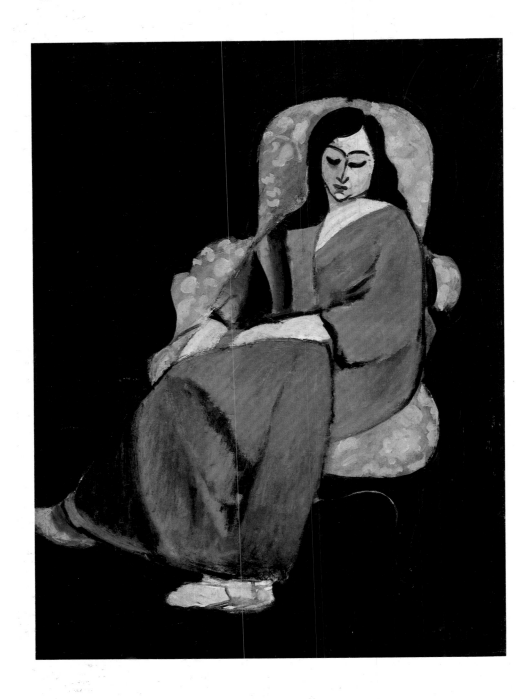

203. Lorette in a Green Robe Against a Black Background
Lorette sur fond noir, robe verte

Paris, quai Saint-Michel, autumn–winter 1916

Oil on canvas, 28¾ × 21⅝″ (73 × 55 cm)
Signed and dated lower right: "H-MATISSE 16"
The Jacques and Natasha Gelman Collection

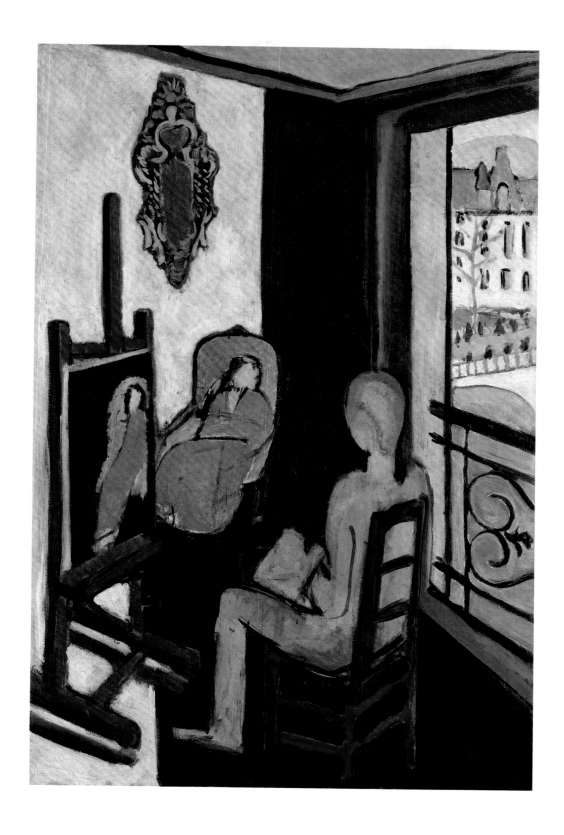

204. The Painter in His Studio
Le peintre dans son atelier

Paris, quai Saint-Michel, [autumn–winter 1916]

Oil on canvas, 57⅝ × 38¼" (146.5 × 97 cm)
Not signed, not dated
Musée National d'Art Moderne, Centre Georges Pompidou, Paris

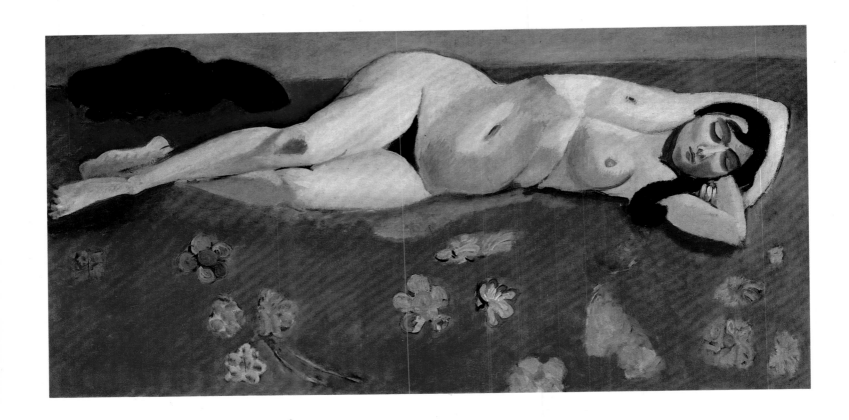

205. Lorette Reclining
Lorette allongée

Paris, quai Saint-Michel, [autumn 1916 to 1917]

Oil on canvas, 37⅜″ × 6′ 5⅛″ (95 × 196 cm)
Not signed, not dated
Private collection

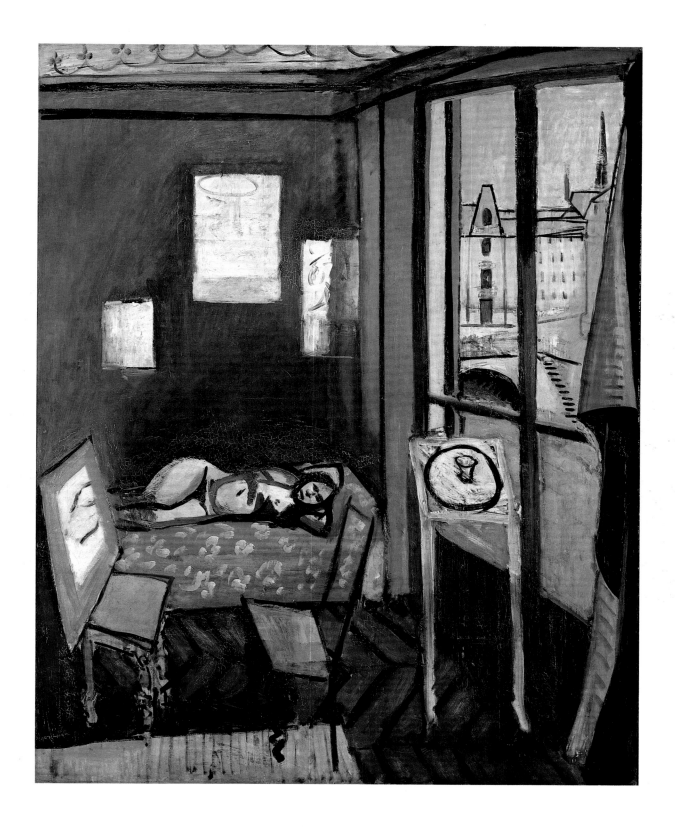

206. The Studio, quai Saint-Michel
L'atelier du quai Saint-Michel

Paris, quai Saint-Michel, [autumn 1916 to 1917]

Oil on canvas, 57½ × 45¾″ (146 × 116 cm)
Not signed, not dated
The Phillips Collection, Washington, D.C.
Formerly collections George Tennant; Kenneth Clark

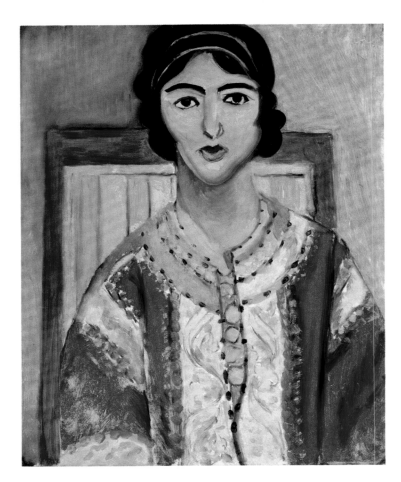

207. Lorette in a Red Jacket
Lorette à la veste rouge

Paris, quai Saint-Michel, or Issy-les-Moulineaux, [1917]

Oil on wooden panel, 18¼ × 14¼″ (46.4 × 36.2 cm)
Signed upper right: "Henri-Matisse"
Columbus Museum of Art, Ohio. Gift of Ferdinand Howald

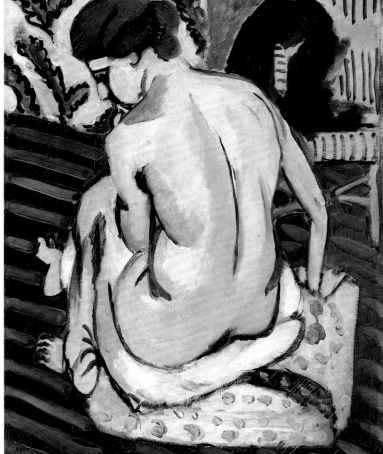

208. Seated Nude with Back Turned
Nu assis, de dos

Issy-les-Moulineaux, [c. 1917]

Oil on canvas, 24½ × 18½″ (62.2 × 47 cm)
Signed lower left: "Henri Matisse"
Philadelphia Museum of Art.
The Samuel S. White 3rd and Vera White Collection

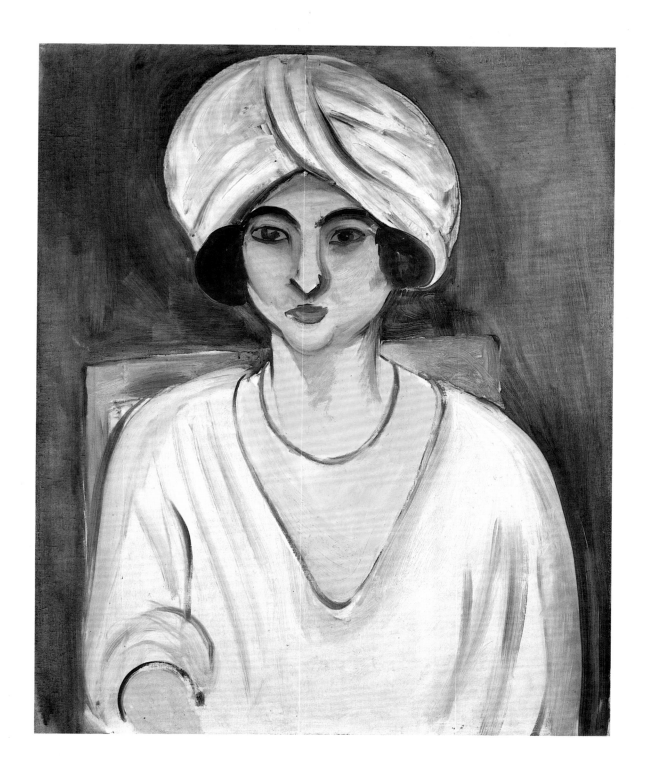

209. Woman in a Turban (Lorette)
Femme au turban (Lorette)

Paris, quai Saint-Michel, or Issy-les-Moulineaux, [winter–spring 1917]

Oil on canvas, 32 × 25¾″ (81.3 × 65.4 cm)
Signed upper right: "Henri-Matisse"
The Baltimore Museum of Art. The Cone Collection, formed by
Dr. Claribel Cone and Miss Etta Cone of Baltimore, Maryland

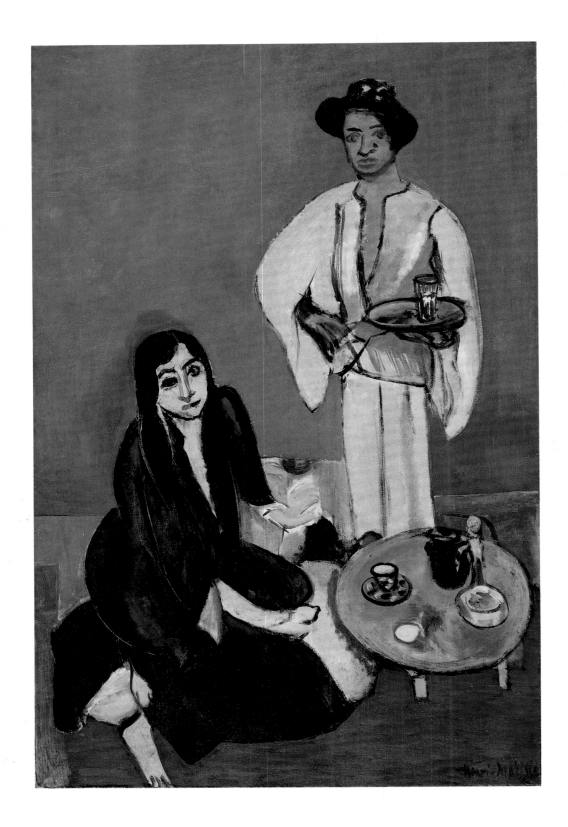

210. Oriental Lunch
Déjeuner oriental

Paris, quai Saint-Michel, or Issy-les-Moulineaux, [1917]

Oil on canvas, 39⅝ × 25¼″ (100.6 × 65.4 cm)
Signed lower right: "Henri-Matisse"
The Detroit Institute of Arts. Bequest of Robert H. Tannahill
Formerly collections Christian Tetzen-Lund; Stephen C. Clark

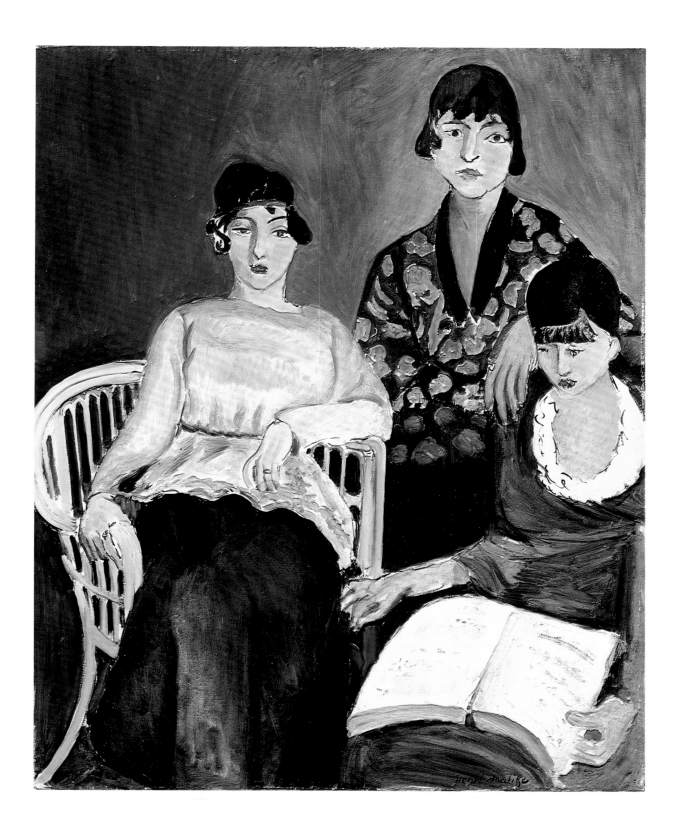

211. The Three Sisters
Les trois soeurs

Issy-les-Moulineaux, [winter–spring 1917]

Oil on canvas, 36¼ × 28¾" (92 × 73 cm)
Signed lower right: "Henri-Matisse"
Musée de l'Orangerie, Paris. Collection Walter-Guillaume
Formerly collections Auguste Pellerin; Paul Guillaume

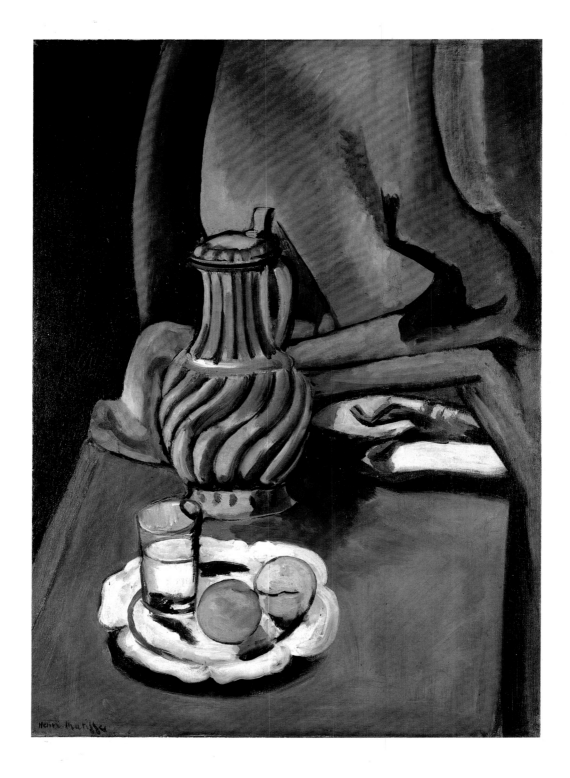

212. The Pewter Jug
Le pot d'étain

Paris, quai Saint-Michel, or Issy-les-Moulineaux, [c. 1917]

Oil on canvas, 36¼ × 25⅝″ (92.1 × 65.1 cm)
Signed lower left: "Henri-Matisse"
The Baltimore Museum of Art. The Cone Collection, formed by
Dr. Claribel Cone and Miss Etta Cone of Baltimore, Maryland

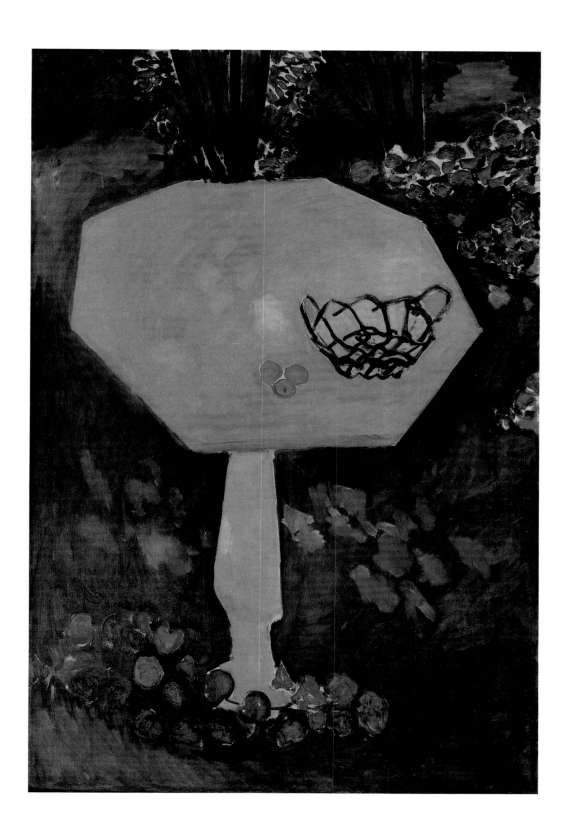

213. The Rose Marble Table
La table de marbre rose

Issy-les-Moulineaux, [spring–summer 1917]

Oil on canvas, 57½ × 38¼″ (146 × 97 cm)
Signed lower right: "Henri Matisse"
The Museum of Modern Art, New York.
Mrs. Simon Guggenheim Fund
Formerly collection Alphonse Kann

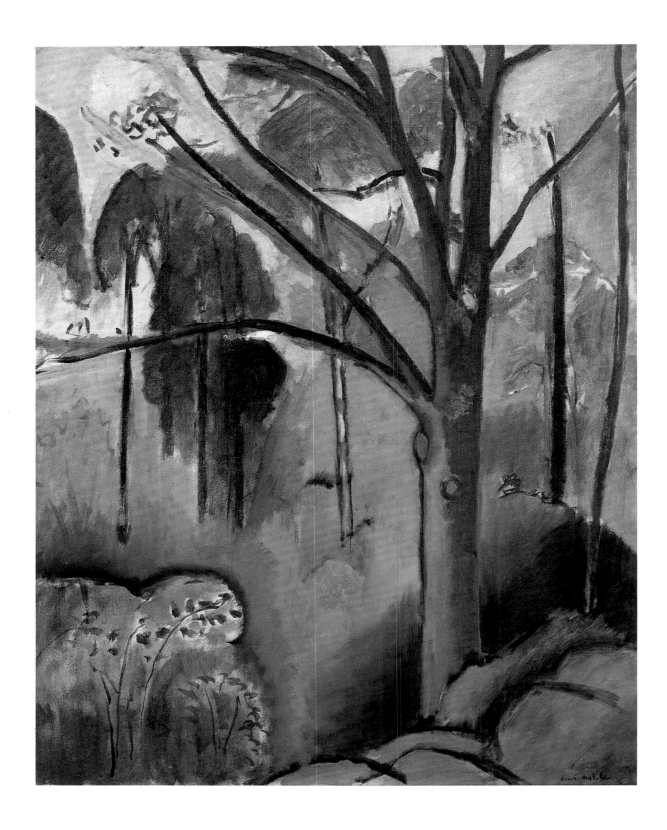

214. Trivaux Pond
L'étang de Trivaux

Environs of Issy-les-Moulineaux, [spring–summer 1917]

Oil on canvas, 36½ × 29¼″ (92.7 × 74.3 cm)
Signed lower right: "Henri-Matisse"
Tate Gallery, London. Bequeathed by C. Frank Stoop, 1933
Formerly collection Paul Guillaume

215. **Shaft of Sunlight, the Woods of Trivaux**
 Coup de soleil, les bois de Trivaux

Environs of Issy-les-Moulineaux, [spring–summer 1917]

Oil on canvas, 36 × 29⅛″ (91 × 74 cm)
Signed lower center: "H. Matisse"
Private collection

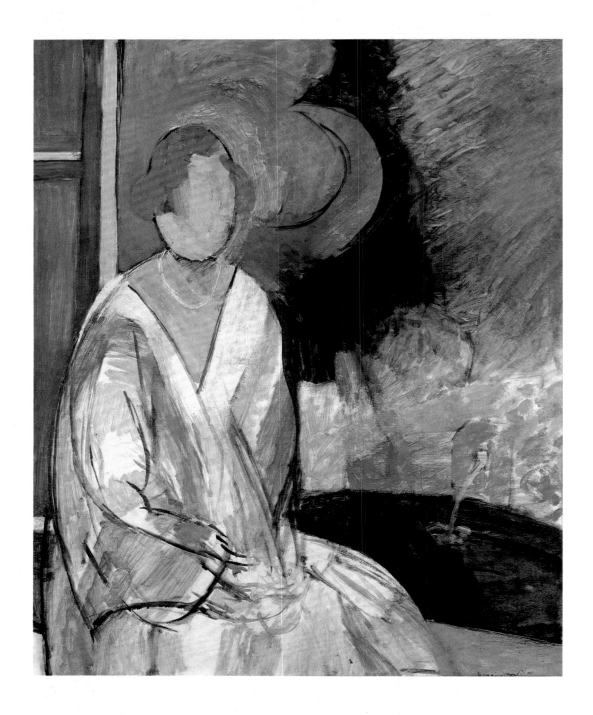

216. Woman at the Fountain
Femme à la fontaine

Issy-les-Moulineaux, [c. 1917]

Oil on canvas, 31¾ × 25½″ (81 × 65 cm)
Signed lower right: "Henri-Matisse"
Private collection

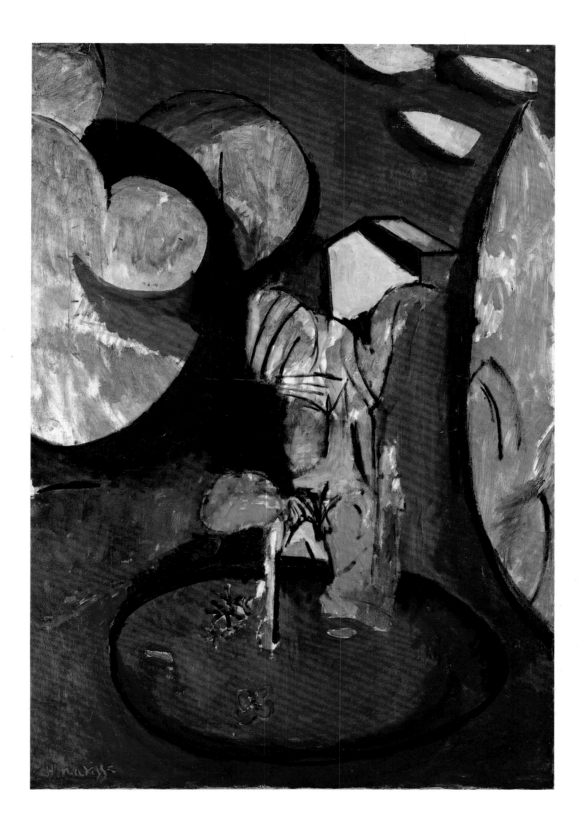

217. Garden at Issy
Jardin à Issy

Issy-les-Moulineaux, [c. 1917]

Oil on canvas, 51⅛ × 35″ (130 × 89 cm)
Signed lower left: "H Matisse"
Private collection, Basel

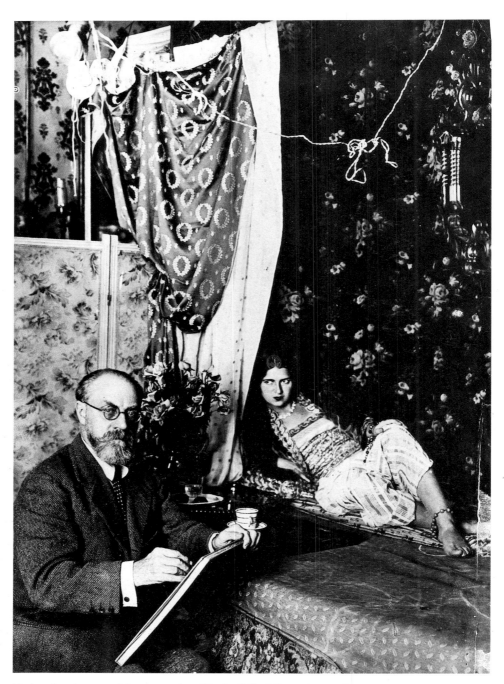

Matisse drawing a model at no. 1, place Charles-Félix, Nice, c. 1927–28.

PART V ✦ 1917–1930

THE EARLY YEARS AT NICE

At the end of 1917, Matisse moved, alone, to Nice. He would live in Nice and its environs for at least part, and usually most, of each year for the remainder of his life. However, it is the span of years through the 1920s that is usually known as his "Nice period." During this time, he painted the harmonious, light-filled, and often profusely decorated interiors, with languorous and seductive models, that sacrificed the interest of the avant-garde, an interest he regained only slowly in later years.

Matisse rejoiced in the light of Nice; color was subordinated to it. Thus, the flat, arbitrary colors of his preceding paintings, both "decorative" and "experimental," were replaced by a much broader range of soft tonalities that convey how reflected light will suffuse an interior, associating whatever or whoever is within it. Light is almost palpable in these paintings. Their sensuality and the quality of meditation they afford both depend on the gentle pulsation of light through them. Often, the pulsation of pattern will form an accompaniment. The world of these paintings therefore appears indolent and becalmed. But it also seems extremely artificial; the rooms, their decoration, the costumes of the models are all a form of make-believe.

In *The Moorish Screen* (pl. 254), the mood is domestic; in *The Hindu Pose* (pl. 264), it is exotic; and in *Odalisque with Magnolias* (pl. 266), unequivocally sensual. But whatever the mood, everything looks orderly and well managed. Matisse paints thinly and carefully, and usually fills out every part of a picture with its appropriate detail. Only occasionally, in a work such as *Interior with a Phonograph* (pl. 258), will he directly recall an artist like Vermeer. But the kind of order he emulates here is indeed that of

a Vermeer, or a Chardin, except that he shows us an unabashed sensuality quite foreign to any such earlier bourgeois vision. He looks also to Renoir and Courbet, and frankly enjoys the seductiveness with which he surrounds himself. The paradisal world he previously only imagined is here made real. The naturalism of these paintings is therefore not ironic (unlike Picasso's and others' at this time), but sincere and entirely unashamed.

And yet, naturalism does disguise abstraction. The spatial organization of a work like *The Moorish Screen* (pl. 254) is as episodic and constructional as that of any earlier Matisse painting. *Large Interior, Nice* (pl. 229) embraces enormous space, and we are led through it part by part. Moreover, the range of pictorial options he uses is extremely broad. The environment, even the models, change at the behest of a changing vision.

The experience of drawing is particularly crucial to what Matisse is doing. At times, most notably with the famous *Plumed Hat* drawings (pls. 233–235, 238), it produces a more detailed counterpoint to the paintings. At others, it explores their tonal underpinnings (pl. 256). In the second half of the decade, sculpture came to preoccupy the artist once again, and he produced his largest freestanding work in this medium, *Large Seated Nude* (pl. 272). As a result, the paintings gain in solidity and in sharpness of definition (pls. 270, 271). The odalisques made toward the end of the decade (pls. 279–282) are as exotic and decoratively patterned as any he had done, but also very crisply designed, and thus seem projected onto the surface. "Nowadays, I want a certain formal perfection," he said. And naturalism retreated before it.

Matisse at the Hôtel Beau-Rivage, Nice, January 1918, seated in front of an early state of *Self-Portrait* (pl. 218). On table at left: the small *Portrait of George Besson* of 1918. Photograph by George Besson.

1917–18 SEASON

1917 (continued)

LATE OCTOBER: Travels south for his first winter in Nice.

Stops in Marseille; visits Marquet and the critic and collector George Besson.

DECEMBER 18: Visits his son Jean, who is stationed at an air-corps base in Istres.

DECEMBER 20: Has arrived in Nice; is staying at the Hôtel Beau-Rivage.

DECEMBER 31: With Besson, visits Renoir at his villa at Les Collettes, in nearby Cagnes-sur-Mer.

1918

JANUARY: Paints at the Hôtel Beau-Rivage, at no. 107, quai du Midi (later called quai des États-Unis) in Nice, where he has moved by December 20, 1917, and where he will work into February or March. At the Beau-Rivage, he paints a self-portrait (pl. 218), *My Room at the Beau-Rivage* (pl. 219), *Interior with a Violin* (pl. 220), and other works. With these paintings, he begins to develop the more naturalistic style he will pursue during the early years at Nice.

JANUARY 18–LATE FEBRUARY: Represented in a large exhibition of nineteenth- and twentieth-century French art at the Kunstnerforbundet in Oslo. The catalogue includes his one-page text on Renoir.

JANUARY 23–FEBRUARY 15: Has a two-artist exhibition with Picasso at the Paul Guillaume gallery in Paris. The catalogue contains separate one-page pieces on each artist by Apollinaire.

LATE JANUARY: Makes another visit to Cagnes and shows Renoir some of his recent paintings.

FEBRUARY OR MARCH: Rents an apartment at no. 105, quai du Midi, next door to the Hôtel Beau-Rivage, to use as a studio. Working there until May, he makes *The Bay of Nice* (pl. 223) and other paintings.

EARLY MARCH: Mme Matisse, who has been in Nice for a visit, leaves for Marseille and Istres, to see Jean, on her way back to Paris.

MID-MARCH: Marquet visits Matisse for eight days. They probably call on Renoir at this time.

SPRING: Works occasionally at the École des Arts Décoratifs in Nice, whose director, Paul Audra, is a former Moreau student. Matisse draws and models from casts of Michelangelo's *Night* and *Lorenzo de' Medici* from the Medici chapel in Florence. He also begins to make landscapes in and around Nice, including *The Château Garden* (pl. 224), and will make numerous such works in the period through 1930.

APRIL 10: His children Marguerite and Pierre visit him for Easter. He makes paintings of Marguerite, including *Mlle Matisse in a Scottish Plaid Coat* (pl. 222). His severe self-portrait, *Violinist at the Window* (pl. 221), may be based on a drawing of Pierre.

APRIL 11: Sees Renoir, who is in Nice.

MAY: The Hôtel Beau-Rivage is requisitioned to house soldiers. Matisse moves to the Villa des Alliés, on the petite avenue du Mont-Boron, in Nice. Near here, he paints several landscapes, including *Large Landscape, Mont Alban* (pl. 225).

MAY 4: Sees Renoir again and shows him earlier paintings he has brought from Paris.

MAY 9: Writes to Henri Laurens that he has seen Aleksandr Archipenko, who has been living in Nice since 1914.

MID-JUNE OR JULY: Returns to Issy-les-Moulineaux for the summer, and visits Maintenon, south of Paris, on the way.

SEPTEMBER: Visits Cherbourg to see his son Pierre, who has enlisted and is now stationed there.

1918–19 SEASON

NOVEMBER: Travels south; visits Bonnard at Antibes on Armistice Day, November 11. On arriving in Nice for his second season there, takes up residence in the first of four rooms he will occupy at the Hôtel de la Méditerranée et de la Côte d'Azur at no. 25, promenade des Anglais; rents this first room until mid-June 1919. He will later recall with pleasure the almost theatrical opulence of the hotel and how the light came into the rooms "from below, like footlights." It is here that the characteristically "Nice period" paintings, with their soft, luminous tonalities, begin to be made. *Interior with a Violin Case* (pl. 227) and *Large Interior, Nice* (pl. 229) show the first room he occupies, with its balcony and stone balustrade. In it, he also

Postcard view of Nice, quai des États-Unis (formerly quai du Midi), c. 1927.

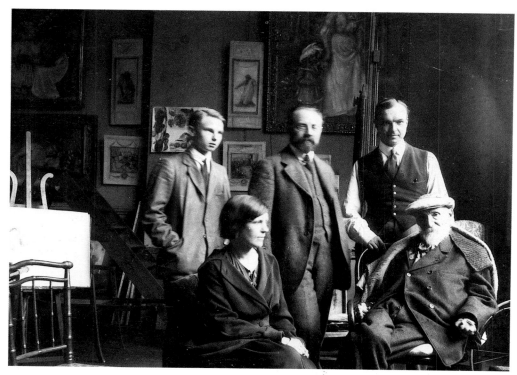

In Renoir's house at Les Colletes, Cagnes-sur-Mer, early 1918. Left to right: Claude Renoir, Greta Prozor, Matisse, Pierre Renoir, Auguste Renoir.

makes a group of still lifes with mirrors painted black (pl. 230, 231) and occasional more severe works such as *Woman with a Green Parasol on a Balcony* (pl. 228)

WINTER: The young model Antoinette Arnoux (or Arnoud) begins posing for him. A series of drawings and paintings of her wearing a white-plumed hat that Matisse himself fabricated (pls. 233–236, 238) will be completed in Nice by June 1919, before he goes to Issy-les-Moulineaux for the summer.

Postcard view of the Hôtel de la Mediterranée et de la Côte d'Azur, Nice, early 1900s.

In the aftermath of the Russian Revolution, during this year the Shchukin and Morosov collections have been confiscated by the Soviet government.

1919

MAY 2–16: At the Bernheim-Jeune gallery, Félix Fénéon organizes Matisse's first one-artist exhibition in Paris since 1913. Consists mostly of recent paintings, although two works from 1914 and one from 1916, *Gourds* (pl. 184), are included. Reviewing the exhibition, Jean Cocteau complains about the conservatism of Matisse's work.

MAY 5–JUNE 30: Represented in the Triennale exhibition of French art at the École des Beaux-Arts in Paris. Shows three paintings, one of which is *Interior with a Violin* (pl. 220). Interviewed by the Swedish art historian Ragnar Hoppe at the quai Saint-Michel studio before the close of the exhibition, he talks of now wanting to achieve "substance, spatial depth, and richness of detail" in his new paintings.

MID-JUNE: Goes to Issy-les-Moulineaux for the summer, bringing the model Antoinette with him; here she poses for *Tea in the Garden* (pl. 241) and other works. He also paints some large still lifes, including *Plaster Figure, Bouquet of Flowers* (pl. 240), in a less atmospheric style than that of the paintings done in Nice. At Issy, is visited by Igor Stravinsky and Sergei Diaghilev, who commission him to do cos-

tumes and sets for the ballet *Le chant du rossignol*, to be choreographed by Léonide Massine for the Ballets Russes.

AUGUST 1–SEPTEMBER: Represented in "Exhibition of Modern French Art," organized by Osbert and Sacheverell Sitwell together with Léopold Zborowski at the Mansard gallery in London. The catalogue preface is by Arnold Bennett. Roger Fry and Clive Bell review the show favorably, although the extensive press coverage is for the most part unfavorable.

SEPTEMBER OR OCTOBER: Visits London to work on the costumes and sets for *Le chant du rossignol*.

OCTOBER 1: The Catalan journal *Vell i nou* publishes the first part of a two-part article on Matisse by J. Sacs (a pseudonym for Felius Elies). The second part, consisting of a long interview with Matisse held in the Issy studio, will be published on November 1; the author notes Matisse's use of a series of photographs (made by Druet) recording successive stages of progress in a work.

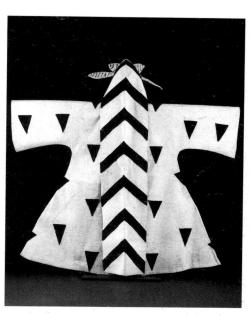

Costume for a mourner (design for *Le chant du rossignol*). 1919–20. Cotton and wool felt robe, appliquéd with silk velvet triangles and stripes, painted hood, 6' 2¾" × 70¾" (190 × 180 cm). Australian National Gallery, Canberra. (Included in the exhibition).

1919–20 SEASON

AUTUMN: Returns to Nice for his third season there. Takes a different room at the Hôtel de la Méditerranée, his second (this one without a balcony), where he stays through the end of the year. This season, he paints *The Breakfast* (pl. 248) and other works, including a series of paintings of a model with a tall Spanish comb in her hair, and also works on *Le chant du rossignol*.

NOVEMBER 1–DECEMBER 10: The Salon d'Automne, suspended during the war, re-opens; Matisse shows seven works, including *Tea in the Garden* (pl. 241). He and other exhibiting artists are denigrated by the Dadaist Georges Ribemont-Dessaignes in a review of the Salon in the Dada magazine *391*.

NOVEMBER 7–DECEMBER 6: Shows six works, including *Music (oil sketch)* (pl. 100), in "Exhibition of Paintings by Courbet, Manet, Degas, Renoir, Cézanne, Seurat, Matisse" at the Marius de Zayas gallery in New York.

NOVEMBER–DECEMBER: Shows fifty-one works, mostly recent, in "Exhibition of Pictures by Matisse and Work by Maillol" at the Leicester Galleries in London. The exhibition is well received and substantial purchases are made by British collectors.

1920

JANUARY 25: Death of Matisse's mother, in Bohain.

JANUARY: Again visits London to work on *Le chant du rossignol*. The ballet will premiere at the Paris Opéra on February 2.

Publication of Marcel Sembat's *Henri Matisse* (no. 1 in Roger Allard's series "Les peintres nouveaux"), the first monograph devoted to the artist. It reproduces works dating from 1897 to 1918–19.

FEBRUARY: Returns to Nice; occupies his third room at the Hôtel de la Méditerranée, again with no balcony. Remains until June.

MAY 8–OCTOBER 31: At the twelfth International Biennale in Venice, where the exhibition of works in the French Pavilion has been organized by Paul Signac, Matisse shows two works: *Carmelina* (pl. 37) and *Tea in the Garden* (pl. 241).

JUNE: Visits London for the first Covent Garden performances of *Le chant du rossignol*.

EARLY JULY: Goes to Étretat on the Normandy coast for the summer; Mme Matisse and Marguerite are with him. He paints a number of still lifes, including *Pink Shrimp* (pl. 242), and a sequence of pictures of the seashore, among them three identically sized works showing respectively an eel, two rays, and fish on beds of kelp beside the ocean (pls. 243–245).

AUGUST 23: Signs his fourth contract with the Bernheim-Jeune gallery, for three years.

SEPTEMBER: He is in Paris. Bernheim-Jeune publishes *Cinquante dessins par Henri-Matisse*, supervised by the artist and with a preface by Charles Vildrac. It comprises mostly recent drawings, many of the model Antoinette. Also this year, Bernheim-Jeune publishes *Henri-*

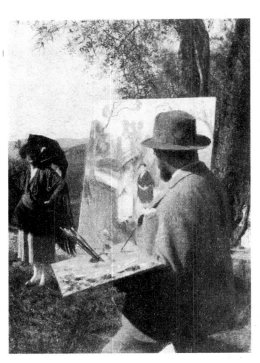

Matisse at work on *Conversation Under the Olive Trees* (pl. 251) near Nice, spring 1921.

Matisse, an illustrated volume with essays by Élie Faure, Jules Romains, Charles Vildrac, and Léon Werth; it will be reissued in 1924 with new illustrations.

1920–21 SEASON

END OF SEPTEMBER: Is back in Nice for his fourth season there; occupies his fourth and final room, with a balcony, at the Hôtel de la Méditerranée, where he remains until spring 1921. Here he paints *Two Women in an Interior* (pl. 246), *The Meditation: After the Bath* (pl. 249), *Woman on a Sofa* (pl. 252), and other works. The model Henriette Darricarrère begins to pose for him in the autumn; she will be his most important model until about 1927.

EARLY OCTOBER: The twenty-odd paintings by Matisse acquired by Christian Tetzen-Lund and Trygve Sagen from Michael and Sarah Stein go on public display for two days at Tetzen-Lund's apartment in Copenhagen before being divided between the two collectors. In the autumn of 1924, Tetzen-Lund will begin to sell his collection and by the time of his death, in February 1936, most of his Matisses will have been acquired by his Danish compatriot Johannes Rump or by the American collector Dr. Albert C. Barnes.

OCTOBER 15–NOVEMBER 6: Has an exhibition of fifty-eight paintings at the Bernheim-Jeune gallery, all recent works from Étretat

and Nice, except for five very early works, among them *Still Life with Books* (pl. 1), shown as *Mon premier tableau*, and *Still Life with Books* (pl. 2), as *Mon deuxième tableau*.

1921

JANUARY: The poet William Carlos Williams publishes "A Matisse" in the second issue of the journal *Contact*; it refers to *Blue Nude: Memory of Biskra* (pl. 93), which had been shown at Marius de Zayas's New York gallery in December 1920 and purchased by John Quinn.

SPRING: On picnics with Henriette Darricarrère and later Marguerite, Matisse paints in the valley of the river Loup, west of Nice, and elsewhere in this region. Among the works is *Conversation Under the Olive Trees* (pl. 251). He also begins a series of *Festival of Flowers* paintings (pl. 250), depicting the spring parade of flower-decorated floats at Nice; the series will be continued in 1922 and 1923, in which years he rents a room at the Hôtel de la Méditerranée at the time of the parade specifically for this purpose.

LATE APRIL: Visits Monte Carlo, to make a portrait drawing of Sergei Prokofiev for a Ballets Russes program. Sees Juan Gris, who has been in Monte Carlo for a week for a ballet project, *Cuadro flamenco*.

MAY 3–SEPTEMBER 5: Represented in "Loan Exhibition of Impressionist and Post-Impressionist Paintings" at The Metropolitan Museum of Art in New York. A few days before its closing, a pamphlet denouncing the exhibition is mailed out by an ad hoc reactionary committee, setting off a well-publicized controversy.

SUMMER: Paints in Étretat.

1921–22 SEASON

EARLY SEPTEMBER: Returns to Nice for his fifth season there, and takes an apartment on the third floor of no. 1, place Charles-Félix, which he will retain probably to 1928. Remains in Nice through the beginning of summer 1922. Until the early 1930s, will generally spend summers in Paris and/or Issy-les-Moulineaux and will there occasionally complete paintings begun in Nice. He will transform the new Nice apartment not only with his own and others' paintings but also with mirrors, decorative screens, and fabric hangings. Has large demountable frames made to support the fabrics used as backdrops in his paintings. In this season, works such as *Interior at Nice: Young Woman in a Green Dress Leaning at the Window* (pl. 253), *The Moorish Screen* (pl. 254), and *Odalisque with Red Culottes* (pl. 263) reveal the wide range of effects, from exoticism to reverie, induced from this theatrical setting.

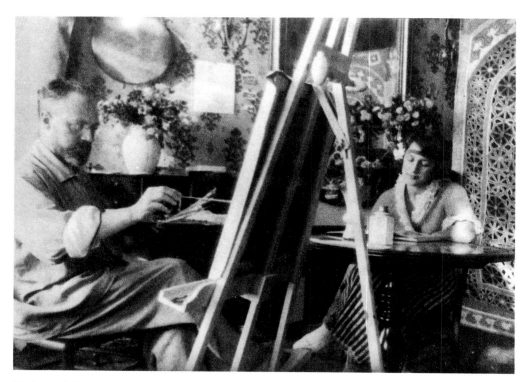

Matisse painting the model Henriette Darricarrère at no. 1, place Charles-Félix, Nice, 1921.

In this season, he paints rich interiors, including *Pianist and Checker Players* (pl. 257), and the Vermeer-like *Interior with a Phonograph* (pl. 258) and *Interior: Flowers and Parakeets* (pl. 259).

NOVEMBER: Following the recommendation of André Breton, then his artistic advisor, Jacques Doucet acquires *Goldfish and Palette* (pl. 179). The picture will be installed along with other masterpieces in Doucet's collection, including *Les demoiselles d'Avignon*, in the studio Doucet establishes as part of an annex to his villa in Neuilly.

DECEMBER 10: Matisse attends his daughter Marguerite's wedding to the scholar of Byzantine and modern art Georges Duthuit, in Paris. Returns to Nice two days later.

1924

FEBRUARY 24–MARCH 22: Exhibition of his works at the Joseph Brummer galleries in New York; includes fourteen paintings from the John Quinn collection and some graphic art. Brummer, a former student at the Académie Matisse, writes the catalogue preface.

MAY 6–20: Has a one-artist exhibition at the Bernheim-Jeune gallery.

JUNE 16–21: Participates with more than sixty other artists in an exhibition and auction at the Paul Guillaume gallery to raise funds for a monument to Apollinaire. Picasso has been commissioned to design the monument.

1922

FEBRUARY 23–MARCH 15: At the Bernheim-Jeune gallery, has an exhibition of paintings done in Nice in 1921, accompanied by an album of reproductions edited by Charles Vildrac. *Odalisque with Red Culottes* (pl. 263) is purchased from the exhibition by the state for the Musée du Luxembourg.

MID-JUNE: Is in Aix-les-Bains; returns to Paris at the end of the month. Presents *Interior with Aubergines* (pl. 145) to the Musée de Grenoble, in the name of his wife and daughter, having retrieved it from Michael and Sarah Stein.

SUMMER: Claribel and Etta Cone begin to develop their Matisse collection, acquiring four bronzes from the artist and six paintings from Bernheim-Jeune.

JULY OR EARLY AUGUST: Goes to Man Ray's studio on rue Campagne Première in Paris to sit for a portrait.

1922–23 SEASON

AUGUST: Has returned to Nice, to place Charles-Félix. During this sixth season, will paint some extremely hieratic odalisques, including *The Hindu Pose* (pl. 264), and sensual, reclining odalisques, probably among them *Odalisque with Magnolias* (pl. 266).

SEPTEMBER 5: Marcel Sembat, one of Matisse's earliest and most faithful supporters,

dies suddenly. Twelve hours later, Sembat's wife, the painter Georgette Agutte, commits suicide. Their art collection, rich in works by Matisse, will be donated to the Musée de Grenoble, in 1923.

This year, Roland Schacht's *Henri Matisse* is published in Dresden.

1923

JANUARY–FEBRUARY: Works recently acquired by Dr. Albert C. Barnes are exhibited at the Paul Guillaume gallery before being shipped to the United States, where they will be shown April 11–May 9 at the Pennsylvania Academy of the Fine Arts in Philadelphia.

APRIL 16–30: Has his annual one-artist exhibition at the Bernheim-Jeune gallery.

SUMMER: Is in Issy-les-Moulineaux.

During the summer and autumn, Claribel and Etta Cone will purchase ten of his works, nearly all of them from the last two years, including the very recent *Still Life: Bouquet of Dahlias and White Book* (pl. 260).

AUGUST 25: Renews his contract with the Bernheim-Jeune gallery for the last time, for three years; to go into effect September 19.

1923–24 SEASON

AUTUMN: Has returned to Nice for his seventh season, the third at place Charles-Félix.

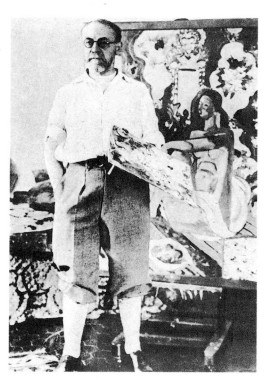

Matisse with *Decorative Figure on an Ornamental Ground* (pl. 271) at no. 1, place Charles-Félix, Nice, spring 1926.

MID-AUGUST: Is in Issy-les-Moulineaux.

SEPTEMBER–DECEMBER: Has his largest retrospective exhibition up to that time, containing eighty-seven paintings, organized by Leo Swane and presented at the Ny Carlsberg Glyptotek in Copenhagen; it subsequently tours to Stockholm and Oslo. Includes works owned by Christian Tetzen-Lund.

1924–25 SEASON

AUTUMN: Is in Nice, at place Charles-Félix, where he will remain until the summer of 1925.

DECEMBER: His son Pierre goes to New York and will begin organizing exhibitions for the Dudensing galleries.

JULY 10: Is created a Chevalier of the Legion of Honor.

AUGUST 13: Is in Amsterdam for a visit.

1925–26 SEASON

AUTUMN: Is in Nice, at place Charles-Félix. By the end of 1925, will make a group of sculpturally modeled lithographs of seated odalisques (pls. 268, 269), as well as softer, more loosely conceived lithographs, including the series *Ten Dancers*, which will be published as an album by Bernheim-Jeune in 1927. In the winter and through the remainder of this season, his painting becomes more solidly volumetric, while retaining its decorative character, as in *Odalisque with a Tambourine* (pl. 270) and *Decorative Figure on an Ornamental Ground*

NOVEMBER 13–28: Exhibition at the Quatre Chemins gallery, Paris, on the occasion of its publishing Waldemar George's book on Matisse's drawings.

1926

JANUARY: Is in Paris and Issy-les-Moulineaux.

FEBRUARY 20–MARCH 21: Exhibits in "Trente ans d'art indépendant, 1884–1914" at the Grand Palais in Paris.

LATE FEBRUARY: Visits Juan Gris at Toulon.

1926–27 SEASON

AUTUMN: Sometime between autumn 1926 and March 1927, takes a lease on the fourth (top) floor of no. 1, place Charles-Félix, which

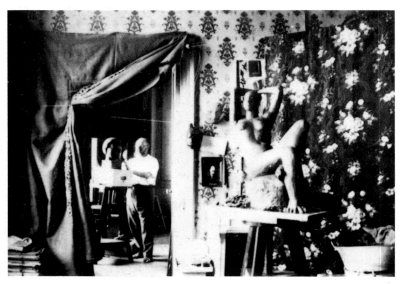

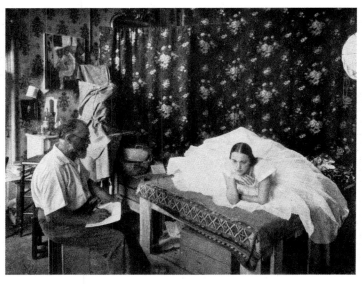

On this and the opposite page: Four views of Matisse's apartment at no. 1, place Charles-Félix, Nice, spring 1926. The photograph above shows Matisse at work on *Henriette (II)* (pl. 274); in the foreground is an early state of *Large Seated Nude* (pl. 272); and partially visible, on the wall, just above the sculpture, is *Odalisque with a Tambourine* (pl. 270).

Matisse drawing the model Henriette Darricarrère. Behind him (wrapped): *Large Seated Nude* (pl. 272). On the wall: *Odalisque with a Tambourine* (pl. 270).

This year, Adolphe Basler's *Henri Matisse* is published in Leipzig.

1925

APRIL 28 TO MID-OCTOBER: Is represented at the "Exposition internationale des arts décoratifs et industriels modernes," Esplanade des Invalides, Paris, in the installation of paintings at the Pavillon-Studio des Éditions Bernheim-Jeune, on the Cours-la-Reine.

SUMMER: Travels in Italy with Mme Matisse, Marguerite, and her husband. Passing through Rome, they visit southern Italy and Sicily. Pages from a sketchbook used during this trip show views of Posillipo, Capri, Salerno, Paestum, and Palermo.

(pl. 271). At this time, probably makes the first two of three sculpted heads of Henriette (pls. 273, 274) and begins his largest freestanding sculpture, *Large Seated Nude* (pl. 272), probably not completed until 1929.

SEPTEMBER 15: His interview with Jacques Guenne, which took place at Issy during the "Exposition internationale des arts décoratifs," is published in *L'art vivant*. In it, he discusses his formative years and expounds upon the importance to him of Cézanne, whom he describes as "a sort of god of painting."

SEPTEMBER 26–NOVEMBER 2: Shows one work in the Salon d'Automne.

SEPTEMBER–EARLY OCTOBER: Is in the mountains near Nice.

will become his residence and which he will retain until 1938. Probably retains his third-floor apartment into 1928; it is here that he seems to have made the sequence of boldly patterned paintings of odalisques, often in Oriental costumes, in front of decorative screens, including the 1926–27 season's *Odalisque with Gray Culottes* (pl. 279). The series is accompanied by etchings and drypoints, and by some lithographs. This will probably be the last season he paints the model Henriette Darricarrère, in works including *Woman with a Veil* (pl. 276).

EARLY OCTOBER–EARLY NOVEMBER: *Piano Lesson* (pl. 188) and *Bathers by a River* (pl. 193) are shown as a two-painting exhibition at the Paul Guillaume gallery in Paris.

OCTOBER 28: At the auction of John Quinn's estate, in Paris, Claribel Cone, who has enlisted Michael Stein to bid for her, buys *Blue Nude: Memory of Biskra* (pl. 93).

NOVEMBER 5–DECEMBER 19: Matisse shows *Odalisque with a Tambourine* (pl. 270) in the Salon d'Automne.

DECEMBER 8: Mme Matisse has by now moved into an apartment at no. 132, boulevard du Montparnasse. Matisse will stay there during his sojourns in Paris.

1927

JANUARY 3–31: Has an important retrospective exhibition of works from 1890 to 1926, organized by Pierre Matisse, at the Valentine

boldly patterned paintings of odalisques, making *Two Odalisques* (pl. 280), *Odalisque with a Turkish Chair* (pl. 281), the large *Harmony in Yellow* (pl. 282), and other works. Also does decorative pen-and-ink drawings; drypoints, etchings, and lithographs; and the sculpture *Reclining Nude (II)* (pl. 284).

OCTOBER 13–DECEMBER 4: At the "Twenty-sixth International Exhibition of Paintings," Carnegie Institute, Pittsburgh, is awarded first prize for one of five paintings he shows, all lent by Bernheim-Jeune. Has exhibited previously at the Carnegie exhibitions of 1921, 1924, 1925, and 1926.

NOVEMBER 4–DECEMBER 16: Exhibits two paintings at the Salon d'Automne.

1928–29 SEASON

AUTUMN: In the 1928–29 season at place Charles-Félix, begins to work in his new, large fourth-floor apartment. Paintings made in its large, brightly lit studio become more boldly simplified while creating an effect of silvery light. He works very extensively in etching (pls. 277, 278), drypoint, and lithography, making a virtual catalogue of posed odalisques; some of the lithographs and their accompanying drawings are almost erotic in character. Is also continuing to work in sculpture. By the end of 1929, will have made the third and final *Henriette* head (pl. 275), in the absence of the model, and *Reclining Nude (III)* (pl. 285).

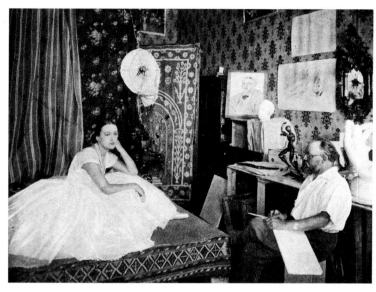

Matisse drawing the model Henriette Darricarrère. Behind him, to the left: *Henriette (I)* (pl. 273) in plaster. To the right: a small, early version of *Large Seated Nude* (pl. 272) in plaster. On the wall: contemporaneous drawings and lithographs.

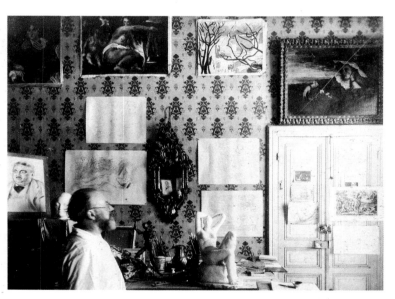

Matisse with, at bottom center, a small, early version of *Large Seated Nude* (pl. 272) in plaster. Above the door: Courbet's oil study for *Young Women on the Banks of the Seine* of c. 1856. Pinned to the door: reproductions of Delacroix's *Barque of Dante*, of a Michelangelo drawing in the Louvre, and of a Marcantonio Raimondi engraving after Raphael's *Judgment of Paris*.

gallery in New York. Includes *The Moroccans* (pl. 192), *The White Plumes* (pl. 236), *The Moorish Screen* (pl. 254), and the recent *Decorative Figure on an Ornamental Ground* (pl. 271). The exhibition will be shown at The Arts Club of Chicago, February 17–27.

JANUARY 24–FEBRUARY 4: Exhibition of his drawings and lithographs at the Bernheim-Jeune gallery.

1927–28 SEASON

AUTUMN: Working at place Charles-Félix in the 1927–28 season, he continues his series of

1928

SPRING: Mme Matisse moves into the apartment at no. 1, place Charles-Félix in Nice. Matisse's paintings of decorative odalisques will end this year, although he continues to explore the theme in printmaking. His *Still Life on a Green Sideboard* (pl. 286), probably made in the summer, is a reaction against the ornamentation of the past decade.

JUNE–OCTOBER: Exhibits fourteen paintings, six sculptures, and thirteen prints and drawings at the sixteenth Venice Biennale.

NOVEMBER 4–DECEMBER 16: Exhibits *Still Life on a Green Sideboard* (pl. 286) at the Salon d'Automne.

1929

JANUARY 14, 22: "Visite à Henri Matisse," by E. Tériade, is published in two parts in *L'intransigeant*. The interview takes place in Paris, where Matisse has spent every day of his stay visiting the "Exposition nautique." He talks at length about Fauvism, its sources in Neo-Impressionism, and its culmination in the 1910 painting *Music* (pl. 126), saying very little about his work of the 1920s. However, he sug-

The Studio. [1929.] Oil on canvas, 18⅛ × 24″ (46 × 61 cm). Private collection. The painting shows Matisse's fourth-floor studio at no. 1, place Charles-Félix, Nice.

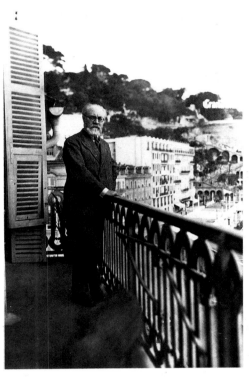

Matisse on the balcony of his fourth-floor apartment at no. 1, place Charles-Félix, Nice, March 1932.

gests that his work is changing: "Nowadays I want a certain formal perfection."

MAY 25–JUNE 7: Exhibition at the Bernheim-Jeune gallery of Paul Guillaume's personal col-lection, which contains sixteen paintings and two sculptures by Matisse.

SEPTEMBER 20: Death of Claribel Cone.

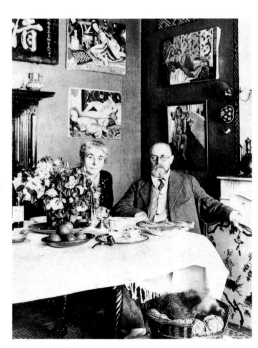

Matisse and Mme Matisse in the dining room of the fourth-floor apartment at no. 1, place Charles-Félix, Nice, c. 1929. On the left wall, above: *Odalisque with a Turkish Chair* (pl. 281); below: *Two Odalisques* (pl. 280).

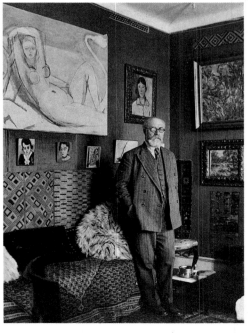

Matisse in his fourth-floor apartment at no. 1, place Charles-Félix, Nice, March 1932. On the left wall: *Europa and the Bull* of 1927–29. To its right: Cézanne's *Portrait of Mme Cézanne* of 1885–87. On the right wall, top: Cézanne's *Bibémus* of c. 1904.

1929–30 SEASON

AUTUMN: In the 1929–30 season, he makes very few easel paintings; among them are *Woman with a Madras Hat* (pl. 289) and *The Yellow Dress* (pl. 283), the latter not completed until 1931. However, continues to work in printmaking and sculpture. Will not return regularly to easel painting until 1934.

DECEMBER 9–JANUARY 4, 1930: Has a one-artist exhibition, of seventeen works from the years 1927–29, at the Valentine gallery in New York.

DECEMBER 28: Marriage of his son Pierre to Alexina Sattler in Cincinnati.

This year, Florent Fels's *Henri-Matisse* is pub-lished in Paris.

1930

JANUARY–FEBRUARY: Mme Matisse, very ill, is bedridden.

JANUARY 19–FEBRUARY 16: Matisse is repre-sented in the exhibition "Painting in Paris, from American Collections" at the newly opened Museum of Modern Art in New York. His works shown include *Music (oil sketch)* (pl. 100), *The White Plumes* (pl. 236), *Woman Before an Aquarium* (pl. 255), *Interior: Flowers and Parakeets* (pl. 259), and *The Hindu Pose* (pl. 264). The catalogue notes that five Ameri-can and eight foreign museums now own paintings by Matisse.

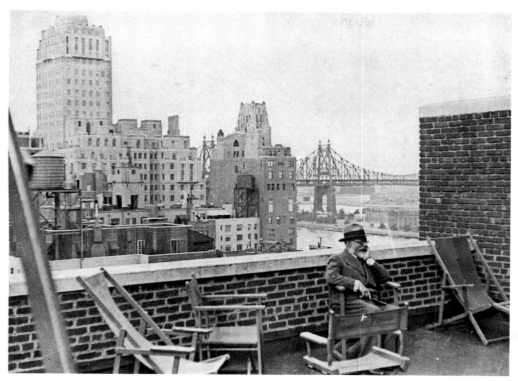

Matisse in New York City, 1930 or 1933.

Matisse in Tahiti, spring 1930. Photograph by F. W. Murnau.

While in Tahiti, visits Bora-Bora and Mooréa in the Society Islands and the atolls Apataki and Fakarava in the Tuamotu Archipelago.

JUNE 15: Sails from Tahiti for France on the *Ville de Verdun*. Stops off at Panama, Martinique, and Guadeloupe. Will arrive in Marseille on July 31 and return to Nice.

AUGUST: In Nice, at place Charles-Félix possibly works on the Tahiti-inspired sculpture *Tiari* as well as on *Venus in a Shell (I)* (pl. 292).

SEPTEMBER: Is in Paris prior to his second trip to the United States, to serve on the jury of award for the "Twenty-ninth International Exhibition of Paintings" at the Carnegie Institute. Sails for New York on September 14. He arrives by September 20, is welcomed by Homer Saint-Gaudens, director of fine arts at the Carnegie Institute, and conducted to Pittsburgh. On September 23, the jury meets and awards first prize to Picasso. Matisse continues his trip before the exhibition opens. (It takes place October 16–December 7; he himself will be represented by three works.) Is in Philadelphia by September 28. Visits Dr. Albert C. Barnes at Merion, outside Philadelphia; Dr. Barnes offers a commission, a mural decoration for the central gallery of his museum. In New York and Philadelphia, Matisse is escorted by René d'Harnoncourt, who accompanies him to private collections and in Philadelphia takes him to a baseball game. By the end of September, boards a ship for France.

Tiari (Le tiaré). Nice, place Charles-Félix, [late summer 1930 or 1931]. Bronze, 8 × 5½ × 5⅛" (20.3 × 14 × 13 cm). Inscribed: "2/10 / HM." The Museum of Modern Art, New York. A. Conger Goodyear Fund. (Included in the exhibition).

FEBRUARY 15–MARCH 19: Has a large one-artist exhibition at the Thannhauser gallery in Berlin. Its 265 works include eighty-three paintings, ranging from an early Louvre copy to works of 1929, as well as sculptures, drawings, and many prints. The catalogue introduction is by Hans Purrmann.

LATE FEBRUARY–MARCH: Travels from Nice to Paris to Le Havre, and leaves on February 27 for the United States on the *Île-de-France*, on his way to Tahiti. On March 4, arrives in New York and is impressed by the skyscrapers and the light; visits The Metropolitan Museum of Art. After a few days, travels by train to Chicago (where he visits the Art Institute), then to Los Angeles and San Francisco. Boards the *Tahiti* on March 21.

MARCH 29: Arrives in Papeete, Tahiti, where he remains until mid-June. Sees something of the director F. W. Murnau, who is filming *Tabu* there.

218. Self-Portrait
Autoportrait

Nice, Hôtel Beau-Rivage, early 1918

Oil on canvas, 25½ × 21¼" (65 × 54 cm)
Signed lower right: "Henri-Matisse"
Musée Matisse, Le Cateau-Cambrésis

219. My Room at the Beau-Rivage
Ma chambre au Beau-Rivage

Nice, Hôtel Beau-Rivage, winter 1917–18

Oil on canvas, 29 × 23⅞″ (73 × 61 cm)
Signed lower right: "Henri Matisse"
Philadelphia Museum of Art. A. E. Gallatin Collection

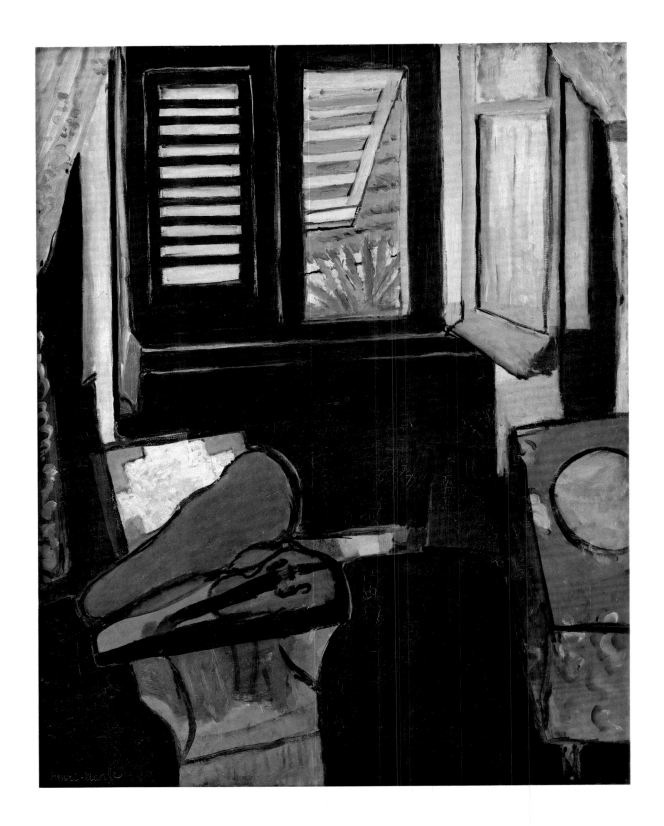

220. Interior with a Violin
Intérieur au violon

Nice, Hôtel Beau-Rivage, winter 1917–18

Oil on canvas, 45¾ × 35″ (116 × 89 cm)
Signed lower left: "Henri-Matisse"
Statens Museum for Kunst, Copenhagen, J. Rump Collection
Formerly collection Walter Halvorsen

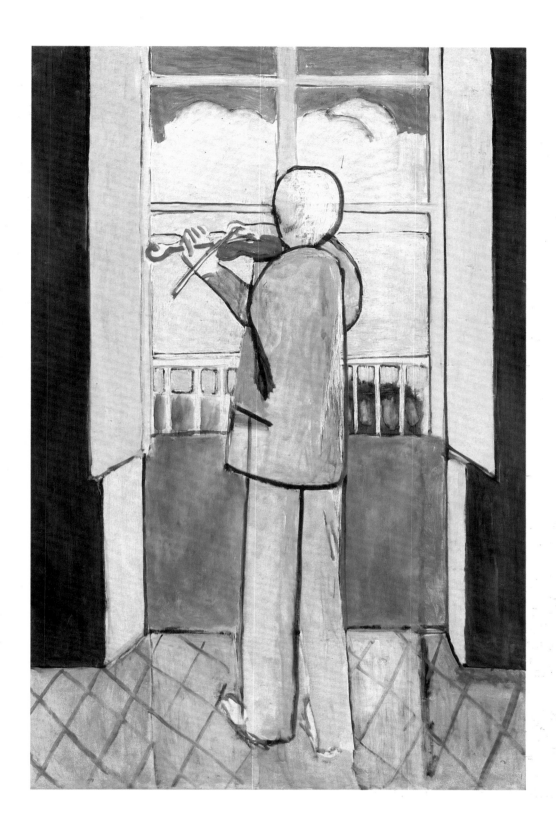

221. Violinist at the Window
Le violoniste à la fenêtre

Nice, no. 105, quai du Midi, spring 1918

Oil on canvas, 59 × 38½″ (150 × 98 cm)
Not signed, not dated
Musée National d'Art Moderne, Centre Georges Pompidou, Paris

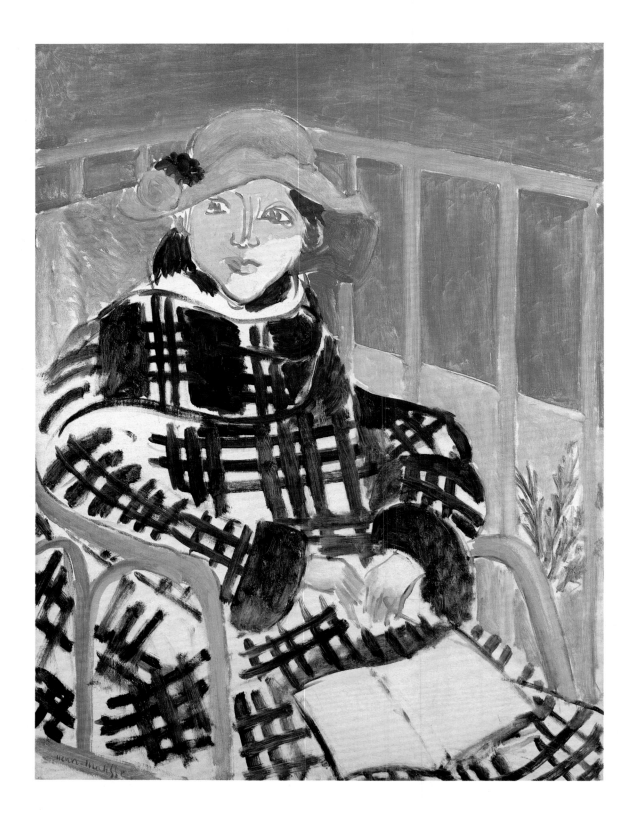

222. Mlle Matisse in a Scottish Plaid Coat
Mlle Matisse en manteau écossais

Nice, no. 105, quai du Midi, spring 1918

Oil on canvas, 37⅜ × 29½" (95 × 75 cm)
Signed lower left: "Henri-Matisse"
Collection Mr. and Mrs. A. Alfred Taubman

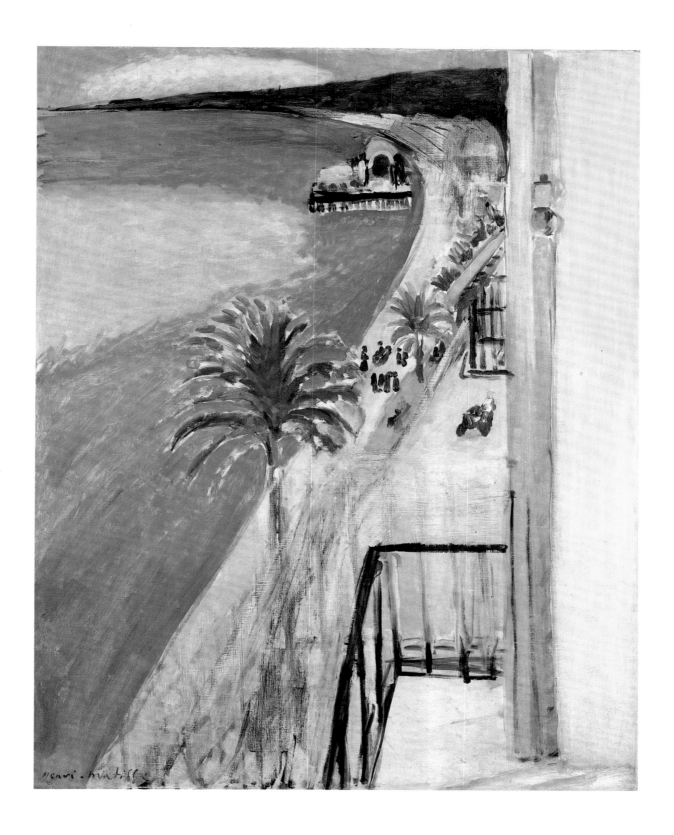

223. The Bay of Nice
La baie de Nice

Nice, no. 105, quai du Midi, spring 1918

Oil on canvas, 35⅜ × 28″ (90 × 71 cm)
Signed lower left: "Henri-Matisse"
Private collection
Formerly collection Michael and Sarah Stein

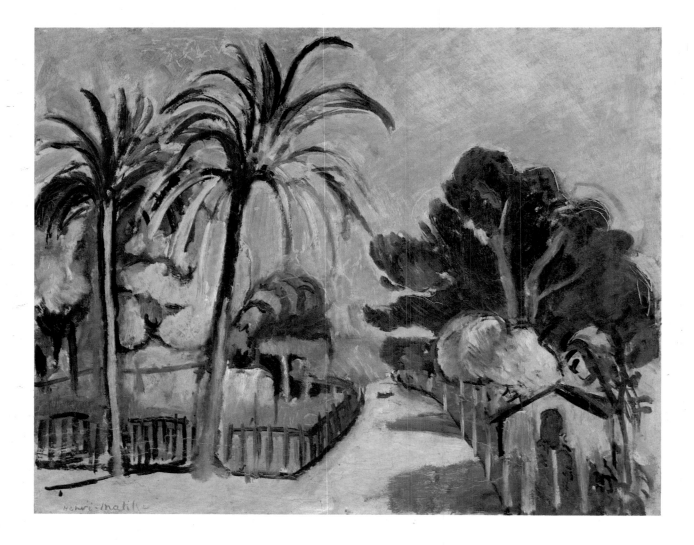

224. The Château Garden
Le jardin du château

Nice, [spring 1918]

Oil on cardboard, 13 × 16⅛″ (33 × 41 cm)
Signed lower left: "Henri-Matisse"
Kunstmuseum Bern

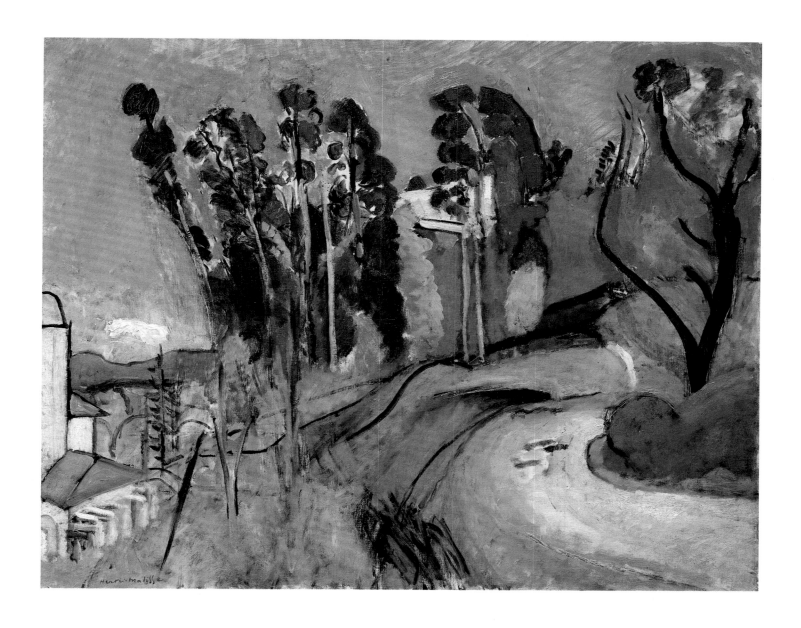

225. Large Landscape, Mont Alban
Grand paysage, Mont Alban

Nice, spring 1918

Oil on canvas, 28¾ × 35¾″ (73 × 90.8 cm)
Signed lower left: "Henri-Matisse"
Private collection

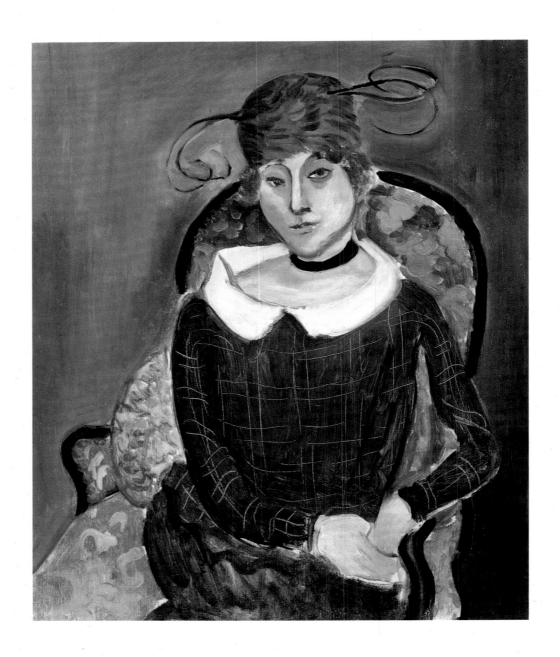

226. The Ostrich Feather Hat
La tocque de goura

[Issy-les-Moulineaux, autumn 1918]

Oil on canvas, 18⅛ × 15″ (46 × 38 cm)
Not signed, not dated
Wadsworth Atheneum, Hartford. The Ella Gallup
Sumner and Mary Catlin Sumner Collection
Formerly collection Paul Guillaume

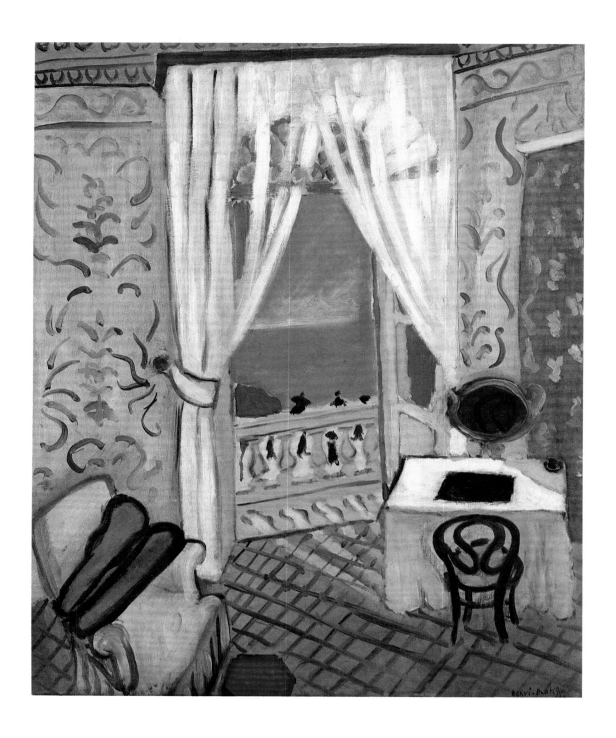

227. Interior with a Violin Case
Intérieur à la boîte à violon

Nice, Hôtel Méditerranée, winter 1918–19

Oil on canvas, 28¾ × 23⅝" (73 × 60 cm)
Signed lower right: "Henri-Matisse"
The Museum of Modern Art, New York. Lillie P. Bliss Collection

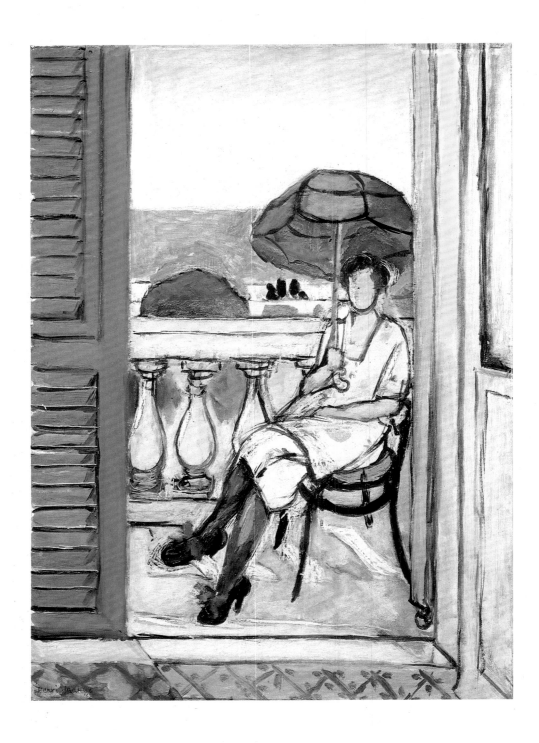

228. Woman with a Green Parasol on a Balcony
Femme au balcon à l'ombrelle verte

Nice, Hôtel Méditerranée, [winter 1918–19]

Oil on canvas, 26⅛ × 18½" (66.5 × 47 cm)
Signed lower left: "Henri-Matisse"
Private collection

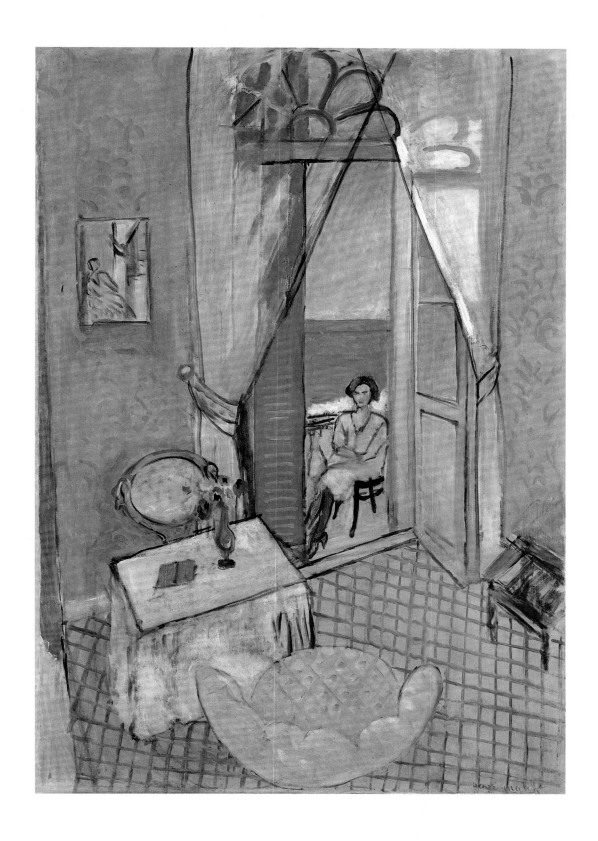

229. Large Interior, Nice
Grand intérieur, Nice

Nice, Hôtel Méditerranée, [late 1918–spring 1919]

Oil on canvas, 52 × 35″ (132.2 × 88.9 cm)
Signed lower right: "Henri-Matisse"
The Art Institute of Chicago. Gift of Mrs. Gilbert W. Chapman

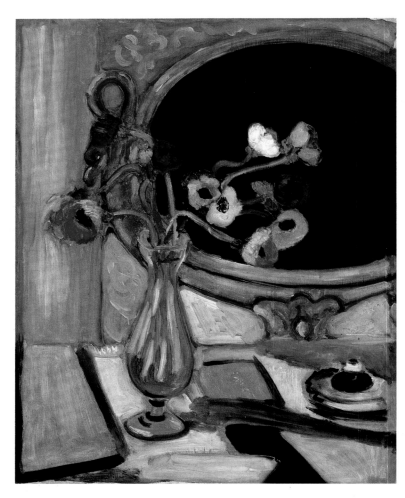

230. Anemones with a Black Mirror
Anémones au miroir noir

Nice, Hôtel Méditerranée, winter 1918–19

Oil on canvas, 26¾ × 20½″ (68 × 52 cm)
Signed lower left: "Henri Matisse"
Corporate Art Collection, The Reader's Digest Association, Inc.,
Pleasantville, New York

231. Still Life with a Vase of Flowers, Lemons, and Mortar
Nature morte, vase de fleurs, citrons et mortier

Nice, Hôtel Méditerranée, late 1918–spring 1919

Oil on canvas, 18⅛ × 15″ (46 × 38 cm)
Signed lower right: "Henri-Matisse"
Alsdorf Collection
Formerly collection Jacques Doucet

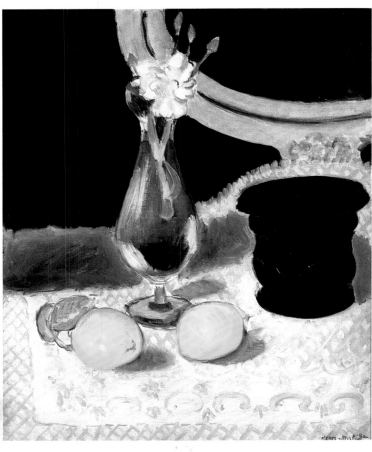

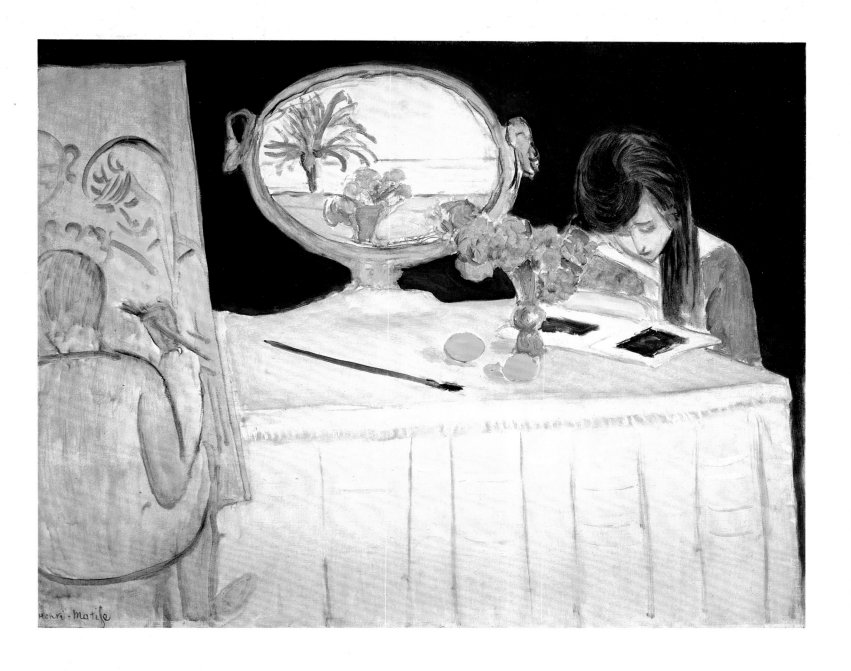

232. The Painting Session
La séance de peinture

Nice, Hôtel Méditerranée, late 1918–spring 1919

Oil on canvas, 29⅛ × 36⅝″ (74 × 93 cm)
Signed lower left: "Henri-Matisse"
Scottish National Gallery of Modern Art, Edinburgh

233. The Plumed Hat
Le chapeau à plumes

Nice, Hôtel Méditerranée, [winter–spring] 1919

Pencil on paper, 13¾ × 11½″ (34.9 × 29.2 cm)
Signed and dated lower left: "Henri Matisse 1919"
Private collection

235. The Plumed Hat
Le chapeau à plumes

Nice, Hôtel Méditerranée, [winter–spring 1919]

Pencil on paper, 21¼ × 14⅜″ (54 × 36.5 cm)
Signed lower right: "Henri Matisse"
The Museum of Modern Art, New York.
Gift of The Lauder Foundation, Inc.

234. The Plumed Hat
Le chapeau à plumes

Nice, Hôtel Méditerranée, [winter–spring] 1919

Pencil on paper, 20⅞ × 14⅜″ (53 × 36.5 cm)
Signed and dated lower left: "Henri-Matisse 1919"
The Detroit Institute of Arts. Bequest of John S. Newberry

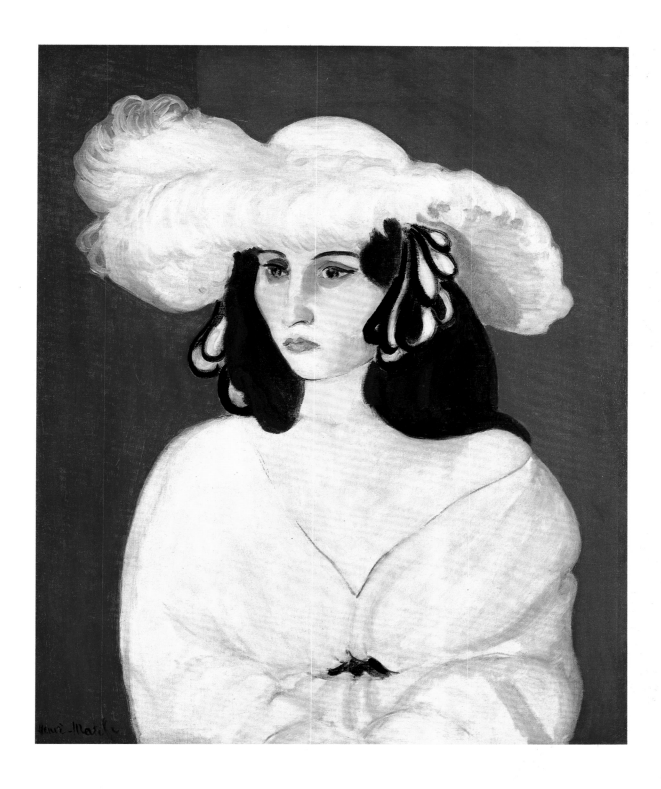

236. The White Plumes
Les plumes blanches

Nice, Hôtel Méditerranée, [early 1919]

Oil on canvas, 28¾ × 23¾″ (73 × 60.3 cm)
Signed lower left: "Henri-Matisse"
The Minneapolis Institute of Arts.
The William Hood Dunwoody Fund.
Formerly collection Stephen C. Clark

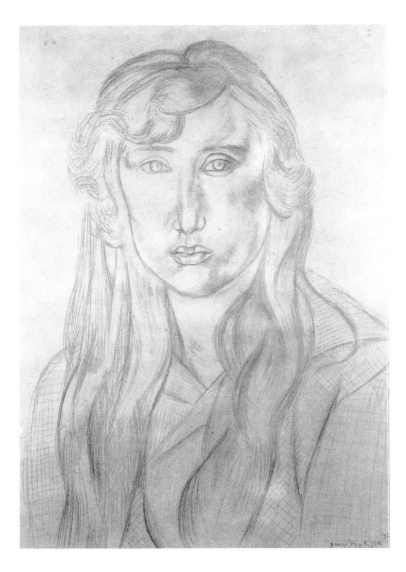

237. **Young Girl with Long Hair (Antoinette)**
La chevelure (Antoinette)

Nice, Hôtel Méditerranée, or Issy-les-Moulineaux, [1919]

Pencil on paper, 21¼ × 14⅝″ (53.9 × 37 cm)
Signed and erroneously dated lower right: "Henri Matisse / 1926"
National Gallery of Art, Washington, D.C. Lessing J. Rosenwald Collection

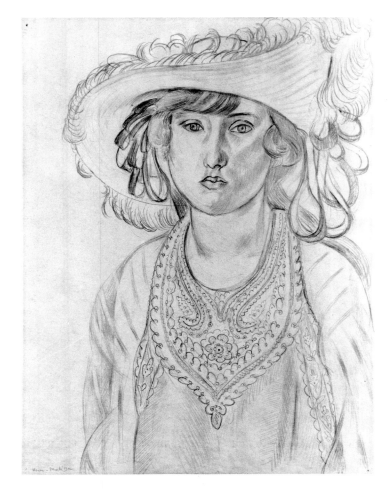

238. The Plumed Hat

Le chapeau à plumes

Nice, Hôtel Méditerranée, [winter–spring 1919]

Pencil on paper, 19⅜ × 14⅝″ (49 × 37 cm)
Signed lower left: "Henri-Matisse"
The Baltimore Museum of Art. The Cone Collection, formed by
Dr. Claribel Cone and Miss Etta Cone of Baltimore, Maryland

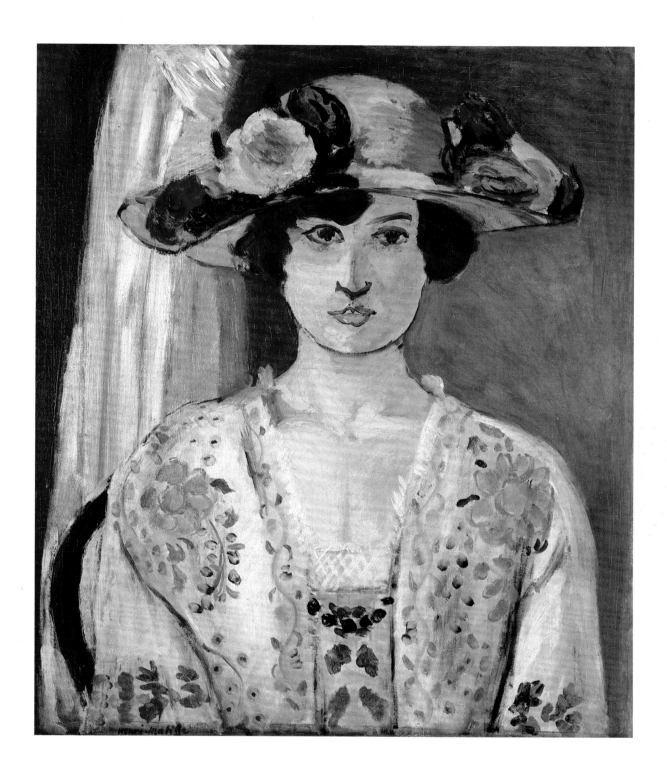

239. Woman in a Flowered Hat
Femme au chapeau fleuri

[Nice, Hôtel Méditerranée, 1919]

Oil on canvas, 23⅛ × 19⅝″ (58.9 × 49.9 cm)
Signed lower left: "Henri-Matisse"
Collection Mr. and Mrs. Herbert J. Klapper, New York
Formerly collection Justin K. Thannhauser

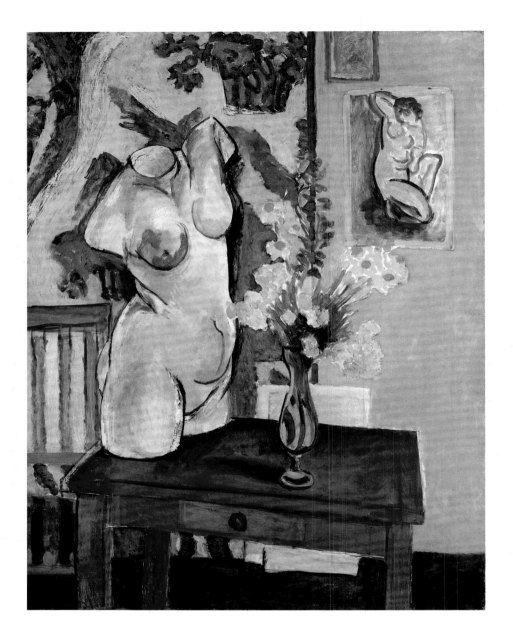

240. Plaster Figure, Bouquet of Flowers
Le torse de plâtre, bouquet de fleurs

Issy-les-Moulineaux, [summer 1919]

Oil on canvas, 45½ × 34¼″ (113 × 87 cm)
Signed lower right: "Henri-Matisse"
Museu de Arte de São Paulo
Formerly collection Leigh B. Block

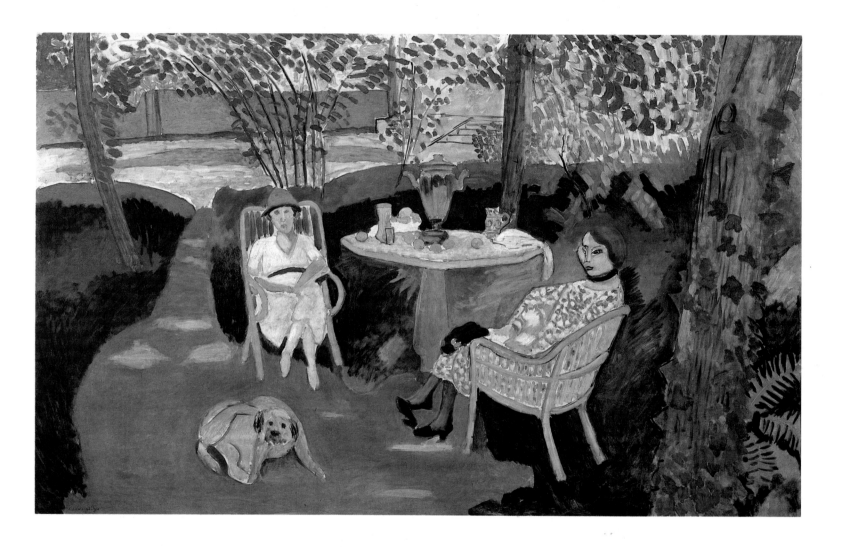

241. Tea in the Garden
 Le thé dans le jardin

Issy-les-Moulineaux, summer 1919

Oil on canvas, 55¼″ × 6′ 11¼″ (140.3 × 211.5 cm)
Signed lower left: "Henri-Matisse"
Los Angeles County Museum of Art. Bequest of David L. Loew in
memory of his father, Marcus Loew
Formerly collection Michael and Sarah Stein

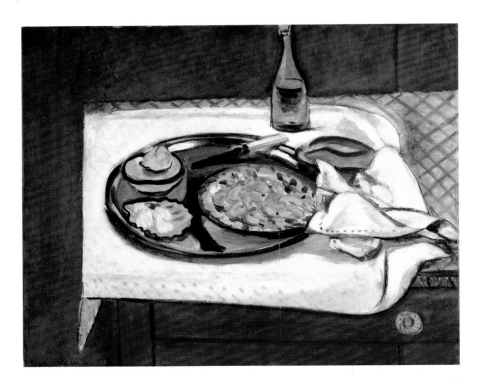

242. Pink Shrimp
Les crevettes roses

Étretat, summer 1920

Oil on canvas, 23¼ × 28¾″ (59 × 73 cm)
Signed lower left: "Henri-Matisse"
Everhart Museum, Scranton, Pennsylvania
Formerly collection Stephen C. Clark

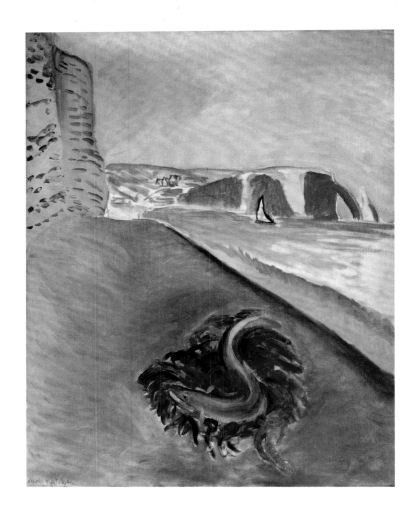

243. Large Cliff: The Eel
Grande falaise, le congre

Étretat, summer 1920

Oil on canvas, 35½ × 28″ (90.2 × 71.1 cm)
Signed lower left: "Henri-Matisse"
Columbus Museum of Art, Ohio. Gift of Ferdinand Howald
Formerly collection John Quinn

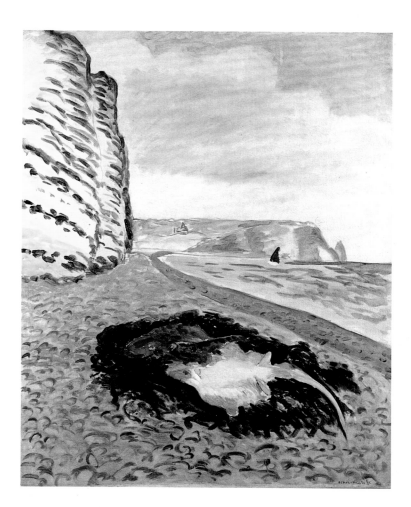

244. Large Cliff: The Two Rays
Grande falaise, les deux raies

Étretat, summer 1920

Oil on canvas, 36½ × 29″ (92.7 × 73.7 cm)
Signed lower right: "Henri-Matisse"
Norton Gallery and School of Art, West Palm Beach, Florida

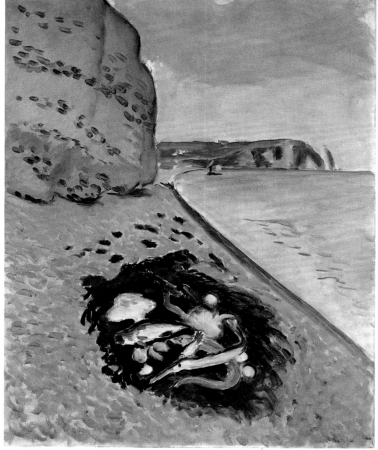

245. Large Cliff: Fish
Grande falaise, les poissons

Étretat, summer 1920

Oil on canvas, 36⅝ × 29″ (93.1 × 73.3 cm)
Signed lower right: "Henri-Matisse"
The Baltimore Museum of Art. The Cone Collection, formed by
Dr. Claribel Cone and Miss Etta Cone of Baltimore, Maryland

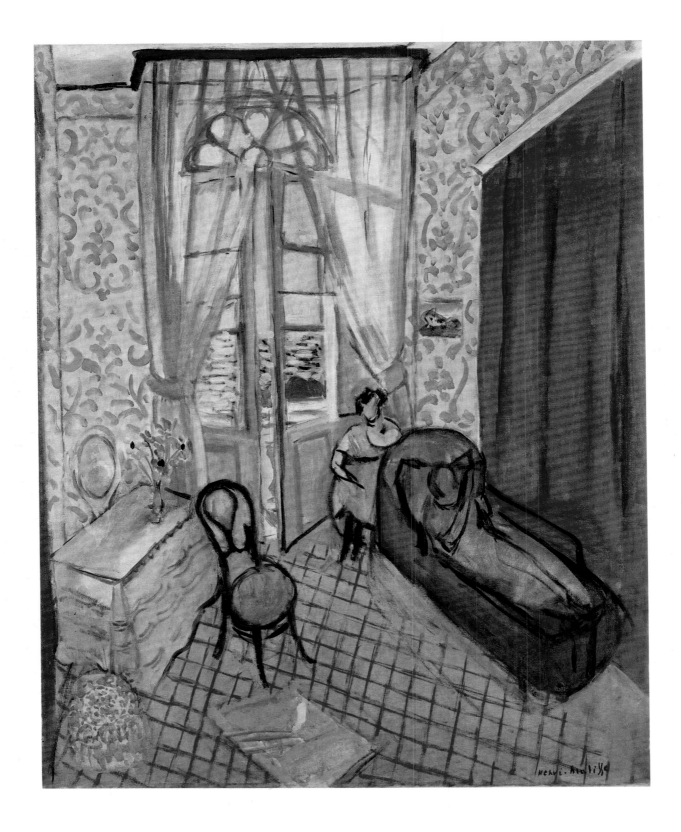

246. Two Women in an Interior
Deux femmes dans un intérieur

Nice, Hôtel Méditerranée, [late 1920–spring 1921]

Oil on canvas, 36¼ × 28¾″ (92 × 73 cm)
Signed lower right: "Henri-Matisse"
Musée de l'Orangerie, Paris. Collection Walter-Guillaume
Formerly collection Paul Guillaume

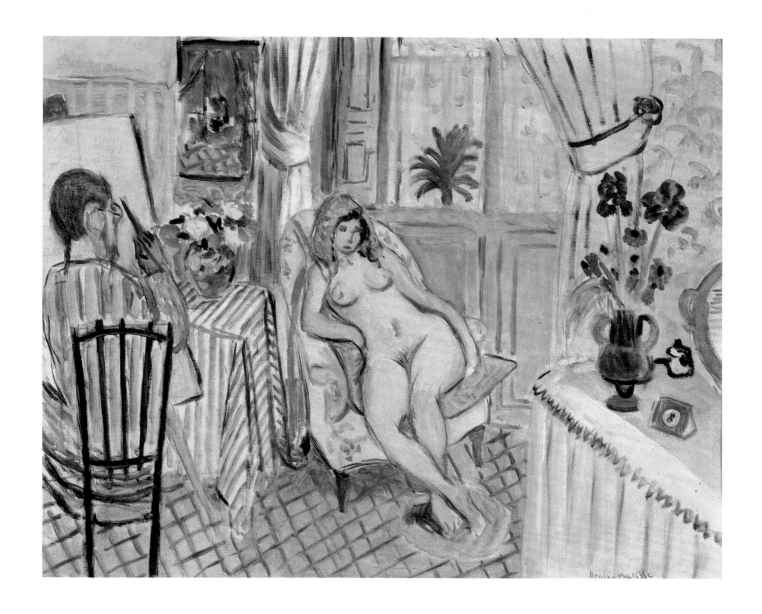

247. The Painter and His Model: Studio Interior
Le peintre et son modèle: Intérieur d'atelier

Nice, Hôtel Méditerranée, [late 1918–spring 1919 or late 1920–spring 1921]

Oil on canvas, 23 ⅝ × 28 ¾″ (60 × 73 cm)
Signed lower right: "Henri-Matisse"
Collection Mr. and Mrs. Donald B. Marron, New York
Formerly collection John Quinn

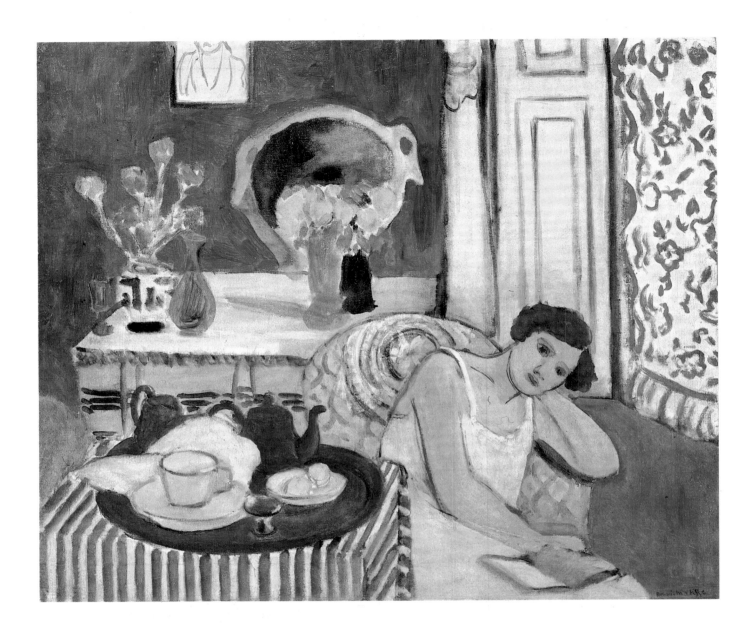

248. The Breakfast
Le petit déjeuner

Nice, Hôtel Méditerranée, [late 1919–spring 1920]

Oil on canvas, 25¼ × 29⅛" (64 × 74 cm)
Signed lower right: "Henri-Matisse"
Philadelphia Museum of Art.
The Samuel S. White 3rd and Vera White Collection

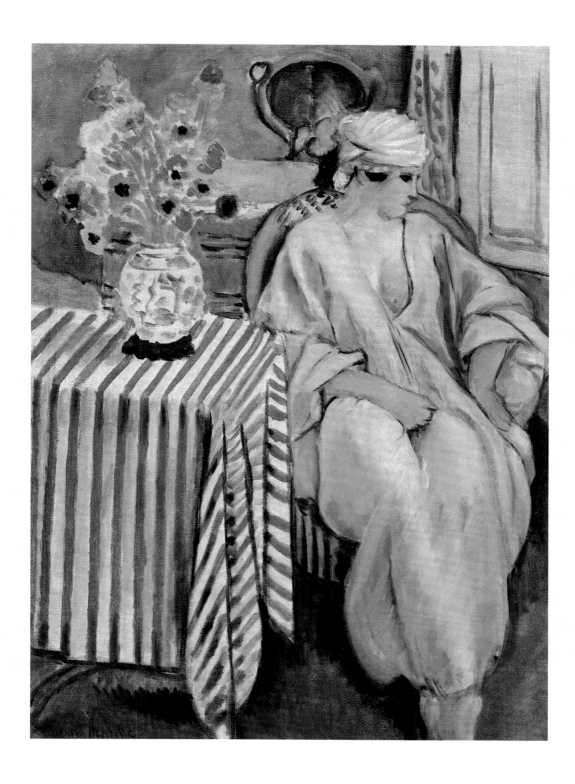

249. The Meditation: After the Bath
La méditation: Après le bain

Nice, Hôtel Méditerranée, [late 1920–spring 1921]

Oil on canvas, 28¾ × 21¼″ (73 × 34 cm)
Signed lower left: "Henri-Matisse"
Private collection
Formerly collection Mr. and Mrs. Albert D. Lasker

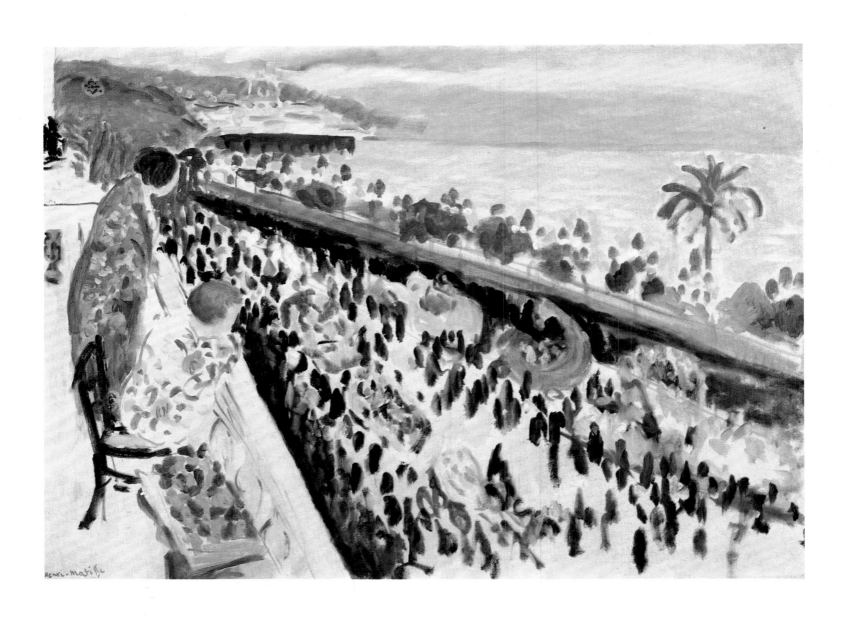

250. Festival of Flowers
Fête des fleurs

Nice, Hôtel Méditerranée, [spring 1921]

Oil on canvas, 28½ × 39″ (72.5 × 99 cm)
Signed lower left: "Henri-Matisse"
Private collection, Switzerland

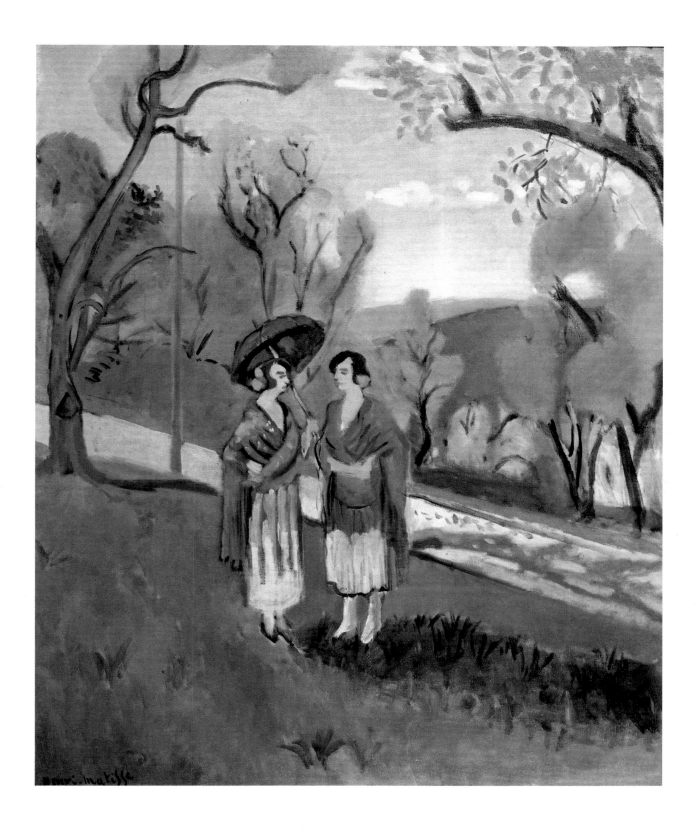

251. Conversation Under the Olive Trees
La conversation sous les oliviers

Environs of Nice, [spring 1921]

Oil on canvas, 39⅜ × 32″ (100 × 81 cm)
Signed lower left: "Henri-Matisse"
Thyssen-Bornemisza Collection, Lugano, Switzerland

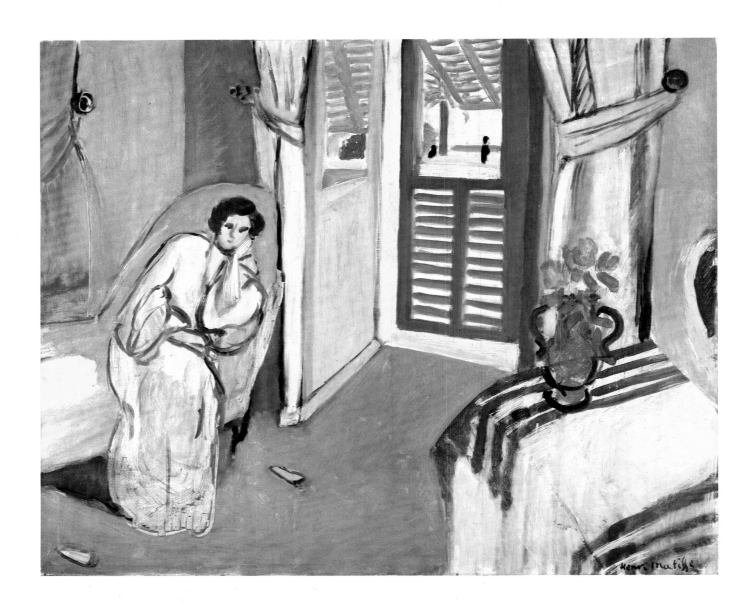

252. Woman on a Sofa
Femme au divan

Nice, Hôtel Méditerranée, [late 1920–spring 1921]

Oil on canvas, 23⅝ × 29″ (60 × 73.5 cm)
Signed lower right: "Henri Matisse"
Oeffentliche Kunstsammlung Basel, Kunstmuseum

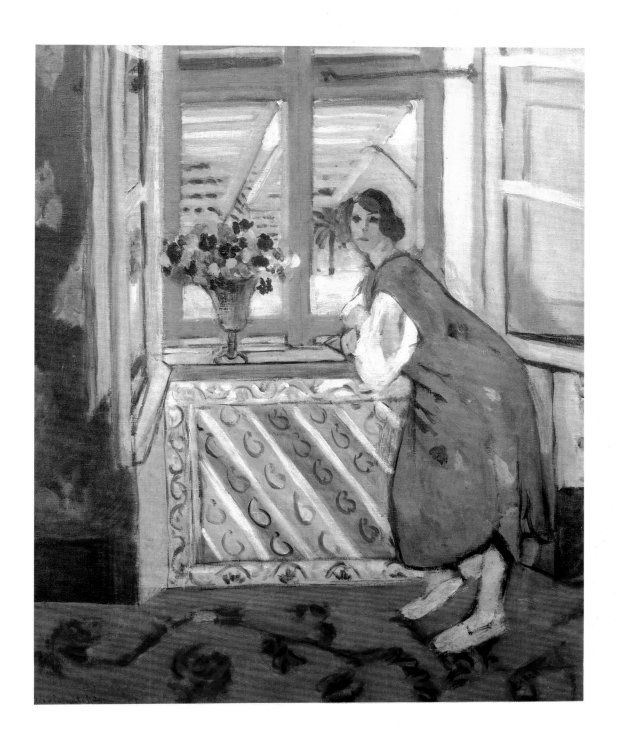

253. Interior at Nice: Young Woman in a Green Dress Leaning at the Window
Intérieur à Nice, jeune femme en robe verte accoudée à la fenêtre

Nice, place Charles-Félix, late 1921

Oil on canvas, 25½ × 21⅝″ (65 × 55 cm)
Signed lower left: "Henri-Matisse"
The Colin Collection
Formerly collection Lillie P. Bliss

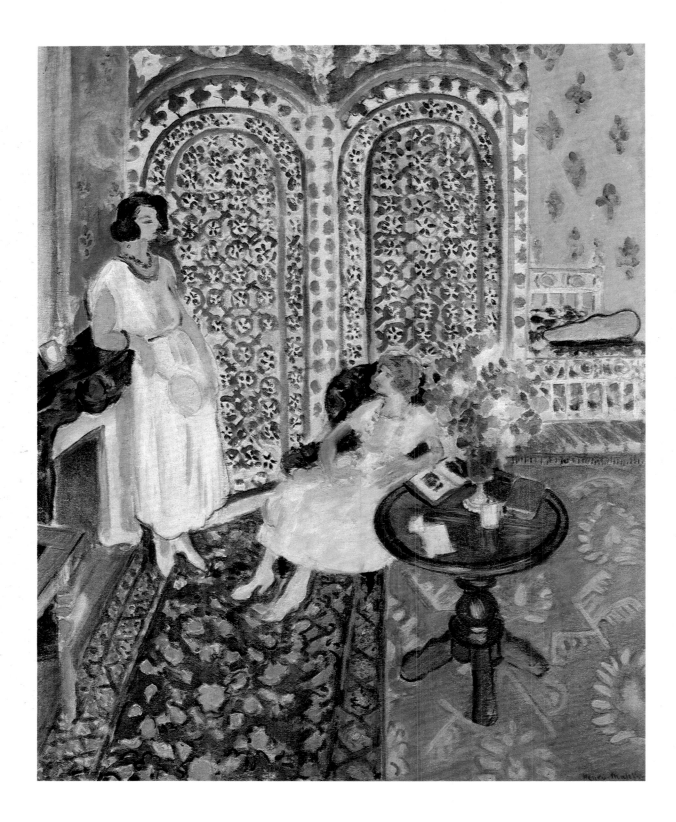

254. The Moorish Screen
Le paravent mauresque

Nice, place Charles-Félix, late 1921

Oil on canvas, 36¼ × 29¼" (90.8 × 74.3 cm)
Signed lower right: "Henri-Matisse"
Philadelphia Museum of Art. Bequest of Lisa Norris Elkins

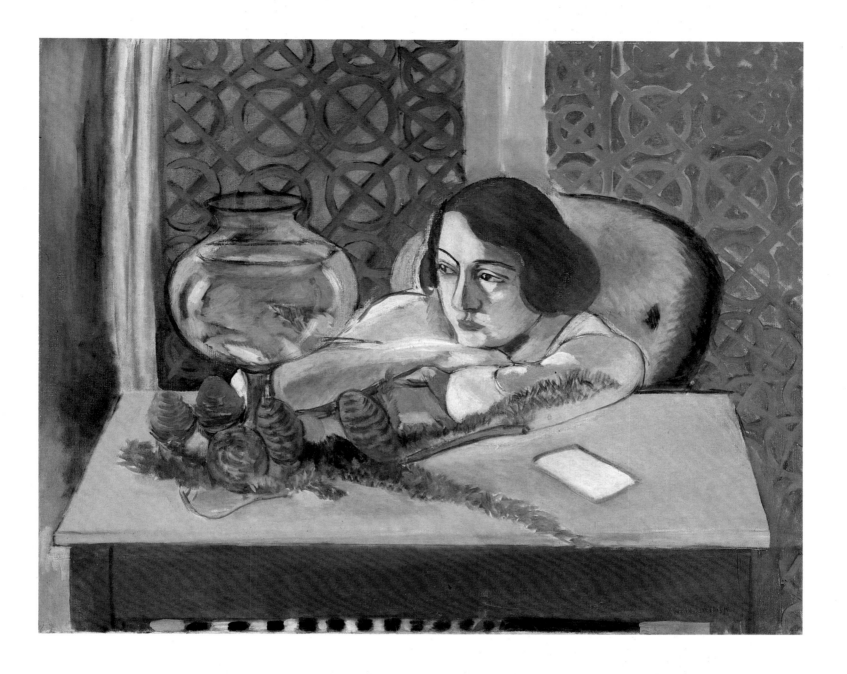

255. Woman Before an Aquarium
Femme devant un aquarium

Nice, place Charles-Félix, [late 1921 or 1923]

Oil on canvas, 32 × 39½″ (81.3 × 100.3 cm)
Signed lower right: "Henri-Matisse"
The Art Institute of Chicago. Helen Birch Bartlett Memorial Collection

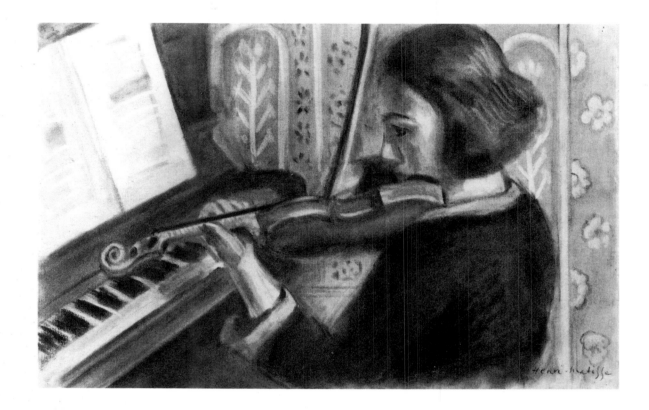

256. Young Woman Playing a Violin in Front of a Piano
Jeune femme jouant du violon devant un piano

Nice, place Charles-Félix, [c. 1924]

Charcoal on paper, 12¼ × 18½″ (31.2 × 47 cm)
Signed lower right: "Henri-Matisse"
Collection Richard L. Selle

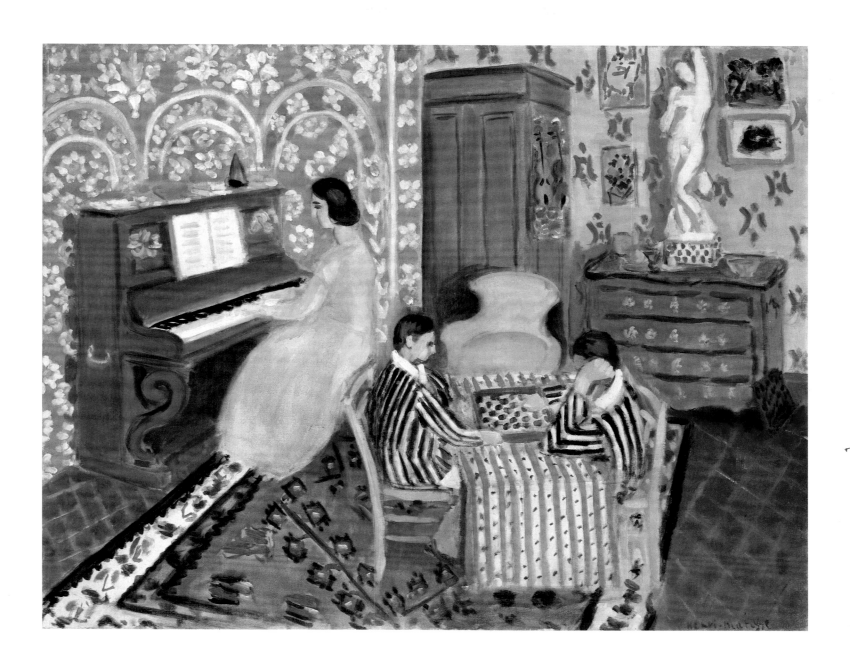

257. Pianist and Checker Players
Pianiste et joueurs de dames

Nice, place Charles-Félix, [early 1924]

Oil on canvas, 29¼ × 36⅜″ (73.7 × 92.1 cm)
Signed lower right: "Henri-Matisse"
National Gallery of Art, Washington, D.C.
Collection of Mr. and Mrs. Paul Mellon

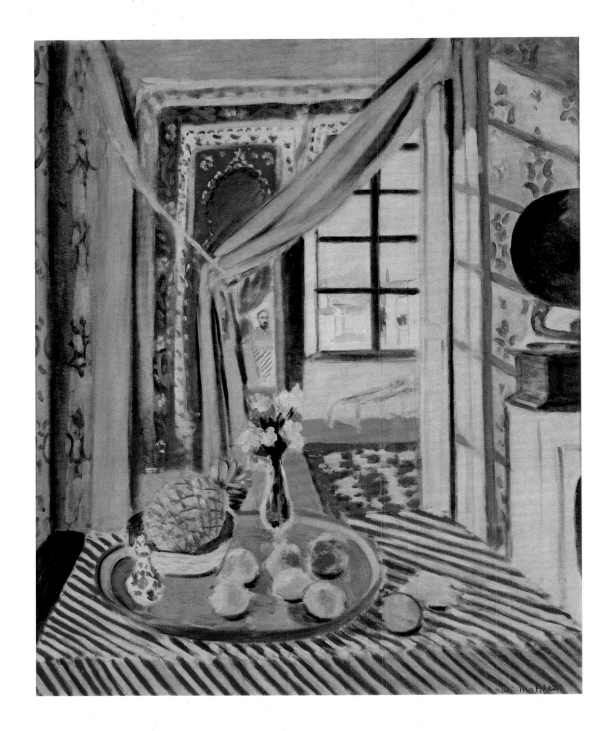

258. Interior with a Phonograph
Intérieur au phonographe

Nice, place Charles-Félix, [early 1924]

Oil on canvas, 34⅝ × 31½″ (100.5 × 81 cm)
Signed lower right: "Henri-Matisse"
Private collection
Formerly collections Stephen C. Clark; Mr. and Mrs. Albert D. Lasker

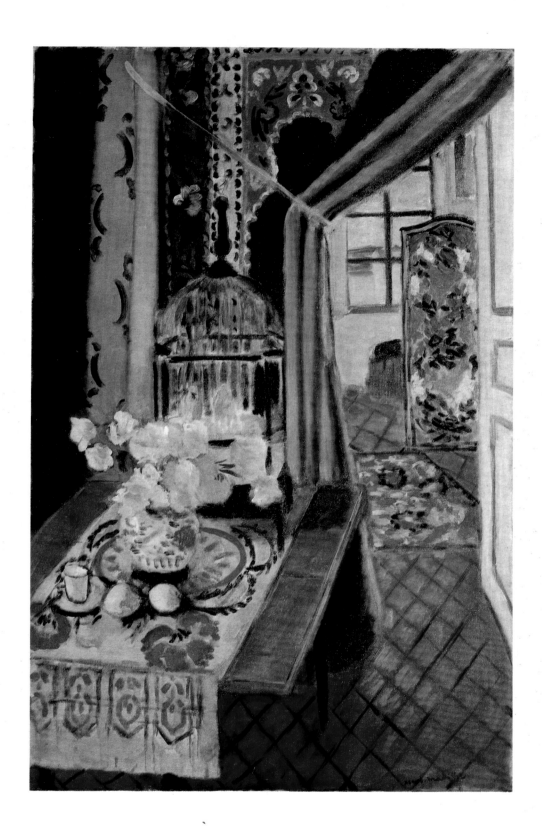

259. Interior: Flowers and Parakeets
 Intérieur, fleurs et perruches

Nice, place Charles-Félix, [early 1924]

Oil on canvas, 46 × 29⅝″ (116.9 × 72.7 cm)
Signed lower right: "Henri-Matisse"
The Baltimore Museum of Art. The Cone Collection, formed by
Dr. Claribel Cone and Miss Etta Cone of Baltimore, Maryland

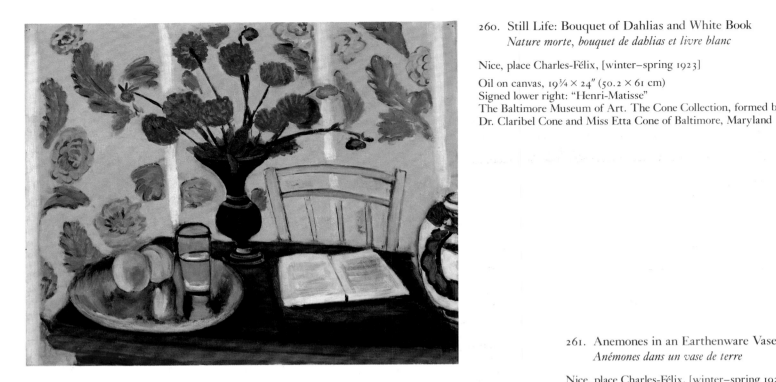

260. Still Life: Bouquet of Dahlias and White Book
Nature morte, bouquet de dahlias et livre blanc

Nice, place Charles-Félix, [winter–spring 1923]

Oil on canvas, 19¾ × 24″ (50.2 × 61 cm)
Signed lower right: "Henri-Matisse"
The Baltimore Museum of Art. The Cone Collection, formed by
Dr. Claribel Cone and Miss Etta Cone of Baltimore, Maryland

261. Anemones in an Earthenware Vase
Anémones dans un vase de terre

Nice, place Charles-Félix, [winter–spring 1924]

Oil on canvas, 28¾ × 36¼″ (73 × 92 cm)
Signed lower left: "Henri-Matisse"
Kunstmuseum Bern

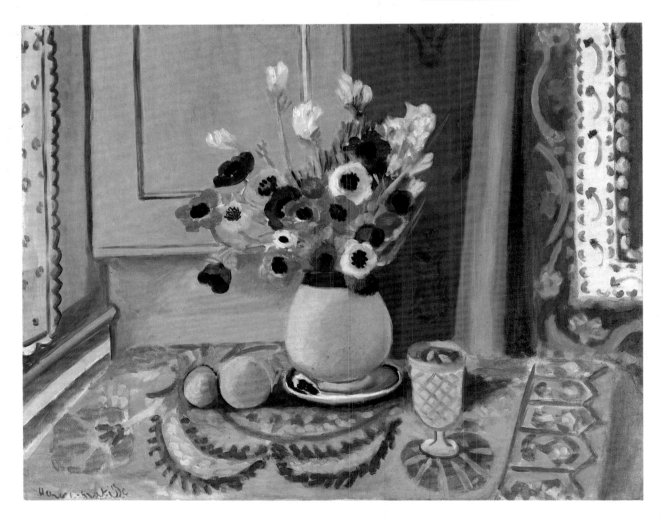

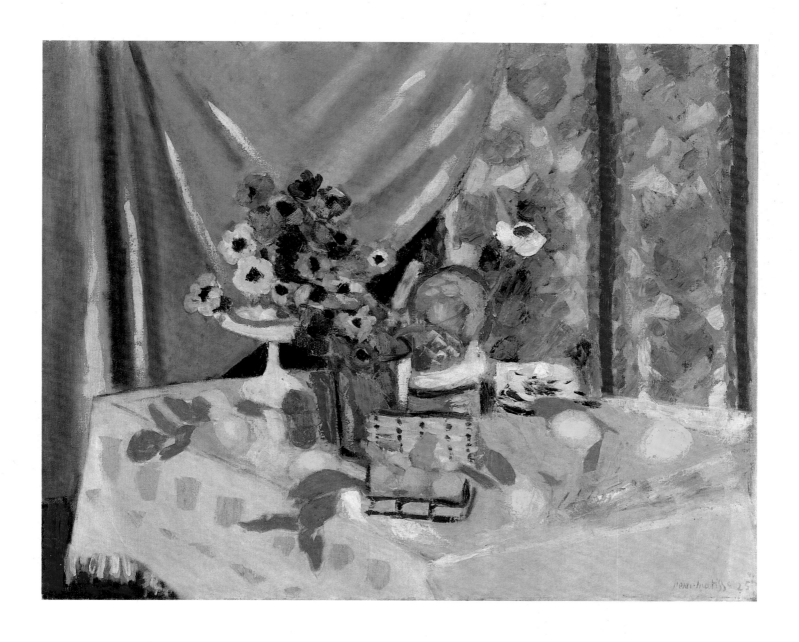

262. Still Life: Pink Tablecloth, Vase of Anemones, Lemons, and Pineapple
Nature morte, nappe rose, vase d'anémones, citrons et ananas

Nice, place Charles-Félix, 1925

Oil on canvas, 31½ × 39⅜″ (80 × 100 cm)
Signed and dated lower right: "Henri-Matisse 25"
Private collection

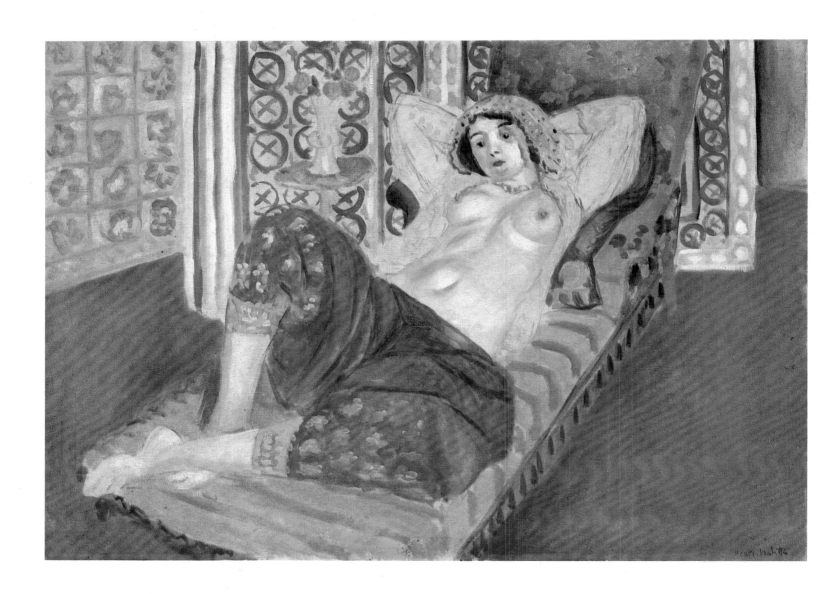

263. Odalisque with Red Culottes
Odalisque à la culotte rouge

Nice, place Charles-Félix, late 1921

Oil on canvas, 26⅜ × 33⅛″ (67 × 84 cm)
Signed lower right: "Henri-Matisse"
Musée National d'Art Moderne, Centre Georges Pompidou, Paris

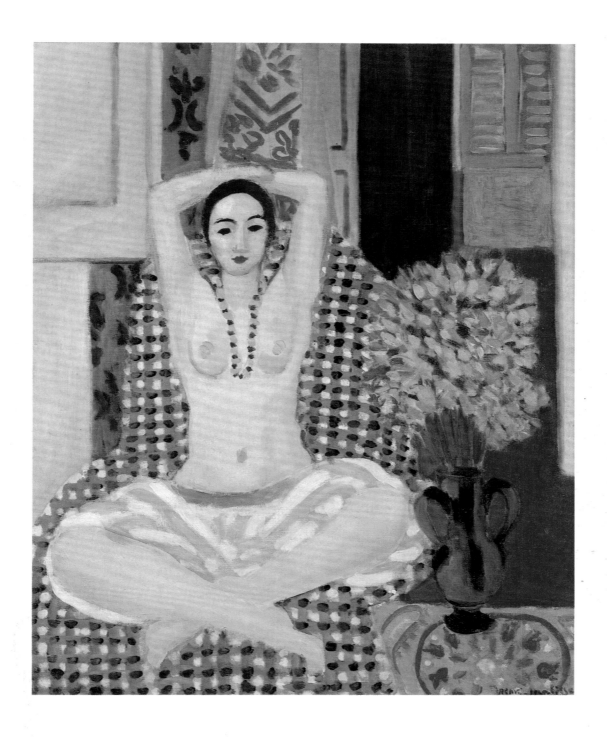

264. The Hindu Pose
La pose hindoue

Nice, place Charles-Félix, [winter–spring 1923]

Oil on canvas, 32⅝ × 23⅝″ (83 × 60 cm)
Signed lower right: "Henri-Matisse"
Private collection
Formerly collections Paul Guillaume; Stephen C. Clark

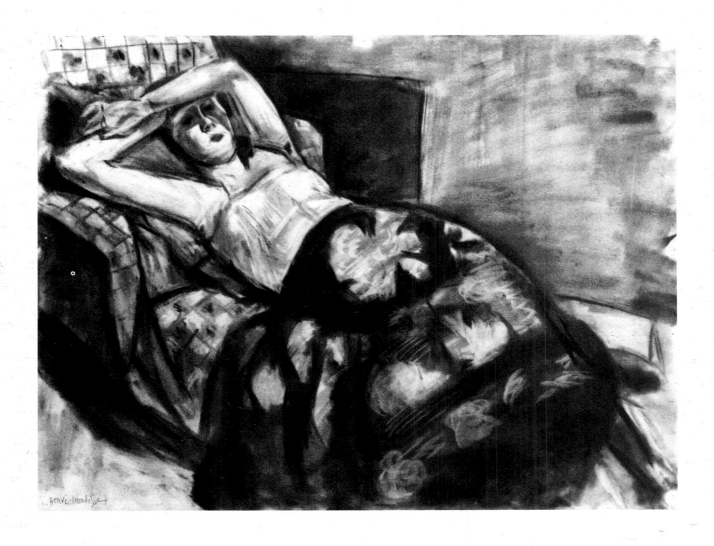

265. Reclining Model with a Flowered Robe
Modèle couché à la robe fleurie

Nice, place Charles-Félix, [c. 1923–24]

Charcoal and estompe on paper, 18⅞ × 24¾″ (48 × 62.8 cm)
Signed lower left: "Henri-Matisse"
The Baltimore Museum of Art. The Cone Collection, formed by
Dr. Claribel Cone and Miss Etta Cone of Baltimore, Maryland

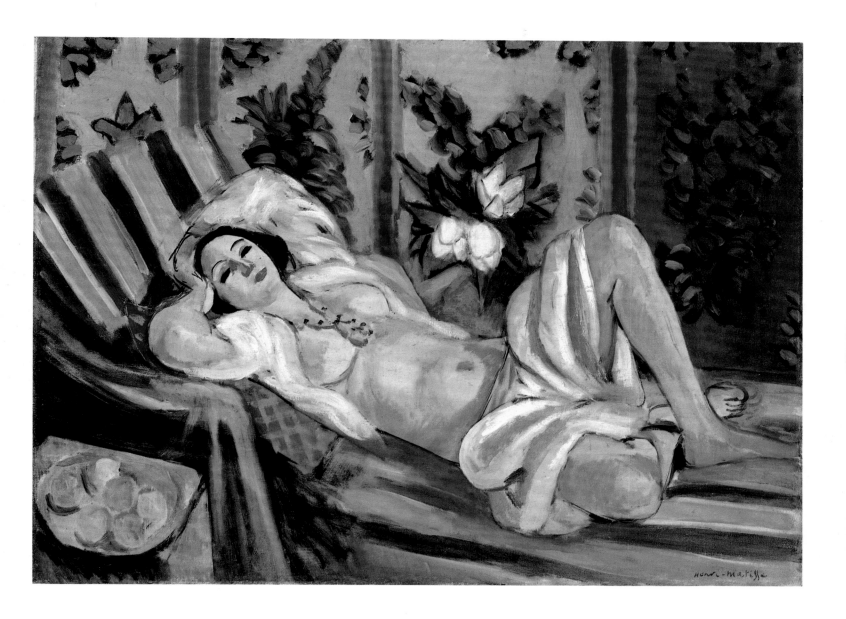

266. Odalisque with Magnolias
Odalisque aux magnolias

Nice, place Charles-Félix, [1923 or 1924]

Oil on canvas, 25⅝ × 31⅞" (65 × 81 cm)
Signed lower right: "Henri-Matisse"
Private collection
Formerly collection Leigh B. Block

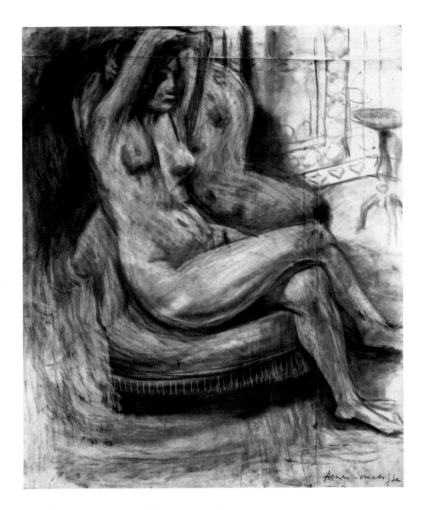

267. Seated Nude with Arms Raised
Nu assis aux bras levés

Nice, place Charles-Félix, [c. 1925]

Charcoal and estompe on paper, 24 × 19½" (61 × 49.5 cm)
Signed lower right: "Henri-Matisse"
The Art Institute of Chicago. The Wirt D. Walker Fund

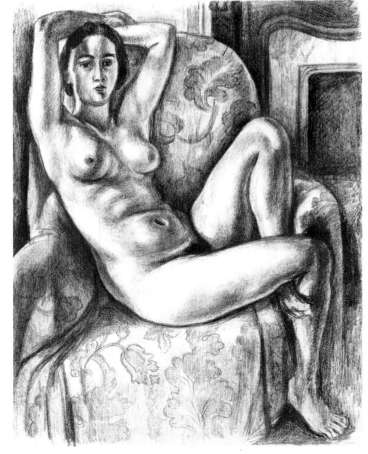

268. Nude with a Blue Cushion Beside a Fireplace
Nu au coussin bleu à côté d'une cheminée

Nice, place Charles-Félix, [1925]

Transfer lithograph, printed in black: composition 25 1/16 × 18 13/16"
(63.6 × 47.8 cm); sheet 29 11/16 × 22 1/16" (75.5 × 56 cm)
Signed lower right of sheet in pencil: "Henri-Matisse"
The Museum of Modern Art, New York. Gift of Abby Aldrich
Rockefeller (by exchange)

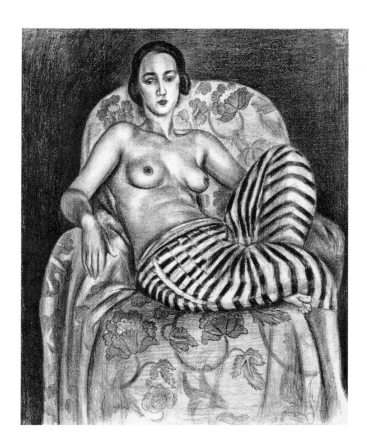

269. Large Odalisque with Bayadère Culottes
Grande odalisque à la culotte bayadère

Nice, place Charles-Félix, [1925]

Transfer lithograph, printed in black: composition 21 5/16 × 17 3/8″
(54.2 × 44.2 cm); sheet 29 1/2 × 22 1/16″ (75 × 56 cm)
Signed lower right of sheet in pencil: "15/50 Henri-Matisse"
The Museum of Modern Art, New York. Nelson A. Rockefeller Bequest

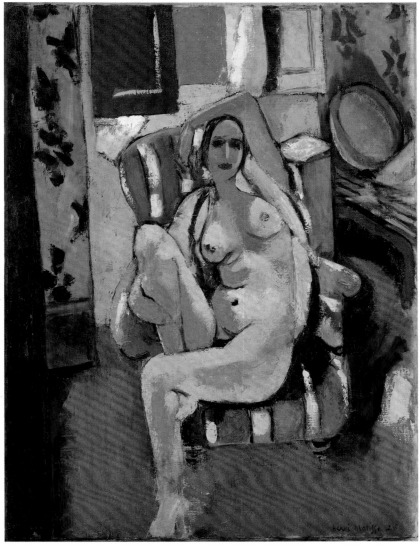

270. Odalisque with a Tambourine
Odalisque au tambourin

Nice, place Charles-Félix, [winter 1925–]26

Oil on canvas, 29 1/4 × 21 7/8″ (74.3 × 55.7 cm)
Signed and dated lower right: "Henri-Matisse 26"
The Museum of Modern Art, New York.
The William S. Paley Collection

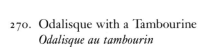

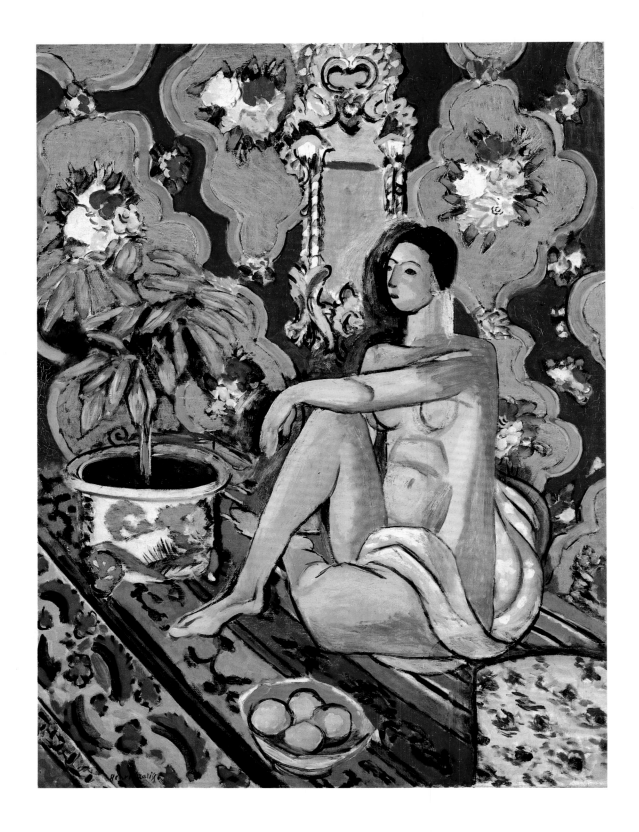

271. Decorative Figure on an Ornamental Ground
Figure décorative sur fond ornemental

Nice, place Charles-Félix, [late 1925–spring 1926]

Oil on canvas, 51⅛ × 38⅝″ (130 × 98 cm)
Signed lower left: "Henri Matisse"
Musée National d'Art Moderne, Centre Georges Pompidou, Paris

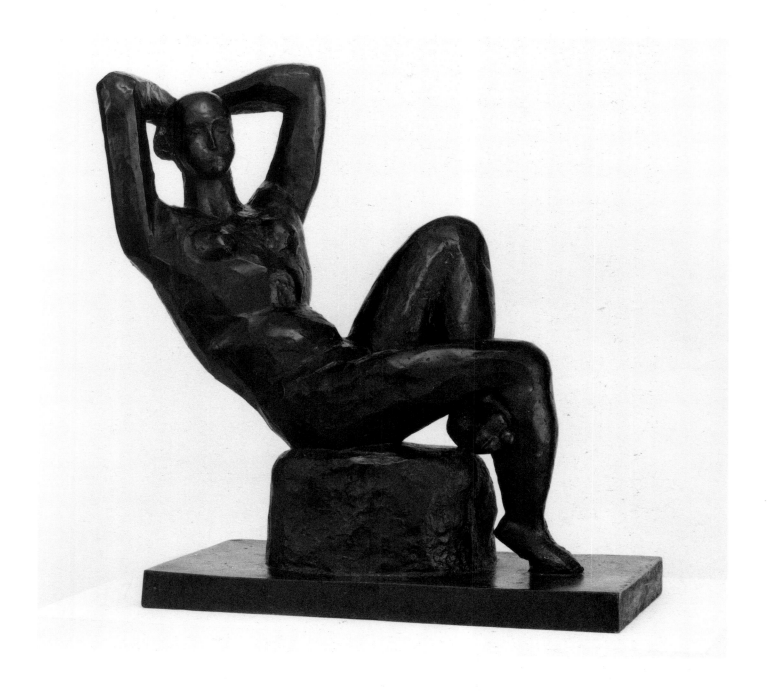

272. Large Seated Nude
Grand nu assis

Nice, place Charles-Félix, [1925–29]

Bronze, 31¼ × 30½ × 13¾″ (79.4 × 77.5 × 34.9 cm)
Inscribed: "HM 5/10"
The Museum of Modern Art, New York. Gift of
Mr. and Mrs. Walter Hochschild (by exchange)

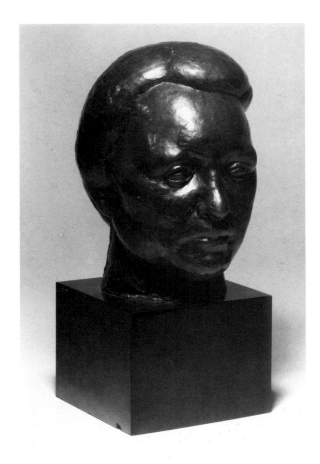

273. Henriette (I)
Henriette (I) (Grosse tête)

Nice, place Charles-Félix, [1925]

Bronze, 11⅝ × 9 × 7⅛″ (29.5 × 23 × 18 cm)
Inscribed: "H.M 2/10"
Founder C. Valsuani
Jan Krugier Gallery, Geneva

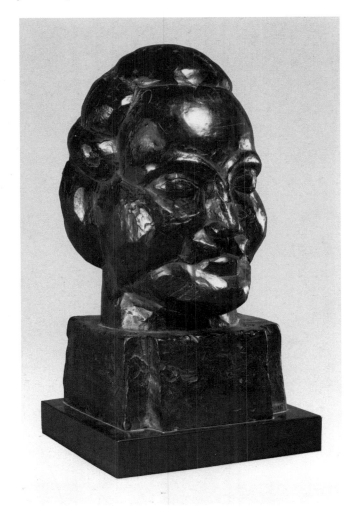

275. Henriette (III)
Henriette (III) (Grosse tête)

Nice, place Charles-Félix, [1929]

Bronze, 16½ × 8⅜ × 10½″ (41.8 × 21.2 × 26.7 cm)
Inscribed: "HM 6"
Founder C. Valsuani
Hirshhorn Museum and Sculpture Garden, Smithsonian Institution,
Washington, D.C. Gift of Joseph H. Hirshhorn, 1966

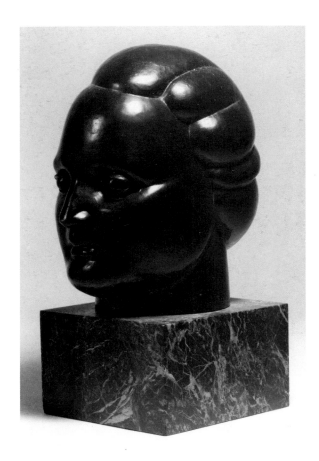

274. Henriette (II)
Henriette (II) (Grosse tête)

Nice, place Charles-Félix, [1925–26]

Bronze, 13 × 11 × 7″ (32.5 × 28 × 18 cm)
Inscribed: "HM" and "7/10"
Founder C. Valsuani
Jan Krugier Gallery, Geneva

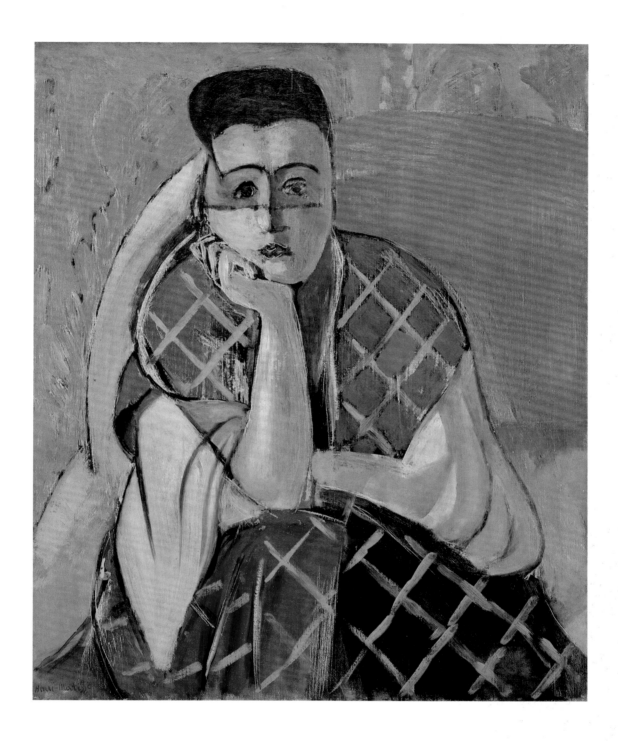

276. Woman with a Veil
La femme à la voilette

Nice, place Charles-Félix, [winter–spring 1927]

Oil on canvas, 24¼ × 19¾″ (61.5 × 50.2 cm)
Signed lower left: "Henri-Matisse"
The Museum of Modern Art, New York. The William S. Paley Collection

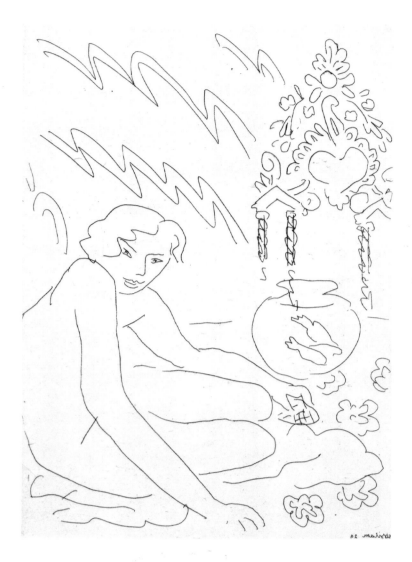

277. Nude with a Moroccan Mirror
Nu au miroir marocain

Nice, place Charles-Félix, 1929

Etching, printed in black: composition 8⁹⁄₁₆ × 6″ (21.7 × 15.3 cm);
sheet 14¾ × 11″ (37.5 × 28 cm)
Signed and dated lower right: "29 [backwards] matisse."
Lower right of sheet in pencil: "Henri-Matisse"
The Museum of Modern Art, New York. Gift of Mrs. Gertrud A. Mellon

278. Study of a Nude Seen Upside Down
Étude de nu renversé

Nice, place Charles-Félix, 1929

Etching, printed in black: composition 6⅝ × 9⁷⁄₁₆″ (16.8 × 24 cm);
sheet 11¼ × 14¹⁵⁄₁₆″ (28.5 × 38 cm)
Signed lower right: "1929 [backwards] Henri Matisse."
Lower right of sheet in pencil: "9/25 / Henri-Matisse"
The Museum of Modern Art, New York.
Gift of Mr. and Mrs. E. Powis Jones

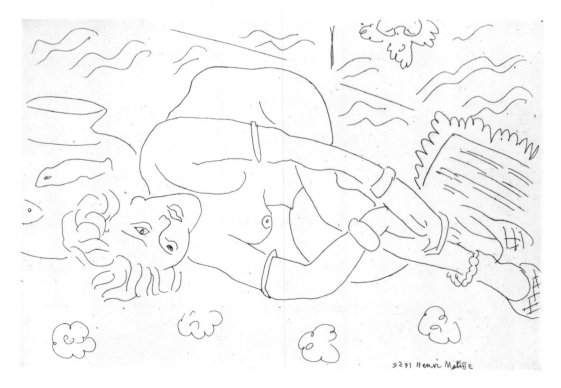

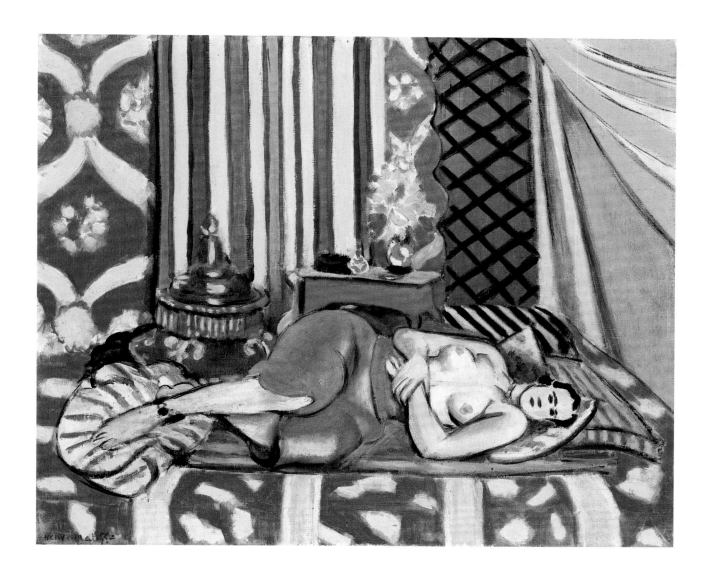

279. Odalisque with Gray Culottes
Odalisque à la culotte grise

Nice, place Charles-Félix, [late 1926–spring 1927]

Oil on canvas, 21¼ × 25½″ (54 × 65 cm)
Signed lower left: "Henri-Matisse"
Musée de l'Orangerie, Paris. Collection Walter-Guillaume
Formerly collection Paul Guillaume

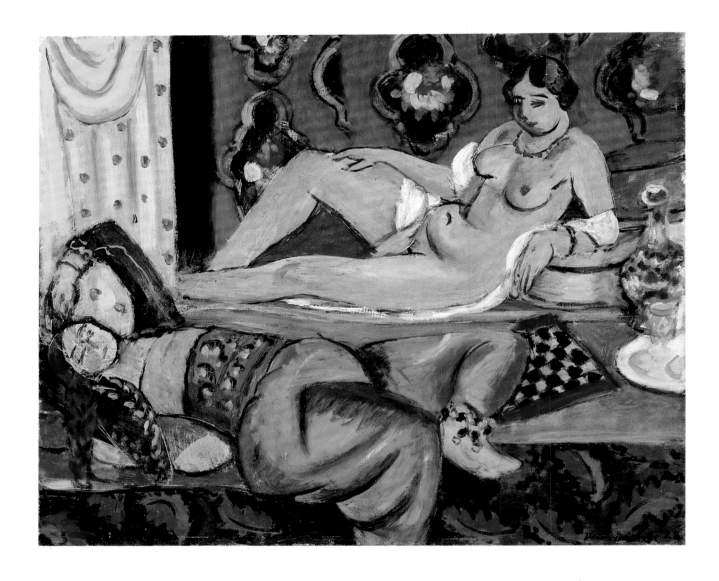

280. Two Odalisques
Deux odalisques

Nice, place Charles-Félix, [late 1927–summer] 1928
Oil on canvas, 21¼ × 25⅝" (54 × 65 cm)
Signed and dated lower right: "Henri Matisse 28"
Moderna Museet, Stockholm

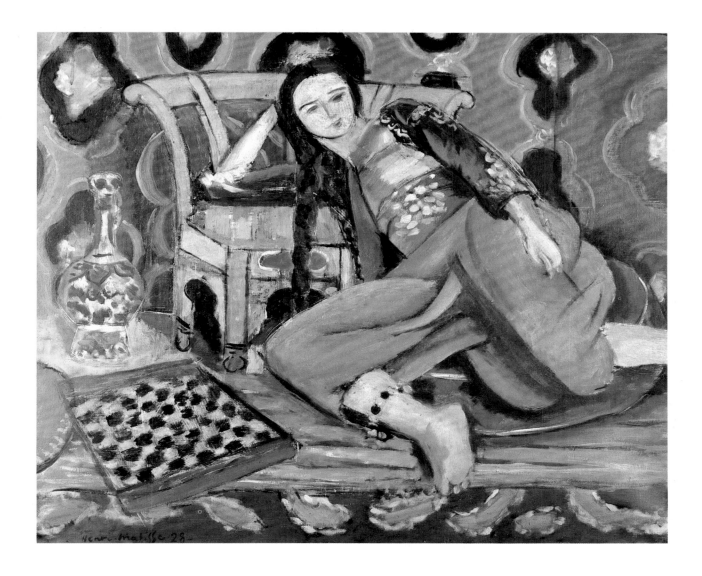

281. Odalisque with a Turkish Chair
Odalisque au fauteuil turc

Nice, place Charles-Félix, [late 1927–summer] 1928

Oil on canvas, 23⅝ × 28¾″ (60 × 73 cm)
Signed and dated lower left: "Henri-Matisse 28-"
Musée d'Art Moderne de la Ville de Paris

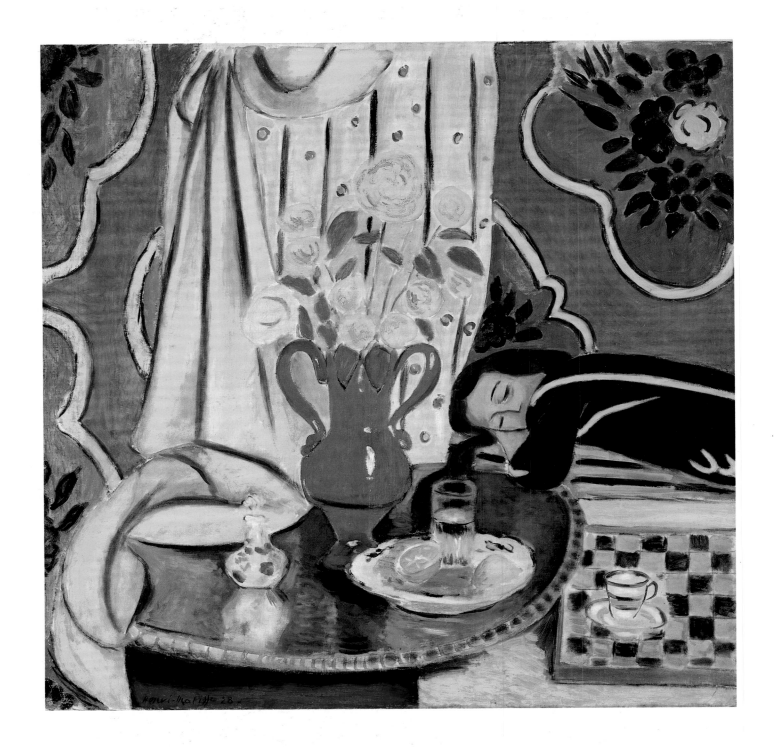

282. Harmony in Yellow
Harmonie jaune

Nice, place Charles-Félix, [late 1927–summer] 1928

Oil on canvas, 34⅝ × 34⅝″ (88 × 88 cm)
Signed and dated lower left: "Henri-Matisse 28-"
Collection S

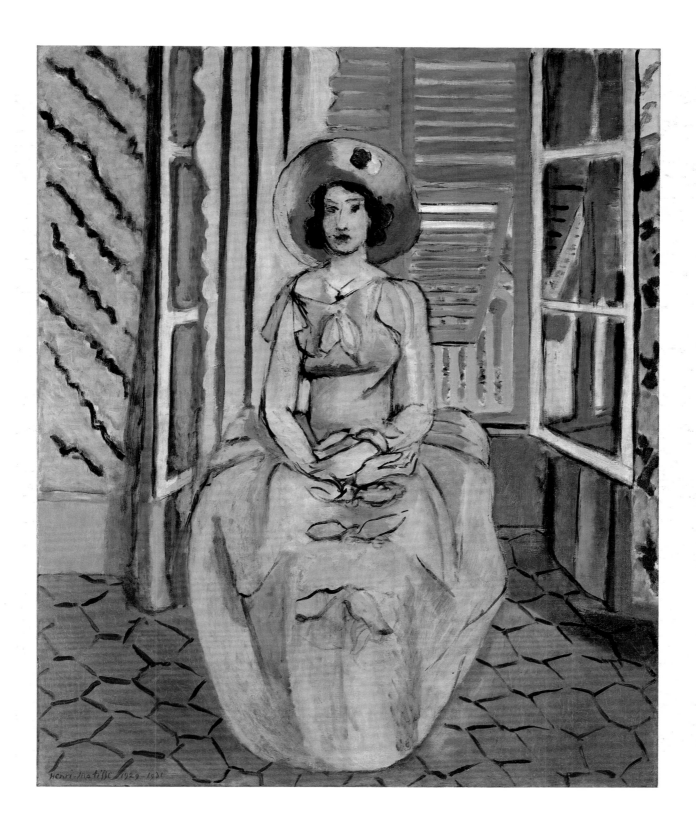

283. The Yellow Dress
La robe jaune

Nice, place Charles-Félix, 1929–31

Oil on canvas, 39¼ × 31¾" (99.7 × 80.7 cm)
Signed and dated lower left: "Henri-Matisse 1929–1931"
The Baltimore Museum of Art. The Cone Collection, formed by
Dr. Claribel Cone and Miss Etta Cone of Baltimore, Maryland

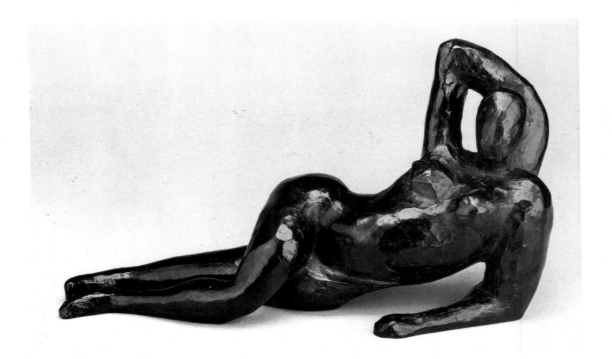

284. Reclining Nude (II)
Nu couché (II)

Nice, place Charles-Félix, [1927]

Bronze, 11¼ × 19¾ × 6″ (28.5 × 50.2 × 15.2 cm)
Inscribed: "No. 8." Founder C. Valsuani
The Minneapolis Institute of Arts. Gift of The Dayton Hudson
Corporation, Minneapolis

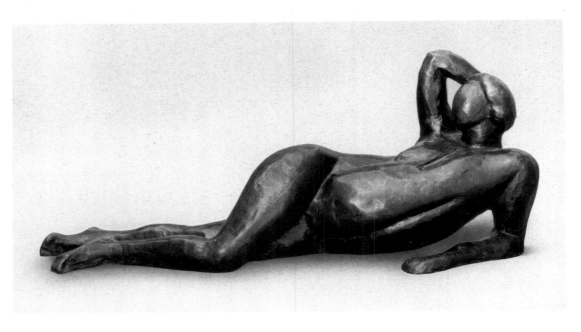

285. Reclining Nude (III)
Nu couché (III)

Nice, place Charles-Félix, [1929]

Bronze, 7⅜ × 18⅜ × 6″ (18.7 × 46.5 × 15.1 cm)
Inscribed: "7/10"
Hirshhorn Museum and Sculpture Garden, Smithsonian Institution,
Washington, D.C. Gift of Joseph H. Hirshhorn, 1966

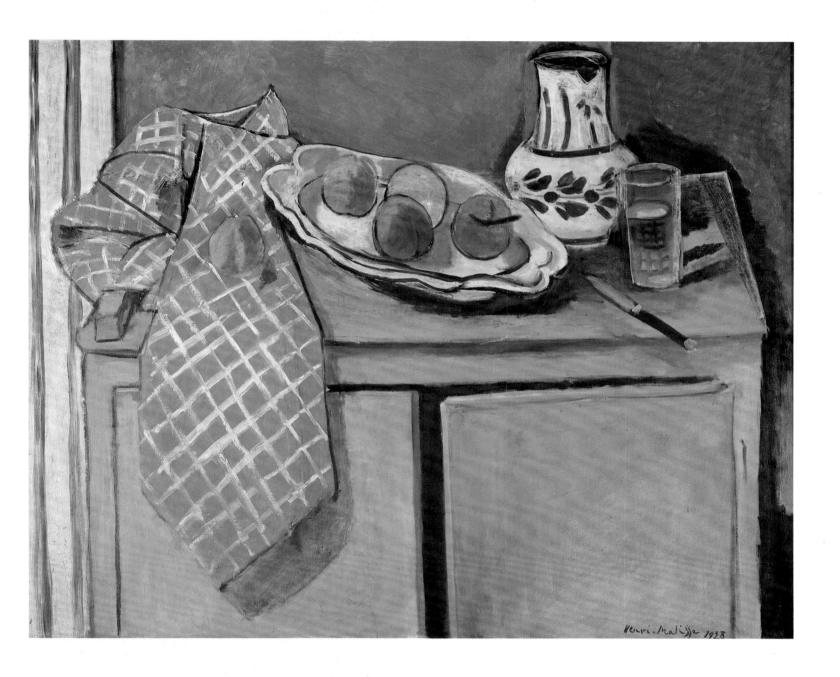

286. Still Life on a Green Sideboard
Nature morte au buffet vert

[Nice, place Charles-Félix, summer] 1928

Oil on canvas, 32⅛ × 39⅜" (81.5 × 100 cm)
Signed and dated lower right: "Henri-Matisse 1928"
Musée National d'Art Moderne, Centre Georges Pompidou, Paris

288. The Lamé Robe
La robe lamée

Nice, place Charles-Félix, October 1932

Pencil on paper, 12¾ × 10″ (32.4 × 25.4 cm)
Signed and dated lower left: "Henri-Matisse / Oct. 1932"
Yale University Art Gallery, New Haven, Connecticut.
Gift of Stephen C. Clark

287. The Persian Model
La persane

Nice, place Charles-Félix, 1929

Pencil on paper, 21⅞ × 15″ (55.5 × 38 cm)
Signed and dated lower left: "Henri Matisse 1929"
Kunsthaus Zug, Switzerland. The Haab Collection
Formerly collection Kenneth Clark

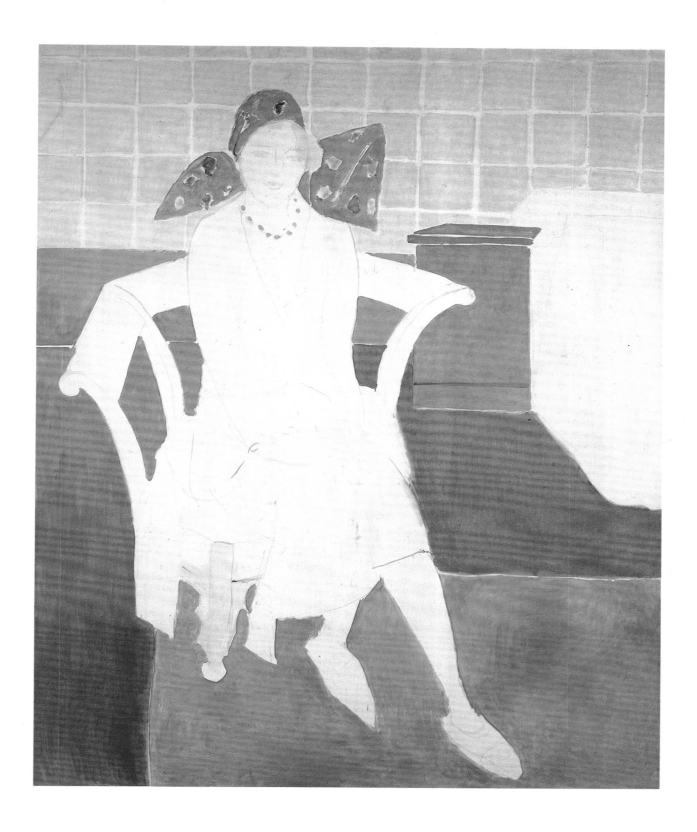

289. Woman with a Madras Hat
Femme au madras

Nice, place Charles-Félix, [1929–30]

Oil on canvas, 70⅞ × 59⅞″ (180 × 152 cm)
Not signed, not dated
Private collection

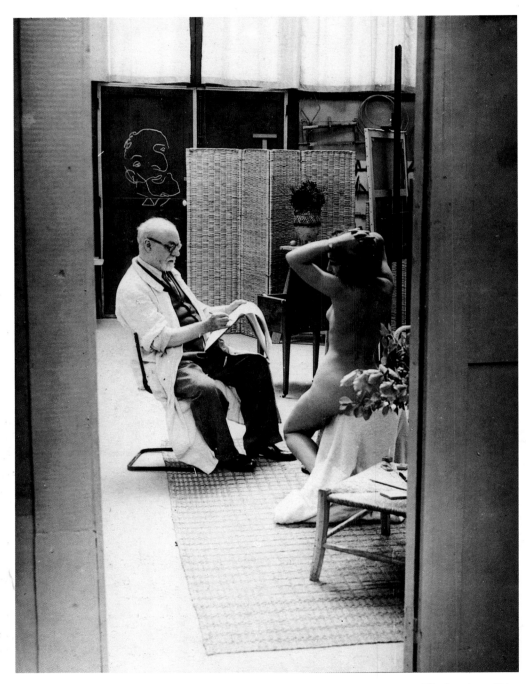

Matisse drawing the model Wilma Javor at the Villa Alésia studio, Paris, summer 1939. The drawing will be depicted in his painting *Reader on a Black Background* (pl. 321). Photograph by Brassaï.

PART VI ✦ 1930–1943

THEMES AND VARIATIONS

Matisse stopped making easel paintings in 1929, not fully to begin again until 1934–35. Some of his most original works in this medium were yet to be created, but never again did the very practice of painting have quite the same absolute priority as before. Painting increasingly became a means for releasing the presence of color, conceived as if some pure and independent element, aloof even from the means of its application.

The return to formal simplicity around 1930 returned Matisse to the kind of clarity he had achieved in works like *Dance (II)* (pl. 125) and *Music* (pl. 126) in 1909–10; but much had changed. The sensuality of his paintings of the 1920s had resided as much in the settings of the figures as in the figures themselves. When he reprised *Dance* to fulfill a mural commission for the Barnes Foundation (pl. 291), what attracted him was how he could form clear-cut figures into an expanding surface pattern by giving equal weight to the spaces between them. What mattered now was a pattern of color that looked as if it had found its way onto a picture of its own accord.

Matisse's use of prepainted cut paper to design the Barnes mural allowed him to touch and manipulate color as an autonomous element. But even before he began, in the early 1940s, to make independent paper cutouts, he was setting down areas of color as discretely and flatly and brightly as possible, erasing a previous day's efforts to keep the picture always fresh; thus *Woman in Blue* (pl. 317), for example, seems almost a collage of color, a marquetry of the thinnest veneers.

When he first returned to easel painting in the mid-1930s, his principal subject was the female nude (pls. 304–306, 309). Increasingly, however, his model is shown in decorative costumes—a striped Persian coat (pls. 314, 315), a Rumanian blouse

(pls. 324, 328)—and the decorativeness and the very construction of a costume and of a painting are offered as analogous. What developed were groups of paintings showing his model in similar or different poses, costumes, and settings: a sequence of themes and variations that gained in mystery and intensity as it unfolded. By the end of the 1930s, Matisse was making both startlingly simplified works, such as the culminating *Rumanian Blouse* (pl. 328), and extremely poetic compositions, such as the group showing a woman asleep or seated at a table surrounded by vegetation (pls. 331–334), works that remind us, again, how the pastoral landscape persisted in his dreams.

The artist's touch, restrained in this new, more deliberated way of painting, nonetheless gains in the unequivocal directness imposed upon it. So does his drawing, which becomes clearer and more condensed than at any earlier time. At the beginning of the decade, the etchings he made to illustrate an edition of Mallarmé's poems (pls. 295–300) had an almost neoclassical quality to their elegant, filament-like lines—a quality fully appropriate to the mythological themes from antiquity that they introduced into Matisse's art of this period. The drawings of nude models in his studio that he made in the middle to late 1930s (pls. 307, 308) are equally disciplined, but additionally possess a grace and poise, and an abundant sensuality, that exceed anything of the sort he had attempted earlier. In 1941, illness and then surgery left him with mainly drawing on which he could concentrate. His famous sequences of *Themes and Variations* drawings (pls. 335–344) effectively summarize a principal motif of this period's work; they comprise suites of successive images, each a reverie on a single subject, what Matisse called "a motion picture film of the feeling of an artist."

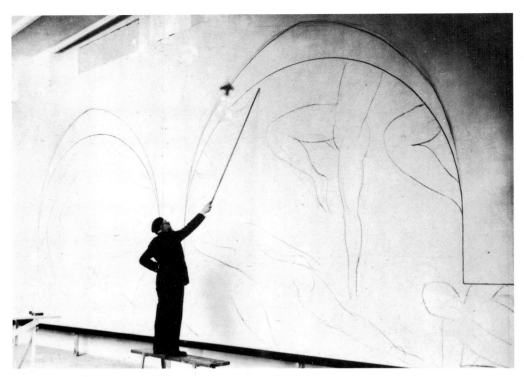

Matisse at work on the first version (pl. 290) of the Barnes Foundation *Dance* in his temporary studio at no. 8, rue Désiré-Niel, Nice, 1931.

1930–31 SEASON

1930 (continued)

EARLY OCTOBER: Is interviewed in Paris by Tériade about his trip to Tahiti and subsequent visit to the United States. In the interview, published on October 20 and 27 in *L'intransigeant*, he enthusiastically describes the collection of the Barnes Foundation and the light in New York City, saying he found there what he had vainly sought in Tahiti, "a very pure, non-material light." He had traveled, he said, because he had always been conscious of "another space in which the objects of my reveries evolved" and was seeking "something other than real space."

MID-OCTOBER: Is in Nice; remains there until early December.

NOVEMBER 16: Has accepted by this date the commission from Dr. Barnes and has probably begun a series of studies for the project in small format.

DECEMBER: Makes his third trip to America. Is met at the pier in New York by the philosopher John Dewey, delegated by Dr. Barnes to welcome him. Matisse goes to Merion to study the site for the mural and evaluate the problems involved. Visits Etta Cone in Baltimore.

1931

JANUARY 3: Matisse sails from Brooklyn on the *Bremen*. Arrives in Cherbourg on January 9; goes to Paris, then travels on to Nice.

George L. K. Morris, the American abstract painter, has met Matisse on board ship and travels on the boat-train with him to Paris. His diary entries will become the basis for the reminiscence "A Brief Encounter with Matisse," published in *Life* magazine in 1970.

In Nice, will work on the mural commission for Dr. Barnes. To aid its composition, he uses painted-and-cut paper and has photographs taken of its various states. Rents a vacant warehouse at no. 8, rue Désiré-Niel to use as a studio. Matisse will discard his first attempt at the mural (a version rediscovered only in 1992), and begin what will become the first completed version (pl. 290). In the years 1931–33, while absorbed by this commission, apparently begins no new easel paintings. However, he does work in sculpture. *The Back (IV)* (pl. 294), the most simplified of the series, parallels *Dance* and similarly exemplifies his new purification of means.

MAY 17–OCTOBER 6: Memorial exhibition at The Museum of Modern Art, New York, of the collection bequeathed to the Museum by Lillie P. Bliss, one of its founders. Among the works are two paintings by Matisse, the first by the artist to enter the collection of a public museum in New York.

JUNE 16–JULY 25: After his early 1930 exhibition at the Thannhauser gallery in Berlin, the second of his four 1930–31 retrospective exhibitions is held, at the Georges Petit gallery in Paris. These exhibitions mark the beginning of a new period of broad, international recognition of his art. The Paris exhibition, his first retrospective in that city since 1910, is organized by Josse Bernheim, Gaston Bernheim de Villers, and Étienne Bignou, and includes 141 paintings (two-thirds of them from the recent Nice period, but also many important early canvases), one sculpture, and a selection of prints and drawings. It is accompanied by a special number of the journal *Cahiers d'art*. Matisse is in Paris for a banquet in his honor on June 16. At that time, meets Alfred H. Barr, Jr., and his wife, Margaret Scolari Barr, who are in Paris to prepare for the Matisse exhibition planned for November 1931 at The Museum of Modern Art. Returns to Nice on July 13.

SUMMER: At work on a commission from Albert Skira to illustrate a new edition of the poems of Stéphane Mallarmé, which will be prepared by numerous drawings and trial etchings. This illustrated book, Matisse's first, develops and expands the mythical iconography of his art some twenty years before.

AUGUST 9–SEPTEMBER 15: Retrospective exhibition at the Kunsthalle Basel; includes 111 paintings, many from the Paris exhibition, augmented by early canvases from Swiss and German collections, and numerous drawings, prints, and sculptures.

SEPTEMBER 4: Is in Turin on his way to Padua; will stop in Milan, where he will see Leonardo da Vinci's fresco *The Last Supper*.

1931–32 SEASON

AUTUMN: Back in Nice, continues to work on *Dance* for Dr. Barnes and on the illustrations to Mallarmé.

Pierre Matisse, who had previously worked at the Dudensing galleries, opens his own gallery in New York.

NOVEMBER 3–DECEMBER 6: Retrospective exhibition at The Museum of Modern Art, New York, organized by Alfred H. Barr, Jr. Containing seventy-eight paintings, plus many drawings, prints, and sculptures, it is not as large as the preceding exhibitions in Berlin, Paris, and Basel, but offers a more evenly balanced view of Matisse's career, with some half of the paintings dating before 1917. The exhibition is praised by nearly all the New York art critics; Meyer Schapiro's "Matisse and Impressionism" stresses the empirical basis of his art.

NOVEMBER 14: Birth in Paris of Marguerite and Georges Duthuit's son, Claude. André Masson is the child's godfather. In 1932 Matisse will visit Masson at Saint-Jean-de-Grasse, and a friendship will develop between the two.

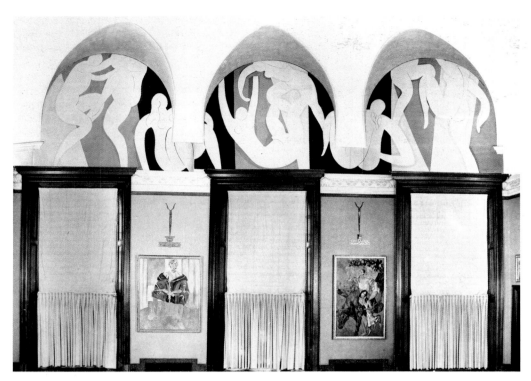

The second version (pl. 291) of *Dance* as installed in the Barnes Foundation, occupying three lunettes, each above a tall window. On the wall, at left: *The Seated Riffian* of 1912–13.

1932

JANUARY 25: An homage to Manet titled "Édouard Manet vu par Henri-Matisse," an interview with Tériade, is published in *L'intransigeant*, in connection with the forthcoming Manet centennial exhibition.

SPRING: Completes the first version of the Barnes mural (pl. 290). Is dismayed to discover an error in its dimensions; feeling he cannot adjust the composition, decides to undertake a second version.

JULY: Is in Paris, where he visits Etta Cone and presumably sees the Manet centennial exhibition held at the Musée de l'Orangerie, June 16–October 9.

1932–33 SEASON

AUTUMN: Back in Nice, works on the second version of the Barnes mural, *Dance* (pl. 291), whose design will be well advanced by the end of November.

OCTOBER: Publication by Albert Skira of *Poésies de Stéphane Mallarmé*, with twenty-nine etchings by Matisse (pls. 295–300). The following spring, Etta Cone will purchase a group of 250 drawings, prints, and copperplates for this book.

NOVEMBER 22–DECEMBER 17: Exhibition at the Pierre Matisse gallery, New York, of the fifty drawings chosen by Matisse for the 1920 publication *Cinquante dessins*.

1933

MID-JANUARY: Spends one week in the Balearic Islands in Spain.

FEBRUARY: First issue of *Minotaure*, the Surrealist review, is published, with Albert Skira as administrative director and E. Tériade as artistic director. Paul Éluard's "Le miroir de Baudelaire" refers to Matisse's portrait of Baudelaire in *Poésies de Stéphane Mallarmé* and is accompanied by a drawing and an engraving by Matisse.

LATE FEBRUARY–APRIL: Matisse often sees André Masson in Nice and in Monte Carlo. Masson is at work on the decor and costumes for *Les présages* for the Ballets Russes de Monte Carlo.

MAY: Having recently completed the second version of the Barnes mural (pl. 291), in early May Matisse boards a ship (which also transports the mural) for New York; arrives on May 11. Is in Merion the next day; the mural is installed at the Barnes Foundation by May 15, and Matisse professes that he is delighted by its congruence with the architecture of its setting. Although taking the same subject as the 1909–10 *Dance* paintings (pls. 112, 125), the mural, monumental in its conception, is more classically restrained in color and in its implied movement. Nevertheless, this commission marks the point of his reengagement with the decorative compositional structures of his early years.

Before May 25, he visits the exhibition "American Sources of Modern Art" at The Museum of Modern Art; in June, the Museum's *Bulletin* will publish a note he has written about the exhibition.

Around this time, *The Art of Henri-Matisse* by Albert C. Barnes and Violette de Mazia is published in New York.

MAY 25: Sails from New York on the *Conte di Savoia*. Returns to Nice.

SUMMER: By mid-June, is in Saint-Jean-Cap-Ferrat. Exhausted by the long strain of work on the second version of the Barnes mural, he is taken ill; returns to Nice in mid-July to convalesce. On August 22, sees Fernand Léger, who is in Nice. Goes to Vittel to take the cure in late August; remains until mid-September.

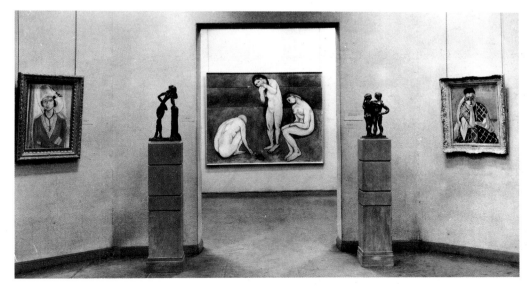

Installation view of Matisse's retrospective exhibition at The Museum of Modern Art, New York, November–December 1931. At center is *Bathers with a Turtle* (pl. 109); to its left is *La serpentine* (pl. 122); and to its right are *Two Women* (pl. 94) and *Woman with a Veil* (pl. 276).

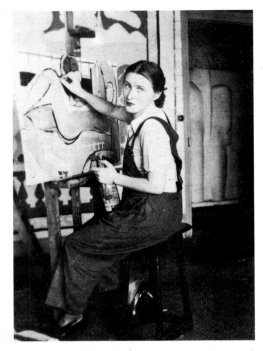

Photograph by Matisse of his new model, Lydia Delectorskaya, posed before a state of *Large Reclining Nude* (pl. 306) at no. 1, place Charles-Félix, Nice, mid-October 1935. In the right background: *The Back (IV)* (pl. 294) in plaster.

1933–34 SEASON

MID-SEPTEMBER: Returns to Nice from Vittel. Begins working again on what had been the first version of the Barnes Foundation *Dance* (pl. 290). Will remain in Nice until early June 1934.

This season, returns to easel painting, but makes only a small number of works. Among them are *Woman in a White Dress* (pl. 301) and the large *Interior with a Dog* (pl. 302), which initiates the flat decorative patterning that will characterize many 1930s paintings.

1934

JANUARY 23–FEBRUARY 24: Exhibition of his paintings at the Pierre Matisse gallery in New York.

MID-JUNE TO MID-AUGUST: In Paris, staying at the Hôtel Lutétia, is at work on illustrations for an edition of James Joyce's *Ulysses* to be published by the Limited Editions Club in New York in 1935. At the Pierre Loeb gallery, sees works by Joan Miró, with whom he is in correspondence in this period. Returns to Nice by August 14.

1934–35 SEASON

LATE SEPTEMBER–EARLY NOVEMBER: Is in Paris, staying at the Hôtel Lutétia. Returns to Nice November 5.

1935

FEBRUARY: Lydia Delectorskaya—who had been Matisse's studio assistant when he was working on the Barnes commission, and who was hired in 1934 as a companion to the ailing Mme Matisse—begins to pose for him. In February–March, he makes the first painting with her as model, *The Blue Eyes* (pl. 303); in April–May, paints *The Dream* (pl. 304). In April, begins *Large Reclining Nude* (pl. 306), also known as *The Pink Nude*, which he will work on through the end of October, photographically documenting its more than twenty states from relative naturalism to near abstraction. The simplified contours, flat patterning, and vivid coloration of the completed painting are characteristic of his art in the mid-1930s, when he makes many paintings and drawings of the nude. Also this year, makes decorative portraits of his new model, including *Hat with Roses* (pl. 311).

BY FEBRUARY 15: *Testimony Against Gertrude Stein* has been published as a supplement to the journal *transition*, no. 23. It contains excerpts from *The Autobiography of Alice B. Toklas* (first published in 1933) with refutations of those passages, charging their inaccuracy, by Matisse and other members of Stein's Parisian circle.

MARCH 18–MAY 19: Matisse lends two Kuba textiles to the exhibition "African Negro Art" at The Museum of Modern Art, New York. The two textiles are subsequently photographed by Walker Evans for the Museum-sponsored *Photographic Corpus of African Negro Art*.

MID-APRIL: Is in Paris for a few days; sees exhibitions of Goya, at the Bibliothèque

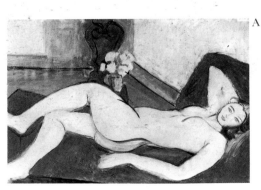
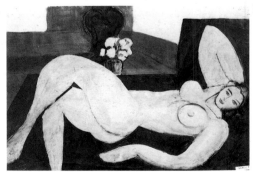
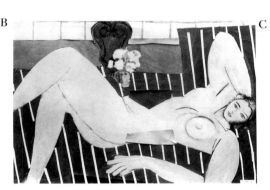

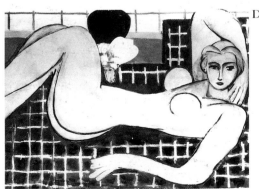
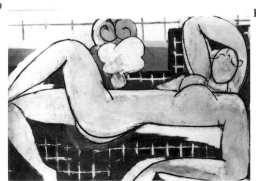
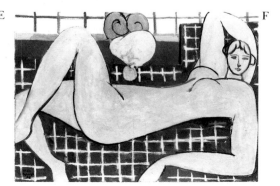

Six of the more than twenty documented states of *Large Reclining Nude* of 1935. (A) May 3, the first documented state. (B) May 20. (C) May 29. (D) September 6. (E) October 16. (F) October 30, the completed work (pl. 306).

Photograph by Matisse of Lydia Delectorskaya in the dress she is depicted wearing in *Woman in Blue* (pl. 317) and other works.

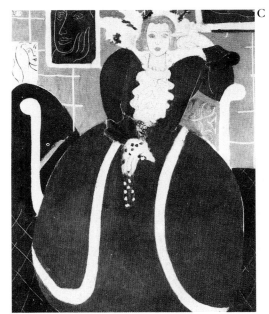

Four of the documented states of *Woman in Blue* of 1937. (A) February 26, the first documented state. (B) March 13. (C) March 23. (D) Late April, the completed work (pl. 317).

Nationale, and of Friesz. After returning to Nice, visits Bonnard at Le Cannet; sees him regularly and maintains a correspondence with him in this period.

MAY: Matisse's essay "On Modernism and Tradition" is published in the London journal *The Studio*. In it, discusses his invention of Fauvism and suggests that he has returned to a new version of it.

LATE JUNE: Is in Paris for a week. Sees the "Exposition de l'art italien de Cimabue à Tiepolo," comprised of over two thousand objects, at the Petit Palais.

JULY 1 TO MID-AUGUST: With Mme Matisse, is at Beauvezer, Basses-Alpes, for a rest in the mountains. Returns to Nice.

1935–36 SEASON

SEPTEMBER: Begins drawing on canvas a composition, presumably first intended as a cartoon for a tapestry, that will become *Nymph in the Forest* (pl. 353); he will work on it intermittently for seven years.

SEPTEMBER–OCTOBER: Makes a design in oil, *Window at Tahiti (I)*, for a Beauvais tapestry commissioned by Marie Cuttoli. Finding the completed tapestry, *Papeete*, not sufficiently faithful to his design, will make a second version in tempera, *Window at Tahiti (II)* (December 1935–March 1936), more suitable for interpretation in tapestry.

LATE NOVEMBER–EARLY DECEMBER: Is briefly in Paris for an exhibition of his drawings and sculpture at the Renou et Colle gallery. Returns to Nice, where he remains until mid-May 1936.

WINTER: Begins an important series of pen-and-ink drawings of nudes in his studio and models wearing decorative costumes, including embroidered Rumanian blouses (pls. 325, 326). Some of the drawings are exhibited at the Leicester gallery in London in January 1936.

This year, Aleksandr Romm's *Henri-Matisse* is published in Moscow; it will appear in English in 1937.

1936

JANUARY 11–FEBRUARY 24: Retrospective exhibition of thirty paintings, four sculptures, one pastel, and drawings and prints at the San Francisco Museum of Art.

SPRING: His important series of 1935–36 ink drawings is published in "Dessins de Matisse," a special number of *Cahiers d'art*; includes an essay by Christian Zervos and a poem to Matisse by Tristan Tzara.

MAY 2–20: Exhibition of twenty-seven recent works at the Paul Rosenberg gallery in Paris. *Nymph in the Forest* (pl. 353) is shown. When the canvas is returned, he will resume intermittent work on it, until about 1942.

MID-MAY TO LATE OCTOBER: Is in Paris, staying at no. 132, boulevard du Montparnasse.

JULY: The first version (pl. 290) of the Barnes Foundation *Dance* is purchased by the city of Paris through the efforts of Raymond Escholier, director of the Petit Palais.

JULY 16: Signs a three-year contract with Paul Rosenberg, who thus becomes his principal dealer.

OCTOBER: Tériade publishes in *Minotaure*, under the title "Constance du fauvisme," two statements Matisse had made to him about having distilled in his recent paintings the ideas of the last twenty years, thus returning to the methods he used before 1917.

1936–37 SEASON

LATE OCTOBER: Is in Nice, through late April 1937.

Begins in this season a series of decorative paintings of models in elaborate costumes—long striped Persian coats, Rumanian blouses, and sumptuous blue dresses—and often surrounded by flowers and plants. Lydia Delectorskaya and Hélène Galitzine pose for these vividly colored works, which include *Small Odalisque in a Purple Robe* (pl. 314), *Woman in a Purple Robe with Ranunculi* (pl. 315), and *Woman in Blue* (pl. 317). Also makes numerous drawings of these subjects and paints some more sparely abstracted works, such as *The Ochre Head* (pl. 316).

EARLY NOVEMBER: Donates Cézanne's *Three Bathers*, which he has owned since 1899, to the City of Paris.

NOVEMBER 23–DECEMBER 19: Exhibition of twenty-one of his paintings, dated from 1912 to 1936, at the Valentine gallery in New York.

1937

MAY: With Mme Matisse, is in Paris, staying at no. 132, boulevard du Montparnasse, preparing for his exhibition at the Petit Palais in June.

JUNE 1–29: One-artist exhibition of twenty-one paintings from 1936 and 1937 at the Paul Rosenberg gallery. At the same time, an exhibition of thirty-four works, mostly recent, is held at the Rosengart gallery, Lucerne.

JUNE 10: Serves on the jury of the Helena Rubinstein Prize, which is awarded to Henri Laurens, whose work he has known for many years.

JUNE 17–NOVEMBER 10: Represented by sixty-one paintings, effectively a small retrospective, in "Les maîtres de l'art indépendant, 1895–1937," an exhibition of some fifteen hundred works, organized by Raymond Escholier and shown at the Petit Palais.

EARLY JULY: Is in London. Returns to Paris, July 12.

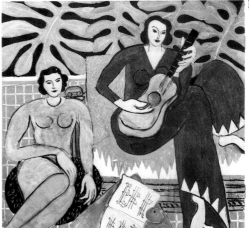

Four of the documented states of *Music* of 1939. (A) March 21. (B) March 30. (C) April 1. (D) April 8, the completed work (pl. 319).

JULY 19–LATE NOVEMBER: Works confiscated by the Nazis from German museums are shown in the exhibition "Degenerate Art" at the Hofgarten in Munich.

JULY 30–OCTOBER 31: Represented by six paintings in the exhibition "Origines et développement de l'art international indépendant" at the Jeu de Paume. Includes *Le luxe (I)* (pl. 102), *Piano Lesson* (pl. 188), and *The Moroccans* (pl. 192); also shown are African sculptures and objects belonging to eleven collectors, Matisse among them.

SEPTEMBER: Is hospitalized in Paris.

1937–38 SEASON

MID-OCTOBER: Returns to Nice; remains there through mid-June 1938.

NOVEMBER 16: Begins the painting *The Conservatory* (pl. 318), which he will work on intermittently until its completion in late May 1938. This and other paintings made during the same period, including *The Arm* (pl. 322)

and *The Striped Dress* (pl. 323), are more simplified and abstracted than most of those done the previous year.

DECEMBER: Publishes the essay "Divagations" in *Verve*; attacks academic art and especially the idea of correct drawing.

WINTER: Begins work on scenery and costumes for *Rouge et Noir* (also known as *L'étrange farandole*), to be produced by the Ballets Russes de Monte Carlo with choreography by Léonide Massine and music from Dmitri Shostakovich's First Symphony. The set designs are freely adapted from the Barnes Foundation *Dance* (pl. 291). Some of his curtain and costume designs are paper cutouts, his first works in this medium.

1938

JANUARY: Has been seriously ill with influenza. While convalescing, is interviewed by the writer Henry de Montherlant; the interview is published as "En écoutant Matisse" in the July 1938 issue of *L'art et les artistes*.

JANUARY 10–FEBRUARY 2: Exhibition "Matisse, Picasso, Braque, Laurens," at Kunstnernes Hus, Oslo, later seen at the Statens Museum for Kunst in Copenhagen and the Liljevalchs Konsthall in Stockholm. Matisse is represented by thirty-one paintings dating from 1896 to 1937, including *Woman on a High Stool (Germaine Raynal)* (pl. 170) and *The Painter in His Studio* (pl. 204). Picasso is represented by thirty-three works, including *Three Musicians* (now in The Museum of Modern Art) of 1921 and *Guernica* of 1937.

JUNE 10: Gives up his lease on the apartment at no. 1, place Charles-Félix, Nice.

BY JUNE 17: Is in Paris for the summer, staying at no. 132, boulevard du Montparnasse, where he makes drawings, probably including two abstracted charcoal reclining nudes (pls. 312, 313).

1938–39 SEASON

AUTUMN: Moves to the Hôtel Régina in the Cimiez suburb of Nice. While waiting for work to be completed on the Régina apartment, during September–October he stays at the British Hôtel in Cimiez; is settled in the Hôtel Regina in early November. Mme Matisse may be with him. Is in Nice through the end of May 1939.

OCTOBER 19–NOVEMBER 11: Joint exhibition "Picasso, Henri-Matisse" at the Boston Museum of Modern Art (now the Institute of Contemporary Art). Picasso is represented by twenty-four works, Matisse by fifteen.

OCTOBER 24–NOVEMBER 12: Has a one-artist exhibition at the Paul Rosenberg gallery in Paris.

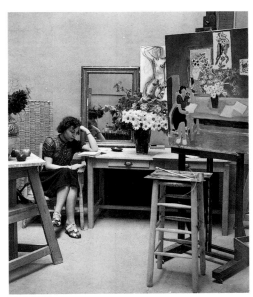

The model Wilma Javor at the Villa Alésia studio, Paris, summer 1939, assuming her pose for *Reader on a Black Background* (pl. 321), a state of which is at right. Photograph by Brassaï.

The Ballets Russes de Monte Carlo performing *Rouge et Noir*, with decor and costumes by Matisse, 1939.

NOVEMBER 15–DECEMBER 10: Exhibition of his paintings and drawings, from 1918 to 1938, at the Pierre Matisse gallery, New York.

NOVEMBER 16–DECEMBER 3: Paints *Le chant* for a commission for the overmantel of Nelson A. Rockefeller's apartment in New York. This winter, continues his series of *Rumanian Blouse* drawings (pl. 327) and in March will paint *Green Rumanian Blouse* (pl. 324).

1939

Remains in Nice until the end of May.

MID-MARCH: Mme Matisse has returned to Paris; this probably marks their separation.

MARCH 17: Begins work on *Music* (pl. 319); completed April 8. Hélène Galitzine and her cousin are models. The painting will be purchased the following year for the Albright Art Gallery (now the Albright-Knox Art Gallery) in Buffalo, New York.

MAY 11: Premiere of *Rouge et Noir* in Monte Carlo. During May, will work on revisions of the scenery, for performances beginning June 5 at the Théâtre National du Palais de Chaillot in Paris.

JUNE–SEPTEMBER: Stays at the Hôtel Lutétia in Paris and works at a studio lent him by the American sculptor Mary Callery at the Villa Alésia, rue des Plantes. Paints *Daisies* (pl. 320) and *Reader on a Black Background* (pl. 321) in a severely simplified, geometrically organized style. Is photographed in the studio by Brassaï with the Hungarian model Wilma

Javor, who poses for these works. During this summer, the process of legal separation from Mme Matisse becomes particularly onerous.

JUNE 30: At the auction in Lucerne of works confiscated from German museums in 1937 for the Nazi "Degenerate Art" exhibition, Pierre Matisse purchases his father's *Bathers with a Turtle* (pl. 109) on behalf of Joseph Pulitzer, Jr. Two other Matisse paintings and a sculpture are also sold: *Flowers and Ceramic Plate* (pl. 164), *The River Bank* of 1907, and a terra-cotta cast of *Reclining Nude (I)* (pl. 92).

JULY: Publishes in *Le point* his important essay "Notes d'un peintre sur son dessin," whose title recalls his famous "Notes d'un peintre" of 1908. In this new essay, discusses his conception of drawn "signs," how he feels his drawings evoke coloristic effects, and the importance to him of his models, for the emotional impetus they provide.

Writes to Jean Renoir, telling of his enthusiasm for the director's *Rules of the Game (La règle du jeu)* and expressing interest in the film's use of montage.

JULY 17: Goes to Toulouse for a one week stay, to see his sister-in-law Berthe, who is about to undergo surgery.

AUGUST 22: Goes to Geneva to see an exhibition at the Musée d'Art et d'Histoire of masterpieces of painting and tapestry from the Spanish state collection. Is obliged to leave after two days because of the imminence of war, and is back in Paris by August 27.

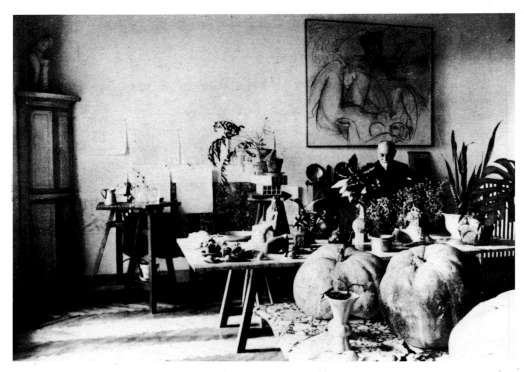

Matisse in his studio at the Hôtel Régina, Nice-Cimiez, c. 1940. On the wall: a state of *Nymph and Faun with Pipes* (pl. 352).

SEPTEMBER 1: Germany invades Poland. Great Britain and France will declare war on Germany on September 3.

EARLY SEPTEMBER: Is in Rochefort-en-Yvelines, near Rambouillet, staying at the Hôtel Saint-Pierre. Returns to Paris in early October.

Early in the war, his son Pierre will be allowed to return to the United States and Jean will be mobilized. His grandson, Claude, is in boarding school near Vichy. Marguerite is in Beauzelle with Mme Matisse, who has been alone since March.

1939–40 SEASON

MID-OCTOBER: Matisse returns to Nice, to the Hôtel Régina. Before leaving Paris, has all his work kept in the city stored at the Banque de France.

NOVEMBER 7: Returns a new contract (probably prepared in July 1939), which he has signed and approved, to Paul Rosenberg, then at Castel Foirac, Gironde. Mme Matisse and Marguerite are by now back in Paris, living on rue de Miromesnil.

DECEMBER: Begins *The Rumanian Blouse* (pl. 328), the culminating work in the series devoted to this subject, an extremely flattened, simplified painting which he will donate to the French state. This winter, also makes a series of equally simplified compositions showing his studio at the Hôtel Régina with a profusion of plants and still-life objects. *Still Life with a*

Sleeping Woman (pl. 333) and other works depict a model wearing a Rumanian blouse and resting on the corner of a marble table. *Dancer in Repose* (pl. 330) and *Interior with an Etruscan Vase* (pl. 331) offset the richness of incident, which includes depictions of Matisse's own work, with areas of dark ground. Such a concentrated series of ambitious paintings will not be repeated until the Vence interiors of the later 1940s.

1940

Is in Nice. Stays until the spring, at the Hôtel Régina.

EARLY JANUARY: Visits Bonnard at Le Cannet.

JANUARY 11: Pierre Matisse, in New York, writes to Etta Cone that his parents are separating. In this period, Matisse is deeply preoccupied with the legal problems surrounding the separation.

SPRING: In April, Germany invades Denmark and Norway, and in May overruns the Low Countries and invades France, trapping the Allied forces at Dunkirk. In June, Paris falls and France signs an armistice. The country is divided into a German-occupied zone in the north and the Vichy regime in the south.

EARLY APRIL: Paul Rosenberg visits him in Nice to select from the paintings completed in the preceding months.

LATE APRIL: Is in Paris, giving his address as no. 132, boulevard du Montparnasse, to final-

ize his separation from Mme Matisse and to prepare for a month-long trip to Brazil.

With Lydia Delectorskaya, leaves Paris about May 20 by train for the south, as Germany invades France. Arrives in Bordeaux, where he stays a few days. By May 25, is in Ciboure, near Saint-Jean-de-Luz, where he remains until the end of June. He had been due to leave France, alone, on June 8 for Rio de Janeiro but cancels plans, saying it "would be deserting."

JULY–AUGUST: Is in Saint-Gaudens, staying at the Hôtel Ferrière, from July 1 until after August 2, waiting for resumption of railway service, to return to Nice. By August 7 is in Carcassonne; by August 17 is in Marseille, where he makes a series of no fewer than eighteen portrait drawings of his grandson, Claude Duthuit (who is being sent to school in the United States in September).

1940–41 SEASON

BY AUGUST 29: Is back in Nice, in his rooms at the Hôtel Régina.

LATE SEPTEMBER: Completes *The Dream* (pl. 334), begun the preceding season, a more abstracted version of the figure in *Still Life with a Sleeping Woman* (pl. 333).

OCTOBER: Declines an invitation from Mills College in California to take a teaching position there.

WINTER: Is in correspondence with Picasso and Bonnard. In poor health (suffers worsening intestinal disorders and a tumor is discovered), he is able to work very little. In December, however, paints the highly simplified and vividly colored *Still Life with Oysters* (pl. 348).

BEFORE DECEMBER 25: Varian Fry, the chief American agent for the Emergency Rescue Committee, offers to help Matisse get a visa and passage to the United States. The artist refuses to be persuaded to leave.

1941

JANUARY 16: In Lyon, undergoes surgery for duodenal cancer at the Clinique du Parc. Remains at the clinic until March 31. Convalesces at the Grand Nouvel Hôtel in Lyon until late May. Does not paint again until the summer.

APRIL 10: Pierre Courthion begins a series of nine interviews with him. Stenographic transcripts of the conversations are intended for a proposed memoir to be designed and illustrated by Matisse and published by Skira in Geneva.

MAY 23: Arrives back in Nice, at the Hôtel Régina; remains in Nice for the rest of the year. Has suffered damage to abdominal muscles; is now confined to bed much of the time, and will remain a semi-invalid for the rest of his life.

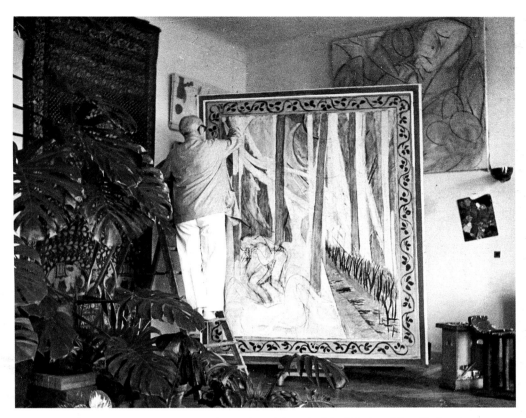

Matisse at work on *Nymph in the Forest* (pl. 353) in his studio at the Hôtel Régina, Nice-Cimiez, August 1941. Photograph by Varian Fry.

JUNE: Germany invades the Soviet Union.

1941–42 SEASON

AUGUST: Varian Fry takes a series of photographs of Matisse at the Régina. Several show him at work on *Nymph in the Forest* (pl. 353), still not completed. Painting again now, although not as regularly as before his operation, he begins a sequence of extremely bold still lifes. The most radical is *Still Life with a Magnolia* (pl. 349). It and works such as *Ivy in Flower* (pl. 347) present circumscribed forms as if pasted onto a flat ground. They anticipate the method of the paper cutouts he will make in increasing quantity through this decade.

OCTOBER 30: Having become dissatisfied with the projected memoir that was to be based on the interviews with Courthion, Matisse proposes instead, when Skira visits him on this date, to illustrate Pierre de Ronsard's *Amours*. This will become *Florilège des amours de Ronsard*, published in 1948.

Works in bed on a series of drawings, *Themes and Variations*, continuing through 1942; it comprises seventeen groups of freely executed pen or pencil "variations" on a figural or still-life subject announced by a "theme" drawing, usually in charcoal (pls. 335–344). The series will be published in 1943 by Martin Fabiani as *Dessins: Thèmes et variations*.

NOVEMBER 10–30: Exhibition of his recent ink and charcoal drawings at the Louis Carré gallery in Paris.

NOVEMBER–DECEMBER: Becomes acquainted with Louis Aragon and Elsa Triolet, who are living in Nice.

DECEMBER 7: Japan attacks Pearl Harbor. The United States formally declares war the following day.

1942

Is in Nice throughout the year.

JANUARY: Begins studies for the illustrations *Florilège des amours de Ronsard*.

JANUARY–FEBRUARY: Gives two interviews broadcast over Vichy radio. Excerpts in English translation will appear in 1951 in *Matisse: His Art and His Public* by Alfred H. Barr, Jr.

MARCH: Is at work on *Dessins: Thèmes et variations*, meeting with Aragon, who writes its introduction, "Matisse-en-France." Aragon's text records conversations with Matisse in which the artist discusses his understanding of "signs."

MAY–JULY: Gall-bladder attacks keep Matisse bedridden for more than two months and largely prevent him from working until mid-August.

EARLY SUMMER: By June 7 has received, as a gift from Picasso, a portrait of Dora Maar.

1942–43 SEASON

SEPTEMBER: Is at work, in bed, on *Dancer and Rocaille Armchair on a Black Background* (pl. 345).

1943

Is in Nice, at the Hôtel Régina, until late June. He works mainly in bed. One of his models is his nurse, Monique Bourgeois, who will later become Sister Jacques of the Dominican Nuns at Vence and play an important role in the realization of the Vence chapel.

JANUARY: Paints the vividly patterned *Michaela* (pl. 350). By January 20, has completed all but two or three pages of his Ronsard illustrations; the rest are completed by February 5.

FEBRUARY: Paints the ornamental interior *The Lute* (pl. 351) and the more severe *Tulips and Oysters on a Black Background* (pl. 346); begins work on illustrations to *Poèmes de Charles d'Orléans*.

FEBRUARY 24: Louis Gillet publishes an interview with Matisse in *Candide*; recounts his description of the aged Renoir.

Makes paper cutouts. From these will develop the book *Jazz* (pls. 357–367), which he will begin to work on in a concentrated way in the autumn.

MAY 23: In the garden of the Jeu de Paume in Paris, the German authorities burn hundreds of works of modern art.

END OF JUNE: Nice is now likely to be evacuated, having become a potential target for bombardment. Matisse goes to the hill town of Vence for safety.

Matisse at work on *Dancer and Rocaille Armchair on a Black Background* (pl. 345) at the Hôtel Régina, Nice-Cimiez, September 1942. Photograph by André Ostier.

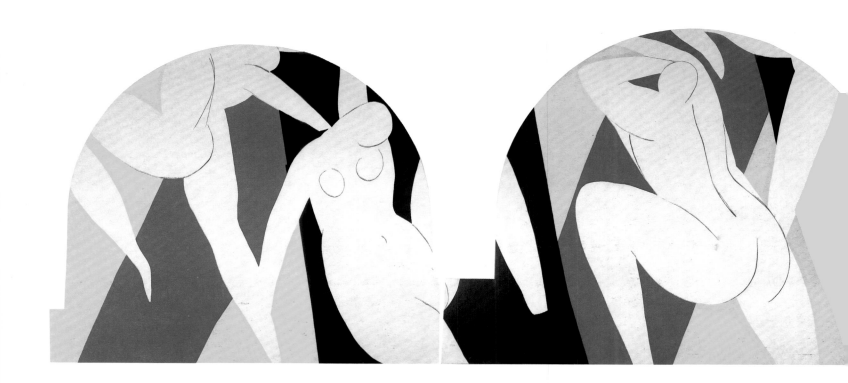

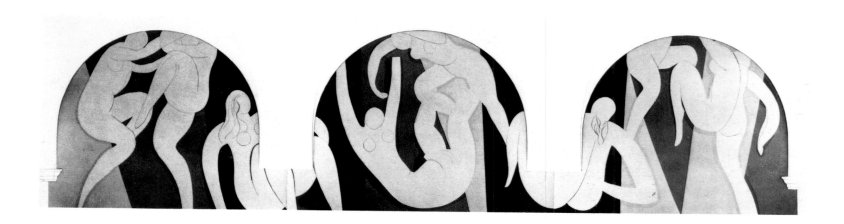

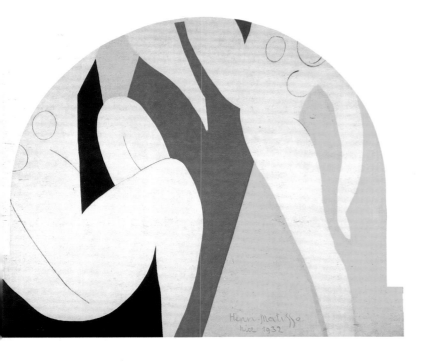

290. Dance (first version)
 La danse (première version)

Nice, rue Désiré-Niel, early 1931–spring 1932 [and autumn 1933]

Oil on canvas, three panels: 11′2″ × 12′8⅜″ (340 × 387 cm);
11′8½″ × 16′4″ (355 × 498 cm); and 10′11″ × 12′10″ (333 × 391 cm)
Signed and dated lower right of right panel: "Henri-Matisse / Nice 1932"
Musée d'Art Moderne de la Ville de Paris

Opposite page:
291. Dance
 La danse

Nice, rue Désiré-Niel, [autumn] 1932–spring 1933

Oil on canvas, three panels: 12′7½″ × 15′7″ (385 × 475 cm);
13′1½″ × 16′5″ (400 × 500 cm); and 12′3½″ × 15′5″ (375 × 470 cm)
Signed and dated lower right of right panel: "HENRI MATISSE / Nice 1933"
The Barnes Foundation, Merion Station, Pennsylvania

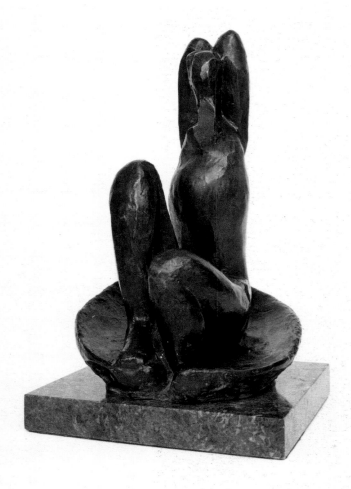

292. Venus in a Shell (I)
Vénus à la coquille (I)

Nice, place Charles-Félix, [late summer 1930 or 1931]
Bronze, 12¼ × 7¼ × 8⅛″ (31 × 18.3 × 20.6 cm)
Inscribed: "2/10 HM"
The Museum of Modern Art, New York. Gift of Pat and Charles Simon

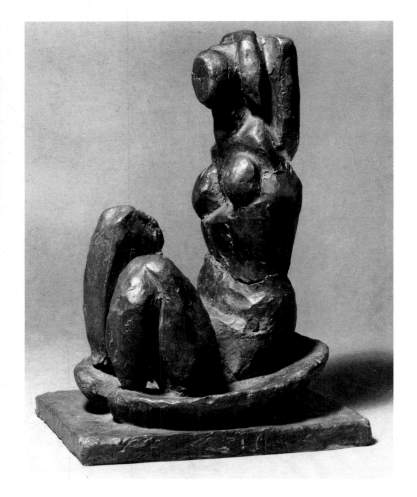

293. Venus in a Shell (II)
Vénus à la coquille (II)

Nice, place Charles-Félix, [1932]
Bronze, 12¾ × 8 × 9⅛″ (32.4 × 20.3 × 23.2 cm)
Inscribed: "HM 3/10"
Founder C. Valsuani
Hirshhorn Museum and Sculpture Garden, Smithsonian Institution,
Washington, D.C. Gift of Joseph H. Hirshhorn, 1966

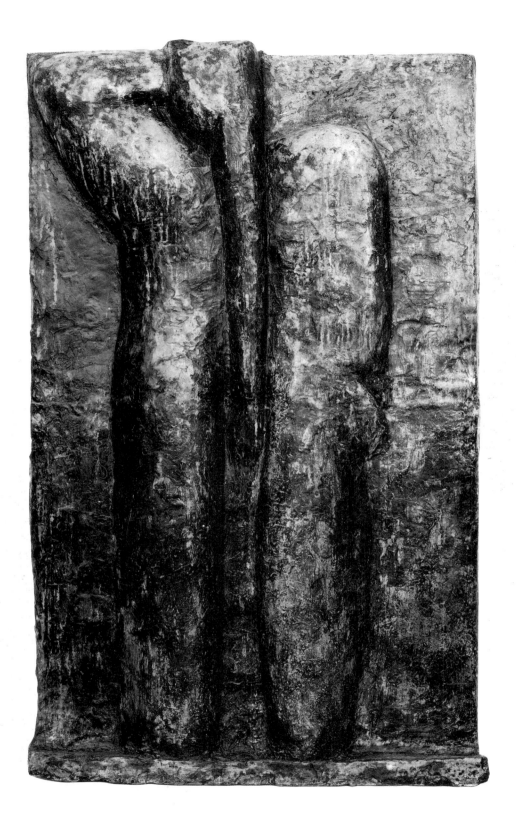

294. The Back (IV)
Nu de dos (IV)

Nice, place Charles-Félix, [c. 1931]

Bronze, 6′2″ × 44¼″ × 6″ (188 × 112.4 × 15.2 cm)
Not inscribed, not dated
Founder C. Valsuani
The Museum of Modern Art, New York.
Mrs. Simon Guggenheim Fund

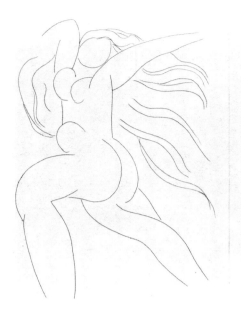

LE GUIGNON

Au-dessus du bétail ahuri des humains
Bondissaient en clartés les sauvages crinières
Des mendieurs d'azur le pied dans nos chemins.

Un noir vent sur leur marche éployé pour bannières
La flagellait de froid tel jusque dans la chair,
Qu'il y creusait aussi d'irritables ornières.

9

Poésies de Stéphane Mallarmé

Published Lausanne, Albert Skira & Cie, October 1932; etchings composed Nice, place Charles-Félix, and Paris, summer 1931–autumn 1932

Twenty-nine etchings, each page 13⅛ × 9⅞″ (33.2 × 25.3 cm)
The Museum of Modern Art, New York.
The Louis E. Stern Collection

295. *Le guignon*

Fausses entre elle-même & notre chant crédule;
Et de faire, aussi haut que l'amour se module,
Évanouir du songe ordinaire de dos
Ou de flanc pur suivis avec mes regards clos,
Une sonore, vaine & monotone ligne.

Tâche donc, instrument des fuites, ô maligne
Syrinx, de refleurir aux lacs où tu m'attends!
Moi, de ma rumeur fier, je vais parler longtemps
Des déesses; & par d'idolâtres peintures,
À leur ombre enlever encore des ceintures:
Ainsi, quand des raisins j'ai sucé la clarté,
Pour bannir un regret par ma feinte écarté,
Rieur, j'élève au ciel d'été la grappe vide
Et, soufflant dans ses peaux lumineuses, avide
D'ivresse, jusqu'au soir je regarde au travers.

O nymphes, regonflons des SOUVENIRS divers.
»Mon œil, trouant les joncs, dardait chaque encolure
»Immortelle, qui noie en l'onde sa brûlure
»Avec un cri de rage au ciel de la forêt;
»Et le splendide bain de cheveux disparaît
»Dans les clartés et les frissons, ô pierreries!
»J'accours; quand, à mes pieds, s'entrejoignent (meurtries

80

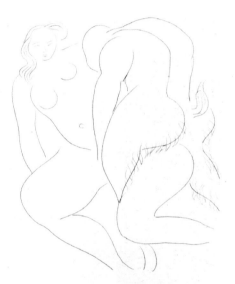

296. *Nymphe et faune*

PROSE

POUR DES ESSEINTES

Hyperbole! de ma mémoire
Triomphalement ne sais-tu
Te lever, aujourd'hui grimoire
Dans un livre de fer vêtu?

Car j'installe, par la science,
L'hymne des cœurs spirituels
En l'œuvre de ma patience,
Atlas, herbiers & rituels.

Nous promenions notre visage
(Nous fûmes deux, je le maintiens)
Sur maints charmes de paysage,
O sœur, y comparant les tiens.

92

297. *Prose pour des Esseintes*

Ses purs ongles très haut dédiant leur onyx,
L'Angoisse, ce minuit, soutient, lampadophore,
Maint rêve vespéral brûlé par le Phénix
Que ne recueille pas de cinéraire amphore

Sur les crédences, au salon vide : nul ptyx,
Aboli bibelot d'inanité sonore
(Car le Maître est allé puiser des pleurs au Styx
Avec ce seul objet dont le Néant s'honore).

Mais proche la croisée au nord vacante, un or
Agonise selon peut-être le décor
Des licornes ruant du feu contre une nixe,

Elle, défunte nue en le miroir, encor
Que, dans l'oubli fermé par le cadre, se fixe
De scintillations sitôt le septuor.

128

298. *La chevelure*

299. *Le cygne*

APPARITION

La lune s'attristait. Des séraphins en pleurs
Rêvant, l'archet aux doigts, dans le calme des fleurs
Vaporeuses, tiraient de mourantes violes
De blancs sanglots glissant sur l'azur des corolles
— C'était le jour béni de ton premier baiser.
Ma songerie aimant à me martyriser
S'enivrait savamment du parfum de tristesse
Que même sans regret & sans déboire laisse
La cueillaison d'un Rêve au cœur qui l'a cueilli.
J'errais donc, l'œil rivé sur le pavé vieilli
Quand avec du soleil aux cheveux, dans la rue
Et dans le soir, tu m'es en riant apparue
Et j'ai cru voir la fée au chapeau de clarté
Qui jadis sur mes beaux sommeils d'enfant gâté
Passait, laissant toujours de ses mains mal fermées
Neiger de blancs bouquets d'étoiles parfumées.

14

300. *Apparition*

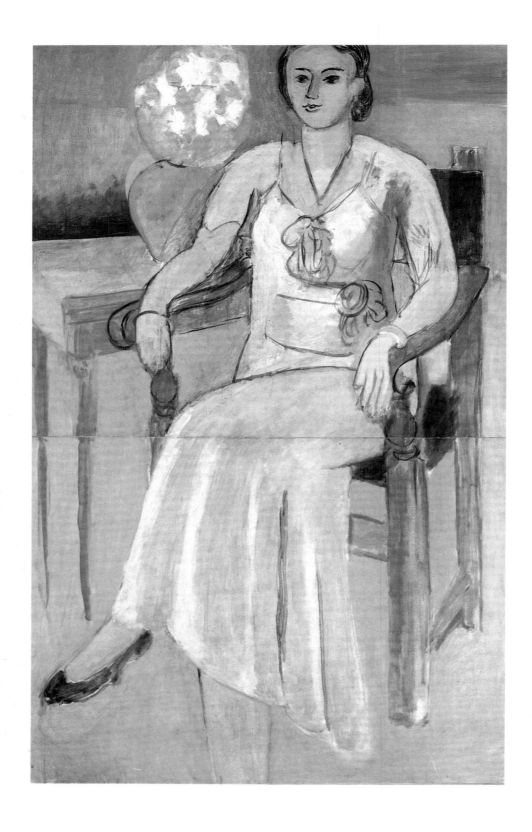

301. Woman in a White Dress
Femme à la robe blanche

Nice, place Charles-Félix, [1933–34]

Oil on canvas, 44½ × 28¾″ (113 × 73 cm)
Not signed, not dated
Private collection

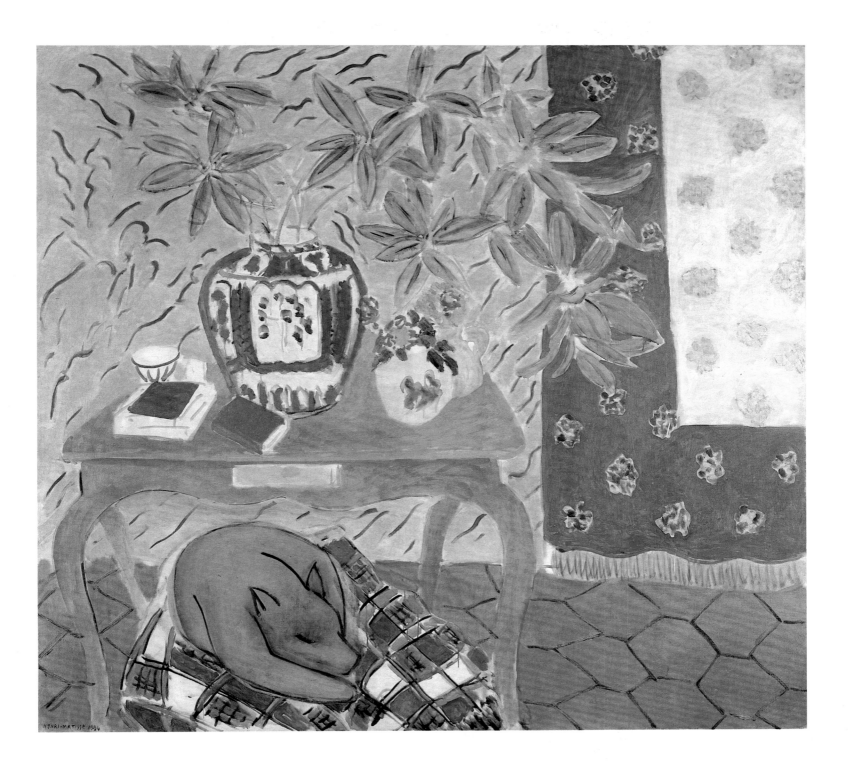

302. Interior with a Dog / The Magnolia Branch
L'intérieur au chien / La branche de magnolia

Nice, place Charles-Félix, [winter–spring] 1934

Oil on canvas, 61 × 65¾" (155 × 167 cm)
Signed and dated lower left: "HENRI-MATISSE 1934"
The Baltimore Museum of Art. The Cone Collection, formed by
Dr. Claribel Cone and Miss Etta Cone of Baltimore, Maryland

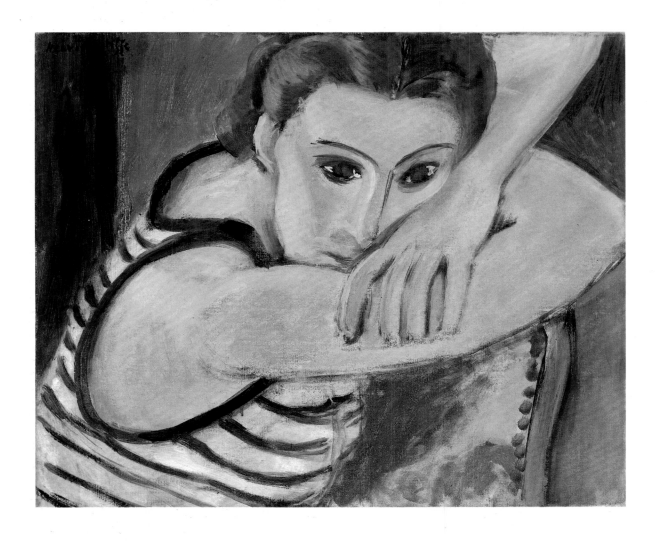

303. The Blue Eyes
Les yeux bleus

Nice, place Charles-Félix, late February–March 1935

Oil on canvas, 15 × 18″ (38.1 × 45.7 cm)
Signed and dated upper left: "Henri-Matisse / 35"
The Baltimore Museum of Art. The Cone Collection, formed by
Dr. Claribel Cone and Miss Etta Cone of Baltimore, Maryland

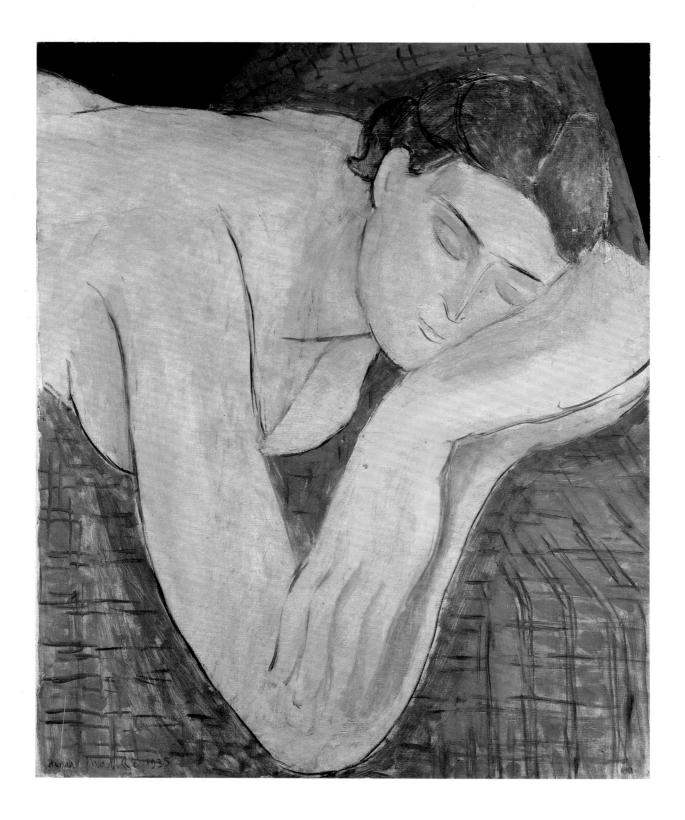

304. The Dream
 Le rêve

Nice, place Charles-Félix, early April to mid-May 1935

Oil on canvas, 31⅞ × 25⅝″ (81 × 65 cm)
Signed and dated lower left: "Henri-Matisse 1935"
Musée National d'Art Moderne, Centre Georges Pompidou, Paris

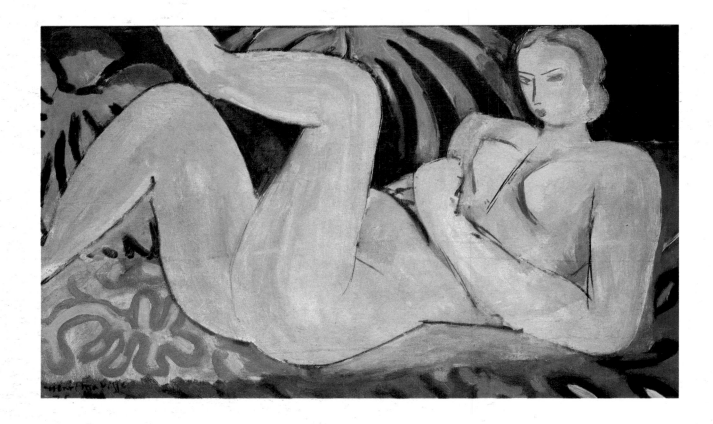

305. Reclining Nude / Nude with Heel on Knee
Nu allongé / Nu au talon sur le genou

Nice, place Charles-Félix, March 4–14, 1936

Oil on canvas, 15 × 24″ (38 × 61 cm)
Signed and dated lower left: "Henri Matisse / 36"
Private collection, Geneva, courtesy Daniel Varenne Gallery, Geneva

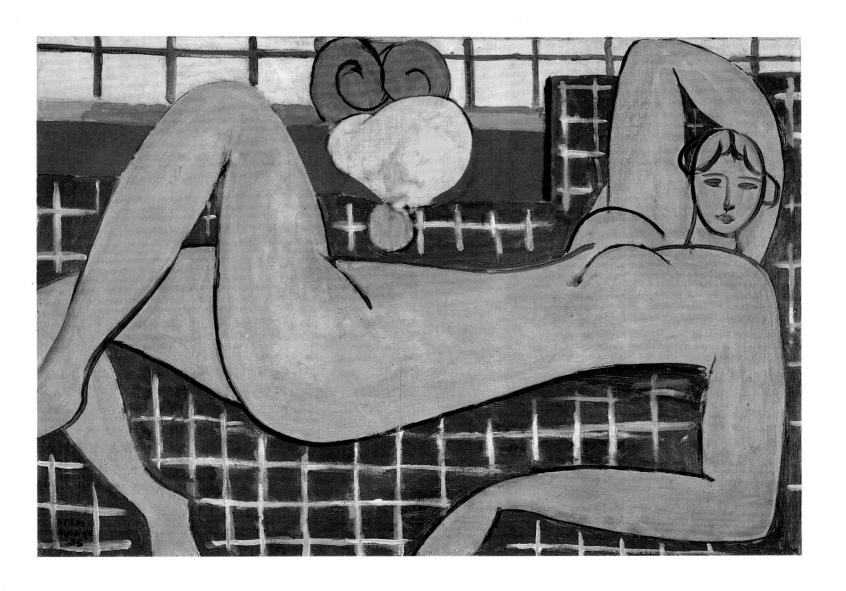

306. Large Reclining Nude / The Pink Nude
Grand nu couché / Nu rose

Nice, place Charles-Félix, late April–October 31, 1935

Oil on canvas, 26 × 36½″ (66 × 92.7 cm)
Signed and dated lower left: "Henri / Matisse / 35"
The Baltimore Museum of Art. The Cone Collection, formed by
Dr. Claribel Cone and Miss Etta Cone of Baltimore, Maryland

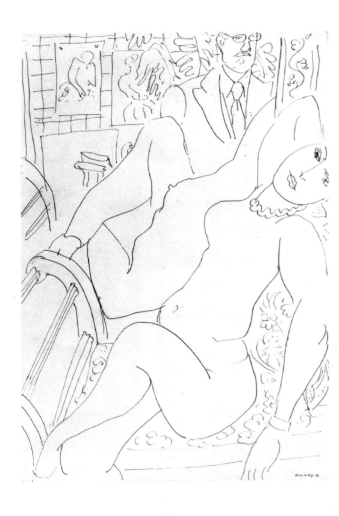

307. Artist and Model Reflected in a Mirror
L'artiste et le modèle reflétés dans le miroir

Nice, place Charles-Félix, 1937

Pen and ink on paper, 24⅛ × 16″ (61.2 × 40.7 cm)
Signed and dated lower right: "Henri-Matisse 37"
The Baltimore Museum of Art. The Cone Collection, formed by
Dr. Claribel Cone and Miss Etta Cone of Baltimore, Maryland

308. Large Nude
Grand nu

Nice, place Charles-Félix, [late] 1935

Pen and ink on paper, 17¾ × 22¼″ (45.1 × 56.5 cm)
Signed and dated lower left: "Henri-Matisse 1935"
Collection Mr. and Mrs. Herbert Kasper

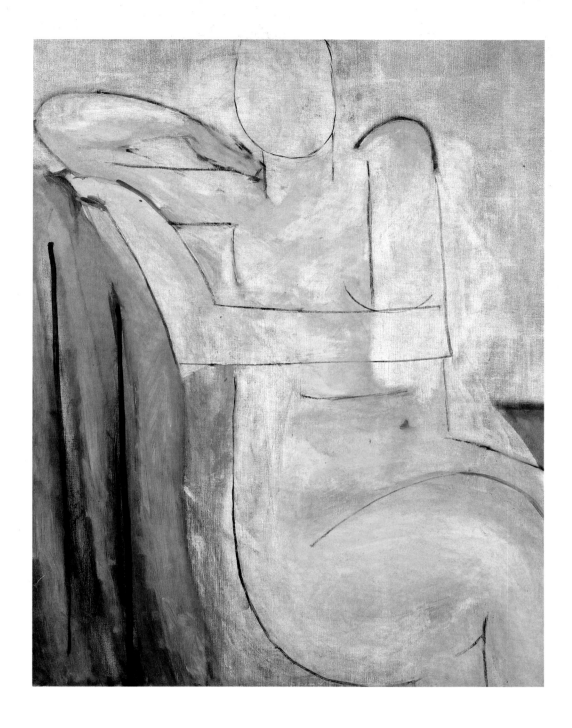

309. Seated Pink Nude
Nu rose assis [Le torse]

Nice, place Charles-Félix, April 1935 to 1936

Oil on canvas, 36¼ × 28¾" (92 × 73 cm)
Not signed, not dated
Private collection

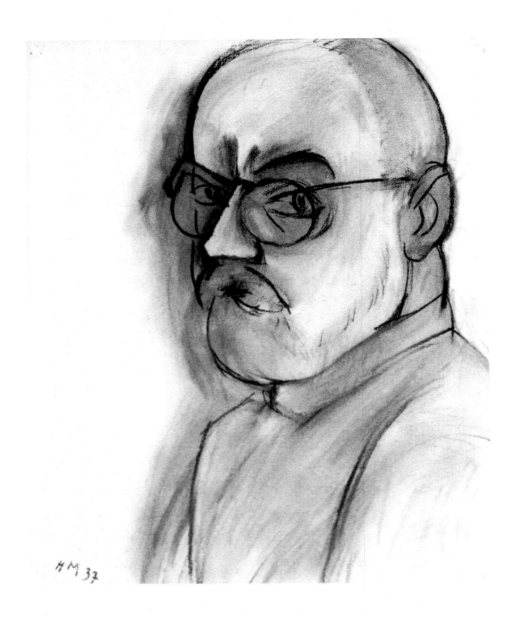

310. Self-Portrait
Autoportrait

Nice, place Charles-Félix, or Paris, boulevard du Montparnasse, 1937

Charcoal and estompe on paper, 18⅜ × 15⅛″ (47.3 × 39 cm)
Signed and dated lower left: "HM 37"
The Baltimore Museum of Art. The Cone Collection, formed by
Dr. Claribel Cone and Miss Etta Cone of Baltimore, Maryland

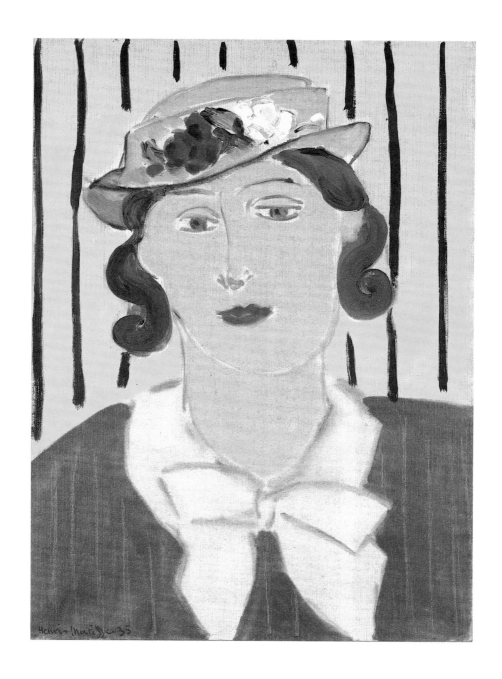

311. Hat with Roses
Le chapeau aux roses

Nice, place Charles-Félix, May 26, 1935

Oil on canvas, 19⅛ × 14⅛″ (49 × 36 cm)
Signed and dated lower left: "Henri-Matisse 35"
Private collection, Switzerland

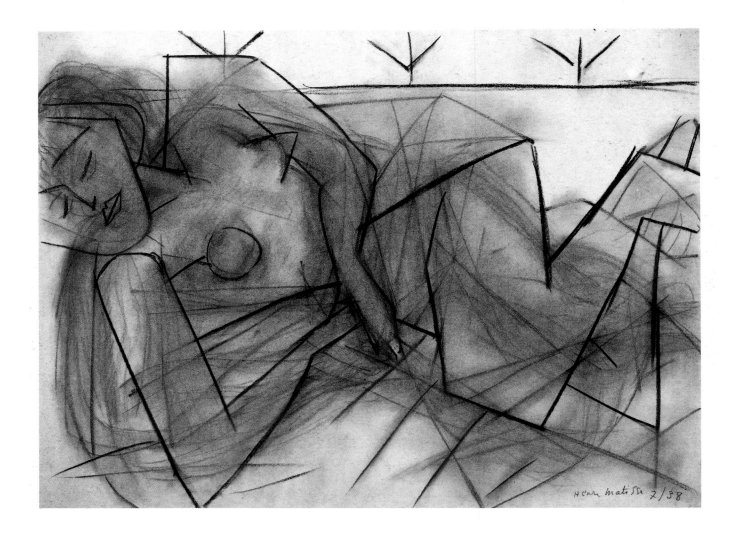

312. Reclining Nude
 Nu allongé

[Paris, boulevard du Montparnasse], July 1938

Charcoal on paper, 25⅝ × 31⅞″ (60.5 × 81.3 cm)
Signed and dated lower right: "Henri Matisse 7/38"
The Museum of Modern Art, New York. Purchase

313. Reclining Nude Seen from the Back
Nu allongé, de dos

[Paris, boulevard du Montparnasse], July 1938

Charcoal on paper, 23⅜ × 31⅞″ (60 × 81 cm)
Signed and dated lower left: "Henri Matisse 7/38"
Private collection

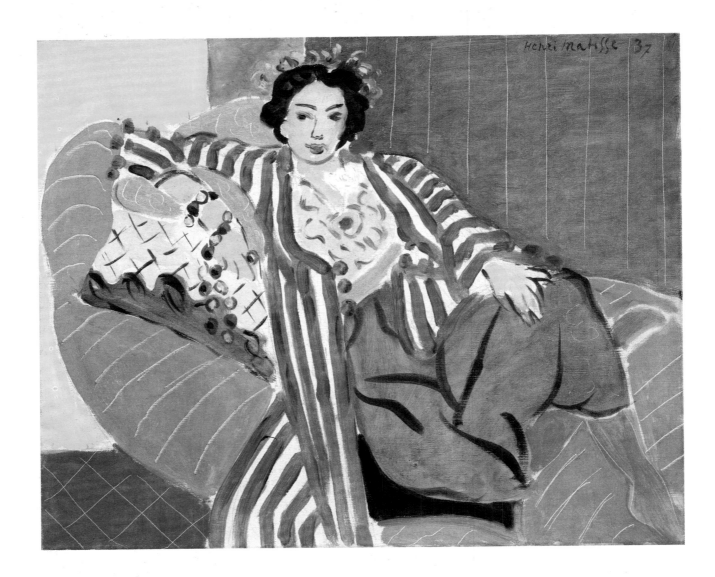

314. **Small Odalisque in a Purple Robe**
Petite odalisque à la robe violette

Nice, place Charles-Félix, January 1937

Oil on canvas, 15 × 18″ (38.1 × 45.7 cm)
Signed and dated upper right: "Henri Matisse 37"
Private collection
Formerly collection Mr. and Mrs. Norton Simon

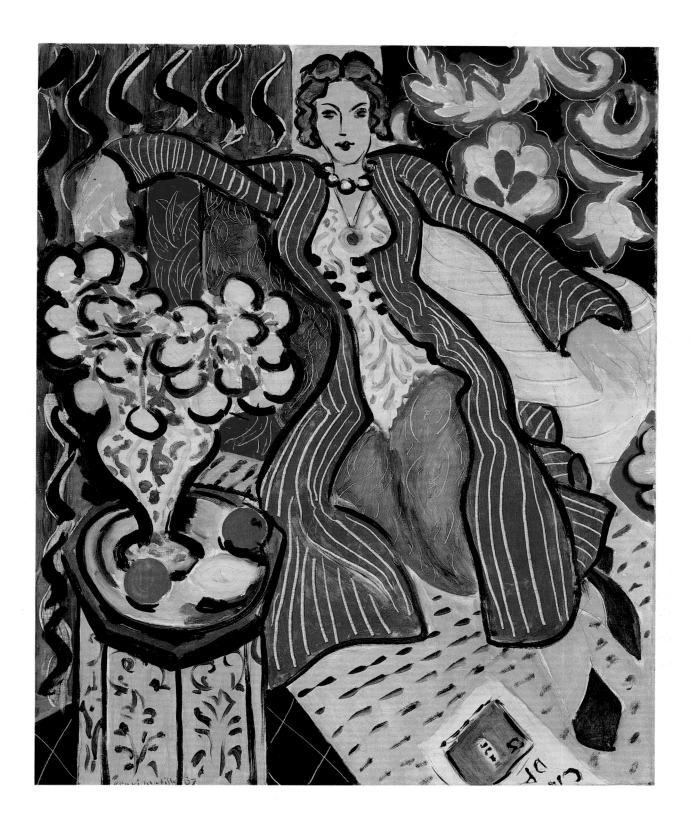

315. Woman in a Purple Robe with Ranunculi
 La robe violette, aux renoncules

Nice, place Charles-Félix, February 1, 3, and 4, 1937

Oil on canvas, 31⅞ × 25⅝″ (81 × 65 cm)
Signed and dated lower left: "Henri Matisse 37"
The Museum of Fine Arts, Houston.
The John A. and Audrey Jones Beck Collection

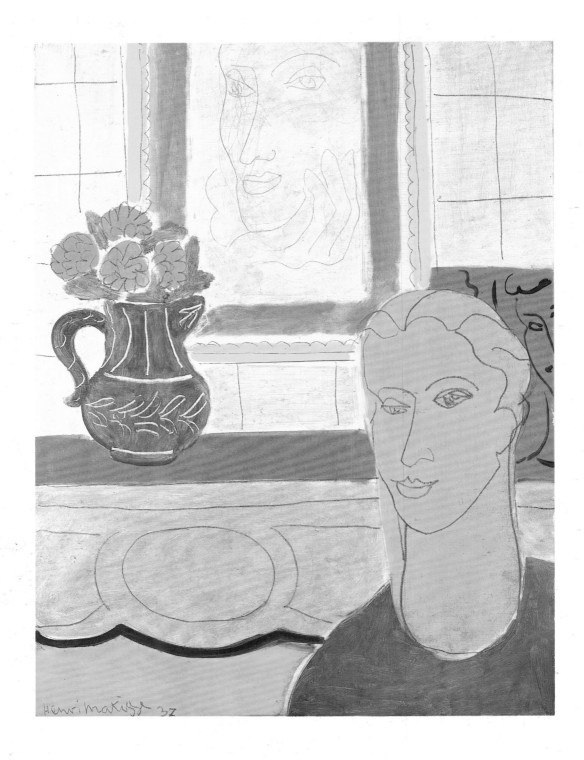

316. The Ochre Head
La tête ocre

Nice, place Charles-Félix, February 1937

Oil on canvas, 28⅝ × 21¼″ (72.7 × 54 cm)
Signed and dated lower left: "Henri Matisse 37"
Private collection

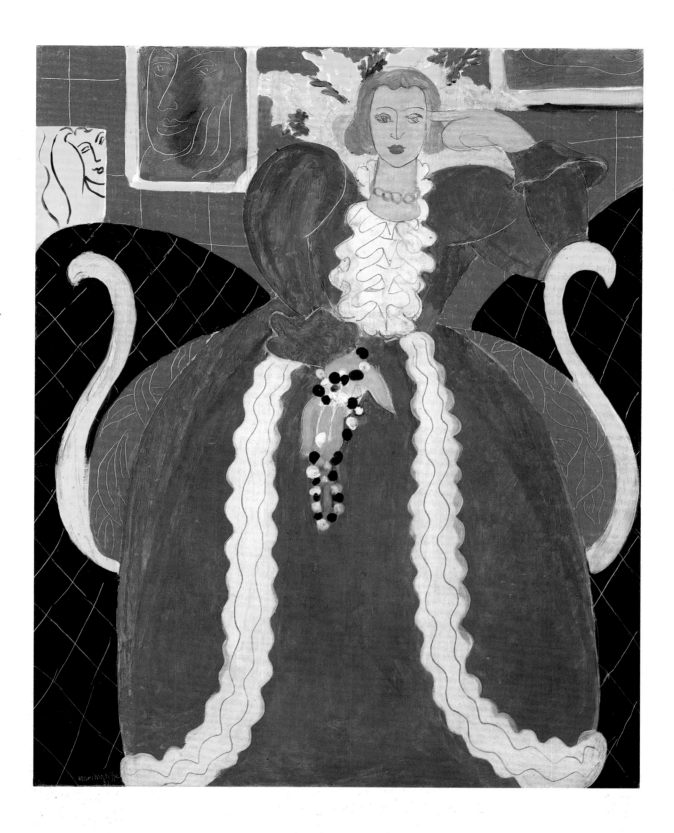

317. Woman in Blue / The Large Blue Robe and Mimosas
La grande robe bleue et mimosas

Nice, place Charles-Félix, February 26–April 1937

Oil on canvas, 36½ × 29″ (92.7 × 73.6 cm)
Signed and dated lower left: "Henri Matisse / 37"
Philadelphia Museum of Art. Gift of Mrs. John Wintersteen

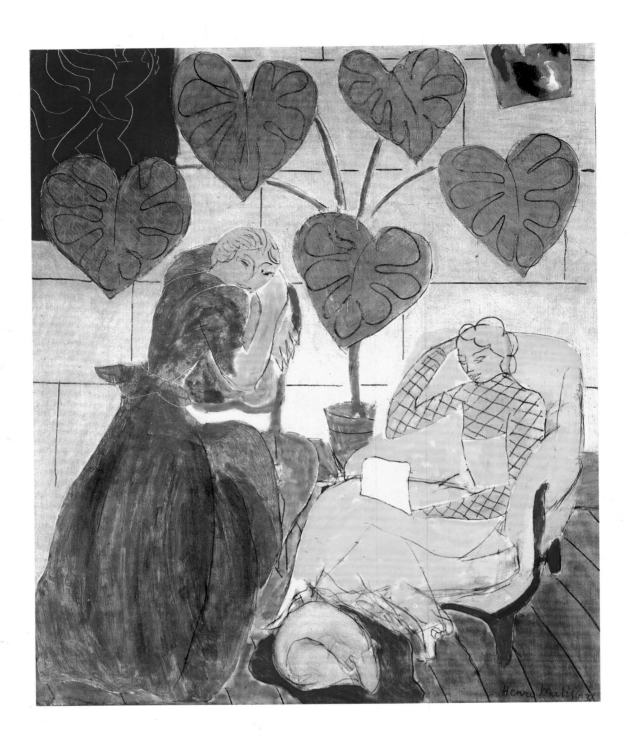

318. The Conservatory

Le jardin d'hiver [Deux personnages féminins et le chien;
Robe bleue et robe résille]

Nice, place Charles-Félix, November 16, 1937–March 3, 1938, and
May 15–25, 1938

Oil on canvas, 28¼ × 23½" (71.8 × 59.7 cm)
Signed and dated lower right: "Henri Matisse 38"
Private collection

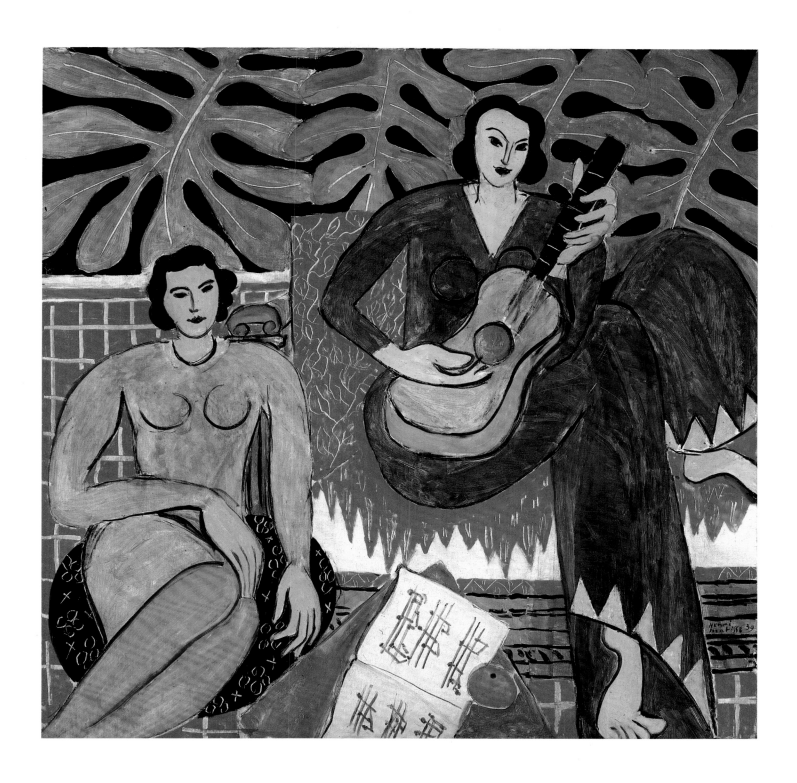

319. Music
La musique [La guitariste]

Nice-Cimiez, Hôtel Régina, March 17–April 8, 1939

Oil on canvas, 45⅜ × 45⅜″ (115.2 × 115.2 cm)
Signed and dated right lower center: "Henri / Matisse 39"
Albright-Knox Art Gallery, Buffalo, New York.
Room of Contemporary Art Fund

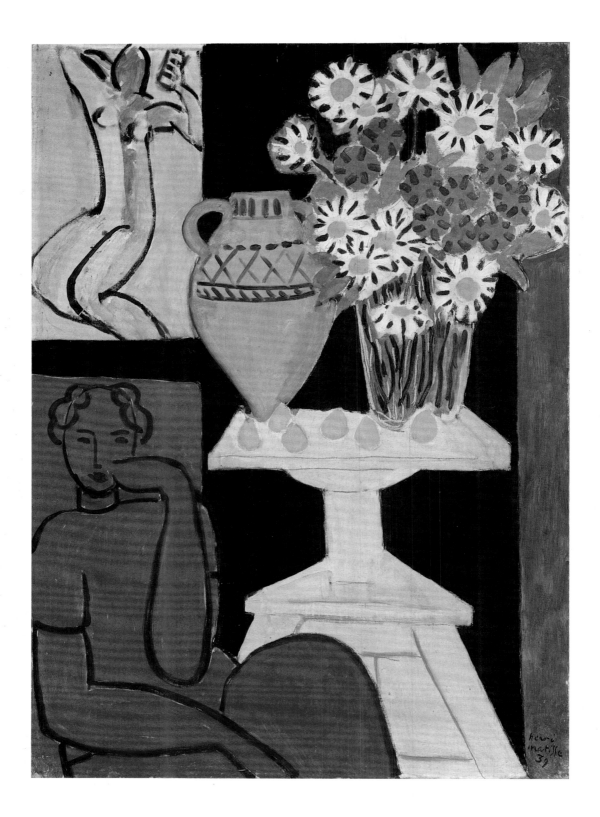

320. Daisies
Les marguerites / Fleurs et figure, pot arabe

Paris, Atelier Villa Alésia, by July 16, 1939

Oil on canvas, 38⅝ × 28¼″ (98 × 71.8 cm)
Signed and dated lower right: "Henri / Matisse / 39"
The Art Institute of Chicago. Gift of Helen Pauling Donnelley in
memory of her parents, Mary Fredericka and Edward George Pauling

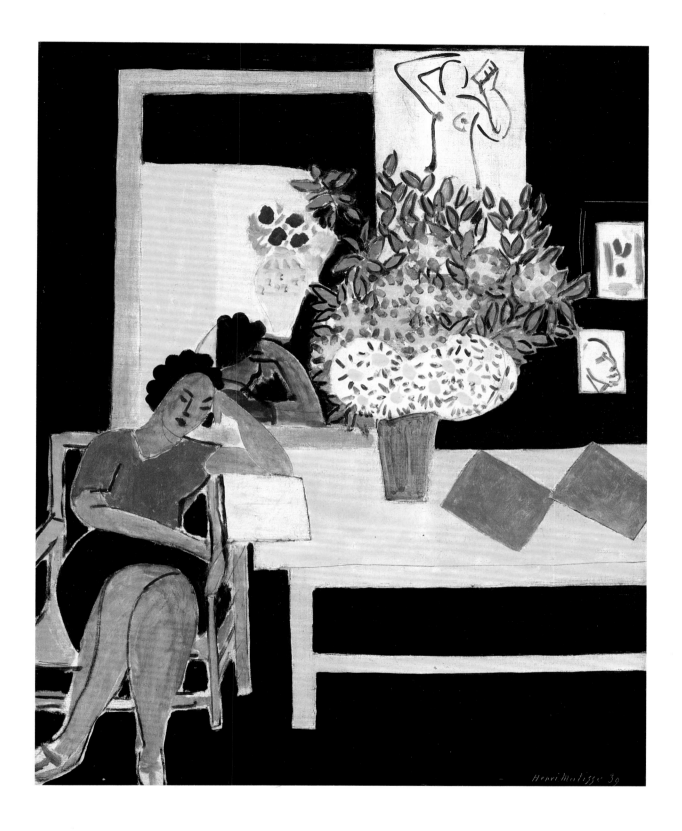

321. **Reader on a Black Background**
 Liseuse sur fond noir [La table rose]

Paris, Atelier Villa Alésia, August 1939

Oil on canvas, 36¼ × 29″ (92 × 73.5 cm)
Signed and dated lower right: "Henri Matisse 39"
Musée National d'Art Moderne, Centre Georges Pompidou, Paris

323. The Striped Dress
La robe rayée [Femme en robe rayée, accoudée]

Nice, place Charles-Félix, January 15 and 26, 1938

Oil on canvas, 18⅛ × 14⅞″ (46 × 38 cm)
Signed and dated lower right: "Henri Matisse 38"
Private collection, Liechtenstein

322. The Arm
Le bras

Nice, place Charles-Félix, January–June 1, 1938

Oil on canvas, 18⅛ × 15″ (46 × 38 cm)
Signed and dated lower left: "Henri Matisse 38"
Private collection, Switzerland

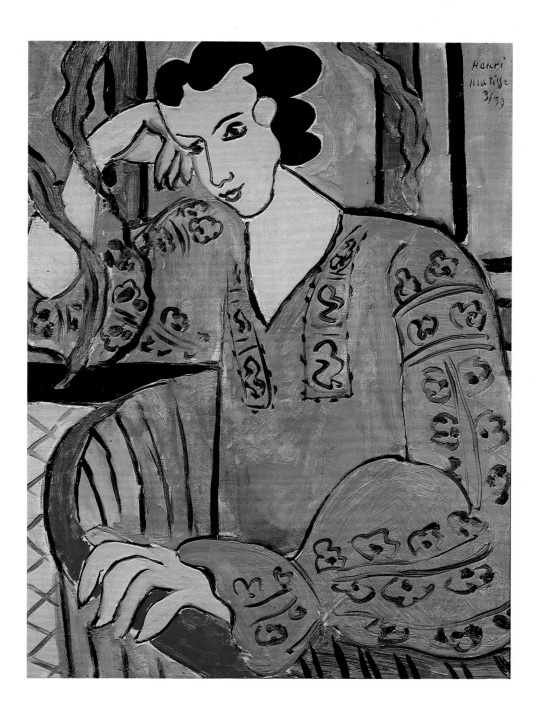

324. Green Rumanian Blouse
Blouse roumaine verte

Nice-Cimiez, Hôtel Régina, March 1939

Oil on canvas, 24 × 18⅛″ (61 × 46 cm)
Signed and dated upper right: "Henri / Matisse / 3/39"
Private collection, Switzerland

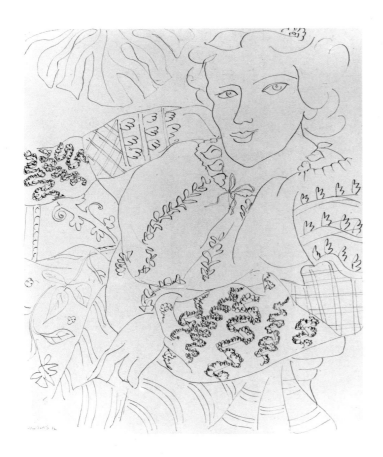

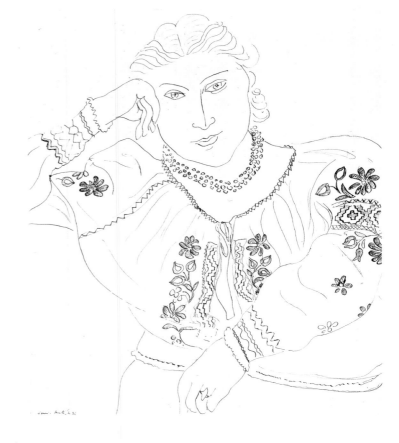

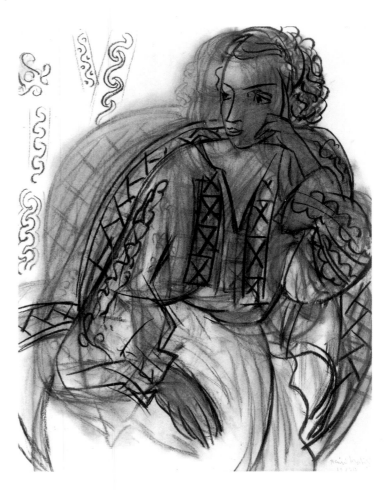

Above, left:

325. The Rumanian Blouse
La blouse roumaine

Nice, place Charles-Félix, 1937
Pen and ink on paper, 24⅞ × 19⅝″ (63 × 50 cm)
Signed and dated lower left: "Henri Matisse 37"
The Baltimore Museum of Art. The Cone Collection, formed by
Dr. Claribel Cone and Miss Etta Cone of Baltimore, Maryland

Above, right:

326. Woman in an Embroidered Blouse with Necklace
Femme au collier, blouse brodée

Nice, place Charles-Félix, 1936
Pen and ink on paper, 21¼ × 17¾″ (54 × 45 cm)
Signed and dated lower left: "Henri-Matisse 36"
The Fogg Art Museum, Harvard University Art Museums,
Cambridge, Massachusetts. Bequest of Meta and Paul J. Sachs

Right:

327. Seated Woman in a Rumanian Blouse
Femme assise en blouse roumaine

Nice-Cimiez, Hôtel Régina, December 1938
Charcoal on paper, 26 × 20″ (66 × 51 cm)
Signed and dated lower right: "Henri Matisse / 12/38"
Private collection

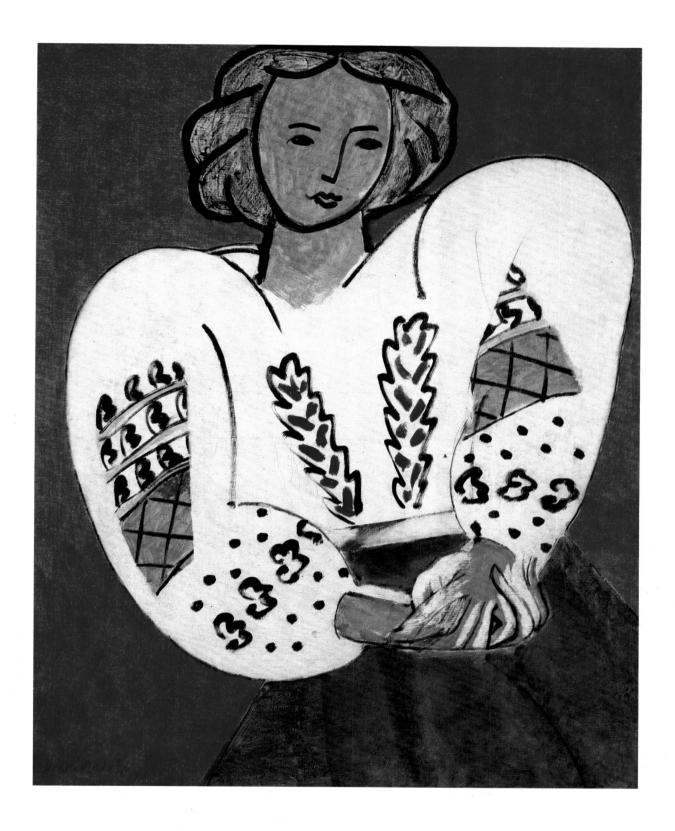

328. The Rumanian Blouse
La blouse roumaine

Nice-Cimiez, Hôtel Régina, [December 1939–April] 1940

Oil on canvas, 36¼ × 28¾″ (92 × 73 cm)
Signed and dated lower left: "Henri Matisse 40"
Musée National d'Art Moderne, Centre Georges Pompidou, Paris

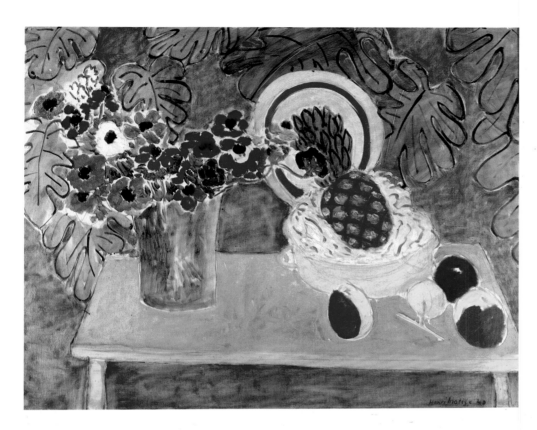

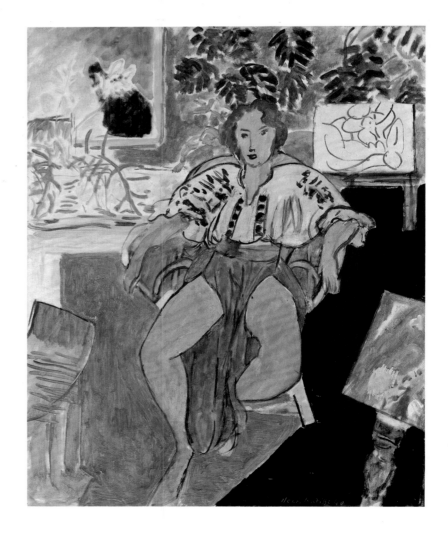

329. Pineapple and Anemones
Ananas et anémones

Nice-Cimiez, Hôtel Régina, [late 1939–early] 1940

Oil on canvas, 29 × 36″ (73.7 × 91.4 cm)
Signed and dated lower right: "Henri Matisse 40"
Private collection
Formerly collection Mr. and Mrs. Albert D. Lasker

330. Dancer in Repose
Danseuse au repos

Nice-Cimiez, Hôtel Régina, [late 1939–early] 1940

Oil on canvas, 32 × 25½″ (81.2 × 64.7 cm)
Signed and dated lower right: "Henri Matisse 40"
The Toledo Museum of Art, Ohio. Gift of Mrs. C. Lockhart McKelvy

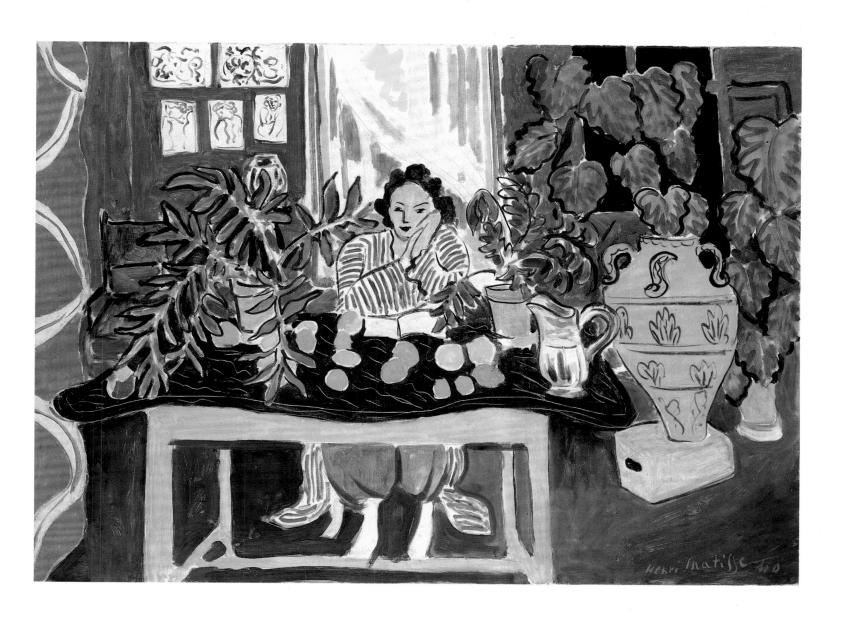

331. Interior with an Etruscan Vase
Intérieur au vase étrusque

Nice-Cimiez, Hôtel Régina, [late 1939–early] 1940

Oil on canvas, 29 × 42½″ (73.6 × 108 cm)
Signed and dated lower right: "Henri Matisse 40"
The Cleveland Museum of Art. Gift of the Hanna Fund
Formerly collection Leigh B. Block

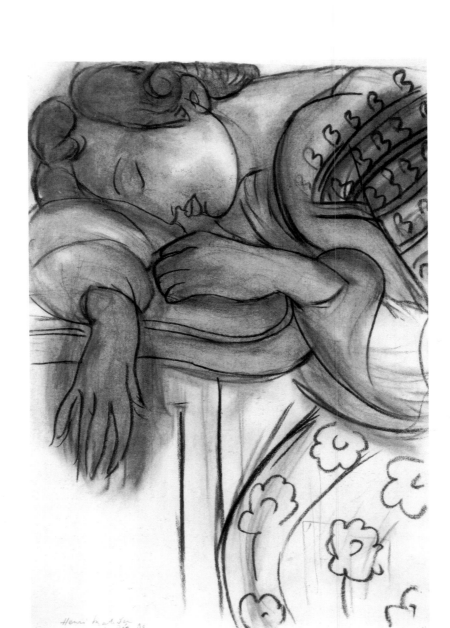

332. Woman Sleeping on the Corner of a Table
Femme dormant sur le coin d'une table

Nice-Cimiez, Hôtel Régina, December 1939

Charcoal on paper, 23¾ × 16″ (60.4 × 40.7 cm)
Signed and dated lower left: "Henri Matisse / Déc. 39"
Collection Dr. and Mrs. Arthur E. Kahn

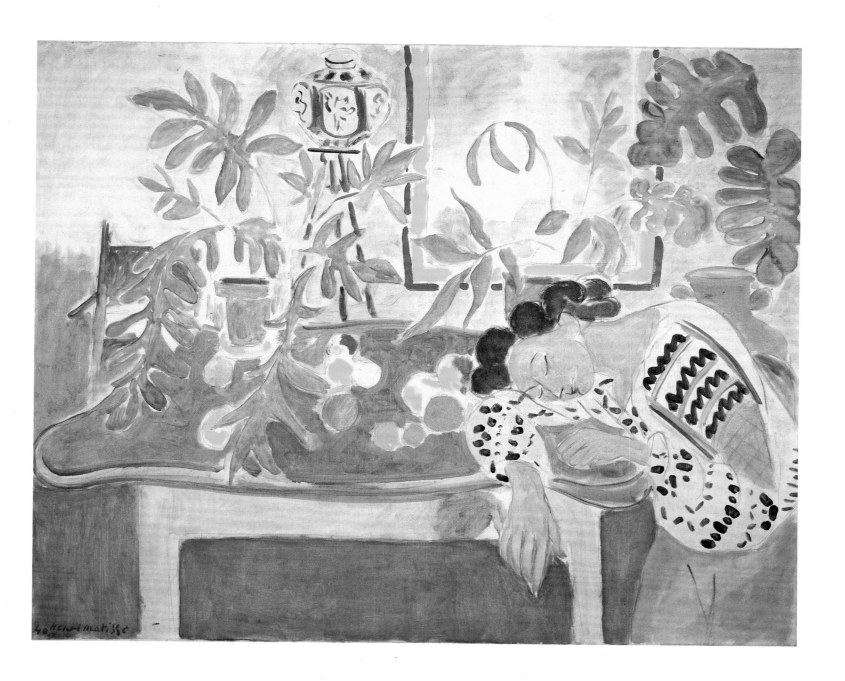

333. Still Life with a Sleeping Woman
Nature morte à la dormeuse

Nice-Cimiez, Hôtel Régina, [late 1939–early] 1940

Oil on canvas, 31⅞ × 39⅜″ (81 × 100 cm)
Signed and dated lower left: "40 Henri Matisse"
National Gallery of Art, Washington, D.C.
Collection Mr. and Mrs. Paul Mellon

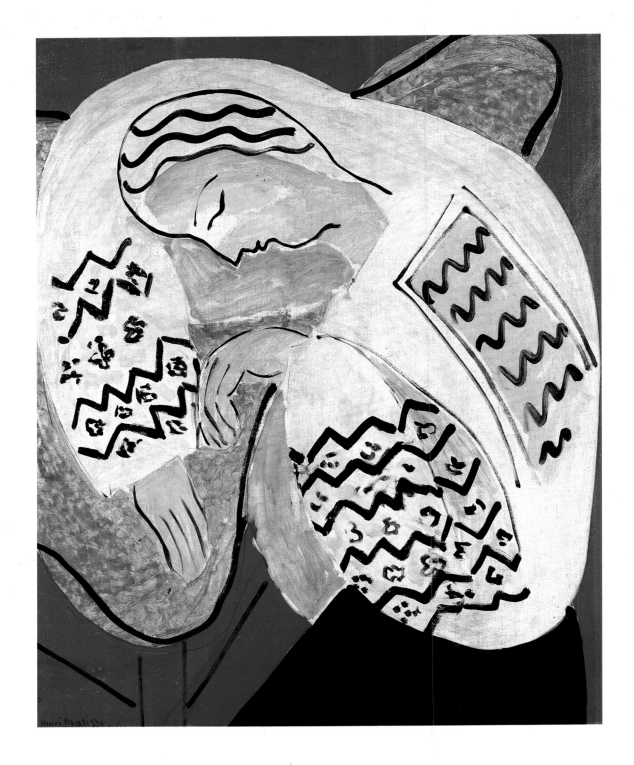

334. The Dream
Le rêve

Nice-Cimiez, Hôtel Régina, [late 1939–] September 1940
Oil on canvas, 31⅞ × 25½″ (81 × 65 cm)
Signed and dated lower left: "Henri Matisse 9/40"
Private collection

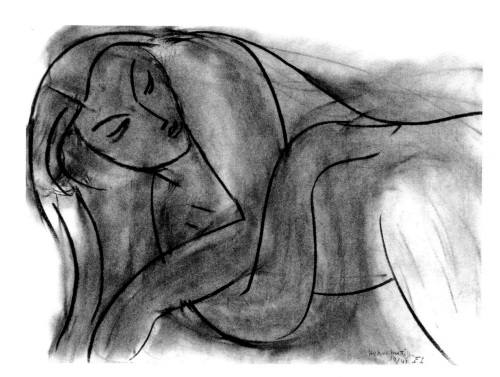

335. Themes and Variations. Series F, theme drawing
Thèmes et variations. Série F, dessin du thème

Nice-Cimiez, Hôtel Régina, October 1941

Charcoal on paper, 15¾ × 20½" (40 × 52 cm)
Signed and dated lower right: "Henri Matisse / 10/41 F1."
Musée de Grenoble

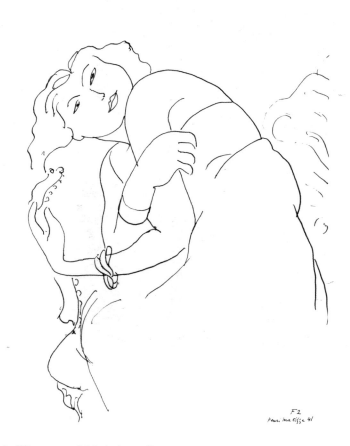

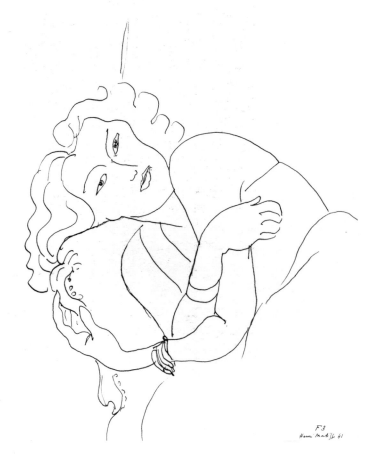

336. Themes and Variations, F2
Thèmes et variations, F2

Nice-Cimiez, Hôtel Régina, [October] 1941

Pen and ink on paper, 20½ × 15¾" (52 × 40 cm)
Signed and dated lower right: "F2 / Henri Matisse 41"
Musée de Grenoble

337. Themes and Variations, F3
Thèmes et variations, F3

Nice-Cimiez, Hôtel Régina, [October] 1941

Pen and ink on paper, 20½ × 15¾" (52 × 40 cm)
Signed and dated lower right: "F3 / Henri Matisse 41"
Musée de Grenoble

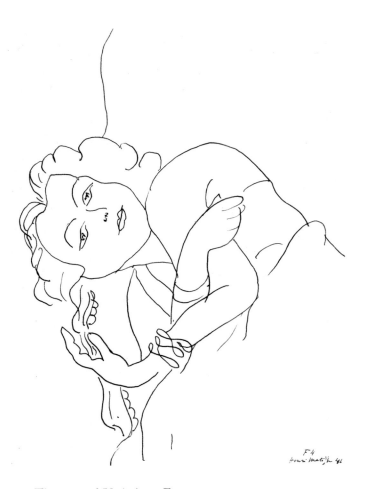

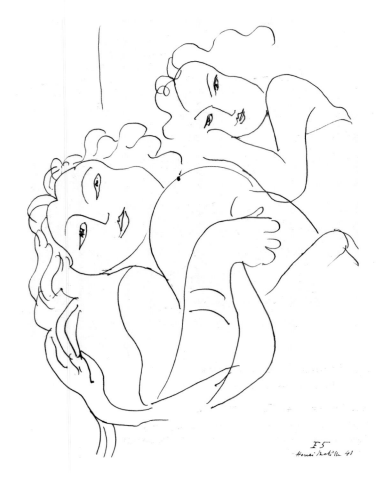

338. Themes and Variations, F4
Thèmes et variations, F4

Nice-Cimiez, Hôtel Régina, [October] 1941

Pen and ink on paper, 20½ × 15¾" (52 × 39 cm)
Signed and dated lower right: "F4 / Henri Matisse 41"
Musée de Grenoble

339. Themes and Variations, F5
Thèmes et variations, F5

Nice-Cimiez, Hôtel Régina, [October] 1941

Pen and ink on paper, 20½ × 15¾" (52 × 39 cm)
Signed and dated lower right: "F5 / Henri Matisse 41"
Musée de Grenoble

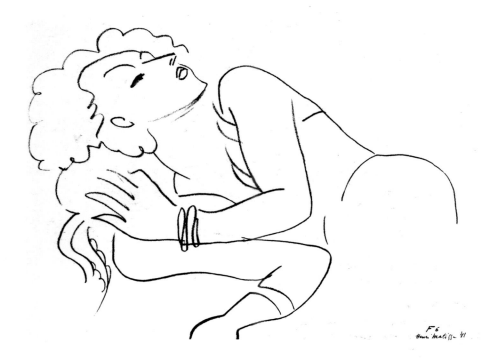

340. Themes and Variations, F6
Thèmes et variations, F6

Nice-Cimiez, Hôtel Régina, [October] 1941

Black crayon on paper, 15¾ × 20½" (40 × 52 cm)
Signed and dated lower right: "F6 / Henri Matisse 41"
Musée de Grenoble

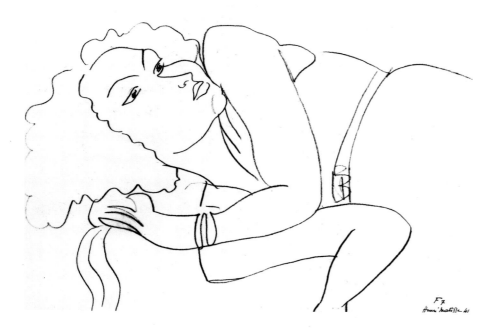

341. Themes and Variations, F7
 Thèmes et variations, F7

Nice-Cimiez, Hôtel Régina, [October] 1941

Black crayon on paper, 15¾ × 20½" (40 × 52 cm)
Signed and dated lower right: "F7 / Henri Matisse 41"
Musée de Grenoble

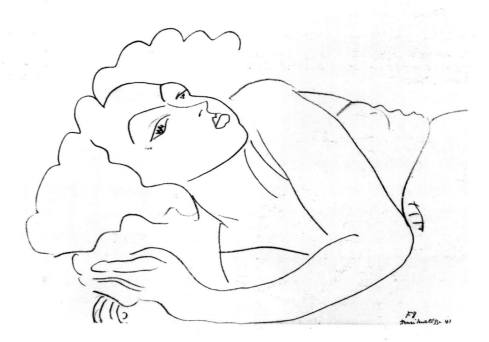

342. Themes and Variations, F8
 Thèmes et variations, F8

Nice-Cimiez, Hôtel Régina, [October] 1941

Black crayon on paper, 15¾ × 20½" (40 × 52 cm)
Signed and dated lower right: "F8 / Henri Matisse 41"
Musée de Grenoble

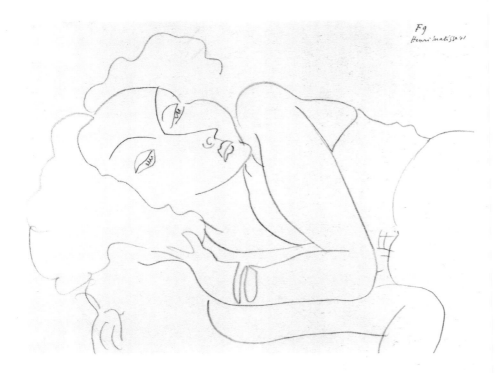

343. Themes and Variations, F9
Thèmes et variations, F9

Nice-Cimiez, Hôtel Régina, [October] 1941

Black crayon on paper, 15¾ × 20½″ (40 × 52 cm)
Signed and dated upper right: "F9 / Henri Matisse 41"
Musée de Grenoble

344. Themes and Variations, F10
Thèmes et variations, F10

Nice-Cimiez, Hôtel Régina, [October] 1941

Black crayon on paper, 15¾ × 20½″ (40 × 52 cm)
Signed and dated upper right: "F10 / Henri Matisse 41"
Musée de Grenoble

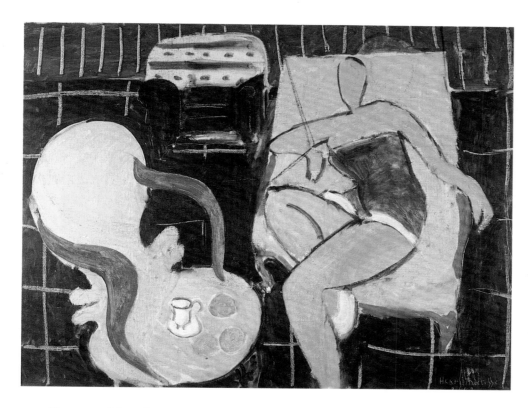

345. Dancer and Rocaille Armchair on a Black Background
Danseuse, fond noir, fauteuil rocaille

Nice-Cimiez, Hôtel Régina, September 1942

Oil on canvas, 20 × 25½″ (50.8 × 64.8 cm)
Signed and dated lower right: "Henri Matisse / 9/42"
Private collection

346. Tulips and Oysters on a Black Background
Tulipes et huîtres sur fond noir

Nice-Cimiez, Hôtel Régina, February 1943

Oil on canvas, 24 × 28¾″ (61 × 73 cm)
Signed and dated lower right: "2/43 Henri Matisse"
Musée Picasso, Paris
Formerly collection Pablo Picasso

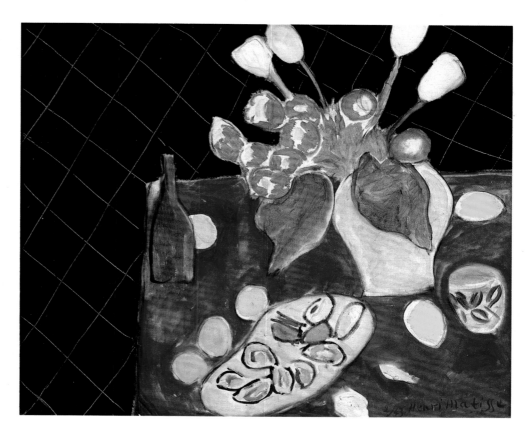

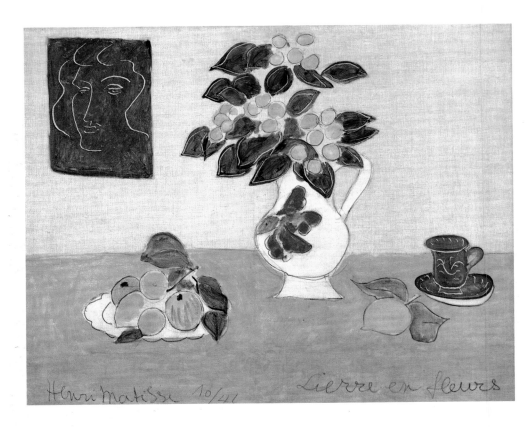

347. Ivy in Flower
Lierre en fleurs

Nice-Cimiez, Hôtel Régina, October 1941
Oil on canvas, 28½ × 36½" (72.4 × 92.7 cm)
Signed and dated lower left: "Henri Matisse 10/41"
Inscribed lower right: "Lierre en fleurs"
Private collection
Formerly collection Mr. and Mrs. Albert D. Lasker

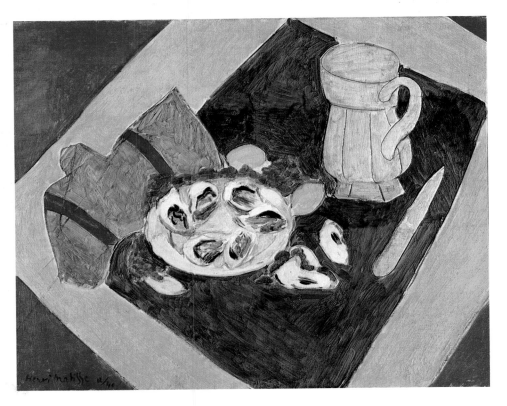

348. Still Life with Oysters
Nature morte aux huîtres

Nice-Cimiez, Hôtel Régina, December 1940

Oil on canvas, 25¾ × 32" (65.5 × 81.5 cm)
Signed and dated lower left: "Henri Matisse 12/40"
Oeffentliche Kunstsammlung Basel, Kunstmuseum

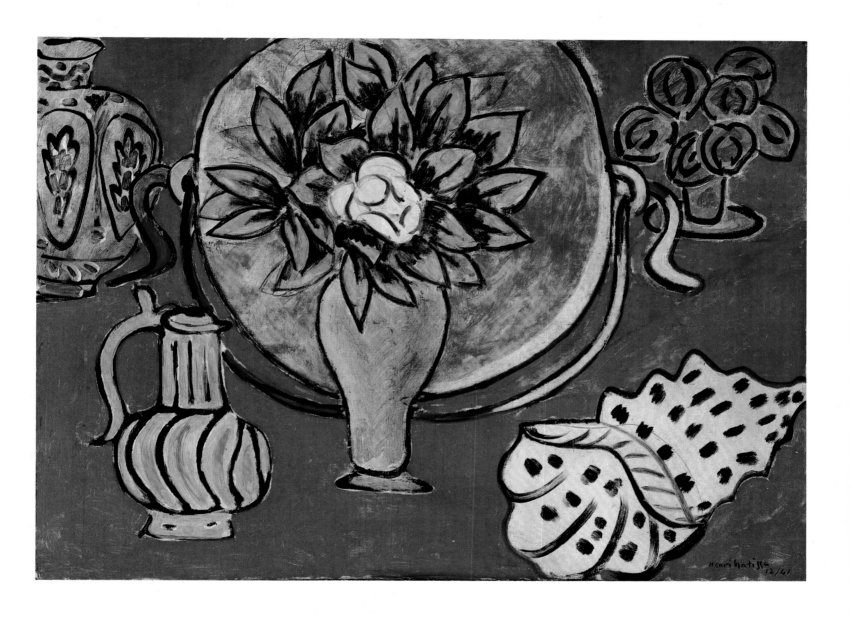

349. Still Life with a Magnolia
Nature morte au magnolia

Nice-Cimiez, Hôtel Régina, [September–]December 1941

Oil on canvas, 29⅛ × 39¾″ (74 × 101 cm)
Signed and dated lower right: "Henri Matisse / 12/41"
Musée National d'Art Moderne, Centre Georges Pompidou, Paris

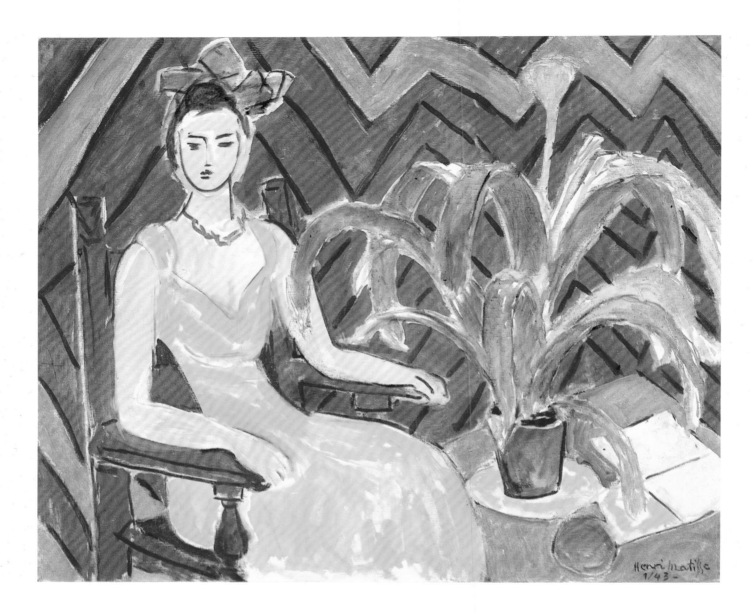

350. Michaela

Nice-Cimiez, Hôtel Régina, January 1943

Oil on canvas, 23⅝ × 28⅜″ (60 × 72 cm)
Signed and dated lower right: "Henri Matisse / 1/43-"
Alsdorf Collection

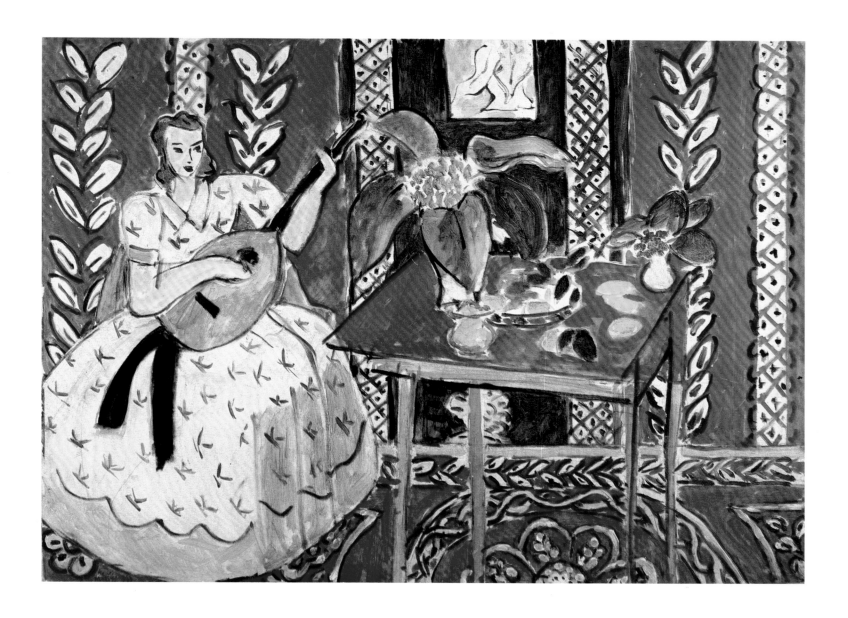

351. The Lute
Le luth

Nice-Cimiez, Hôtel Régina, February 1943

Oil on canvas, 23⅜ × 31⅜″ (59.4 × 79.5 cm)
Signed and dated lower left: "Henri / Matisse 2/43"
Private collection

352. Nymph and Faun with Pipes
Nymphe endormie et faune jouant de la flûte

Nice-Cimiez, Hôtel Régina, [1940–43]

Charcoal on canvas, 60¼ × 65⅛″ (153 × 165.5 cm)
Not signed, not dated
Musée National d'Art Moderne, Centre Georges Pompidou, Paris

353. Nymph in the Forest / La verdure
Nymph dans la forêt / La verdure

Nice, place Charles-Félix and Hôtel Régina, 1935–c. 1942

Oil on canvas, 7′8¼″ × 6′4¾″ (242 × 195 cm)
Not signed, not dated
Musée Matisse, Nice-Cimiez

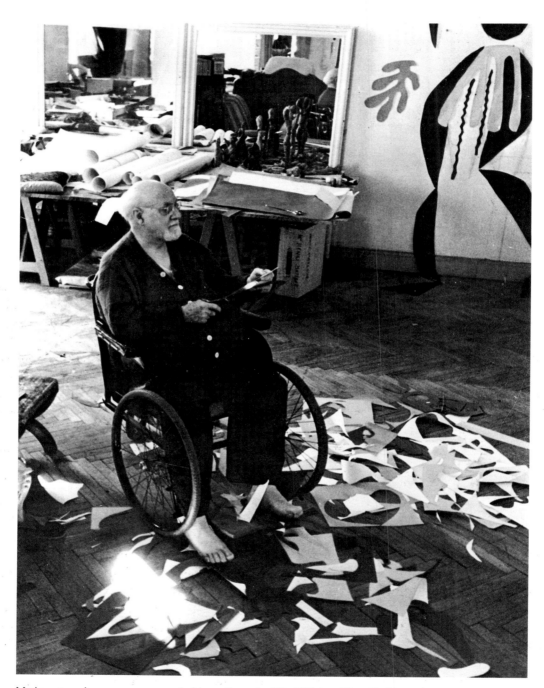

Matisse at work on a paper cutout in his studio at the Hôtel Régina, Nice-Cimiez, early 1952.

PART VII • 1943–1954

THE FINAL YEARS

Matisse spoke of "the eternal conflict of drawing and color." The different periods of his long career show differing forms of reciprocation between these two basic pictorial elements. The paper cutout maquettes he made in the early 1940s for his illustrated book *Jazz* (pls. 357–367) revealed to him a novel way of actually conflating these elements. "Instead of drawing an outline and filling in the color . . . I am drawing directly in color," he said. Drawing with scissors—cutting shapes from paper he had prepainted—meant that the contour of a shape and its internal area were formed simultaneously. The large ink drawings of the 1940s, done with a broad brush (pls. 379, 381, 382), afforded precisely the same symbiosis of contour and internal area in each stroke. Matisse thought of them as a new kind of monochrome painting.

Eventually, cutouts and brush drawing formed virtually his only means of expression. But before this happened, his painting came to a dazzlingly original conclusion. He made his final studies of that perennial subject, the decoratively costumed female figure, now more flatly and brightly painted than ever before. The last great work of the series, *Asia* (pl. 374), fittingly recapitulates the languorous exoticism that had so often attached to this subject. Matisse's very last series of paintings, however, culminates a quite different aspect of his art. The Vence interiors of 1946–48 (pls. 375–387) are so flooded with intense color that it seems at times to overflow the limits of the canvas. Matisse shows us at once a mysterious interior space of colors and patterns, within which the specific identities of things are nevertheless retained, and an elemental chromatic plane, real and substantial, that radiates light into the space around it. His last style, like the last style of other great artists, amounts to a coincidence of opposites. The calmness of the interior space and the energy that is released into our own space are inseparable and interfused.

The walls of his studios had been filling, in the meantime, with loosely pinned-up shapes of colored paper resembling leaves, algae, coral, and the like, a sort of imaginary garden to be harvested for making a new kind of work of art. In 1946, Matisse had made his first large-scale cutouts: open, expansive designs for silkscreens on the theme of Oceania (pls. 370, 371). Toward the end of the decade, cutouts were used to design windows (pls. 388, 389), and later the priests' chasubles (pls. 390, 391), for the Vence chapel, with his complementary medium, brush drawing, being used to design the ceramic-tile murals. Matisse spoke of the chapel as a summation of his life's work. But a further, more radical summation would follow in the few years that remained to him. In 1950–54, there was a virtual outpouring of independent cutouts. Most comprised organic signs set in modular compartments or floated across brilliantly illuminated white grounds.

A sequence of nudes cut from blue paper in 1952, with volumetrically suggestive contours (pl. 398–402, 405), added a new, sculptural dimension to the medium. The environmental *Swimming Pool* (pl. 406) conflates a sense of color carved into substantial shape with an effect of soaring movement that escapes the limitations of the physical, even the limitations of the pictorial frame. At the end, with *Memory of Oceania* (pl. 411) and *The Snail* (pl. 412), vast slabs of color paper the surface—positive presences whose radiance and rhythmic organization distribute an implicit voluptuousness throughout these works. Matisse thus completes his demonstration of how the most complex as well as most direct emotion may be produced by the simplest of means.

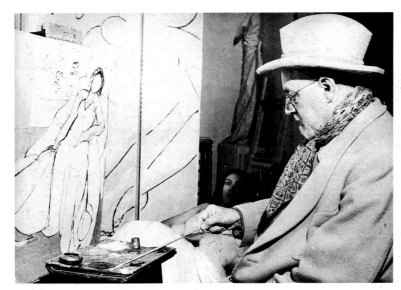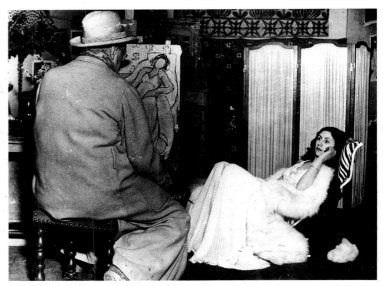

Matisse in his studio at the villa Le Rêve, Vence, 1944, at work on *Young Woman in White, Red Background* (pl. 372). Behind it, in the photograph at left, is an early state of the *Leda and the Swan* triptych of 1944–46. Photographs by Thérèse Bonney.

1943–44 SEASON

1943 (continued)

END OF JUNE: Because of the risk of Allied bombing in Nice, moves to the villa Le Rêve, on route de Saint-Jeannet at Vence; this will be his principal residence until early 1949.

At work on illustrations for Henry de Montherlant's *Pasiphaé: Chant de Minos (Les Crétois)*, to be published in May 1944 (pls. 354–356).

During this year and the next, will complete most of the energetic cutout designs for *Jazz*, some based on popular imagery, to be published in 1947 with a text that Matisse will compose and which will be reproduced in his own handwriting (pls. 357–367). With this work, paper cutouts become central to his artistic practice and will increasingly occupy him, eventually to the exclusion of painting, in this last period of his career.

SEPTEMBER 25–OCTOBER 31: Exhibits four works at the Salon d'Automne, held at the Palais des Beaux-Arts de la Ville de Paris, including *Tulips and Oysters on a Black Background* (pl. 346), which he subsequently gives to Picasso.

1944

FEBRUARY 29: Death of Félix Fénéon.

SPRING: Mme Matisse and Marguerite, who have been active in the Resistance, are arrested by the Gestapo. Matisse subsequently learns that Mme Matisse has been sentenced to a six-month prison term, but can discover nothing about Marguerite until she is freed, after the

Allies' liberation of Paris. During the summer, Nazi armed forces are driven from much of France: the Allies invade Normandy on June 6; Paris is liberated on August 25, and the area around the Riviera a few days later.

MAY: *Pasiphaé: Chant de Minos (Les Crétois)*, Henry de Montherlant's book of poems with linoleum-cut illustrations by Matisse (pls. 354–356), is published in Paris by Martin Fabiani.

JUNE–JULY: Matisse is at work on a commission from Ambassador Enchorrena of Argentina for a triptych that will be developed in the autumn, using the theme of Leda and the Swan, but he will not complete it until March 1946. By now he is producing fewer easel paintings, but this year makes some highly simplified, brightly colored works, including *Young Woman in White, Red Background* (pl. 372).

The villa Le Rêve, Vence.

1944–45 SEASON

SEPTEMBER 6: Has drawn a series of thirty-five heads on lithographic transfer paper for his project to illustrate a new edition of Charles Baudelaire's *Les fleurs du mal*. Technical problems interfere with production of the book, which will not be published until February 1947.

OCTOBER 6–NOVEMBER 5: The "Salon de la Libération," the first Salon d'Automne after the end of the German occupation, honors Picasso with a special exhibition. Picasso includes Matisse's *Basket of Oranges* (pl. 148), which he now owns.

This year, two monographs on Matisse are published: Isaac Grünewald's *Matisse och Expressionismen* and Leo Swane's *Henri Matisse*, both in Stockholm.

1945

Is in Vence at his villa, Le Rêve.

JANUARY: Is visited by Marguerite; hears about her imprisonment during the Occupation.

MAY 7: Germany surrenders to the Allies.

JULY 1: Matisse leaves for Paris, where he will remain until November. Stays at no. 132, boulevard du Montparnasse.

JULY 26: In honor of Matisse's first visit to Paris since the fall of France in June 1940, André Warnod publishes in *Arts* a text titled "Matisse est de retour."

SEPTEMBER 28–OCTOBER 29: Like Braque in 1943 and Picasso in 1944, he is honored

with a retrospective exhibition at the Salon d'Automne. Includes thirty-seven paintings, most of them made during the war. In an interview with Léon Degand published in *Les lettres françaises* on October 6, he defends the decorative quality of his work and stresses its consciously organized form.

1945–46 SEASON

LATE NOVEMBER: He is back in Vence at his villa, Le Rêve.

DECEMBER: Matisse and Picasso have simultaneous one-artist exhibitions at the Victoria and Albert Museum in London. Matisse's, numbering thirty works, is a retrospective; the catalogue text is by Jean Cassou. Picasso's includes twenty-five works dating from 1939 to 1945; the catalogue text is by Christian Zervos. Both exhibitions will be shown at the Palais des Beaux-Arts in Brussels in May 1946.

A special issue of *Verve*, titled "De la couleur," is devoted to Matisse. Contains color reproductions of paintings of 1941–44, his own diagrams analyzing the palette of each picture, and a statement about his painting in which he suggests that artists may escape the influence of the immediate past by seeking inspiration in earlier art, including the art of other civilizations. He had designed the cover, title page, and frontispiece during the summer of 1943 for this issue, which could not be published until after the Liberation.

During this year, Gaston Diehl has published in his book *Problèmes de la peinture* Matisse's "Rôle et modalités de la couleur," in which he talks of color as "a means of liberation" but stresses the integral relationship of drawing and color.

DECEMBER 7–29: Exhibition of his paintings, drawings, and sculpture inaugurates the Galerie Maeght in Paris. Six paintings done between 1938 and 1944 are the focus of the exhibition, each shown with photographs of its preceding states.

This year, the French state acquires for the newly created Musée National d'Art Moderne no fewer than six paintings by Matisse, among them *Le luxe (I)* (pl. 102), *The Painter in His Studio* (pl. 204), *Reader on a Black Background* (pl. 321), and *Still Life with a Magnolia* (pl. 349).

1946

In the first part of the year, makes the earliest works in his series of Vence interiors, which will comprise his last sustained achievement as a painter. These earliest works include *Interior in Venetian Red* (pl. 375), *Interior in Yellow and Blue* (pl. 376), and *The Rocaille Armchair* (pl. 378). The series is accompanied by broadly conceived brush-and-ink drawings.

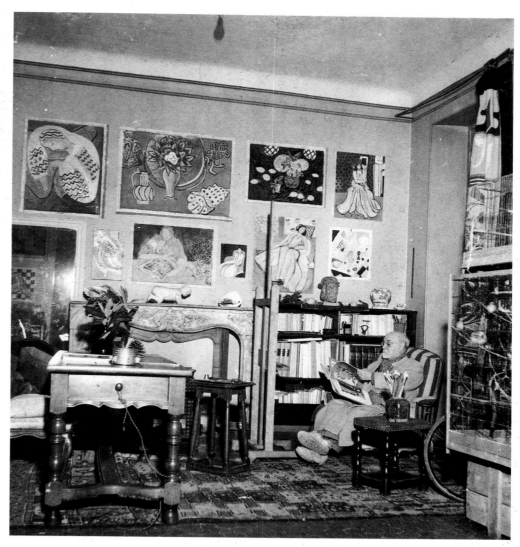

Matisse reading in his studio at the villa Le Rêve, Vence, c. 1945. On the wall, top row from left: *The Dream* (pl. 304) and *Still Life with a Magnolia* (pl. 349). Photograph by Thérèse Bonney.

FEBRUARY: His illustrated book *Visages*, with poems by Pierre Reverdy, is published by Les Éditions du Chêne in Paris.

SPRING: At Vence, is visited by Picasso and Françoise Gilot, the first of several visits between 1946 and 1954.

APRIL: Sends biographical information to François Campaux, who is planning a documentary film on him. Made in Paris and Vence, *Matisse* (or *A Visit with Matisse*) will be completed later in the year. The film will include sequences showing him at work on *Young Woman in White, Red Background* (pl. 373), one of the decoratively flattened paintings he makes in the spring of this year. The most ambitious work of the group is the large *Asia* (pl. 374).

MID-JUNE: Is in Paris, at no. 132, boulevard du Montparnasse; will remain there until early

April 1947. Turns down a new contract with Paul Rosenberg, saying he will hardly paint in the near future, and will concentrate instead on decorative projects.

1946–47 SEASON

SUMMER–AUTUMN: Although unwell at times, prepares the text for *Jazz* and works on a decorative commission from Zika Ascher for two large silkscreens, prepared by paper cutouts: *Oceania, the Sky* (pl. 370) and *Oceania, the Sea* (pl. 371). These represent his first attempt to use paper cutouts to make works of large size.

OCTOBER: Marianna Alcaforado's *Les lettres d'une religieuse portugaise*, with illustrations by Matisse, is published by Tériade.

OCTOBER 4–NOVEMBER 10: Shows three paintings in the Salon d'Automne.

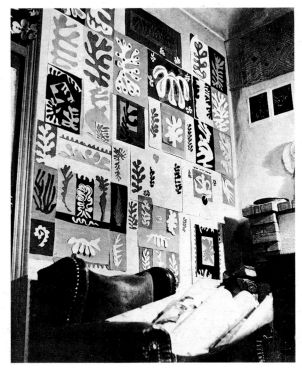

Matisse's studio at the villa Le Rêve, Vence, with small paper cutouts pinned to wall, c. 1947. Lower left: *Amphitrite* (pl. 369). To its right: *Composition with a Red Cross* (pl. 368).

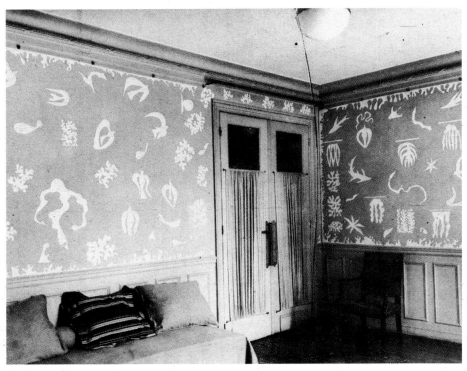

Matisse's studio on the boulevard du Montparnasse, Paris, summer 1946. On the wall, left: an early state of *Oceania, the Sky* (pl. 370). Right: *Oceania, the Sea* (pl. 371).

1947

JANUARY: Matisse is in Paris. Is made a Commander of the Legion of Honor.

JANUARY 23: Death of Pierre Bonnard, a friend for some forty years.

FEBRUARY: Edition of Baudelaire's *Les fleurs du mal* illustrated by Matisse is published in Paris by La Bibliothèque Française.

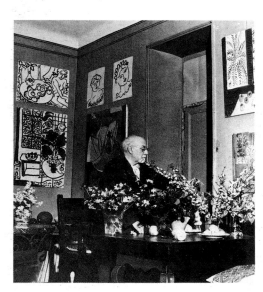

Matisse at the villa Le Rêve, Vence, 1948, in the corner of his studio depicted in *Large Red Interior* (pl. 387). On the walls: recent brush-and-ink drawings and *The Pineapple* (pl. 386).

APRIL: Has returned to the villa Le Rêve in Vence, after an absence of ten months. Briefly travels to Saint-Jean-Cap-Ferrat; returns to Vence. Is continuing to make numerous, relatively small paper cutouts, this year including *Composition with a Red Cross* (pl. 368), *Amphitrite* (pl. 369), and other works. Also this year, develops his series of Vence interiors: makes a sequence of relatively small paintings of two women before a window, among them *The Silence Living in Houses* (pl. 377), but also larger works in the series, including *Red Interior: Still Life on a Blue Table* (pl. 380), as well as making brush-and-ink drawings (pls. 381, 382).

SPRING: André Rouveyre's *Repli*, designed and illustrated by Matisse, is published by Éditions du Bélier in Paris.

JUNE 13: Death of Albert Marquet, whom he has known for more than fifty years.

JUNE 27–SEPTEMBER 30: Represented by twelve works, dating from 1894 to 1946, in the "Exposition de peintures et de sculptures contemporaines" at the Palais des Papes in Avignon.

EARLY SEPTEMBER–EARLY OCTOBER: Is in Paris, at no. 132, boulevard du Montparnasse, for three weeks. While he is there, *Jazz* is published by Tériade as a folio of twenty color plates, reproduced from pochoirs based on paper cutouts, and as a bound book with a reproduction of Matisse's handwritten text (pls. 357–367). In this text, describes his cutouts as "drawing with scissors" and also says that "cutting directly into color reminds me of a sculptor's carving into stone."

Returns to Vence.

1947–48 SEASON

Continues his series of Vence interiors, making the concluding and most ambitious paintings in the winter and spring of 1948, among them *Plum Blossoms, Green Background* (pl. 383), *The Black Fern* (pl. 384), *Interior with an Egyptian Curtain* (pl. 385), *The Pineapple* (pl. 386), and the largest of the group, *Large Red Interior* (pl. 387). These comprise his final fully realized paintings. (He will make two unfinished paintings in 1951.) In them, he composes with broad, virtually uninflected areas of vivid color in a way that recalls his decorative post-Fauve paintings of some forty years before.

DECEMBER 3–20: At the Librairie Pierre Berès in Paris, an exhibition of *Jazz* designs: twenty stencil-printed plates, based on original paper cutouts (pls. 357–367). Also shown in New York, January 20–February 3, 1948. *Jazz* is very enthusiastically received.

DECEMBER 4: At Vence, receives his first visit from Brother Rayssiguier, a Dominican novice, concerning decorations for the Chapel of the Rosary in Vence. The two meet again in April 1948.

1948

At the villa Le Rêve, begins work on designs for the Dominican chapel at Vence, which will include stained-glass windows, ceramic murals, an exterior spire, and a pattern for the ceramic roof, as well as sets of vestments and liturgical accoutrements. He will also create a figure of Saint Dominic for Notre-Dame-de-Toute-Grâce at Assy. Will make no paintings until the chapel decorations are finished, in 1951. His first window design is *Celestial Jerusalem* (pl. 388).

APRIL 3–MAY 9: "Henri Matisse: Retrospective Exhibition of Paintings, Drawings, and Sculpture, Organized in Collaboration with the Artist" is held at the Philadelphia Museum of Art; the catalogue foreword is by Henry Clifford, the exhibition's curator, and the essay by Louis Aragon. This exhibition of ninety-three paintings, nineteen sculptures, and eighty-six drawings, along with prints and illustrated books, is the first of the celebrations of the artist's upcoming eightieth birthday. (It does not include his paintings from early 1948, which will be shown at the Pierre Matisse gallery in New York in February 1949.) The catalogue includes two contributions by Matisse: the essay "Exactitude Is Not Truth," in which he stresses that his art does not merely copy nature; and a letter to Henry Clifford, in which he warns against being misled by "the apparent facility" of his drawing, and emphasizes the importance of an artist's identifying with nature.

EARLY JUNE: Leaves Vence for Paris, where he will stay at no. 132, boulevard du Montparnasse until mid-October.

SUMMER: Is at work on designs for the chapel at Vence.

OCTOBER: A special issue of *Verve*, titled "Les tableaux peints par Henri Matisse à Vence, de 1944 à 1948" and designed by Matisse, is published by Tériade.

1948–49 SEASON

MID-OCTOBER: Returns to Vence. By mid-November, the architectural setting and general layout of the murals and windows for the Vence chapel have been established.

NOVEMBER: *Florilège des amours de Ronsard*, with illustrations by Matisse, is published by Albert Skira in Paris.

1949

EARLY JANUARY: Moves back to the Hôtel Régina in Nice-Cimiez. In his apartment, despite his increasing infirmity, he can work at life scale since his two large rooms, taken together, correspond to the interior size of the proposed chapel. Here, he makes the *Tree of Life* maquettes for the window of the chapel (pl. 389), which become the definitive design. Will remain in Nice throughout the year.

FEBRUARY: Exhibition of his recent paintings, drawings, and paper cutouts at the Pierre Matisse gallery in New York. Includes about ten cutouts, which are shown for the first time. In a review of the exhibition, the critic Clement Greenberg describes Matisse as the greatest living painter.

JUNE 9–SEPTEMBER 25: Exhibition of his recent works at the Musée National d'Art

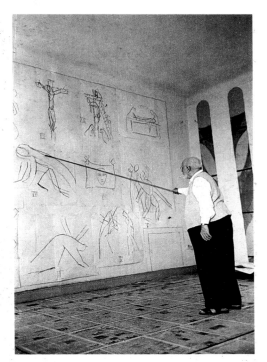

Matisse in his studio at the Hôtel Régina, Nice-Cimiez, August 1949, at work on a sketch for the ceramic-tile mural *The Stations of the Cross*. Photograph by Robert Capa.

Moderne, Paris, in honor of his upcoming eightieth birthday. Includes twenty-one paper cutouts (their first presentation in France); thirteen Vence interior paintings and twenty-two of their related brush-and-ink drawings; and recent illustrated books. The catalogue introduction is by Jean Cassou.

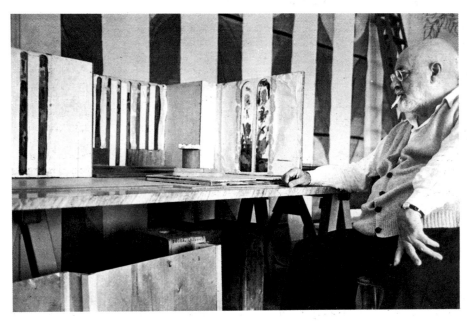

Matisse with a model of the Vence chapel in his studio at the Hôtel Régina, Nice-Cimiez, August 1949. Behind the model: the paper cutout *The Tree of Life*, a maquette for the chapel's nave window. Photograph by Robert Capa.

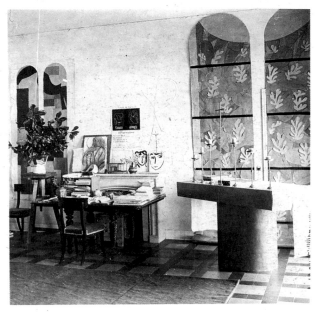

Matisse's studio at the Hôtel Régina, Nice-Cimiez, c. 1950, with preparatory designs for the Vence chapel. On the wall, at left, *Celestial Jerusalem* (pl. 388), and at right, *The Tree of Life* (pl. 389), two maquettes for the apse window. Also, a full-scale model of the altar.

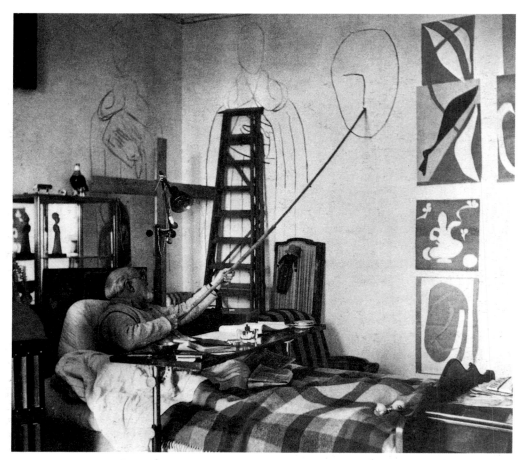

Matisse in his bedroom at the Hôtel Régina, Nice-Cimiez, April 1950, drawing a head. On the wall, at left: sketches for the ceramic-tile mural *Saint Dominic*. At right: paper cutout elements that will be used in *The Thousand and One Nights* (pl. 408) and *The Beasts of the Sea . . .* (pl. 393).

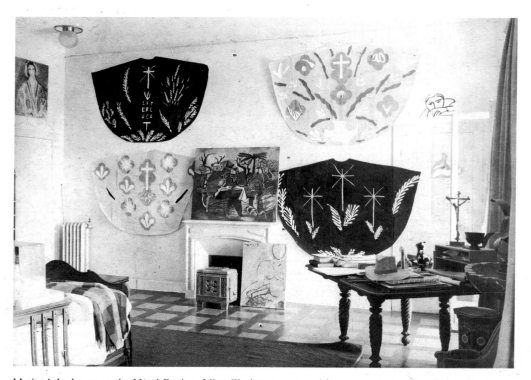

Matisse's bedroom at the Hôtel Régina, Nice-Cimiez, c. 1952, with paper cutout maquettes for the Vence chapel chasubles on the wall. On the mantel, at center: Picasso's *Winter Landscape* of 1950, on loan to Matisse. Above the door, at left, is *Woman in a Blue Gandoura Robe* of 1951 and on the floor, to the right of the mantel, is *Katia* of 1951, Matisse's last two paintings.

JULY 9–OCTOBER 20: Retrospective exhibition of 308 works, dating from 1890 to 1946, at the Musée des Beaux-Arts in Lucerne. Includes a survey of his sculpture.

AUGUST: At the death of Etta Cone, the collection formed by her sister Claribel and herself is bequeathed to the Baltimore Museum of Art. Includes forty-three paintings, eighteen bronzes, more than one hundred drawings, and hundreds of prints.

1949–50 SEASON

DECEMBER 12: The cornerstone of the Vence chapel is laid, by Monsignor Rémond, Bishop of Nice.

1950

This year, begins consistently to make large, independent paper cutouts, mostly in a narrow rectangular format developed from his work on the Vence windows. *Zulma* (pl. 396) is exceptional in being conceived like a figurative picture. *The Beasts of the Sea . . .* (pl. 393) and *The Thousand and One Nights* (pl. 408) are more typical in the additive, modular form of their compositions.

JANUARY: Considers doing the decor for the ballet of Maurice Ravel's *La valse* at the Opéra-Comique in Paris, but the project is abandoned by its organizers.

JANUARY–MARCH: Retrospective exhibition of thirty-eight paintings, with drawings, sculptures, and tapestries, at the Galerie des Ponchettes in Nice; the catalogue texts are by Georges Salles and J. Cassarini.

FEBRUARY: *Poèmes de Charles d'Orléans*, with one hundred lithographs by Matisse, is published by Tériade in Paris.

MARCH: A short essay of his is published under the title "Henri Matisse vous parle" in *Traits*, a small journal aimed at art students. In it, he repeats Cézanne's dictum, "Defy the influential master," and warns his audience against imitating the techniques of those they admire.

MAY 9–31: The Salon de Mai includes the first presentation of the large paper cutout *Zulma* (pl. 396), which is acquired by the Statens Museum for Kunst in Copenhagen.

JUNE 8–OCTOBER 15: Represents France at the twenty-fifth Venice Biennale; receives first prize.

JULY 5–SEPTEMBER 24: Has an exhibition at the Maison de la Pensée Française in Paris, a communist-dominated institution. Includes paintings, drawings, maquettes for the Vence chapel, and recent cutouts as well as fifty-one sculptures, among them the five *Jeannette* heads (pls. 127, 128, 138, 139, 189), here shown together for the first time. The exhibition in-

cludes *Luxe, calme et volupté* (pl. 50), which is shown publicly for the first time since 1905. The catalogue introduction is by Louis Aragon.

MID-JULY: Is in Paris, at no. 132, boulevard du Montparnasse; will remain there until late October.

AUGUST: In an interview with Georges Charbonnier, broadcast in 1951 and published in 1960 in Charbonnier's *Le monologue du peintre* (vol. 2), discusses the Vence chapel and his earlier *Dance* compositions; says that "all art worthy of the name is religious" and that his role "is to provide calm."

1950–51 SEASON

LATE OCTOBER: Returns to Nice. Begins working on designs for the chasubles for the Vence chapel, which he will complete in 1952 (pls. 390, 391).

DECEMBER 3: The stained-glass windows of the Vence chapel are in place.

1951

This year, continues to make large, vertical, window-shaped independent cutouts of increasingly vivid color, among them *Vegetables* (pl. 394), *The Wine Press* (pl. 395), and the cooler *Chinese Fish* (pl. 392), which is made as a maquette for a stained-glass window for Tériade.

In an interview with Maria Luz, published as "Témoignages: Henri Matisse" in *XXe siècle* in January 1952, will discuss his cutouts as "signs" that combine drawing and painting, and says: "From *Bonheur de vivre*—I was thirty-five then—to this cutout—I am eighty-two—I have not changed . . . because all this

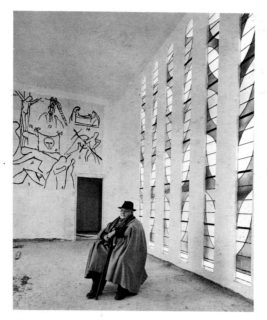

Matisse seated between *The Stations of the Cross* mural and *The Tree of Life* nave window in the partially completed Vence chapel, which will be consecrated in June 1951.

time I have looked for the same things, which I have perhaps realized by different means."

MARCH 3–JUNE 6: Has a large exhibition at the National Museum in Tokyo; it subsequently travels to Kyoto and Osaka. The catalogue includes a preface by the artist and a text by Asano. Also has exhibitions in Hamburg and Düsseldorf.

JUNE 25: Consecration of the chapel at Vence. His physician has forbidden his attending the ceremonies, but Pierre Matisse represents

him. The consecration is conducted by Monsignor Rémond. In a picture book produced for the occasion, *Chapelle du Rosaire des dominicaines de Vence*, Matisse's introduction talks of the chapel as the culmination of his life's work, begun by Fauvism, and characterizes his aim in creating the chapel as "to balance a surface of light and color against a solid wall with black drawing on a white background." He refers to the contrast between the *Tree of Life* stained-glass windows and the ceramic-tile murals *The Stations of the Cross*, *Saint Dominic*, and *Virgin and Child*.

EARLY JULY: Is in Paris, at no. 132, boulevard du Montparnasse. Makes an extended autobiographical statement to Tériade, published as "Matisse Speaks," in *Art News Annual* in 1952. Discusses a wide range of topics, but the main emphasis is on the years through 1917. Will return to Nice in mid-November.

1951–52 SEASON

NOVEMBER 13–JANUARY 13, 1952: Retrospective exhibition at The Museum of Modern Art, New York; subsequently shown at the Cleveland Museum of Art, The Art Institute of Chicago, and the San Francisco Museum of Art. The exhibition numbers about 144 works, including seventy-three paintings, as well as sculptures, drawings, watercolors, and prints; a section devoted to the Vence chapel is installed after the rest of the exhibition has opened.

Publication of Alfred Barr's monograph *Matisse: His Art and His Public*. Matisse makes cover designs for the monograph and for the exhibition catalogue.

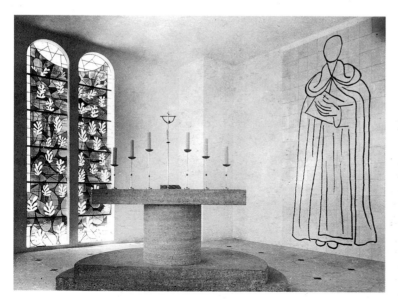

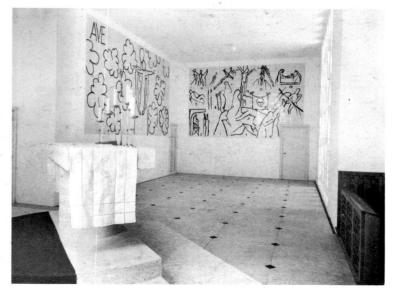

The Chapel of the Rosary, Vence. Left: *The Tree of Life* apse window. Center: the altar, with crucifix and candlesticks. Right: the ceramic-tile mural *Saint Dominic*.

The Chapel of the Rosary, Vence. From left: the altar, *The Virgin and Child* mural, the door of the confessional, *The Stations of the Cross* mural, *The Tree of Life* nave window, and the nuns' stall.

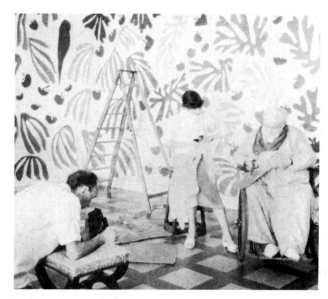

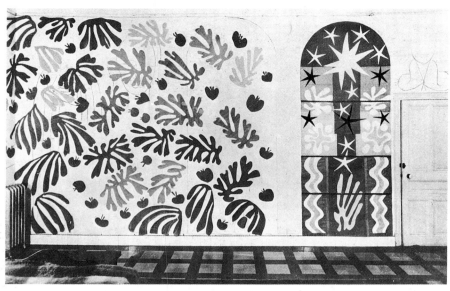

Matisse in his studio at the Hôtel Régina, Nice-Cimiez, 1952. On the walls: the left and central sections of *The Parakeet and the Mermaid*.

Matisse's studio at the Hôtel Régina, Nice-Cimiez, 1952. On the wall, at left: the central and right sections of *The Parakeet and the Mermaid*, not yet completed. At right: *Christmas Eve* (pl. 409).

1952

JANUARY 15: He receives a commission from *Life* magazine for a stained-glass window, *Christmas Eve*. Will complete the paper cutout maquette (pl. 409) by February 27, initiating this most productive year, during which he makes many ambitious paper cutout compositions.

END OF MARCH: Is at work on the large cutout *The Parakeet and the Mermaid*, which will extend around a corner of one of his studios. It will not be completed until late in the year.

APRIL: Makes four *Blue Nude* cutouts (pls. 399–402); related blue figural cutouts will be made through the spring and summer, including *The Flowing Hair* (pl. 398) and *Acrobats* (pl. 405). These works are accompanied by broad brush-and-ink drawings (pl. 403, 404).

APRIL–MAY: In an extended interview with André Verdet, published in Verdet's *Prestiges de Matisse* later in the year, suggests that "one day easel painting will no longer exist . . . there will be mural painting," and discusses how his recent work derives from his discoveries in making *Jazz*.

SUMMER: Works on *The Swimming Pool* (pl. 406), the largest of his cutouts, which extends around the walls of his dining room, with the cutout *Women with Monkeys* (pl. 407) above the doorway. Also moves from the spring–summer series of blue cutouts to develop multicolored works. At this time, begins the large, square, highly abstracted cutouts *Memory of Oceania* (pl. 411) and *The Snail* (pl. 412).

1952–53 SEASON

OCTOBER 8–JANUARY 4, 1953: Is repre-

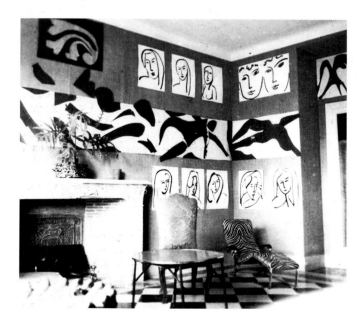

The Swimming Pool (pl. 406), surrounded by brush-and-ink drawings, in the dining room of Matisse's apartment in the Hôtel Régina, Nice-Cimiez, c. 1952.

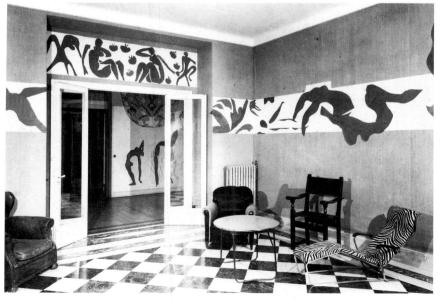

Women with Monkeys (pl. 407), above door, and *The Swimming Pool* (pl. 406) in the dining room of Matisse's apartment in the Hôtel Régina, Nice-Cimiez, c. 1952. *Acrobats* (pl. 405) is visible through the doorway.

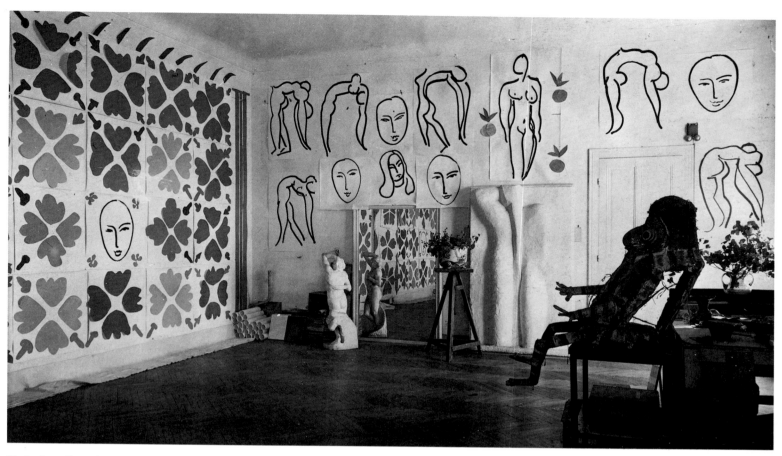

Matisse's studio at the Hôtel Régina, Nice-Cimiez, c. 1953. On the wall, at left: the right section of the paper cutout *Large Decoration with Masks* of 1953. On the facing wall: brush-and-ink drawings, including *Nude with Oranges* (pl. 397) and six *Acrobat* studies (see pls. 403–405). Against the wall: *The Back (IV)* (pl. 294) in plaster. To the left of the mirror: a plaster of Michelangelo's *Bound Slave*. In the right foreground: a New Hebrides sculptural figure owned by Matisse, and which he gave to Picasso (now in the Musée Picasso, Paris).

sented by thirty-one works in the exhibition "Les Fauves" at The Museum of Modern Art, New York, organized by John Rewald. Subsequently shown in Minneapolis, San Francisco, and Toronto.

NOVEMBER 8: Inauguration of the Musée Matisse at Le Cateau-Cambrésis. Georges Salles, director of the Musées de France, conducts the ceremony in the presence of Marguerite Duthuit, Jean Matisse, and the mayor of Le Cateau-Cambrésis. For the occasion, Matisse has sent a written "Message à sa ville natale," which is read during the ceremony.

1953

JANUARY: Is at work on the mural-size cutout *Large Decoration with Masks*. This year will make other similar works for ceramic commissions.

JANUARY 9–FEBRUARY 22: "Exhibition of the Sculpture of Matisse and Three Paintings with Studies" at the Tate Gallery in London. The catalogue includes a preface by Philip James and an introduction by Jean Cassou. A selection of thirty-eight sculptures is also shown at the Curt Valentin Gallery in New York, February 10–28.

FEBRUARY 6: The London journal *Art News and Review* publishes Matisse's recent essay "Looking at Life with the Eyes of a Child," in which he claims that the artist must look at the world as if seeing it for the first time.

FEBRUARY 27–MARCH 28: Exhibition "Henri Matisse: Papiers découpés" at the Berggruen gallery in Paris; he designs the catalogue cover.

1953–54 SEASON

NOVEMBER 6–DECEMBER 6: Has a retrospective exhibition at the Ny Carlsberg Glyptotek in Copenhagen; includes paintings, sculptures, and cutouts.

DECEMBER: Is persuaded to design a relief or fountain for a monument to Apollinaire, after Picasso has been officially relieved of the commission, which has dragged on since December 1920. Soon renounces the project because his health is poor.

1954

This year, the book *Portraits* is published in Monte Carlo, with reproductions of thirty-nine paintings, and an introduction, by Matisse. In this last formal statement about his work, he recalls his early rejection of academic drawing for an art of "feeling or memory," and describes how he projects his own feelings into the subjects he draws.

MAY 20: Death in London of Simon Bussy, a close friend since their days as pupils of Gustave Moreau.

Alberto Giacometti makes a dozen drawings of Matisse during visits to the Hôtel Régina between May 20 and July 6, and again in September. These are studies for a portrait medal commissioned by La Monnaie, the French mint, but never executed.

SUMMER: Stays at a house he has rented near Saint-Paul-de-Vence. Returns to Nice in September.

AUTUMN: At work on a design for the rose window of the Union Church of Pocantico Hills, New York, commissioned by Nelson A. Rockefeller in memory of his mother, Abby Aldrich Rockefeller, one of the founders of The Museum of Modern Art. This will be Matisse's last work.

NOVEMBER 3: Matisse dies, in Nice. Is buried at Cimiez, November 8.

 aintenant, toi, approche, fraîchie sur
des lits de violettes.

Moi, le roi aux cils épais, qui rêve dans le
désert ondulé.

. moi, je vais rompre pour toi mon pacte fait
avec les bêtes.

et avec les génies noires qui dorment la nuque
dans la saignée

de mon bras. et qui dorment sans crainte que
je les dévore.

Des sources qui naissent dans tes paumes je
ne suis pas rassasié encore.

26

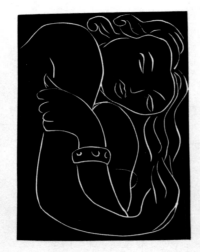

... fraîchie sur des lits de violettes...

Pasiphaé: Chant de Minos (Les Crétois)
by Henry de Montherlant

Published Paris, Martin Fabiani, 1944;
prints executed Nice-Cimiez, Hôtel Régina, and Vence,
villa Le Rêve, 1943–May 1944

148 linoleum cuts: 18 full-page plates, cover,
45 decorative elements, 84 initials;
each page 12⅞ × 9¾″ (32.7 × 24.8 cm)
The Museum of Modern Art, New York.
The Louis E. Stern Collection

354. "*...fraîchie sur des lits de violettes...*"

Les oiseaux de l'extase ont leurs nids dans
tes yeux.

La mélodie du monde inonde tes cheveux.

L'angoisse qui s'amasse en frappant sous ta
gorge

crève contre ma bouche en un cri de bonheur.

Et moi, sans relâcher la bête que j'égorge.

j'adore sur ses traits cette chose qui meurt.

 e l'ai frappée avec mes serres. et mes
serres se sont teintées!

30

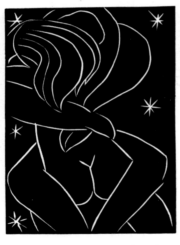

... emportés jusqu'aux constellations...

355. "*...emportés jusqu'aux constellations...*"

le délavement doux de nos brèves bontés.

comme on voit. quand l'aurore au ciel a
éclaté.

des perles de rosée à l'airain de nos casques?

 'ombre meurt. Le matin étonné se
répand.

Que mon âme s'accorde avec le Tout-
Puissant!

Prosterné sur le sol, je mâche la Matière.

Et, ma joue appuyée au sable frais, j'entends

42

... Mais soudain le soleil, secouant sa crinière...

356. "*...Mais soudain le soleil, secouant sa crinière...*"

Jazz by Henri Matisse
"Jazz" par Henri Matisse

Published Paris, E. Tériade, 1947, in an edition of 270 copies

Twenty pochoir plates plus text, each double sheet 16⅝ × 25⅝"
(42.2 × 65.1 cm)
The Museum of Modern Art, New York. The Louis E. Stern Collection

In addition to the book *Jazz*, the exhibition includes the paper
cutout maquettes, executed at Vence, villa Le Rêve, 1943–46, after
which the pochoirs for the plates of *Jazz* were made (lent by the
Musée National d'Art Moderne, Centre Georges Pompidou, Paris).
Jazz was also published by Tériade as a portfolio without text,
in an edition of 100 copies.

357. The Clown (*Le clown*). Plate I (frontispiece), with title page, from *Jazz*

358. The Knife Thrower *(Le lanceur de couteaux)*. Plate XV from *Jazz*

359. Destiny *(Le destin)*. Plate XVI from *Jazz*

360. Lagoon *(Le lagon)*. Plate XVII from *Jazz*

361. The Heart *(Le coeur)*. Plate VII from *Jazz*

l'esprit humain.
l'artiste doit
apporter toute
son énergie,
sa sincérité
et la modestie
la plus grande
pour écarter
pendant son
travail les
vieux clichés

90

362. The Sword Swallower *(L'avaleur de sabres).* Plate XIII from *Jazz*

363. The Swimmer in the Aquarium *(La nageuse dans l'aquarium).* Plate XII from *Jazz*

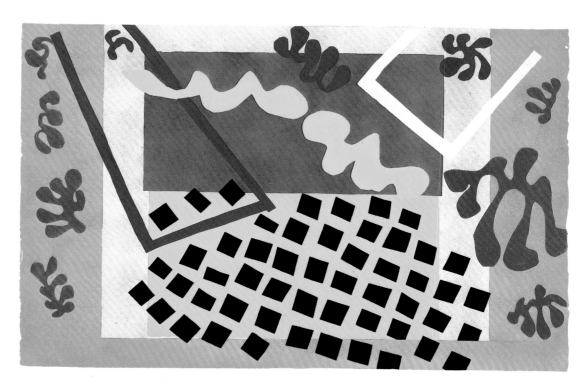

364. The Codomas (*Les codomas*). Plate XI from *Jazz*

de contes
populaires
ou de voyage.
J'ai fait ces
pages d'écri-
tures pour
apaiser les
réactions,
simultanées

142

365. The Toboggan (*Le toboggan*). Plate XX from *Jazz*

366. Circus *(Le cirque)*. Plate II from *Jazz*

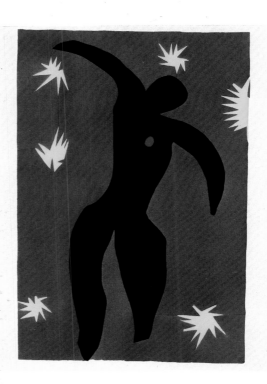

367. Icarus *(Icare)*. Plate VIII from *Jazz*

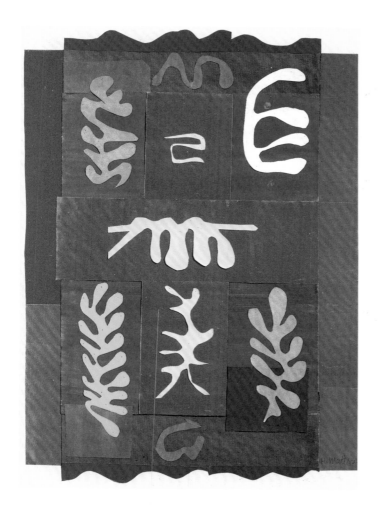

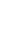

369. Amphitrite

Vence, villa Le Rêve, [1947]

Gouache on paper, cut and pasted, 33⅝ × 27⅝″ (85.5 × 70 cm)
Not signed, not dated
Private collection

368. Composition with a Red Cross
Composition à la croix rouge

Vence, villa Le Rêve, [1947]

Gouache on paper, cut and pasted, 29⅛ × 20⅝″ (74.1 × 52.4 cm)
Signed lower right: "H. Matisse"
Collection Mrs. Maruja Baldwin

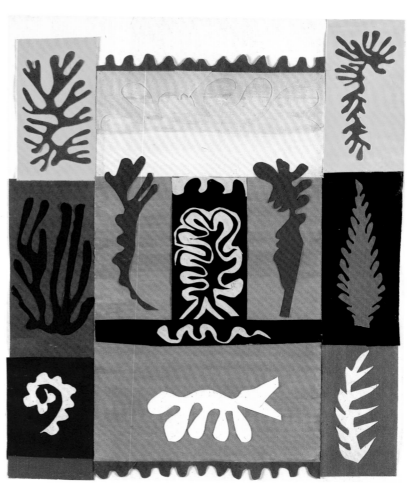

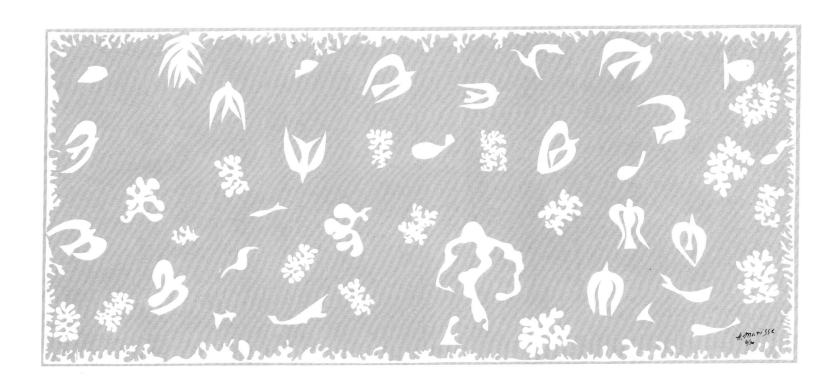

370. Oceania, the Sky
Océanie, le ciel

After a paper cutout maquette made in Paris, boulevard du
Montparnasse, summer 1946

Stencil on linen, 69⅝″ × 12′ 1⅝″ (177 × 370 cm)
Signed lower right: "H. Matisse 6/30." Inscribed lower left: "6/30"
Musée National d'Art Moderne, Centre Georges Pompidou, Paris

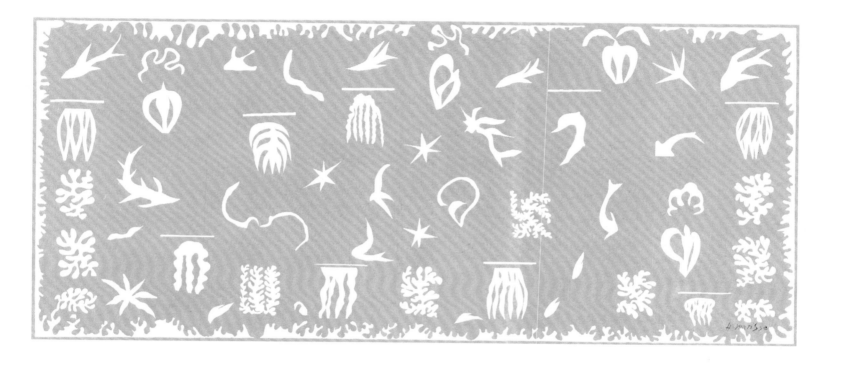

371. Oceania, the Sea
Océanie, la mer

After a paper cutout maquette made in Paris, boulevard du
Montparnasse, summer 1946

Stencil on linen, 65 ⅜″ × 12′ 5 ⅝″ (166 × 380 cm)
Signed lower right: "H. Matisse"
National Gallery of Art, Washington, D.C. Gift of Mr. and Mrs. Burton Tremaine

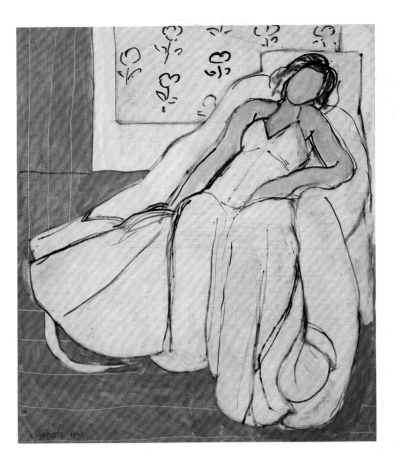

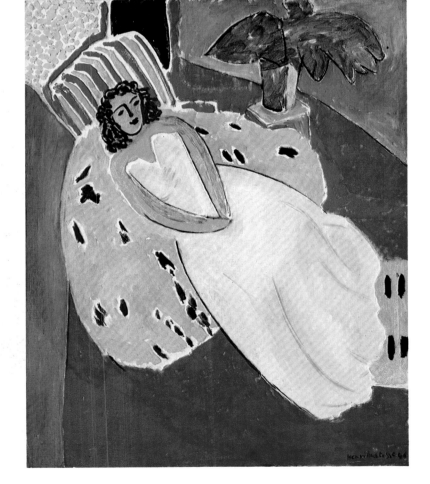

372. Young Woman in White, Red Background
Jeune femme en blanc, fond rouge

Vence, villa Le Rêve, 1944

Oil on canvas, 28⅜ × 23⅝" (72 × 60 cm)
Signed and dated lower left: "H. MATISSE 1944"
Private collection

373. Young Woman in White, Red Background
Jeune femme en blanc, fond rouge

Vence, villa Le Rêve, [spring] 1946

Oil on canvas, 36¼ × 28¾" (92 × 73 cm)
Signed and dated, lower right: "Henri Matisse 46"
Musée National d'Art Moderne, Centre Georges Pompidou, Paris

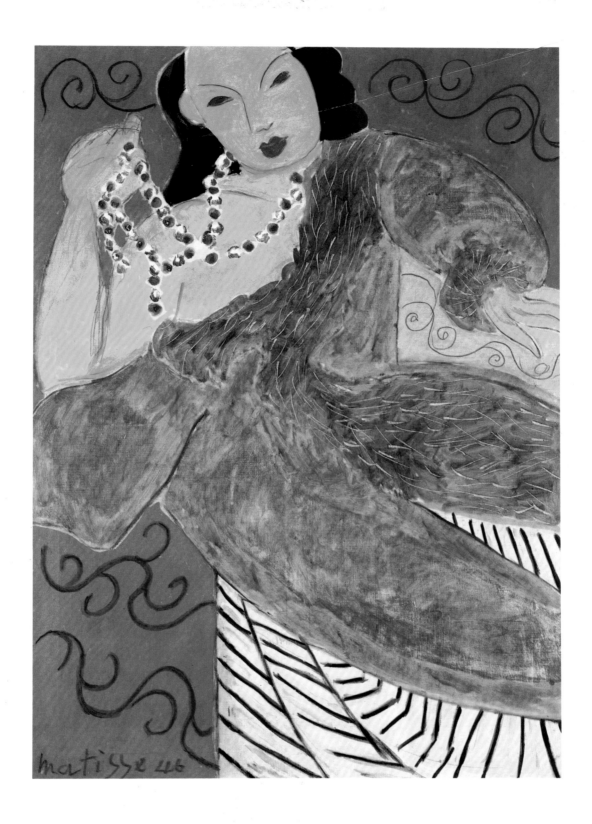

374. Asia
 L'Asie

Vence, villa Le Rêve, [winter–spring] 1946

Oil on canvas, 45⅝ × 31⅞" (116 × 81 cm)
Signed and dated lower left: "Matisse 46"
Collection Mollie Parnis Livingston

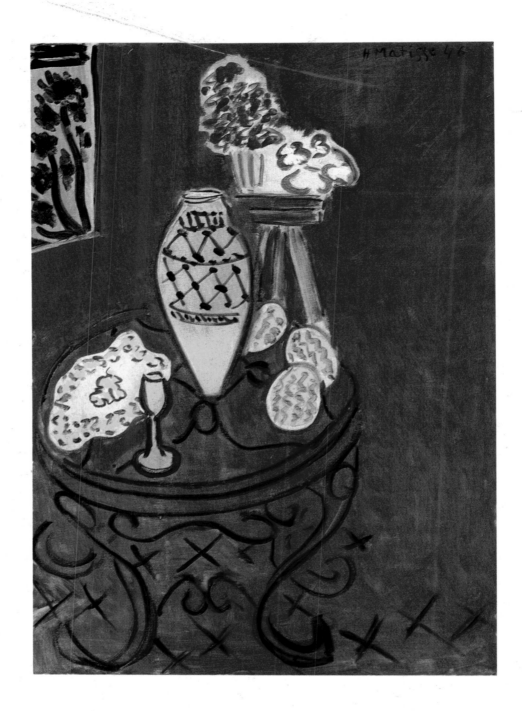

375. Interior in Venetian Red
Intérieur rouge de Venise

Vence, villa Le Rêve, [winter–spring] 1946

Oil on canvas, 36¼ × 25½″ (92 × 65 cm)
Signed and dated upper right: "H Matisse 46"
Musées Royaux des Beaux-Arts de Belgique, Brussels

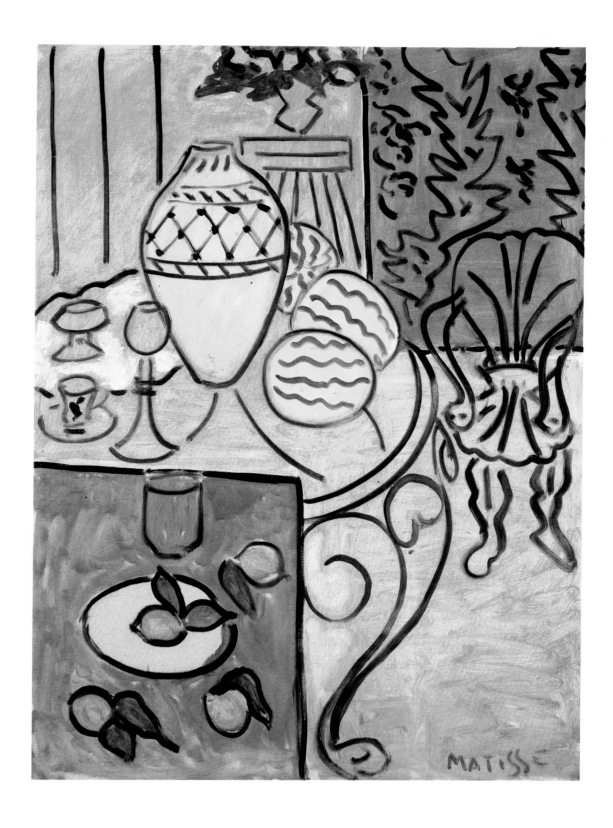

376. Interior in Yellow and Blue
 Intérieur jaune et bleu

Vence, villa Le Rêve, [winter–spring 1946]

Oil on canvas, 45⅝ × 35¾″ (116 × 81 cm)
Signed lower right: "MATISSE"
Musée National d'Art Moderne, Centre Georges Pompidou, Paris

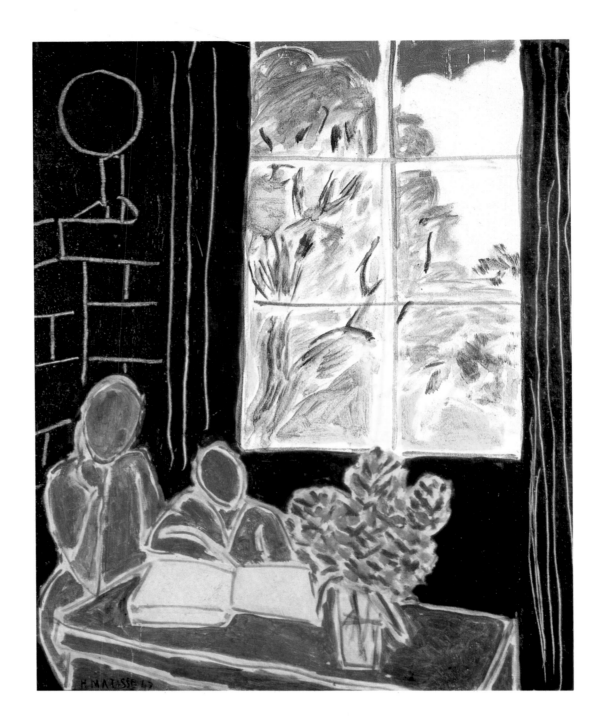

377. The Silence Living in Houses
Le silence habité des maisons

Vence, villa Le Rêve, [summer] 1947

Oil on canvas, 24 × 19⅝″ (61 × 50 cm)
Signed and dated lower left: "H. MATISSE 47"
Private collection

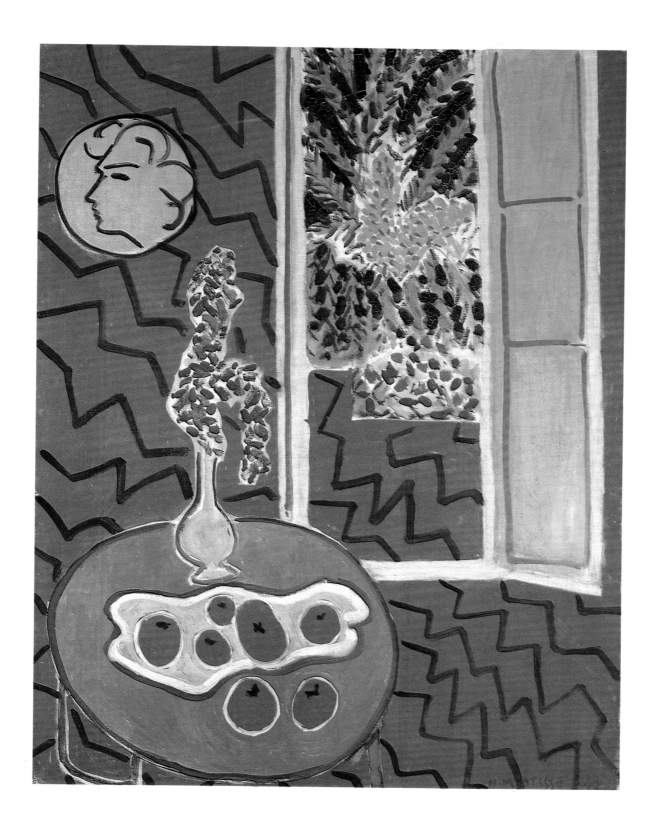

380. Red Interior: Still Life on a Blue Table
Intérieur rouge: Nature morte sur table bleue

Vence, villa Le Rêve, [spring–winter] 1947

Oil on canvas, 45⅝ × 35" (116 × 89 cm)
Signed and dated lower right: "H. MATISSE 47"
Kunstsammlung Nordrhein-Westfalen, Düsseldorf

381. Dahlias and Pomegranates
Dahlias et grenades

Vence, villa Le Rêve, [spring–winter] 1947

Brush and ink on paper, 30⅛ × 22¼″ (76.4 × 56.5 cm)
Signed and dated lower left: "H. Matisse / 47"
The Museum of Modern Art, New York.
Abby Aldrich Rockefeller Fund

382. Dahlias, Pomegranates, and Palm Trees
Dahlias, grenades, et palmiers

Vence, villa Le Rêve, [spring–winter] 1947

Brush and ink on paper, 30 × 22¼″ (76.2 × 56.5 cm)
Signed and dated lower left: "H. Matisse / 47"
Musée National d'Art Moderne, Centre Georges Pompidou, Paris

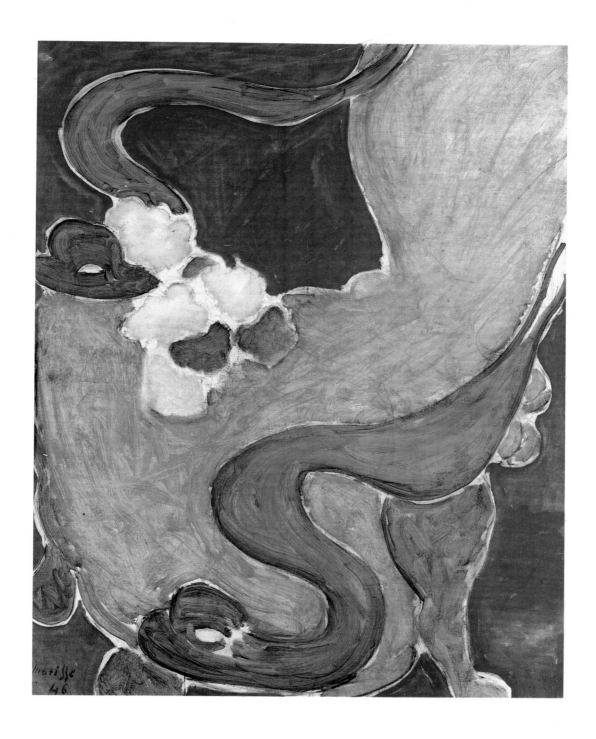

378. The Rocaille Armchair
Le fauteuil rocaille

Vence, villa Le Rêve, [winter–spring] 1946

Oil on canvas, 36¼ × 28¾" (92 × 73 cm)
Signed and dated lower left: "H. Matisse / 46"
Musée Matisse, Nice-Cimiez

379. Composition with a Standing Nude and Black Fern
Composition avec nu debout et fougère noire

Vence, villa Le Rêve, [winter–spring] 1948

Brush and ink on paper, 41⅜ × 29¾″ (105 × 75 cm)
Signed and dated upper left: "H. Matisse / 48"
Musée National d'Art Moderne, Centre Georges Pompidou, Paris

383. Plum Blossoms, Green Background
La branche de prunier, fond vert

Vence, villa Le Rêve, [winter–spring] 1948

Oil on canvas, 45 ⅝ × 35″ (115.9 × 89 cm)
Signed and dated lower left: "H. Matisse 48"
Private collection
Formerly collection Mr. and Mrs. Albert D. Lasker

384. The Black Fern
La fougère noire

Vence, villa Le Rêve, [winter–spring] 1948

Oil on canvas, 45⅝ × 35″ (116 × 89 cm)
Signed and dated lower center, sideways:
"Matisse / Vence / 1948"
Beyeler Collection, Basel
Formerly collection Leigh B. Block

385. Interior with an Egyptian Curtain
Intérieur au rideau égyptien

Vence, villa Le Rêve, [winter–spring] 1948

Oil on canvas, 45¾ × 35⅛″ (116.2 × 89.2 cm)
Signed and dated right lower center: "Matisse 48"
The Phillips Collection, Washington, D.C.

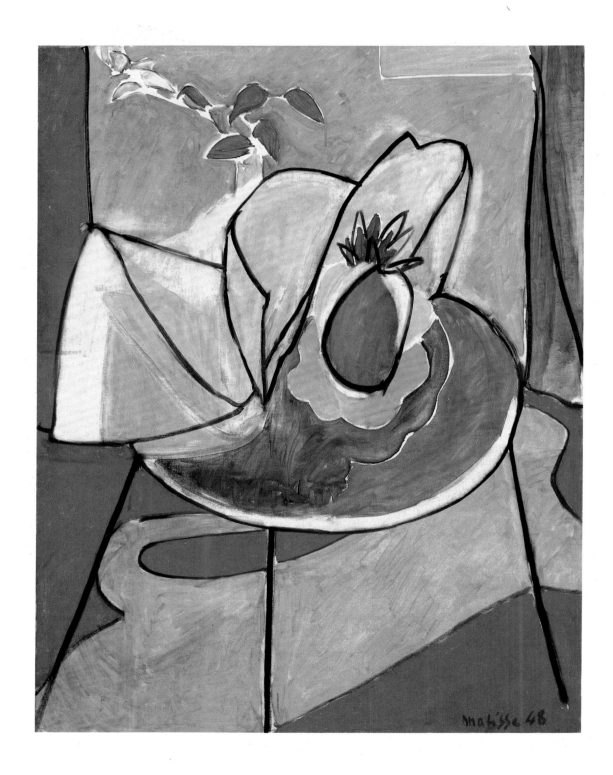

386. The Pineapple
L'ananas

Vence, villa Le Rêve, [winter–spring] 1948

Oil on canvas, 45 ¾ × 35″ (116 × 89 cm)
Signed and dated lower right: "Matisse 48"
Collection of the Alex Hillman Family Foundation

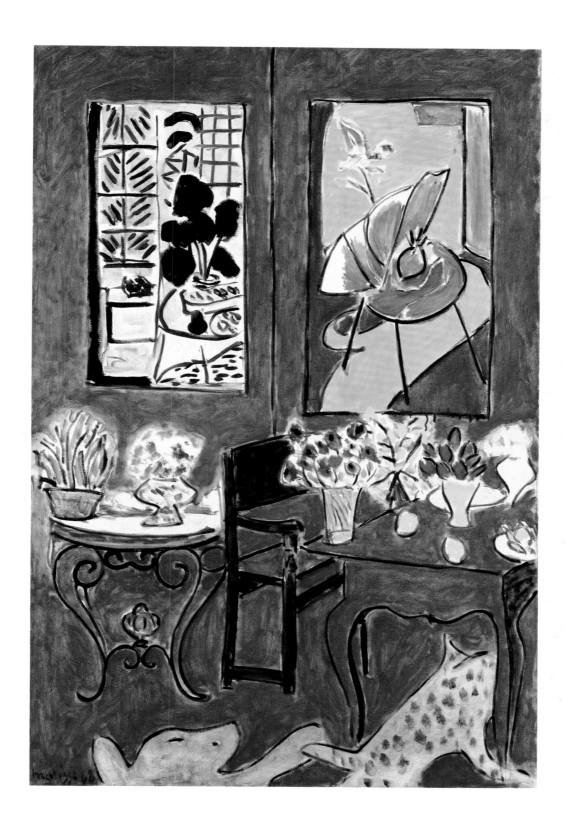

387. Large Red Interior
Grand intérieur rouge

Vence, villa Le Rêve, [winter–spring] 1948

Oil on canvas, 57½ × 38¼″ (146 × 97 cm)
Signed and dated lower left: "Matisse 48"
Musée National d'Art Moderne, Centre Georges Pompidou, Paris

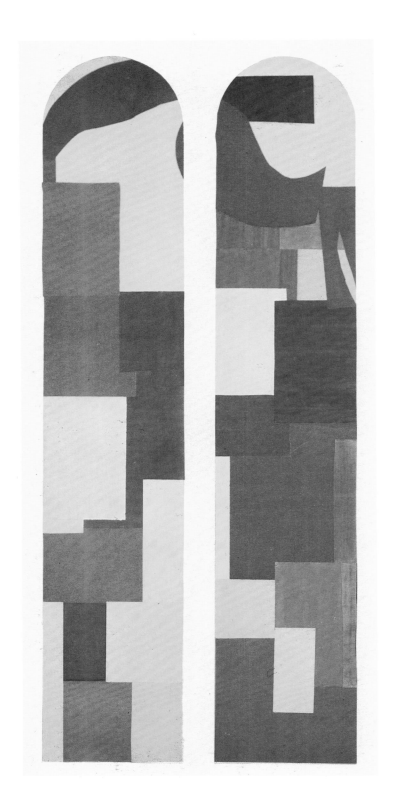

388. Celestial Jerusalem
 Jérusalem céleste

Vence, villa Le Rêve, [winter–spring] 1948

Preliminary maquette for stained-glass window in the apse of the Chapel
of the Rosary of the Dominican Nuns of Vence: gouache on paper, cut
and pasted, on white paper, 8′ 10⅜″ × 51⅛″ (270 × 130 cm)
Not signed, not dated
Private collection

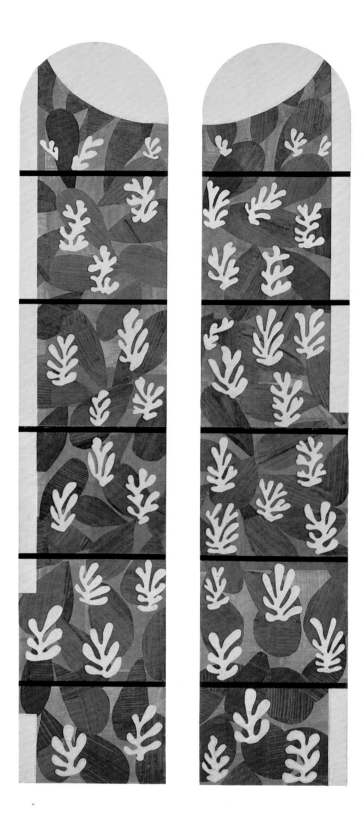

389. The Tree of Life
L'arbre de vie

Nice-Cimiez, Hôtel Régina, 1949

Final maquette for stained-glass window in the apse of the Chapel of the
Rosary of the Dominican Nuns of Vence: gouache on paper, cut and
pasted, 16′ 10¾″ × 8′ 3⅛″ (515 × 252 cm)
Not signed, not dated
The Vatican Museums. Collection of Modern Religious Art

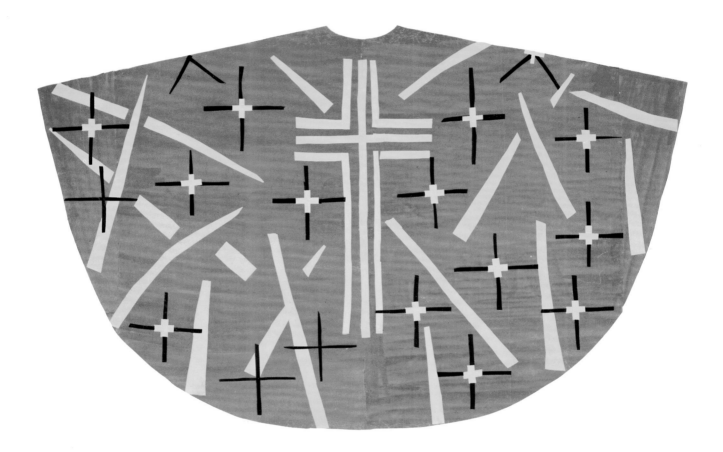

390. Maquette for red chasuble (front) designed for the Chapel of
the Rosary of the Dominican Nuns of Vence
Maquette pour la chasuble rouge (face) dessinée pour la
chapelle du Rosaire des dominicaines de Vence

Nice-Cimiez, Hôtel Régina, [late 1950–52]

Gouache on paper, cut and pasted, 52½″ × 6′6⅛″ (133.3 × 198.4 cm)
Not signed, not dated
The Museum of Modern Art, New York. Acquired through the
Lillie P. Bliss Bequest

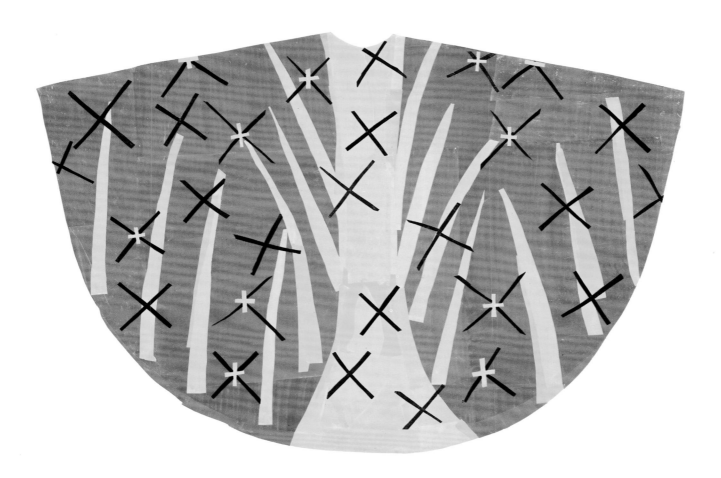

391. Maquette for red chasuble (back) designed for the Chapel of
the Rosary of the Dominican Nuns of Vence
*Maquette pour la chasuble rouge (dos) dessinée pour la
chapelle du Rosaire des dominicaines de Vence*

Nice-Cimiez, Hôtel Régina, [late 1950–52]

Gouache on paper, cut and pasted, 50½″ × 6′6½″ (128.2 × 199.4 cm)
Not signed, not dated
The Museum of Modern Art, New York. Acquired through the
Lillie P. Bliss Bequest

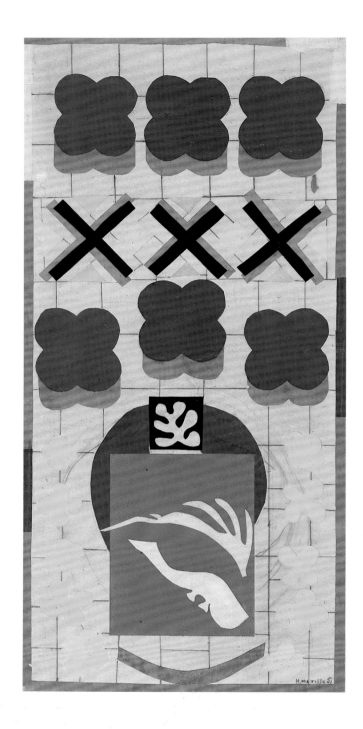

392. Chinese Fish
Poissons chinois

Nice-Cimiez, Hôtel Régina, 1951

Maquette for a stained-glass window: gouache on paper, cut and
pasted, on white paper, 6′ 3¾″ × 35⅞″ (192.2 × 91 cm)
Signed and dated lower right: "H. MATISSE 51"
Collection Vicci Sperry

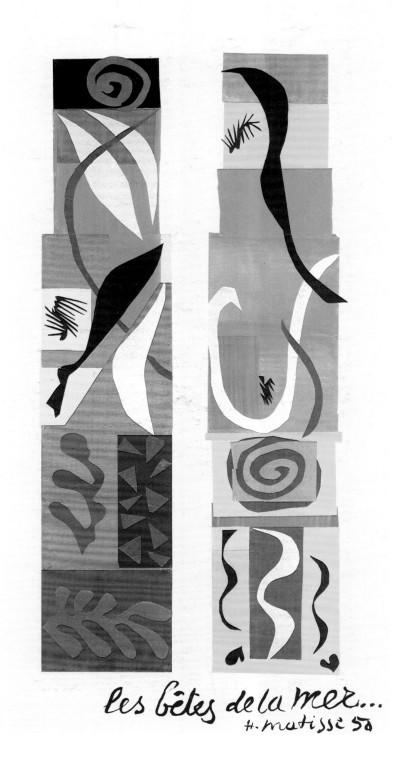

393. The Beasts of the Sea . . .
 Les bêtes de la mer . . .

Nice-Cimiez, Hôtel Régina, 1950

Gouache on paper, cut and pasted, on white paper, 116⅜ × 60⅝″ (295.5 × 154 cm)
Inscribed lower right: "les bêtes de la mer . . . / H. Matisse 50"
National Gallery of Art, Washington, D.C. Ailsa Mellon Bruce Fund

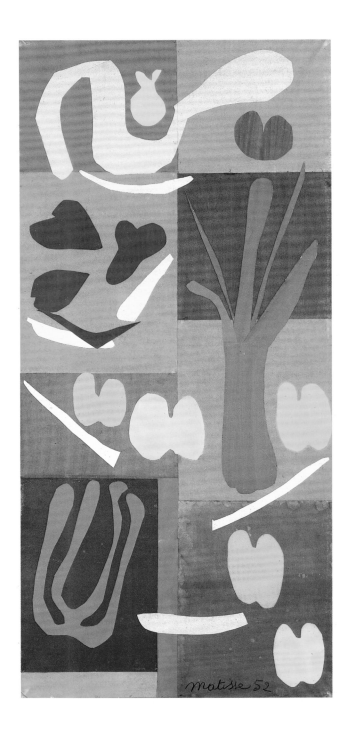

394. Vegetables
Végétaux

Nice-Cimiez, Hôtel Régina, [c. 1951]

Gouache on paper, cut and pasted, 69 × 31⅞″ (175 × 81 cm)
Signed and dated (probably later) lower right of center: "Matisse 52"
Private collection

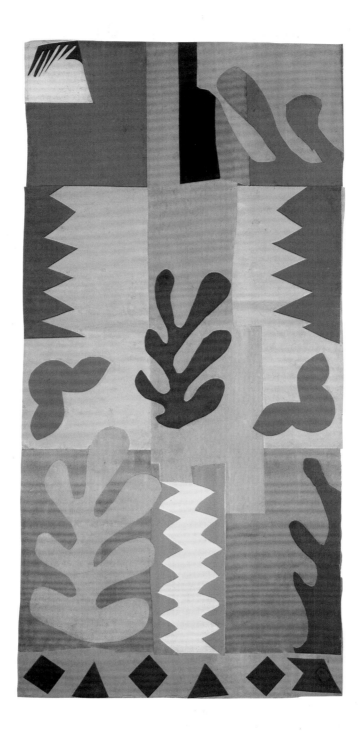

395. The Wine Press
La vis

Nice-Cimiez, Hôtel Régina, [c. 1951]

Gouache on paper, cut and pasted, 68⅞ × 32¼″ (175 × 82 cm)
Not signed, not dated
Private collection, courtesy Ellen and Paul Josefowitz

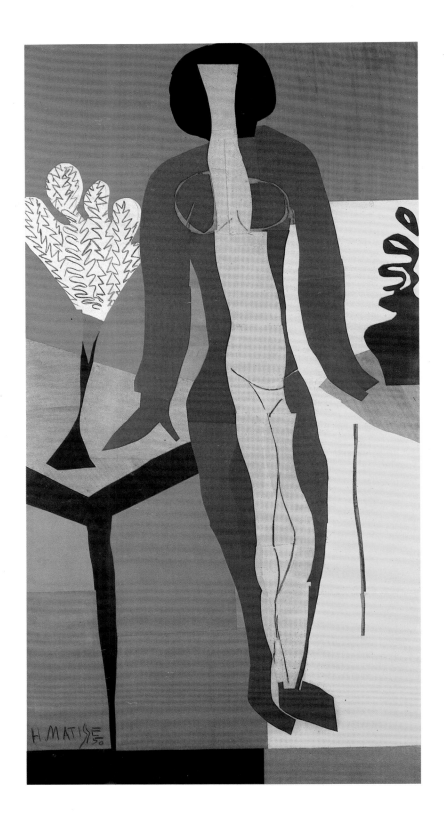

396. Zulma

Nice-Cimiez, Hôtel Régina, [winter–spring] 1950

Gouache on paper, cut and pasted, and crayon, 93¾ × 52⅜″
(238 × 133 cm)
Signed and dated lower left: "H. MATISSE / 50"
Statens Museum for Kunst, Copenhagen. J. Rump Collection

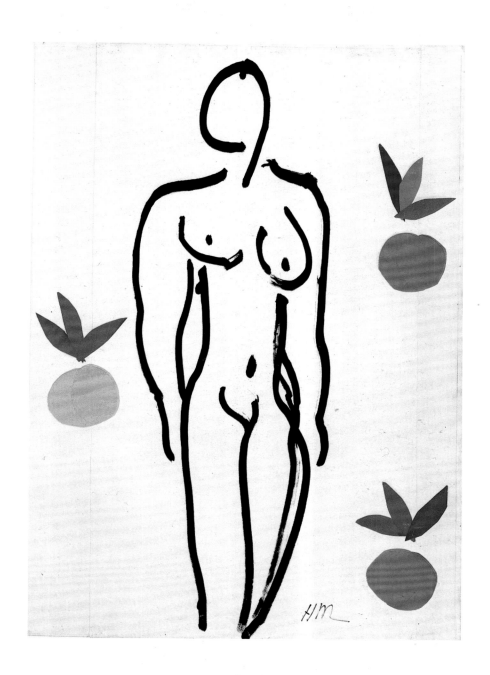

397. Nude with Oranges
Nu aux oranges

Nice-Cimiez, Hôtel Régina, [1952–53]

Gouache on paper, cut and pasted, and brush and ink on white paper,
60¾ × 42¼″ (154.2 × 107.1 cm)
Signed lower right of center: "HM"
Museé National d'Art Moderne, Centre Georges Pompidou, Paris

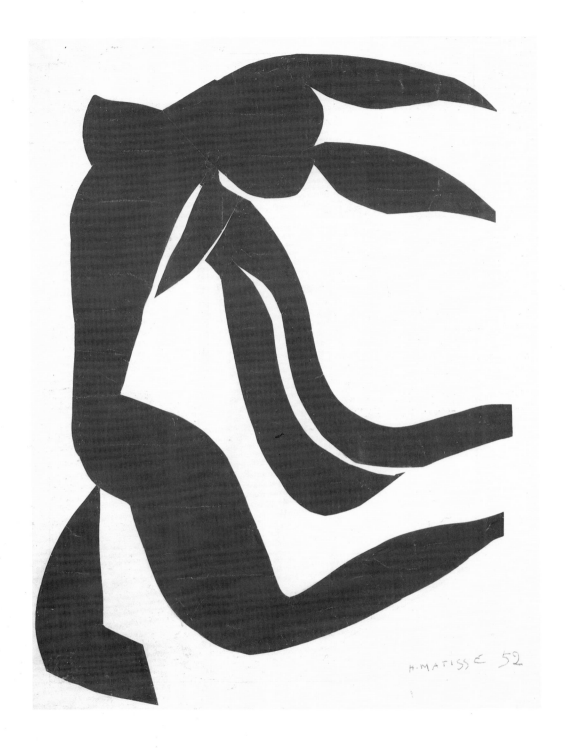

398. The Flowing Hair
La chevelure

Nice-Cimiez, Hôtel Régina, [spring] 1952

Gouache on paper, cut and pasted, on white paper,
42½ × 31½″ (108 × 80 cm)
Signed and dated lower right: "H. MATISSE 52"
Private collection

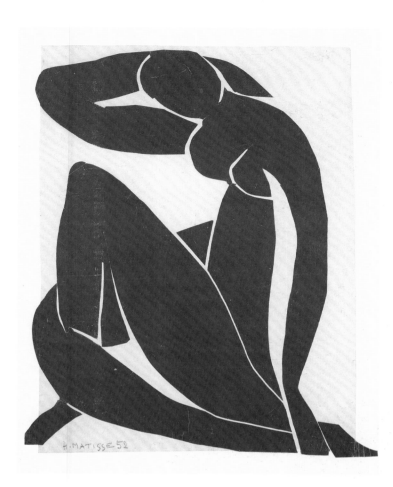

399. Blue Nude (II)
Nu bleu (II)

Nice-Cimiez, Hôtel Régina, [spring] 1952

Gouache on paper, cut and pasted, on white paper,
45¾ × 32¼″ (116.2 × 81.9 cm)
Signed and dated lower left: "H. MATISSE 52"
Musée National d'Art Moderne, Centre Georges Pompidou, Paris

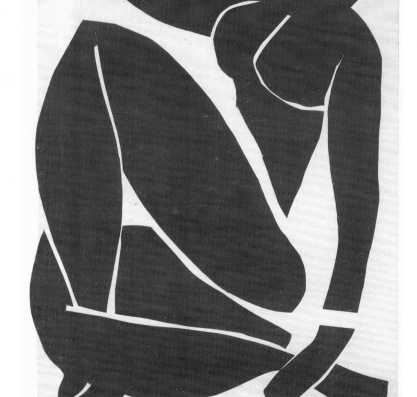

400. Blue Nude (III)
Nu bleu (III)

Nice-Cimiez, Hôtel Régina, [spring] 1952

Gouache on paper, cut and pasted, on white paper,
44 × 29″ (112 × 73.5 cm)
Signed and dated lower left of center: "H MATISSE 52"
Musée National d'Art Moderne, Centre Georges Pompidou, Paris

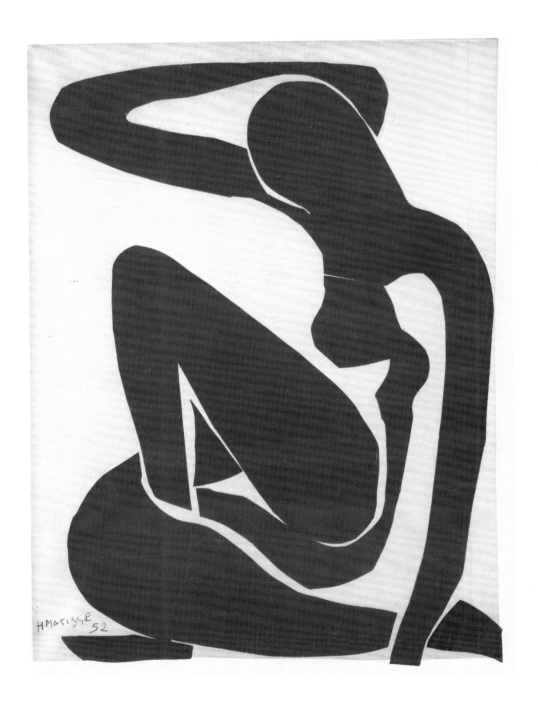

401. Blue Nude (I)
Nu bleu (I)

Nice-Cimiez, Hôtel Régina, [spring] 1952

Gouache on paper, cut and pasted, on white paper,
41¾ × 30¾" (106 × 78 cm)
Signed and dated lower left: "H MATISSE / 52"
Beyeler Collection, Basel

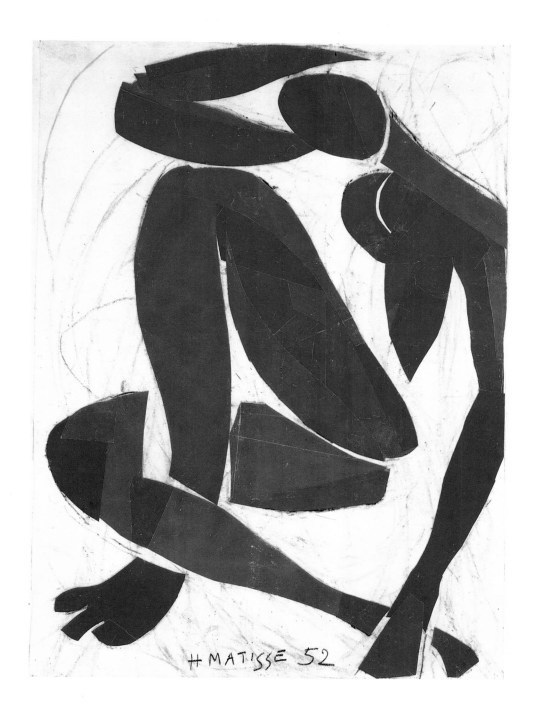

402. Blue Nude (IV)
 Nu bleu (IV)

Nice-Cimiez, Hôtel Régina, [spring] 1952

Gouache on paper, cut and pasted, and charcoal on white paper,
40½ × 29⅛″ (103 × 74 cm)
Signed and dated lower center: "H MATISSE 52"
Musée Matisse, Nice-Cimiez

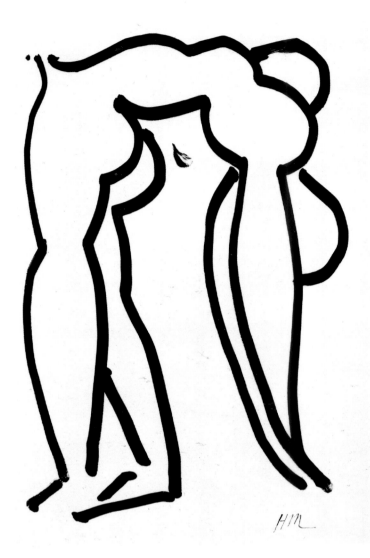

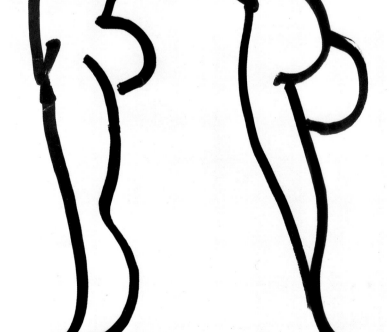

403. Acrobat
Acrobate

Nice-Cimiez, Hôtel Régina, [1952]

Brush and ink on paper, 41½ × 20⅜″ (105.5 × 74.5 cm)
Signed lower right: "HM"
Musée National d'Art Moderne, Centre Georges Pompidou, Paris

404. Acrobat
Acrobate

Nice-Cimiez, Hôtel Régina, [1952]

Brush and ink on paper, 41½ × 20⅜″ (105.5 × 74.5 cm)
Signed lower right of center: "HM"
Private collection

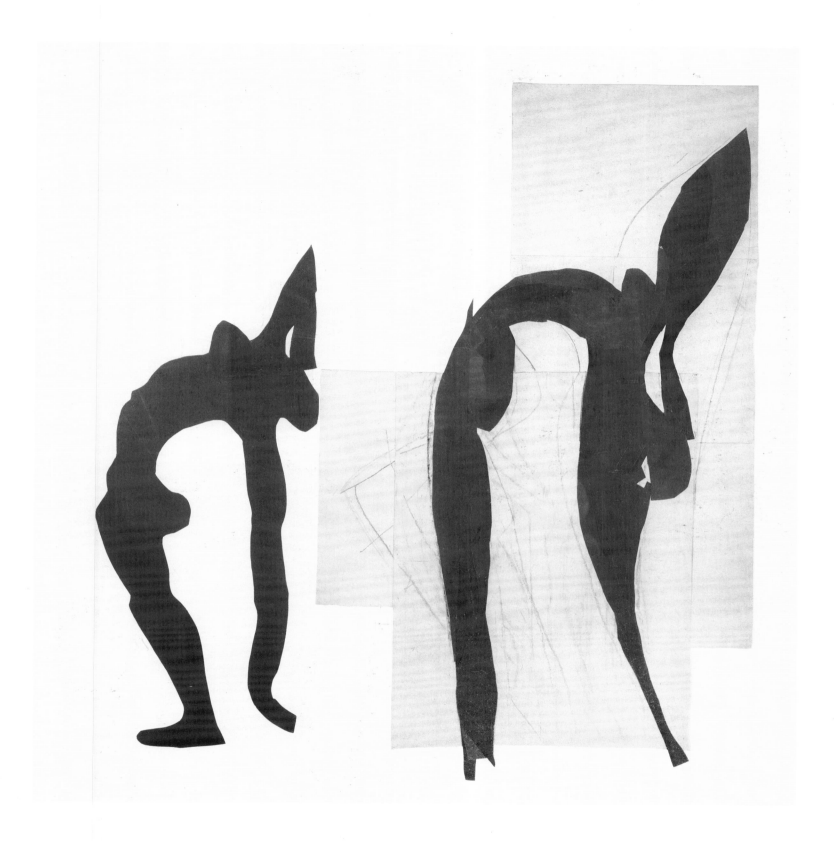

405. Acrobats
Acrobates

Nice-Cimiez, Hôtel Régina, [spring–summer 1952]

Gouache on paper, cut and pasted, and charcoal on white paper,
6′ 11¾″ × 6′ 10½″ (213 × 209.5 cm)
Not signed, not dated
Private collection

406. The Swimming Pool
La piscine

Nice-Cimiez, Hôtel Régina, [late summer 1952]

Nine-panel mural in two parts: gouache on paper, cut and pasted,
on white painted paper mounted on burlap; a–e, 7′6⅝″ × 27′9½″
(230.1 × 847.8 cm); f–i, 7′6⅝″ × 26′1½″ (230.1 × 796.1 cm)
Not signed, not dated
The Museum of Modern Art, New York. Mrs. Bernard F. Gimbel Fund

For two views of the work as installed at the Hôtel Régina, c. 1952, see p. 420.

407. Women with Monkeys
Femmes et singes

Nice-Cimiez, Hôtel Régina, [spring–summer] 1952

Gouache on paper, cut and pasted, and charcoal on white paper,
28¼″ × 9′ 4⅝″ (71.7 × 286.2 cm)
Not signed, not dated
Museum Ludwig, Cologne

408. The Thousand and One Nights
Les mille et une nuits

Nice-Cimiez, Hôtel Régina, [spring–] June 1950

Gouache on paper, cut and pasted, on white paper, 54¼″ × 12′ 3¼″ (139.1 × 374 cm)
Signed and dated lower right: "H. Matisse Juin 50"
The Carnegie Museum of Art, Pittsburgh. Acquired through the
generosity of the Sarah Mellon Scaife Family, 1971

409. Christmas Eve
Nuit de Noël

Nice-Cimiez, Hôtel Régina, early 1952

Maquette for a stained-glass window: gouache on paper, cut and
pasted, 10′7″ × 53½″ (322.6 × 135.9 cm)
Signed and dated lower right: "MATISSE 52"
The Museum of Modern Art, New York. Gift of Time Inc.

410. Ivy in Flower
Lierre en fleur

Nice-Cimiez, Hôtel Régina, 1953

Maquette for a stained-glass window: gouache on paper, cut and
pasted, and pencil on colored paper, 9′ 3⅞″ × 9′ 4⅝″ (284.2 × 286.1 cm)
Signed and dated lower right: "Matisse / 53"
Dallas Museum of Art. Foundation for the Arts Collection.
Gift of the Albert and Mary Lasker Foundation

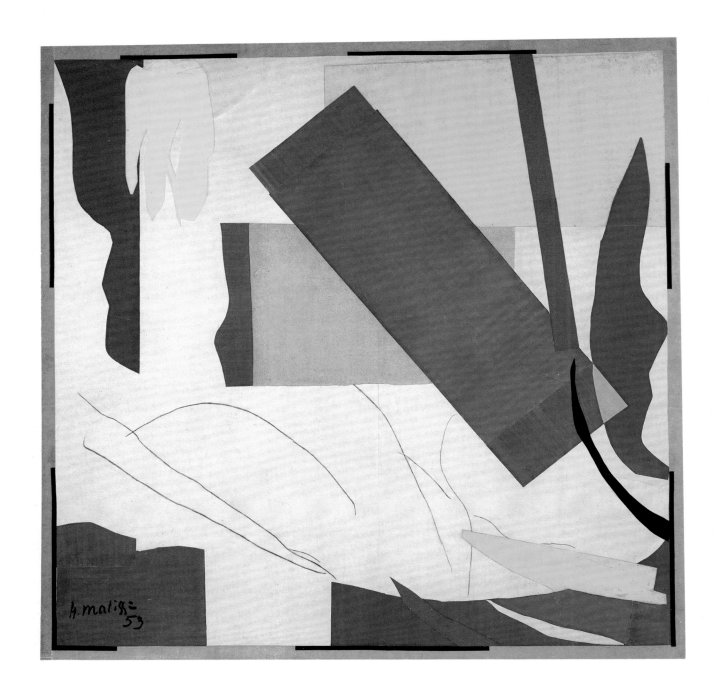

411. Memory of Oceania
Souvenir d'Océanie

Nice-Cimiez, Hôtel Régina, [summer 1952–early] 1953

Gouache on paper, cut and pasted, and charcoal on white paper,
9' 4" × 9' 4⅞" (284.4 × 286.4 cm)
Signed and dated lower left: "H. Matisse / 53"
The Museum of Modern Art, New York. Mrs. Simon Guggenheim Fund

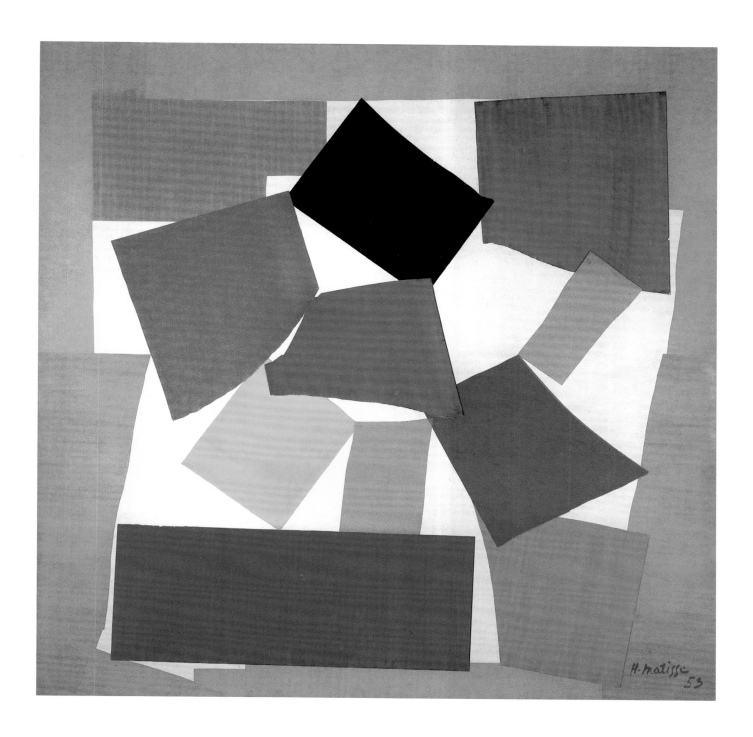

412. The Snail
L'escargot

Nice-Cimiez, Hôtel Régina, [summer 1952–early] 1953

Gouache on paper, cut and pasted, on white paper, 9′ 4¾″ × 9′ 5″
(287 × 288 cm)
Signed and dated lower right: "H. Matisse / 53"
Tate Gallery, London. Purchased with the aid of the
Friends of the Tate Gallery, 1962

BIBLIOGRAPHICAL NOTE

The literature on Matisse is enormous. This is a brief overview of only the most indispensable sources. A full account, Catherine C. Bock-Weiss's *Henri Matisse: A Guide to Research* (New York: Garland), is promised for 1993. In the meantime, there is an excellent review of the historical development of Matisse literature in Jack Flam, *Matisse: The Man and His Art, 1869–1918* (Ithaca and London: Cornell University Press, 1986). This same author's *Matisse: A Retrospective* (New York: Levin, 1988) is an extremely useful compilation of excerpts from critical writings on the artist from 1896 to 1957. Extensive bibliographies may be found in Alfred H. Barr, Jr., *Matisse: His Art and His Public* (New York: The Museum of Modern Art, 1951); Jack D. Flam, ed., *Matisse on Art* (New York: Phaidon, 1973; rpt., New York: Dutton, 1978); Pierre Schneider, *Matisse* (Paris: Flammarion, 1984; English ed., New York: Rizzoli, 1984); and Isabelle Monod-Fontaine, *Matisse* (Paris: Musée National d'Art Moderne, Centre Georges Pompidou, 1989).

MATISSE'S WRITINGS AND STATEMENTS. There are two invaluable collections. In French: Dominique Fourcade, ed., *Henri Matisse: Écrits et propos sur l'art* (Paris: Hermann, 1972), which is arranged thematically, with detailed annotations and a most useful index; in English: Flam, ed., *Matisse on Art* (1973; see above), arranged chronologically, with each text separately introduced and annotated. Fourcade's book is supplemented by his "Autres propos de Henri Matisse," *Macula*, no. 1 (1976), pp. 92–115. Most of Matisse's letters remain unpublished. Those that have been published are included in: *Bonnard–Matisse: Correspondance, 1925–1946*, ed. Jean Clair, Introduction and notes by Antoine Terrasse (Paris: Gallimard, 1991), translated as *Bonnard/Matisse: Letters Between Friends, 1925–1946*, trans. Richard Howard (New York: Abrams, 1992); Danièle Giraudy, ed., "Correspondance Henri Matisse–Charles Camoin," *Revue de l'art*, no. 12 (1971), pp. 7–34, whose documentation, unfortunately, is unreliable; and Barbu Brezianu, ed., "Correspondance Matisse–Pallady," *Secolul*, vol. 20, no. 6 (1965).

CATALOGUES. Catalogues raisonnés exist only for Matisse's prints and illustrated books (see below). However, there are catalogues of the principal public collections of his work. The most detailed are John Elderfield, *Matisse in the Collection of The Museum of Modern Art* (New York: The Museum of Modern Art, 1978); and Monod-Fontaine, *Matisse* (1989; see above). The Russian collections are recorded in *Matisse: Paintings, Sculpture, Graphic Work, Letters* (Moscow: The State Pushkin Museum, 1969); and A. Izerghina, *Henri Matisse: Paintings and Sculptures in Soviet Museums* (Leningrad: Aurora, 1978). The collections at Grenoble and Baltimore, respectively, are recorded in Dominique Fourcade, *Matisse au Musée de Grenoble* (Grenoble: Musée de Grenoble, 1975), and Brenda Richardson et al., *Dr. Claribel and Miss Etta: The Cone Collection of The Baltimore Museum of Art* (Baltimore: The Baltimore Museum of Art, 1985). Indispensable are the catalogues of the major retrospective exhibitions. These include: *Henri Matisse: Retrospective Exhibition of Paintings, Drawings, and Sculpture* (Philadelphia: Philadelphia Museum of Art, 1948); *Henri Matisse*

(New York: The Museum of Modern Art, 1951); *Henri Matisse: Retrospective Exhibition, 1966* (Los Angeles: UCLA Art Galleries, 1966); *Matisse, 1869–1954* (London: Arts Council of Great Britain, 1968); and especially *Henri Matisse: Exposition du centenaire* (Paris: Grand Palais, 1970), whose documentation is valuable because it was established by the Archives Henri Matisse, although some of it has now been superseded. Other useful catalogues of survey exhibitions of Matisse's work include *Matisse: En retrospectiv udstilling* (Copenhagen: Statens Museum for Kunst, 1970); and *Henri Matisse* (Zurich: Kunsthaus, 1982).

MONOGRAPHS. Alfred Barr's *Matisse: His Art and His Public* (1951; see above), although now an historical monument, is still indispensable, full of brilliant analyses and important documentation, and includes material derived from questionnaires to the artist and his family. But it is no longer entirely reliable. Neither are any of the early monographs. The following, however, are of particular interest: Marcel Sembat, *Henri Matisse* (Paris: Nouvelle Revue Française, 1920), if only because it was the very first monograph; Roger Fry, *Henri-Matisse* (Paris: Chroniques du Jour; New York: E. Weyhe, [1930]), with an important text by a major critic; the idiosyncratic volume by Albert C. Barnes and Violette de Mazia, *The Art of Henri Matisse* (New York and London: Scribners, 1933); Raymond Escholier, *Henri Matisse* (Paris: Floury, 1937), an early biographical study; Aleksandr Romm, *Henri Matisse* (Leningrad: Ogiz-Izogiz, 1937), a sympathetic Marxist critique; Pierre Courthion, *Le visage de Matisse* (Lausanne: Jean Marguerat, 1942), which likewise includes first-hand materials; Frank Anderson Trapp, "The Paintings of Henri Matisse: Origins and Early Development, 1890–1917" (Ph.D. dissertation, Harvard University, 1951), an important study of the years before Nice; Gaston Diehl, *Henri Matisse* (Paris: Pierre Tisné, 1954; English ed., Paris: Pierre Tisné, 1958), still a most essential work; and Raymond Escholier, *Matisse ce vivant* (Paris: Fayard, 1956), another biographical study, translated as *Matisse from the Life* (London: Faber, 1960). Among more recent works, the following general appreciations are well worth consulting: Clement Greenberg, *Henri Matisse (1869–)* (New York: Abrams; Pocket Books, 1953); John Russell, *The World of Matisse, 1869–1954* (New York: Time Life, 1969); Nicolas Watkins, *Matisse* (New York: Oxford University Press, 1985). So is the useful, but by no means comprehensive Mario Luzi and Massimo Carrà, *L'opera di Matisse dalla rivolta fauve all'intimismo, 1904–1928* (Milan: Rizzoli, 1971), translated as *Tout l'oeuvre peint de Matisse, 1904–1928*, Introduction by Pierre Schneider (Paris: Flammarion, 1982). However, the truly essential studies besides Barr's are [Louis] Aragon, *Henri Matisse: Roman*, 2 vols. (Paris: Gallimard, 1971), translated as *Henri Matisse: A Novel* (London: Collins, 1972), comprising this poet's collected writings on Matisse, many of which the artist himself annotated; Lawrence Gowing, *Matisse* (New York and Toronto: Oxford University Press, 1979), an unsurpassed concise account; Schneider, *Matisse* (1984; see above), a large and impressive volume with a rich, thematically organized text; and Flam, *Matisse: The*

Man and His Art, 1869–1918 (1986; see above), extraordinarily thorough, the best art-historical study in recent years, to be followed by a second volume encompassing the remainder of Matisse's career.

PERIODICALS. There have been a number of issues of periodicals devoted to Matisse. Well worth consulting are *Cahiers d'art*, vol. 6, nos. 5–6 (1931); *Le point*, vol. 4, no. 21 (July 1939); *The Yale Literary Magazine*, vol. 123 (Fall 1955); "Hommage à Henri Matisse," a special issue of *XXᵉ siècle* (1970); *Critique*, vol. 30, no. 324 (May 1974); *Arts Magazine*, vol. 49, no. 9 (May 1975); *Art in America*, vol. 63, no. 4 (July–August 1975); and *Louisiana Revy*, vol. 25, no. 2 (January 1985). There is not the space here to survey the numerous individual articles; however, a few are cited below for specialized aspects of Matisse's work.

SPECIALIZED STUDIES. Among the noteworthy publications on Matisse's early work are: *Matisse: Ajaccio-Toulouse, 1898–1899: Une saison de peinture* (Toulouse: Musée d'Art Moderne, 1986), the fourth publication in the continuing occasional series *Cahiers Henri Matisse*, prepared by the Musée Matisse, Nice-Cimiez; Catherine C. Bock, *Henri Matisse and Neo-Impressionism, 1898–1908* (Ann Arbor, Mich.: UMI Research Press, 1981); and Roger Benjamin, "Recovering Authors: The Modern Copy, Copy Exhibitions and Matisse," *Art History*, vol. 12, no. 2 (June 1989), pp. 176–201.

Of all the periods of his work, the Fauve years have occasioned the most books, all of which discuss the works of Matisse's colleagues as well. The most important are Georges Duthuit, *Les fauves: Braque, Derain, van Dongen, Dufy, Friesz, Manguin, Marquet, Matisse, Puy, Vlaminck* (Geneva: Trois Collines, 1949), translated as *The Fauvist Painters*, Documents of Modern Art, no. 11 (New York: Wittenborn, 1950); Ellen Charlotte Oppler, "Fauvism Reexamined" (Ph.D. dissertation, Columbia University, 1969; rev., New York: Garland, 1976); John Elderfield, *The "Wild Beasts": Fauvism and Its Affinities* (New York: The Museum of Modern Art, 1976); Marcel Giry, *Le fauvisme: Ses origines, son évolution* (Fribourg: Office du Livre, 1981), translated as *Fauvism: Origins and Development* (New York: Alpine, 1982); Judi Freeman et al., *The Fauve Landscape* (New York: Abbeville, 1991); and Sarah Whitfield, *Fauvism* (London: Thames & Hudson, 1990). The artist's first major theoretical statement and its critical context are the subject of Roger Benjamin, *Matisse's "Notes of a Painter": Criticism, Theory, and Context, 1891–1908* (Ann Arbor, Mich.: UMI Research Press, 1987). His contemporaneous decorative commissions are studied in John Hallmark Neff, "Matisse and Decoration, 1906–1914: Studies of the Ceramics and the Commissions for Paintings and Stained Glass" (Ph.D. dissertation, Harvard University, 1974). The paintings and drawings he made in Morocco are extensively discussed in *Matisse in Morocco: The Paintings and Drawings, 1912–1913* (Washington, D.C.: National Gallery of Art, 1990). A useful introduction to the still insufficiently explored subject of Matisse's relation to Cubism is John Golding, *Matisse and Cubism* (Glasgow: University of Glasgow Press, 1978). For Matisse's work during the so-called Nice period, the essential pub-

lication is *Henri Matisse: The Early Years in Nice, 1916–1930* (Washington, D.C.: National Gallery of Art, 1986), but a full-scale narrative account is still needed. The early study by Elie Faure, Jules Romains, Charles Vildrac, and Léon Werth, *Henri-Matisse* (Paris: Georges Crès, 1920), is still fascinating as an apologia for Matisse's changed style. The artist's principal model and assistant during the 1930s has published indispensable documentary photographs and other materials, in Lydia Delectorskaya, *L'apparente facilité . . . : Henri Matisse—Peintures de 1935–1939* (Paris: Adrien Maeght, 1986), translated as *With Apparent Ease . . . : Henri Matisse—Paintings from 1935–1939* (Paris: Adrien Maeght, 1988). For the 1940s, which have received little attention, the best introductions are two special issues of the magazine *Verve*, which had the artist's own collaboration: *Henri Matisse: De la couleur* (vol. 4, no. 13 [November 1945]) and *Vence, 1944–48*, ed. Tériade (vol. 6, nos. 21–22 [1948]). The chapel at Vence is the subject of Henri Matisse, *Chapelle du Rosaire des dominicaines de Vence* (Vence, 1951; Paris: France-Illustration, 1951); and Norbert Calmels, *Matisse: La chapelle du Rosaire des dominicaines de Vence et de l'espoir* (Digne: Morel, 1975). It, too, awaits detailed study.

Of the many publications on specialized thematic issues, only a few can be mentioned. Alan Bowness, *Matisse and the Nude* (Lausanne and Paris: Éditions Rencontre; UNESCO, 1969), is a sympathetic short account of a subject that badly requires attention. Jack D. Flam, "Matisse and the Fauves," in William Rubin, ed., *"Primitivism" in Twentieth-Century Art: Affinity of the Tribal and the Modern*, vol. 1 (New York: The Museum of Modern Art, 1984), is now the essential study of this important topic. A great deal of fascinating material is collected in Pierre Schneider, *Henri Matisse: Matisse et l'Italie* (Venice: Museo Correr, 1987). The ramifications of a single motif are explored in Theodore Reff, "Matisse: Meditations on a Statuette and Goldfish," *Arts Magazine*, vol. 51, no. 3 (November 1976), pp. 109–15; and Isabelle Monod-Fontaine, *Matisse: Le rêve, ou les belles endormies* (Paris: Adam Biro, 1989); and that of a single picture in Dominique Fourcade, "Rêver à trois aubergines," *Critique*, vol. 30, no. 324 (May 1974), pp. 467–89; Dominique Fourcade, "Greta Prozor: Henri Matisse," *Cahiers du Musée national d'art moderne*, no. 11 (1983), pp. 101–07; and Margaret Werth, "Engendering Imaginary Modernism: Henri Matisse's *Bonheur de vivre*," *Genders*, no. 9 (Fall 1990), pp. 49–74. Among the specialized critical overviews, of great interest are Clement Greenberg, "Matisse in 1966," *Boston Museum Bulletin*, vol. 64, no. 336 (1966), pp. 66–76; Marcelin Pleynet, "Le système de Matisse," in *Système de la peinture* (Paris: Seuil, 1977), translated as "Matisse's System (Introduction to a Program)," in *Painting and System* (Chicago and London: University of Chi-

cago Press, 1984); *Henri Matisse: Das goldene Zeitalter* (Bielefeld: Kunsthalle, 1981); W. S. Di Piero, "Matisse's Broken Circle," *The New Criterion*, vol. 6, no. 9 (May 1988), pp. 25–35; and Yve-Alain Bois, "Matisse and 'Arche-drawing,'" in his *Painting as Model* (Cambridge, Mass., and London: MIT Press, 1990). And among the biographical reminiscences these especially should be consulted: Janet Flanner, *Men and Monuments* (New York: Harper & Brothers, 1957); Jane Simone Bussy, "A Great Man," *The Burlington Magazine*, vol. 128, no. 995 (February 1986), pp. 80–84; and Françoise Gilot, *Matisse and Picasso: A Friendship in Art* (New York: Doubleday, 1990).

OTHER MEDIUMS. Early, important publications on Matisse's drawings include *Cinquante dessins par Henri Matisse* (Paris: Galerie Bernheim-Jeune, 1920) and Waldemar George, *Dessins de Henri-Matisse* (Paris: Quatre Chemins, 1925). The early drawings are the subject of William John Cowart III, "'Ecoliers' to 'Fauves': Matisse, Marquet, and Manguin Drawings: 1890–1906" (Ph.D. dissertation, Johns Hopkins University, 1972). And there are catalogues of two important collections: *Henri Matisse: Dessins—Collection du Musée Matisse* [Nice-Cimiez] (Paris: Adrien Maeght, 1989), no. 6 in the series *Cahiers Henri Matisse;* and Dominique Szymusiak, *Dessins de la donation Matisse* (Le Cateau-Cambrésis: Musée Matisse, 1988). The essential publications, however, are three exhibition catalogues, the third of which is also a book-length study: Victor I. Carlson, *Matisse as a Draughtsman* (Baltimore: The Baltimore Museum of Art, 1971); *Henri Matisse: Dessins et sculpture* (Paris: Musée National d'Art Moderne, 1975); and John Elderfield, *The Drawings of Henri Matisse* (London: Arts Council of Great Britain; Thames & Hudson, 1984).

Many publications exist on Matisse's printed works. The standard references are Marguerite Duthuit-Matisse and Claude Duthuit, eds., *Henri Matisse: Catalogue raisonné de l'oeuvre gravé*, in collaboration with Françoise Garnaud, Preface by Jean Guichard-Meili, 2 vols. (Paris, 1983); and Claude Duthuit, ed., *Catalogue raisonné des ouvrages illustrés*, in collaboration with Françoise Garnaud, Preface by Jean Guichard-Meili (Paris, 1987). These are usefully supplemented by William S. Lieberman, *Matisse: Fifty Years of His Graphic Art* (New York: Braziller, 1956); *Matisse: L'oeuvre gravé* (Paris: Bibliothèque Nationale, 1970); *Henri Matisse, 1869–1954: Gravures et lithographies* (Fribourg: Musée d'Art et d'Histoire, 1982); John Neff, "Henri Matisse: Notes on His Early Prints," in *Matisse Prints from The Museum of Modern Art* (Fort Worth: The Fort Worth Art Museum; New York: The Museum of Modern Art, 1986), pp. 17–24; and Margrit Hahnloser, *Matisse: Meister der Graphik* (1987), translated as *Matisse: The Graphic Work* (New York: Rizzoli, 1988).

The fullest study of the sculpture is Albert E.

Elsen, *The Sculpture of Henri Matisse* (New York: Abrams, 1972). Much remains to be done in this area, however, including the establishment of an accurate chronology. Nevertheless, there are some excellent and useful studies. Among these are Alicia Legg, *The Sculpture of Matisse* (New York: The Museum of Modern Art, 1972); William Tucker, *The Language of Sculpture* (London: Thames & Hudson, 1974), an insightful view by a sculptor, which should be supplemented with the same author's "Matisse's Sculpture: The Grasped and the Seen," *Art in America*, vol. 63, no. 4 (July–August 1975), pp. 62–66; *Henri Matisse: Dessins et sculpture* (1975; see above), an essential catalogue; the fascinating comparative study, Michael P. Mezzatesta, *Henri Matisse, Sculptor / Painter: A Formal Analysis of Selected Works* (Fort Worth: Kimbell Art Museum, 1984); and Isabelle Monod-Fontaine, *The Sculpture of Henri Matisse* (London: Arts Council of Great Britain, 1984), a full-length study as well as an exhibition catalogue. Two recent, well-illustrated catalogues are Xavier Girard and Sandor Kuthy, *Henri Matisse, 1869–1954: Skulpturen und Druckgraphik / Sculptures et gravures* (Bern: Kunstmuseum, 1990); and Ernst-Gerhard Güse, ed., *Henri Matisse: Zeichnungen und Skulpturen* (Munich: Prestel, 1991), translated and abridged as *Henri Matisse: Drawings and Sculpture* (Munich: Prestel, 1991). The plasters for Matisse's *Back* sculptures are published in *Matisse: Les plâtres originaux des bas-reliefs—Dos I, II, III, IV*, Introduction by Dominique Szymusiak, catalogue by Isabelle Monod-Fontaine (Le Cateau-Cambrésis: Musée Matisse, 1989); and sculptures in early exhibitions are identified and discussed in Roger Benjamin, "L'arabesque dans la modernité: Henri Matisse sculpteur," in *De Matisse à aujourd'hui: La sculpture du XXe siècle dans les Musées et du Fonds régional d'art contemporain du Nord-Pas-de-Calais* (Le Cateau-Cambrésis: Musée Matisse 1992), pp. 15–22.

The early publications on the cutouts, still worth consulting, are "Dernières oeuvres de Matisse, 1950–1954," *Verve*, vol. 9, nos. 35–36 (July 1958); *Henri Matisse, 1950–1954: Les grandes gouaches découpées* (Bern: Kunsthalle, 1959); *Henri Matisse: Les grandes gouaches découpées* (Paris: Musée des Arts Décoratifs, 1961); and *The Last Works of Henri Matisse: Large Cut Gouaches* (New York: The Museum of Modern Art, 1961). However, the essential work is the catalogue by Jack Cowart, Jack D. Flam, Dominique Fourcade, and John Hallmark Neff, *Henri Matisse: Paper Cut-Outs* (St. Louis: The St. Louis Art Museum, 1977). Two recent, general studies of these works are John Elderfield, *The Cut-Outs of Henri Matisse* (New York: Braziller, 1978) and Jean Guichard-Meili, *Les gouaches découpées de Henri Matisse* (Paris: Fernand Hazan, 1983) translated as *Henri Matisse: Paper Cut-Outs* (London: Thames & Hudson, 1984).

Acknowledgments

An exhibition of this scale and ambition owes its existence to the assistance and collaboration of a great number of individuals and institutions. We have been most fortunate in the extraordinarily generous help that we have received, and the good will with which it has been given.

Our first debt of gratitude is to the museums, foundations, and private collectors who, by graciously consenting to the loan of works of exceptional importance, have made possible the realization of the exhibition. Those lenders who allowed us to publish their names are listed on page 475. But we want to add here our deepest thanks to all of them for their generosity and their contribution to public knowledge and enjoyment.

Among our colleagues in other institutions, we are especially indebted to the directors, curators, and administrators of two institutions which, along with The Museum of Modern Art, own preeminent public collections of Matisse's work. At The Hermitage Museum, St. Petersburg, we were fortunate to have the essential support of Vitaly Souslov; also the collaboration of Albert Kostenevich, who has been a strong advocate of our cause and outstanding in his commitment to understanding of Matisse's work, and of Larissa Doukelskaya, Irina Novoselskaya, and Michail Piotrovski, also most amicable colleagues. At the Musée National d'Art Moderne, Centre Georges Pompidou, Paris, we owe particular thanks to Dominique Bozo, who made truly unusual efforts to make this project possible; also to Marion Julien and Martine Silie. We have worked particularly closely with Isabelle Monod-Fontaine and Dominique Fourcade, co-organizers of the exhibition of Matisse's works from 1904 through 1917 that will be shown at the Centre Pompidou after our own exhibition in New York. They have immeasurably assisted our efforts; it has been a very great pleasure to have been able to rely on their friendship, expertise, and professional support.

No Matisse exhibition is possible without the collaboration of the heirs of Henri Matisse. This has been an especially complicated undertaking, requiring exceptional arrangements. We are therefore most fortunate to have had the commitment of especially Claude and Barbara Duthuit and of Mrs. Pierre Matisse; also of Mme Jean Matisse, Mme Alexina Duchamp, Jacqueline Matisse Monnier, Paul Matisse, Pierre-Noël Matisse, and Gérard Matisse. We thank them all most sincerely for their efforts on our behalf.

Many museums have made special concessions so that crucial pictures could be included in the exhibition. We owe an enormous debt of gratitude especially to the major public repositories of Matisse's work, each of which has sacrificed a large group of its most prominent holdings in order to ensure our full representation of the artist's development. In addition to our colleagues in St. Petersburg and Paris, the following made extraordinary efforts on our behalf: At The Pushkin Museum of Fine Arts, Moscow, which has generously allowed us to borrow essential works, we are most grateful for the collaboration of Irina Antonova and of Alla Butrova and Marina Bessanova. At the Baltimore Museum of Art, whose Cone Collection is indispensable to a comprehensive understanding of Matisse's art, we are deeply indebted to Arnold

L. Lehman and to Brenda Richardson and Jay M. Fisher. At the Statens Museum for Kunst, Copenhagen, which took special measures to allow the superlative Matisses in the J. Rump Collection finally to be exhibited outside its doors, we thank most sincerely Villad Villadsen. At The Art Institute of Chicago, whose exceptional generosity has extended to allowing the pivotal *Bathers by a River* to travel for the first time, we are especially grateful to James N. Wood and to Charles F. Stuckey and Douglas W. Druick. At the San Francisco Museum of Modern Art, which through a special dispensation made it possible for us to extend our already considerable request to include works from the recent Elise S. Haas Bequest, we thank John R. Lane for his commitment to our work. At the Philadelphia Museum of Art, which accorded us unlimited access to its great collection, we owe an enormous debt of gratitude to Anne d'Harnoncourt. At the Musée de Grenoble, which lent generously from the Agutte-Sembat bequest, we thank most sincerely Serge Lemoine. At the Hirshhorn Museum and Sculpture Garden, Smithsonian Institution, Washington, D.C., from which many of the sculptures are borrowed, we are deeply grateful to James T. Demetrion. At the Tate Gallery, London, from whose collection a group of indispensable works is borrowed, we thank Nicholas Serota for his exceptional generosity. Additionally, the two museums devoted to Matisse's work have allowed crucial works to be included in our exhibition. We thank most sincerely Dominique Szymusiak at the Musée Matisse, Le Cateau-Cambrésis, and Xavier Girard at the Musée Matisse, Nice-Cimiez, for their generous support.

Other museum directors and curators to whom special thanks are due for crucial loans include: At the Kunstmuseum Basel, Christian Geelhaar and Dieter Koepplin; at the Kunstmuseum Bern, Hans Christoph von Tavel; at the Isabella Stewart Gardner Museum, Boston, Anne Hawley and Hilliard T. Goldfarb; at the Museum of Fine Arts, Boston, Alan Shestack; at the Musées Royaux des Beaux-Arts de Belgique, Brussels, Elaine de Wilde; at the Albright-Knox Art Gallery, Buffalo, New York, Douglas G. Schultz; at the Fitzwilliam Museum, Cambridge, England, Simon Jervis; at The Fogg Art Museum, Harvard University Art Museums, Cambridge, Massachusetts, James Cuno; at the Australian National Gallery, Canberra, Betty Churcher and Michael Lloyd; at The Cleveland Museum of Art, Evan H. Turner; at the Museum Ludwig, Cologne, Siegfried Gohr; at the Columbus Museum of Art, Ohio, Merribel Parsons; at the Dallas Museum of Art, Richard R. Bretell and Susan J. Barnes; at The Detroit Institute of Arts, Samuel Sachs II and Jan van der Marck; at the Kunstsammlung Nordrhein-Westfalen, Düsseldorf, Armin Zweite; at the Scottish National Gallery of Modern Art, Edinburgh, Timothy Clifford and Richard Calvocoressi; at the Museum Folkwang, Essen, Georg W. Költzsch; at the Stadelsches Kunstinstitut, Frankfurt, Klaus Gallwitz; at the Weatherspoon Art Gallery, Greensboro, North Carolina, Ruth K. Beesch; at the Wadsworth Atheneum, Hartford, Patrick McCaughey; at The Menil Collection, Houston, Dominique de Menil, Walter Hopps, and Paul Winkler; at The Museum of

Fine Arts, Houston, Peter C. Marzio and Alison de Lima Greene; at The National Gallery, London, Neil MacGregor and John Leighton; at the Los Angeles County Museum of Art, Earl A. Powell III; at The Minneapolis Institute of Arts, Evan M. Maurer; at the Musée Fabre, Montpellier, Aneth Jourdan; at the Yale University Art Gallery, New Haven, Connecticut, Mary Gardner Neill, Sasha Newman, and Richard Field; at The Brooklyn Museum, New York, Robert T. Buck and Sarah Faunce; at the Solomon R. Guggenheim Museum, New York, Thomas Krens; at the Metropolitan Museum of Art, New York, Philippe de Montebello and William S. Lieberman; at The Chrysler Museum, Norfolk, Virginia, Robert H. Frankel; at the Nasjonalgalleriet, Oslo, Knut Berg and Tone Skedsmo; at the National Gallery of Canada, Ottawa, Shirley L. Thomson; at the Musée d'Art Moderne de la Ville de Paris, Suzanne Page; at the Musée Picasso, Paris, Gérard Regnier; at the Musée de l'Orangerie, Paris, Michel Hoog; at The Carnegie Museum of Art, Pittsburgh, Phillip M. Johnston; at the Museum of Art, Rhode Island School of Design, Providence, Franklin W. Robinson; at The St. Louis Art Museum, James D. Burke; at the Washington University Gallery of Art, St. Louis, Joseph D. Ketner; at the Museu de Arte de São Paulo, Fabio Magalhaes; at the Everhart Museum, Scranton, Pennsylvania, Kevin O'Brien and Barbara Rothermel; at the Kunstmuseum Solothurn, André Kamber; at the Moderna Museet, Stockholm, Bjorn Springfeldt; at the Staatsgalerie, Stuttgart, Peter Beye and Karin Frank von Maur; at The Toledo Museum of Art, Ohio, David Steadman; at the Tikanoja Art Gallery, Vaasa, Finland, Anne-Maj Salin; at The Vatican Museums, Carlo Pietrangeli; at the National Gallery of Art, Washington, D.C., J. Carter Brown, Jack Cowart, and Andrew Robison; at The Phillips Collection, Washington, D.C., Laughlin Phillips and Eliza Rathbone; at the Norton Gallery and School of Art, West Palm Beach, Florida, Christina Orr-Cahall; at the Kunsthaus Zug, Switzerland, Matthias Haldemann; at the Kunsthaus Zürich, Felix Baumann and Christian Klemm.

This undertaking has drawn upon the expertise of many scholars. In addition to Isabelle Monod-Fontaine and Dominique Fourcade, I am especially indebted to Jack Flam, who has given liberally of his time and profound knowledge of Matisse. He has made a most important contribution to this project. Among those others who have given freely of their knowledge, and to whom I owe my deepest thanks, are: Roger Benjamin, Catherine C. Bock-Weiss, Jack Cowart, Judi Freeman, John Golding, the late Sir Lawrence Gowing, Lanier Graham, Margrit Hahnloser-Ingold, Alicia Legg, William S. Lieberman, John Rewald, William Rubin, Pierre Schneider, Charles F. Stuckey, William Tucker, and Sarah Whitfield. I am additionally grateful for the gracious assistance of Mme Lydia Delectorskaya. Special thanks are additionally due to Wanda de Guébriant of the Archives Henri Matisse. Needless to say, we have also benefited from many other scholars' work. Books and articles we frequently consulted are listed in the Bibliographical Note.

Numerous individuals have been instrumental in helping us trace and secure crucial loans. Here,

we owe a special debt of gratitude to Irène Bizot, William S. Lieberman, and John Rewald, who selflessly made great efforts in our behalf; also to Peter G. Peterson, for his help in one particularly complicated issue. Additionally, we are deeply obliged to: Thomas Ammann, Alexander Apsis, Ernst Beyeler, Heinz Berggruen, John Berggruen, Richard Calvocoressi, Camilla Cazalet, Desmond Corcoran, Barbara Divver, Walter Feichenfeldt, Richard Feigen, Thomas Gibson, Chieko Hasegawa, Catherine Hodgkinson, Carroll Janis, Paul Josefowitz, Jan Krugier, Ellen Kyriazi, Gilbert Lloyd, Jason McCoy, Stephen Mazoh, David Nash, Geoffrey Parton, Manuel Schmit, Martin Summers, John Tancock, Alain Tarica, Eugene V. Thaw, and Daniel Varenne. For help in facilitating loans we are grateful to: Monique Beudert, Frances Chaves, Gunnar Dahl, Owen Hungerford, Elizabeth Kujawski, Meg Perlman, Bertha Saunders, Colette Tanaka, and Jennifer Wells.

We owe generous thanks for their interest and support to Patrick Talbot and Annie Cohen-Solal. And we owe a special word of thanks to Francis X. Clines for his hospitality in Moscow.

We owe a particular debt of gratitude to William R. Acquavella, upon whose expertise we relied throughout the project, and who has offered much assistance in conjunction with our application for U.S. Government indemnification. We are grateful to him for valuable information provided by his gallery and to the assistance of Duncan MacGuigan and Jean Edmonson.

For their patience and assistance in providing detailed information for our catalogue, our thanks are extended to: Laurence Berthon, Mme Jacqueline George Besson, Jeanne Bouniort and Bernard Piens, François Chapon, Courtney Donnell, Andrea Farrington, Michael Cowan Fitzgerald, Thomas K. Frelinghuysen, Colette Giraudon, Dr. Bonnie Hardwick, Alice Lefton, Bernard LeLoup, Robert S. Lubar, Sylvie Maignan, Julie Martin and Billy Klüver, Fundacio Pilar i Joan Miró a Mallorca and members of the Miró family, Trygve Nergaard, Robert E. Parks, Anne Lise Rabben, Naomi Sawelson-Gorse, Hélène Seckel, Susan Sinclair, Anne Slimmon, Will Stapp, Mme Odette Traby, Laurie Wilson, and Celine Wormdal. We also owe a debt of gratitude to Dr. Theodore Feder of Artists Rights Society, New York, for his cooperation in this project, and to Leslie Pockel, for arranging much-needed photography on short notice.

The preparation of the exhibition and publication has drawn upon the resources of virtually every department in The Museum of Modern Art. My foremost thanks go to the Director of the Museum, Richard E. Oldenburg, who has supported this extremely complex project with enthusiasm and conviction and has supervised its administration with characteristic vision, diplomacy, and skill. I am profoundly grateful for his personal encouragement and support. And I am additionally indebted to Ethel Shein, Executive Assistant to the Director, who has contributed to the realization of the project in a variety of ways, not least by her advice and counsel, and to Bonnie Weissblatt, for cheerfully accepting the additional burdens it imposed.

James S. Snyder, Deputy Director for Planning and Program Support, played a crucial role in the administration of the project. He skillfully coordinated its overall planning and was particularly involved in the negotiations with our colleagues in

Russia and Paris that made the exhibition a possibility. It has been a pleasure to have had his tireless, enthusiastic support and wise counsel throughout the long and often difficult period during which the exhibition was initiated and prepared. The same is true of Richard L. Palmer, Coordinator of Exhibitions, who has been sorely tried by the extraordinary scope of this project but who has, nevertheless, superbly managed its intricate logistics with characteristic conscientiousness and expertise. He has been ably assisted by Eleni Cocordas, who attended to many important administrative concerns, as well as by Rosette Bakish.

Very particular thanks are due to the Museum's Secretary and General Counsel, Beverly M. Wolff. Too few people will ever know the extraordinarily important role she played in the realization of the exhibition and publication. I and the Museum owe her a great debt of gratitude. In her office, we also thank most sincerely Carol Rosenfeld, who supported her in her work, as well as Charles Danziger, who made a most crucial contribution.

Sue B. Dorn, Deputy Director for Development and Public Affairs, has worked tirelessly to enlist support for this exhibition in an economic climate that makes exhibitions like this even more difficult to realize. We thank her for her invaluable efforts, and we thank too Daniel Vecchitto, Director of Development, James Gara, Director of Finance, and William Fellenberg, Director of Membership, who have been deeply involved in, respectively, the funding, financial planning, and membership aspects of the whole project.

To my colleagues, the directors of the other curatorial departments in the Museum, goes my deep appreciation for their disinterested generosity in supporting so enthusiastically a project that caused them innumerable inconveniences. I am especially indebted to Kirk Varnedoe, Director, Department of Painting and Sculpture, whose support was indispensable. He has facilitated the exhibition in numerous ways: most importantly by agreeing to dismantle the entire permanent collection of painting and sculpture so that the exhibition could occupy its galleries on the second and third floors of the Museum; and by agreeing to make many reciprocal loans of paintings to other institutions, thus making possible crucial loans to the exhibition which otherwise would have been unobtainable. Through these extraordinary gestures, he helped us create an exhibition of such scope and size. Needless to say, these efforts required complex curatorial and administrative support; for this, we are mainly indebted to the professionalism and good will of Cora Rosevear. Also in the Department of Painting and Sculpture, I am most grateful to Kynaston McShine and Carolyn Lanchner for their sympathetic understanding, counsel, and support; also to Laura Rosenstock, and to Susan Bates, Fereshteh Daftari, and Victoria Garvin, who helped the project in different ways. And I owe a particular debt of gratitude to William Rubin, Director Emeritus, Department of Painting and Sculpture, who first provided the opportunity for me to work on Matisse projects at the Museum and who was deeply encouraging of this particularly ambitious endeavor.

I am indebted to Riva Castleman in two broad ways: in her role as Deputy Director of Curatorial Affairs, she has advised on the interdepartmental aspects of the planning of the exhibition; in her role as Director of the Department of Prints and Illustrated Books, she is a generous lender to the exhibi-

tion, aided in this by Wendy Weitman. The Department of Photography has helped us obtain photographs of Matisse for the catalogue, and we are grateful to Peter Galassi, its Director, and to Susan Kismaric and Grace M. Mayer. Those few members of the Department of Drawings who were not specifically enrolled in this project, especially Bernice Rose and Magdalena Dabrowski, deserve our thanks for putting up with the constantly encroaching demands of our work on the space and time of the entire department.

A considerable burden has been assumed by the Department of Registration. Diane Farynyk, Registrar, assisted chiefly by Ramona Bannayan, has smoothly and skillfully coordinated a daunting volume of shipping and in-house transportation of works of art. Thanks are also due to Aileen Chuk, Tina DiCarlo, and Sarah Tappen, as well as to Eleanor Belich and Peter Russell. The Department of Conservation deserves deep appreciation for the scrupulous care and attention they have given to loans coming to this exhibition, and additionally, for having agreed to undertake cleaning of certain crucial Matisses in our own collection. For this, I am especially grateful to Antoinette King, Director of Conservation, and James Coddington, our principal painting conservator, as well as to Anny Aviram, Karl Buchberg, Patricia Houlihan, and Carol Stringari. The installation of the exhibition, and the relocation of the Museum's collection that this required, would not have been possible without Jerome Neuner, who planned the complex arrangements thus necessitated and offered invaluable help in technical aspects of the installation. We thank him for his professionalism and ingenuity as well as for his patience.

Jeanne Collins, Director of Public Information, has played an even larger role than usual; we are in her debt in numerous ways. She has been tireless, tactful, and graciously accommodating of the special demands the project has imposed. Among her staff, Jessica Schwartz, with Holly Evarts, Christopher Lyon, Lucy O'Brien, and Trudy Rosato, also have our deep thanks for their efforts in finding the broadest possible audience for the exhibition. Phillip Yenawine, Director of Education, and Emily Kies Folpe, have also been extremely helpful in planning and implementing the associated public programs. Dulce Jo Pike and her staff in the department of Visitor Services have had an extremely challenging and complicated task. So have Joan Howard and her staff in the Department of Special Events. We thank them all most sincerely for their efforts.

The preparation of this book has been an enormous task, and I am deeply grateful for the dedication of the Department of Publications. Osa Brown, its Director, accepted from the start that the exhibition should have a catalogue of the dimensions it merited and worked tirelessly to make it possible. Paul Gottlieb, President of Harry N. Abrams, Inc., the distributor of the book, also made an essential contribution, as did Nancy Kranz and Louise L. Chinn, Director of Retail Operations, assisted by Marisa Scali. It was my great fortune and great pleasure to work once again with James Leggio, who edited this extremely complex and demanding publication with enormous intelligence and skill. He has contributed countless improvements to every aspect of it. His patience and support with respect to an unusually complex chronology and a somewhat unconventional introductory essay are especially ap-

preciated. I would also like to offer particular thanks to Jody Hanson, for her extremely sensitive work on the design of the book. She has displayed extraordinary grace under the most demanding pressure. To her and to Michael Hentges, Director of Graphics, we owe a great debt. Timothy McDonough, Production Manager, has once again brought to bear all his accustomed professionalism in overseeing all phases of the book's production, most especially the making of the color plates. He, with Marc Sapir, and assisted by Rachel Schreck, is to be thanked most sincerely for making this book possible at all, given the almost impossible deadlines it enforced on them.

The Museum's Library has been extremely understanding of our need to preempt virtually its entire Matisse holdings for some three years. Our appreciation is due especially to Clive Phillpot, its Director, and to Janis Ekdahl and Eumie Imm. Likewise, the Museum's Archives have been particularly helpful. We thank Rona Roob for her support and for the assistance of Rachel Wild. And the Department of Rights and Reproductions most efficiently accepted the additional burdens we placed on its resources. We are most grateful to its Director, Richard L. Tooke; to Mikki Carpenter, for making the Museum's photographic archives available to us; to Andre Berryhill; and to Kate Keller and Mali Olatunji for producing the photographs we have used of works from the Museum's collection.

The chief burden of this project, however, has fallen on the curatorial and research team who worked directly with me in preparation of both exhibition and publication. The demands on their time, intelligence, professional commitment, and good will have been extraordinary. In the Department of Drawings, Mary Chan and Kathleen Curry have played especially crucial roles, and I owe to them my deepest thanks and my most profound admiration for what they have achieved. Mary Chan has worked with exemplary professionalism, performing detailed art-historical research as well as assuming a myriad of responsibilities, not the least of which was the assembling of transparencies for the catalogue. Kathleen Curry, with customary grace and efficiency, has applied her invaluable administrative and organizational talents to virtually every aspect of the project. Carolyn L. Maxwell undertook essential art-historical research and, with characteristic conscientiousness, displayed infinite patience in the many detailed tasks she cheerfully accepted. Catalogue information on Matisse's individual works, and information on his artistic development in the chronology, relied upon their extensive archival documentation. The project further profited by the researches of Wendy Wallace and by the assistance of Monica Tagliavia. And as the pressures increased, Catherine Truman joined the team to offer much-needed secretarial support, making a most helpful contribution in many areas.

The biographical aspects of the chronology included in the catalogue section of this book were researched by Judith Cousins, Research Curator, who brought to this task her unsurpassed professional diligence and ingenuity, and thereby uncovered materials crucially important to the project as a whole. I am deeply in her debt. She was aided in her work by Christel Hollevoet and Sharon Dec, both of whom made valuable contributions, the former in documentary research, the latter in photo research.

Of all those who have worked on this project, I must single out the contribution of Beatrice Kernan, to whom I and the realization of the project owe far more than I can possibly express. She has been a collaborator in the truest sense. She not only assumed an enormous administrative burden but was also intimately involved in the selection of the exhibition and the preparation of this publication. I have relied on her curatorial judgment and scholarly insight in establishing the scope of the exhibition and making the decisions to request individual works. Together, we prepared the catalogue section of this publication; researched the information it contains; and, with the indispensable collaboration of Judith Cousins, compiled the chronology. Without her professional knowledge and critical support, neither the exhibition nor this publication would have been possible.

Lastly: many personal friends have patiently suffered through my long preoccupation with this project. I want especially to thank Carl Belz, Jack Flam, and William O'Reilly for their encouragement and support. And I owe an immeasurable debt to Jill Moser, my wife, for her insights as a painter into the questions I have endlessly discussed with her, as well as for her forbearance in the face of a professional schedule that has been demanding, to say the least. However, one friend as well as colleague is especially to be acknowledged here: my assistant, Kevin Robbins, whose recent, untimely death is a great loss to all who knew him. I, and the Museum, owe him a great debt. He lent an unfailing enthusiasm to this project, as to everything he did. His involvement in the project far exceeded his customary administrative responsibilities. I wish he could have seen this volume and the exhibition.

J.E.

LENDERS TO THE EXHIBITION

The Baltimore Museum of Art

Oeffentliche Kunstsammlung Basel,
Kunstmuseum

Kunstmuseum Bern

Isabella Stewart Gardner Museum, Boston

Museum of Fine Arts, Boston

Musées Royaux des Beaux-Arts de Belgique,
Brussels

Albright-Knox Art Gallery, Buffalo, New York

The Syndics of the Fitzwilliam Museum,
Cambridge

The Fogg Art Museum, Harvard University Art
Museums, Cambridge, Massachusetts

Australian National Gallery, Canberra

Musée Matisse, Le Cateau-Cambrésis

The Art Institute of Chicago

The Cleveland Museum of Art

Museum Ludwig, Cologne

Columbus Museum of Art, Ohio

Statens Museum for Kunst, Copenhagen

Dallas Museum of Art

The Detroit Institute of Arts

Kunstsammlung Nordrhein-Westfalen, Düsseldorf

Scottish National Gallery of Modern Art,
Edinburgh

Museum Folkwang, Essen

Städelsches Kunstinstitut, Frankfurt

Weatherspoon Art Gallery, Greensboro,
North Carolina

Musée de Grenoble

Wadsworth Atheneum, Hartford

The Menil Collection, Houston

The Museum of Fine Arts, Houston

The Trustees of The National Gallery, London

Tate Gallery, London

Los Angeles County Museum of Art

The Minneapolis Institute of Arts

Musée Fabre, Montpellier

The Pushkin Museum of Fine Arts, Moscow

Yale University Art Gallery, New Haven,
Connecticut

The Brooklyn Museum, New York

Solomon R. Guggenheim Museum, New York

The Metropolitan Museum of Art, New York

The Museum of Modern Art, New York

Musée Matisse, Nice-Cimiez

The Chrysler Museum, Norfolk, Virginia

Nasjonalgalleriet, Oslo

National Gallery of Canada, Ottawa

Musée d'Art Moderne de la Ville de Paris

Musée National d'Art Moderne, Centre Georges
Pompidou, Paris

Musée de l'Orangerie, Paris

Musée Picasso, Paris

Philadelphia Museum of Art

The Carnegie Museum of Art, Pittsburgh

Museum of Art, Rhode Island School of Design,
Providence

The St. Louis Art Museum

Washington University Gallery of Art, St. Louis

The Hermitage Museum, St. Petersburg

San Francisco Museum of Modern Art

Museu de Arte de São Paulo

Everhart Museum, Scranton, Pennsylvania

Kunstmuseum Solothurn

Moderna Museet, Stockholm

Staatsgalerie, Stuttgart

The Toledo Museum of Art, Ohio

Tikanoja Art Gallery, Vaasa, Finland

The Vatican Museums

Hirshhorn Museum and Sculpture Garden,
Smithsonian Institution, Washington, D.C.

National Gallery of Art, Washington, D.C.

The Phillips Collection, Washington, D.C.

Norton Gallery and School of Art, West Palm
Beach, Florida

Kunsthaus Zug, Switzerland

Kunsthaus Zürich

Alsdorf Collection

Mrs. Maruja Baldwin

Beyeler Collection

Mrs. William A. M. Burden

The Colin Collection

The Jacques and Natasha Gelman Collection

Stephen Hahn

Alex Hillman Family Foundation

Dr. and Mrs. Arthur E. Kahn

Mr. and Mrs. Herbert Kasper

Mr. and Mrs. Herbert J. Klapper

Jan Krugier Gallery, Geneva

Mollie Parnis Livingston

Alex Maguy

Mr. and Mrs. Donald B. Marron

Gaby and Werner Merzbacher

Mr. and Mrs. J. Irwin Miller

Mr. and Mrs. Gifford Phillips

The Phillips Family Collection

Corporate Art Collection, The Reader's Digest
Association, Inc.

The Duke of Roxburghe

Collection S

Richard L. Selle

Marion Smooke, Trustee of the Smooke Family
Revocable Trust

Vicci Sperry

Rudolf Staechelin Family Foundation

Mr. and Mrs. A. Alfred Taubman

Thyssen-Bornemisza Collection

Mrs. John Hay Whitney

An anonymous lender, courtesy Barbara Divver
Fine Art, New York

An anonymous lender, courtesy Ellen and Paul
Josefowitz, London

An anonymous lender, courtesy Stephen Mazoh
and Company, Inc., New York

An anonymous lender, Geneva, courtesy Daniel
Varenne Gallery, Geneva

35 other anonymous lenders

CREDITS

The following list, keyed to page numbers, applies to photographs for which a separate acknowledgment is due:

Hélène Adant: 86, 132, 414 bottom center, 416 top right, 418 bottom, 419 bottom left and bottom right, 420 top right, bottom left, and bottom right. David Allison: 28, 158 bottom, 164, 228, 258, 315, 321, 323, 332, 335, 337, 406 top, 429 bottom, 433, 441, 452. ©1992 Artists Rights Society, New York/ ADAGP, Paris: 134 top left, 134 bottom, 293 top left. Courtesy ARTnews/ARTnews Associates: photograph by Hélène Adant, 87 bottom right. Artothek: photograph by Ursula Edelmann, 242. Reproduced from *The Arts*, 11 (January 1927): 294 right. The Baltimore Museum of Art: The Cone Archives, 137 top left and top right; six photographs sent by the artist to Etta Cone, in letters of September 19 and November 16, 1935: 360 bottom. The Bancroft Library, University of California, Berkeley: 414 top left, 414 top right, 415. ©1992 The Barnes Foundation, Merion Station, Pennsylvania: 55 top right, 153, 241 bottom left and bottom right, 359 top, 366 bottom. Photograph by George Besson, courtesy Madame George Besson: 290 top. ©1992 Gilberte Brassaï, all rights reserved: 356, 363 bottom left. The Brooklyn Museum, New York: photograph by Ellen Grossman, 156 bottom. Courtesy *Cahiers d'art*, Paris: 295 left. Copy print by Camera Photo, Venice; original photographer unknown: 416 top left. Archives Charles Camoin: 185 mid-right. Courtesy Cornell Capa: 417 bottom left. Prudence Cuming Assoc. Ltd, London: 354 top. Courtesy Maxwell Davidson Gallery, New York: photograph by Steven Tucker, 308 bottom. Courtesy Lydia Delectorskaya: 360 top left, 361 top left. Toni Dolinski: 450. Walter Dräyer, Zurich: 142 bottom. Ali Elai, Camerarts, Inc.: 117, 327. M. Lee Fatherree: 303. Thierry Froidevaux: 350. Isabella Stewart Gardner Museum, Boston: photograph by Heins, 125. Édition Giletta, Nice: 291 bottom left. Studio Patrick Goetelen, Geneva: 113, 344 top and bottom. ©The Solomon R. Guggenheim Foundation: photograph by David Heald, 272. Courtesy of the heirs of Walter Halvorsen, Oslo: 180 top right; photograph by Walter Halvorsen, 291 top left. Colorphoto Hans Hinz: 211, 326, 381, 406 bottom. Hirshhorn Museum and Sculpture Garden, Smithsonian Institution, Washington, D.C.: photographs by Lee Stalsworth, 45 bottom center, 87 top left, 154 bottom, 168, 188 top, 214 bottom, 344

right, 352 bottom, 368 bottom. Jacqueline Hyde: 25 top left, 94 bottom, 95, 96, 101, 104, 116, 355, 372, 379, 400, 446. Courtesy International Museum of Photography at George Eastman House, Rochester, New York: 236, 238 left and right, 239 top left, top right, and bottom right, 240 top center and top left. Bruce C. Jones: 39. Mikko Julkunen, Finland: 264 bottom. Keystone/Sygma: 293 bottom right. Mary Louise Krumrine Collection: 68 top center. Kunstmuseum Bern: photograph by Peter Lauri, Bern, 1991, 304, 334 bottom. Life Magazine, ©Time Warner Inc.: photograph by Dmitri Kessel, 419 top center. Copy print by Pierre-Louis Mathieu: 83 bottom. Courtesy Archives Henri Matisse, Paris: 83 top left, 84 top right, 136 bottom, 181 bottom right, 184 bottom. The Menil Collection, Houston: photograph by Robert Mates, 170. Claude Mercier Photographe: 393. The Metropolitan Museum of Art, New York: 158 top; ©1986, 222; ©1988–90, photographs by Malcolm Varon, 165, 171, 274. Musée Fabre, Montpellier: photograph by Fréderic Jaulmes, 92 bottom. Musée de Grenoble: 83 top right, 112 bottom, 202 bottom, 401 top, bottom left, and bottom right, 402 top left, top right, and bottom, 403 top and bottom, 404 top and bottom; photographs by André Morin, 160 bottom, 161, 218. Musée Matisse, Le Cateau-Cambrésis: photographs by Claude Gaspari, 114, 298. ©Musée National d'Art Moderne, Centre Georges Pompidou, Paris: 42 top left, 68 top right, 197, 268 top right, 270, 301, 342, 353, 375, 391, 395, 430, 435, 438, 440 bottom, 445, 457 top and bottom; photograph by Jacqueline Hyde, 91; photographs by Charles Bahier, Philippe Migeat, 85 bottom, 100, 105, 176, 247, 254, 256 top, 271, 275, 336, 407, 410, 432 bottom, 455, 460 bottom. Courtesy Musée National d'Art Moderne, Centre Georges Pompidou, Paris: 90, 94 top. Musées Royaux des Beaux-Arts de Belgique, Brussels: photograph by G. Cussac, 434. Museu de Arte de São Paulo: photograph by Luiz Hossaka, 316. The Museum of Modern Art, New York: photograph by Rudolph Burckhardt, 368 top; photographs by Kate Keller, 47 bottom right, 98 top, 109, 138 top and bottom, 154 top, 174, 193, 200 top, 216 top, 217, 219, 220, 226 top, 243, 245, 248, 253, 255, 259, 263, 266, 283, 296 bottom left, 307, 340 bottom, 341 top and bottom, 343, 345, 346 top, 370 middle and bottom, 371 top, middle, and bottom, 382, 422 top and middle, 423, 424 top and bottom, 425 top and bottom, 426 top and bottom, 427 top and bottom, 428 top and bottom, 448, 449, 466, 468; photographs by James Mathews, 46 top center, 53 top left, 80, 151 bottom, 183 bottom right, 202 top, 206 right, 250 top and right; photographs by Mali Olatunji, 265, 312 right, 330, 346 bottom, 369; photographs by Soichi Sunami, 45 bottom right, 47 bottom left, 64, 66, 108, 112 top, 150 top, 151 top, 166 top, 201, 206 top left and bottom left, 214 top left and top right, 250 bottom, 264 top, 297 bottom right, 370 top, 422 bottom, 440 top; photographs by Malcolm Varon, 462–63. Archives of The Museum of Modern Art, New York: 45 bottom left, 46 top left, 47 bottom center, 53 top right, 54 top right, 135 top, 180 top left, bottom right, 181 top center and center, 182 top center, bottom left, mid-

right and bottom right, 183 bottom left and top left, 184 top left and top right, 185 bottom left and bottom right, 240 bottom right, 241 top left and top right, 288, 292, 294 left, 295 right, 296 top left, 297 top, 358, 359 bottom, 361 top center, top right, and left center, 362 top left, top right, and bottom left, 412, 416 bottom left, 417 bottom right, 421; photograph by F. W. Murnau, 1930: 297 center; gift of Mrs. Annette Fry: 365 top left. Courtesy The Museum of Modern Art, New York: gift of Edward Steichen, 178; gift of Robert Capa, 417 top right. Nasjonalgalleriet, Oslo: photograph by Jacques Lathion, 188 bottom. National Gallery of Art, Washington, D. C.: 314 top, 331, 399, 451; photograph by Jose A. Naranjo, 431. Courtesy André Ostier, Paris: 365 bottom right. Paris-Match: photograph by Walter Carone, 364 top, 418 top, 420 top left. Douglas M. Parker: 429 top. Photographs by Albert Eugene Gallatin, courtesy Philadelphia Museum of Art, A. E. Gallatin Collection: 296 top right and bottom center. ©The Phillips Collection, Washington, D.C.: 277; photograph by Edward Owen, 443. Pilgrim Press Ltd., Derby, England: photograph by Hector Innes, 161 top. Eric Pollitzer, New York: 129, 130, 398. Antonia Reeve Photography, Edinburgh: 311. Courtesy of Alex Reid & Lefevre, London: 148, 396 top. R. and B. Reiter, Zurich: 276. ©Réunion des Musées Nationaux: 25 top right, 33, 43, 131, 172, 185 top left, 221, 281, 320, 347, 405 bottom. Rheinisches Bildarchiv, Cologne: 464. Rostand et Munier, Éditions d'Art, Nice, courtesy M. Guillot. Studio Nice: 290 bottom. Adam Rzepka: 432 top. San Francisco Museum of Modern Art: photographs by Ben Blackwell, 55 top left, 140 top left, bottom left, and bottom right, 146, 152, 268 left, 268 bottom right, 269; Don Myer, 194. Margery Schab: 126. Mario und Beatrix Schenker Fotostudio: 252. Statens Konstmuseer, Stockholm: 122 bottom; photographs by Tord Lund, 273 bottom, 348. Statens Museum for Kunst, Copenhagen: photographs by Hans Petersen, 54 top left, 141, 147, 162, 163, 177, 199, 226 bottom, 300, 454. Reprinted with the permission of Joanna T. Steichen: 182 top left. Jim Strong, Inc.: 122 top, 143. Copy print by Studio Madonnes, original photographer unknown: 82 right, 84 top left. Yoshio Takahashi: 24 top left, 63, 67, 107, 120, 144, 187, 189, 191, 192, 195, 198, 203, 207, 209, 210 top and bottom, 213, 232, 233, 246. ©Tate Gallery, London: 111, 134 bottom, 139; photographs by John Webb, 169, 284, 469. ©1969 Time-Life Books; original photographer unknown, copy print by Eddy van der Veen: 183 top right. Michael Tropea: 310 bottom, 408. Charles Uht, New York: 56. Original photographer unknown, copy print by Eddy van der Veen: 82 left. Malcolm Varon, New York: 118; ©1982, 149, 339. Atelier Walter Wachter: 128. Weatherspoon Art Gallery, North Carolina: photograph by C. Timothy Barkley, 110. John Webb: 142 top. Courtesy Tatiana Massine Weinbaum, New York: 363 top right. Yale University Art Gallery, New Haven, Connecticut: photographs by Michael Agee, 161 bottom, 354 bottom. Reprinted with the permission of Virginia M. Zabriskie, Galerie Zabriskie, Paris: 137 bottom.

INDEX OF PLATES

COLLATERAL WORKS

The following works, which appear as text illustrations, are cited by page number.

7100 025